PEERLESS IMAGES

Persian Painting and Its Sources

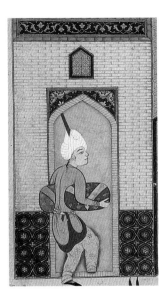

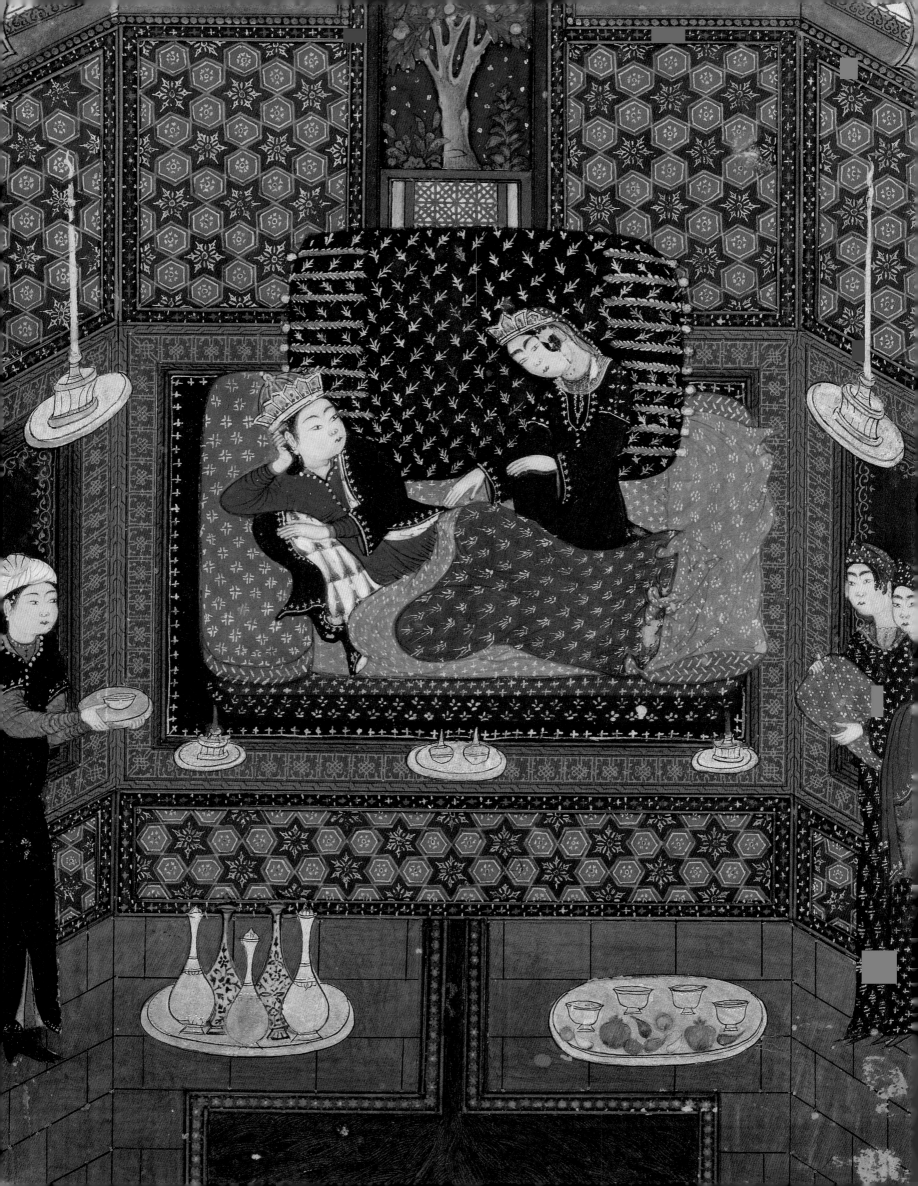

Peerless Images

PERSIAN PAINTING AND ITS SOURCES

Eleanor Sims

with Boris I. Marshak

and Ernst J. Grube

YALE UNIVERSITY PRESS

NEW HAVEN AND LONDON

*This book is dedicated to the memories of
Ida, who made it possible from the beginning,
and Deborah, who did not live to see it completed*

Copyright © 2002 by Hossein Amirsadeghi

Design: Richard Foenander, Sally Salvesen
Set in Monotype Bembo by SNP Best-set Typesetter Ltd.
Hong Kong
Printed in Singapore

LIBRARY OF CONGRESS CATALOGING–IN–PUBLICATION DATA

Sims, Eleanor.
Peerless images: Persian painting and its sources /
Eleanor Sims with Boris I. Marshak and Ernst J. Grube
p. cm.
Includes bibliographical references
ISBN 0 300 09038 2 (hardback : alk. paper)
1. Figurative painting, Iranian. I. Marshak, Boris I., 1933–
II. Grube, Ernst J. III. Title.
ND980 .S57 2002
757'.0955—DC21 2002004501

ILLUSTRATIONS
Half-title page: detail from "The Sufi in the Hamman," Number 111
Frontispiece: detail from "Bahram Gur and the Indian Princess in the Black Pavilion on Saturday," Number 115
Page 6: detail from "A Convivial Gathering at the Court of Sultan-Husayn Bayqara in Herat," Number 34
Page 10: detail from "The Portrait of Khusrau Shown to Shirin," Number 77

CONTENTS

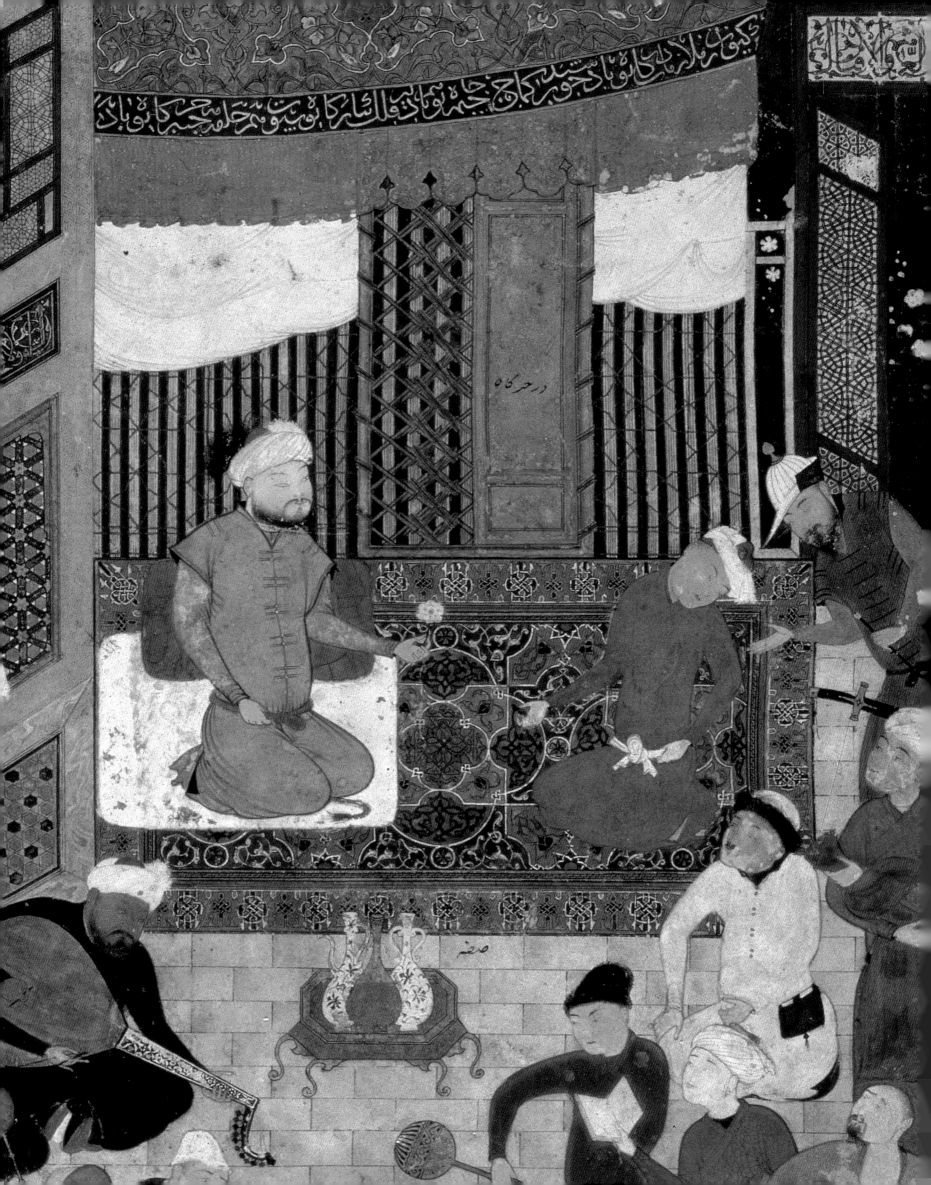

FOREWORD

The earliest historical mention of Persians appears in the annals of the Assyrian King Shalmaneser II in 836 BC. Throughout this long period in history, a Persian sense of cultural identity in political, social, religious, and artistic terms has resulted as much from adaptability as resistance. Herodotus, the Greek historian writing in the fifth century BC, remarked on the propensity of Persians to imitate peoples of other lands. This continuity in change is perhaps the most remarkable of its people's achievements.

Persian painting visually defines this historical characteristic, being so universally recognized. This art form has played a central role in Iranian culture, helping to weave its indigenous pre-Islamic past with Arab, Turkic and Mongol influences. It has produced an art form as dazzling as it is mystifying and intriguing.

For this and other reasons, I have wanted for some time now to explore these different themes within one cover, to create a magnificent book through the use of the storytelling medium of Persian painting. Not merely to highlight the glories of this important art form, but also to glimpse into the past, seeking insights into the lives of ordinary people behind extraordinary pictures. The book had to be a radical departure from all that has appeared on the subject in the last half-century, during which time the study of Persian painting has assumed an importance beyond recognition. It was to encompass the entire sweep of Persian history, from Neolithic times to the early twentieth century.

Having published *The Arts of Persia* with Yale University Press in 1989, I approached John Nicoll with my new project. Whilst intrigued by the idea, he was understandably skeptical at the scope of my ambitions: where were the scholars with the sweep of knowledge and expertise to undertake such a task, in an unorthodox and demanding manner? We managed to put the pieces together, but the journey has not been without adventure.

For me, this journey became a magic carpet ride through history in the company of heroes, princes and poets. It was a search for the unifying elements weaving a heritage rooted in a culture centered on the Iranian Plateau, whose creative origins date back some 7,000 years. It was a need to explain the resilience of a people who have withstood countless military invasions and cultural onslaughts, positioned as they have been at the very crossroads of civilization for so long.

How have Persians managed to overcome their misfortunes, conquering the conquerors, in turn civilizing threadbare cultures? Searching for the roots of Iranian genius, historians are at times vexed by stark contrasts: of courage, imagination and resourcefulness coupled with self-destructiveness. Love for the innate pleasures of life contrasting with physical austerity and national melancholy.

This rich and extravagant legacy is born as much from resignation as determination, where citizens have too often been eager to surrender their free will to despotism. Fashioned from fatalism and nurtured in fundamentalism, religion has often acted as a historical brake on cul-tural and social renewal, encouraging society's blame of others for all their ills.

Art, propaganda tool of faith and ideology, has suffered equally at the hands of such destructive traits. From the torture of Mani, the third-century prophet and legendary painter put to death by fundamentalist Zoroastrian clergy, to wholesale religious and dynastic cultural desecration wrought on Iranians from within and without in a turbulent history.

This history of Eranshahr (Greater Iran) has long held a fascination for me. The pull of tradition versus the push of modernism, the latter-day battle between East and West, took up much of my intellectual energy during formative years spent in Europe. What was an appropriate balance between the constraints of the old and the vitality of the new in a fast-changing world?

This stark dilemma has confronted Iranians since the break-up of the old historical order, beginning with the collapse of the Safavids in the early eighteenth century. The history of Persian painting is in itself a reflection of this eternal conundrum. At its peak, Persia has imposed its reach over some of the mightiest empires in history. At other times during its three-thousand-year history, Iran has stumbled and faltered. Despite these heartbreaking nadirs, the country's culture and ethos survived and prospered.

The history of Persian painting reveals an extraordinary degree of continuity in change, for painters in the Islamic period are heirs to an ancient pictorial tradition. As late as the mid-nineteenth century, an Isfahani painter could still sign his name to his work as "a man from the line of Mani." This book is a celebration of the spirit and genius of Iranian people and their culture.

In its realization, foremost tribute is due to Eleanor Sims. Her broad scholarship and inspiring writing combine to deliver the volume in its present form. To Professor Boris Marshak, my gratitude for his dedication in extending the bounds of knowledge, my thanks also to Professor Ernst Grube for his contribution.

John Nicoll at Yale University Press deserves equal thanks for patience and foresight. *Peerless Images* would not have been possible without qualities endured beyond the call of a publisher's duties. Yale's Sally Salvesen has also been instrumental as a strong editor, bringing all the strands together, bridging views, helping weave the tapestry of the book. A note of recognition to Ronald Ferrier, an old friend with whom I conceived *The Arts of Persia*, and who was present at the birth of *Peerless Images*. Many who have helped along the way remain nameless, but our book is the better for their thoughts and inspiration.

The final word belongs to Dr Sims herself who, corresponding at the start of work back in March 1996, wrote: "I feel that you have entrusted me with some deeply felt hopes and dreams on the subject." I believe that we have fulfilled those hopes and dreams.

Hossein Amirsadeghi
London, May 2002

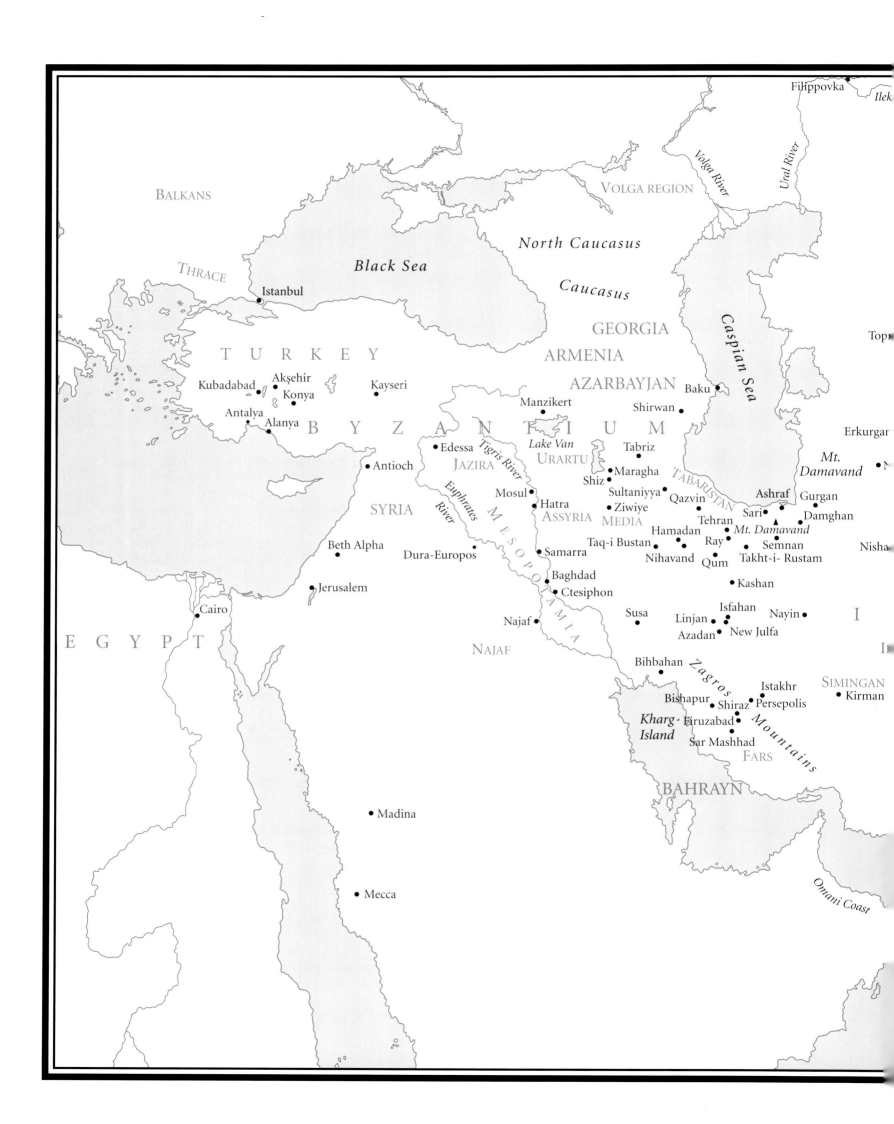

BALKANS

THRACE

Black Sea

North Caucasus

Caucasus

VOLGA REGION

Volga River

Ural River

Filippovka

Ilek

Istanbul

GEORGIA

ARMENIA

AZARBAYJAN

Caspian Sea

Top

T U R K E Y

Kubadabad

Akşehir

Konya

Kayseri

Baku

Shirwan

Erkurgar

Antalya

Alanya

B Y Z A N T I U M

Manzikert

Lake Van

Tabriz

Mt.
Damavand

N

Edessa

Tigris River

URARTU

Maragha

TABARISTAN

JAZIRA

Shiz

Ashraf

Gurgan

Antioch

SYRIA

*Euphrates
River*

Mosul

Hatra

ASSYRIA

Sultaniyya

Ziwiye

Qazvin

Sari

Damghan

MEDIA

Tehran

Mt. Damavand

Beth Alpha

Dura-Europos

M
E
S
O
P
O
T
A
M
I
A

Samarra

Taq-i Bustan

Hamadan

Ray

Nihavand

Qum

Semnan

Takht-i- Rustam

Nisha

Baghdad

Ctesiphon

Jerusalem

Cairo

Najaf

Susa

Linjan

Azadan

Isfahan

New Julfa

Nayin

Kashan

I

I

E G Y P T

NAJAF

Bihbahan

Zagros

Istakhr

SIMINGAN

Kirman

Bishapur

Shiraz

Persepolis

*Kharg
Island*

Firuzabad

Mountains

Madina

Sar Mashhad

FARS

BAHRAYN

Mecca

Omani Coast

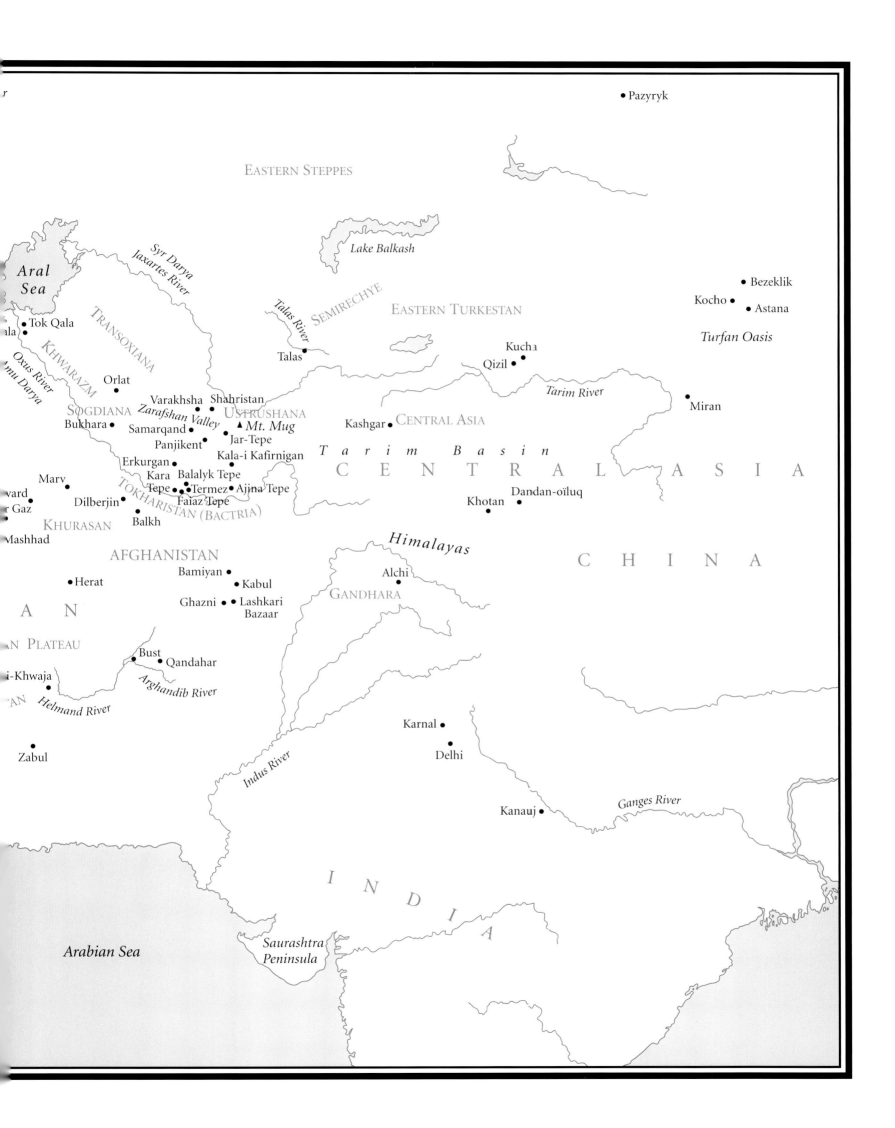

• Pazyryk

EASTERN STEPPES

Lake Balkash

Syr Darya
Jaxartes River

• Bezeklik
Kocho •
• Astana

Aral Sea

• Tok Qala

TRANSOXIANA

Talas River

SEMIRECHYE

EASTERN TURKESTAN

Turfan Oasis

KHWARAZM

• Orlat

Talas

Kucha

Oxus River

Qizil

Amu Darya

SOGDIANA

Varakhsha Shahristan

Zarafshan Valley

USTRUSHANA

Kashgar •

CENTRAL ASIA

Miran

Bukhara • Samarqand •

▲ *Mt. Mug*

Tarim River

Miran

Panjikent •

Jar-Tepe

T a r i m B a s i n

Erkurgan •

Kala-i Kafirnigan

C E N T R A L A S I A

Kara
Tepe • Balalyk Tepe
• Termez • Ajina Tepe
Faiaz Tepe

Marv •

vard

Dilberjin •

Dandan-oïluq

r Gaz

TOKHARISTAN (BACTRIA)

Khotan •

KHURASAN

Balkh •

Mashhad

Himalayas

C H I N A

AFGHANISTAN

Bamiyan •

Alchi •

• Herat

• Kabul

GANDHARA

Ghazni • • Lashkari
Bazaar

AN PLATEAU

Bust •

i-Khwaja

• Qandahar

Arghandib River

Karnal •

AN

Helmand River

Delhi •

• Zabul

Indus River

Kanauj •

Ganges River

Arabian Sea

I N D I A

*Saurashtra
Peninsula*

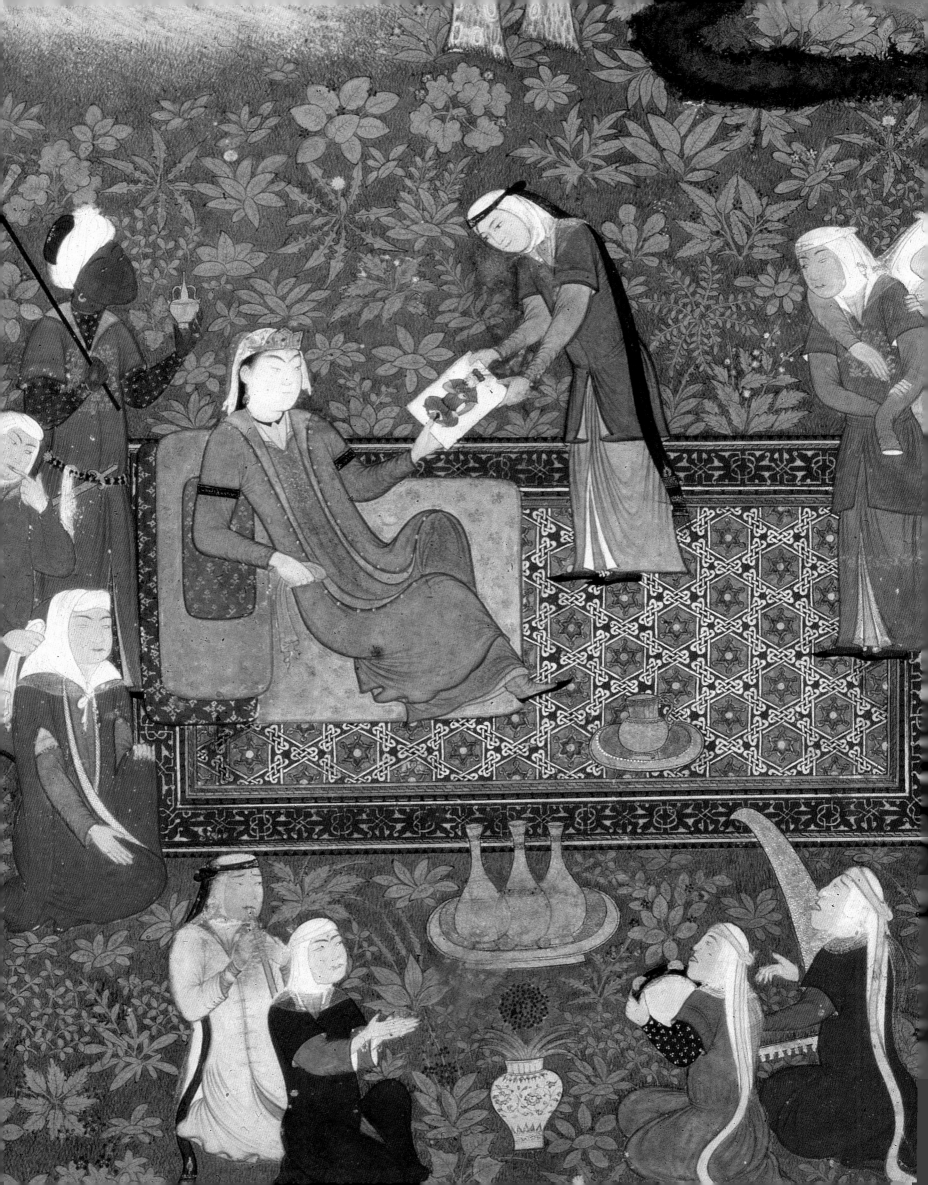

A NOTE TO THE READER

This volume – which should carry the subtitle, *Iranian Figural Painting and its Sources* – took shape from a challenge: to write a book on "Persian painting" from a new point of view. As I considered the possibilities and reviewed the literature on the subject that has marked the past century, I thought I might develop an approach that was not historical; instead I would shape the book by means of the themes displayed by the subjects of its illustrations. My very next thought was that such a book would not be limited to the Islamic period but would look at the phenomenon of Iranian painting from as early as it survives, and as recently as is still appropriate. Its scope would perforce be much broader, both chronologically and geographically, than most recent publications on the subject, and I should surely have to seek learned assistance.

Yet the more I thought about such an approach, the more possibilities it appeared to offer. In good part this is because the study of Iranian painting of all periods has progressed by leaps and bounds, especially during the past two decades; the outlines of its history are now well established. Publications of significant ensembles of paintings that have been revealed by excavations, and of collections of the arts of the book, both public and private, are now routine; monographs, however unevenly they yet cover the ground and however few are illustrated in color, appear with increasing frequency; stylistic questions no longer have the urgency they once possessed. The moment seemed ripe for a challenge by theme.

For certain thematic subjects are clearly fundamental to Iranian painting of whatever period, but especially to the illustration of classical Persian literature: battles and the duel, hunting scenes, feasting in the out-of-doors or in a palatial interior; just as certain figural types are standard protagonists – the hero, the noble prince, lovers and the aged crone who attends them, the beautiful and still-beardless youth, the bent and white-bearded sage or scholar. The settings in which these figures act are, more often than not, set-landscapes: the green and verdant garden with its perpetual spring-time blossoming trees, the boundless desert watered at the lower edge of a picture by a silver stream fringed by green and flowering foliage, the piled-up rock of fantastically colored mountains in which ibexes cavort and dragons snarl; and they are always shown under a clear blue sky or the burningly brilliant gold of a sunlit day, even when the event clearly takes place at night. All of these are *topoi*, archetypes, stock images – stock settings, to be more precise – as the figures are usually types and their activities typically predictable.

Thus, themes, types and *topoi* are the primary focus of this book and have essentially shaped its organization. Pictures are arranged in corresponding groups, and each is accompanied by a caption – a comment, a telling of the tale illustrated, or an essay which sets the picture into its thematic context. Their range is very wide. The images selected to illustrate the themes of Iranian figural painting may be as early as the fourth millennium BC and as late as the nineteenth century. Their geographical range is equally wide: they come both from what is the modern Republic of Iran as well as all the areas that have at times comprised "Iran proper," as Marshak writes, Eranshahr, as the Sasanians called it – a swathe of territory extending through modern Afghanistan and the post-Soviet states of Central Asia as far east as Western Turkestan, and as far west as modern 'Iraq, or Mesopotamia. Moreover, because illustrated manuscripts, single-figure drawings and paintings, or architectural murals are by no means the only examples of Iranian painting in the Islamic period, I have taken the liberty of extending the notion of "Iranian figural painting" to include examples of the medieval Muslim decorative arts. Painted ceramics and wood, carved stucco and stone, and even metalwork inlaid with precious metal may all display figural decoration reflecting now-lost examples of Islamic Iranian painting that predate the Mongol invasions.

Assembling a book that pictorially explores themes of Iranian painting and overrides questions of style and history has not been without its perils. Prime among them will no doubt be the perception that the thematic organization is not all it purports to be; close behind will be the charge that important material has been omitted. Indeed, I am most conscious that my framework diverges from the way in which others may interpret the "themes" of Iranian painting, as I am conscious of lacunae.

Let me immediately say, however, that the material surveyed for this book virtually always imposed its own order. I did not pull the "thematic" categories out of thin air but organized them as the pictures appeared to ordain. Some themes are relatively obvious – the *razm u bazm*, the combats and celebratory feasts, of classical Persian literature, whose subjects are pictorially evident and which translate into equally obvious visual forms and formats. The category is subdivided – again, it is the pictures themselves that suggested this. For instance, the duel is a special kind of *razm*, or combat, which has ancient reflections in Iranian literature as well as in the decorative arts. Feasts may take place either in an interior or in the out-of-doors, even though the figures staging the feast may be disposed according to a traditional formula that appears and reappears over centuries. Other themes posed difficulties, none more than the images of religious ceremonies and the pictures commemorating the ritual passages of life, especially those of mourning; they did not easily lend themselves to a thematic visual analysis – other than their very subject – and were harder to categorize. Indeed, the entire group of "religious" pictures resisted convincing placement. At an early stage, paintings that were clearly illustrations of narrative religious texts – the Old and New Testaments, histories of the Prophets, texts of parable and fable, and even splendidly glorified works of superstition – were moved to the final category, primarily devoted to text-illustration. Over time, I came to feel that the others did indeed constitute a thematic category and kept them where I had first placed them, following images depicting the "feasting and fighting" that so engaged the tenth-century poet Firdausi, who was himself recounting much older aspects of Iranian culture for his own contemporaries. But the group also included an assemblage of five text-illustrations picturing the five religious obligations of the devout Muslim – all five being rare and unique paintings of the highest quality – along with a series of superb illustrations from several different texts of the

Muslim period, as well as pre-Islamic cult images and objects, and they still seemed ill-at-ease with each other; thus their placement was altered yet again during the final stages of editing this volume. No doubt some readers will continue to find them misplaced, but it is not for want of consideration of the problem they present.

The next three categories are clearly not those of themes – if by "themes" is meant only the subject of a picture. But analyzing any of the pictures in the first two categories – and those in the final category, devoted to the illustrations of texts – discloses that virtually all are constructed as well-established types of settings and inhabited by equally well-established types of personages. Again the pictures imposed the categories, and thus "Settings" and "Types" coalesced. Each of these is also broken down still further: outdoor settings – the "Natural World" – has a sub-category for a specific outdoor landscape, the garden, while architectural settings – the built world – may be either exterior or interior: each deserves appropriate focus. The representation of events at night is still another type of setting that called for a sub-section of its own, since the solutions of Iranian artists to the problem posed by the need to show both the means, and the effect, of artificial light often resulted in pictures that are quite remarkable to behold. As for figural types, the multitude that peoples Iranian figural painting is paralleled by the types of persons in Iranian poetry, a subject that could be explored at very great length elsewhere. Analyzing who did what in any Iranian figural image usually discloses the typical – indeed, the archetypal – nature of that figure: young prince or grizzled hero, beardless youth and bearded sage, beautiful maiden and bent old attendant. All of these, and more, are explored separately. And because they are types, they are followed by a related category, figural images that are the exception to type, pictures intended as real representations of persons: true portraits. Their development is another feature of the "golden age" of Iranian painting: almost unthought of in the late fourteenth century, within a hundred years certain figures almost step off the page. In addition, the tension between depicting the reality of face and figure, and yielding to the force of the type onto which a realistic representation might be merged often makes for a particularly fascinating picture – no matter how lifelike is the resulting image.

The depiction of beasts and birds posed yet another problem of organization that some no doubt will query: to what extent do the representations of animals partake of true textual illustration and thus find their place within my last category, the illustration of classical Persian literature? I am not certain I have found the exact solution to the problem: it is evident that animals are among the most ancient of decorative motifs – everywhere in the world – and were often invested with symbolic significance, while they also figure in imaginative and didactic literature that is almost as ancient. The animals of the *Pancatantra–Kalila and Dimna–Anwar-i Suhayli* stories attest to the length of the Asian tradition and exemplify the genre in the Iranian context.

The fact that we may so quickly move from animals as a special genre of Iranian painting to animals as the protagonists of literary works is one reason that animal-images stand at the beginning of my final category, devoted to illustrated literature of the Islamic period in Iran. In this section will be found examples of the summation of the figural art of Iranian painting that, at its best, transforms themes, *topoi*, and types into the wondrous images serving as a bridge to the magic of wondrous words. It includes some of the finest pictures illustrating Firdausi's *Shahnama*, and the poetry of Nizami and Khwaju Kirmani, Sa'di and 'Attar and Nau'i. Stories illustrated over a particularly long span of time, often in different media, are here shown together; subjects shared by Firdausi and Nizami are explored, as are illustrations of the uses of painting in classical Persian literature. Animal-fables, stories of the

prophets and sages, wisdom literature and sufi allegories, are also found in this category. Each of these pictures, of course, displays personages – almost always typical ones – in a setting whose elements combine features from one or more sub-categories; yet each of these pictures is usually superior to the sum of its parts: distinguished by an unusual and evocative subject, by the audacity, the imagination, or the thoughtfulness of its composition, or the sheer beauty of its drawing and palette. In such illustrations to the tales of epic and romance, yearning and wisdom; in the illustrated manuscripts that are the primary repository of painting in the "golden age" of Islamic Iran, ancient themes, human archetypes, and contemporary architectural settings and landscapes transcend their archetypal nature and speak – in images – to some of the greatest joys, the most profound concerns, the deepest sorrows, of the human condition. Such memorable images stand at the very pinnacle of Iranian figural painting.

That a historical account of Iranian painting precedes the pictorial exploration nonetheless indicates that the novelty of the approach was thought to call for it. This should signal to the interested but non-specialist reader the editorial intent of approachability. To such an end, notes have largely been limited to the identification of quotations. In keeping with the chronological scope of the book, dates are given as BC (or AD – when the context requires), or else as equivalents in the Christian calendrical system; only when a date in the Muslim calendar is precisely referred to does it appear in Hijri terms: "900, 1494–95," for instance. Proper names present a different problem, especially since Persian is not the native tongue of any of the three authors, and I am aware that the solution may not please all of our Iranian friends and colleagues. The names of persons and places are transcribed according to the system used in the *International Journal of Middle East Studies*, in which a letter is transliterated instead of the sound it makes in one, or another, modern spoken language. The exception is the *ezafa*, the construction denoting possession and – although it is unwritten in Persian – usually transcribed (according to the *IJMES* system) by -i: Kuh-i Tang, Taj-i Mah. Moreover, diacritical markings, even those for written vowels, have been omitted except for ', *ayn*, and ', *hamza*, retained since they represent written letters. Only Chapter I, by Boris I. Marshak, may differ where it is more appropriate to his subject and its predominantly pre-Islamic time-frame.

And because the pictures in this book are, in large part, thematically arranged, some system of cross-referencing – to identify other pictures from the same manuscript, the same school or artist, or the same detail of treatment or style – was evidently necessary. Thus, within brackets, references to the primary pictures in the thematically arranged section (pp. 89–330) are simply made to the number of the image in question. References to the text-figures are distinguished as Fig.: thus the reference [1; Fig. 1] indicates that the reader is invited to look at both primary picture 1 and text-figure 1.

In compensation for the few notes, the bibliography is copious, and it is arranged by subjects (each then chronologically listed) – for Professor Marshak's material, by categories and sites and, for the Islamic period, by collections, dates, texts, materials, and artists, among other topics – which may attract the attention of readers with questions, or curiosity, in diverse areas. All translations from the *Shahnama* are from the Warners' Edwardian opus: *The Shahnama of Firdausi*, Done into English by Arthur George Warner and Edmond Warner, 9 volumes, London, 1905–1925. However old-fashioned and even ponderous its blank verse may now seem, it is nonetheless a complete text that is relatively accessible, and its indices have been exceptionally useful in the process of assembling this book; for this reason, *Shahnama* quotations are not further identified. Translations from two other classics of

Persian literature, the *Haft Paykar* and the *Mantiq al-Tayr*, are taken from the works of my contemporaries who have rendered Persian poetry into rhymed English verse. They are: Nizami, *Haft Paykar: A Medieval Persian Romance*, Translated (into rhyming verse) with an Introduction and Notes by Julie Scott Meisami, Oxford, 1995; and Farid ud-Din Attar, *The Conference of the Birds*, Translated with an Introduction by Afkham Darbandi and Dick Davis, London, 1984; quotations from both – and also because they are not numerous – are identified by page (and, for *The Conference of the Birds*, by line-number).

This volume owes its very being to many people: the list is long and – try as I have tried – there will surely be omissions, for which I apologize in advance and extend my thanks for assistance and advice that was always graciously offered. I wish, first, to express immense gratitude to my two distinguished collaborators, Boris I. Marshak and Ernst J. Grube, from whom I have learned so very much over so many years and in whose intellectual – not to speak of practical! – debt so clearly I stand. A. S. Melikian-Chirvani's oeuvre on Iranian material culture underlies much of what I have endeavored to put into this volume, albeit that he could not accept my invitation to contribute to it. The pioneering research of Ivan Stchoukine is another foundation on which any further work in this field must be based: I was privileged to have known him in his later years and I hope that the chain of tradition is as evident to others as I myself feel it to be. It is a pleasure, next, to thank many friends and colleagues for innumerable professional courtesies over the years, and friendship that goes well beyond the collegial: in Britain and the Republic of Ireland, first, the present doyen of the field of "Persian" painting, B. W. Robinson; and then, starting with the British Library, both past and present: Norah Titley, Muhammad Isa Waley, Henry Ginsburg, and J. P. Losty; at the British Museum – again, past and present – Ralph Pinder-Wilson and J. Michael Rogers, Sheila Canby, Venetia Porter, and John Curtis; at the Victoria & Albert Museum – yet again past and present: Robert Skelton, Rosemary Crill, Susan Stronge, Oliver Watson, and now, Tim Stanley; at the Royal Asiatic Society, Graeme Gardiner and Michael Pollock; for the Nasser D. Khalili Collection of Islamic Art, Nasser D. Khalili and Nahla Nassar; at the Islamic Art Society, Rebecca Foote; at the Royal Library in Windsor – yet again, past and present – Oliver Everett, Jane Ades, Jane Roberts, Margaret Westwood, and Bridget Wright; in Oxford, Teresa Fitzherbert, Julie Meisami, Doris Nicholson, and – now in Washington, DC – Julian Raby; in Dublin, Elaine Wright; and then a host of other colleagues, friends, and acquaintances in Britain, mostly in London: Bob Alderman, Manijeh Bayani, Doris Behrens-Abouseif, Barbara Brend, Audrey Burton, John Carswell, Margaret Morris Cloake and John Cloake, Anna Dallapiccola, Margaret Erskine Edwards, the late Toby Falk, F. Farmanfarmaian, Géza Fehérvári, Ronald Ferrier, Sam Fogg, Sven Gahlin, Farhad Hakimzadeh, Jenny Housego, Robert Irwin, Ezra Levin, Helen Loveday, Diddi Malek, Katie Marsh, Maryam Massoudi, George Michell, A. H. Morton, Claire Penhallurick, Christine van Ruymbeke, Julia Schottlander, Nabil Saidi, Michael and Henrietta Spink, Jill Tilden, Edmund de Unger, and the late Mark Zebrowski.

Elsewhere in Europe, I wish to express my thanks, for unquantifiable assistance and kindnesses over many years – including last-minute requests for photographs and measurements! – to: Kjeld von Folsach, in Denmark; in France, Chahriyar Adle, Firouz Bagherzadeh, Marthe Bernus-Taylor, Marie-Christine David, Sophie Makariou, Francis Richard, the late Jean Soustiel, and Laure Soustiel; the late Dieter George, and Joachim Gierlichs, Claus-Peter Haase, and David King in Germany; in Italy, Alessandro Bruschettini, Maria Vittoria Fontana, Dalu Jones, Umberto Scerrato, and Cristina Tonghini; and in Russia, A. T. Adamova, Oleg F. Akimushkin, Anatol A. Ivanov, Sergei Tourkin, and Olga Vassiliyeva. In Turkey, Nurhan Atasoy, Filiz Çağman, and Zeren Tanındı have been colleagues, as well as friends, of a professional lifetime, while Talat Halman, in a career of many parts, has more than once been in the right place to offer much-needed official assistance; in Egypt, the late Waffiya Izzy made it possible for me to see the Cairo *Bustan* as long ago as 1971; in Kuwait, I thank Husayn Afshar and, for gracious hospitality at a period when this book was being revised, Shaykh Nasser and Shaykha Hussah al-Sabah, and Salam Kaoukji, Manuel Keene, and all the staff of the Dar al-Athar; in Iran, it is a pleasure to acknowledge the long friendship of Ezzat Malek Soudavar and the more recent courtesies of Mohammad-Hasan Semsar.

In the US and Canada, I must thank first, the late Alfred Neumeyer, and Oleg Grabar and Peter Chelkowski, all of whom have taught me, and conveyed to me their love for the disciplines of art history and Persian literature; and then, there are so many friends, colleagues, travelling companions, and relatives, who have in one way or another contributed to the success of this book and to whom I am pleased to express my great thanks: Michele de Angelis, Esin Atıl, Julia Bailey, Jere Bacharach, Sheila Blair and Jonathan Bloom, Marco Brambilla, Stefano Carboni, Martha Fuller Clark, Layla Diba, Walter Denny, Massumeh Farhad, Sarah Frank, András Fejér, the late Joseph Fletcher, Anita Gold, Lisa Golombek, William Hanaway, Renata Holod, Caroline Karpinski, Trudy Kawami, Linda Komaroff, Tom Lentz, Judith Lerner, Judy Levin, Glenn Lowry, Robert McChesney, Mary Anderson McWilliams, the late Dorothy Miner, John Seyller, Shreve Simpson, Ellen S. Smart, Priscilla P. Soucek, Abolala Soudavar, Geri Thomas, Wheeler Thackston, Anna Tulin, Howard Turner, Daniel Walker, the late Estelle Whelan, Richard Winkler, and Irene Winter.

I am deeply grateful to those at Yale University Press in London who shepherded this project, from the proposal with its "new slant" – so skeptically received at first – through so many pitfalls to its splendid realization: John Nicoll, Managing Director, and Sally Salvesen – editor, designer, and general trouble-shooter – who, with the able assistance of Ruth Applin, so diplomatically moved the work ahead and bore with my all-too-frequent overreactions. Richard Foenander undertook the pictorial design at fearfully short notice and did so with thoughtful sensitivity; Margot Levy provided the index and did so with equally thoughtful results: I am indebted to them both. Hossein Amirsadeghi asked for the new approach in the first place: without his initial proposal and continuing support this volume would surely not have been imagined, let alone undertaken. Last – but truly first and foremost – I am profoundly grateful to my family, who gave me time when there was none to give.

New York and London, July 2002

INTRODUCTION

The pictorial impulse has always been present in Iranian lands. Never far below the surface, it percolates upward like shards of ancient pottery, emerging at different times throughout Iran's history in a welter of figural manifestations that are all the more surprising for their stylistic dissimilarities and their degrees of stylization, as well as for the variety of the materials in which, over the past six millennia and more, such figural images have been executed. From the delicately stylized animals forever racing around the thin walls of Susa pottery of the fourth millennium BC [196], to the stamped and gilded angels on the lobed medallion impressed at the center of a lacquered binding on an album made for Shah Tahmasp Safavi (Fig. 1); to the pictures on late-nineteenth-century tiles made in Tehran for wall-decoration (the images copied from contemporary newspaper illustrations either by transfer-printing or painting): figural representation has always been a fundamentally Iranian expression. The phenomenon appears to function similarly for Iranians and those who came to live in their lands, in the lands colonized by Iranians, as in the art of peoples otherwise subject to their cultural influence.

In fact, painting in an Iranian milieu can be documented from as early as the Mesolithic period, between 10,000 and 6,000 BC, in the primitive figures of hunters painted on the walls or ceilings of mountain-caves. The earliest, from perhaps as early as 10,000 BC, is in Shakhty Cave in the Pamir Mountains in Tajikistan, showing a hunter and a boar, a speared bear, and an ox (or cow), perhaps being hunted in a *battue* [26], the circle of hunters slowly closing in on its prey. Somewhat later are the three scenes, possibly reflecting a hunting cult, painted on the ceiling of a cave north-west of Tirmiz, in the mountains called the Kuh-i Tang (in modern Uzbekistan). In large part, however, prehistoric, and early historic, ensembles of paintings in these lands have not survived. Instead, our understanding of so fundamental a feature of Iranian culture, at least until the middle of the thirteenth century AD, has had to be built up from the combined evidence of chance finds, controlled archaeological investigations (Fig. 2), and text references. This is made amply clear in the contribution by my distinguished Russian colleague, Boris I. Marshak: the excavations in Panjikent (on the Zaraf-shan River in modern Tajikistan, south-east of Samarqand) with which he has been associated for nearly half a century have virtually written the Sogdian chapter in the history of Iranian painting.

By contrast, our understanding of painting in Iran in the Islamic period has been developed from examples of the art itself, and then elucidated by relatively few documentary sources. Moreover, these references are as often found in classical Persian literature as in the inventories, biographies, histories, and the kinds of critical writing and philosophical commentary that complement the history of painting in the West. Nonetheless, Iranian figural painting commands a significant place on the stage of world art: enchanting, seductive, and – to the European eye – exotic, it deserves to be known for its innate qualities of line, color, and design as much as for the kings it glorifies, the stories it tells, and the states of mind it may illuminate.

1. Flap of the lacquered and gilded binding of the Shah Tahmasp Album, Tabriz, mid-1550s; Istanbul, Istanbul University Library, F. 1422

The words "Persian painting" usually call to mind a specific kind of image – a small picture in a book of exquisitely colored illustrations of romantic tales or epic poetry [116]. An alternative image is a single-page painting of fashionably dressed and sensuously engaged lovers, limbs entwined but faces showing curiously detached expressions [160]. Both are perfectly representative of the painting produced in Islamic Iran between the fourteenth and the seventeenth centuries, which may be truly be called the "golden age" of this art. The first image is exemplified by illustrations in the princely volumes of literature commissioned by the family of Timur – Tamerlane, as he is known in the West – from workshops in Shiraz and Herat, or in Tabriz by monarchs descended from the charismatic Shah Isma'il Safavi; the second is exemplified by

2. "Hunting Scene" (later copy), part of a wall painting, Susa, fourth century

the single-image paintings typical of the sixteenth and early seventeenth centuries, especially in the reign of Shah ʿAbbas I – the "great sophy" of the many European travelers who sought his court in Isfahan. Such paintings represent the best-known examples of this art in the Iranian-influenced East when Islam was its predominant religion.

The period between the mid-fourteenth century and the late seventeenth century also saw the rise, consolidation, and fall of two important dynasties in Iran, the Timurid (conveniently enough, it ruled throughout the fifteenth century) and the Safavid (which, equally conveniently, reigned for the entire sixteenth and seventeenth centuries). It is probably no coincidence that this was also the time when Iranian painting attained the apogee of its position as a supremely significant medium of expression in the Eastern Islamic world. Whether in a manuscript, on a single piece of paper, or on a wall, Iranian figural imagery of this general period is an art as truly classical, and as expressive, a cultural instrument as Greco-Roman architecture, Sasanian silver,

Buddhist sculpture, and the medieval European illuminated manuscript. The "language" spoken by an illustrated volume of Persian literature executed in Timurid Iran was as thoroughly understood in Safavid times as it was by the contemporary Uzbek rulers of Transoxiana; and equally so in Mughal India, in Ottoman Turkey, and even – however briefly – in late Mamluk Cairo.

At their princely best, such works were executed in highly refined mixes of pigments and gold applied to carefully made papers; they were ornamented with illuminated abstract designs of gold and other precious mineral-pigments; and bound in covers of gilded and stamped leather or lacquered papier mâché, occasionally enriched with mother-of-pearl inlay (Fig. 1): creations of supreme luxury, precious for their content as well as their intrinsic value. A set of fascinating parallels could be drawn between the illustrated manuscripts made at the orders of the princes of the House of Timur and those commissioned at approximately the same time by the sons of the Valois monarch of France, Jean II le Bon. When we realize that among the latter are Jean, Duc de Berry and Philippe le Hardi of Burgundy, we may appreciate that we are in the presence of very great patrons of the art of the book. Yet there is no recorded contact between, say, the Turko-Mongol prince Iskandar ibn ʿUmar Shaykh – Timur's grandson, who lived between 1384 and 1415 – and the French Duc de Berry, born in 1340 but who lived a year longer than Iskandar, to 1416. Instead, the parallels between the manuscript commissions of these two princes appear to be what Percy Brown once termed "a similarity of mental texture." Both

occurred at a certain moment in human history, East and West, when writing words in, and on, the finest materials available was a laudable and highly respected human endeavor, and illustrating these words so very handsomely an even more respected activity. Both conferred prestige on him who commissioned and him who executed – and in the Eastern world sometimes that person was one and the same.

Among the many remarkable features of painting in the Islamic period (and they are the majority of the images in this volume) is the self-confidence of the pictorial component in the very best manuscripts of classical Persian literature. All these pictures appear to possess a peculiar integrity, a sense of perfect completeness in themselves, despite the diverging developments standing behind them. Such divergencies most often take the form of differences in style that will be evident to even the most casual observer who looks, for instance, at a painting from one of the so-called "Small *Shahnama*" volumes [137] and compares it with a painting from the great *Shahnama* manuscript connected with the Safavid Shah Tahmasp [139]. Sometimes such pictures may be so different in all but the tale they tell that it can be difficult to appreciate how such stylistically disparate images may come from the same source. Nonetheless, the tradition from which both examples may spring is almost always extremely ancient in the Iranian world and survives on a very long continuum, in materials and modes that one would hardly – at first – associate with "Persian painting" at its most classical. Yet such apparently unrelated arts as the impressively large Scythian gold buckles of the fourth century BC [19, Fig. 10], and the narrative

3. "Fighting Camels," ink drawing on paper, eighteenth century; whereabouts unknown

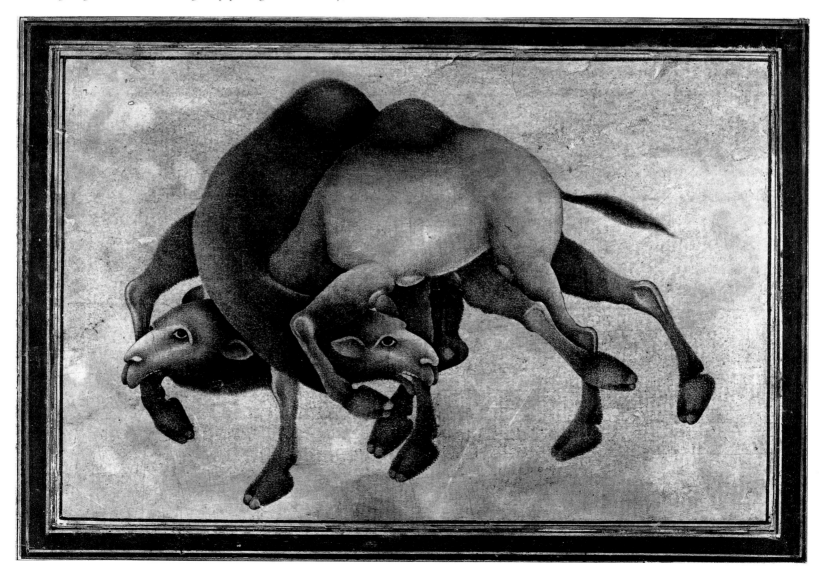

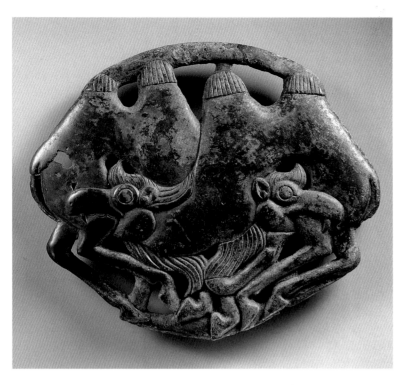

4. "Fighting Camels," one of a pair of bronze *phalera* found at
Filippovka in the Eurasian Steppe, mid-first millennium BC;
Ufa, Archaeological Museum

scrolls unfolding in segments that were used by Indian folk-perform-
ers of perhaps the same date, have contributed to classical Iranian paint-
ing of the Timurid and Safavid periods in less obvious but as important
ways as have the more obvious Iranian pictorial arts – Sasanian rock-
cut monumental sculptures [Fig. 12, 13], Sogdian mural painting of the
seventh and eighth centuries [129, 132–33, 206], and the medieval
Iranian decorative arts, primarily painted pottery [Figs. 39, 42, 44–47;
2, 3, 123, 135] and glass [201; Fig. 49], and inlaid metalwork [Figs. 50,
51, 63].

One reason for the largely unperceived length of this pictorial
tradition is that many images from very ancient times seem to have
survived only in the substratum of Iran's cultural memory, although
they often did so for a millennium or more, re-emerging in a differ-
ent material at some later moment when figural representation became
again a favored mode of expression. An extraordinary example is
afforded by drawings of a pair of Arabian camels fighting – not by
Bihzad, whose softened, balanced, and almost balletic camels in a land-
scape are attended by grooms to keep the animals from harming each
other, but a fiercer version (Fig. 3) – showing only the beasts, bodies
interlocked and teeth sunk into each other's rear leg or ankle. A number
of drawings reflecting a specific model are known, none dated but all
datable between the seventeenth and the nineteenth centuries; two
earlier drawings of unattended fighting camels deriving from another
model (in addition to at least three more, of camels with attendants)
are mounted in some of the scrap-book albums still kept in the
Ottoman Imperial Library in Istanbul. The core image, the fighting
camels alone, strikingly resembles the design on a metal example dating
from the middle of the first millennium BC, a pair of curved bronze
plaques (Fig. 4) found at the entrance to a *kurgan*, a burial mound, at
a site called Filippovka (in the Eurasian Steppe, at the confluence of
the Ural and the Ilek Rivers, not far north of the Caspian Sea). The
plaque is openwork, a widened oval in shape, and it shows a pair of
fighting Bactrian camels, bodies dramatically entwined and teeth sunk
into each other's haunches. Large soldered loops on the reverse suggest

that the plaques may be *phalera*, equine chest ornaments; they are late
Sarmatian in style and thought to date from the fourth century BC.
Nor is the motif unique among the materials recovered from this
mound: a treasure-pit further into the kurgan yielded a set of thirty
gold rectangular plaques with the same motif of intertwined fighting
Bactrian camels. These are smaller, less symmetrical than the bronze
plaques, but even more stylized. The semi-realistic image on the bronze
plaque, recognizable even in its decorative compression, appears to have
carried the weight of the visual memory, re-emerging nearly two
millennia later in the Islamic Iranian world as a subject for both draw-
ings and paintings executed between the fourteenth and the nineteenth
centuries.

The abundance of paper on which to write, and also to draw and
paint, is a significant feature of the period. Indeed, the widespread
development of paper in the Eastern Islamic world must surely be one
of the factors contributing to the development of Iranian figural paint-
ing in these centuries, when the illustration of classical Persian litera-
ture was a primary – but not the only – mode of figural painting. A
current theory suggests that Islamic paper-making acquired serious
momentum in the late tenth and early eleventh centuries. Other illus-
tration-rich periods no doubt occurred earlier in Iran's Islamic history,
as well as in her pre-Islamic past; but most have simply not survived
the ravages of time and weather, as well as the wholesale destruction
of material culture wrought by the Mongol invasions of Iran and the
rest of the Middle East, beginning about 1224, that remains such a
watershed in the living, as well as in the literary, history of this part of
the world. As Carl Sagan so aptly observed, "Absence of evidence is
not evidence of absence."

Nearly five centuries before that date, in a battle fought in the
summer of 751, paper – Chinese paper – is said to have come to the
attention of Muslim forces that bested a Chinese army and its Turkish
allies in the neighborhood of the Central Asian town of Talas. The
town itself is possibly Sogdian in origin, and as late as the eleventh
century both Sogdian and Turkish were said to have been spoken there.
These details, in addition to its location – on the Talas River in a valley
that served as an ancient trade route – all underscore the fact in the
early eleventh century, the Iranian world extended far beyond the
Oxus, or Amu Darya, River. Transoxiana, Khwarazm – ancient Choras-
mia, and even Farghana, in the middle reaches of the Jaxartes, or Syr
Darya, River, still formed an integral part of greater Iran. Iranian paint-
ing, thus, is not to be understood only as an art confined to the borders
of what is, today, the Republic of Iran. In fact, the richest surviving
body of any Iranian painting before the advent of Islam comes from
seventh- and eighth-century Sogdiana, an Iranian land lying between
the Oxus and the Jaxartes rivers. It is the only substantial corpus of
post-Arab-invasion Iranian figural art [1, 13, 21, 37, 45, 46, 129; 132; 133,
149, 155, 155, 184, 206, 243–5] that appears to have survived time,
weather, and the Mongols.

Russian scholars have been excavating in Sogdiana and publishing
their finds for well over a century but, until recently, almost always in
Russian, so that this large body of surviving mural painting from the
early medieval Iranian world remains less well known than it should
be. Yet in the palaces and houses of Sogdiana is a series of interiors
painted with the same figural subjects, themes, and types as are found
elsewhere in Central Asia, and in Iranian painting of the Islamic period,
on paper and in monumental wall decoration – to judge from what
still exists, mostly in Safavid Isfahan. So it is hardly a surprise that paint-
ings illustrating two of the favorite, and most widely disseminated, lit-
erary works of the Islamic period in Iran were to be found decorating
houses in Sogdiana. One is exemplified by an ensemble of pictures illus-

trating a precursor [129, 132, 133] of the *Book of Kings*, the *Shahnama*, Firdausi's tenth-century account of Iran's mythic and historical past that so potently appealed to the Iranian soul that it has been called "the title-deeds of the Persian nation's nobility."[1] The other is a Sasanian version [206] of the Pahlavi animal tales that ultimately derive from the much older Indian *Pancatantra*; in the Islamic period, the tales took the name of *Kalila and Dimna* and are known and loved throughout the entire Muslim world.

That both pre-*Shahnama* stories and the stories prefiguring the most popular of all Muslim imaginative literature should appear in paintings in Iranian Sogdiana before its conversion to Islam exemplifies, as it reiterates, the underlying dual conceptions in this book: one exploring the themes of Iranian figural painting and another that explores the length of its reach. Some images, such as the "Fighting Camels," extend very deep into Iran's pre-Islamic cultural history, however different may seem to have been the cultural context in which such themes and images operated, and the media in which recurrent themes might have been expressed. Often it proved impossible to separate the two concepts. Yet considering the thematic similarities among paintings of different periods together with the question of their sources sometimes helped to bring into clearer focus certain unique and consistent features of Iranian culture that have always been – and will remain – characteristic of this civilization, whatever the religious dispensation of the moment.

Two of these features of Iranian material culture profoundly shaped its painting and emerge as constants in this volume. One had already been noted by Herodotus in the Achaemenid period: the Iranian taste for foreign elements which were then transformed into something different but clearly Iranian. The second has already been noted but it bears repeating: the presence of Central Asian cultural forms and materials in the arts of Iran proper. Images and types from the varied mix of cultures inhabiting the lands between Iran and China often survived transplantation into the culturally fertile soil of the Iranian Plateau even when the religious and civil parameters under which they had developed had been drastically altered. Thus, the seventh-century spotted horse painted on a Buddhist wooden votive stele [199] recovered by Aurel Stein in Khotan, an eastern Iranian center on the Southern Silk Route, reappears often in the Middle East of the Islamic period: in the paintings of a uniquely surviving manuscript made in Eastern Anatolia in the thirteenth century [4], on any number of Iranian overglaze-painted ceramic vessels and tiles of approximately the same date, and in friezes of Iranian style painted onto Syrian blown-glass bottles of the thirteenth and early fourteenth centuries [201]; as well as in illustrations to classical Persian works by Firdausi [167] and Sa'di (Fig. 68). As for the Iranian taste for the foreign and exotic, this is well demonstrated by the pictorial propaganda developed by that most picturesque of Iranian monarchs, the Qajar Fath 'Ali Shah: full-length portraits of himself painted in oil-pigment on canvas (Fig. 5). It is only relatively recently that a second source for these pictures has been recognized as having as much importance in late eighteenth-century Iran as did the monumental rock-cut sculpture of Achaemenid and Sasanian Iran – the full-length single-figure European oil painting. Examples had found their way into Iran from as early as the fourth decade of the seventeenth century, and they were then often imitated in a curious and hybrid style that is one important strand of painting of the second half of this century [Fig. 82] and early into the eighteenth. The most resplendent pictures of Fath 'Ali Shah have recently been shown to derive from a painting of Napoleon Bonaparte as Emperor (Fig. 6) that is earlier by only five years.[2] With all these European paintings, Iranian

artists did what they had always demonstrated a genius for doing: taking some foreign aesthetic or technique into their own hands and manipulating it until it coalesced into something new but unmistakably Iranian. The splendid series of oil paintings of Fath 'Ali Shah is the Qajar version of this tendency, but it has procedural parallels in the art of the Achaemenids, the Sasanians, the medieval Seljuqs, and the Safavids in the seventeenth century.

The prevalence of recognizable figural images on Iranian objects – whether functional or commemorative, shaped and three-dimensional or flat – deserves further comment, especially since the painted ceramics, glass, and wood (Fig. 47) illustrated in this book have already been signalled as important carriers of Iranian imagery from at least the Sasanian period. The very notion of using a curvilinear surface on which to display an ostensibly narrative or representative subject is ancient: Greek painted pottery of the sixth and fifth centuries BC is the unparalleled example. In the Iranian world, wares of silver from the Sasanian period are the primary class of ostensibly useful objects decorated with figural imagery. Marshak has, however, pointed out that the only truly narrative image to be found on Sasanian silver dishes [224] is what would later – in the hands of poets writing in New Persian – become the story of Bahram Gur and Azada, his audacious slave-musician [225–28]. More frequently encountered on silver dishes are images in which a king demonstrates his prowess hunting [20], or slaying ferocious beasts [Fig. 15], and again, Marshak notes that the king so depicted is always the contemporary shah (albeit usually identifiable, and datable, by the shape of his crown). More to the point is that such images usually consist of a single human figure and an animal, or pairs of them, so that the challenge of harmonious arrangement on a curving, circular surface would not have presented difficulties for an able craftsman. More figures, however, always pose a problem that exposes the fundamental difference between the modes of true illustration and effective decoration. The Greek handling of their painted pottery (and also their metalwork) displays such consummate skill that the inherent tensions between the two modes are largely unremarked, but the tension is innate and always underlies a figural image used in anything other than a purely representative context. Thus, on other pieces of Sasanian and post-Sasanian silver, scenes with an implied narrative content may be compressed, symmetrically disposed, or arranged in several registers [Figs. 16, 120]: all ways of making the "action" fit into limited, curving spaces that never seem entirely appropriate to the story being "told" in images.

The medieval Iranian equivalent of a curvilinear and functional surface for a narrative image – painted overglaze-pottery, in the *mina'i* technique – presents a similar set of issues that again expose the perceptible tensions between the modes of narrative, and decoration with figures. Indeed, of the quantity of *mina'i* wares today recorded – perhaps several thousand pieces, innumerable bowls and dishes but fewer vases and ewers, cups and plates – very few actually "tell" a complete story in images [2, 135; Fig. 45]. The somewhat larger number of *mina'i* objects evoking a literary event or personage usually do so by a single image with an attribute that immediately identifies the event or the person: a king riding on an ox or carrying an ox-headed mace must be Faridun, a couple on a camel – especially if the man pulls a bow and the woman carries a harp – must be Bahram Gur and Azada [226; Fig. 51]. Similarly, in the case of flat ceramic tiles, either *mina'i* or luster-painted, the illustrative content is usually evoked by single figures (or pairs of them), sometimes accompanied by an evocative phrase or even a rubric [3, 225; Fig. 39]. What is now beginning to be apparent is that the luster-painted tiles whose decoration includes recognizable verses from Firdausi's *Shahnama* usually have no accompanying "picture" illustrating the text (but the reassembling of luster-painted *Shahnama* tiles

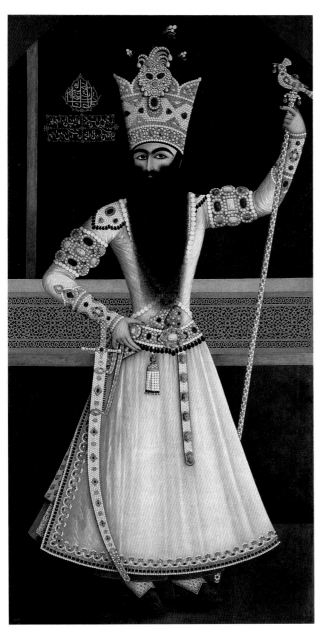

5. "Fath ʿAli Shah," oil on canvas by Mihr ʿAli,
 Tehran, 1809–10; St Petersburg, State Hermitage
 Museum, VR-1107

6. "Napoleon Bonaparte in Coronation Robes," oil on canvas by Robert Lefevre, Paris,
 1811 (after the original of 1806); Musée nationale du Chateau de Versailles, MV 5134

remains incomplete and that "picture" may be altered in years to come). Nonetheless, it is clear that, in the medieval Iranian world, the flatness of ceramic tiles or even of wall-surfaces did not always conduce to the creation of true narrative: before a kind of watershed date that seems to lie in the second half of the thirteenth century, decoration rather than illustration appears to have been the predominant mode of figural representation.

Medieval Islamic metalwork has a peculiarly apposite role to play in this context: figural decoration is a principal feature on the objects of brass or bronze inlaid with small plaques of precious metal made everywhere in the Muslim world at this time, from Khurasan (roughly the north of modern Afghanistan and western Transoxiana) to Anatolia, Syria and Egypt, and even the Yemen. Why the painstaking technique should have developed in the first place is impossible to say, but it lent itself admirably to small-scale decoration of exceptional density, which included a broad and well-executed figural repertoire, whether the object was made in the Jazira or Syria, Egypt or ʿIraq or Iran [Figs. 50, 51, 63]. It is true that the inlaid metalwares made in Arab lands often display richer and more varied figural draughtsmanship, and are far

more accomplished in quality, than that on most inlaid Iranian metalwares – at least, if we are to judge from what survives today. Clearly, "painting in precious metals" – as inlaid metal objects have more than once been described – is another highly significant aspect of the history of figural representation in the Iranian world. If the dynamic of pictorial influences flowing between the Arab and the Iranian worlds goes well beyond the scope of this book, nonetheless it should at least be mentioned, as should the question of the influences of medieval manuscript painting from the Arab world. Without doubt there are significant connections, and they have been briefly touched upon; they too constitute material for a deeper study and a different book.

The innate tensions between the two figural modes, of decoration and illustration, however, remain crucial to any broader account of Iranian figural imagery: I believe it has much to do with understanding why anything that merits even being called a "golden age" of this art should have occurred in the first place. Interestingly enough, the figural arts of the penultimate dynasty to rule in Iran shed some light on the subject.

The Qajar period now appears to have attained the age at which – or better, the distance from which – its fundamentals can be evaluated.

It is now evident that of all the kinds of figural representations executed between about 1780 and 1924, what is both the least frequent as well as the least successful imagery is that integral combination of text and picture so characteristic of the finest Iranian painting in its "golden age:" illustrations in manuscripts. To be sure, illustrated volumes of Persian poetry were produced in the nineteenth century, for instance, the four (surviving) illustrated copies of a panegyric poem written during the reign of Fath 'Ali Shah to glorify the accomplishments of the dynasty; in frank imitation of Firdausi, it is called the *Shahanshah-nama, Book of the King of Kings*. It is also evident that what best exemplifies the figural art of the time of Fath 'Ali Shah are the monumental images: not only the splendid oil-painted canvases (Fig. 5) and the murals celebrating the fecundity of the dynasty, but those carved into the living rock of the land (Fig. 85). These are equally frank imitations, deriving in technique and purpose from the rock-reliefs of the Achaemenid and Sasanian periods; indeed they are often sited adjacent to reliefs celebrating the achievements of Iran's pre-Islamic dynasties. At the opposite end of the scale are portrait-miniatures of Fath 'Ali Shah and his descendants: not that paintings on a very small scale are unknown in prior centuries, but that the genre, the true portrait on a miniature scale, is as alien to classical Iranian painting in its "golden age" as is a life-size oil painting on canvas. Both genres come from beyond Iran but their lure was such – or so it seems – that to paint them well, many Iranian painters appear to have turned their backs on their own traditions to work in the newer modes, in which many excelled brilliantly.

Two notable exceptions to this statement immediately call for attention. Both date from the middle years of the nineteenth century and both are connected with Nasir al-Din Shah, whose long reign of nearly half a century, from 1848 to 1896, was probably as significant for Qajar figural imagery as was that of his great-grandfather Fath 'Ali. The first is the extraordinary series of lacquered objects of papier mâché made between 1847 and 1865 by Muhammad Isma'il, scion of a virtual dynasty of painters from Isfahan: book-covers, pen-boxes [11], a celebrated mirror-case and large casket (Fig. 92). The most important of them depict historical subjects and personages – the surfaces are literally covered with myriad, miniature figures, and among them are recognizable portraits: Muhammad Shah, his feared and powerful vizier Manuchihr Khan, Nasir al-Din as a very young crown-prince sitting on the lap of the Russian Tzar Nicholas I. No Iranian object could be more typically traditional than a painted papier mâché pen-box, and no painter could better exemplify the traditional Iranian painters' milieu than does Muhammad Isma'il. He was trained by elder male family-members in the family workshop; he learned his craft by early apprenticeship that grounded him in long-practiced techniques, taught him to create new works by copying the styles and manners of his elders. Yet in painting objects such as the pen-boxes commissioned by Manuchihr Khan, and the casket on which is depicted the siege laid upon Herat by Muhammad Shah in 1838, we may observe that he, too, rejected the traditional, archetypal mode in favor of showing specific, recognizable places and times and persons. His lacquered objects are wondrous – if retardataire – creations, and for such work he earned from Nasir al-Din an appointment as *naqqash-bashi* (a post carrying the sense of "painter laureate").

The second exception is also a royal commission from Nasir al-Din Shah and it is virtually contemporary with the prime working period of Muhammad Isma'il. Nasir al-Din conceived the wish for an illustrated manuscript of the *Thousand and One Nights*, the Arabian compendium of tales that had recently been translated into Persian, and he commissioned a "copy" from his father's *naqqash-bashi*, Abu'l-Hasan Ghaffari II (later to be known by the honorific title *Sani' al-Mulk*, "Craftsman of the Kingdom"). Completed in 1855, the massive opus comprised six copiously illustrated volumes – over a thousand pages which each bore from two to six pictures, and it is probably the last princely Iranian commission of an illustrated manuscript of *belles-lettres*. Not only was the text, in this instance, a non-Iranian one – notwithstanding that translated texts of the same genre are hardly unknown in the history of the illustrated Persian manuscript – but the talent and aesthetic instincts of the chief painter were other than traditionally Persian. Even his training was partly European, for he had been sent to Paris by Muhammad Shah soon after the latter named him *naqqash-bashi*. A very great number of painters, including Nasr al-Din Shah himself, contributed to this work, which can today be appreciated as virtually an album of painted vignettes of mid-nineteenth-century life in Iran, not a series of illustrations to imaginative but classical Persian literature. Indeed, literature of the kind that had formerly circulated as true manuscripts – copied out by a scribe – whether with or without illustrations, was now being mass-produced: printed books with lithographically reproduced illustrations of classical poetry, religious literature, romantic epics and popular narrative.[3]

In the second half of the nineteenth century, the most esteemed, and successful, artists of Qajar Iran studied not in traditional craftsmen's ateliers but in academies of the arts, either in Tehran or abroad. There they learned to make portraits in water-color, to take photographs, to paint large canvases in oil-pigments, and they largely abandoned what must by then have seemed like a constraint – the written word that had been so intrinsically linked with the works of generations of Iranian artists from the fourteenth to the seventeenth centuries. Earlier Qajar artists returned to their pre-Islamic pictorial roots for inspiration; later Qajar artists looked to Europe for new techniques and forms to provide novelty and aesthetic challenge. And both shook themselves free of the traditional melding of text and image – the texts of poets writing in New Persian and the images made by artists working from archetypes that had so profoundly informed the traditions of illustrated manuscripts and the mounting of single-figure images within frames of appositely chosen poetry. If, altogether, what they prove to have created was a new and "modern" Iranian figural art, it was no longer the classical, flexible instrument of the "golden age" of their own past, and while it might be argued that Iranian figural imagery from the twentieth century onward is the poorer for having done so, that is, once more, the stuff of a different book. What is striking, however, is the connection still felt by a nineteenth-century painter to the lengthy tradition in which still he worked: on that lacquered penbox finished at the middle of the century [11], Muhammad Isma'il signed himself as "a man from the line of Mani."

PRE–ISLAMIC PAINTING OF THE IRANIAN PEOPLES AND ITS SOURCES IN SCULPTURE AND THE DECORATIVE ARTS

Boris I. Marshak

Throughout the history of Iran and her eastern neighbors each epoch has assimilated the arts and enriched ancient traditions in its own distinctive fashion. Iran in the Islamic period inherited artistic traditions from the Sasanian dynasty, which ruled between the third and the seventh centuries, and from the civilization of Central Asian Sogdiana, from the fifth to the eighth centuries. The arts of these cultures, while sharing many traits, also exhibit a number of dissimilarities. The disparities at issue were due in part to cultural interactions; yet some tendencies of cardinal importance had taken shape in far earlier times reaching back into the remote past of the Iranian peoples.

Thus, in geographical terms, Iranian figural art may be documented for at least seven millennia, but the period of the ninth to the seventh centuries BC is when Iranian peoples – nomad Scythians and their eastern "cousins," the Sakas, as well as the founders of the first Iranian Empire, the Medes, and their Persian vassals who succeeded them – entered the arena of world history. In these centuries, there was much interaction between the nomadic tribes who roamed the steppes that extend from the borders of Thrace, in the Balkans, to the frontiers of China in East Asia. This accounts for the diffusion over that enormous territory of objects made in the early Scythian style which, despite some local distinctions, displays a remarkable integrity.

SCYTHIAN FIGURAL ARTS

It seems paradoxical that a discussion of Iranian figural art should begin with spectacular images largely of animals – in a series of objects decorated with creatures of various types that, taken together, comprise the Animal Style of the ancient world. Named after the prevailing representation of animals to the virtual exclusion of human figures and vegetal motifs, beasts such as the recumbent stag, the standing wild boar, and the coiled panther were especially favored visual themes. In the Caucasus and Iran, especially in Ziwiye, early Scythian culture came into contact with the cultural forms of Assyria and Urartu, resulting in the manufacture of articles of gold, the decoration of which combined both Scythian and ancient oriental elements. Scythian animal motifs were thought to embody magical powers, imparting the panther's strength, the stag's swiftness, and the wild boar's fury to the owner of the weapons, harness, or finery, securing him victory in battle and, consequently, wealth. It is likely that fantastic figures composed of several animals of the same species, or even those combining in one image parts of different beasts, were thought to perform a similar function. Scythian artists emphasized the potential force and vigor of the animals they depicted, which never convey the slightest suggestion of inertia. Indeed, the Scythian stag has so dynamic an appearance, even when it is apparently at rest, that many scholars believe it is always intended as a bounding, rather than a recumbent, animal (Fig. 7).

ACHAEMENID IRAN

The nomadic invasions of the Near East, in the eighth and the seventh centuries BC, the establishment of Achaemenid rule in Iran from the sixth century BC, and the fact that excellent Saka horsemen served in the Persian army, all help to account for the elements of the Animal Style found on the sword-scabbards and pickaxes of Achaemenid warriors. Yet the fundamental features of Achaemenid art derive from the ancient traditions of settled Near Eastern monarchies. The carved-stone reliefs decorating the palaces and rock-cut tombs in Persepolis and elsewhere are the most typical specimens of this imperial Achaemenid art, the purpose of which was to glorify the power of an upright king (Fig. 8). The reliefs represent formal occasions – the king and his subjects, or processions of Persian guardsmen and the tribute-paying envoys of subject

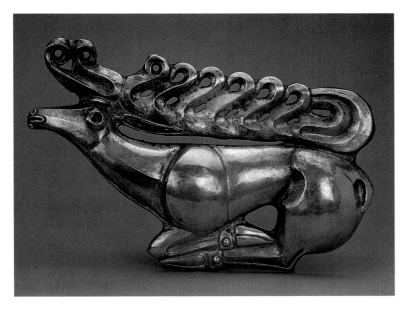

7. "Bounding Stag," gold repoussé plaque, Kostromskaya, seventh century BC; St Petersburg, State Hermitage Museum

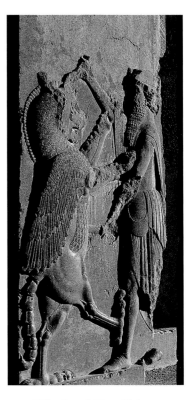

8. "The Royal Hero Fights a Monster," carved stone relief in the Palace of Darius at Persepolis, sixth century BC

peoples; and symbolic scenes – the king in single combat with a monster or a lion, a lion attacking a bull [202], or a bull with a human head. In this art which asserts the inviolable order of the Achaemenid Empire – and thus, of the entire universe – ruled by a King of Kings, even scenes of mortal combat are represented as ceremonious and static (Fig. 8). This conception of a world order expressed in the image of an all-powerful and invariably victorious ruler is one of the most enduring of Iranian visual themes. Indeed, as late as the nineteenth century, the depiction of official themes, which were expressed in a hieratic style – meticulous care shown in the rendering of garments, weapons, items of harness, and plate and vessels, coupled with a notably conventional treatment of human visages and bodies – remained characteristic of the figural art of Iran at whatever level of patronage it was executed, royal, noble, or popular [Figs. 85, 90, 92].

Surviving examples of Achaemenid painting are as yet unknown, but testimony by Chares of Mytilene (fourth century BC) has come down to us in a later account of Athenaeus (second–third century AD). Chares wrote that in temples, palaces, and even private houses, painters illustrated the love-story of Zariadres and Odatis, among whose characters are the king of Media, the sovereign of Middle Asian lands extending up to the Tanais River (the modern Syr Darya), and the king of the Marathi, a people who lived beyond the Tanais and who wore Scythian garments. Different versions of the story were told for centuries in Iran, and one variant, the episode of Gushtasp and Katayun, daughter of the King of Rum [125], found its way into the tenth-century *Book of Kings*, the *Shahnama*, of Firdausi, whose epic poem became in later centuries perhaps the most frequently illustrated work of classical Persian literature. No pictures resembling those described by Chares have yet been found in Iran, but numerous figural paintings decorating houses in the much later Sogdian town of Panjikent, in western Central Asia, suggest that his narrative was based on observations made in these places by participants in the campaigns of Alexander of Macedon, Alexander the Great. In fact, in writing of the inhabitants of Asia, Chares did not specifically mention "Persians" and it is possible that he was referring to other Iranian peoples subordinate to the Achaemenid monarchs – Medes, Bactrians, or Sogdians – when he described such aspects of Western Asian civilization.

"Illustrations" to epics written down in late Achaemenid times have been identified in the reliefs on the golden belt buckles of the eastern Scythians, so many of which are in the Siberian Collection of Peter the Great of Russia, now in the Hermitage [19]. Such epic themes are believed to have appeared east of the Oxus River, the Amu Darya, under Achaemenid influence, although stylistically the buckles demonstrate the survival of the highly expressive manner typical of nomad objects from the Scythian to the medieval periods.

Alexander's conquest of Iran in the fourth century BC brought Greek craftsmen to Iran and to Bactria, on the middle Oxus River. Stone columns in purely Greek style appeared in Bactrian palaces and temples, as in Ai Khanum, Takht-i Sangin, and Saksanakhur, where the layout and other architectural elements had exclusively oriental prototypes. Unfired clay statues and reliefs of a kind unknown in Hellas were also executed in Bactria, yet the style of such works was purely Greek.

In Iran, such cultural exchanges took somewhat different forms. Ancient Iran had had neither cult statuary nor an iconographical tradition of its own. It was only in the fourth century BC that Artaxerxes II ordered the erection of statues to Mithra and Anahita in temples. As a consequence of Alexander's conquests, statues of Greek gods began to appear throughout the country, and the Iranians gradually came to identify them with their own deities. Thus the God of Victory, Verethragna, was venerated in the image of Heracles. Moreover, the splendor of the Persian court dazzled the Greeks; hence the appearance of vessels

made of precious metals combining Greek decorative motifs and older Achaemenid forms, which often makes it difficult to distinguish between early Hellenistic and Achaemenid wares of silver.

PARTHIAN IRAN AND KUSHAN BACTRIA

Little changed in the arts when Greek rule ended in Parthia (the geographical entity later known as Khurasan) and the whole of Iran came under the rule of the Parthian Arsacid dynasty in the later half of the third and the second centuries BC. The monarchs of Parthia created a great power in Iran and Mesopotamia and, despite their Iranian origin, they highly valued the workmanship of Greek artists. Among the finds from the Arsacid palaces of Nisa, not far from modern Ashkabad, are imported Greek marble statues and ivory rhytons in the old oriental form but decorated with Greek reliefs, a combination that is characteristic of Hellenistic art. Even the clay statues and wall paintings discovered at Nisa are purely Greek in style, although they were locally executed.

In Bactria, the Greeks held sway at least until the middle of the second century BC. Just as in Sogdiana and especially in the Zarafshan Valley, after this date power passed into the hands of nomads who, assisted by settled craftsmen, created remarkable specimens of jewelry in a new and polychromatic version of the Animal Style. Barbarized Greek mythological images such as those from Tilla Tepe (a first-century AD site), also date from those times.

The Arsacids reigned for approximately five hundred years, until the early third century AD, but very little is known about the art produced in that period in Iran proper. For example, the two reliefs of Parthian kings carved alongside each other on Mount Bisutun are in a very poor state of preservation. Instead, Parthian art is primarily to be assessed from works found in vassal Elymais in the south-west of the country, in Sistan to its east, and in the Syro-Mesopotamian region straddling the western boundary of the Parthian empire.

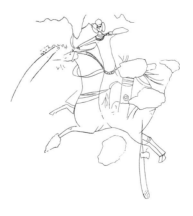 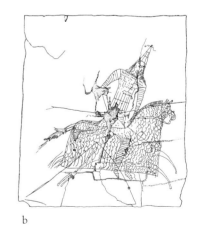

a b

9. "Parthian Horsemen," third-century graffiti found on the walls of houses in Dura-Europos on the Euphrates, Syria

Art from these lands on the Parthian borders tells us that new materials – stucco carving and wall painting – as well as new themes – the banqueting king or dignitary, the heroic hunt (Fig. 9a), and scenes of combat peopled by heavily armed horsemen – are characteristic of the Parthian period (Fig. 9b).

To some extent, such subjects may be considered as traditional in Western Asia since Assyrian times, beginning in the ninth century BC; but Assyrian palace decorations were limited to royal themes, royal feasting and hunting, and military actions led by the king himself. Instead, in the Partho-Mesopotamian houses of local notables in trade cities such as

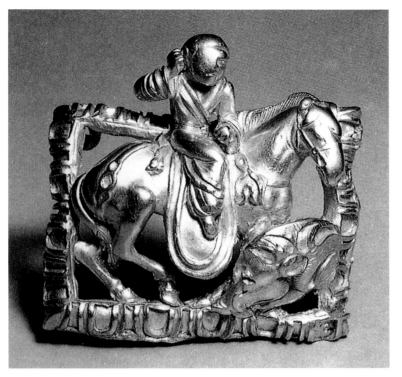

10. "The Boar Hunter," gold repoussé belt buckle from Saksanakhur in Northern Bactria, first century

11. "Face of a Woman," fragment of a wall painting, found at Toprak Qala, Khwarazm, third century

Hatra and Dura-Europos, it is the nobles, not the kings, who are shown reclining on feasting couches or riding in pursuit of wild beasts, subjects not characteristic of Achaemenid art as it is known today.

However, objects bearing similar themes have been widely diffused, both west of Iran and east of the country, where they appear in conjunction with typically nomadic features, such as the horn plaques and buckles with engraved decoration recovered from a nomad grave in Orlat, in Sogdiana. The buckles have intricate and crowded figural scenes, on which fighting and hunting episodes include neither kings nor heroes, whereas the latter are the primary and almost indispensable subjects of epic tales and their illustrations. The simple representation of fighting or hunting, devoid of epic or historical content, must also have been thought to bring good fortune to the hunter-warrior, for finds from Bactrian locations include a gold buckle decorated with a nomad horseman spearing a boar, from Saksanakhur (Fig. 10), and a horn plaque with several hunters on horseback shooting at wild rams, found at Takht-i Sangin.

The powerful state of the Kushans, which also held sway over a considerable part of north-western India, was established in Bactria between the first and the third centuries AD. Descendants of nomads, the Kushan kings fostered more urban cultural patterns among their settled subjects: building cities and introducing new religious cults for which they then built temples, striking coins, and erecting commemorative statues of reigning monarchs and their ancestors. They also created statues of gods, and it was in such Kushan statuary that the images of many Iranian deities first evolved. Nor did the Kushans neglect the themes of battles, hunts, and the royal banquets in their figural art. As regards the style of these figural images in sculpture and in their representation on coins, the images of the Kushan kings are markedly different from the accompanying figures, being distinguished not only by their attire but also in their bulky proportions, which possibly reflects a nomad prototype.

As for the representation of Kushan gods, the designers of Kushan coin dies appear either to have sought a suitable iconographic type for an Iranian deity or else depicted the god in question as an Iranian nobleman; Indian deities were similarly treated in the Indian fashion, for images embodying both cultures were as yet rare. Equally rare is the figure of the Buddha on coins, although it was under the Kushans that Greco-Buddhist art flourished in Gandhara and found its way to Bactria.

From that time Indian motifs began to be common in Central Asia whereas previously, Indian articles had been brought to Bactria, under the Greeks, but were not imitated. In the third-century Khwarazmian palace of Toprak Qala, at the delta of the Oxus River, influences of Near Eastern art travelling via Parthia, as well as Indian elements from the Kushan kingdom, are both encountered in the clay sculpture and the wall paintings decorating the same palace (Fig. 11).

SASANIAN IRAN

In 226 AD Sasanian rule was established over Iran for a period that was to last for over four hundred years. The ruler of the province of Fars, Ardashir I (226–ca. 43), routed the troops of the last Parthian monarch, Artabanus V and then subjugated the entire country of Iran, becoming the first King of Kings of that celebrated dynasty. Sasanian Iranian art is exemplified by royal rock reliefs (Fig. 12) and by stucco decorations, mosaics, and wall paintings in palaces (Figs. 2, 25); by silver vessels [20, 48, 120, 224; Fig. 15] with relief decoration and engraved motifs; by polychrome silks, coins, and carved gems; and it is very rich in figural representations. The royal and proclamatory nature of Iranian figural art under the Sasanians was as manifest as it had been under the Achaemenids. For this reason, art of the Sasanian period is often regarded as a kind of renaissance of Achaemenid art, whereas in fact it was primarily the appreciation of art as a potent tool of propaganda that was revived; the themes, the devices, and almost all the images of art in the Sasanian period were original.

SASANIAN SCULPTURE

After his accession, Ardashir I commanded the carving of rock reliefs near Firuzabad. One depicts the decisive battle in which he killed Artabanus in single combat; another his alliance with the chief deity, Ahura Mazda, who hands the king a wreath with ribbons. From the viewpoint of the Zoroastrian religion, a god is incomparably more powerful than any earthly sovereign, but in Sasanian times the two figures

were shown as equals, the king being identical to Ahura Mazda in every respect, including his size. On the reverse of coins of Ardashir's successors, the king and Ahura Mazda, or the king and the goddess Anahita, are placed on either side of a fire-altar, and Anahita is shown in the queen's attire. The king does not make an offering, unlike the Kushan monarchs represented on coins or the sculptured Khwarazmian rulers in the Toprak Qala palace; instead, he stands at one side of the base of a high altar and on the other side stands the deity.

Such coins are a visual interpretation of the political formula ascribed to Ardashir I: "The throne props up the altar and the altar props up the throne;" they imply a sort of alliance between the two powers, divine and royal, that maintain order in the world, and express, in images, concepts that could have appeared heretical in words. What might be termed "monarchocentrism" is a significant feature of Sasanian art, which had no icons nor worshipped statues of gods.

Reliefs depicting a deity handing a wreath to the king, or scenes of single combat, were carved under Ardashir and under his descendants as well. Yet already in the reign of Shapur I, Ardashir's son and successor (ca. 243–71), new themes were emerging: the king and his court, and the triumphs of Shapur, who repeatedly won victories over the Romans. According to Zoroastrian beliefs, the legitimate king of Iran possessed a distinctive charisma, *farr*, that crowned all his enterprises with success. Like victories in battle, hunting exploits were manifestations of *farr* and presumably account for the representation of Varahran II (276–93) – never a military hero – killing a lion (or a pair of them) with his sword, in a relief at Sar Mashhad (Fig. 12). He does so while offering his left hand to his perfectly composed spouse, behind whom are portraits of the chief priest of the time, Kartir, and another dignitary. This symbolic scene was designed to emphasize the importance of the queen as she who would assure the continuity of the dynasty by bearing her husband an heir. The family circle at this time however included another potential heir, in the person of Prince Narseh, son of Shapur I (and grandson of Ardashir I, the dynasty's founder); he did eventually become king in 293, after executing Varahran III (son of Varahran II).

Without dwelling further on the rock reliefs of the third and the early fourth centuries, or touching upon the complicated problems of the interpretation of reliefs of the second half of the fourth century, it is pertinent to note that the hunting feats of the monarch have been recorded (or survive) only at Sar Mashhad and (although later) at Taq-i Bustan. These reliefs have been dated by some scholars to the second half of the

fifth century, or – as I believe to be more correct – to the late sixth or the early seventh centuries.

Taq-i Bustan, near Kirmanshah, is the site of a pair of vaulted niches, or grottoes, cut into the living rock; the larger is decorated with high-relief statues and low-relief friezes that are an integral part of its architecture (Fig. 13). Only the upper scene on the back wall of the larger grotto resembles earlier Sasanian sculpture: the crowned king stands between Ahura Mazda, who hands him a wreath, and Anahita, who holds another in her raised hand; their garments and the king's sword are similar to their attributes in other Sasanian reliefs. Yet in the zone below is a horseman wearing the most up-to-date armor and weapons, such as those of the Turkic cavalrymen who dominated the steppes east of Iran during the sixth and seventh centuries. The two rectangular compositions on the side walls of the grotto show the king in his hunting grounds. In one relief he is depicted shooting boar from a boat mired in thick reeds growing out of the water, and in the other pursuing a stag on horseback; in both he is dressed in hunting attire and without a crown but is surrounded by hosts of courtiers, servants, and musicians. The entrance arch is decorated with the royal diadem surmounted by a crescent, and inside the tympana are flying Victories with wreaths and bowls full of fruit. The style of the carvings in the grotto contrasts with earlier, third-century reliefs, which had been developed within a very short span of time. These works combined the sculptural techniques of classical art – well-proportioned figures and a fine, naturalistic treatment of volume – with more oriental aspects, certain compositional schemes, postures, and facial types regarded as correct and beautiful – but most notably, the repetition of figures composed according to this canon of beauty.

The Taq-i Bustan method of conveying space and time is frankly conventional. The king is shown twice in each of the side reliefs, representing different moments of time; depicting him hunting both on land and on water presumably symbolizes the universality of royal power. The king's face, rectangular and with enormous eyes, is stylized in the same way as are the faces on a group of late Sasanian gold coins. Yet the symbolism and conventionality of the reliefs at Taq-i Bustan are combined with verism, a feature calling to mind ancient oriental traditions. Here, the environment of the royal hunt with its multitudes of persons and animals is represented with the utmost accuracy. Details of the latest weapons, and the fashionable kaftans of heavy silk, intricately patterned or embroidered, which had replaced the early Sasanian lightweight attire hanging in graceful folds, are all meticulously drawn. The

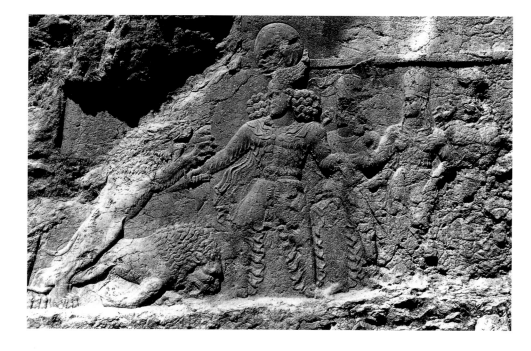

12. "Varahran II Slays a Lion," rock relief, Sar Mashhad, third century

Taq-i Bustan animals, too, are more true-to-life than the human figures, a feature that recalls the stylistic modes of earlier oriental figural representations. Indeed, Sasanian rock reliefs make it possible to compare the earlier and the later style of rock-carving, although they provide no material to follow, step by step, the broader changes in Sasanian art.

In the summer of 1994, excavations in Khurasan, at a site called Dar Gaz, first revealed an ensemble of figural stucco reliefs in the reception hall of a manor house. Their subjects splendidly exemplify the life of the Sasanian aristocracy. Because of the Middle Persian inscriptions accompanying the ensemble, the excavators suggest that the reliefs are to be dated around 420 to 440, given personal names and a word similar to the name of the Hephthalite "<w>ptlyt", that accompanies the ensemble. The reading of the latter, however, is disputable, and personal names may have been in use over a long period of time. As the script is similar to that of the fourth-century inscriptions at Taq-i Bustan, a date in the prior century is also possible, although it is true that the style of the reliefs is more conventional than the royal rock reliefs.

The reception hall had four columns and a recessed niche for worship, but it also opened onto a garden. Entering from the garden, the left wall shows horsemen hunting deer, and then a battle-scene. The back wall once bore an open-air scene of which only the lower edge, a meadow, remains. Near the recess is a female figure, carrying a ewer and approaching a curtain; on the side walls of the recess were portraits of the inhabitant of the manor house and his relatives, one woman standing near a horse; the back wall of the niche shows a male and a female figure flank-

ing the religious objects – a pair of candlesticks, a curtain, and the typical Sasanian fire-altar. On the right wall of the reception hall stand several figures, both men and woman, wearing rich garments and facing the niche – they would be worshippers – and to the extreme right is a scene of feasting. Considered together, the separate subjects of these stucco reliefs testify to the habits and the preoccupations of the Sasanian nobility: the Zoroastrian rituals, and the making of war, the demonstration of physical and personal prowess in the hunt, and feasting – the classical Iranian *razm u bazm*. What seems remarkable, however, is the exclusion of any historical or literary subject in this ensemble.

SASANIAN PAINTING

Very little is known of Sasanian painting in Iran. A specimen of early Sasanian date is the third-century battle-scene in Dura-Europos executed in a rather primitive style, soon after the town was captured by the Sasanian army. Ammianus Marcellinus wrote, in the fourth century, that the usual subjects of Persian pictures were war and killing – evidently meaning, by the latter, the killing of animals by hunters. The capture of Antioch by Khusrau I (531–79) was represented in a painting in his Ctesiphon palace which, unfortunately, has not survived. A lost, but partially copied, fourth-century mural from Susa [Fig. 2], its fragments found in the wall-plaster rubble, represents hunting on horseback and is executed with red and yellow-ocher figures set against an ultramarine

13. The grottoes at Taq-i Bustan, ca. 600

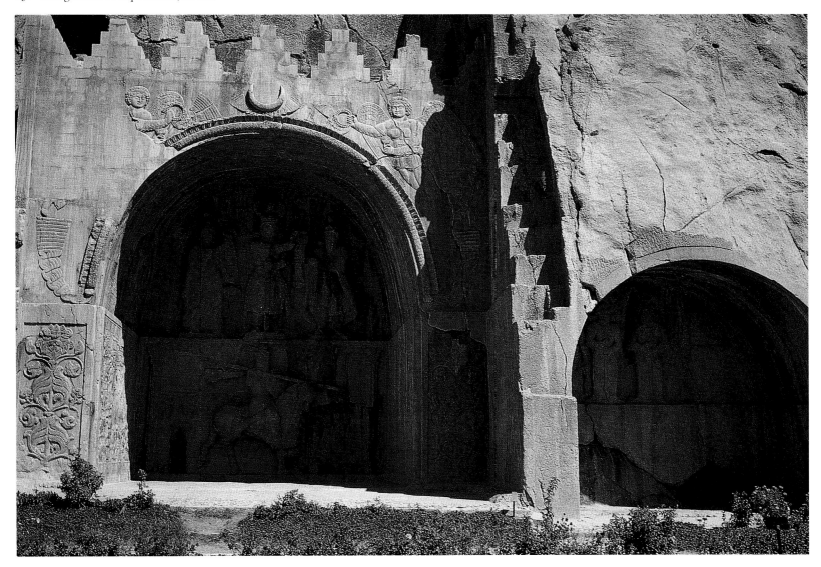

background. Paintings with "portraits" and figures of horsemen – hunters? – from Hajjiabad, in Fars Province, are also dated to the fourth century, and mounted horsemen are shown in the paintings of the late, or post-Sasanian, palace in Damghan. Of surviving Sasanian mural compositions in other media, mention may be made of the mosaics in the palace of Shapur I in Bishapur, executed by Greek artists after Iranian sketches and depicting a female dancer, a harpist, masks, and various fruit; the elements of the feast reflect the conception of the king's blissful life which was the consequence of his just rule.

Sasanian painting on a smaller scale is virtually only known from documentary evidence. A person – Mani – rather than an actual painting provides the clearest evidence that painting was a much-practiced art in Sasanian Iran. Mani was the eponymous founder of a new and syncretic religion in the third century who had initially found favor with Shapur I but later one of his successors, Bahram I, ordered the prophet's arrest, and he died in jail. Nobly born, at once a courtier, a missionary, and a teacher, Mani was also an artist who is said to have illustrated his own religious doctrine in a special book named "Arzhang." In later Sasanian writings Mani was always described as an artist rather than as a prophet, and indeed in Islamic Iran he was celebrated as the quintessential painter, to whom all later practitioners of the art were compared. Yet virtually nothing in any illustrated Manichaean manuscript of his own date survives; only a small series of later manuscript fragments, found in Turfan, in Chinese Turkestan, attests to the kind of illumination with which Manichaean texts were illustrated. One of these, showing female faces, is painted in a style alien to the art of Central Asia and undoubtedly harks back to its third-century Sasanian model (Fig. 14).

14. "Four Noblewomen," fragment of a Manichaean book illustration on paper, found in Turfan, Western Turkestan, eighth–ninth century; Berlin, Museum für Indische Kunst, III 4937

In the mid-eighth century – and thus well into the Islamic period – a certain ʿAbdallah Ibn al-Muqaffaʿ translated from Pahlavi into Arabic a set of animal tales of Indian origin composed by the Sasanian physician Burzoe, who was in the service of Khusrau I (531–79), known as Khusrau Anushirwan. In an introductory chapter, Ibn al-Muqaffaʿ says that his manuscript showed "the images . . . of the animals in varieties of paints and colours" and hoped that the miniatures "might be repeatedly copied and recreated in the course of time."[1] The Arab tradition of illustrating books was still in its earliest stages, and if Ibn al-Muqaffaʿ had in his possession a Sasanian original of Burzoe's book, it may well have been one with illustrations from the Sasanian period. And the tenth-century Masʿudi reports seeing in Istakhr a book containing portraits of all the

Sasanian kings, each wearing his own crown.[2] This point is noteworthy, given the great diversity of Sasanian crowns with symbolic details indicating a patron deity. Some Sasanian monarchs changed crown-styles twice or more in their lifetimes, and it is the depiction of their individual headdresses that has permitted the identification of many Sasanian rulers.

Turning from painting known only from written documentation, to surviving examples of early Iranian paintings – or painted objects – a sixth or seventh-century painted clay amphora from Marv [30] exemplifies its classical subjects as well as some of its stylistic features, simplicity, and boldness. The vessel had been intended as an ossuary in the Zoroastrian custom, for the safekeeping of bones, but it fell into the hands of Buddhist monks who placed in it a Buddhist palm leaf manuscript.

SASANIAN SILVERWARES

Sasanian silver vessels and plates decorated with figural scenes survive in far greater numbers and are, hence, far better known than is Sasanian painting. Indeed, given the absence of surviving painting of royal quality, Sasanian silverwares appear to be the finer of the two figural arts, not only for the innately precious material of which they are made but also in the rigor of the figural compositions that is one of their essential features [48, 120; Fig. 16]. Typical of this period are shallow bowls, often called "dishes" or "plates," decorated on the interior with compositions in relief, mostly hunting scenes [20, 224; Fig. 15], which were particularly popular between the third and the fifth centuries. As a rule, the hunter is a king or a prince, but one surviving third-century piece is decorated only with a prince.

It is unlikely that all such dishes depicting the royal hunt were designed for kings' palaces; some could have been gifts received from the sovereign or else made for other patrons. In many cultures, scenes of hunting on horseback denoted happiness and good fortune, and it is therefore apparent that such silver dishes carried *farr*, the king's charisma, and imparted it to anyone who might own the dish in question. As interest in the past was never a characteristic of Sasanian art, the king on any silver hunting-dish is always the artist's own sovereign. The stylistic distinctions between dishes with portraits of the same king, the differences in the quality of workmanship, and the variations in the weight of these vessels (often important to know) are due, in my opinion, to the existence of several groups, or schools, of craftsmen who either catered to different social strata or lived in different silver-making centers.

Between the third and the late fifth centuries, only slight alterations can be seen in the style of the central Iranian silver dishes whose style is akin to that of early Sasanian reliefs. The techniques of execution – cutting away the background for low relief, and soldering details into place for works in high relief – are often examples of the finest workmanship, knowledge of which was handed down from master-craftsman to apprentice in a tradition of continuous renewal.

Another group of silver dishes representing roughly the same long period manifests major changes. Several new schools which sprang up between the fifth and the seventh centuries are stylistically similar, in varying degrees, to the Taq-i Bustan reliefs. In early Sasanian times, the hunting scene was by no means the sole theme to be found on these dishes. There are also dishes and bowls with bust portraits, in profile, of the king, the queen, the heir to the throne, and noblemen, all placed within a medallion (183; Fig. 17).

The first symbolic Sasanian representations of animals occurs in the third century. As in Scythian times, images of the wild boar, the lion or

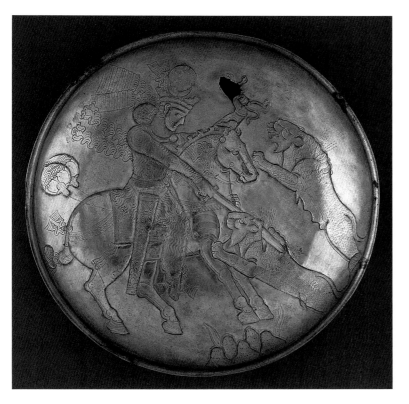

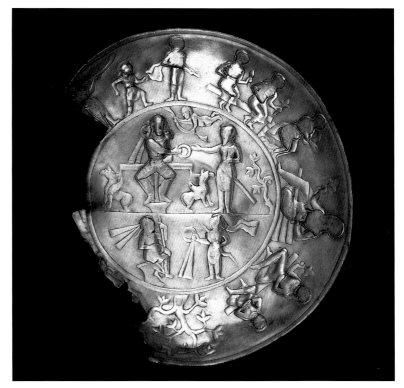

15. "Varahran V Hunts Lions," silver dish, fifth century; London, British Museum, BM 194092

16. Kushano-Sasanian silver plate, Central Asia, fourth century; London, British Museum, BM 124093

tiger (2, 224; Fig. 15), the bear, the stallion, the bull, and other animals, all imply power and courage, and these qualities would be imparted to the owner of any such vessel. In some cases, an association with the zoomorphic incarnation of Zoroastrian deities known from the Avesta seems quite plausible – the wild boar and the bull; other animals such as the bear hardly fit into such a scheme. In the late Sasanian period, the symbolic and allegorical compositions on silver dishes, bowls, and ewers become not only more frequent but also more complicated; royal-hunting dishes become less common. On some vessels [48] the entire universe was displayed, with its waters and mountains, herbivorous and predatory animals and birds, and sometimes fantastic creatures. Figures of female dancers and musicians apparently stood for merrymaking and happiness [183]. Indeed, every detail of the decoration on a Sasanian silver vessel was intended to glorify the owner and bring him good fortune in this world, and the compositions on these later bowls varied enormously. With only one exception, the celebrated "Stroganoff ewer," the images of the gods do not appear on Sasanian silver wares. The same images as seen on silver also decorate Sasanian carved-stucco architectural decorations and carved seal-gems. If a generalization can be made, it is that portraits were more frequently used in early Sasanian times and symbolic images in the late Sasanian period.

Sasanian art, as has already been noted, ignored the historical and legendary past and displayed no interest in fiction. The story of the fifth-century Varahran V (420/1–38/9), the legendary hero also known as Bahram Gur, and his concubine Azada, is the sole invented narrative to be "illustrated" by late Sasanian artists [224]. The theme must have become especially popular after 628, when fortune frowned on the Sasanian dynasty and Iranians sought solace in their glorious past, contrasting this with the woes of their own times.

KUSHANO–SASANIAN ART

The lands east of Iran entered the sphere of Iranian cultural influence in the third century, when the Sasanian King of Kings vanquished the Kushan empire. In the fourth century, the Iranians turned it into a vassal state that became the appanage of Sasanian princes who bore the title

"Kushanshah." On the reverse side of the coins of these rulers, and also on a silver dish made somewhere in their domains (Fig. 16), occur figures of gods usually quite different from the image of the Kushanshah. Kushano-Sasanian cult iconography did not follow Kushan patterns in every detail; their deities are often depicted as a Sasanian king seated on a throne.

Between the fourth to the early fifth centuries, the Sasanians lost the Kushan lands to nomadic tribes – the Chionites, the Kidarites, and somewhat later, the Hephthalites. Time and again the Sasanians tried to win back these possessions but in 484 Peroz lost his life fighting against the Hephthalites, who imposed on the Sasanian state a heavy tribute. The Hephthalites captured Sogdiana in the north and intruded far into India in the south. Yet their rule was short-lived: they were defeated in India around 530, and in the 560s an Iranian force, together with Turks from the eastern steppes, overcame the Hephthalites and divided between themselves Hephthalite possessions. Soon, however, the recent allies were fighting each other, and at the beginning of the seventh century the Turks occupied all the previously Hephthalite lands and extended their sway to the borders of India.

BACTRIAN SILVER

In Bactria (which had come to be called Tokharistan) and in adjoining lands, there evolved between the fourth and the seventh centuries an art which combined Kushan and still older Greco-Bactrian, Indian (Guptan), and Sasanian elements. The type of silver bowl shaped as a segment of a sphere and decorated on the exterior [183; Fig. 17] is usually called "Bactrian" and, at the earliest, is likely to be fourth-century in date but may well be a century later. The style of reliefs on such bowls may be traced back to Greek models but they always incorporate some apparently anachronistic feature typical of Kushan, late Roman, or Sasanian art. Of particular interest is the silver ewer found in northern China in the tomb of a general who died in 569; it is purely Sasanian in shape, but the reliefs decorating it apparently illustrate a tale of the Trojan war. Craftsmen from Tokharistan, who did not quite understand Greek themes, often reproduced works of their Hellenistic counterparts,

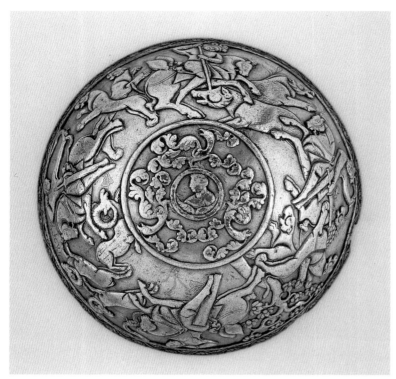

17. Hephthalite "portrait" on the base of a silver bowl, Central Asia, fifth century; London, British Museum, BM 1963-12-10.1

although not without distortions or additions. Bactrian, and even rarer Sasanian and Sogdian, replicas of silver vessels in the classical style (Fig. 30) suggest that the exotic art of "Rumi" – Roman – craftsmen was highly valued in the East. In the fifth century, the so-called "Hephthalite portrait" developed, a genre known from coins, from carved gems, and from "Bactrian-type" silver bowls (Fig. 17). The medallion portrait of the owner on one such piece is encircled by a royal hunting scene executed on the exterior. In contrast to Iranian silver vessels, more than one hunter is depicted, two wearing Kidarite crowns and one a Hephthalite headdress. Another displays the portrait of a Hephthalite in the center [183] and, on the walls, six female figures under an arcade, four of the women holding mirrors or garlands in their hands, and two dancing. The ornaments and the minor motifs on both bowls are Indian, typical of the Guptan period. Indeed, the period between the fifth and the eighth centuries saw the diffusion of Sasanian forms in silver into Tokharistan, Kabulistan, and the neighboring Indian lands, although the decorations often also include Indian elements.

BUDDHIST-INFLUENCED ART

In some of the Buddhist monastic communities that had been established on the trade routes of Central Asia connecting China and India with Iran and the West, grottoes, or caves, were cut from the living rock and their sanctuaries adorned with wall paintings. Between the fifth and the seventh centuries, the sites of Bamiyan, Kakrak, and Dukhtar-i Nushirwan were so decorated; at Dilberjin, Balalyk-Tepe, Qal'a-i Kafirnigan, and Ajina-Tepe it was the free-standing temples that were decorated with paintings. During the sixth and seventh centuries, many of these served the Buddhist communities then moving westward from India. In Buddhist temples, the Buddha and other holy personages were represented in conformity with the canonical Buddhist iconography, of Indian origin, while the figures of any local participants in the rituals were depicted in local styles, their treatment being exactly alike whether in sacred Buddhist art or in secular painting. As for the local nobility, its

representatives are shown, both standing [46] or seated (and banqueting) [37], with the same verism as that which distinguished them in Achaemenid, Parthian, and Sasanian Iranian art.

These Buddhist wall paintings are not always datable but sometimes a comparison with Sasanian silver furnishes a means of refining the dates. On the walls of one of the side sanctuaries of the courtyard of the temple at Dilberjin – not a Buddhist establishment, two layers of painting still survive. In the lower layer are depicted fabrics with no patterns, the clothing and footgear similar to those on two Sasanian dishes [120]. Both the painting and the dishes display a distinctive oversight: the lower part of both boots is shown in profile but the upper part of one is shown frontally. The dishes are datable, by crowns, to the time of Peroz (458–84) at the earliest. Thus, the painting, too, may be assigned to the Hephthalite period, between the fifth and the sixth century. The upper layer shows fabrics with pearl-edged circles; these were not common before the end of the sixth century, which suggests that the later painting dates from Turkic times, as do the murals of Dukhtar-i Nushirwan, Balalyk-Tepe (Fig. 18), and Bamiyan. On the other hand, the paintings of Qal'a-i Kafirnigan and Ajina-Tepe are datable to the end of the seventh century at the earliest.

A characteristic feature of the art of Tokharistan is the representation of the Iranian gods (for instance, in Ghulbiyan, a late fourth-century grotto with mural paintings), the most renowned of whom is Mithra with his distinctive halo, that was painted on the vault over the head of the colossal statue of the Buddha in Bamiyan. As distinct from Iran, the worship of images was a common practice in Tokharistan. At times the Greek substratum of a deity image would be modified under the

18. "Figure at a Banquet," copy of a detail of a wall painting found at Balalyk-Tepe, Tokharistan, sixth–seventh century

influence of the Sasanian mode of representing monarchs, as with the so-called Athena of Dilberjin; at other times the distinctive features of a Sasanian royal image predominated, as at Dukhtar-i Nushirwan. In the local cult iconography, there was no indication whatsoever of the god–king partnership that was so characteristic of Sasanian art. The deities are instead represented as sovereigns, with the monarchs and the highest dignitaries as their subordinates. In Dukhtar-i Nushirwan, the worshippers are shown on a different scale than are the gods, dramatically smaller. Alongside the Iranian divinities there may also be Hindu gods, such as the group of Shiva and Parvati seated on the bull Nandi in Dilberjin. Tokharistan paintings differ greatly between themselves in workmanship, the color scheme of the better ones recalling the fragmentary fourth-century AD mural from Susa (Fig. 2).

Thus, the figural art of Tokharistan is characterized by the presence of a number of techniques and individual details of Sasanian origin, yet the ideas inspiring patrons and artists were distinctly un-Sasanian: Sasanian "monarchocentrism" was absent, and a strong emphasis was placed on the rituals of deity worship. Moreover, in Tokharistan commissions would occasionally be secured by painters whose mastery of their art was not great, whereas Sogdian works of art of the early medieval period, as will be seen, invariably manifest workmanship that was performed at the highest level. It is true that Sogdian objects have received much more study than those of Tokharistan, which has given rise to speculation about Sogdian influences and the migration of Sogdian artists to Bamiyan. As regards the treatment of the human face, the proportions of figures, and the manner of execution in general, there are indeed marked distinctions between the art of these two countries, even though features common to both appear to have originated in Tokharistan at the same time, if not earlier than in Sogdiana.

SOGDIANA

Sogdian art is often mistakenly regarded as a variant of Sasanian art, a misconception that ignores the peculiarity of the historical path traversed by the Sogdians. Ancient Sogdian towns were fortified around the seventh century BC. In the second half of the sixth century, Sogdiana became part of the Achaemenid Persian Empire, but the cultural influence of western Iran failed to stifle deeply held local traditions, and cultural ties with Bactria and Khwarazm were always much closer than with Persia. In the fourth century BC, Sogdiana and its capital, Samarqand, were occupied by the army of Alexander the Great; the population rebelled but was ruthlessly overwhelmed. It was probably at this time that Sogdian emigrants began settling further to the east, in Central Asia; Sogdian colonies in the Tarim Basin and north-western China are attested from the first centuries AD. From the third century BC, nomadic conquerors from the East streamed across Sogdiana on their way to Bactria. In the third century AD, Sogdia submitted to the Iranian Shapur I, but its culture did not yet display any traces of Sasanian influence.

By about 300 AD, Sogdian merchants controlled the Silk Route and the upper Indus pathways; in the fourth century, power in Sogdiana was seized by Huns, or possibly Kidarites or Chionites. Nonetheless, Sogdiana's rise to affluence, which had begun towards the end of the fourth century, continued through this period when the Sogdian principalities were under the control of the Hephthalites, from about 509, and then Turks, from about 560. By 658, the Sogdians recognized China's protectorate but actually gained their independence. Soon thereafter, the Arabs, having conquered Iran, mounted an offensive against the Sogdian domains. More than once, local rulers submitted to, and then revolted

from, the Caliph's administration. Islamicization proceeded at a very slow pace, and it was not before the middle of the eighth century that, in Sogdia, conversions to Islam began, first among the nobility and the townsfolk, and then among the country people. The borderline between the pre-Islamic and the Islamic periods in the culture of Sogdiana was laid down in the second half of the eighth century, about a century later than in Iran. In Sogdia, the advent of Islam was also accompanied by the diffusion of Farsi, which was to replace Sogdian as both a written and a spoken language. Yet throughout the whole of its history, Sogdia was never a strong military power. Between the fifth and the eighth centuries, and possibly earlier, it had been divided into several city-states under the formal supremacy of Samarqand. Correspondingly, the patrons of Sogdian artists, as distinct from Iran, were the petty lords, landowners, and the city patricians, and never an all-powerful monarch.

As in pre-Achaemenid Persia, the early figural art of Sogdiana, of the seventh to the fourth centuries BC, is unknown to us. Of the arts of the Hellenistic period, all that survives are terracotta ex-voto figurines, often resembling Mesopotamian specimens. The rapid development of fine Sogdian art is only traceable from as late as about the fourth or the very early fifth century. In its architecture, the ancient Near Eastern tradition was still prevalent, whereas in painting and sculpture the images of the gods were fashioned in the Hellenistic style. It is difficult to form an opinion about the earliest Sogdian murals, from the third century AD, from a temple in Erkurgan (in south Sogdiana), since they are poorly preserved. What is apparent is that they have little in common with later Sogdian painting. Thus, the uninterrupted development of this art can be traced only from the fifth (or possibly fourth) century, with the erection of the temple at Jar-Tepe, a day's journey eastward from Samarqand.

SOGDIAN PAINTING: JAR-TEPE

On the façade of the temple at Jar-Tepe was cut a large recess with a niche in the back wall, which was painted with a repeat-design of tulips inside lozenges; perhaps the niche would have contained a small sculpture placed there during rites. On each side of the niche, were painted figures of worshippers, shown frontally but with their heads in profile. Their appearance, the clothing in particular, resembles Parthian and Kushan personages, and the only classical element is the ornamental frieze in the zone below their feet, the design of which recalls Roman mosaics (Fig. 19). This exterior painting is unsophisticated in its drawing, with thick contours, and simple in its color scheme.

19. "Standing Worshippers in a Landscape," drawing of a fragmentary mural in a temple, Jartepe, Sogdia, fifth century

On the interior, there were two entrances to the cella, as there were two "resident" deities inside it. On the walls of one passage to the cella is painted a donor couple; preceding them is a celestial (?) harpist shown as larger than the donors. On the back wall of the cella are painted a god and a goddess seated on a throne that has two lions as supports. Surrounding them are standing and dancing figures (among the standing ones there are princes, each of whom holds a wreath supposedly received from the goddess), and below are several riders (not royal, as they do not wear crowns) hunting different animals which, in some details, recall nomadic figures of horsemen and animals, as at Orlat and in Bactrian images. The sole Hellenistic element is the throne, reminiscent of Cybele's. The deities are represented on the same scale as the humans, and all the themes – music, dancing, and successful hunting – imply the good fortune and happiness that are rewards from the gods.

SOGDIAN PAINTING: PANJIKENT

The subsequent development of Sogdian cult iconography can be traced in Panjikent, the city founded in the fifth century and abandoned by its inhabitants around 780. Panjikent is about sixty kilometers east of Samarqand, and the ruins of the early medieval city are on the outskirts of modern Panjikent, in what is now Tajikistan. Approximately fifty years of excavation have uncovered more than half the territory of the eighth-century city, including a citadel, two temples, bazaars, and dozens of private houses. The fifth- to sixth-century strata have been investigated in the citadel and in the temples, as well as several houses, and the city walls of that period. In the seventh and early eighth centuries, Panjikent had its own princes and coinage. Yet compared to other Central Asian cities it was small, about 80,000 square meters in the fifth century and approximately 135,000 square meters between the sixth and the eighth centuries (excluding the citadel). Samarqand, which only as late as the end of the eighth century had expanded beyond its pre-Achaemenid walls, was many times larger.

Finds from the temples in Panjikent include a fourth–fifth-century sculpture of essentially Hellenistic character: a stucco figure of a seated goddess, only thirty-four centimeters high and composed of separately molded elements. Another object of Hellenistic character is a fifth-century clay relief of a pair of Tritons, symbolizing water. Dating from about the end of the fifth century is a cult painting of a goddess seated on a throne and several donors. Much in it resembles the Jar-Tepe temple murals, but here the workmanship is much finer. The tenaciousness of the Hellenistic tradition of painting may be seen in the way in which volume is conveyed, by modulating color and by shading, by the silver–ocher color scheme, and in the ornament of the lower frieze; yet the posture of the goddess and her throne are already treated according to Kushan-Sasanian standards.

Another feature making its appearance in painting – or rather, regaining acceptance – in the early sixth century is a warm color scheme saturated with hues of red, its prototype dating from Achaemenid times and typified by the woven parallel of the Pazyryk carpet (Fig. 20). At this time in the sixth century, when Sogdiana was under Hephthalite control, Indian features began to be found in the mix of Greek and Sasanian figural elements that then characterized Sogdian art. Widespread in Sogdiana and Khwarazm at about this time was the image of a four-armed goddess sitting on a lion and holding the sun and the moon in two of her hands. This is a new version of the iconography of the goddess Nanaia, known in Mesopotamia since the late third millennium BC. Nanaia was a deity with an important role to play in the religion of all the East Iranian lands, and her image is attested in Sogdiana by paintings

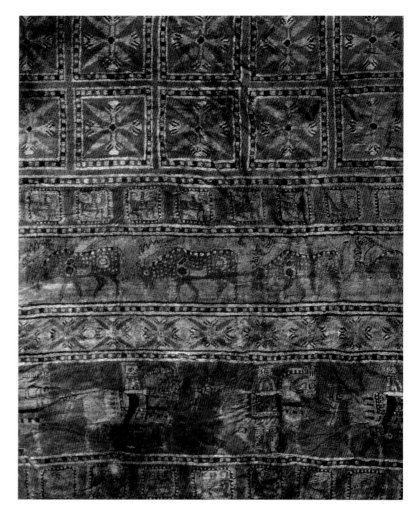

20. Detail of a knotted woolen-pile carpet, found at Pazyryk, in the Altai Mountains, fifth century BC; St Petersburg, State Hermitage Museum

and by sculpture of unfired clay and of terracotta, and in Khwarazm by reliefs on votive silver bowls of the sixth to the eighth centuries. Panjikent decoration included not only temple-sculptures and paintings, but also contemporary relief-molded terracotta plaques representing gods, the gods often placed under an arch as if set in a temple niche. Some are unique to this material, while others are also encountered in paintings. Mythological compositions also appear in painting, such as the famous scene of mourning rites, apparently the funeral of a young goddess – and not of the Iranian hero of the *Shahnama*, Siyawush, as previously presumed [100; Fig. 57]. The four-armed Nanaia, with two other goddesses, is among the mourners.

Numerous painted scenes of the worship of different gods, dating between the sixth and the eighth centuries, were found in the temples, palaces, and dwellings of Sogdiana: in Panjikent [45, 46], Samarqand, Varakhsha (near Bukhara), and Shahristan, the ruler's residence in the Ustrushana region north-east of Samarqand. The Sogdians borrowed from existing images and they also created new iconography, drawing on motifs and organizational schemes of Greek, Indian (mainly Shivaite), and Sasanian origin. Figures of musicians, actors, and dancers are frequent in these compositions, as well as in scenes of feasting; worshippers with portable altars, however, occur only in the proximity of deities and are never shown in connection with banquet scenes. Fighting, hunting, and feasting – the *razm u bazm* celebrated in Iranian poetry and painting of the Islamic period – are also common themes in the painting of both temples and secular buildings. These tend to be monocultural in their compositional make-up, as do scenes with representations of donors, which rarely, if ever, exhibit the borrowed elements so typical of the images of Sogdian gods and which made possible an iconography in which the gods are quite unlike human beings as well as differing significantly one from another. A Sogdian peculiarity is that their artists

often imparted to the Iranian gods an almost Indian appearance. For instance, the wind god, Veshparkar, may resemble the three-faced Shiva Mahadeva. Occasionally there seems to be evidence of the infiltration into Sogdiana of other foreign cults. Another example is a sculptural group of Shiva and Parvati on the bull Nandi from Panjikent, as also in Dilberjin, to which we can hardly ascribe an Iranian interpretation. The art of Panjikent also displays Buddhist features, although Buddhism is more typical of Sogdian colonies in the east than of Samarqand in Sogdiana proper.

In the seventh century, the people of Samarqand demanded from their neighbors a reverence for the gods and the "scripture" of the Samarqand city state, apparently rejecting Buddhism; as they had not adopted the more orthodox Iranian forms of Zoroastrianism, whose influence there probably dates from pre-Achaemenid times but whose role was never the same as in Iran. Instead, under its conditions of political disunity, Sogdia placed more importance on the cults of specific deities that were acknowledged as patrons by cities, by dynasties, or by noble families. These gods also included non-Zoroastrian divinities, in particular the reverently worshipped Nanaia. Absent from Sogdian culture was that intolerant Zoroastrianism characteristic of Iran which, under the Sasanians, had been inculcated by a militant priesthood backed by a powerful monarch. For example, in the city temple of Panjikent at the turn of the eighth century, place was set aside for a chapel housing a sculptural group of Shiva and Parvati, although it could only be reached via an entrance from the street and not from the temple courtyard, as was the case in other minor sanctuaries.

Sogdiana boasts an extensive array of paintings in palatial and more modest houses: in the early eighth century, a third of all Panjikent dwellings were decorated with painted murals. A wealthy home-owner might have had between one and five rooms decorated with paintings and carved woodwork. A scene of the worship of a deity would be placed in the main audience hall, facing the entrance, and it would be flanked by scenes of feasting or hunting, and narratives of legendary, or actual, events. Underneath would run an ornamental frieze, or a series of separate scenes in rectangular panels. Thus, the paintings displayed on a wall in a dwelling in Panjikent may be classed in three categories, each differing in size and significance. Paintings in category I were typically from three to three and a half meters in height, in category II about a meter high, and those in category III between forty and fifty centimeters high. The subjects of category I were primarily images of gods; in category II heroes [129, 132, 133], noblemen, and city patricians prevailed; and the paintings of category III illustrated fables and tales, including those in which animals are the primary characters [206, 243]. The first category is quite typical of painting in Sogdia, both early and later in date, and in Tokharistan as well; the second is characterized by its extensive repertory, incomparably richer than elsewhere; and the third – when it is figural – is known exclusively in the Panjikent of that date.

In contrast to Sasanian artists, Sogdian painters seldom reproduced events associated with the exploits of their kings. One exception is in the mid-seventh-century house of a dignitary in Samarqand, in which the murals depict the reception of embassies by the contemporary king and, presumably, a procession led by the king to his ancestors' shrine (Fig. 21).

21. "A King Leads a Procession," copy of a detail from a wall painting, Afrasiyab (Old Samarqand) ca. 600

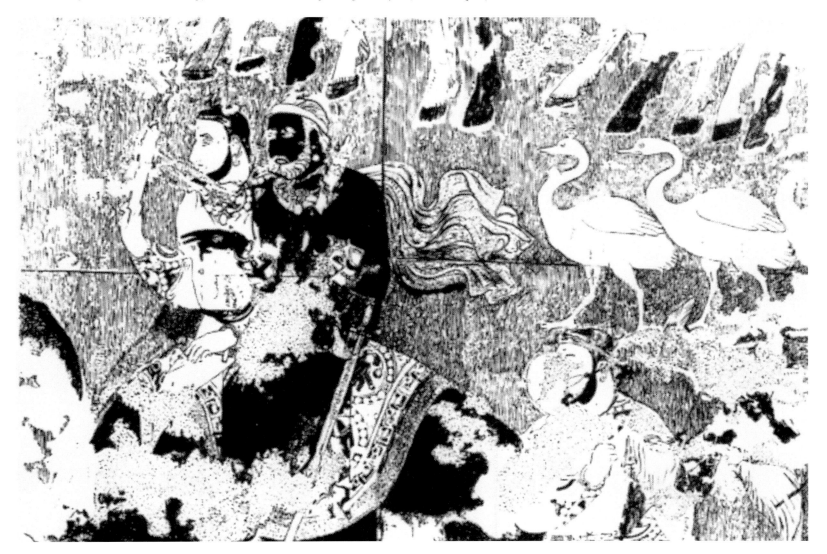

22. Fragment of a "Coronation Scene," wall painting from the Citadel Palace, Panjikent, Sogdia, early eighth century

Another is the category II paintings in the eighth-century palace of a ruler of Panjikent, which include scenes of a city siege and of the king's coronation (Fig. 22). Among the participants of some episodes are Arabs, whose presence in Sogdiana is only recorded from the end of the seventh century, which suggests that the subjects in this particular ensemble reflect something that had but recently occurred. In several Sogdian houses are paintings of kingly feasts – different kings of the world, each surrounded by his subjects but apparently being held at the same time and thus implying some kind of worldwide festival (Fig. 23). Such scenes are unknown in Sasanian art, where foreign rulers were portrayed only in defeat by the King of Kings.

Of special interest are the paintings of the second and third categories. Many of those in the second are large continuous narrative friezes that show a hero in several successive episodes. Painted on the walls of buildings in Panjikent are scenes from an epic with Rustam as its hero [129, 132, 133], including a cycle of his *haft khwan*, his "Seven Exploits," that relates to one of the sources drawn upon by Firdausi when writing the *Shahnama*. Also present in Panjikent are scenes of "The Battle of the Amazons," "Virataparvan," from Book IV of the *Mahabharata* [244, 245], and illustrations from several epics previously unknown [155]; while on the Shahristan in Ustrushana are paintings illustrating the tale of Romulus and Remus. Some of these are original Sogdian legends, while others have clearly been borrowed. Most popular of all was the great hero Rustam, for in addition to the cycle devoted especially to his heroic feats he also appears as a minor protagonist in two more epic cycles, the texts of which remain to be identified.

Category III, placed in the lowest zone of a Sogdian painted ensemble, comprises scenes from literary genres other than the epic: fables, anecdotes, tales, and the like. Each story is illustrated by one of a series of separate panels, sometimes dozens in a room. The subjects so far identified include illustrations from the *Fables of Aesop*, the *Pancatantra*, the *Sindbadnama*, a fairy-tale known only from a Sogdian text-fragment, and several others whose subjects are attested by the folklore of Iranian and neighboring cultures. Thus, Aesop's tales, and episodes from the *Pancatantra* and what later came to be known as *Kalila and Dimna* [206,

243] – traceable, by way of the Sasanian physician Burzoe, back to an older version of the *Pancatantra* – are among the earliest stories with documented illustrations. Indeed, the paintings of the third category in Panjikent's painted houses may perhaps be termed book-illustrations transferred onto walls.

A different situation obtains with the epic friezes characterized by their finely developed techniques of pictorial narration. Such friezes appear around the turn of the eighth century (although perhaps we simply do not, at present, know of earlier examples) in rooms of state. It is also likely that friezes of this category represent a transfer of images, this time to a monumental scale, from portable painted scrolls whose stories and legends would have been performed in song or recitation by a single performer. Such "theater" is known in many Asian cultures and perhaps originated in India as early as the fifth century BC. And it can hardly be by chance that both the story of Rustam, which was to be incorporated by Firdausi in his epic poem of the Iranian past, and the *Kalila and Dimna* tales, are among the literary works that inspired a host of Iranian painters in the later Islamic period, from at least the fourteenth century onward. Indeed, these Sogdian paintings from the sixth to the eighth centuries testify that Iranian painters in the Islamic period were heirs to a very ancient pictorial tradition.

They also raise a question: *Kalila and Dimna*, the *Sindbadnama*, and especially the *Shahnama*, are medieval, classical Persian texts which all possess Middle Persian prototypes; why, then, are no illustrations to these stories, so greatly admired in Iran, known before about the twelfth century, except in Sogdiana? It would be difficult to imagine that illustrated scrolls and codexes did not exist in pre-Islamic Iran, and indeed literary evidence confirms this. But it would seem that only in Sogdiana were book-illustrations considered appropriate for decorating the walls of palaces and houses where they then preserved the tradition in both Sogdiana and in Iran, while the more fragile illustrated scrolls and volumes were liable to decay and disappear.

The undeniable distinctions between the themes of Sasanian and Sogdian painting seem perhaps more significant than they are in actuality, since what we know in Iran is primarily associated with

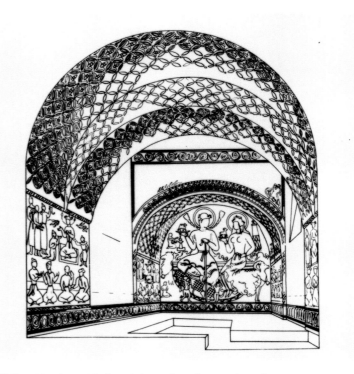

23. "Kings Feasting with their Subjects," rendering of a wall painting on the rear and side walls of a reception room in a private house, Panjikent, Sogdia, eighth century

official propaganda rather than with the cultural interests of the middle class. The essentially local iconography and style of Sogdian narrative paintings incorporated very few Roman, Indian, Hephthalite, or Sasanian motifs. The better murals with their ultramarine background resemble, in their color schemes, the Sasanian hunting scene from Susa but are unlike Sasanian painting in their drawing. Especially the seventh- or eighth-century type of Sogdian hero, with the broadest shoulders, slimmest waists, and light hands with long lissome fingers [121], had little in common with the late Sasanian ideal of massive might. This image of power without inert mass is strikingly reminiscent of the early nomadic style of Pazyryk. Uncharacteristic of Sogdian art are intricate allegorical compositions on any scale and in any medium; equally, symbolic figures are less common than in Iranian art of the same period. Sogdian silver vessels of the sixth century are plain and thin-walled, resembling Parthian silver wares that originated in the Achaemenid silver tradition; the seventh century saw the flourishing of this art in Sogdia and it was practiced well into the eighth century [12]. The forms and decoration of Sogdian silver became more elaborate, incorporating Byzantine, Sasanian, and Chinese motifs as a consequence of Sogdian ties with the far-flung countries linked by the Silk Route. Among Sogdian silver dishes there are none with portraits of reigning kings; and representations of animals in silver, as with every aspect of Sogdian art, are less solemn and more dynamic than their Sasanian counterparts. The images of gods in Sogdian paintings have parallels on Khwarazmian, but never on Sasanian, silver wares. In Sogdia, it would seem, such silver dishes were intended for feasting occasions and not for donation to temples, although a single dish was recovered from the sanctuary of Jar-Tepe.

How closely aesthetics and ethics were tied to each other in Greater Iran has become evident in the course of the last half century in the study of Sogdian painting. For in them, themes of Ancient Near Eastern origin – rites, feasts, hunts, and battles – set against equally ancient background color schemes of monochromatic red or blue, were altered to a great extent, in accordance with new ideas. Thus, in the murals of category I, the luminous faces of gods and goddesses, their heads haloed with a bright disk and tongues of flame, expressed theological and aesthetic conceptions of the divinity of light, conceptions so typical of many Eastern cultures in the first millennium AD.

Inspired by the heroic and knightly ideal, the pictorial narratives of the murals of category II are dramatically emotional, unlike their ancient prototypes. The contrasting background, the bright colors, and the detailed depiction of luxurious garments, armor, and personal ornaments, all helped to emphasize the importance of the subject matter, which was the only aspect of interest to the Sogdians. With few exceptions, the world in which the stories of these Sogdian paintings takes place is practically absent; the most minimal of details – a castle, a tuft of grass or a hill – defines the setting, like that of Shakespeare's theater; while the stature of the heroes depicted in them is the full height of the composition.

In comparison with the murals of category II, those of category III are small and prosaic; their backgrounds are pale and their figures relatively small. In place of dramatic effects, we find instead a sense of humor. The modesty of such scenes corresponds to the modest place of practical wisdom – the point of the texts here illustrated – in the ethics of the pre-Islamic period.

With the advent of Islam, the images of the gods naturally disappeared from Sogdian painting. Nonetheless, so many of the later illustrations in manuscripts of Persian classical literature of the Islamic period – the *Shahnama*, *Kalila and Dimna*, and other texts as well – should be considered the heirs of the still undiscovered (or no longer surviving) Iranian illustrative paintings, for they bear true kinship to the Sogdian mural paintings of Panjikent. As for the larger concerns of the origins, and sources of painting in the Iranian world in the centuries before the advent of Islam, what is clear is the affinity between all the Iranian cultures in the early medieval period, as there were also important distinctions between its eastern and western manifestations. This is primarily because it was the western Iranians who, in subduing their neighbors in the ancient Near Eastern land between the rivers, adopted the Mesopotamian imperial mode to their own uses and created an official, proclamatory art. Such a mode is almost unknown in the Iranian East but its presence can be discerned for nearly a millennium and a half in the West and, in the context of Islamicized Iran, it shaped a human conception of the world, as expressed in painting, that would long outlive more ephemeral changes in the styles of such painting.

Translated from the Russian by Boris I. Groudinko

THE EARLY ISLAMIC PERIOD

MANI: LEGENDARY IRANIAN MASTER-PAINTER

The signature on a mid-nineteenth-century papier mâché pen box, made in Isfahan by a member of a distinguished dynasty of painters, names the artist neither in the terms of his parentage nor his sons, in the classical Muslim manner, but as "a man from the line of Mani." Mani is the syncretistic religious figure of third-century Iran with whom painters in the Islamic period were consistently compared. He surely considered himself the prophet of a new faith, but he is renowned far more for his art than for his arcane and eclectic religious system: his name resonates throughout later centuries in Iran like that of Leonardo da Vinci, Raphael, or Michelangelo in the West. For the tenth-century poet Firdausi writing in the *Shahnama*, Mani is "a man of eloquence, / Whose peer in painting earth will not behold." Firdausi also says he comes from Chin – Turkestan – and has him proclaim " 'I prove my mission by my painting, / And am the greatest of evangelists.' " For the fifteenth-century Timurid historian Khwandamir wishing to praise a contemporary, Kamal al-Din Bihzad, only this fabled predecessor was worthy of comparison with the most celebrated of all contemporary Iranian painters:

> His brush, like Mani's, wins eternal fame;
> Beyond all praise, his virtuous qualities;
> Bihzad, acknowledged as supreme in art, . . .
> Has turned the name of Mani to a myth.[1]

Dust Muhammad, the sixteenth-century critic, historian, and librarian to Bahram Mirza, brother of Shah Tahmasp Safavi, wrote that "Mani pretended to prophesy and made this claim acceptable in the eyes of the people by cloaking it in portaiture. . . . Mostly these things were done by Mani in the regions of Iraq, . . . but thereafter he set out for Cathay and did amazing things there too."[2] Nineteenth-century painters in the traditional style, as we have seen, still saw themselves as followers in the tradition of Mani's accomplishments. And as late as the beginning of the twentieth century, an Iranian poet could write a *Tale of Mani the Painter*, testimony to the fact that even in recent times, it is as a painter, rather than as a prophet, that Mani's name still lives in Iranian hearts and minds.

What facts underlie this suggestive myth? Mani was born about 216 AD in southern Mesopotamia, to parents of noble Parthian Arsacid blood who came from Hamadan, in western Iran. His father was "a seeker after God" and had removed himself from court life to a part of the empire where a number of religious sects had established themselves, especially those with a gnostic or baptismal component to the beliefs and practices they promulgated. About the time of the accession of the Sasanian King of Kings Ardashir I, when Mani was about twelve years of age, he is said to have had a divine revelation, which caused a temporary break with his father's religious community; toward the end of Ardashir's reign he received another revelation that exhorted him to "Call the peoples to the truth and to proclaim . . . the good message of the truth. . . ."[3] Mani thereupon converted his father and his co-religionists and set off upon the travels which would spread his new religion throughout Asia. This first proselytizing trip took him to the north-west provinces of Iran and

then into India, to Gandhara, and seems to have lasted about a year; when Shapur I succeeded his father, Ardashir I (in 242 or 243), Mani returned to Iran. His father's connections brought him into court circles: in Ctesiphon, capital of Sasanian Iran, he obtained audiences with Shapur himself, who was said to have been so impressed with Mani's teachings that he sent letters throughout the realm permitting Mani the freedom to preach his message. Mani himself wrote that he spent some years in Shapur's retinue and even accompanied the King of Kings on military campaigns – victorious – in western lands.

Mani's religion was fundamentally dualistic: a deliberate mix of Christianity and ancient Iranian dualism overlying a gnostic baptist belief that sprang from contemporary Mesopotamian traditions. The Buddhism which he encountered in the Indian north-west had a lasting impact on his religious (and also on his practical) formulations, just as gnostic Christianity and Mithraism had affected his earlier thinking. Essentially, Mani saw the world as the theater of incessant strife between two principles, described as Light and Darkness, or Truth and the Lie; the older Iranian Zoroastrianism had personified these principles, naming them Ahura Mazda and Ahriman. The message had been delivered to its prophet, Mani, by divine revelation, and it would be further promulgated by the Word, either as preached by him and his disciples, or in written form – beautiful volumes of religious teachings, prayers, and hymns enhanced with much gold and adorned with painted images. Here, then, is the feature that connects this early Sasanian prophet with his reputation as a miraculously fine painter in the Islamic period. By contrast, his religious system of ephemeral and syncretistic dualism, in which ancient Iranian fire-worship was shed for less complex practices but a more complex and arbitrary system of beliefs, eventually brought him into conflict with Kartir, Shapur's Zoroastrian chaplain at court, and led to to his imprisonment and a gruesome death.

Before this occurred (in 276 or 277), Mani and his disciples spread the Manichaean message far beyond the boundaries of Iran: to the north-western frontier with Rome, to Egypt, to Khurasan in the north-east, and deep into Central Asia. Indeed, it is from lands far to the east of his Iranian homeland, and from some centuries later, that have survived virtually the only Manichaean books to give us a sense of the art that had become so famous during his lifetime [49; Figs. 14, 26]. These books also hint at the kind of painting practiced in lands of Iranian culture between the end of the Sasanian period and the appearance of the painted ceramics and inlaid metalwork of medieval Iran.

As to the books Mani may himself have painted, practically nothing survives; only in written contemporary references, and later poetic echoes, does the name of a legendary work called the *Arzhang*, or *Artang*, glimmer across the centuries. According to some sources, it was a painted span of silk; in others it was a book, containing drawings and paintings having little to do with Mani's religious activities and has thus been described as "extra-canonical;" according to still others,

It contained virtually an encyclopaedia of the sage's cosmological doctrines, while the pictures represented single portions of his fantastic

24. "Head of A Princely Figure," fragment of a wall painting found at Kuh-i Khwaja, sixth–seventh century; New York, The Metropolitan Museum of Art, 45.99.1

globe and scenes taken from the cosmic drama, from the first meeting of Light and Darkness up to the tragedy of primitive Man, the birth of aeons and the battles with the giants.[4]

The *Arzhang* is said to have been executed with unheard-of skill and achieved under strange circumstances – written in a cave in Turkestan. A certain Abu'l-Maʿali admired a copy in the treasury of the Sultans of Ghazna in 1092 although, like so many volumes mentioned in historical sources, this too subsequently disappeared. A century earlier, Firdausi wrote of a "letter worthy of the Artang, / Decked with a hundred colours and designs: –."

The texts Mani may have illustrated himself were probably written on parchment and could have been either in the form of a scroll or a bound book, a codex; the script was probably eastern Aramaic and formally related to the Syriac ecclesiastical script practiced in Edessa (in northern Mesopotamia); while the lavish bindings were the subject of envious attention by both Christian and Muslim religious opponents. Gold and silver were apparently used in profusion, to be judged from a telling episode in the early tenth century in Baghdad when, from a fire on which fourteen sacks of Manichaean books were being burned, rivulets of precious metal ran freely.[5] The paintings illustrating Mani's devotional texts are most likely to have been in the general Parthian style known, today, largely from fragmentary mural examples, such as those at Dura-Europos (on the Euphrates River), in the painted remains found in the palace of Kuh-i Khwaja, in Sistan (in south-eastern Iran) (Fig. 24); and possibly from the equally fragmentary remains of sixth-century paintings recovered from excavations in the Sasanian capital of Ctesiphon, Mada'in (further south on the Tigris, in Babylon) (Fig. 25).

The fragmentary Manichaean paintings so dramatically discovered in 1905 in the Turfan Oasis in Chinese Turkestan are much later in date. An astounding quantity was discovered, some in a state of advanced

25. "Face of a Woman," fragment of a wall painting found at Ctesiphon (Mada':n), ʿIraq, ca. sixth century (?)

rot and decaying; still more had been judged "sinister" by the local peasants and were already destroyed. They were written on paper and painted with gold leaf and costly mineral pigments, ample testimony to the prosperity of the Manichaean community in Turfan under the aegis of the Uyghur Turks. That both paintings and texts were often found on two sides of a fragment confirms that the preferred format was the codex. Stylistically, most of the paintings reflect an eastern Turkish, Buddhist, figural canon and a non-illusionistic manner of using color; but they appear to have been as lavishly decorated with gold as were the books completed in Mani's own lifetime and his native land.

Almost more significant is the manner in which Turfan Manichaean painting foreshadows medieval Iranian painting, on painted ceramics and – however rare – on paper. The scale of the figures, the drawing, color and its application; the very conception of compositions, the massing and disposition of figures or groups of them, and the depiction of faces and coiffures; the details of textiles and furnishings and accoutrements: all of these features of medieval Iranian painting seem to be adumbrated in the extraordinary remains of Central Asian Manichaeanism as it was practiced under the aegis of the Uyghur Turks in the eighth and ninth centuries. For the most part, then, the Turfan Manichaean paintings appear to differ greatly from the more classically influenced Central Asian figural painting of the Parthian and Sasanian periods, although one paper fragment found in Turfan shows women painted illusionistically, and with dark hair and the spit-curls known from earlier Central Asian sites where Hellenism was still a potent stylistic influence, such as at Miran, on the Southern Silk Route [Fig 14].

THE CENTRAL ASIAN–TURKIC COMPONENT IN IRANIAN PAINTING

These fragments of Manichaean sacred books, and many other significant examples of Central Asian painting and sculpture, are today in the Berlin State Collections as a result of four "Turfan-Expeditions" undertaken by the Berlin Museums between 1902 and 1913, following the discovery of a single fragmentary manuscript in Kucha (north of the Tarim River in Western Turkestan, on the Northern Silk Route). Written in an ancient Indian script in the Sanskrit language, and datable to the fifth century AD, the fragment was older than any Indian text then known, and it served to focus the attention of certain parts of the scholarly world on the relatively unknown area of Chinese Turkestan. The second Berlin expedition to Central Asia arrived in the Turfan Oasis (further east from Kucha, along the Northern Silk Route) in late 1904 and continued work in the large field of ruins of the city of Kocho. The primary finds of this rather short campaign are actually among the richest and most interesting of the four: manuscripts, "written in no less than twenty-four scripts with texts in seventeen languages, some of them entirely unknown at the time. . . ."[6] They include all the fragments of Manichaean sacred texts now in the Berlin State Collections, many of which are illustrated [49; Figs. 14, 26]. Before 1905, none could even have been imagined, anywhere in the world; since that date, they have been shedding enormous light on the material culture of Eastern Turkestan and all of the surrounding regions between China and Iran at this fascinating time.

For the later history of Iranian painting, their importance lies in the similarity they bear, in scale, figural style, and composition, to the style of human representation practiced in all media in the medieval Muslim world. This style was centered in Iran but is also generally found on works produced everywhere in Eastern Islam, from Khurasan to eastern Anatolia and Syria. In a few surviving fragments of Seljuq mural painting [38, 101; Fig 53], in the illustrations of a single surviving manu-

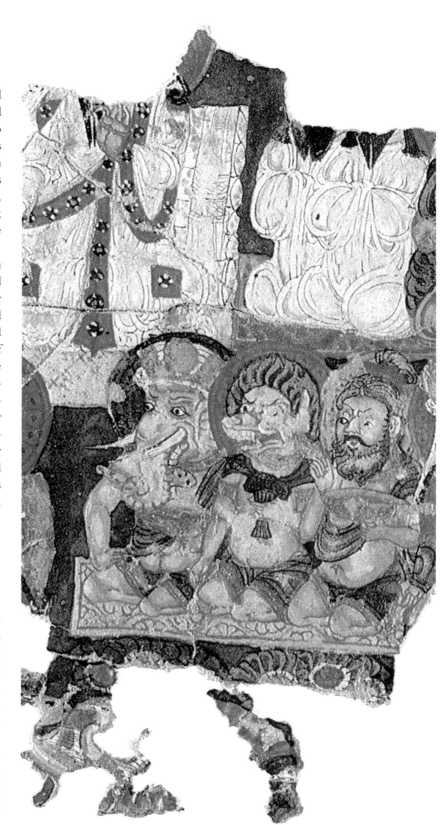

26. "Priest, Prince, and Court," fragment of a Manichaean manuscript (the back of [49]), found in Kocho, Chinese Turkestan, eighth-ninth century; Berlin, Museum für Indische Kunst, III, 4979

script [4, 57, 140, 166], in stucco sculpture [Fig. 53], on countless numbers of painted or lustered ceramic tiles and vessels [2, 3, 135, 225, 226; Figs. 40–47], on inlaid metalwork [Figs. 50, 51], painted glass [201; Fig. 49], on lacquered wooden vessels [Fig. 47], and even on the stones carved for impressing designs into leather [Fig. 48], can be seen figures of astonishing similarity, in style as well as in scale and scope of activity, to many of the Manichaean manuscript fragments usually dated to the eighth or ninth centuries. This is one significant feature of the treasure-trove whose discovery, by Europeans, came at virtually the same time as the local population was in the process of destroying the finds when they came to light.

Equally significant is the fact that this body of painted and gilded manuscript-fragments adds significant testimony to the fact that later Iranian objects decorated in the so-called "Seljuq International Style" exemplify a historically continuous, and remarkable, aspect of painting as it was practiced in Iran: the figural models for the most important personages represented in its sculpture and painting have often been taken from those of neighboring cultures. As Marshak has observed, the sources for the figures of gods in Achaemenid Iran had been Greek. In this third period of Iranian cultural cohesion, the pictorial models for princes, and indeed for all idealized representations of human types, were Central Asian-Turkic in origin, and often Buddhist in religious culture.

The Buddhist ideal visage is full-faced, narrow of eye and small of mouth – the moon-faced beauty. Both sexes have long dark hair, men's often falling in long plaits. The figures tend to be short in stature and are often shown as either frenetically active or else immobile, seated cross-legged in conversation with peers, consorts, or disciples, or in contemplation. And they are often robed in intensely patterned long garments that may be enhanced with gold, cut in a manner that would come to be identified with Turkic peoples.

The sartorial aspect of this proto-Turkic mode had already made its way into Sasanian monumental sculpture by the later fifth or sixth century. It is clearly depicted in the hunting reliefs at Taq-i Bustan, where Khusrau II is shown in fashionable hunting attire wearing a front-closing kaftan patterned with large roundels containing stylized four-petalled rosettes and cinched at the waist by a belt with hanging thongs, or straps, set with a series of small round elements. Different versions of this garment can be seen in numbers of wall paintings from Central Asian sites that range in date from the early sixth century to the eleventh, suggesting the very strong presence either of ethnic Iranians, or Iranicized Turks, in the mixed cultural context of Central Asia. The seventh-century procession of donors painted on the walls of the Cave of the Sixteen Sword-Bearers in Qizil [47], and the eleventh-century guards painted standing at ease – forever – on the walls of the throne-hall in the Southern Palace in Lashkari Bazar [122] are strikingly similar in the details of their clothing as well as in their formal conception.

A different version of the Turkic front-closing garment, the lapels emphasized by a contrasting border, can be seen in an early sixth-century mural in another cave temple in Qizil: worn by the painter who signs himself "Tutuka" and who is shown working on a large wall panel with a picture of the Buddha preaching (Fig. 27). It has no belt with hanging vertical straps or thongs, it appears to be undecorated other than the dark border, and it is also shorter, so that the full trousers tucked into what appear to be high boots are visible. Whether the length and the lack of trimming are appropriate to a manual occupation – as can still be seen a millennium later in Timurid manuscript painting – or are instead typical for the fairly early date of this painting, is unclear; but his Turkic dress sets him apart from the donor figures seated at the lower right of the panel on which he is working.

A later, and elaborated, version of the kind of garment worn by Khusrau II in the Taq-i Bustan relief is seen in several painted images in temples in the eleventh-century Buddhist monastery complex of Alchi, in the Himalayas of western Tibet. In a princely drinking scene painted on a wall near the entrance of the monks' assembly hall, the Dukhang, a seated, cross-legged prince wears a front-closing kaftan patterned with large roundels containing a prancing quadruped (Fig. 28). On the left leg of an immense cult statue in the principal temple, the Sumtsek, is painted a procession of turbaned riders dressed in similar kaftans with *tiraz* (an inscribed band of cloth on the upper sleeves of the garments of high-ranking Muslim men). The procession sets out for the hunt, a falcon perched on the wrist of one who turns backward toward another

27. "The Painter Tutuka," detail of a wall painting in the Cave of the Painters, Qizil, Western Turkestan, ca. 500

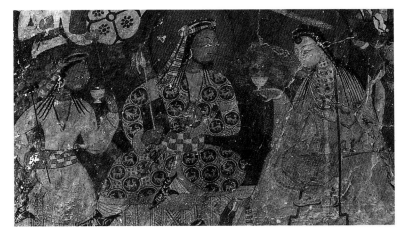

28. "Seated Men at a Princely Gathering," detail from a painting in a temple in the Dukhang, Alchi, Western Tibet, eleventh century

mounted on a white horse whose trappings include yak-tails. The facial types and full black beards of the prince, and other men, make them stand out as foreigners among the crowd of Buddhist figures, as do their garments: distinctive patterned kaftans, short pointed black boots, and the baggy trousers just visible under the hem of the long garments. Even their long black hair in many plaits, a narrow scarf tied around the head with its ends hanging loose, calls to mind the Seljuq figural style of the twelfth and thirteenth centuries practiced in Iran and neighboring lands. The seated prince may actually have been an Indo-Iranian who married into a local Tibetan family.[7] It is true that, by this date, such Turkic garments, developed for their practicality by riding peoples of the steppes, were worn all over the Central Asian and Islamic worlds. In any case, ethnic Turks had become a major racial component of Muslim society: the armies of the ʿAbbasid Caliphate, from early in the ninth century, were predominantly composed of Turks from Farghana and Ushtrusana, in Central Asia. Iran proper and the surrounding outer Iranian lands were no exception to this fact of medieval Western Asian history, and the Turkic presence would profoundly affect Iranian material culture, painting included, in the centuries to come.

THE EARLIEST ISLAMIC PERIODS

With the "Victory of Victories" of the Arab forces over the Sasanian armies at Nihavand in 641–42, the south-western part of Iran, locus of Sasanian imperial power, was overcome by Arab Muslims who opened up the area for further Islamic incursions into the vast and culturally rich empire of Iran. The Arab conquest was hardly accomplished overnight: the last King of Kings, Yazdigird, fled eastward and was only killed a decade later, outside Marv, near the frontier between northern Khurasan and Sogdiana. Nor did Iranians easily submit to drastic changes in language and religion without resistance, although conversion occurred at different rates within the different classes of Iranian society. In certain parts of the country, such as Fars Province – ancient Persis, where the Achaemenid capitals of Susa and Persepolis were located – and in the highlands of the Alburz Mountains south of the Caspian Sea, pre-Islamic Iranian social and religious customs, languages and stories lived on well into the Islamic period (Fig. 29). Yet Iran may again be seen to have conquered its conquerors: providing an army of bureaucrats to administer

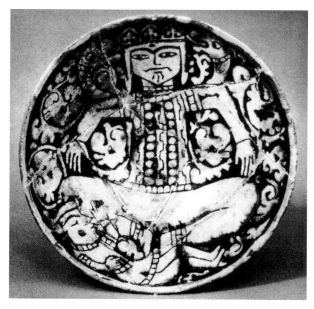

29. "The Tyrant Zahhak" (?), sgraffiato ceramic bowl, eleventh–twelfth century, so-called Garrus District-ware; New York, The Metropolitan Museum of Art, 64.274.3

the vastly enlarged Muslim territories of the new Caliphate, enriching the Arabic language with its long linguistic experience in managing such matters, and even providing the new and Arab-dominated religion with notions of a past history – albeit a past ultimately to be read as epic and Eastern. As for the revelation to the Arab prophet, it has also been said that Iran rescued early Islam from its narrow bedouin outlook, altering it in the experience of "conquering" a land of such ancient civilization and enabling it to attain the status of a truly universal religion open to adherents of exceptionally diverse cultural backgrounds.[8] The process of the Conquest, and the continuous unrest in Iranian cities lasting well into the ninth century, partly explains why so little in the way of early Islamic Iranian material culture has survived. Painting, whether in books or on walls, is no exception. Indeed, almost all we know of Iranian painting in the earliest Islamic centuries is that gleaned from written sources, historical and poetry alike, and such information almost always concerns the survival of Sasanian painting or, at the least, Sasanian subjects. For instance, as late as the end of the ninth century, we read of what must have been life-size murals in the Sasanian Palace of Ctesiphon: the battle between the Sasanians and the Romans at Antioch, in 538, is described by the Arab poet al-Buhturi as being still so realistic in its effect that the observer can hardly believe it is merely paint on plaster until he feels the wall.[9] In a city near Persepolis in 915, the historian al-Masʿudi saw a large manuscript recounting the history of the Sasanian Kings of Kings, with illustrations of twenty-five kings and two queens, each shown as he appeared toward the end of his reign and attired in his own distinctive crown; it had been translated from Persian into Arabic at the order of the Umayyad Caliph Hisham, and the copy seen by al-Masʿudi had purple-tinted folios and was ornamented with gold, silver, and ground copper pigments.[10] Toward the middle of the same century the geographer al-Istakhri describes having seen a similar history of the Sasanian rulers in Shiz – later to be called Takht-i Sulayman, near the celebrated Zoroastrian fire-temple.[11]

Another, anonymous, tenth-century geographical text describing the regions of the world speaks of paintings in Balkh which had been decorated with Sasanian pictures that had since fallen into ruins; it also offers the fascinating information that in Simingan, white stone was cut for dwellings, halls, pavilions, and "idol-temples," among other buildings, which were painted with figures in the fashion of the Indians.[12] Finally, a lavish silk carpet enhanced with precious stones and metals, depicting a garden in springtime blossom intersected with paths and channels for water, was noted at the time of the Arab sacking of the palace at Ctesiphon, in 637.[13] This is little material testimony indeed, given the authoritative accounts of pre-Islamic Iranian painting traditions and the longevity of prior practices, which had led Herzfeld to suggest that in both Parthian and Sasanian times, painting was the most "prominent branch of art," contemporary rock-cut sculptural reliefs being merely "drawings on rock."[14] As for Iranian painting that might have been executed in this period, few of the works themselves have come down to us, whether manuscript or mural, while the sources, and the archaeology as well, are close to mute upon the subject.

Several reasons may account for this silence, perhaps the most significant being a diversion of collective communal energy, however temporary it would prove to be. Those classes of Iranian society that would have continued to decorate the buildings or commission the illustrated volumes that were occasionally – and so briefly – mentioned by historians or poets may have been deflected from prior patterns of activity by the fundamental alterations, at all levels of society, in three areas of human endeavor: in religion, from Zoroastrianism to Islam; in language, from Pahlavi to Arabic or, at the very least, from Pahlavi to Arabic script; and to a very different kind of civic and social organization, in which

religion now dictated behavior in many areas of life that had previously been matters of personal decision.

Secondly, the ninth and tenth centuries witnessed the emergence of a series of local dynasties arising in eastern Iran, each claiming its right to rule by virtue of Iranian descent. The usual pattern was the appointment of an especially capable man to a significant post as governor or military commander, often in lands of non-Arab culture and at some distance from Baghdad, the capital of the Muslim community and the seat of power of the ruling dynasty, the ʿAbbasid Caliphs. Within a short period of time, the governor (or his descendants) would establish his right to rule, independently of the Caliphs, in Khurasan and Transoxiana, with a seat in one or another of the major cities in the Iranian east. The Tahirids, who made Nishapur, in western Khurasan, their capital from the second decade of the ninth century, were descended from an Iranian "client" (sometimes a local ruler, but more often, a man, or woman, taken captive in an early military encounter with Arab forces, who then gained a second-class freedom by converting to Islam). The Saffarids, natives of Sistan (in south-eastern Iran), supplanted the Tahirids in Nishapur for the remainder of the ninth century but were themselves – there – succeeded by the Samanids, who traced their descent from the Sasanian Kings of Kings (or, according to other sources, from the great Sasanian military commander Bahram Chubina). From early in the ninth century, the grandsons of a certain Saman-Khuda had been effective governors for the Caliphs in Samarqand-Sogdiana, Farghana, and Herat, and by 893 the line was established as rulers of all of Transoxiana and Khurasan; their capital was Bukhara. In all these eastern centers, under the patronage of Iranian rulers, New Persian was developing as an important language distinct from the Arabic which all educated persons spoke and read. New Persian would henceforth be written in the Arabic script, while the collective experience of using Arabic as a *lingua franca* for several centuries would broaden both its patterns of thought and its vocabulary. By the tenth century it had become a formidable instrument of Iranian culture. Thirdly, one of the growing preoccupations of the Muslim clergy, and eventually, Muslim society as a whole, was whether it was lawful to make representations of living beings. It is true that only one verse in the Qurʾan specifically mentions the subject, warning against the making of statues (along with the drinking of wine and the playing of games of chance). The underlying concern was to avoid idol-worship, a pre-Islamic practice in any case more frequent in Arabia and Mesopotamia than in Iran, or even in the Christianized Middle East. There is much evidence that the Prophet Muhammad himself did not feel nearly so strongly about this matter as did his later followers, inasmuch as he permitted pictures of the Virgin Mary and Jesus painted on a pillar inside the Kaʿba in Mecca, the universal focus of Muslim religious practices, to remain there during his lifetime.

The stricture against decorating the mosque (the Muslim house of worship) with images of living beings was fairly quickly accepted by the new adherents of monotheistic Islam, whether the mosque was public and communal, or private, as in palaces and home. But what kind of figural decoration might be acceptable in secular settings in the newly Muslim community, even at the princely or gubernatorial level, was a matter hotly debated in the early Muslim period. Accounts of theological arguments on the topic, often with brief and anecdotal evidence of breaches, fill volumes of histories and legal commentaries. A stricter perspective is offered by the large body of sayings traditionally attributed to the Prophet called *hadith*, the authority of which is considered almost as great as that of the Qurʾan itself. *Hadith* are a specifically Islamic category of religious literature that, in codified and pared-down form, attempt to interpret what the Prophet Muhammad might have meant to ordain for the entire Muslim community on one or another topic, mostly

regarding religious practices, and interpersonal and commercial relations. *Hadith* have an unmistakable attitude to this question. As Arnold puts it:

> On the subject of painting the Traditions are uncompromising in their condemnation and speak with no uncertain voice . . . : "The angels will not enter a house in which there is a picture or a dog." "Those who will be most severely punished on the Day of Judgement are the murderer of a Prophet, one who has been put to death by a Prophet, . . . and a maker of images or pictures." And "The Prophet . . . cursed the painter."[15]

Arnold further observes that the prohibition against the making of images gained such strength among Muslims because the word in Arabic for "painter" – and by extension, "sculptor" – is *musawwir*; it literally means "forming, fashioning, giving form," all powers that are reserved to the Deity alone. Indeed, the word *musawwir* is used in the Qurʾan (LIX, 24) as an epithet for Allah himself: "He is God, the Creator, the Maker, the fashioner." Small wonder, then, that many pious Muslims were disposed to heed later theologians' constraints against the making of images in any way, whether carved, painted, or even woven. The Prophet is said to have allowed figurally decorated textiles to be used in his home for cushion-covers, but not for a hanging curtain, although he was satisfied that his youngest wife, ʿAʾisha, might continue to play with dolls. Similarly, images on carpets were acceptable because they were consistently being walked upon. But with time, orthodox Muslim opinion hardened upon this sensitive subject, as made clear by the account of a precious metal censer – perhaps Byzantine – decorated with figures and acquired as booty in an early Muslim victory, and then used by the observant Caliph ʿUmar to perfume the mosque of Madina. ʿUmar had presented the censer to the treasury of the mosque, but a later governor, in 783, ordered the figures to be removed. In Arnold's words, "he apparently could not tolerate what the most devoted Companion of the Prophet, the revered model for later generations, had regarded with indifference."[16] It is of course true that in the early Islamic centuries, princes and others, especially if they were not bedouin Arab by blood or upbringing, continued to use figurally decorated objects in their private lives. A Chinese traveller passing through Marv in 765 – when the city had already been subject to Muslim rule for a century – reports seeing painted wall decoration in "free-standing" houses. Some of the mural decoration, and the objects, recovered in the excavations of the ninth-century ʿIraqi palace called the Jausaq al-Khaqani in Samarra (the alternate capital of the ʿAbbasid Caliphs, established north of Baghdad on the Tigris because the populace of the capital could no longer live with the intrusive violence of the Turkish soldiery) reveal a taste for figural compositions that are entirely executed in the late Classical style.[17] Equally, there is much evidence that a great deal of the decoration in new Muslim buildings was aniconic, making use instead of floral ornament organized on a clearly perceptible geometrical foundation, or frankly geometric designs, or even decoration based upon Arabic calligraphy.

In Iran proper and in Khurasan, early Islamic architectural decoration was often made of stucco. It had been widely used already in Sasanian times but it was developed to an extraordinary degree in the early Islamic period in Iran. Stucco was relatively inexpensive and relatively quick to work with, and it offered almost unlimited opportunity for the working out of infinitely varied geometrical and vegetal patterns, suitable for both religious architecture and secular buildings. Excavations in Samarra and at many early Islamic sites in Iranian lands, as well as surviving buildings, attest to its great popularity. Designs were often organized in friezes of repeating square and rectangular panels, and decorated with molded patterns, vigorous and inventive combinations of floral and vegetal forms overlying a geometrical grid; the ensemble might also

30. Corner of a room decorated with wall painting (above) and molded stucco (below), Nishapur, ninth–tenth century

be enhanced with color. Interiors could quickly – and completely – be covered with rich designs that, at their finest, appear to be draperies of precious textiles. A varying scheme confined the molded stucco to the lower part of the wall, as a dado, while the upper wall was painted with figural designs: such a disposition was frequent in the ninth-century palace-complex of Samarra and in a number of structures in Nishapur (Fig. 30).

THE WALL PAINTING OF NISHAPUR

Indeed, it is only from about the tenth century that we can begin to consider Islamic Iranian painting from what actually survives in the important center of Nishapur, in eastern Iran. The material recovered from excavations there, conducted by the Metropolitan Museum of Art between 1935 and 1940, is therefore of prime interest. Probably founded – as its name suggests – by one of the Sasanian Shapurs, in the Islamic period Nishapur attained a position of some importance as the westernmost of the four major cities of Khurasan, along with Marv (to the north), Herat (on the Hari River to the south), and Balkh (in the east, in ancient Bactria, later Tokharistan). Historical and geographical sources all confirm that it soon grew to be a rich, thriving, and intellectually accomplished community. Early in the ninth century, under the earliest of the independent Iranian dynasties to govern Khurasan, Nishapur became the Tahirid capital; it maintained that position when a second dynasty of Iranian origin, the Saffarids, succeeded to power little more than half a century later. Important building projects were carried out, both underground – in the construction of tunnels (called *qanat*s) for transporting fresh water from distant sources to the growing city – as well as above the ground: palaces and barracks, mosques and schools, baths and homes. In the course of excavations, many of the latter structures were found still retaining their original wall decoration, molded or painted stucco dados with panels of figural paintings on the upper zone of the walls. Thus, although the primary material now associated with Nishapur (and neighboring) sites, is ceramic [Fig. 23], the wall-decorations recovered from various sites in the area are the earliest surviving body of Iranian painting of the Islamic period known at present, however fragmentary and not absolutely datable they may be. They shed enormous light on the history of this long-practiced art in Iran, for sty-

listically they reflect the disparate sources shaping figural painting in the Iranian world at this time, from Turkic Central Asia to Rome.

The recovered paintings come from several different places thoroughly excavated over the six years of fieldwork. From an area with the descriptive name of Sabz-i Pushan, "Green Mound," a number of small houses with interior courtyards were uncovered. In one was found a quantity of architectural elements of a particular curved form – three-dimensional niches with pointed tops, called *muqarnas* – and of graduated size ranging between 290 and 360 millimeters in height. Their inner surfaces were decorated with geometrically arranged arabesques and rosettes outlined

31. Painted stucco *muqarnas* elements, Nishapur, ninth–tenth century, Nishapur; New York, The Metropolitan Museum of Art, 38.40.252 and 38.40.250

in black and painted in red and blue on a white background (Fig. 31). To judge from their finished red edges, they were probably elements of a set of squinches forming the transitional zone from a square room to a domed ceiling.

From another room came a highly suggestive series of fragments found in the top of a drain under the floor: figural subjects including both human beings – weeping women and a bearded man – and *div*s, or demons. The eyes of many of these figures had been rubbed out or the entire face scored by some kind of blunt instrument. This is surely evidence of some later "defacement" performed by a conscience-stricken owner or inhabitant. The excavators surmised that the defacement had occurred while the paintings were still on the wall; they were then removed, broken into fragments, but carefully collected and buried together in the drain under the floor. The *div*s are bearded and blue, with almond-shaped eyes encircled with white, and horns growing from a point just above the nose; they are outlined in black and set against a blue-green ground with decorative pearled strapwork (Fig. 32). The heads of the human figures, the weeping woman (Fig. 33) and the bearded man (Fig. 34), are set against a plainer background but their heads are encircled with a nimbus. Both sexes have almond-shaped eyes with the

32. "Face of a *Div*," fragment of a wall painting found at Nishapur, ninth–tenth century; New York, The Metropolitan Museum of Art, 38.40.267

33. "Head of a Weeping Woman," facsimile of a wall painting found at Nishapur, ninth–tenth century, Iran; New York, The Metropolitan Museum of Art, 38.40.248

34. "Head of a Bearded Man," fragment of a wall painting found at Nishapur, ninth–tenth century; Tehran, The National Museum of Iran

35. "Head of a Woman," fragment of a wall painting found at Qasr al-Hayr al-Gharbi, Syria, eighth century; Damascus, National Museum of Syria

pupil hanging from the upper lid, and black eyebrows; the man's beard and mustache are full and black, while the woman's hair escapes from a head-covering in a series of black spit-curls over her forehead.

All these features recall numerous other paintings in the particular style practiced in both the late Classical and early Islamic periods (Fig. 35), but also seen sporadically in parts of Central Asia for centuries, and reflected in one of the Manichaean manuscript fragments from Turfan [Fig. 14]. The human figures of the Sabz-i Pushan paintings had been outlined first with red, a technique still used, some centuries later, for drawing faces in fourteenth- and fifteenth-century manuscript illustrations [39, 49, 63]; hair, eyebrows, and eyes were then overdrawn in black, but the red drawing was left to delineate noses and chins, mouths and the outlines of the faces; while the clothing was painted in local colors, primarily blue, white, and gray. The date for the paintings in these houses is most likely to be the period coincident with that of Tahirid and Saffarid domination, the ninth and tenth centuries. The number of coins found from this same date – 102, the second most numerous group found at Sabz-i Pushan – gives an idea of the prosperity of Nishapur at this period.[18]

From the area called Qanat Tepe, where similar small houses were uncovered, the most interesting paintings were found in a bath-house. They included human figures, part of a larger frieze and quite fragmentary,[19] and

37. Panel of painted wall decoration from
 Nishapur, ninth–tenth century; New York,
 The Metropolitan Museum of Art,
 40.170.176

36. "A Quadruped Looking Backward," fragment of a wall painting
 found in a bath-house at Nishapur, ninth-tenth century; New York,
 The Metropolitan Museum of Art

animals, a dog (or a bear) (Fig. 36) and the hind legs of another quadruped being the most easily recognizable, although fragments of birds of various types were also found. The quadrupeds are outlined in brownish black and painted in yellowish brown against a white ground decorated with scrolling arabesques and palmettes, and floating rosettes. A framing device is suggested by the pair of unoutlined red lines under the hindquarters of the fragmentary animal, just as some of the panels of floral and abstract decorations from the probable site of the Tahirid palace, Tepe Madrasa, are outlined with thick medium-blue frames (Fig. 37). The bath may, or may not, be earlier than the ninth or tenth century: coin-finds from Qanat Tepe accord less conveniently with this date, since the most numerous are from the second half of the eighth century.[20]

At a third mound, called Vineyard Tepe, buildings of "impressively substantial" construction were uncovered, similar to the size and breadth of buildings at Tepe Madrasa, the possible site of the Tahirid palace in Nishapur. A room in one of these buildings had a wall decorated with a large composition that, although in parlous condition, could still be made out to show two men, a mounted hunter and a figure walking behind him.[21] The latter, on the right, was so badly damaged as to be almost unreadable, but on the left was to be seen a splendidly attired falconer on a galloping stallion, the bird perched on his left wrist and the horse's reins held lightly in his right hand (Fig. 38). His face had been purposely destroyed but the details of his garments, and the shape of his horse and its trappings, are still immensely instructive in what they reveal. The falconer wears a long garment patterned with rows of large roundels inside of which are rosettes with four pointed petals; above the elbow are wide *tiraz*, one of which still retains (or has been repainted with) what appear to be stalks, each ending in half a palmette to one (or the other) side and rising from three loops; this is clearly meant to be a series of letters in Arabic, the long hasps being perhaps an *alif* or *lam* – the letters "a" and "l" – which suggest the word *allah*. What appears to

to tell how the garment closed; the headgear is also hard to read but appears to be high, dark, and crowned with decorated metal plates and a finial. The horse-trappings are straps set with small square and round elements, as is the rider's belt. That his horse is a stallion accords with Sasanian Iranian, and also Sogdian, practices; his chaps and the stirrups can be seen on contemporary painted pottery [23]. His upper garment, and the belt with its hanging thongs, and his horse-trappings, are instead identical to the garb of Khusrau II in the rock-relief at Taq-i Bustan, of the sword bearers in Qizil [47], and of the Turkish guards in the throne room of the Ghaznavid Southern Palace in Lashkari-Bazar [122]. Altogether, the figure is a fascinating mix of Iranian and Turkic elements that seems perfectly typical for an early Iranian image from this important city of Khurasan. Apart from the quantity, and the differing styles, of this body of paintings recovered from the palaces, houses, and baths of early Islamic Nishapur, perhaps the most striking feature of the ensemble is how different it is from the figural painting on Nishapur ceramic vessels [23]. Coloristic differences aside — for the glaze-colors of ceramic wares are controlled by the chemistry of body and glaze-materials, lead-glazes on a buff body producing a limited palette of colors, yellow, green, and black — very few stylistic or material details are shared by the paintings from Nishapur buildings and the painted figures typical of Nishapur ceramic wares. A sartorial similarity is the chaps worn by both the large falconer and the painted-ceramic hunter. The drawing of the latter's eyes, the pupil hanging from the line of the upper lid, is also seen on the faces of the man and the weeping women from Sabz-i Pushan, and also the men and women from the bath-house of Qanat Tepe. Lastly, the floating floral elements so typical of painted Nishapur pottery might perhaps have a parallel in the floating rosettes of the panels painted with animals from the bath-house of Qanat Tepe, although so little remains from this ensemble that the resemblance may signify very little. Thus, the overall impression of the painting of early Islamic Nishapur is one of great stylistic disparity in sources, style, and perhaps also function. In later centuries, this will not be the case.

THE THEMES OF EARLY ISLAMIC PAINTING

The themes of early Iranian painting in the Islamic period are not easily categorized, so fragmentary and scattered is the evidence presently at hand. Its paucity contrasts strikingly with that of relatively contemporary Sogdiana.

Where houses of many classes in Panjikent had rooms painted with apposite illustrations from literary works and even contemporary life [129, 132, 133, 206], where a painted pottery vessel [30] might summarize in four succinct images the fulfilling life of a wealthy married man, and where even a dented battle shield yields the picture of a brave prince vainly battling the Arab warriors of a new religion [121]: no painting from virtually contemporary Iran remains. Only written references attest to its widespread occurrence, such as the often quoted anecdote of the Samanid prince who ordered the poet Rudaqi to compose a metrical version of the animal-tales known as *Kalila u Dimna, Kalila and Dimna*, and then had it illustrated by Chinese (or Chinese-influenced) artists.[22] The locus for the anecdote occurs in this same eastern Iranian milieu and underscores its importance at this early period, for the Samanids were essentially established in Bukhara and Samarqand — successor, in the Islamic period, to Sogdiana. Ammianus Marcellinus had already commented, some centuries prior, that the subjects of pre-Islamic Iranian painting appeared to be war and killing — presumably the killing of animals, as Marshak has suggested. And the falconer discovered at Vineyard Tepe in Nishapur (Fig. 38), if not a prince or governor, is surely a member

be protective chaps are worn over high boots with pointed toes, his feet thrust into stirrups hanging from the saddle. His belt is composed of small square elements from which hang three vertical straps strung with small round elements, and two swords, one long and curved in a dark scabbard. The defacement at the center of the figure makes it impossible

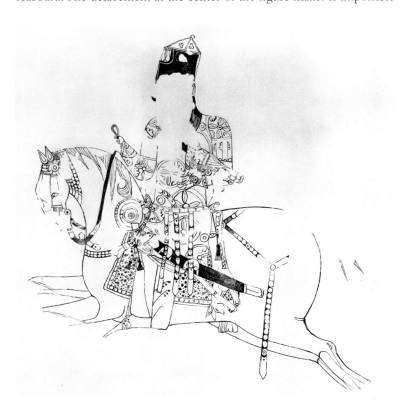

38. "A Mounted Falconer," drawing of a large figure painted on the wall of a building in Nishapur, ninth–tenth century

of an army, or a princely attendant, and portrayed as a hunter: all themes, and typical figures, of Iranian painting that will become far more numerous in later centuries. The excavators in Nishapur also surmised that the fragments of painting including the bearded man, several women, and the horned and bearded blue *div*s, might in some way be connected with part of the Rustam story: if not in Abu'l-Qasim Firdausi's *Shahnama*, perhaps in one of the precursory versions. Suggestive as the remaining fragments are, it is impossible to do more than note so tentative an attribution; it may also be that the collected fragments did not even come from the same picture, or set of pictures. Another major theme of Iranian figural imagery in this early period, one among those we shall most frequently encounter in the centuries after the Mongol invasion, must largely be evoked by the kinds of written references we have already seen: the prince and his appurtenances.

Several tantalizing references to painting can be added to the meager gathering, if we turn our attention to the mighty Ghaznavids. As so often in the Islamic world, this Turkic dynasty sprang into political prominence from the service of a prior dynasty: its founder, Nasir al-Daula Sebuktigin, had governed Khurasan for the Samanids but broke with them towards the end of the tenth century and established an independent Ghaznavid sultanate in lands strategically located between India and Iran. Historians recount, and archaeological investigation confirms, the exceptional brilliance of its material civilization.

The first independent Ghaznavid sultan, Yamin al-Daula Mahmud ibn Sebuktigin, extended the dynasty's political sway from India in the East, into the Saurashtra Peninsula and down the Ganges River as far south as Kanauj, and west to Iran [5]. He assumed all the privileges of a medieval ruler, offering munificent patronage to countless literary figures, and building palace-complexes and places of worship that were constructed of finely fired brick and ornamented with beautifully carved panels of white marble, molded tiles, and, apparently, also painting. In Balkh, says the poet Farrukhi, alcoves in the palace were decorated with paintings of Mahmud shown either in battle, a javelin in his hand, or holding a goblet at a feast.[23] Farrukhi was only one of the many writers who thronged Ghazni in search of princely patronage; Firdausi is Mahmud's best known, if also his least well rewarded, court poet [84]. A second reference to mural paintings made for Mahmud mentions his armies and his war-elephants, but also adds that the painter, having been admonished by his grandson, repented of his blasphemy and destroyed the pictures. Still another tantalizing reference to Ghaznavid pictorial decoration is to an *Alfiyya*, a cycle of rather licentious painting that Mahmud's son ordered to be painted in a palace in another Ghaznavid center, Herat, to the fury of his father: this is not the anonymous collection of tales that later came to be called the *Thousand and One Nights* but more likely the erotic *Alfiyya Shalfiyya*, said to have been versified by the Herati panegyrist known as Azraqi.

The last general theme of Iranian painting to be deduced from these meager early notices is that of animals, embodied in those actually surviving from the bath-house at Qanat Tepe, in Nishapur, and implicit in the wished-for illustrations for a Samanid copy of *Kalila and Dimna*. This last reference to the celebrated pan-Asian animal-fables, the oldest imaginative work in all Islamic literature, offers concrete evidence of the importance of the illustrated book in the earliest periods of Islamic Iran, even if virtually nothing of this date has survived. The earliest Arabic version of these tales, made by ʿAbdullah ibn al-Muqaffaʿ before the middle of the eighth century, is already a translation of a yet earlier Pahlavi text dating from the sixth century. As for its pictorial component, some would place the beginning of the *Kalila and Dimna* illustrative tradition as early as the third century. *Kalila and Dimna* stories were not only known in Sogdian Panjikent but some were illustrated [206], as episodes painted on the walls of Sogdian houses in Panjikent in the period after the Arab invasions. And Ibn al-Muqaffaʿ's introduction to his translation testifies to the extent to which illustrated books must have circulated among the literate all over the Muslim world at this date:

> He who peruses this book should know that its intention is fourfold. Firstly it was put into the mouths of dumb animals so that light-hearted youths might flock to read it and that their hearts be captivated by the rare ruses of the animals. Secondly, it was intended to show the images . . . of the animals in varieties of paints and colours . . . so as to delight the hearts of princes, increase their pleasure, and also the degree of care which they would bestow on the work. Thirdly, it was intended that the book be such that both kings and common folk should not cease to acquire it; that it might be repeatedly copied and re-created in the course of time thus giving work to the painter and copyist. The fourth purpose of the work concerns the . . . apologues put into the mouths of animals. . . .[24]

How well Ibn al-Muqaffaʿ's hopes were ultimately to be realized can be appreciated by the large number of surviving illustrated copies of *Kalila and Dimna* – more than ninety, from all over the Muslim world [79, 97, 103, 106, 112, 185, 200, 203, 205, 207, 210] – made over the course of the past seven centuries. Other early writers, too, mention manuscript illustrations: Firdausi's contemporary Abu Mansur al-Thaʿalibi, from Nishapur, speaks of ". . . the great numbers of pictures on pages of books. . . ."[25] So we may only speculate as to just how many illustrated volumes of imaginative, or historical, literature have been lost throughout the entire Islamic world from the period before the thirteenth century.

III

THE MEDIEVAL PERIOD

It has been said that the tenth century in eastern Iran belonged to the Samanids, the third Muslim dynasty of Iranian descent to break free from the control of ʿAbbasid Baghdad and establish itself as an independent power in the eastern lands of the Caliphate. The tenth century was also the period in Iran when rulers, scholars, writers, and the literate classes in general found themselves ready to think and to write in the Persian language once more. New Persian was now universally written in the Arabic script, while the collective experience of using Persianized Arabic as a *lingua franca* for several centuries must have gone some way towards preparing for the renaissance of the language in the Islamic period. Many important figures of the early Muslim centuries who wrote in Arabic were in fact Iranian and Persian was their mother tongue, although some, like al-Thaʿalabi, Firdausi's contemporary and fellow citizen of Tus (in western Khurasan), never did compose in New Persian. But by the tenth century, the instrument was retuned in its Islamic mode, so to speak, and some of the finest Persian literature of the Islamic period, both prose and poetry, was composed under Samanid patronage. Abu'l-Qasim Firdausi's *Shahnama*, which celebrates Iran's mythical, heroic, and historical past in rhyming couplets (said, variously, to number between 48,000 and 60,000) is far and away the most significant example of New Persian literature.

FIRDAUSI'S *SHAHNAMA*

Abu'l-Qasim Mansur, known as Firdausi of Tus, is one of the towering figures of Islamic culture, notwithstanding the fact that his principal accomplishment is a poem: a very long rhyming poem written entirely in New Persian, the subject of which is nothing less than a history of the world – the Iranian world – from its creation to the downfall of the Sasanian monarchy.

Firdausi's date of birth is not certain and may have been anywhere between 932 and 943, although 934 is now considered to be correct; similarly, his date of death is placed anywhere between 1020 and 1026. In social status he was a *dihqan* – a member of the landed Iranian aristocracy; in literary status Firdausi was an original poet, heir to the pre-Islamic Iranian literary traditions, which were quite current matters in Samanid Tus. Abu-Mansur Muhammad ibn ʿAbd al-Razzaq, the mid-tenth-century ruler of the city, had gathered together a small number of scholars of eastern Iranian, Zoroastrian background – four, say most sources – who retained a familiarity with the Middle Persian language of Pahlavi. They were charged with collating the authentic Sasanian texts of the *Book of the Kings*, *Khodaynama*, together with other pre-Islamic Persian documents, and then transcribing them into New Persian prose; their task was completed in 957. In Tus at the same time lived and wrote the poet Abu-Mansur Muhammad Daqiqi, whose lyrical poetry won him much contemporary fame but whose lasting reputation owes as much to his epic verse on the theme of Iran's pre-Islamic past. Presumably working from the same *Shahnama* materials as were available to Firdausi, Daqiqi had composed a work of just under

1,000 rhyming couplets, on the subject of Gushtasp's introduction of the religion of Zoroaster, before he was assassinated (at some date between 976 and 981). Firdausi incorporated the younger poet's entire *Shahnama* fragment into his own composition – presumably they had already agreed upon a meter in which to cast this massive work. Thus, the *Shahnama* is written in the meter called *mutaqarib*, which, according to one specialist, itself arises out of a specific Middle Persian metrical-verse form.[1] In this feature as well as in its vocabulary, the *Shahnama* is almost entirely a Persian work: very little of its vocabulary is Arabic, or derived from Arabic.

Its sources, of course, are varied and some of them are extremely old – they include a history of Persia written by a Greek physician at the Achaemenid court about 400 BC. In addition to the *Shahnama* verses of Abu-Mansur Daqiqi of Tus, Firdausi made use of ancient Iranian folk legends and popular heroic songs; he built aspects of the life of his most renowned figure – the hero Rustam – from Sistani literature, and other materials from patriotic Iranian legends preserved in Marv, and quoted yet other eastern Iranian authorities; but all was transmuted into a rhyming whole that, if it cannot be considered truly coherent or even historically consistent, nonetheless displays coherent patterns that tie it together into a magnificent opus.

Several themes dominate Firdausi's *Shahnama*. Primary is the ancient Iranian moral dilemma of the conflict between Good and Evil (which, in the terms of the equally ancient Iranian religious dualism, had been expressed as Ahura Mazda and Ahriman). Related to this is the age-old conflict between Iran and the Turanian world [7, 8]– perhaps a metaphor for the inherent conflicts between settled and nomadic peoples; in the *Shahnama*, the conflict stems from the early slaying of a monarch's chosen heir, Iraj, by his brothers Salm and Tur [99]. The Iranian insistence on a legitimate line of monarchical succession is another fundamental theme that arises directly out of this issue [124]; while the notion of the rightful ruler's *farr*, his aura of divine charisma, is intimately related to that of lineal legitimacy, since the begetting of an heir to the throne is one manifestation of *farr*. Lastly, it has been said that the doing of justice is central to Firdausi's *Shahnama*, and while in the mythical, earliest parts of the *Shahnama* justice sometimes appears to be a matter of revenge, in the last, the Sasanian, section which is truly based on historical materials, justice is usually seen to prevail.

In its language, in its ideals, and in the feudal setting that obtains throughout the fifty episodes comprising the work, Firdausi's *Shahnama* is also the product of the early medieval world of the Samanids in which it came to life. So it is a dreadful and ironic injustice that by the time Firdausi was approaching the end of his lifetime's labor the Samanid dynasty should have been eclipsed politically, and ensuing civil unrest made literary endeavors at least temporarily unprofitable. It is unclear how far afield from Tus Firdausi was obliged to travel in seeking the patronage that would reward his lifetime's work. The tales of his vain attempts at finding financial support from the Turkic Mahmud of Ghazna surely have some grounding in truth. Firdausi's lack of success at Mahmud's court may have much to do with the sultan's appointment

of a new vizier, and hence a change in his official policy toward the Caliphate and its religious and linguistic orientation; this occurred in about 1010, the very year in which Firdausi appears to have completed his *Shahnama*. He died too early to take advantage of the next major shift in Ghaznavid policy; presumably he died in straitened circumstances, despite the fact that his *magnum opus* was quickly recognized as a work of immense power and significance. It garnered him lasting fame – albeit posthumous – and over nearly a millennium has never ceased to be an influential force in the land where it was composed, even among those who cannot read it themselves but can only listen to it being recited. Indeed, from the time Iran had set up a nationwide radio system in 1941, until after the events of 1979, each day's radio broadcast opened with a recitation of verses from the *Shahnama*. On the occasion of the millennary celebrations of Firdausi's birth, an Iranian of great literary culture, who also later served as Prime Minister, summarized his feelings about Firdausi and his text thus: "In short, Firdausi composed the title-deeds of the Persian nation's nobility. . . ."[2]

DOCUMENTARY SOURCES FOR LOST PAINTINGS

The verbal impact of Firdausi's *Shahnama* over the centuries of its existence has probably been incalculably great; but it was also to have an impact on the figural arts in Iran, one that may be charted almost from the time of its completion. Yet as might have been expected, the surviving evidence for any figural painting executed in Iran in the three centuries following Firdausi's submission of the completed work to Mahmud of Ghazna is scanty. What does remain instead largely survives in materials quite different from the more usual "pictures on pages of books and on walls of edifices."[3] In addition, the documentary sources confirming the widespread practice of figural painting from the eleventh to the fourteenth century are virtually always to be found in contemporary poetry, not in historical texts or chronicles. And as the most assiduous compiler of this genre of evidence has more than once trenchantly remarked, historians – even of the arts – are little disposed to read even the poetry of the periods with whose material culture they concern themselves.

The references so far gathered by A. S. Melikian-Chirvani mostly speak of wall painting, although a panegyric poem dating from the first half of the twelfth century, by Suzani Samarqandi, compares the deeds of the poem's subject, a minor Qarakhanid prince (of a Turkish-speaking house that fancied itself descended from Afrasiyab), to those painted on the pages of *Shahnama* manuscripts.[4] Moreover, Firdausi himself must surely have been familiar with figural painting; he mentions it often enough to confirm its frequency in the Samanid milieu in which he composed the greater part of his versified epic. For instance, the hero Sam receives not only news of the birth of Rustam, his prodigious grandson, but also a picture of the man-like child painted on silk [241]. Munzir, the Yemeni prince under whose tutelage Bahram Gur "that great hunter" was raised, calls for painters of the Yemen to assemble at his court:

> He bade them limn
> On silk a picture of Bahram Gur shooting.
> They drew with ink thereon a cavalier
> . . . On his tall camel, shooting wondrously

The silken portrait was then dispatched to Yazdigird, Bahram's father, in Iran. And paintings are the principal decoration in the great hall of the palace of Siyawushgird, built by the Iranian hero Siyawush at the crafty instigation of the Turanian Afrasiyab, whose daughter Farangis he had just taken in marriage:

> He limned within the hall full many a picture
> Of kings, of battle, and of banqueting,
> And painted there Kaus with mace and armlets,
> Crowned on his throne, with elephantine Rustam,
> With Zal, Gudarz, and all that company.
> Elsewhere he limned Afrasiyab, his army,
> Piran, and Garsiwaz the vengeful one.

A. M. Belenitsky, who noted as many as fifteen references to painting within Firdausi's great work, observed that

> . . . the close resemblance . . . between the interpretation of certain motifs and descriptions of realia in the Shah-nama . . . is not a matter of chance . . . : . . . ancient art may have formed one of the sources of Firdawsi's inspiration.[5]

References in later poetry to wall paintings in which the kings and heroes of the *Shahnama* figure include one, by the Seljuq poet Azraqi (who died before 1072), to a cycle of paintings in which Rustam features; in the same poem is mentioned a king whose killing of lions the poet compares to the bravery of Bizhan slaying a ferocious boar.[6] The twelfth-century poet Khaqani, in a panegyric to the Khwarazmshah ʿAla al-Din Atsız, asks the prince to consider the images of the champions painted over the palace-entry onto the *maydan*; the poem also speaks of images of Rustam and Isfandiyar painted onto the walls of an alcove in the palace itself.[7] And an anonymous work of the early thirteenth century mentions a pavilion in a park in Tabaristan (southeast of the Caspian Sea) on whose three-story walls were painted images of the wars of Afrasiyab, in gold – and presumably also in colors.[8]

PAINTING IN THE CONTEMPORARY DECORATIVE ARTS

Perhaps the most unusual manifestation of the *Shahnama*'s impact on medieval Iranian life is one now being painstakingly reassembled by Melikian-Chirvani: the widely scattered frieze of luster-painted tiles that once adorned the later thirteenth-century Ilkhanid palace at Takht-i Sulayman, the site of the famous fire-temple of Sasanian Shiz. The decoration consists not of images, but of verses from the *Shahnama*, which are clearly written in the trilobed arch on each tile. They constitute what he has called "an edition on ceramic" of the poetic work that, by early in the thirteenth century and for the Mongol overlords of Iran, had attained a status of authority virtually equal to that of the Qur'an. Moreover, other contemporary tiles of different size and decorative schemes also bearing molded or written *Shahnama* verses testify to the widespread use of this text for the purposes of tile-decoration in the period just following the Mongol invasions of the earlier thirteenth century. But figural images of the most famous of *Shahnama* characters [225; Fig. 39], or scenes with generic *Shahnama* descriptions, were also painted, or molded, upon tiles in this period. Large numbers of them, varying slightly in size and shape, in background color and decorative techniques, must have been made for the interiors of secular buildings and have simply not survived the ravages of the Mongol invasions, unlike those in religious buildings which often remained intact up to the late nineteenth or the early twentieth century. In the same way, images, and whole cycles, taken from the *Shahnama* or its sources were sometimes used in the figural decoration on vessels [235; Fig. 45] made entirely of the new ceramic body that appears to have been an invention of potters in the Seljuq period of Iran's history. Let us turn back a century or two, to set into context both the Seljuq Turkish

39. "Rustam at the Cave," luster-painted ceramic tile, twelfth–
thirteenth century; London (Ham), The Keir Collection, 182

rulers of Iran and neighboring lands to the north and west, and the important development in ceramic technology that permitted "editions in ceramic" to be painted, and written, on vessels and tiles, for they are truly one of the hallmarks of medieval material culture in Iran and its neighbors in the Caliphate.

Political hegemony in Iran from the mid-eleventh century, and in Khurasan from the end of the prior century, effectively came to be concentrated in the hands of yet another dynasty of Turkic origin, the Seljuq Turks, conquering invaders from the east who were, themselves, ultimately conquered by the land and people they appeared to rule. In western Iran from fairly early in the tenth century, separatist movements had given rise to the establishment of minor Iranian dynasties who assumed independent status, about which the increasingly impoverished ʿAbbasid Caliphs could do little other than award honorific titles to their rulers. They included the Ziyarids, centered in Tabaristan (south-east of the Caspian Sea), the Kakuyids (whose court was in Isfahan), and the Daylamites (south-west of the Caspian). Most important among them were the Buyids, originally established in both Ray and Shiraz; they actually occupied Baghdad in 945 and for a century exercised supreme political authority in the entire Muslim community alongside the spiritual authority of the Caliphate. Some of these petty Iranian dynasts encouraged the maintenance of pre-Islamic Iranian cultural patterns, and the Daylamites actively promoted the cause of Shiʿism, the primary opponent to Sunni orthodoxy from the earliest years of Islam. All afforded patronage to significant literary figures of the period, of whom the most famous are probably Avicenna and the celebrated polymath al-Biruni [Fig. 60].

Yet all these dynasties had effectively disappeared from the Iranian political scene by the middle of the eleventh century, under the relentless pressure of Turkic "migrations" whose history is encapsulated by the arrival of the Seljuq Sultan Tughril Beg in Baghdad, in 1055.

The Seljuqs were one of the nine Oghuz Turkish tribes mentioned in the Orkhon inscriptions of Outer Mongolia in the eighth century.

For reasons still incompletely understood, the entire confederation started moving south and west throughout the latter part of the eighth century, towards the Farghana Valley, Ghazna, and Transoxiana; by early in the ninth century, notices of these nomadic Turkic peoples begin to appear in the writings of Muslim geographers and historians. Within two centuries the Seljuq family had established itself in Bukhara, wrested power in Khurasan from the Ghaznavids, and set its sights on Iran proper. In 1038, Tughril Beg, Rukn al-Dunya waʾl-Din Tughril I, proclaimed himself sultan in Nishapur and quickly moved against the Buyids, expelling them from their centers in central and western Iran; the Seljuqs occupied the former Buyid capital of Isfahan and shortly thereafter, Baghdad itself.

Greater Iran and Mesopotamia were once more united under the governance of a single power, that of the Great Seljuqs; they would soon also incorporate northern Syria and the Jazira (the land lying between the upper reaches of the Euphrates and the Tigris Rivers) into their empire. An energetic but rebellious Seljuq leader, Sulayman, would then lay the foundations for Turkicized Anatolia, again conveniently epitomized by the Battle of Manzikert in 1071. This dynasty, often referred to as the Rum-Seljuqs (to distinguish it from the Great Seljuqs of ʿIraq and Iran), traced its foundation to the same decade. And from about 1192 until early in the fourteenth century, it would even become customary for Rum-Seljuq sultans to include the names of legendary Iranian rulers from the *Shahnama* in their official titulature: Kay Khusrau, Kay Kaʾus, Kay Kubad.

The overrunning of such vast territories by nomadic tribesmen, whose need to pasture sheep and goats effectively altered not only the historic landscape but also the economy of previously fertile agricultural lands, is often accounted a tragedy of human history. Yet in many other ways, the coming of the Seljuq Turks into the settled Iranian heartland – and beyond, into Syria, the Jazira, and Anatolia – also brought a certain level of cultural continuity to the Central Muslim lands, in the form of religion and institutions as well as in language and the forms of material culture. As would so often be the case, the Turkish rulers of Iran were conquered by the land they ruled; Persian would become the Seljuq literary language, as it would also come to be the cultured *lingua franca* in parts of Anatolia; while one of the most significant technologies of the Seljuq period in Iran – a new ceramic body – would be imitated in one form or another everywhere in the Seljuq domains. Both language and technology have important ramifications for Iranian figural painting in this medieval period.

CERAMIC "FRITWARES" AND SELJUQ FIGURAL PAINTING

By the early twelfth century, Iranian potters were creating an extraordinarily wide range of ceramic wares: vessels of all shapes and sizes and functions, tiles for architectural cladding [3, 225; Figs. 39, 42, 43], objects [Figs. 5, 40–41], figurines, and even large sculptural pieces. Their purposes range from the most humble – a bath-scraper – to the grandest furnishings and decorations of innumerable palaces and pavilions for Seljuq rulers and minor princelings; to the most frivolous, such as tablefountains; to the holiest, adorning the walls of shrines and mausolea of the most venerated of Shiʿa saints and sufi masters [173], built all over Iran from Mashhad to Najaf, from Baku on the Caspian Sea, to Kharg Island in the Persian Gulf.

The enabling technology was an artificial "ceramic" body composed largely of quartz; it may have been invented in Egypt and was certainly known in Iran from early in the twelfth century. Sometimes called

40. A "house-model," glazed ceramic, twelfth–thirteenth century; New York, The Metropolitan Museum of Art, 67.117

41. Glazed and molded ceramic vessel in the form of a seated lute-player, twelfth–thirteenth century; New York, The Metropolitan Museum of Art, 22.218

"fritware" (or recently, "stone-paste"), this new artificial body was white (or notably whitish), and it was stiffer than potter's clay while remaining malleable. These qualities permitted the making of vessels with far thinner walls than had previously been possible, as well as the shaping and molding of wares of often fantastic shapes (Fig. 40), even if they served mundane and merely functional purposes. This artificial "fritware" was produced in centers all over Iran. The most celebrated types of Seljuq ceramic wares – *minaʾi* and luster – were apparently made in large quantities in the western cities of Kashan and Ray, although a hoard of exceptionally fine Seljuq ceramics was also found in Gurgan (on the Caspian Sea), giving temporary rise to the theory of another important center for the manufacture of fine Seljuq painted ceramic wares. Controlled archaeological work confirms that fritwares were made in Nishapur and Samarqand, and also in Bamiyan, under its Ghurid rulers in the twelfth century; while excavations and chance finds all over Iran have yielded numbers of finely decorated Seljuq fritwares and literally millions of broken pieces – potsherds.

The possibilities of decorating the new ceramic wares were as varied as their shapes, and Iranian potters of the Seljuq period developed a number of different techniques for decorating the thin fritware surfaces. The material lent itself admirably to shaping by mold, both as vessels (Fig. 41) and tiles, and frequently the molded decoration was figural [225]. Alkaline glazes, producing colors of dark lapis lazuli [235] or pure turquoise, adhered well to the whitened, glassy surface of the artificial ceramic body. White wares were the result of the simple application of colorless glaze over a very pure and white fritware body; they also provided the foundation for two of the most painterly, if also the most labor-intensive, of all the Seljuq potter's decorative techniques, *minaʾi*, and luster-painting.

Luster-glazed pottery is overglaze-decorated pottery. The metallic overglaze is achieved by mixing metal compounds in a liquid in which the metal salts are suspended, and then painting designs on the surface of a glazed and fired piece of fritware. The object is then refired, in a muffle-kiln that deprives the interior atmosphere of oxygen and precipitates metallic particles onto the glazed ceramic surface. If the firing is successful, opening the kiln reveals a ceramic object covered with a shining, metallic film of decoration. The typical colors of Seljuq luster are a dark coppery-red or a yellowish-gold; occasionally dabs, lines, or panels of lapis or turquoise will enrich the finish. But the aesthetic effectiveness of a luster-painted Seljuq object depends primarily on the deftness with which the small-scale designs – figures, garments and accoutrements, or abstract floral and geometrical patterns – are applied, to make maximum use of the contrast between glossy white and shining lustrous patterns [123; Fig. 42].

Minaʾi – Persian (from Arabic) for "enamel" – denotes the application of pigment, in a wide palette of colors and gold, onto a glazed and fired fritware surface which was then refired (often more than once) to fix the colors; hence the term "overglaze painting." Again, the decoration might be ornamental or figural, and the former may be painted directly onto the glazed surface, especially on the exterior of a vessel. Figural compositions are treated differently: the outlines are drawn in black, in quick and sprightly lines (Figs. 43–45), and the resulting fields filled with color, creating miniature pictures, or vignettes, that are the epitome of the intensely figural culture of Seljuq Iran and its neighbors. An entire world in miniature dances across the painted surfaces of *minaʾi* vessels of all shapes, sizes, and functions, and on a smaller number of *minaʾi* tiles. Princes, sometimes seated cross-legged on low thrones, hold audience in the midst of attendants or dignitaries and feast them with beakers and glasses; they hunt, sometimes in procession [135], or duel on horseback; they wage war, occasionally from the backs of elephants, attacking strongholds with hordes of archers [2; Fig. 44], leaving victoriously with pennons flying, or mourning their dead. As on luster-painted Seljuq ceramics, the figural types conform to the Buddhist ideals of beauty and deportment. *Minaʾi*, then, is true painting on the miniature scale of an illustrated book, even though in this case the painting is done on a ceramic surface that is sometimes molded, shaped, or curved (Fig. 45).

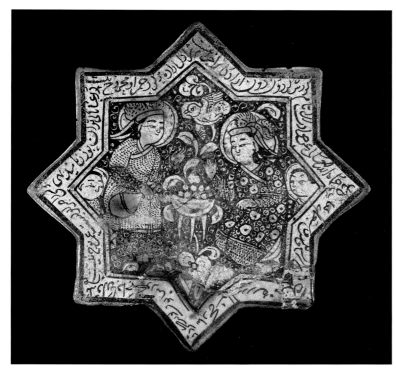

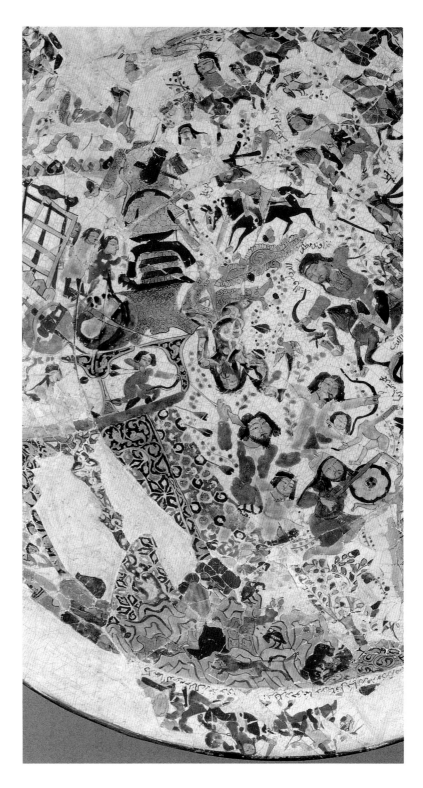

42. "Seated Figures in an Interior," luster-painted ceramic tile, 1339; London, British Museum, OA 1123

43. Drawing on the reverse of a ceramic tile, twelfth–thirteenth century; London, British Museum, OA G 1983.487

44. "The Siege of a Citadel," detail from the "Freer Plate," *mina'i* ceramic, ca. 1220; Washington, DC, The Freer Gallery of Art, 43.3

45. Fragment of a *mina'i* ceramic bowl painted with scenes from Firdausi's *Shahnama*, twelfth–thirteenth century; The Nasser D. Khalili Collection of Islamic Art, Pot875

46. "A Musician," *mina'i* and luster-painted ceramic tile decorative
elements, Kubadabad, Anatolia, thirteenth century; Berlin, Museum für
Islamische Kunst, I 936

47. Fragment of a painted and lacquered circular wooden box, late
twelfth–thirteenth century, found at Rabat-i-Sharaf in Khurasan

These decorative techniques were also used to decorate tiles made
in Seljuq Anatolia, in centers associated with the Rum-Seljuqs and
especially with ʿAlaʾ al-Din Kay Kubad I (1219–37). In a fortress in
Alanya (on the south coast of Anatolia) and another, near the same
town; in a palace converted from a Roman theater near Antalya, also
on the south coast; in a bath in Kayseri, and in a celebrated small pavil-
ion, or *kösk* in the Rum-Seljuq capital of Konya (Fig. 46): all of these
sites have yielded interior tiles decorated with figural and animal
designs in underglaze painting as well as in luster and *mina'i*. Their
shapes display the usual range of Seljuq variations of star-and-cross pat-
terns, or compound hexagons composed of stars, diamonds, and
lozenges. The designs display the usual repertoire of Seljuq decorative
motifs: figures from the courtly milieu, especially princes seated cross-
legged with male and female attendants, sometimes holding beakers or
musical instruments; riders, and animals both real and fantastic. Still
other examples survive from sites where Seljuq historians, such as Ibn
Bibi, speak of palaces that no longer exist, in Kayseri and Akşehir. The
richest finds were made in excavations in the mid-1960s at the site of

ʿAlaʾ al-Din Kay Kubad's summer palace, called Kubadabad, near Lake
Beyşehir.[9] The throne room, the banquet hall, and adjacent rooms had
originally been covered with "the finest faience tiles of the period" and
those on the walls of the audience hall, a smaller adjoining room, and
even on the eastern terrace, were still *in situ*. A smaller pavilion, built
for the sultan's vizier, had originally been decorated with the same kind
of tiles, although they were fewer in number and in poorer condition.
All the Kubadabad shapes are similar: quantities of eight-pointed stars
with interstitial cross-shapes, and smaller numbers of square tiles. Those
with figural decoration are, again, in the Anatolian Seljuq techniques
of underglaze, luster, and *mina'i*. The repertoire is drawn from the
courtly cycle and occasionally accompanied – on the eastern terrace –
by fragmentary inscriptions of Persian poetry, the birds and beasts of
the real world, and a rich range of fantastic and symbolic animals
reflecting contemporary Muslim literature. Astrological images are fre-
quent, as well as those harking back to the ancient origins of the Turkic
peoples, such as birds of prey and dragons; others reflect the Sasanian
Iranian traditions appropriated by the Turks in the course of their
migrations westward through Iranian lands.

ENAMELLED GLASS AND SELJUQ FIGURAL PAINTING

Painting similar in scale, materials, and style to that found on so much
Iranian pottery was also used to decorate glass objects in the Seljuq
period.[10] Small flasks of colored glass bearing enamelled patterns in
contrasting colors have been found in the bazaars of Kabul, some said
to have come from Sistan and others from Khurasan. Another group,
of small circular molded medallions, is said to have come from Ghazni
and has been attributed to Khurasan in the eleventh or twelfth century.
They are decorated with birds or animals; one shows an elephant with
a mahout on its neck and an indeterminate figure seated on the
howdah on its back, perhaps a female musician holding a lute. Other
contemporary glass objects presumably made in Mamluk Syria were
inspired by Seljuq Iranian styles in their shapes, their decoration, or

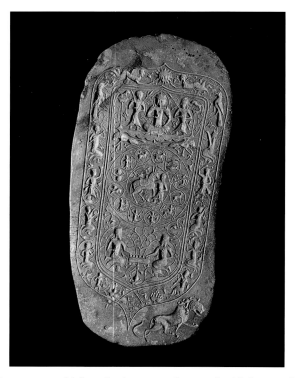

48. Soapstone mold for a leather purse decorated with human figures and
arabesques, thirteenth century; Kuwait, Dar al-Athar al-Islamiyya,
LNS 108 S

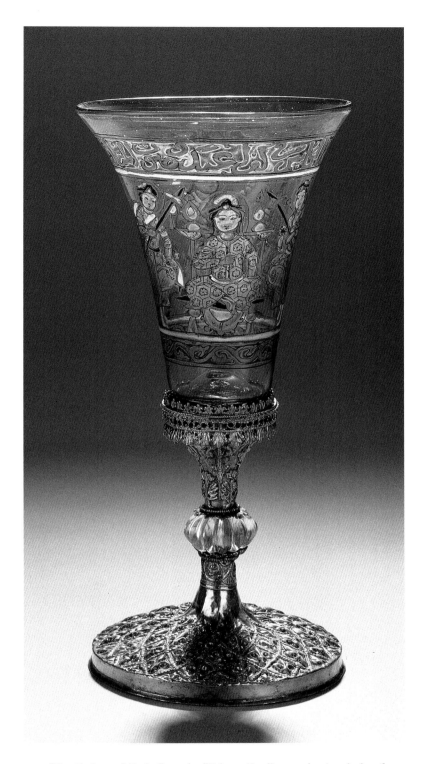

INLAID METALWARES AND SELJUQ FIGURAL PAINTING

The third major category of the Seljuq decorative arts that reflects the vigorous figural imagination of Iran in this period is metalwork. A host of useful brass and bronze objects – basins and ewers, bowls and buckets, candlesticks and incense-burners, pen boxes and inkstands, caskets and small lidded boxes, and even keys – is frequently inlaid with tiny pieces of precious metals cut and shaped to form patterns. As with glass and ceramics, the patterns on these inlaid metalwares display a combination of vegetal and geometrical decorative designs, inscriptions in both Arabic and Persian, and figural compositions. The effect is based on the color contrast of materials: in this case, of gold, silver, and copper against the bronze or brass in which they are set. Once again, the subjects, and the style in which they are executed, derive largely from the Iranian repertoire of princely imagery, and conceptual or serial narrative (Figs. 50–51) activities, also seen on painted or lustered fritwares. The figural decoration may simply evoke the status of a prince by whom a piece was commissioned. Sometimes it is organized in schemes of some complexity – the seven planets, the twelve signs of the zodiac, the labors of the months. Less frequent are identifiable scenes from literary sources, such as a male figure on a dromedary, in a panel on a candlestick who – as he brandishes a large ox-headed mace – must be Faridun (Fig. 50). The same wide-ranging figural repertoire is found

49. "An Enthroned Ruler" on the "Palmer Cup," enamel-painted glass from thirteenth-century Syria set in a later silver mount; London, British Museum, Waddesdon Bequest, no. 53

50. Inlaid bronze/brass candlestick, thirteenth century; Paris, Musée des arts decoratifs

both. How close is the pictorial influence on such pieces, and how uncertain their dates, can be appreciated by the fact that recent studies venture neither the origins nor dates of the most interesting pieces. For example, a wide glass bowl whose shape is ultimately derived from Seljuq (or fourteenth-century) Iranian metal bowls is decorated with enamelled figures of dancers and musicians; it is said to have been found in Hamadan, in western Iran. The "Palmer Cup," a glass beaker (Fig. 49) with later silver-gilt mounts whose original shape is not dissimilar to the *mina'i* "Freer Beaker" [135], is decorated with stanzas of Arabic wine-drinking poetry and an enamelled frieze showing a cross-legged enthroned ruler flanked by four youthful attendants carrying arms and musical instruments; it may be thirteenth century in date.

on contemporary metalwares from Anatolia and the Jazira. Notable is the figural decoration inlaid onto the faceted sides of a thirteenth-century beaten brass goblet (probably from the Jazira) for it includes a figure mounted on a camel and drawing a bow, while behind him sits a harp-player, presumably female – perhaps they are Bahram Gur and his musician Azada (Fig. 51).

In addition to such portable Seljuq objects, materials used in the decoration of architecture – stone that was carved, and molded stucco panels suitable for lavish interior ornamentation – also frequently bore figural decoration in the Seljuq period. Even stucco sculpture, on a scale approaching reality, was not uncommon (Fig. 52). Religious strictures seem to have little affected the sensibilities of those who commissioned,

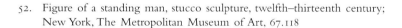

51. "Bahram Gur Hunts with Azada," detail from a brass goblet once inlaid with precious metal, probably the Jazira, mid-thirteenth century; Istanbul, Museum of Turkish and Islamic Art

52. Figure of a standing man, stucco sculpture, twelfth–thirteenth century; New York, The Metropolitan Museum of Art, 67.118

made, and used these objects – so exceptionally rich in human and animal decoration – in the Seljuq period in Iran and in neighboring countries. Like the few fragments of actual painting, mural or miniature, that do survive from this time, and in whatever medium and scale they were made, all demonstrate a common – and a positive – approach to the use of the human figure in decorating useful objects and the milieu in which they were used. Nor was there any apparent concern that an object or an ensemble, a wall painting or a manuscript, be the work of (or commissioned by) Iranian, Turkish, or Arab peoples, apart perhaps from the language in which an accompanying inscription might be written; indeed, very often both Arabic and Persian will be found on the same Seljuq object. Thus, in every possible way, this very large body of figurally decorated objects and ensembles together constitutes the stuff of a true Seljuq "International Figural Style" operating in the medieval Muslim world.

THE INTERNATIONAL STYLE OF SELJUQ IRAN AND NEIGHBORING LANDS

The references Melikian-Chirvani has gleaned from Seljuq poetry suggest that contemporary wall painting was made on many scales, both large enough to be seen over a portal between a palace and the *maydan* it faced, and small enough to fit onto the wall of an alcove in the same palace. Three Seljuq wall paintings [38, 101; Fig. 53] – a minute sample, and surviving today only in fragmentary form – epitomize what must, once, have been a very large body of painted buildings; yet the differences among even three examples are informative. First, they bear out

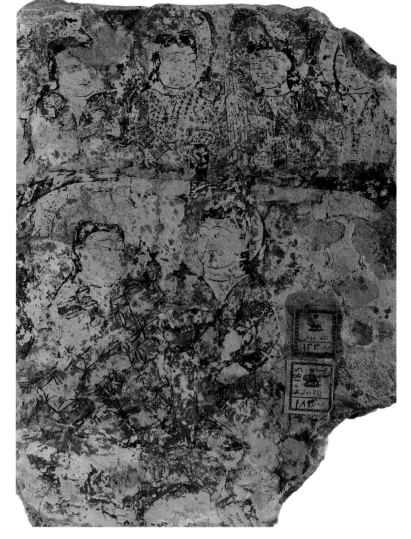

53. Two registers of seated figures, fragment of a wall painting, twelfth century; present whereabouts unknown

the truth of the poetic references suggesting variations in size: some (Fig. 53) bear figures that must be approximately similar to the tiny figures on the more numerous vessels and tiles, and even of manuscript illustrations; whereas one "fragment" depicts a large group of men on a chunk of painted plaster that may originally have been two meters wide and a meter tall [101]. The execution ranges widely: one displays skill and some care in the drawing, while another is simply clumsy. Indeed, as so often is the case with any popular and widely practiced genre of art, quality differs widely.

If the surviving examples of Seljuq Iranian wall painting are very few and far between, surviving illustrated manuscripts made in Iran in the same period are almost equally limited. Virtually no dated and illustrated literary or historical manuscripts that are indisputedly from Iran are known to have survived until well after the Mongol invasions of the 1220s. Even references to illustrated Iranian manuscripts of the Seljuq period that no longer survive are sparse. Little surprise, then, that a precious description of a Seljuq manuscript with illustrations should be found, if not actually in a work of poetry, then in an account of such a work. The volume in question was an anthology of poetry prepared for the Great Seljuq Sultan Rukn al-Din Tughril III, in 1184–85;[11] a portrait introduced the verse of each poet collected in the anthology, and a gathering of facetious stories appended to the volume also had figural illustrations. The copyist was a certain Zayn al-Din Ravandi, the illustrator was called Jamal *naqqash-isfahani* – the painter, presumably from Isfahan; regrettably, the volume no longer exists.

Compounding our lack of knowledge of Seljuq manuscript painting in Iran, even the few surviving manuscripts that also carry dates often leave open the question of where they were made. And they may also have no illustrations – as is the case with the earliest known copy of the *Shahnama*, only a first volume that was completed on the thirtieth

of the month of Muharram in the year equivalent to 1217.[12] Abu'l-alma'ali Nasrallah's Persian translation of *Kalila u Dimna* had been made for a later Ghaznavid prince, Bahram-Shah, between 1143 and 1145; of the three earliest illustrated copies known today, none indicates where it might have been made, and only one is actually dated: well after the end of the Seljuq period, in the years 1307–08.[13] All three have illustrations that are related to the Seljuq "International" figural style but are frankly provincial [200]. These are manuscripts that could have been made anywhere in the Seljuq world where Persian was read and appreciated, from Anatolia to Azarbayjan and northern 'Iraq, to western Iran. Even more tantalizing is the uniquely surviving manuscript of a copy of 'Ayyuqi's *Warqa u Gulshah*, a romantic tale that recounts the story of a pair of young Arab lovers but sets them entirely within the social framework of the Muslim, Seljuq Iranian world [4, 57, 140, 166]. The text is in Persian, while the style of its seventy-one pictures resembles the few surviving examples of Iranian wall painting and the far more numerous examples of contemporary Iranian and Anatolian painted fritware vessels and wall tiles, although they are nonetheless also provincial in style. The manuscript has neither a date nor a stated place of completion. Only a painter's signature on one folio provides a clue to one of several towns in Anatolia. This repository of provincial images, then, appears to have been made in the north-western fringes of the Seljuq world but the date has not been defined any more narrowly than the first half of the thirteenth century.

Perhaps the finest of all surviving painted images in any Seljuq-period manuscript is a picture today comprising only the left half of a double-page frontispiece to a book of Arabic poetry (Fig. 54). It opens the seventeenth volume of what was, once, a twenty-volume set of poems collectively known as the *Kitab al-Aghani*, *The Book of Songs*.

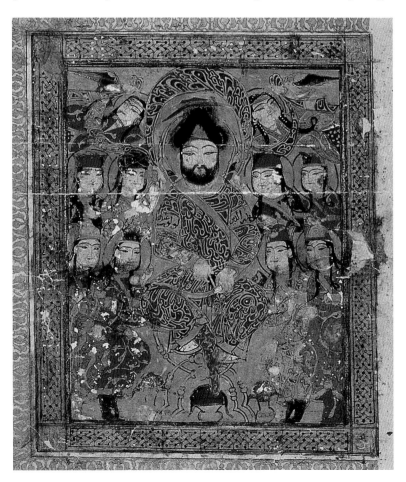

54. "A Seated Ruler," frontispiece from volume seventeen of the *Kitab al-Aghani*. Mosul (?), the Jazira, 1215–19; Istanbul, Süleymaniye Library, Feyzullah Efendi 1566, folio 1r

Some of the six surviving volumes are dated between 1215 and 1219 but none has any indication where the set was copied or illustrated; all of the six retain only half of their original double-page frontispiece. Yet even in their truncated format, they exemplify the themes of the pre-Islamic Iranian princely imagery that recur, over and over again, throughout the history of Iranian figural painting from its earliest periods: a prince receives homage at a feast, or he hunts on horseback, or he is shown surrounded by courtiers and the perquisites of his rank.

The frontispiece of Volume Seventeen exemplifies the classical Seljuq Iranian princely image: the prince shown frontally and placed at the center of a densely patterned picture, flanked on both sides by two registers of courtiers than whom he is much larger. At his shoulders hovers a pair of winged genie holding the looped ends of a cloth of honor that bellies out, like an additional nimbus, over the prince's head; its origin is actually Roman and had been adopted by the Sasanians. All the heads are nimbed; all the faces are of the classical, full "moon-faced" ideal type of the Central Asian, Buddhist canon, with narrow, elongated eyes, tiny mouths, and a simple straight line for the nose; long black hair falls in tresses over their shoulders. Against the golden background interrupted only by the black outlines of the golden haloes, the full faces and clothing provide contrasts of color and pattern, red and blue for the left-closing kaftans and varied headgear, and the high black

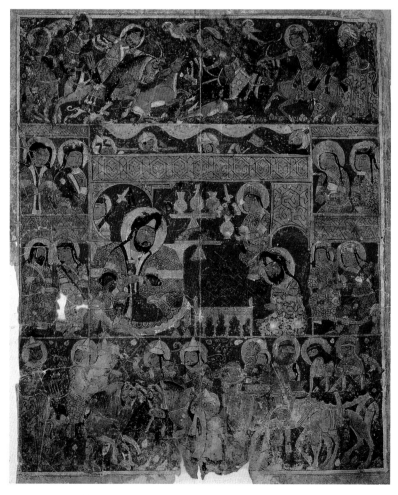

55. "Scenes of Courtly Life," frontispiece of the *Kitab al-Diryaq*, Mosul (?), the Jazira, mid-thirteenth century; Vienna, Nationalbibliothek, AF 10, folio 1r

boots. The *tiraz* on the upper sleeves of the prince's garment bear an inscription in black reading "Badr al-Din Lu'lu' ibn 'Abdallah," and the proposal has been made that these words – a personal name – were added after the painting was completed, to mark its dedication to a patron other than the one for whom it had been prepared. In fact, Badr al-Din Lu'lu' was a personage of some importance in the thirteenth-century Middle East, a freed slave who had become vizier to one of the later Seljuq Atabegs, or viceroys, of the Zangid dynasty ruling in northern Syria and the Jazira. On the death of Nur al-Din Arslan Shah I, in 1193, Badr al-Din assumed power as regent in Mosul and after the death (in 1222) of the last prince in the primary Zangid line in Syria, effectively he became the Zangid Atabeg, a position he held until his death in 1259, the year after the Mongol capture of Baghdad. It would be hard to point to a better example of high Seljuq princely imagery than this. But it is also extraordinarily ironic that the picture perhaps most representative of all the painted images of the entire Seljuq period, executed in the most formally Iranian composition and style, should be found at the head of a volume of Arabic poetry (composed by an Arab albeit born in Isfahan), copied in a part of the Muslim world that was culturally and linguistically a mix of Arabic and Turkish, and that the set was ultimately dedicated to a manumitted slave.

If Badr al-Din Lu'lu' in the *Kitab al-Aghani* is the epitome of the Iranian prince at the center of a formal tableau – an Iranian image that is Sasanian-Persian (at the very least) in inspiration – another image of a prince, also found in a frontispiece in a volume of a different Arabic text, the *Kitab al-Diryaq*, or *Book of Antidotes* (Fig. 55) is also noteworthy. This manuscript too is usually attributed to Mosul and dated toward the middle of the thirteenth century, and in its frontispiece the prince sits at the center of a lively narrative image, whose story seems just to elude us. In formal terms the picture is organized asymmetrically: the prince is placed at the side of the central section, represented as larger than his attendants but in the midst of them, and not frontally enthroned but placed at an angle. In pictorial terms, he sits cross-legged on a terrace watching the preparations for a meal of roasting kebabs while gardeners work beyond the terrace wall. Above and below the central space where the prince is seated are two more registers, a hunting scene and a procession of camels carrying colorfully veiled ladies in howdahs, accompanied by attendants. Again, the figural norms derive from Iranian conventions of Central Asian origin: full round faces with small eyes and tiny mouths, men and women alike wearing their black hair long, golden haloes setting off the heads of even the humblest or tiniest of persons in this busy scene. The use of registers to organize the picture is another feature frequently seen in Iranian painting, as generally in ancient Middle Eastern art [211; Fig. 16]: it is a compact way of clarifying a series of themes or activities and its usefulness is surely one of its attractions. The solid red background, quite striking here, is usually considered to be of pre-Islamic Iranian origin, perhaps Parthian; it will reappear in Iranian painting of the next century, in fourteenth-century manuscripts made in western Iran [177, 227, 230].

Yet in the end, all of this is little enough to testify to the intensely pictorial nature of Islamic Iran up to the middle of that century, when a new set of Turkic invaders from the east appeared in the heart of the Caliphate.

THE FOURTEENTH CENTURY

With the arrival of yet another army of East Asian, nomadic origin at the walls of Baghdad in early 1258, Islamic civilization reached a watershed. The sober Ibn al-Athir, writing later of events beginning in the year 1221–22, speaks of "the greatest catastrophe and the most dire calamity . . . which befell all men generally, and the Muslims in particular," wrought by

> a people who emerged from the confines of China and attacked the cities of Turkistan, . . . and thence advanced on the cities of Transoxiana, . . . one division then passed on into Khurasan, until they had made an end of taking possession, and destroying, and slaying, and plundering, and thence passing on to Ray, Hamadan and the Highlands, . . . even to the limits of ʿIraq, whence they marched on the towns of Adharbayjan and Arraniya, destroying them and slaving most of their inhabitants, . . . and all this in less than a year . . .[1]

The people from the confines of China were Mongols. Another horse-riding nomadic confederation, it had coalesced in the late twelfth century around the energetic figure of Temuchin, scion of a noble family of the tribe of Manghol. In 1196, he was accorded the position of paramount Mongol chief and at the same time received the title of Chinghis Khan. In less than a decade he had established himself as unquestioned leader of all the Mongol tribes whose homelands lay north of China and had held a national assembly, a *quriltay*, at which his title was confirmed and his leadership accepted. His descendant, Timur, would follow a similar military course and hold a similar assembly to establish his sovereignty in Balkh in 1370; a century later, Timur's great-great-grandson, Sultan-Husayn Bayqara, would have a superb picture painted of this very event [33], emphasizing the Timurid right to govern in Iran. Yet in the second quarter of the thirteenth century, the Mongols were destroying virtually all that lay before them as they overran the Islamic world and pressed, however briefly, into eastern Europe. In the terser words of a refugee from Bukhara: "they came, they uprooted, they burned, they slaughtered, they plundered, and they left."[2] Those who could, escaped and went elsewhere: the fathers of two celebrated literary figures both fled from Balkh, Jalal al-Din Rumi's family settling in Konya, in Seljuq Anatolia, and the poet Amir Khusrau finding favor in the Muslim courts of Delhi, in northern India, whence his father had sought refuge. Small wonder that relatively little of what was made in pre-Mongol Islamic Iran survived, even though it was also Mongol policy from the outset to spare those who could, in some way, be of use to the unlettered nomads with, suddenly, vast foreign lands to administer; indeed, even in these horrendous years, bureaucrats and skilled craftsmen were often pressed into service and carried back to the Mongol capital, Qara-Qorum.

The establishment of Mongol political power over Iran and the central lands still subject to the Caliphate did not occur either immediately or steadily. Chinghis Khan himself died in 1227, which drew his sons, their military leaders, and the armies back to Qara-Qorum for the new disposition of lands and posts. In the next three decades,

Mongol control over the Islamic world south of the Oxus River slipped. Not until after the middle of the century did a Mongol ruler return to Iran to complete the task of conquest the beginning of which was so chillingly described by Ibn al-Athir. Hulagu, brother of the Great Khan Qubilay, was assigned the central Islamic lands and the title of Ilkhan, meaning "subordinate to the Great Khan." His army swept through Iran, attacked the stronghold of the dreaded Ismaʿili Assassins [91] and in 1256 executed their leader Hasan al-Sabah, the "Old Man of the Mountain." They besieged Baghdad and murdered the last ʿAbbasid Caliph in 1258, took the Jazira and northern Syria, and were only stopped in 1260, in Palestine, by the well-trained (and kindred Turkic) forces of the Mamluks of Egypt. Thereafter, Hulagu and his descendants turned their energies to the rebuilding of Iran.

Azarbayjan, in the north-west of the country, became the Ilkhanid heartland: international trade routes between East and West passed through the capital city of Tabriz, the great open plains afforded good pasturage for quantities of livestock, and there was ample space for the building of new centers such as Takht-i Sulayman and Sultaniyya. Devastated cities were rebuilt; learned men again found learned patronage at the Ilkhanid court and the production of books of all kinds was resumed. That these included Qurʾans is evidence that Islam was both practiced and tolerated long before Ghazan Khan's official conversion in 1295. Before then religious pluralism was acceptable, for the Ilkhanid rulers had variously practiced Shamanism, Buddhism, and Christianity (of both the Jacobite and Nestorian persuasions), a fact that had briefly raised the hopes of European kings and popes in the second half of the thirteenth century.

ILLUSTRATED MANUSCRIPTS

The arts and crafts of the Ilkhanid period in Iran are among the earliest Islamic artifacts for which we can begin to match objects with material or intellectual context, written sources, or all three. Textiles, especially those woven with precious metal, were much prized by the Ilkhanids and their Mongol relatives in the East; they were traded all over the world and have survived in large numbers in locales as distant as Christian tombs in Spain and Lamaist shrines in Tibet, mute, if eloquent, evidence of the freedom with which men and materials moved between Europe and the farthest East while the *Pax Mongolica* held. But at the beginning of the twenty-first century, books – of all kinds and on innumerable subjects – may arguably be considered the real prize of Ilkhanid Iranian culture; they may be more subtle in effect, perhaps, than gold-woven shrouds, but they speak as loudly, and in the longer term they are surely as important, if not more so.

Among the manuscripts on all the subjects commissioned and copied under Ilkhanid patronage – as elsewhere in Iran in the areas to the south and west that never really fell under Ilkhanid rule – a surprising number of illustrated volumes survives. For the first time in the history of Iranian painting, the pictorial concerns and interests of Iranian

culture which have simply not survived from earlier periods either as pictures in books, or in painting on walls, may be fleshed out. From this date as well, another kind of Islamic book must also be understood as an integral part of the history of Iranian painting, that with no pictures but only illumination. Earlier volumes, notably those of the Qur'an, had been so decorated, with panels or even pages of abstracted geometrical or floral decoration, although few have survived with the exception of Qur'ans. But from the middle of the thirteenth century, any real understanding of the arts of the book in the next four centuries of Iranian culture must also be based upon manuscripts that are not illustrated: paper, calligraphy, illumination, and bindings must all be taken into account, however peripheral they may at first appear to be.

Of the flood of post-invasion illustrated manuscripts, a few nonetheless stand out. Whether this is simply because so many more of them have been preserved from after 1260, or whether from this period the figural impulse primarily expressed itself in painting on paper bound into codices, is a much-argued issue. The fact remains that, from the later thirteenth century, surviving illustrated books permit this chapter of the history of Iranian painting to be written with more certainty. These are volumes of remarkably different levels of execution and they display markedly different pictorial styles: indeed, distinguishing among them, especially those of the fourteenth century, has been until relatively recently a primary concern of scholarship.

In one sense, the new chapter begins just after the Ilkhanid conquest of Baghdad when, on the advice of the new court astronomer, the

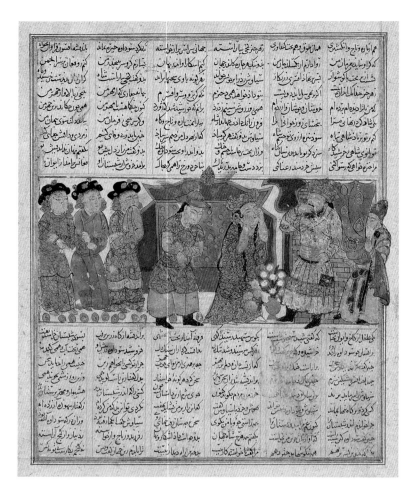

57. "Sudaba Accuses Siyawush," from the "First Small *Shahnama*," early fourteenth century; Washington, DC, Freer Gallery of Art, 30.90

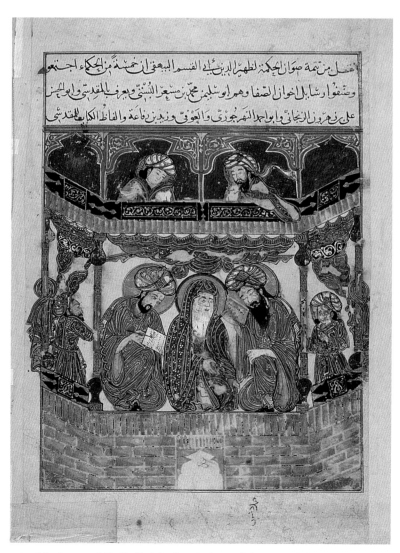

56. "Authors and Scribe," right frontispiece of the *Rasa'il Ikhwan al-Safa*, Baghdad, 1287; Istanbul, Süleymaniye Library, Esad Efendi 3638, folio 3v

eminent Nasir al-Din Tusi, an observatory was built on a hill to the west of the town of the original Ilkhanid headquarters, in the town of Maragha [31, 197, 198]. Although the rulers and their Mongol attendants resided very little in settled places, the presence of the observatory must have drawn scholars to Maragha to meet and exchange ideas. Astrology and astronomy, works on the natural sciences, and history – since "of the writing of histories in Persian there is no end" – would have been the primary subjects of interest. Information contained in the colophons, or tail-pieces, of both sacred and secular manuscripts reveals that texts, some illustrated, on many of these subjects were copied in Maragha, well before the establishment of Tabriz as a more permanent capital, which was then to usher in the great period of the Ilkhanid illustrated book.

Other Ilkhanid centers also figure in this new chapter in the art of the book. From as early as 1286, a series of large and splendidly illuminated Qur'ans, some in sets of many volumes, was copied by scribes in cities under Ilkhanid rule – Tabriz and Maragha, Hamadan and Sabzavar, Mosul and even Baghdad. In the former capital of the entire Islamic community, scholarly activity continued, and a series of important books, both with and without illustrations, bear dates from just after the Mongol invasion (Fig. 56) throughout the fourteenth century, first under Ilkhanid patronage and then under the aegis of the Jalayirids. And in the second quarter of the century, illustrated manuscripts were also being made in other western Iranian cities: Isfahan, Shiraz, and other centers as yet unidentified (Fig. 57).

Thus, for any post-invasion Iranian manuscript or single illustration, a description will usually include a place of execution as well as a date, the place serving as a shorthand indicator of style (and often also of

date), as well as of quality. In turn, these features often reflect the presence, or absence, of a princely court in the city in question, since quality is usually an indicator of the level of the support available for the making of a manuscript, not to speak of the level of a craftsman's remuneration. At various times in the course of the next four centuries, Tabriz, Baghdad, Shiraz, Herat, Qazvin, Mashhad, and Isfahan were all important court centers, or capital cities where significant and beautiful illustrated manuscripts were created.

But it was in Tabriz, the Ilkhanid capital, and under the direction of a figure of great talent and capability, that the exceptional potential of the illustrated manuscript of classical Persian literature was first realized. It is true that Persian texts had already been produced in Iran before the early fourteenth century: this is attested by numerous references in poetry as well as in prose texts. Yet the motivation for doing so appears to have been profoundly altered, early in the fourteenth century, by an appreciation of how the illustrated book could be "charged" with a significance particular to the person who commissioned it. At least, such appears to be the case with certain illustrated Persian manuscripts made in the course of this formative century.

THREE NOTABLE MANUSCRIPTS

Among the illustrated volumes made in the fourteenth century, three deserve special mention: for their size, for various aspects of their execution – the splendor, or the sheer number, of their pictures; for the way they embody a particular moment in the history of this art; and for reasons connected with their patron, or with the circumstances of their creation. The first is an illustrated copy of a magisterial *History of the World*, commissioned by the Ilkhanid Ghazan Khan and begun early in the fourteenth century, as a history of the Mongols. Another is a fragmentary *Shahnama* lacking a date and a named place of execution, but undoubtedly also produced in Tabriz perhaps a decade later, possibly under the aegis of Ghazan's nephew Abu Sa'id. The third, a mid-century copy of the earliest Persian translation of the *Kalila u Dimna* tales, today exists as only a set of cuttings pasted into an especially beautiful sixteenth-century album, but it provides evidence of the real progression of book illustration in the course of perhaps half a century, and it also contains some of the most wonderful paintings of animals ever produced in the Iranian world.

THE ARABIC *JAMI' AL-TAVARIKH*

The earliest of the three is a new text, unlike the *Shahnama* and the *Kalila u Dimna*: the *History of the World*, the *Jami' al-Tavarikh*, which may also be translated as *Compendium of Chronicles*. The earliest surviving copy was originally a volume of some 400 pages, illustrated with perhaps 110 pictures; today 325 folios are preserved in two parts but with almost all of the illustrations – 105 [5, 6, 50, 69, 88, 212, 213]. The text was composed by Rashid al-Din, physician and vizier to the Ilkhanid dynasty he chronicled. Born a Jew from Hamadan around the middle of the thirteenth century, he entered the employ of Abaqa Khan as a physician, when he was about thirty; his conversion to Islam occurred at about the same time and was probably not unconnected. He found great favor with the Ilkhanid princes, coming to occupy a number of posts in their vizierate and, in the process, acquiring great wealth. In 1309 he endowed a charitable foundation in an outlying quarter of Tabriz, called the Rab'-i Rashidi, which included a congregational mosque, a guest house, a sufi hospice, a hospital, and a scriptorium; he also built himself a tomb near

the mosque. Ghazan Khan had asked Rashid al-Din to write a history of his Mongol forebears; during the reign of Ghazan's brother and successor, Oljaytu, the history was much expanded until it came to be a virtual encyclopedia of the peoples of Eurasia.

Rashid al-Din intended his history to be widely disseminated, a task his foundation would undertake. An appendix to the document of its endowment stipulated the transcribing of two copies of the text yearly, one each in Arabic and in Persian, which were then to be sent to ". . . the cities of Islam, Arabic to Arab lands and Persian to Persian lands."[3] So thoughtfully ambitious a public service was not to be achieved; like the earlier Ilkhanid historian 'Ala' al-Din 'Ata Malik Juvayni [91, 198] and his brother Shams al-Din, who had both risen through the bureaucratic ranks but incurred the jealousy of rivals in doing so, Rashid al-Din found himself the target of grave accusations made by his co-vizier, and he was executed in the summer of 1318. Of the grandiose historical project, only parts of three contemporary illustrated copies and a number of detached illustrations (Fig. 58) from at least one more survive today. The manuscripts are an Arabic text, long separated into two parts, that was completed in 1314, and portions of two Persian copies with the dates 1314 [6] and 1317.

All were surely produced in the scriptorium in the Rab'-i Rashidi in Tabriz by what must have been a team of artists of many nationalities. The paintings remain anonymous: virtually nothing is known of those who created them, although careful study of Rashid al-Din's *waqf* document, and the evidence of colophons of other contemporary Ilkhanid manuscripts, have begun to throw up suggestions.[4] They are a fascinating compendium of the styles, influences, and manners of illustrating texts that would have been available to artists in Tabriz, the

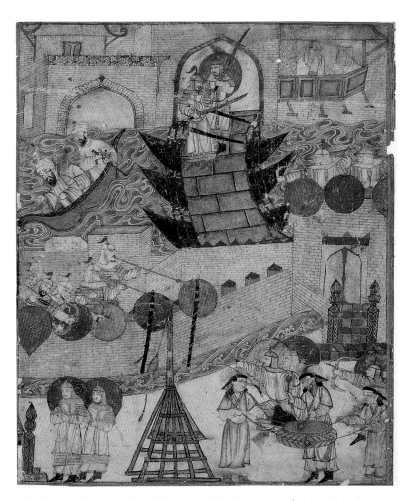

58. "Siege of a Walled City," folio probably from a *Jami' al-Tavarikh* of Rashid al-Din, Tabriz, 1310–18; Berlin, Staatsbibliothek, Diez A Fol.70, S.4

59. Ma Lin, "Fragrant Spring After Rain," ink and light color on silk, mounted in an album, mid-thirteenth century; Taipei, National Palace Museum

most cosmopolitan center of Ilkhanid Iran in the early years of the fourteenth century.

When illustrating Rashid al-Din's text became a desideratum is unclear; given that two copies were to be made yearly, speed was evidently of the essence and pictorial models therefore needed in great numbers. Earlier Islamic illustrated manuscripts, as well as Latin and Byzantine Christian volumes, provided some models. One feature they share − whether Muslim or Christian, from Syria, Seljuq Anatolia, Baghdad or Seljuq-ruled Mosul − is the imposition of a discrete boundary for the illustrations: the picture-space is covered with color, even when in fact the bare paper of the page falls within that boundary. This formality is often to be observed in pre-Mongol Iranian painting − insofar as we can judge from painted *minaʾi* ceramic wares, on which both modes appear [2, 135; Fig. 45]. An alien feature that pre-

sents the newer element in the early fourteenth-century Ilkhanid style is surely due to the presence in Tabriz of painting from the East − Chinese and Chinese-influenced pictures, brought westward from the Mongol heartlands. Such paintings must have been in Ilkhanid possession in some number, given the contacts between Qara-Qorum and the outlying areas of the Mongol empire; indeed, Chinese influences are frequent in the *Jamiʿ al-Tavarikh*. Landscapes brushed with diluted colors onto bare paper, and thin, transparent washes of color with no preliminary underdrawing; ink-drawn foliage of species alien to the Middle Eastern eye, such as spiky bamboo or fungus-like growths; and the massing of forms in a rhythmic rise and fall − as if the picture were painted on a section of a hand-scroll temporarily opened to that image − or images only partially shown and "cut" by a margin: all these features could have been seen in, and learned from, Chinese painting (Fig. 59). Not all of them are evident in all of the illustrations in the Arabic *Jamiʿ al-Tavarikh*, but they are selectively present, to different degrees, throughout the ensemble.

As the illustrated Arabic *Jamiʿ al-Tavarikh* is the work of a number of different hands, a formula was imposed onto the illustrations to effect a semblance of unity over the massive work. Each illustration, no matter what its stylistic model, is set into an enclosed and bounded space defined by a cluster of ruled lines, of greater color and variety than those defining the written surface of the text; this last feature had been typical of good secular manuscripts written in Persian for at least a century. Inside the rulings, the paintings can be seen to be stylistically related to those in a slightly earlier Ilkhanid manuscript, a copy of al-Biruni's *Al-Athar al-Baqiya . . . , Chronology of Ancient Nations*, completed in 1307 (Fig. 60), as well as to their many models. Given the variety of sources from which they are constructed, as an ensemble they are remarkably cohesive.

Moreover, many pictures represent quite original compositional responses to new textual demands. Perhaps the most remarkable feature

60. "The Defeat of al-Muqanna," from *Al-Athar al-Baqiya* of al-Biruni, Tabriz, 1307; Edinburgh, University Library, NS Arab 161, folio 93v

of the early Ilkhanid style is the rendition of human beings, with highly expressive faces and demonstratively contorted figures [6]. This is in striking contrast to the impassive moon-faces of Seljuq painting in whatever medium, and it adds another dimension to the astonishing pictures in the Arabic *Jami' al-Tavarikh*, as well as those of manuscripts of the next decade. Even more significant, because of its long-term influence, is the illustrative program of the manuscript. This being a new text as well as a newly illustrated genre of text, what was to be illustrated was "up for grabs," so to speak. How was each section to be illustrated? and how might something of importance be emphasized, something minor played down? The choices made appear to reveal a clear and programmatic intention. In this manipulation of the visual program, modulating words by accompanying them with specific and meaningful images, resides the true achievement of Rashid al-Din's artists. In effect, they were beginning to forge a way of combining text and pictures which, in its most significant examples, would prove to be inseparable from the reasons any text so treated was illustrated in the first place.

Adhering to such an approach, and building from what Rashid al-Din's artists were able to do with the texts given them, the makers of later illustrated manuscripts must have come to realize that their creations, too, could be invested with a significance beyond that of mere luxury and prestige: an illustrated manuscript could acquire meaning as an instrument of personal, or dynastic, propaganda. It could become the highly "charged" medium in which political and dynastic aims could be expressed in the guise of a precious, and relatively small, accoutrement. This could only occur in an exceptionally literate society in which literature, especially history and poetry, was taught to the young by those for whom it was the stuff of the deepest conviction and the highest passion. One immediate corollary is that the sponsor of such an illustrated manuscript would play a primary role in selecting what would be illustrated. A second is that people at every level of society might then also wish to commission, or at least to possess, good illustrated manuscripts, in imitation of princes and their courts, even if non-princely manuscripts were not "charged" in the same way. The widespread demand for such objects between the fifteenth century and at least the end of the seventeenth is surely to be explained, at least in part, by this investiture of a relatively small, precious, and essentially private object with so very great a significance. A third corollary is that text and pictures are, in the end, intended to be apprehended together, so that the loss of even one picture from the ensemble weakens its intrinsic unity. Thus did Rashid al-Din's scriptorium – however little of its output today survives – influence in one way or another the making, and the illustration, of fine and significant manuscripts all over the Eastern Islamic world for several centuries to come.

THE "GREAT MONGOL *SHAHNAMA*"

Illustrated manuscripts of Firdausi's *Shahnama* occupy a peculiarly prominent position in this period. At least ten fourteenth-century illustrated copies survive in some way or another and they have engendered an enormous amount of discussion, none more than the dispersed manuscript now known as the "Great Mongol *Shahnama*." It is the second of the great markers by which the history of this art is usually charted. It also exemplifies in the most extraordinary way, and at an early date, the achievement of Rashid al-Din's scriptorium in the forging of an instrument that could be invested – indeed, permeated – with personal significance for its sponsor.

Today, the manuscript survives only as fifty-seven widely dispersed paintings [14, 58, 124, 150, 167, 229] on very large folios. Incompletely,

but vividly, these paintings present a world of kings and heroes, human tragedies and unreal fantasies that has never been equalled. Missing from what survives of the manuscript is any statement of a date of completion, as well as any indication of where this would have been; but its great size – the written surface alone measures 410 × 290 millimeters – and the quality of its calligraphy, paper, and the majority of its paintings have virtually always argued for an attribution to Tabriz, and at a time somewhat later than the documented illustrated copies of Rashid al-Din's histories. Between 1330 and 1335 is a date now widely accepted; since 1980 the proposal that its sponsor was the son of Rashid al-Din, who from 1328 served the last effective Ilkhanid sultan, Abu-Sa'id, has also found general acceptance.

Less widely accepted is the proposition that the many illustrations in the manuscript were conceived as a mirror of specific events in the lives of the Mongols Chinghiz Khan and Qubilay Khan, and their Ilkhanid successors in Iran, from Hulagu to Abu Sa'id. Not all of the fifty-seven known paintings in the manuscript conduce to such a proposition; whereas pictures [102] removed from some other large but no-longer-extant manuscript of the *Shahnama* (and remaining uncertainly attributed), lend themselves particularly well to such an interpretation. Thus, whether or not they may eventually prove to have – once – belonged to the "Great Mongol *Shahnama*" is almost less important than the overall approach to the problem: seeing, in certain princely copies of chosen texts, a profoundly "charged" and significant statement, whether it be personal or dynastic.

The proponent of the Ilkhanids-reflected-in-the-*Shahnama* theory also proposes a deeper explanation for the phenomenon by which a small and essentially private object was made such an instrument in the first place: the highly educated Persian cultural background of the Iranian men who served their foreign rulers as viziers, and advisors in all aspects of their lives. The Ilkhanids were the first of a series of successive Turco-Mongols to establish political hegemony over the land of Iran where Islam was its religion and Persian almost universally the spoken language, as important a literary instrument as Arabic: like the Timurids (and elsewhere, the Mughals, and the Ottomans), the Ilkhanids were essentially outsiders whose legitimacy as rulers had to be established and accounted for. They chose to assert their position in different ways. The historian Juvayni persuaded Abaqa Khan to build a princely dwelling at the ruins of the Sasanian fire-temple at Shiz, called Takht-i Sulayman by the Ilkhanids – so conveniently located on the route between their first headquarters of Maragha and Baghdad. Rashid al-Din took Ghazan Khan's initial commission for a written history of the Mongols and made of it not only a history of the peoples of Eurasia but devised a program for providing it with illustrations of textually significant subjects and passages. His son Ghiyath al-Din, who became vizier to the last effective Ilkhanid sultan Abu Sa'id and had overseen his Persian education, may have taken the process a step further: perhaps it had been his idea to make of the *Shahnama* an epic Persian reflection, in the genre of the "mirror for princes," for the Turco-Mongol ruling dynasty, matching *Shahnama* illustrations with Mongol and Ilkhanid history wherever this could be done. Not all of the illustrated copies of Persian texts commissioned by princes in Iran (and elsewhere in the Eastern Islamic world wherever Persian literature, or its counterparts in various Turkish dialects, was the supreme cultural model), are so dynastically invested. Yet those that *are* are always exceptional manuscripts, adding layers of depth to an understanding of their period in ways that the mass of less significant contemporary manuscripts do not. As with architecture in the fourteenth and fifteenth centuries in Iran, such illustrated manuscripts are a supremely significant index of the values, concerns, and aspirations of the patrons who brought them into being.

The paintings in this impressive fragmentary *Shahnama* show several technical advances from those in the Arabic *Jami al-Tavarikh* in their format, and in the application of pigment. All the images in the "Great Mongol *Shahnama*" are contained within rulings, and the majority are, formally speaking, rectangles stretching across the full width of the written surface; but they are often taller [58, 124, 150] than the *Jami al-Tavarikh* paintings and thus give the impression that they are pictures of substantial size. The shapes of other images can be seen as developing from another format of the *Jami al-Tavarikh*, the smaller rectangle, often centered; they have a symmetrically broken upper outline, usually termed "stepped," used especially for hieratically composed scenes in which an enthroned king is the primary subject. As for the element of color, these pictures are conceived as fully painted images set within the rulings defining the shape of the picture. Apart from certain Chinese-style landscape effects and foliage details, very few illustrations in this manuscript are painted in the Far Eastern manner of brushing pigments onto bare paper.

These observations on shape and proportion, and on the completeness of pigment-cover, exemplify fundamental aspects of the illustration of manuscripts in Iran that characterize the art at its best, from about 1340 onward, ". . . the kind of painting which is current at the present time." So wrote the sixteenth-century critic Dust Muhammad, librarian of Prince Bahram-Mirza Safavi, brother of Shah Tahmasp. This perceptive and sensitive man of arts and letters offers the best (and virtually the only) statement on the notions of style and format that characterize the illustration of Persian texts from about the first third of the fourteenth century and for several centuries to come. Dust Muhammad was writing toward the middle of the sixteenth century; the compilation from which this statement comes is dated early in 1545, but his observations are clearly based on much visual experience and the perspective furnished by his position as librarian to one member of a family of superlative bibliophiles. In the preface to the album compiled for Bahram-Mirza, he provides nothing less than a genealogy of "Painters and Limners of the Past" that extends in an almost unbroken line from the period of Abu Said to 1545. Moreover, he names some of the manuscripts illustrated by the master-painter by whom the greatest of past and present painters were either taught or influenced:

> Master Ahmad Musa . . . lifted the veil from the face of depiction, and the [style of] depiction that is now current was invented by him. Among the scenes by him that lighted on the page of the world in the time of the aforementioned emperor, an *Abusaidnama*, a *Kalila u Dimna*, [and] a *Mi'rajnama* . . . were in the library of the late emperor Sultan-Husayn Mirza.[5]

Whether the "Great Mongol *Shahnama*" is really to be identified with Dust Muhammad's *Abusaidnama*, illustrated by the legendary Ahmad Musa, remains moot. Instead, a small number of related paintings mounted in other albums may be the meager remains of this superlatively illustrated manuscript.

THE *KALILA U DIMNA*

Less doubtful is the identification of fifty fragmentary paintings [103, 203, Fig. 61] from a Persian translation of *Kalila u Dimna*; for many reasons, this classical text, of which Dust Muhammad also writes as having been illustrated by Ahmad Musa, can be associated with a number of pictures mounted in the Shah Tahmasp album. They are truly only a set of fragments, mostly mounted two to a page without the accompanying text, but in them we gaze upon images that fully embody

61. Fragment from a *Kalila u Dimna*, Baghdad or Tabriz, ca. 1360; Istanbul, University Library, F. 1422, folio 24v

the style of the next gen-eration. Their human gatherings inside buildings breathe a certain spaciousness not seen in the "Great Mongol *Shahnama*," [103] and a more equilibrated expressiveness has returned to faces, hands, and gestures – save when situation or class demands otherwise. The core of the scenes set in interiors is usually a rectangle higher than it is wide, but almost always the picture is extended into the margin by an element naturally occurring outside of an interior – a tree or a shrub, painted on the bare paper outside the ruling of the picture. In the more numerous paintings of animals, landscapes are again the usual stuff of the extensions, but occasionally the vertical space is also used for a crucial aspect of the story, such as a well. And the pictures of animals [203], are superlative, the textures of hair and fur and feathers rendered as if they were palpable to a finger brushing against the painted page. It is difficult not to see this once-splendid manuscript as having been made by an artist of the greatest talents working in the service of an equally perceptive patron. The obvious candidate is Sultan Uways Jalayir.

THE EARLY JALAYIRID PERIOD

In the chaos that attended the death of Abu Said and the political disorder that followed, power in western Iran was eventually assumed by yet again another former governor. Taj al-Din Hasan Jalayir descended from a Mongol tribe in the following of Hulagu; he had governed Anatolia under Abu Said and, on the deaths of both the sultan and his vizier, in 1335–36, consolidated his own independence and made Baghdad his capital. In fact, for the next two centuries – as in the Sasanian period – the lands west of the Zagros Mountains extending as far as Baghdad belonged culturally in the sphere of Iran, 'Iraq-i Ajami, or "Iranian 'Iraq." For the remainder of the fourteenth century, however, the Jalayirids shared political hegemony in western

62. Painted trees flanking a painted and molded *mihrab* in the tomb-chamber of the shrine at Pir-i Bakran, Linjan, early fourteenth century

Iran with the Chupanids in Isfahan and the Inju, and then the Muzaffarids, in Shiraz, often bolstering their relationships by alliances of marriage. Literary figures, including Hafiz and Khwaju Kirmani, found sustaining patronage, and fine volumes in some numbers, both with and without illustrations, were made in Baghdad, Isfahan, and Shiraz throughout the course of the century. But in the second half of the fourteenth century, Jalayirid patronage for the making of fine manuscripts of classical Persian literature permitted a refined stylistic development of the genre that make Jalayirid-sponsored commissions stand head and shoulders above those made in Isfahan and Shiraz. Indeed, it is in Jalayirid Baghdad that the real foundations of the "classical style of Persian painting" were laid.

Dust Muhammad provides valuable information about the middle years of the century, in a brief mention of Hasan Jalayir's son Uways I: in his time an artist called Shams al-Din, student of a student of Ahmad Musa, was trained, and when Sultan Uways passed away, Shams al-Din worked for no other patron. Given the stylistic advances of the fragmentary *Kalila u Dimna* manuscript over the "Great Mongol *Shahnama*," again it is hard to escape the connection with Sultan Uways Jalayir, who reigned between 1356 and 1374.

A last manuscript noted by Dust Muhammad survives today entirely bereft of whatever text might have accompanied the eight large paintings mounted in the same album as the fragments from what might be the *Abusa'idnama*. Their subject is the *Mi'raj*, the miraculous Night Journey of the Prophet Muhammad [61-63], and the marvels of his travels – carried above the land and the waters by the angel Jibra'il, in the Aqsa (the farthest place of his journey) in Jerusalem, in heaven surrounded by angelic beings, and in the infernal regions of hell. Large, fully colored rectangular paintings of visionary subjects, unique in their iconography but without any indication of date or place of execution, they remain among the most impressive mysteries of fourteenth century Iranian painting. Some now have labels, written in beautifully calligraphed letters on an illuminated ground in the best sixteenth-century style: *kar-i ustadh ahmad musa*, "the work of Master Ahmad Musa." Again, it is irresistibly tempting to consider them as once having been part of the lost *Mi'rajnama* of which Dust Muhammad also wrote, and thus essentially Jalayirid, rather than Ilkhanid, creations.

PAINTING IN OTHER CENTERS: ISFAHAN

The early fourteenth-century landscape in a small, domed, circular room behind the tomb chamber in the Mausoleum of Shaykh Muhammad ibn Bakran, in Linjan (thirty kilometers south-west of Isfahan), is witness to how much painting other than that in illustrated manuscripts once flourished in Iran, but how little of it survives. The small mausoleum is renowned for its extraordinarily rich and exuberant carved-plaster decoration; the painting in the small dome chamber remains far less well known. Surviving in pale tones of green, turquoise, and blue on a white ground, what may still be seen today (Fig. 62) is a rudimentary landscape of large trees with foliage of several distinct kinds, and a pair of tall, tapering minarets; they flank a *mihrab* (a prayer niche) defined, and framed, by a two-tiered molded Arabic inscription and surmounted by a panel of palmettes in very high relief. The minarets are decorated with glazed-tile squares of turquoise set in neutral brick, a typically Ilkhanid decorative treatment on both interiors and exteriors. And the foliage of the willow trees to right and left of the *mihrab* is executed in the chacteristic herring-bone pattern seen in the illustrations of a manuscript on the uses of animals that had been finished not long before – in 1291 – in Maragha, the first Ilkhanid capital. Shaykh Muhammad died in 1303, and the site where he lived, and taught, was converted into a shrine in the following decade. During the rebuilding, the humble chamber was probably also decorated with plaster, perhaps by a young apprentice learning his craft, and the painting then added to ennoble the *mihrab* by flanking it with minarets in the midst of a paradise garden. As a reflection of the painting styles and mannerisms of the Ilkhanid court and capitals in regions where Ilkhanid political control was sporadic, the ensemble testifies to the strength of Ilkhanid aesthetic influences in those regions in the years following the construction of the stupendous Mausoleum of Oljaytu in Sultaniyya. Nor was it unique: other fourteenth-century provincial buildings were similarly decorated, to judge from an example surviving in a small mosque in Azadan, on the western outskirts of Isfahan.

Not only painting on walls, but also painting in manuscripts made in Isfahan during the fourteenth century, can now be documented. A unique copy of the *Mu'nis al-ahrar fi daqa'iq al-ash'ar*, a large anthology

of poets and poetry compiled by Muhammad ibn Badr al-Din Jajarmi, was completed in 1341, and both its frontispiece [39] and one fascinating chapter [246] are illustrated. A recent textual analysis of the second of the scribe's poems included within it, in which the contemporary condition of the city of Isfahan is described as lamentable, argues that this important anthology could only have been produced in Isfahan.[6] In turn, some of the stylistic features of the landscapes in its frontispiece now help to assign to the same center several other illustrated copies of Firdausi's *Shahnama* that had hitherto "floated" without a secure geographical attribution [125, 136].

SHIRAZ

During the first half of the fourteenth century Shiraz was governed by an administrator for the Ilkhanid domains who, in the classic pattern, made Fars into his "personal fiefdom" even before the death of Abu Sa'id, in 1335. A group of manuscripts copied and illustrated for members of the Inju elite seem to speak an aesthetic language entirely different from that spoken by the "Great Mongol *Shahnama*" and what remains of the *Abusa'idnama*. In the second quarter of the century, both ruler and vizier shared literary interests that were embodied in the figure of the great Hafiz. The poet's first patron in the city where he lived the better part of his long life was Abu Ishaq Inju, second of a very short-lived dynasty; his vizier, Qiwam al-Din, also contributed to Hafiz's continued well-being in Shiraz, and both ruler and vizier are mentioned in a later poem that praises the lost brilliance of the court of Abu Ishaq. Inju interest in fine books, both with and without illustrations, is also attested by the survival of a number of them: sections of a number of Qur'an manuscripts, a tiny and apparently unique text combining astrology and history, four illustrated copies of the *Shahnama* [70, 227, 230], and a unique, three-volume, illustrated copy of a prose novel [177].

The Qur'ans, however incompletely they survive, are especially important for any assessment of the quality of Inju manuscripts, since the illustrated volumes display a peculiarly slapdash, if vigorous, style of painting – in sharp contrast to the pictorial quality of the roundels decorating an impressive inlaid brass candlestick made for Abu Ishaq (Fig. 63). The illumination in several of the Qur'an volumes is much better in the standard of its drawing and composition, and in the quality of the pigments and their application. This discrepancy has yet to be explained. On the other hand, for some reason that also awaits explanation, Inju manuscript illustration appears to retain profound visual memories of Iranian painting of the Sasanian and Parthian periods – Fars Province is ancient Pars, or Persis, the Persian heartland [Fig. 8]. In pictures whose shapes are predominantly large strip-like rectangles, painted in thin washy pigments and a limited palette that incompletely covers the ground within the simple outlines of the picture, Inju artists laid before their viewers the formal and hieratic images of an ancient Iranian world of princes and their courts, the hunt and the battle; retold tales of the deeds of Bahram Gur and his harpist Azada [227], and the scheming of the jackals Kalila and Dimna. The four Inju volumes of the *Shahnama* are an especially fascinating grouping, both textually and pictorially. Each of the four has a different number of illustrations but often a key episode appears in all four, even in the same illustrative formula. The text surrounding the pictures often contains significantly variant readings, even though the illustration visually recounts the text with surprising exactitude.

It is also clear from the stylistic sources of some of the illustrations in the Inju *Shahnama* volumes that, just as architectural craftsmen,

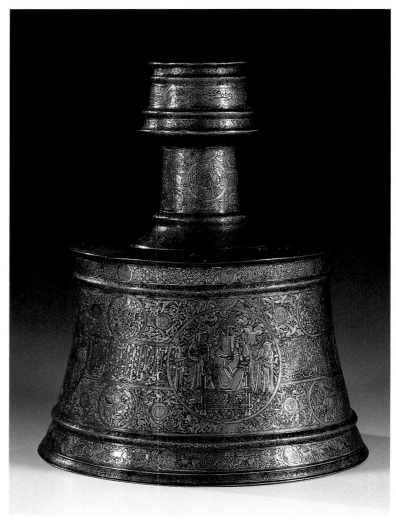

63. Brass candlestick decorated with large figural scenes inlaid in precious metals, made for Abu Ishaq Inju, Shiraz, 1341–56; Doha, Museum of Islamic Art, MW-122-99-HU

deprived of work and patronage at the death of Abu Sa'id, carried the Ilkhanid metropolitan style of architecture to many other centers in Iran, so the painters and gilders who had worked for Rashid al-Din, and later his son Ghiyath al-Din, looked elsewhere for patronage after 1335. Some apparently found it in Shiraz at the Inju court, to judge from the echoes of metropolitan Tabriz in the illumination and the illustration of Shiraz manuscripts in the period between 1335 and 1357. Inju painting, then, represents a fascinating sub-chapter in the history of fourteenth-century manuscript painting in Iran. Moreover, its exceptional combination of provincial pictorial style with much higher standards of illumination will be repeated again, in the same city, under the governance of a grandson of Timur, Ibrahim-Sultan.

In 1357, Abu Ishaq Inju was slain by a prince of a rival dynasty with whose name is associated the next style of painting in Shiraz, the Muzaffarids [71, 74]. They too were the offspring of a governor appointed by an Ilkhanid sultan but who took advantage of the chaos after 1335 to establish a base of power in the south-west, first in Isfahan and then in Kirman, and finally in Shiraz.

LAYOUTS AND ILLUMINATION

The small number of surviving illustrated manuscripts made under Muzaffarid rule in the second half of the century is far outweighed by the numbers of fine, unillustrated manuscripts issuing from Shiraz

workshops that appear to have little, if any, connection with the interests of the nominal rulers. Such changes are most evident in the quality and style of calligraphy, the modes of illumination, and the quality of paper and pigments. A feature that was developed to an especially complex level at this period, apparently in Shiraz, and one that serves as a useful kind of visual "diagnostic," is the page-layout. In all Islamic manuscripts this comprises the size and shape of a standard folio within it, the disposition of the text on the folio, and the placement of any passages of illumination; for works of poetry, it also includes the number of columns in which the text is copied. The resulting proportional relationships, between height and width, and ruling to page-dimension, are almost always characteristic of the time and place at which a manuscript was copied. For instance, throughout the fourteenth century most *Shahnama* volumes were arranged in six columns. This holds true for the very large page of the "Great Mongol *Shahnama*" as well as for some of the very small copies of provincial fourteenth-century volumes, for another larger copy, and even for the two Muzaffarid *Shahnama*s dated 1371 [71] and 1393–94. Yet this format may come to be seen as a feature only typical of the fourteenth century, for the earliest (presently) recorded *Shahnama*, that of 1217, is copied in four columns.

Whatever will prove to be the explanation of the six-column format, it serves to demonstrate that from the fourteenth century onward, the written surface of a manuscript, and the disposition of the text within it, are essential features of our knowledge of any manuscript – they are a part of the larger "grid" that is virtually its signature, displayed by each folio within it. Overall, the "grid" includes the size and proportion of the ruled frame defining the written surface, and the number of lines of text written within it – prose or poetry, together with the number of columns in which a poetic text is organized – in addition to the style and hand of the calligraphy, and the nature of the paper on which it is written. The "grid" helps to identify folios removed from the manuscript; it can establish the "parentage" of lost folios; and it permits the reconstruction of a dispersed text, even when the outer margins of a manuscript (or the folios from it) have been trimmed, remargined, or completely lost or destroyed.

It also seems that, in the Muzaffarid period, scribes in some Shiraz workshops were experimenting with variant versions of the standard page-layout, for fascinating compositions appear in Shiraz manuscripts of this date. The most typical, and also flexible, is a plan consisting of a block of text at the core of the page with a different text copied on the diagonal in the margins at the top, the outer sides, and the bottom of the page. Other craftsmen must have been exploring variations of abstract illumination. Extraordinarily inventive passages of painted decoration, both geometric and vegetal, appear in secular manuscripts in the later Muzaffarid period whereas, prior to this time, the most inventive of fourteenth-century illumination, breathtakingly rich with burnished gold and lapis lazuli, seems to have been restricted to the ornamentation of Qur'ans. Even important manuscripts made in the Rab'-i Rashidi ateliers in Ilkhanid Tabriz are relatively sparing in their use of gold and lapis, illuminated instead in dusty shades of red, blue, and green, and displaying practically no polish to the surface. But from the Shiraz ateliers of the last third of the century issued innumerable, and infinitely varied, designs for small-scale passages of illumination, whose patterns were developed around a plethora of small straight-sided geometrical figures and curvilinear forms; the same designs and dispositions are occasionally to be seen in contemporary woodwork. These passages characteristically occur at the beginning of texts or their sub-sections, and in the mid-page triangle resulting from a shift in the direction of the diagonal on which a marginal text was copied [239],

the so-called "thumb-piece." And since volumes of multiple texts – anthologies, compilations, compendia – were also a frequent product of Shiraz ateliers late in the fourteenth century [74], opportunities abounded for the placement of such illuminated passages in a manuscript, even in volumes with no illustrations. These later fourteenth-century Shiraz illuminations combine formal geometry with a deliciously free floral element of unoutlined gold set against lapis blue; in some manuscripts red, green, and white, turquoise, orange, and a distinctive chestnut-brown heighten the rich impression of form and color these manuscripts convey, even without illustrations.

Pictures added to a fascinating manuscript not originally planned to contain them contribute another aspect to the question "who did what?" in the making of a good Shiraz manuscript. The exceptionally fine landscapes [74] painted into the blank spaces between the chapters or on the colophon pages of a large anthology of poetry completed in 1398 display the same delicacy of touch evident in the unoutlined floral sprays of contemporary Shiraz illumination. Perhaps the gilder, the artist responsible for illumination, was also the painter of the verdant landscapes enriching this typical Shiraz anthology, a pattern of workmanship that may have been repeated in many Shiraz workshops over the next two centuries.

The rather more summary landscapes of the vertical compositions, in which the two Muzaffarid *Shahnama* figures [71] enact their drama, show the same delicate touch, even though not only the landscapes but also the settings and the palette are also relatively summary. A more interesting feature of their *dramatis personae* is the figural type, doll-like but rather lithe, the silhouettes often interrupted by elbows held akimbo; faces are notably oval in shape and the men's beards and mustaches have a spiky quality. Perhaps the most significant aspect of the paintings in Muzaffarid manuscripts is a landscape feature. Just as inexplicably as the primitive and strip-like Inju pictures, of the second quarter of the century, disappear without a trace, so too – and apparently out of nowhere – there first appears in Muzaffarid painting a mannerism seen in much later Iranian painting, the high, rounded horizon. Typically, its form is exaggerated in this early period, leaving visible only a tiny glimpse of the sky, at a corner or in the dip between a pair of high, rounded hills. Again, the mannerism lives on in the most mannered of Shiraz schools of painting, that of Ibrahim-Sultan [17], while in other classical schools it is seen in a far less exaggerated way.

BAGHDAD

As Dust Muhammad is able to provide the earliest links in the genealogical chain of past and present painters, from the mid-fourteenth century up to the moment at which he was writing – in the middle of the sixteenth century, so he provides the corresponding links in the chain of the earliest patrons about whom we have independent information – Sultan Uways I Jalayir, who died in 1374, and his son Ahmad, who succeeded a brother in 1382. Indeed, they are not only the respective patrons of Shams al-Din and his pupil, 'Abd al-Hayy, but Sultan Ahmad was also the latter's student:

> . . . Khwaja Abdul-Hayy, in the time of the emperor Sultan-Ahmad of Baghdad, whose countenance shone in patronizing the masters of learning and perfection, took up the pen of uniqueness and instructed Sultan Ahmad in depiction. . . ."[7]

Sultan Ahmad ibn Uways Jalayir is probably the least appreciated of all the figures whose informed and enlightened patronage shaped the fifteenth-century illustrated Iranian manuscript of Persian literature at

its most classical. The biographer Daulatshah, writing toward the end of the same century, records that, among his accomplishments, he wrote poetry in both Persian and Arabic, composed music, engraved seals, and was a good painter. And some of the manuscripts produced at his behest are true landmarks in the development of the illustrated Persian manuscript and the associated arts of the book [40, 171]. Among them, an illustrated copy of the *mathnawi*s (romantic narrative poetry in rhyming doublets), by the poet called Khwaju Kirmani, stands out [73, 105, 114]. It was finished in Baghdad in 1396 and is, in its present state, illustrated with nine paintings, one signed by Junayd *al-sultani* – "Junayd in the service of the sultan" – the sultan in question being Ahmad Jalayir. At least one more painting [179] is known to have been removed from it: now mounted in the very album for which Dust Muhammad's "Painters and Limners of the Past" was composed, it was given a sixteenth-century "label" attributing it to ʿAbd al-Hayy, who, as Dust Muhammad avers, had taught Sultan Ahmad the art of painting.

All the pictures still within the Khwaju Kirmani of 1398 are also remarkable, and for many reasons. Those showing interiors are among the most lovingly detailed and beautifully painted of any Iranian book illustrations, anywhere, at any period; the landscape pictures are equally rich, detailed, and complete. Both types of settings are fully developed examples of these classical genres in the illustration of classical Persian poetry that are not only remarkable for their appearance, apparently *ex nihilo*, but also for the early date at which they are so perfectly worked out – the very end of the fourteenth century. Moreover, certain pictures from this manuscript have lineal descendants that appear for a century and more, in compositions copied almost exactly; the visual echo of others resounds for just as long in many other fine fifteenth-century paintings. Again, that curious dynamic of Iranian painting of the Islamic period is manifest: the best, the finest, the most carefully developed – and also the largest, or the most vigorous – is also the earliest to appear. Still another striking feature of the illustrations in Sultan Ahmad's Khwaju Kirmani manuscript is that some [105] play, visually, on the words of Khwaju's text;[8] this is, in itself, worth noting because the poet died nearly half a century before the making of this manuscript was begun. The interplay between word and image speaks much for the sensitive acuity of a pre-Timurid patron of an art usually considered to have reached so sophisticated a level only in the Timurid century. Instead, it is clear that all the significant aspects of the art of manuscript illustration in the "Golden Age" of painting in the Iranian-influenced East, were actually in place at the death of Sultan Ahmad Jalayir in 1410.

THE FIFTEENTH CENTURY

The history of painting in Iran in the fifteenth century is essentially one of illustrated manuscripts. It is a period when texts of classical Persian poetry and history were illustrated, and survive in important and beautiful examples, as never before nor since. Yet this chapter begins with a set of paintings never intended to illustrate books.

THE ISTANBUL ALBUM PICTURES

The material now generally referred to as "the Istanbul album paintings" is just that – a group of paintings and drawings that do not come from manuscripts and whose dates and places of origin have posed a problem since they were first described and published at the beginning of the twentieth century.[1] Most are mounted in albums in the library of the Topkapı Saray. Formerly kept in the treasury of the palace, the *hazine*, the albums containing this fascinating group of images now bear this name – *hazine* – and the numbers 2152, 2153, or 2160. Other paintings of similar, or related, subjects, as well as folios and cuttings from manuscripts, single-page images, and calligraphic samples that are, today, kept in widely-spread European and American collections, also originally came from these and still other albums that were deposited (or even assembled) in the Topkapı libraries at various moments throughout the fifteenth and sixteenth centuries.

64. "Three *Div*s with Dragon-Headed Tails," painting on paper mounted in an album, Western Central Asia, late fourteenth–fifteenth century; Istanbul, Topkapı Saray Library, H. 2153, folio 122r

The overall group has a number of distinguishing features. Material matters set them apart from the content of other important albums in other Istanbul libraries (or originally from Istanbul, including the "Diez Albums" in Berlin). They are relatively large pictures, for the most part. The majority are painted on paper, by no means always the same type of paper, but some are on a fine ecru plain-weave silk. The use of bare paper [104] or silk [151] to represent sky or foreground is another unifying feature. None includes any contiguous text in any language, although some have inscriptions written in Arabic (and surely at a date later than the paintings themselves), in which the words *siyah qalam*, "black pen," appear, sometimes preceded by the name "Muhammad" (Fig. 64). The workmanship is extremely accomplished, no matter what the technique. Some pictures are almost monochrome brush-drawings in a limited palette occasionally heightened with gold [178]; others are true paintings of very fine quality, with outlined figures painted in strong, bright colors and much golden detail [113]. One notable mannerism, especially seen in the drawings, is an exaggerated massing of materials that shows as multiple folds of skin, wrinkled hide, or bunched cloth.

For the most part, these pictures show human figures, and animals and birds, or both; objects are frequently represented but architecture is rare. The subjects are quite varied, but elements from one sub-group often appear in a picture of another sub-group, suggesting some underlying but integral linking mechanism – of time or place or milieu. Some paintings seem to present a world that is East Asian in culture rather than West Asian, some geographical locale where the weather was cold, garments were heavy, and animal skins used for clothing. The men,

women, and children in this group have been called "nomads," and they do perform tasks with donkeys, dogs, and camels, but "rural" is a better adjective for what seems to be a milieu of poverty [170], if not true misery. Sometimes included in pictures of this group are men (never women) who appear to be slaves, and *div*s – demons (Fig. 64) – and monsters; even when "nomads" and monsters are separately depicted the latter group is related to the former by techniques of execution. The "slaves" are mostly light-skinned and sometimes red-haired, either hairy or bald; a few are black Africans with short fuzzy hair and broad facial features; while the demons and monsters are horned or furred, or both. In contradistinction to the "nomads," these creatures are simply garbed or even scantily dressed, but they wear many personal adornments of gold; they are preoccupied with activities that seem nomadic but also suggest shamanistic cultures; many play musical instruments, and some perform the Turkic dance in which a cloth is held in each hand and opposing limbs are rhythmically raised and lowered together.

A different group of pictures is evidently Chinese in inspiration, either in subject, in style, or both. Both men and women display Chinese facial types and wear layers of elaborate, brightly colored Chinese-style garments; this has given rise to the appellation "Chinese people," although few (if any) pictures of the larger group are actually Chinese in execution. There are also a great many pictures of birds, usually pairs of them, perched in flowering foliage, a genre ultimately deriving from Sung dynasty painting. A smaller group of technically related pictures seems to show men of Turkic origin, to judge by facial features and dress; the images are fully colored and the clothing bright; the figures carry or use implements of ceramic or metal, and some again are posed in the movements of the Turkic dance, one leg and the opposite arm raised.

Among the most impressive paintings in the overall group are the few compositions with architectural components and finished settings in which many finely painted figures – men, women, and children – of some amplitude are engaged in activities requiring implements and furnishings. The objects are all depicted in great detail, prominent among them being ceramic vessels of white with dark blue decoration; the origins of these objects again defy precise attribution but lie somewhere on the continuum between the Islamic and the Chinese worlds. Along the same line are virtuoso depictions of Chinese dragons in Chinese-style landscapes. A small number of paintings on a silk ground showing finely executed figural elements from different groups, such as princesses and flying *div*s [247], seem to be sheer fantasies but surely illustrate tales of East Asian origin not as yet identified. Still other paintings depict a more "western" milieu in which the settings, garments, and accoutrements are identifiably the Turco-Mongol world [15, 104, 113] as it is known from paintings in Iranian manuscripts of the fourteenth and the fifteenth centuries, the "Great Mongol *Shahnama*," for instance.

The larger group also includes a number of sheets, or scrolls, of studies, especially of animals, executed in styles ranging from one or another of the manners noted above, to others recognizably related to dated and localized manuscripts of the late fourteenth and the fifteenth centuries [204, 205]. Lastly, there are a great many copies of key pictures – of single figures, or groups of them – and several series in which the same image is executed on different grounds: on coarse paper, on fine white paper, and on silk.

The last categories are significant for several reasons. Most important is the evidence they offer for the proposition that an interrelated group of eastern images, or a collection of them, came in some way into a milieu more westerly than the one in which they were created. They were found to be of interest, and studied, copied, and otherwise worked with, before the entire group was carried further west, falling

into the possession of the Ottoman sultans in Istanbul where they were preserved in what was already a formidable treasure house, the Ottoman imperial library in the Topkapı Palace.

Just where the original milieu in which these extraordinary images were created would have been has provoked nearly a century of speculation. The ultimate source of the imagery would seem to be somewhere on the eastern fringes of the Iranian world but apart from it, a place where Islam came into contact with Inner Asia. Mongolia, Chinese Turkestan, Transoxiana, the Volga region, and the north Caucasus have all been proposed as accounting for features in one or another of the constituent groups. Places and events as diverse as the thirteenth-century Anatolian esoteric darvish orders, and illustrations of the "beastly practices of *jinn*s" – as opposed to true shamanism; the exceptionally cosmopolitan fourteenth-century center of Tabriz; the booty brought to Samarqand from Kashgar and the Farghana Valley by the Timurid prince Iskandar ibn 'Umar Shaykh, late in the fourteenth century; and the trading missions masquerading as embassies that passed between the Timurids and the Ming court of China in the late fourteenth and the early fifteenth centuries: all have at one time or another been thought to contribute something to the overall characteristics of this fascinating group of paintings and drawings. Theories about the intermediate locales where this material was worked upon have ranged from Yuan China, to Samarqand, and even as far west as Iran in the second half of the fifteenth century, when princes in the Aq Quyunlu Turkman confederation briefly held sway in Tabriz. The one place-name recurring in the speculative literature for over half a century is Timur's Samarqand.[2] This seems the most likely locale in the Eastern Islamic world for painters trained in Central Asia to have come into contact with artists from other Asian traditions, and with craftsmen having a sophisticated object-tradition of their own. Central Asian painters might not themselves have yet possessed experience of the essentially narrative and fully-painted aesthetic of the Iranian illustrated manuscript, but they would have been ready to learn something of this narrative manner from painters whose presence in Samarqand toward the very end of the fourteenth century was involuntary, such as the Jalayirid 'Abd al-Hayy [179].

TIMUR'S "RISE AND RULE"

If Timur's Samarqand is the locus of this meeting of East and West – as historical texts, and the evidence from other decorative arts such as metalworking both attest – it is in the Samarqand of Timur's successors that an echo of these mixed traditions of painting seems to linger – in the paintings of a unique manuscript finished three decades after Timur's death whose subject is again the *Mi'raj*, the *Night Journey*, of the Prophet Muhammad. Indeed, painting traditions from both East and West, native Iranian and imported, underly all Iranian court painting in the first third of the fifteenth century. This history is indissolubly linked with the details of Iran's governance by members of the family of the next Turkic invader from the east, Timur – known in the West as Tamerlane.

Timur's rise to power and the establishment of his hold over western Central Asia and Iran in many ways mirrors that of Chinghiz Khan (his ancestor in spirit, if not in actuality). Born in 1336 in Transoxiana, he consolidated a position of strength in Western Turkestan among the Turco-Mongol tribes descended from Chaghatay, eldest son of Chinghiz Khan; eventually Timur built a "steppe-empire" in Turkestan with Samarqand as his capital before he too turned his attention westward. Like so many before him, his path lay by way of Khwarazm and

Khurasan; like so many of his predecessors his hold on a far-flung empire stretching from India to Anatolia did not outlast his lifetime. Transoxiana and Iran are the exceptions where, in the last years of the fourteenth century and throughout the fifteenth, Timur's heirs continued to rule in the lands they had first been given to govern.

Timur began to campaign in Iran in the spring of 1381: and some have called his career an uninterrupted sequence of bloodthirsty wars and predatory raids devoid of any purpose other than plunder. Nonetheless, from 1386 he began to send men skilled in the building crafts back to Samarqand, perhaps motivated by the wish to make his own capital even more impressive than those he had seen in Iran. By 1387, Shiraz and Isfahan had capitulated; in 1393 Baghdad was first occupied. Writing of events in that year, the Timurid historian Sharaf al-Din ʿAli Yazdi tells us: "All of the most skillful of the craftsmen and artisans of the provinces of Fars and Iraq were transferred by Timur to Samarqand." So it is another of those ironies in the history of Iranian painting that virtually none of their works survives. Nothing executed in the time of Timur himself can today be indisputably connected with Samarqand, and the wall paintings in the garden pavilions mentioned by the captive writer Ibn Arabshah, and also by the Spanish ambassador Ruy Gonzales de Clavijo, have entirely disappeared. Instead it is from the cities where Timur installed his sons, and then his grandsons, as governors that have survived the most beautiful, brilliant, and durable of illustrated manuscripts of classical Persian poetry. The history of fifteenth-century Iranian painting is, at least for the first half of the century, the history of the manuscripts made in Tabriz, Shiraz, and Herat under the sponsorship of Iskandar, Timur's grandson; of Shahrukh, Timur's fourth son and successor; and Shahrukh's sons Baysunghur, Ibrahim, Ulugh Begh, and Muhammad Juki. The manuscripts sponsored by Baysunghur in Herat are the culmination of the Persian-centered, highly literate education that was, by about 1430, the Iranian norm – even for the Turco-Mongol grandsons of a nomadic military genius whose appreciation of material culture was no doubt focused only on the impression he might make upon others, and whose adherence to Islam was a matter of politics rather than conviction.

Timur died in 1405, in the early stages of a campaign whose object was the conquest of China; not until about 1420 did Shahrukh establish firm control over the many unruly relatives who vied with him for mastery of the lands of his father's conquest. Nonetheless, the subsequent years of his reign were stable enough so that he and his sons could also indulge themselves in bibliophilia while fulfilling their responsibilities as governing princes. Each of them did so, with extraordinary results.

SHIRAZ: THE LINE OF ʿUMAR SHAYKH IBN TIMUR

From 1387, the governorship of this important center in the ancient Iranian heartland was given to ʿUmar Shaykh (Timur's second son). On his death in 1394, all of central Iran was assigned to his three sons: the eldest, Pir Muhammad, governed Fars until his death in 1409, after which Iskandar, the youngest, ruled in Shiraz until 1414. Each of the illustrated manuscripts connected with that city in this first period of Timurid hegemony contains stylistically different paintings, yet all display some combination of fundamentally similar material characteristics that argue for the depth of the Shiraz book-making tradition, even when it was overlaid by "foreign" influences. The best Muzaffarid-style paintings, large and delicately lyrical landscapes [74], were probably painted only slightly later than the small but dynamic illustrations in a volume of collected epic poems in Persian [7] whose paint-

ings are surely a *mélange* of contemporary eastern modes and colors, as well as a *soupçon* of something Jalayirid. Both are datable between 1398 and about 1405. Less than a decade later, when Iskandar was commissioning volumes from Shiraz workshops himself, the new style first seen in the *Epic* volumes had, in the now-familiar pattern, settled into one that was less dynamic but pictorially more tempered and homogeneous. Figures retain their amplitude and the oval shape of the large heads, and the taste for strong primary colors "powdered" with small golden patterns is still evident. In two important anthologies made early in the second decade of the century, one with a large folio size and another much smaller Iskandar's artists developed a series of master-compositions for favorite stories [239] that are as classical as the texts they illustrate. The smaller anthology has twenty full-page paintings and a double-page picture [51]; fourteen illustrate Nizami's *Khamsa* and constitute a virtual pattern-book for later pictures [115, 157] of the same, or related, episodes, serving painters of the entire century as models. In some part this is due to the fact that in the summer of 1414, when Iskandar's continued insubordination had led to capture and blinding, his treasury and his library, as well as his painters, were appropriated by his uncle Shahrukh and brought to Herat. Shiraz features of this first Timurid period then appear in the paintings of several Herat manuscripts connected with Shahrukh, one a small copy of Nizami's *Khamsa* that carries his library seal, and another, a large compendium of historical texts [180]. Figures with a certain flexible and expressive amplitude and oval faces, the peculiarly wide gold rulings, and the positive uses of empty space within the picture are all features that entered the Herat sphere of painting by way of Iskandar's earlier Shiraz creations.

SHIRAZ: IBRAHIM-SULTAN IBN SHAHRUKH

Shahrukh bestowed the governorship of Shiraz on his second son Ibrahim-Sultan at the time of his cousin Iskandar's downfall. It remained in the hands of this "virtuous and talented prince who patronized the arts," as the historian Daulatshah described him, for the next two decades. Many of the gilders, binders, and scribes who had executed Iskandar's manuscripts appear to have remained in Shiraz, and Ibrahim made full use of their services in a fascinating series of manuscripts of poetry, and illustrated epic and dynastic history.

Ibrahim's education cannot have been very different from that of his next younger brother Baysunghur; both were fine calligraphers, and as adults they corresponded on matters of poetry. There is thus every reason to think that Firdausi's *Shahnama* was a subject discussed by the brothers in the years when Baysunghur was preoccupied with Firdausi's great work; the results are his revision of the preface, at least two unillustrated copies of the text, and a large and majestic illustrated copy. Ibrahim's response was to commission his own illustrated *Shahnama*. Its pictorial program reveals it to be as personal, if different, a statement as Baysunghur's manuscript; its calligraphy is good and the illumination superb, but Ibrahim's Shiraz painters were still finding their stylistic way, and many pictures are simple and formulaic in the extreme. Ibrahim's *Shahnama* is probably the best example of the stylistic disparity between the illustrative and illuminative components considered acceptable in manuscripts made in Shiraz, even at the highest level of sponsorship [17, 131, 222; Fig. 65].

The finest example of the stark, dramatic, stripped-down Shiraz style of Timurid painting occurs in the illustrated copy of Ibrahim's history of Timur, Sharaf al-Din ʿAli Yazdi's *Zafarnama*, the *Book of Victory* [25, 59]. The text represents the work of Ibrahim's lifetime in the service of family propaganda. Sharaf al-Din, a noted prose stylist of the day,

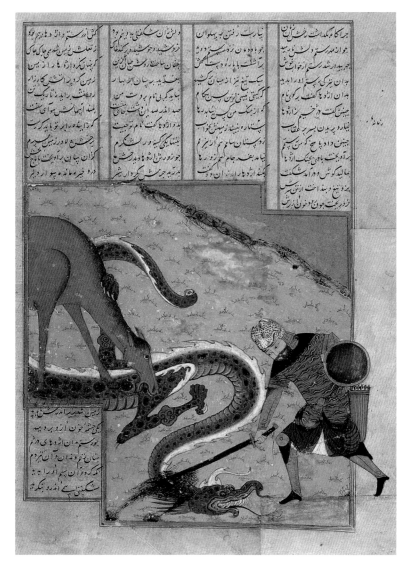

65. "Rustam's Third *Khwan*: He Slays the Dragon," from Ibrahim-Sultan's *Shahnama*, Shiraz, 1432–35; Oxford, Bodleian Library, Add. MS 176, folio 68v

After Ibrahim's untimely death in 1435, a shift in the focus of Shiraz workshops occurs, from ornament to illustration. Shiraz manuscripts would never again display the wondrous and imaginative wealth of illuminated ornament that characterizes them from about 1370 to 1435. It was, instead, their illustrations, in the style developed by Ibrahim-Sultan's artists, that remain a constant in the manuscripts made in Shiraz after 1435 [32, 91, 238]. A surprising number of good, but not princely, illustrated Shiraz manuscripts date from before about mid-century, including at least seventeen copies of Firdausi's *Shahnama* alone. Moreover, the stark and extremely simplified compositions, peopled by figures with notably oval heads, constitute a kind of Timurid export-style of painting and can be found in fifteenth-century manuscripts copied in places as distant as Delhi, and in the nearer capital of Cairo (Fig. 67).

TABRIZ AND HERAT: BAYSUNGHUR IBN SHAHRUKH

Well before Timur's death Shahrukh had been made governor of Khurasan with his administrative capital in Herat. After 1405 he chose to remain based in Herat during the years in which he was establishing himself as sole heir to Timur, and the city was much improved

had been employed to turn the facts of the Persian and Chaghatay Turkish chronicles, kept daily during Timur's life, into fine and laudatory Persian prose laced with exalted Arabic poetry. The resulting text is nothing less than an apologia for the bloodthirsty career of Ibrahim's redoubtable grandfather, a panegyric justification for the right of yet another Turco-Mongol family of foreigners to rule over an Iranian Islamic people. One copy was enhanced with pictures, over half in double-page format [59], whose function was to present Timur and his heirs in the line of Shahrukh as heroic kings in the ancient Iranian mode: victorious in war, courageous in the hunt, generous in feasts after victory, powerful in arranging alliances of marriage, and favored by the birth of sons. Ibrahim-Sultan did not live to see its completion, and the ornamental illumination in the finished manuscript is sparse, no doubt an indication of a lack of direction, and of funds, once Ibrahim had "charged the steed of life from the arena of this world." How much effect such dynastic propaganda, in the form of a relatively small and private object such as an illustrated manuscript, could really have been expected to exert, and upon what segment of Iranian society, is uncertain – at least in modern terms. Yet in the context of fourteenth- and fifteenth-century Iran, it is clear that volumes of certain texts with carefully considered illustrative programs were thought to do so; and the prestige they conferred upon their patrons was equal to the construction of an important public building (Fig. 66), if not greater.

66. The Great Mosque of Samarqand, 1399–1404

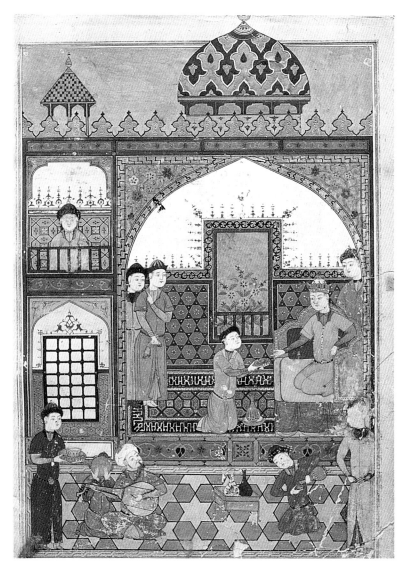

67. From a *Shahnama* made for an officer of the Mamluk Sultan Qansuh al-Ghuri, Cairo, 1510; Istanbul, Topkapı Saray Library, H. 1519

in the years after 1420: in effect Herat became the Paris of the Timurid world. For over a century it was the brilliant and cultured metropolis of the Turco-Mongol East, where learning, literature, and the visual arts were matters of paramount importance in the everyday lives of those who governed as well as those who wrote – often the same men [187]. In his father's pattern, Shahrukh assigned his sons as governors in the lands remaining within the much-reduced Timurid empire. As regards painting, the most significant of these assignments was that of Baysunghur to Tabriz, after it again fell into Timurid hands in 1420.

A decade after Sultan Ahmad Jalayir had died in Tabriz, it appears that manuscripts made for him, and artists who had worked for him, were still to be seen and consulted in that city; they were even available for appropriation. Dust Muhammad tells us that Baysunghur brought painters and a bookbinder from Tabriz to Herat, expressly with the purpose of recreating a book of Sultan Ahmad Jalayir's "in exactly the same format and size . . . and with the same scenes depicted." According to Dust Muhammad, the much-admired manuscript of Sultan Ahmad was a volume of miscellaneous texts; but what the paintings themselves give evidence of is a *Shahnama*. Baysunghur's illustrated Firdausi contains several paintings copied directly from compositions in the dispersed and fragmentary "Proto-Baysunghur" *Shahnama* [72, 75] that must date from the 1380s. But the Jalayirid influence is manifest in the entire series of fine, illustrated manuscripts made for Baysunghur

in Herat between about 1425 and the end of his life. One aspect of this influence would seem at first unrelated to painting, the calligraphy of a fine manuscript. That fine illumination and illustration should complement each other in the same volume had already been a characteristic of Shiraz manuscript production, from at least the third quarter of the fourteenth century; the Tabrizi tradition would add calligraphic excellence, in the form of the new style called *nasta'liq* already seen in Sultan Ahmad's volume of *masnavi*s [73, 105, 114, 179], to the equation of the fine Timurid court-produced manuscript in the classical style. The newer calligraphy is embodied in the person of Baysunghur's favorite scribe, Farid al-Din Ja'far of Tabriz, who copied three illustrated manuscripts for Baysunghur [52], as well as several other unillustrated works. It is probably no coincidence that he is the scribe of a manuscript that is a kind of Jalayirid "souvenir" in Baysunghur's library. The "mount" for nineteen small and delicate Jalayirid (or Jalayirid-style) illustrations to *Kalila u Dimna* tales [207, 209] is a Herat manuscript only completed by Ja'far in 1431. This date is several years after Baysunghur's artists had finished another *Kalila u Dimna* manuscript that was made entirely in his Herat workshop [106, 185, 205]; the differences between the two sets of illustrations clearly enunciate the differences between the two styles.

Yet something of Shiraz, especially the Shirazi preference for the anthology, must also have helped to shape the earliest of the illustrated manuscripts that survive from Baysunghur's library. It is a slender volume of prose and poetical texts on subjects of importance in a princely education [24, 126], with seven pictures that both illustrate the texts and comment upon them. Baysunghur himself appears in four of the seven, as the princely "hero" of his own manuscript. This volume may thus be seen as an early step toward the creation of the formalized and theatrical vision of Timurid life that is represented by the overall ensemble of Baysunghur's illustrated manuscripts, and others partaking of this classical manner.

The perfect Timurid example of this formal and theatrical vision is indisputably Baysunghur's copy of Firdausi's *Shahnama*. It is the most majestic of all of the illustrated manuscripts created for this most discerning and passionate bibliophile prince. Large, beautifully calligraphed and grandly illuminated, it is illustrated with twenty-one images [8, 16, 75, 90], a very small but carefully chosen pictorial program emphasizing the duties of princes and the responsibilities of rulers toward the people they govern. It is, in effect, an illustrated "mirror for princes," one devised for the Turco-Mongol princes of the house of Timur who exercised political control over Islamic Iran in the fifteenth century and who were still concerned with justifying their position. Judging by its size and the lavish program of illuminated pages with which it opens, the creation of this manuscript must have occupied Baysunghur's workshop in Herat for some years. It also seems to figure in a unique surviving workshop document, a report to Baysunghur of the work accomplished by craftsmen engaged on various projects for him. Entitled – and therefore referred to as – the *'arz dasht*, "review," it is preserved in the library of the Topkapı Saray Museum in one of the Hazine albums.[3] In it are several references to work being done on a *Shahnama* manuscript; these may not all refer to the illustrated copy, for another, without illustrations, was also completed in the same year.[4] That at least two copies of this most significant of texts should have been made for him, one with pictures and one without, suggests that in the fifteenth century, as in the fourteenth, a picture was thought to heighten and intensify the impact of even the most marvellous of words. Baysunghur therefore chose the subjects of the very large pictures for his illustrated *Shahnama* with great care, investing them with solemnity and grave import.

The illustrative programs of the *Shahnama* volumes made for two of Baysunghur's three brothers again offer instructive comparisons. That of Baysunghur is restricted in size and focuses on themes of princely gravitas. That of Ibrahim has over twice as many pictures; highly personal in its focus, it lays the greatest stress on family relationships. Muhammad Juki's manuscript [76, 84, 116, 228, 240] might have had at least as many illustrations as Ibrahim's copy had it not been left unfinished at his death. Incomplete, so that the shape of its program is unclear, nonetheless it appears to lay far greater stress on legendary Iranian history and is probably the most perfect example of the highly poetic combinations of color and form ever achieved in the illustration of a Persian epic poem.

HERAT: SHAHRUKH IBN TIMUR

With regard to painting and the arts of the book, the position of the father of these princely bibliophiles might appear anomalous. His name is most frequently associated with the illustrations in several large volumes of a contemporary history composed by his court historian, Hafiz-i Abru, the *Majma' al-Tavarikh*, which takes up where Rashid al-Din's *Jami' al-Tavarikh* perforce had ended. For the most part the illustrations in these volumes are relatively simple pictures in a manner derived from the same fourteenth-century text-models; one copy is even bound together with part of a fourteenth-century Rashid al-Din volume. The finest paintings in the historical genre associated with Shahrukh are again the earliest, illustrating the history of al-Tabari in a large historical compendium being worked on in Herat in 1415–16. Its anthological format, as well as the wide golden rulings around the pictures [180], reflect Shiraz mannerisms that had come into Shahrukh's hands in 1414, with the appropriation of the treasury of his recalcitrant nephew Iskandar. The Hafiz-i Abru manuscripts dating from the decade of the 1420s are more formulaic in style, composition, and even their position on the very large pages. During the nearly half-century of his reign, many more volumes without illustrations, on subjects ranging from science and grammar to history and poetry, were either commissioned by Shahrukh or dedicated to him. Some of these are exceptionally fine examples of the arts of the book in every aspect: paper, calligraphy, illumination, and binding, even if the illustrative element is absent.

The manuscripts issuing from his son Baysunghur's workshop must have prompted Shahrukh's commission of at least one illustrated volume of poetry, a *Khamsa* of Nizami completed in 1431 [89, 236, 240]. An exquisite example of the Timurid book in every aspect, it is also a perfect instance of the classical style of manuscript-making forged in Herat by the end of the first quarter of the fifteenth century. Its size, shape, and proportions are quite different from any of Baysunghur's surviving illustrated manuscripts, and yet it is recognizably a work speaking the same aesthetic language. Its text-layout, three columns of poetry to a page with the outer column set at a single diagonal, is unusual but had already been used in an earlier illustrated volume made for Baysunghur. It contains quantities of very fine illumination, both as abstract compositions and within the illustrations. It now has thirty-eight pictures (one was removed, long ago) whose subjects are both old and new, and they are cast as both old [236, 240] and new [89] compositions. With one exception they are not full-page images, but a master-designer adroitly planned each page using the outer text-column to great pictorial advantage; the resulting picture is an original version of even the simplest of subjects. Those paintings that have not been retouched, or overpainted in the nineteenth century, testify

to the fact that Shahrukh's little *Khamsa* of Nizami was among the finest of illustrated Herat manuscripts ever made.

WESTERN IRAN: THE QARA QUYUNLU AND THE AQ QUYUNLU CONFEDERATIONS

Until well past the middle of the twentieth century, the existence of a parallel school of fine manuscript painting, flourishing in western Iran and Iranian 'Iraq in the second half of the fifteenth century, was virtually ignored. This was so, even though the paintings in a series of illustrated manuscripts made in the cities of western Iran – Shiraz, Baghdad, Tabriz – displayed a knowledge of everything learned, in the first half of the century, from the same western Iranian schools that had helped to shape Baysunghur's notions of the standards to which a carefully thought-out and executed copy of a classical Persian text should adhere. Some of the finer manuscripts carried dedications to princes of the Qara Quyunlu, and then the Aq Quyunlu – Black Sheep and White Sheep – Turkman clans. Other manuscripts had no dedication, but a date, or a place (or both) [92], helped provide a locus for the paintings in them. Still others were illustrated in styles related to, but not so fine as, pictures in the dedicated or dated manuscripts. But all sat uneasily in the lists of scholarship, until sheer weight brought about a delayed recognition, largely due to the work of B. W. Robinson and several Turkish colleagues. The entire group, both with and without illustrations, is now known as the "Turkman School" and often further qualified as either "Imperial" or "Utility" in style.

What is now clear is that Turkman painting is the first of a number of variants on classical Iranian painting that speak the Timurid pictorial language, but in a different dialect. Turkman court painting draws on styles and manners that had coalesced in the hands of painters working for Timurid princes all over Iran, including the very strong Jalayirid element of the late fourteenth century; the best of it is strongly influenced by the classical style of Herat painting as it had been shaped by Baysunghur and his artists. Turkman utility painting is often dismissed for its lack of splendor and brilliance, but it has much to tell us. It appears in very large numbers of good, if not fine, manuscripts made in Shiraz throughout the second half of the fifteenth century and testifies to the continuing role of Shiraz as a repository of manuscript skills, and an instrument in the maintenance of standards in all the arts of the book, not least of which is the illustrative tradition.

The varying styles of Turkman painting clearly reflect the stages of Turkman residency in Shiraz, Baghdad, Tabriz, and even Herat. The Qara Quyunlu claim to power in western Iran dates to even before the time of Timur's incursions, despite the fact that Qara Quyunlu hegemony was never securely established anywhere for long. Throughout the first half of the fifteenth century, the Qara Quyunlu took, lost, and retook Azarbayjan and Iranian 'Iraq; after the death of Shahrukh in 1447, Isfahan, Fars, Kirman, the Omani Coast, and even Khurasan fell, however briefly, into their hands. Their most significant adversary, even more than the House of Timur, was the rival Aq Quyunlu confederation, whose sultan Uzun Hasan had spent years in the struggle to establish Aq Quyunlu power in Iran, and the Jazira and Anatolia. In November of 1467, the Qara Quyunlu sultan Jahanshah was caught unaware by Uzun Hasan Aq Quyunlu [26] in a campground west of Lake Van and killed in the ensuing battle.

The period of Aq Quyunlu domination in western Iran, and its emergence as a power of some significance in the struggle for control of lands stretching from the Bosphorus to the Persian Gulf thus dates from 1467; so does the best period of its manuscript-making. The Aq

Quyunlu made Tabriz their capital. Uzun Hasan and his sons, Khalil and Yaʿqub Beg, built splendid monuments and painted their walls with scenes of battles and the reception of foreign ambassadors. They made their "court the resort of poets," and they commissioned fine manuscripts both with and without illustrations until the latter's demise in 1490, when "the victor death seized him by the collar, and he . . . stepped into the wilderness of non-existence." Turkman power then began to wane, but the political alliances forged by Yaʿqub Beg's brothers and cousins, often bolstered by judicious marriages, brought some of them into positions close to the emerging Safavid power in Azarbayjan.

Indeed, there is a strong Turkman stylistic element in early Safavid painting [95], and a particularly dynamic artist who first appears in the Aq Quyunlu period, Sultan-Muhammad, was one of the stellar painters at the first Safavid court in Tabriz. He has sometimes been associated with the latest paintings in a manuscript, a *Khamsa* of Nizami, that embodies over half a century of princely Timurid and Turkman patronage in the names of the princes through whose hands it passed. The volume was originally begun for one of Baysunghur's sons Babur, who died in 1457; it probably fell into the hands of Pir Budaq Qara Quyunlu when Herat was briefly occupied in 1458; it then came into the possession of the Aq Quyunlu in Tabriz, where work on it continued for Uzun Hasan at the order of his son Khalil; after the latter's death in 1478, his brother Yaʿqub Beg had ten paintings executed, by some of the finest Turkman court painters, but it was unfinished at his death in 1490; it then came into the possession of Shah Ismaʿil, the first Safavid Shah of Iran, under whose direction another nine paintings [66] were added. The long and unusually detailed colophon recounts the course of calligraphers' and painters' work and ends, speaking of the successive princes: "none of them was able to achieve his goal or drink in fulfillment from the goblet of completion."

HERAT: SULTAN-HUSAYN BAYQARA

Sultan-Husayn was the great-great-grandson of Timur, descended in the line of ʿUmar Shaykh: he was effectively the last Timurid prince to rule from Herat over any of the lands at the heart of the Timurid empire. He spent a good part of his early manhood in the struggle to regain control over Khurasan, for Timurid power had lapsed precariously as early as the middle of the century in the face of growing Turkman power. Even Herat had briefly fallen to Jahanshah Qara Quyunlu, in 1458, before being handed back to the Timurid Abu-Saʿid. It then fell to Sultan-Husayn to re-establish the glories of Timurid culture in the city of his birth, which he re-entered in triumph in the spring of 1469.

Sultan-Husayn [186] had been imbued with the same culture, and brought up in the same intensely literate, Persian-focused milieu, as had his Timurid forebears. Indeed, literary society flourished in later fifteenth-century Herat to an extraordinary degree. The poets Jami [248], Sultan-Husayn's viziers Ahmad Suhayli al-Kashifi [97] and Mir ʿAli Shir Nawaʾi [187], Asafi [95], and Hatifi [188] (nephew of Jami), were present at one or another of the celebrated gatherings, the "memorable events," that took place in the suburbs north-east of Herat, where Sultan-Husayn's own Bagh-i Jahan-Ara, the World-Adorning Garden, lay in the midst of smaller gardens. Such intense literary activities are reflected in the illustrative programs of some of the finest manuscripts of the period: the complex architectural settings of a celebrated manuscript may even reflect the architecture of this splendid garden [34]. And as his garden stood out among those established by his wealthy subjects, so Sultan-Husayn is prominent in any account of finely made and illus-

trated later Timurid manuscripts. He actually stands at its beginning since, even before he had triumphantly entered Herat, he had commissioned an illustrated manuscript, a copy of Sharaf al-Din's *Zafarnama*, the *Book of Victory*, in anticipation of his retaking of the city and, symbolically at least, the Timurid empire.

Sultan-Husayn's *Zafarnama* was planned to include six pairs of double-page paintings. The copying of the text was completed in 1467–68, while it is usually assumed that the paintings were added later, for reasons concerning the uncertain chronology of the career of the painter Kamal al-Din Bihzad. In the best Timurid tradition, the subjects of the paintings were very carefully chosen: they illustrate four scenes of battle [9], one of an audience held upon Timur's confirmation as head of the Chaghatay confederation, or *ulus* [33], and one of the building of the Great Mosque of Samarqand (94; Fig. 66). Even more carefully chosen is the "hero" of each picture: the battles in ancestral Timurid lands east of Khurasan were commanded not by Timur but his eldest surviving son ʿUmar Shaykh – Sultan-Husayn's great-grandfather. In this, as in the marble platform he erected for the tombs of his father and other male relatives at the Shrine of ʿAbd Allah Ansari outside Herat [60], Sultan-Husayn effectively restored his own family line to a prestigious position in Timurid society. So effective was this restoration, that his nephews in the line of Miranshah (Timur's third son), who were to rule in India in the sixteenth and the seventeenth centuries as the Great Mughals, constantly invoked Sultan-Husayn's Herat in shaping their own cultural patterns to the demands of a very different land.

The illustrated manuscripts produced in Sultan-Husayn's Herat in the last third of the fifteenth century are distinct creations. The notions of the superlatively fine illustrated manuscript developed in the first third of the century in Baysunghur's workshops include superb calligraphy on fine paper, exceptionally beautiful illumination and, perhaps, a carefully chosen number of illustrations. If these standards are clearly adhered to in all Timurid princely illustrated manuscripts, later Herat volumes differ in significant ways. Even the texts illustrated were different: no important later Timurid prince is known to have commissioned an illustrated *Shahnama* nor even a *Khamsa* of Nizami.

Instead, the illustrated manuscripts made for Sultan-Husayn and his circle (including many left unfinished) are a historical text glorifying his own family, and many works of sufi poets writing in Persian – Saʿdi, Jami, and ʿAttar, and also ʿAli Shir Nawaʾi, whose language, Chaghatay Turkish, is the only non-Iranian aspect of his poetry. The finest of these finished manuscripts have a very limited number of illustrations – three, or five, as in Sultan-Husayn's *Bustan* [34, 248]; the four volumes of Mir ʿAli Shir's *diwan* have only eleven pictures altogether. Lastly, what was chosen for illustration in these volumes was very different from the illustrations in princely manuscripts of the first half of the century: subjects, let alone themes, never before illustrated, in which the life of princes in courtly settings is often abandoned for arresting images of more ordinary men.

A celebrated copy of Farid al-Din ʿAttar's *Mantiq al-Tayr*, the *Language of the Birds*, conforms in all these ways to the late Herat model of the splendid illustrated manuscript. The poem is one of the greatest of sufi allegories ever written in the Persian language. Sultan-Husayn's volume was copied by Sultan ʿAli *al-mashhadi*, a man of perfect expertise in the writing of *naskh-taʾliq* calligraphy, wrote the contemporary historian Khwandamir; and it has eight spaces for illustrations, of which four are late Timurid in date [60, 168] but only one an image of a prince in a courtly setting.

It would be hard to decide whether the *Mantiq al-Tayr*, or Sultan-Husayn's copy of the *Bustan* of Saʿdi, is the finest of all late Timurid illustrated manuscripts. The calligrapher of both was Sultan ʿAli *al-*

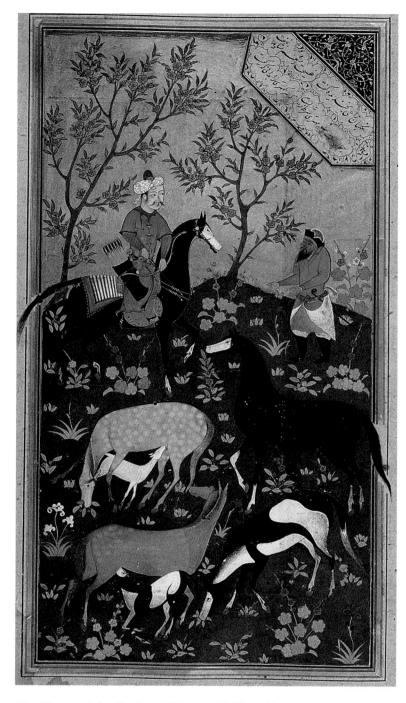

68. "Dara and the Herdsman," *Bustan* of Sa'di, Bukhara, ca. 1530; London, Royal Asiatic Society, Morley 251, folio 20v

mashhadi, the *Bustan* having been completed five years later, in 1488–89. This manuscript is one of the largest of any Timurid illustrated manuscript – its folios are 305 millimeters high and 215 wide; it contains lavish illumination throughout the volume, including two double-page spreads; and its five pictures are all virtually full-page in size. All five have the signature of Bihzad (or traces of it); two also have dates, one also in 1488 [248]. And all the paintings are exceptionally fine: spacious in their compositions, varied in their settings and palettes, their figures well proportioned and lively without being frenetic. One picture, *Dara and the Herdsman*, seems to have been a special favorite in the program of illustrated manuscripts made, or completed, for the more discerning Uzbek patrons in Bukhara in the sixteenth century, for it was repeated a number of times (Fig. 68). The double-page frontispiece [33] is surely set in Sultan-Husayn's own garden north-east of Herat; and the *Yusuf u Zulaykha* [248] is a unique vision of sufi practice expressed in form and color, envisioned in the richest and most

complex architectural setting of late fifteenth-century Herat. It is perhaps the finest of all late Timurid pictures ever painted, in one of the finest of all late Timurid manuscripts ever produced.

At the same time that Sultan-Husayn's circle was commissioning illustrated works by celebrated sufi poets, a distant cousin, Sultan 'Ali Farsi Mirza Barlas, was commissioning a copy of the most beloved of all classical Persian poetry, Nizami's *Khamsa*. Sultan 'Ali was also descended in the line of Miranshah, and Babur, first of the Great Mughals, was his first cousin; he ruled briefly in Samarqand, from the summer of 1496 to the time of his death in 1500. His *Khamsa* was completed before then; the colophon page is missing but the date of 900, equivalent to 1494–95, is found on one of its twenty-one illustrations. Following the example of Sultan-Husayn, Sultan 'Ali Mirza Barlas' name occurs in inscriptions written on two paintings in it. Most are of very high quality [77, 94, 117]; some are either unusual versions of older subjects or new pictures altogether. The names of four contemporary Herati artists – Bihzad, Mirak, 'Abd al-Razzaq, and Qasim 'Ali – are written in the margins or between the text-columns of almost every picture (unfortunately, sometimes more than one name); and the Mughal emperor Jahangir has also left his opinion of who painted what, written on the flyleaf of the manuscript. Thus, while Babur's opinion of his cousin Sultan 'Ali was not high, it is clear that the latter had (or was advised to have) an interest in owning one of those small but precious Timurid signs of cultural prestige, an illustrated manuscript of classical Persian poetry.

ON SIGNATURES AND PORTRAITS

Until about the end of the fifteenth century, Iranian figural painting in any medium, at any period, is virtually always anonymous; so rare are authentically signed paintings that they may almost be counted on the fingers of one hand [114]. Late in the fifteenth century a change is noticeable: some painters begin to sign their pictures, just as scribes had been doing for some centuries in the Muslim world. When the image was intended to represent a particular person, he (or she) may even be identified by a written inscription. In other words, from late in the fifteenth century, paintings begin to be qualified, modulated, explained and – most significantly – specified by words, a fact that represents a profound change in certain of the norms by which literate Iranian Islamic society viewed itself.

There is something to be said for the argument that such verbal and visual specificity is a Turkic attribute. The Timurids were, after all, a Turkic people – "Turco-Mongol" is the usual term – and Timurid painters, whatever their actual ethnic background, were employed at a court that retained Turkic models and mores in its thinking and its protocol. The physical appearance of the Ottoman Turkish Sultan, Mehmet Fatih, is recorded in several mid-fifteenth-century portraits made of him by both Muslim and European artists (Fig. 69); and from the early sixteenth century, series of Sultans' portraits showing men of distinctive physical appearance who were also named in accompanying inscriptions were regularly produced. As for India, the "gallery" of portraits – the subjects identified by matter-of-fact inscriptions – made by artists working at the Mughal and the Deccani courts rivals any group of portraits painted in contemporary Europe: we recognize Shah Jahan and Jahangir, their children and wives, vassals and courtiers, just as we recognize the Habsburg Emperor Charles V, and the Stuart Charles I and his wife and children, siblings, and courtiers.

One of the fundamental differences between the signatures and identifications on Ottoman and Mughal painting, and those in Iranian painting, is that both the former are relatively straightforward, functioning

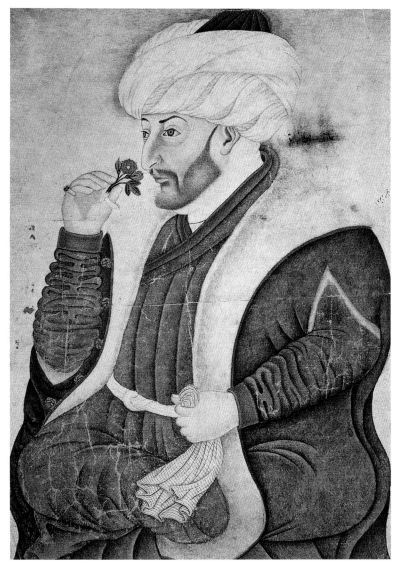

69. "Sultan Mehmet Fatih Smelling a Rose," painting now mounted in an album, Istanbul, ca. 1460; Istanbul, Topkapı Saray Library, H. 2153, folio 10r

in connection with specific pictures in Baysunghur's *Gulistan* manuscript, the relevant pictures in it are not actually signed, and we are left to speculation about what picture was made by which named painter.

It is only from about 1490 that Iranian artists' names begin to be mentioned by contemporary writers. Kamal al-Din Bihzad [231] and Amir Ruh Allah Mirak *naqqash* [60], are the two from whose hands we also have signed paintings. The names of a dozen others stand quite alone, unconnected by documentation to any pictures they may have painted: Qasim ʿAli, Shah Muzaffar and Master Mansur, Maqsud, ʿAbd al-Razzaq, Master Baba Haji and his brother Master Shaykh Ahmad, Maulana Junayd, Master Husam al-Din Gharadagar, Maulana Wali, and Mulla Yusuf.[5] At this time, too, the sense of a distinct personal style operating within a given set of stylistic conventions begins to be more prevalent. Not that what we see, in a painting of this period, ever truly accords with what can be read in the meager critical literature. Even the perceptive Dust Muhammad writes in essentially the same kind of uninformative hyperbole about Mirak – "he became without equal or peer"[6] – as he does about Bihzad: "the rarity of the age, . . . beyond all description."[7] This is not usefully descriptive writing.

A better contemporary match between words and images occurs in another later Timurid phenomenon, the "portrait" that truly attempts to render some aspect of the physical reality of the person portrayed. Just as artists' signatures begin to be more frequent on paintings toward the end of the fifteenth century, so painted portraits of important contemporary figures begin to appear. Sultan-Husayn [186] and his court in Herat, as well as his Uzbek rival Shaybani Khan (Fig. 70), present an interesting visual comparison. In the celebrated Bahram-Mirza Album were formerly bound several pages composed of separate single-

primarily as documentation. Signatures on Timurid paintings, if they are present at all, are usually couched in a formula of humility and self-deprecation, such as "the least of the slaves," the slave in question then declining to name himself. Or they may be "disguised" within the context of an architectural inscription [34], or further hidden in a written or a visual pun. The most famous, and still most bedeviling, of punning signatures on Iranian works of art is associated with the name of the seventeenth-century painter Muhammad Zaman ibn Haji Yusuf: *ya sahib al-zaman*, "O Lord of Time" [100]. The reading of others, such as *ya sadiq al-vaʿd*, "O Thou who art True," [Fig. 86] often depends as much upon a knowledge of contemporary literature, history, and religious practices as upon visual connoisseurship.

Not that it is impossible to recognize the hands of certain painters in earlier fifteenth-century pictures – quite the opposite is often true. But it is more usual that the name borne by the hand is not recorded, and it is often impossible to connect even the most individual of hands with the few names that occur in a contemporary written context: Baysunghur's ʿarz dasht, Dust Muhammad's preface to the Bahram-Mirza Album, or the colophon to the celebrated *Khamsa* worked on, respectively, by Timurid, Turkman, and Safavid painters. Thus, to a short fifteenth-century list of Timurid painters, up to about 1490, that starts with the Jalayirid painters Junayd and ʿAbd al-Hayy [179], we may add the names of Pir Ahmad Baghshimali and Khwaja ʿAli of Tabriz; Shaykhi and Darwish Muhammad; Amir Khalil and Khwaja Ghiyath al-Din. The last two epitomize the problem: while they are named in the ʿarz dasht

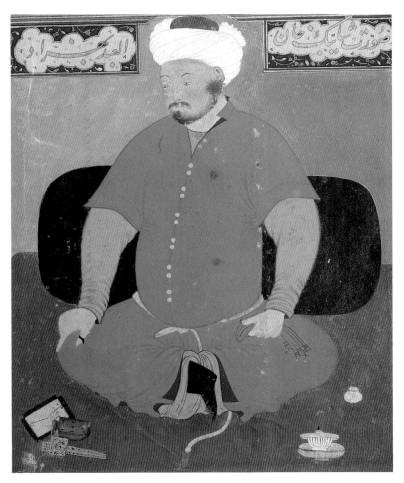

70. "Shaybani Khan the Uzbek," painting formerly mounted in the Bahram Mirza Album, Bukhara (?), early sixteenth century; New York, The Metropolitan Museum of Art, 57.51.29

figure paintings of late fifteenth-century male personages, including both the Timurid [186] and the Uzbek (Fig. 70) antagonists. As with the mid-century Shah Tahmasp Album, some portraits were (or still are), mounted four or five to the page, even though they are the work of different hands at different dates. The overall group includes both drawings and fully colored paintings, some set against bare paper and others with monochrome colored backgrounds [188] that were no doubt added when the album was being assembled; and the subjects are presented kneeling, seated cross-legged, or standing. No longer types but differentiated, real persons, most are identified by inscriptions, so that it is evident that the subjects were denizens of Herat under both Timurid and early Safavid rule. They did not originally comprise a coherent series of recorded images of "great men;" but each group was almost surely collected to make up such a series and then mounted together, creating what must have been an informal "picture gallery" of notable Timurid personalities. The various images were probably assembled in Tabriz, the first Safavid capital, early in the 1540s, since the Bahram-Mirza Album was completed there in 1544. Another portrait gathering, of personages [189] at the court of Shah Tahmasp, was assembled in the mid-1550s, the presumed date by which the Shah Tahmasp Album was completed.[8]

Such a "gallery" of Sultan-Husayn's circle of writers and poets, sufis, literati, and artists, albeit mounted in different albums and disparate in the size and styles of the images, nonetheless brings to life the creators of the Timurid *fin de siècle*. Thus we have reasonably contemporary portraits of, among others, the Sultan himself, his vizier Mir 'Ali Shir Nawa'i [187], the poet Hatifi [188], and the painter Kamal al-Din Bihzad [189]. The image of Sultan-Husayn is the largest, and in many ways the most impressive, of this stylistically dissimilar group of Timurid portraits, according wonderfully with the vivid verbal description by Babur of the last effective ruler of Timurid Herat.

KAMAL AL-DIN BIHZAD

The most famous of all historically attested Iranian painters, Kamal al-Din Bihzad, worked at the time of Sultan-Husayn in Herat. Presumed to have been born around the middle of the fifteenth century – the date is nowhere recorded – Bihzad is the bridge between the traditions of later Timurid painting and the next period of the early Safavids: indeed, it is a very old Bihzad, in Safavid garb and Safavid service, whose portrait was mounted in the Shah Tahmasp Album. The few facts of his life, and a very small signed oeuvre, are exceptionally difficult to reconcile with the exalted luster of his reputation. By late in his lifetime and certainly in later centuries, Bihzad was being described as a second Mani, the difference being that he lived and worked at the time of both the last Timurid in Herat, and the second Safavid Shah in Tabriz, both courts at which writers deeply interested in aesthetic matters were present.

Bihzad does figure, however briefly, in many contemporary sources: among them are Mirza Muhammad Haydar Dughlat, and Babur, both Timurid relatives of Sultan-Husayn; his Timurid contemporary, the historian Khwandamir; the Safavid critic and librarian Dust Muhammad, the biographer Qadi Ahmad, the historian Iskandar Munshi, and even the sixteenth-century Ottoman biographer Mustafa 'Ali. Yet none of these writers alone provides a set of indisputable facts about either Bihzad's life or his art and, considered together, they sometimes even contradict each other. For example, Mirza Haydar comments that Bihzad does not match Shah Muzaffar's delicacy of touch but that he surpasses him in preliminary sketches and the grouping of figures;[9] while Babur says Bihzad's work was very dainty. Babur also says that

he lengthened the double chin and did not draw beardless faces well but "bearded faces he drew admirably."[10] Khwandamir's comments are typically uninformative:

. . . a creator of marvelous pictures and rare artistic manifestations. Wielding his brush like Mani, he has abrogated the monuments of mortal painters, and his miraculous hands have effaced the depictions of human artists.

He adds one brief but useful comment on Bihzad's career: "This master owes his rise to fame to the patronage of Amir Nizamuddin 'Ali Sher, and the emperor himself also favored him with much patronage."[11] Qadi Ahmad's entry is somewhat lengthier: it includes Bihzad's being orphaned, and brought up – and, presumably, trained – by the older painter Mirak, but he is not altogether trustworthy in the details of Bihzad's later life. And he too draws the parallel to Mani:

His drawing in charcoal by its fluency
Is superior to work by the brush of Mani.
Had Mani only known about him,
He would have imitated his sense (?) of proportion.[12]

The Mughal Emperor Jahangir (Babur's great-grandson), provides perhaps the most useful comments in the search for the style and the oeuvre of Bihzad. For on the flyleaves of three Timurid manuscripts in the Mughal library – Sultan-Husayn's *Zafarnama* of 1467, a *Gulistan* dated 1486, and the *Khamsa* of 1494–95 – Jahangir noted the presence, and the quantity, of paintings by Bihzad. Yet even the testimony of this exceptional connoisseur of styles, hands, and signatures does not always accord with the evidence of the pictures themselves, while the few signatures of Bihzad are not on pictures that Jahangir knew, or could have known. In other words, nothing really matches: pictures, painter's signature, or contemporary documentation.

The only documentation that indisputably connects painter to painting is Bihzad's signature: the Arabic phrase *sawarrahu al-'abd bihzad*, "written by the slave Bihzad," in tiny black letters in inconspicuous places on a picture [34]. Yet paintings signed in this manner, by Bihzad, are found on pictures in only three surviving manuscripts: the *Bustan* of 1488–89 [248], a tiny *Khamsa* of 1442 with later paintings [231], and the *Khamsa* of Amir Farsi Mirza Barlas [117]; and on only two independent pictures.

In answer to the question so often asked over the centuries – "Did Bihzad paint this?" – these pictures do exemplify much of what Bihzad is usually credited with doing: introducing into the classical Baysunghuri canon a human liveliness, imparting to archetypical compositions of the 1420s and 1430s a sense of specific place and of human interaction. It is probably no coincidence that the subjects of later Herat paintings are so very different from those of Baysunghur's classically illustrated manuscripts. Instead of ferocious battles and duels with adversaries, or the besting of monsters and witches, are to be found images suggesting Herat and its environs, and the concerns of daily life: the building of mosques and palaces, the holding of receptions in gardens by day or conversations between mystics and scholars by night; wrestling matches, visits to the bath-house, and the gathering of wood; a funeral in a local setting, or a profound sufi experience. Bihzad is probably better understood as a late fifteenth-century *primus inter pares* who painted many very fine pictures within the framework of the classical Baysunghuri canon of painting, rather than as the genius alone responsible for humanizing it. And for all of the apparent naturalism in the best later Herat painting – by whomever it was painted – stock figures and compositional patterns continue to be used as foundations for manuscript illustration throughout the next two centuries.

THE SIXTEENTH AND SEVENTEENTH CENTURIES

In the summer of 1501, a youth of sixteen years called Ismaʿil "entered the Türkmen capital Tabriz, ascended the throne and took the title of Shah." Ismaʿil was descended from a fourteenth-century sufi shaykh who, about 1300, had founded a religious order in Ardabil (in Azarbayjan, south-west of the Caspian Sea), a town where his family had lived for generations. Shaykh Safi al-Din Ishaq was pious and ascetic but also politically minded, possessed of a militant but pragmatic activism. These qualities, together with his position as grand master of the Safaviyya order in Ardabil, permitted him to function in both the religious and the political spheres during more or less the period in the fourteenth century when the Ilkhanid dynasty ruled Iran. For the first two and a half decades of the sixteenth century, his descendant Ismaʿil would function similarly, ordaining both the religious and political forms of a Safavid Iranian polity over which he and his descendants would rule as shahs for more than two hundred years. The Safavids

> . . . endowed the country and its peoples with a unique character . . . , which has in part endured even up to the present day. Its typical features include the revival of the monarchist tradition, . . . the spread of the Shiʿi creed as the state religion, the Iranicisation of Persian Islam, the continued progress of modern Persian towards becoming the language of politics and administration in modern Iranian history, and the development of a specific culture which reached its peak in architecture . . . but which also produced remarkable results in the intellectual life of the Persian nation.[1]

The transformation of fourteenth-century sufism (Shaykh Safi's creed also tinged with practices of popular Islam) into the sixteenth-century militant Shiʿa state is a subject outside the scope of this volume. But some background is useful, since a minor, but material, aspect of Safavid Shiʿism is reflected in sixteenth-century painting and manuscript illustration. Moreover, the continued conflict between the Shiʿa Safavids and the Sunni Ottomans, throughout the sixteenth and the seventeenth centuries, not only accounts for the fact that the Safavids moved their capital twice in a single century – from Tabriz, to Qazvin, and then to Isfahan – but also explains the transfer of large parts of the Timurid, and then the Safavid, libraries to Ottoman Istanbul by ransom, booty, or gift.

One of Shah Ismaʿil's first edicts was to impose Shiʿa Islam upon Iran. This is a land whose prior religious practice had been a tolerantly syncretistic blend of Sunni and Shiʿa Islam, with a sufi presence exemplified by a number of darvish orders and a scattering of heretical movements arising throughout the fourteenth and the fifteenth centuries. Young at his accession to power and exceptionally charismatic in personality, Ismaʿil surely made Shiʿism the state religion of his newly acquired kingdom out of religious conviction, rather than from political expediency. He may (or may not) have been the first of Shaykh Safi's descendants to embrace Shiʿism, but he is the first whose fervent Shiʿa beliefs cannot be doubted. Shiʿism – the *shiʿat ʿali*, the "party of ʿAli" – holds that legitimate Muslim political succession, in the person

of the Caliph, descends directly from ʿAli, the son-in-law of the Prophet, and therefore virtually from the Prophet himself. This is in contrast to Sunnis – *sunna* means "path" – who hold that the first four Caliphs, the *rashidun*, or "rightly guided" companions of the Prophet, were wise and just men whose elevation to the position of Caliph, supreme as political and religious leader alike, depended upon merit.

Of the many modalities of Shiʿism current in the early sixteenth century, Ismaʿil favored the Twelver Shiʿa. This group accepts the existence of twelve legitimate successors to ʿAli, the Twelfth and last Imam who, so the Shiʿa believe, did not die in July 874 but was miraculously carried off, to return at the end of time. An early Safavid genealogy links Shaykh Safi through twenty generations to the last Imam, Musa al-Kazim; Shah Ismaʿil, only six generations further removed from Shaykh Safi, clearly also believed himself to be a successor to the Prophet. As H. R. Roemer puts it succinctly: "If one pursues Ismaʿil's thought to its conclusions and relates it to his political intentions, one realises that he is proclaiming a Shiʿi theocracy with himself at its head as a god-king."[2]

It is not an overstatement to say that Shiʿa Islam has always been given to extremes; Ismaʿil's Shiʿism was no exception. It can be seen in his *fiat* decree of Twelver Shiʿism, the first proclamation of which was in the entirely Sunni town of Tabriz. It is expressed in the fervid tone of his collected poetry, his *diwan* [141], written in Turkman Turkish; the charismatic religious poetry in it must have made for better communication with the Turkman element of his army. His extreme religious passion even extended to redesigning the Safavid turban, the so-called *taj-i haydar*, or "crown of Haydar." Haydar was the name of Shah Ismaʿil's father, but it also means "lion," in Arabic, and was an epithet bestowed by Shiʿites upon ʿAli. The design of the new turban (attributed by some to Haydar instead of his son, and hence its name) is not without relevance to Safavid figural painting. It consists of a cap, or *kulah*, shaped in twelve gores from which a baton rises, a foundation around which a turban-cloth could be wrapped twelve times, in commemoration of the twelve Shiʿa imams: the silhouette is unique (Figs. 71, 72). The Safavid *taj* is an unmistakable feature in Iranian painting of the sixteenth century, and it sometimes provides an important clue to the date, or even the provenance, of a picture, for it was not worn in lands that were not subject to Safavid rule, such as Bukhara [164].

TABRIZ: THE EARLIEST SAFAVID PAINTING, 1501–24

When Ismaʿil took power in the former Turkman capital of Tabriz, he must also have taken possession of the Aq Quyunlu library and its workshops. Whether he actually cared for ornamented books or had only, astutely, recognized the Timurid practice of using fine illustrated manuscripts as an instrument of dynastic propaganda is not clear. For while a number of illustrated Safavid manuscripts were made in the first quarter of the century – Ismaʿil died in 1524 – their general quality is not especially high. An exception is the early Safavid paintings in the

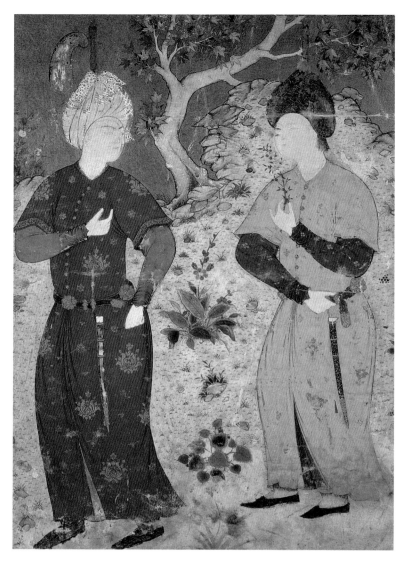

71. "Two Men in a Landscape," painting on paper, Tabriz, 1530–40;
London, British Museum, 1930.11-12.01

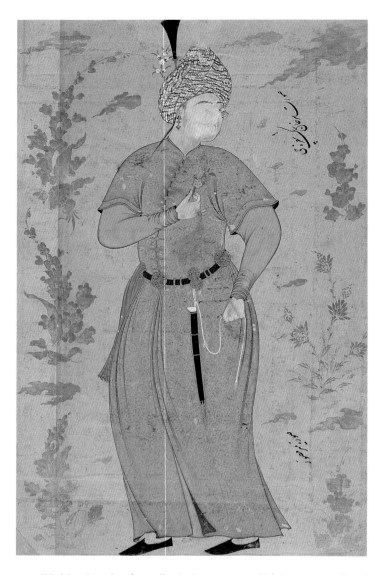

72. "A Man in a Landscape," painting on paper, Tabriz, 1530–40; London,
British Museum, 1930.11-12.02

Khamsa of Nizami, begun before 1457 but completed only for Shah
Isma'il; one truly remarkable picture in it is dated 1505 [66]. Given the
family connection between the Aq Quyunlu and the Safavids – Isma'il
was the son of a sister of Ya'qub Beg Aq Quyunlu, his nephew as well
as his son-in-law – this manuscript must have been a principal conduit
for the transmission, to the Safavid manuscript workshops, of the
element of Aq Quyunlu painting usually attributed to the painter
Sultan-Muhammad. His energetically charged, almost frantic, composi-
tions in which usually inanimate landscape is as active as animate life
[78], are to be seen in some of the most remarkable pictures
in a Tabriz manuscript of the next decades [223]. And there is surely a
connection between this *Khamsa* and Muhammad Asafi's *Dastan-i Jamal
u Jalal* [95], copied in Herat in 1502–3: their dimensions are practically
identical, and the latter's thirty-four (remaining) illustrations display the
same two styles of painting, Aq Quyunlu and early Safavid. In both
manuscripts, the Safavid pictures show the distinctive Safavid *kulah* but
its protruding red baton is still thick and stumpy, as if the object itself
were still finding its final shape.

A taller and thinner baton is seen in the three paintings to an
undated copy of Shah Isma'il's own poetry [141] made during his life-
time. Although now incomplete and damaged, the subjects of the paint-
ings appear to be generalized scenes of courtly life but they actually
render, in explicit images, the words of the poetry in which each is
embedded. This feature suggests that Isma'il, too, recognized the value

of words enhanced with images in the context of a luxurious manu-
script, and that the whole could play a part in projecting an image of
learned refinement for a ruler. On the other hand, it is hard to see much
connection between the charismatic, energetic first Safavid Shah, whose
military activities were paramount up to 1514, and this small, now anony-
mous manuscript, very fine in scale but quite conventional in its picto-
rial compositions. By contrast, while they may be earlier in date, the
Turkman-influenced Safavid pictures of the *Khamsa* are highly sophisti-
cated creations: complex pictures, imaginative in composition and refined
in style, execution, and coloring, they prefigure Safavid painting as it
would develop under Shah Isma'il's son and successor, Tahmasp.

Isma'il made several other significant contributions to the Safavid arts
of the book and to its figural painting in general. A year after the death
of Sultan-Husayn Bayqara in 1506, Herat and a portion of its biblio-
phile riches had fallen to Shaybani Khan, the Uzbek ruler [Fig. 70].
Sultan-Husayn's son and heir, Badi' al-Zaman, had fled westward to the
protection of Shah Isma'il, bringing with him treasure, a large portion
of the Timurid princely libraries. In turn, the Uzbeks were themselves
defeated by Shah Isma'il, the presumptuous Shaybani dying at his hand
in 1510; Isma'il could then add Khurasan and its cultural capital, Herat,
to the Safavid realm. While his spoils may have included still more treas-
ures from the Timurid libraries, literary life in Herat certainly did not
come to an abrupt halt; intellectuals continued to compose texts, and
scribes and painters to produce manuscripts. Shah Isma'il is also respon-

sible for bringing the "second Mani" to his western capital: a document dated the equivalent of April 24 in the year 1522 conveys the Shah's invitation to Kamal al-Din Bihzad to come to Tabriz and appoints him Director of the Royal Library.[3] Unfortunately, like all the other details of Bihzad's life, there is no real consensus as to when the second Mani actually did leave Herat for Tabriz. Other sources suggest differently: some say that it was around 1514 (although, coincidentally, that is the same year in which Isma'il and the Safavid forces were disastrously defeated by the Ottomans in the battle of Chaldiran in the late summer, Tabriz even being occupied by the Ottomans for a week in September); or that Bihzad's arrival was delayed until the beginning of Shah Tahmasp's reign, in May of 1524. His influence, however, is evident in Safavid painting in many ways, especially in the overall Timurid sense of composition and balance that will re-emerge in slightly later painting made for Tahmasp.

TABRIZ: SAFAVID PAINTING UNDER SHAH TAHMASP

Tahmasp ibn Isma'il ruled as Shah of Iran for over half a century, and the figural arts of this period are indelibly marked by his passions – first by the presence of his patronage and, later, by its absence. As regards painting, his long reign falls into three distinct phases. The first is from 1524 to about 1545, when his taste, position, and means created a bibliophile's paradise during which were created two manuscripts that may truly be called the "wonders of the age." Indeed, some would say that the finest of all Iranian painting was achieved in this period. The second phase is from 1545 to nearly the end of his life, when what is usually described as puritanism led to a revulsion from painting as well as from the other worldly pleasures in which he had earlier indulged. About 1574, or so it has been conjectured, recovery from an illness brought about a change of heart and a return, albeit brief, to his passionate earlier interest in painting. It also caused him to recall from exile the family-member who most shared this passion, Ibrahim-Mirza ibn Bahram-Mirza. Tahmasp was the prime bibliophile in a family of great bibliophiles: brothers, children, this favorite nephew, are all known to have taken a particular interest in these refined objects which mingled intellectual and aesthetic concerns. He was born in 1514 and, in the Timurid pattern, was sent to another city in the realm to govern in his father's name, albeit at the age of two. Tahmasp went to Herat, which must have been the Safavid equivalent of Oxford or Harvard. Equally Timurid was his education in the Persian literary tradition (although the Shi'a religious education was not). He is supposed to have been taught painting by Bihzad himself, and he was also trained to appreciate fine calligraphy by learning to practice it. At about the age of ten he copied a volume of 'Arifi's *Guy u Chaugan*, the *Ball and the Polo-Stick*, a sufi poem relating the love of a darvish for a prince in terms of the princely game of polo; it was illustrated by prominent court artists, including Sultan-Muhammad, who, according to another contemporary source, also instructed Tahmasp in painting. Succeeding his father in 1524, he must then have set his entire atelier to a more demanding task: the production of a copy of Firdausi's *Shahnama* that was to be lavishly illustrated. It was a majestic document of accession.

Tahmasp's next brother, Sam-Mirza, was also educated as a youth in Herat. Calligrapher, patron of calligraphers, and author, in 1550 he compiled an anthology of poets, and painters, illuminators, and calligraphers called the *Tuhfa-yi Sami* (later revised to include the second half of the century). He has been associated with a manuscript that was surely the finest and most interesting of all illustrated copies of the *Diwan* of Hafiz, by virtue of the appearance of his name in a replacement inscrip-

tion in one of its paintings [55]. The picture is signed by Sultan-Muhammad, then in the employ of the court in Tabriz. This is one reason the *Diwan* is usually associated with Tahmasp's patronage, although there is no actual written evidence for the connection. A fact not unconnected to this continuing uncertainty is that in 1534 – a decade after Tahmasp's accession – Sam-Mirza was the focus of an unsuccessful plot to overthrow Tahmasp, his place on the throne to be taken by the younger brother. The appearance of Sam-Mirza's name in a manuscript illustration showing a prince presiding over an important court ceremony may not, in the end, resolve the issue of the *Diwan*'s sponsor. But it does confirm the continuing Safavid adherence to the Ilkhanid conception of an illustrated manuscript: the use of pictures in ostensibly literary volumes as a medium for conveying messages of political and dynastic import.

Tahmasp's second (and favorite) brother, Bahram-Mirza, contributed as much to the history of Iranian painting as did Tahmasp himself, if not more so. Sam-Mirza speaks of Bahram-Mirza as being skilled in calligraphy, especially the *nasta'liq* hand, and drawing, *tarrahi*. Bahram-Mirza's order for the assembly of the celebrated album [61–63, 156, 179, 186, 188; Fig. 70] which gathered together, in one carefully modulated construct, older and contemporary calligraphy, drawings, and paintings, and the even more celebrated preface which set these arts in an unbroken tradition of at least two centuries, would alone be full evidence of the depth of his interests. And he passed these passionate interests on to at least one member of the next generation of Safavid princes, his son Ibrahim-Mirza, born in 1540. A profound love of the arts of the book was both inherited by, and nurtured in, this prince, a connoisseur and practitioner of the arts of the book fully equal to Tahmasp himself. And for good reason: when Bahram-Mirza died in 1549, Ibrahim-Mirza's education was overseen directly by Tahmasp, and his considerable inherited talents focused on the Safavid family's bibliophile traditions. The Shah then strengthened this tradition still further by marrying his daughter Gauhar-Sultan to his favorite nephew.

THE TAHMASP *SHAHNAMA*

Probably the largest and most ambitious product of the Tabriz ateliers at the time of Shah Tahmasp is a massive *Shahnama*, the manuscript described by Dust Muhammad as being so beautifully illustrated that the pen was inadequate to describe it [139, 233], that manuscript in which was to be found the painting before which ". . . the hearts of the boldest of painters were grieved and they hung their heads in shame before it" [223]. Complete (or virtually so) until around 1960, it was originally a volume of 760 gold-sprinkled folios with nearly 260 illustrations that have been called "a portable art gallery . . . [in which] one can trace the evolution of Safavid painting through the formative early 1520s to its maturity in the mid-1530s and beyond."[4]

Yet much about this celebrated manuscript remains unknown: for instance, the name of its scribe, the date at which it was begun – or even completed, and which artists worked on it. A single date, 1527–28, on a single painting, and signatures on three of the 258 illustrations it contained in 1959 comprise its only intrinsic written documentation. Even a richly illuminated *shamsa*, saying that it was commissioned for the library of Shah Tahmasp, has not prevented speculation that the stupendous project was actually begun by Shah Isma'il as a princely gift to his son. Tahmasp himself, during his period of renunciation of the intellectual and sensuous pleasures of his youth, presented the manuscript to the Ottoman Sultan Selim II not long after the latter's accession in 1566. Until about 1900, it lay in the Ottoman library in Istanbul, so unheeded

that the silver streams in some of its illustrations remained untarnished from lack of exposure to the air. Less than a century later, it had been taken apart and widely dispersed into public and private collections all over the world, including the land in which it was created. Today it is probably the most reproduced – if also the most scattered – illustrated manuscript of a classical Persian text in existence.

Its creation must have occupied a small army of craftsmen and artists over a very considerable period of time. The single date in it, 1527–28, occurs on a painting deep into the manuscript, so perhaps it was begun shortly after Tahmasp's accession in 1524, in magnificent celebration of this event; it was most likely complete – or nearly so – shortly before 1540. And it was surely undertaken in considerable knowledge of earlier illustrated copies of the text, including the proto-Baysunghur *Shahnama*, and no doubt Baysunghur's own copy as well: some of its finer paintings recast familiar Jalayirid [221] and Timurid compositions in a larger and more magnificent Safavid format [223].

Yet it is wildly uneven in its pictorial quality – as any manuscript with so large a number of pictures might be expected to be. Some of its paintings are superlatively fine and merit every word of praise, contemporary or modern, ever lavished on them; others are good but undistinguished illustrations; still others are compositionally banal, even boring. Towards the middle of the volume the need to produce many illustrations at great speed appears to have dictated a pictorial formula: a picture sharing the written surface with a good deal of text, the image composed of the minimum of essential figures or other elements in the simplest of settings, often with a pictorial void somewhere in the center. Such pictorial expediency seems hard to reconcile with a princely manuscript of such quality in all other aspects of its production, in its paper, ornamentation, and binding, and its calligraphy; and above all, in illustrations of the order of Sultan-Muhammad's celebrated "Court of Gayumarth" [223].

THE TAHMASP *KHAMSA*

Tahmasp's second major pictorial commission from his workshop at court is a *Khamsa* of Nizami. It was copied by Shah Mahmud *nishapuri*, a celebrated scribe of the period, and the paintings were executed between 1539 and 1543. It contains rich and gorgeous illumination, and the manuscript is further enhanced by the wide margins ornamented by drawings, in gold, of animals cavorting in windblown landscapes still further embellished with touches of silver. Not so large in its folio size as the *Shahnama*, its pictorial program is also far smaller: today it contains fourteen illustrations [67, 96, 127] contemporary with the date of its copying and three that are later, while at least four others [109, 172] have been removed. Overall, it is aesthetically more coherent, and more uniformly high in quality in the conception, execution, and finish of its illustrations. Inscriptions written onto the pictures attribute them to five Tabriz painters of the highest stature: Sultan-Muhammad, his son Mirza ʿAli, Aqa Mirak, Muzaffar ʿAli, and Mir Sayyid ʿAli. The name (partly effaced) of the latter's father, Mir Musawwir, also appears as a signature on another picture [96]. Three of these artists are named by Dust Muhammad among the "portraitists and painters of the royal library": Sultan-Muhammad, Aqa Mirak, and Mir Musawwir.

Like the *Shahnama* however, many questions may still be raised about this princely commission. The paintings appear to have been executed separately and pasted into the text-block in spaces left for them, but the manuscript must have remained unfinished: three pictures in the *Haft Paykar* were later painted by Muhammad Zaman [118, 232] who signed them in 1086, equivalent to 1675, in Mazandaran; another, from

the *Iskandar-nama*, was never fixed into the manuscript. Several pictures are mounted in the wrong place in the volume, most notably "Nushaba Shows Iskandar His Own Portrait" [242]. Nonetheless, its paintings are the *locus classicus* of the style developed in the workshops of Tahmasp in Tabriz. They illustrate many of Nizami's best-known stories; consequently most have compositional antecedents of some age over which the elaborate Safavid picture was constructed [73, 127]. All the pictures are either set outdoors or have a garden in the background. Palatial terrace or nomad camp, enchanted wilderness pool or barren hunting ground, each picture is a broad, balanced composition conveying the sense of seemingly limitless space, whether the picture has many figures or relatively few. All the components of earlier Safavid painting have merged and matured in these *Khamsa* paintings: the frenetic, expressive landscapes so unusually colored and peopled by visionaries or otherworldly beings that came from Turkman Tabriz; the limpidly still, coolly colored and perfectly balanced compositional tradition of Bihzad's Herat; the sixteenth-century's increasingly naturalistic depiction of human beings in the full range of their daily activities; and the contemporary taste for the multiplication of patterns, as textiles and tile panels, tent shapes and architectural forms, pools and fountains and the smaller accoutrements of Safavid life. But they are now altogether more temperate in feeling, and less cramped, than either their Timurid or Turkman antecedents. They seem instead to be a set of variations on a pictorial aesthetic, with a surprisingly wide range of styles in the manipulation of each picture's elements, in which the hands of a number of very fine painters are clearly distinguishable. The protagonists of the two hunting scenes have been called idealized portraits of Tahmasp, and the court scenes suggest aspects of his own court in Tabriz [35, 234], sometimes apparently containing a very personal reference. Again, the process seems to have been selective, single pictures used to convey a particular message, rather than manipulating the overall illustrative program of the manuscript, as had been so intensely done in the Timurid century.

SAFAVID WRITING ABOUT PAINTING: WORDS AND IMAGES I

Literary sources on painting in the Timurid period are few, and laconic. By the middle of the Safavid sixteenth century, this aspect of cultural life had assumed a notably different disposition, especially at Tahmasp's court but also at those of his brothers and his nephew, Ibrahim-Mirza. So different, in fact, that – for the 16th century, at least, a new and specific category of art-historical writing, in Persian about Iranian painting, has recently been identified. It is the album-preface, of which ten important examples, nine composed between 1491 and 1609, have recently been studied.[5] Altogether, the information in this newly-recognized genre of writing refocuses not only what was known about painting and the arts of the book in the Timurid century, but also the way in which information can be corroborated. The most well-known of such sixteenth-century prefaces is that in the celebrated Bahram-Mirza Album. Together with two other Safavid literary sources from the end of the sixteenth century – the *Gulistan-i Hunar*, or *Rose Garden of the Arts* (a version of the classical biographical compendium) by Ahmad ibn Mir Munshi, usually called Qadi Ahmad, and a seventeenth-century history, the *Taʾrikh-i ʿAlam-ara-yi ʿAbbasi* – it serves to epitomize the kind of writing about pictures that circulated in learned Safavid circles, both at court and elsewhere.

Dust Muhammad's account in Bahram-Mirza's album is important, first, for the coherent picture he gives of the nature and practice of the arts of the book in Iran over more than two centuries, especially the

unbroken chain by which ideals and practices were transmitted from one generation of artists to the next; and second, for the names of the first generation of bibliophile patrons and the numbers of artists' names and works − if tantalizingly brief − he supplies. Four of the seven Safavid painters named by Dust Muhammad, and at least six others, of the second and third generations, also figure in the much longer treatise written toward the very end of the century by Qadi Ahmad. In form it combines elements of both the album-preface and the biographical compilation: the author first discusses the art and practice of calligraphy to which he then adds biographical accounts of former and contemporary craftsmen, both calligraphers and painters. He had both personal and professional connections with the Safavid princely family: his father had served in the chancery of Sam-Mirza in Herat and was later vizier to Ibrahim-Mirza when the latter governed Khurasan from Mashhad; Qadi Ahmad himself also served Ibrahim-Mirza in several capacities. Moreover, he had been trained as a calligrapher and illuminator − and also as a painter, by one of Tahmasp's court painters, ʿAli Asghar, father of the celebrated Riza: the links between the two families seem to have been close. And virtually all the sixteenth-century Safavid artists whose names appear on contemporary paintings and drawings are also named in the third contemporary source connected with the Safavid court and its personalities. A more straightforward history (if stylistically artificial and high-flown in its style), it is entitled *Tarikh-i ʿAlam-ara-yi ʿAbbasi* and was completed in the reign of Shah ʿAbbas I − as its name suggests − around 1616, by Iskandar Beg Munshi. Another court-trained secretary who was also a fine calligrapher, he was appointed historian at the court of ʿAbbas and is still regarded as one of Iran's greatest writers of history. Each of these three is distinguished by his exceptionally close court connections, as well as for his personal experience in the arts of calligraphy and painting. All were therefore exceptionally well prepared to chronicle the intense interest of the Safavid princes in painting, their high level of achievement in its practice combined with their connoisseurship, and their encouragement of painters and illuminators.

The intense aesthetic interest and preoccupations exemplified by these three Safavid courtiers and writers may also help to explain how broadly the taste for such fine and private arts spread throughout Safavid society during the sixteenth century, a taste satisfied not only by workshops in Tabriz but by a great many in Shiraz and, later in the century, in a number of centers in Khurasan, in eastern Iran. By the second quarter of the sixteenth century, the production of good illustrated manuscripts was widespread throughout literate Persian-speaking society. Patrons tended to be governors, amirs, merchants, and others of the upper and middle classes. Texts illustrated were often Persian classics, works of both the most famous writers and those of lesser luster: Firdausi and Nizami, Rumi, Hafiz and Jami; the Herat writers Nawaʾi, Hatifi, and Asafi; Amir Khusrau of Delhi, ʿAssar, and many other poets.

If we really wish to gauge the breadth of the Safavid interest in good illustrated manuscripts of Persian literature, we might propose a variation on Carl Sagan's dictum: "Partial absence of evidence is actually positive evidence." For many volumes with sixteenth-century paintings had been copied and even illuminated in Timurid Herat, leaving only the pictorial complement unfinished. Volumes evidently still in this state in 1507 were carried elsewhere by fleeing Timurids, and victorious Uzbeks and Safavids, to be finished in Bukhara [164] or Tabriz [95, 231]; other volumes traveled as far afield as India, to be completed in the library of the Mughal descendants of the Timurids, where they then joined precious completed Timurid volumes [76, 84, 116, 228, 240; 9, 33, 94].

But toward the middle of the sixteenth century, fine manuscripts, and those who made them, began to travel out of Tabriz. This was due

to a change in Shah Tahmasp's interests, beginning in the mid-1530s; it can be epitomized by the so-called "Edict of Sincere Repentance." In the words of Qadi Ahmad, the Shah, ". . . having wearied of the field of calligraphy and painting, occupied himself with important affairs of state, with the well-being of the country, and the tranquility of his subjects. . . ."[6] In his own words, he "washed in the water of repentance."[7] Iskandar Munshi put it somewhat differently, writing that painters were henceforth "permitted to practice their art by themselves,"[8] a euphemistic locution for dismissal, as Ivan Stchoukine dryly pointed out.[9] By 1556, Tahmasp had virtually banned the secular arts throughout his kingdom.

SINGLE-FIGURE PICTURES, ALBUMS, AND THE DECORATIVE ARTS

The effect of this ban was felt all over the Eastern Islamic world. In the land of the Edict, some artists sought employment elsewhere. In Shiraz the making of good manuscripts had never ceased, and internal pictorial evidence makes clear that some Safavid court painters from Tabriz moved south, to Shiraz [110]. Some of the finest painters of Tahmasp's erstwhile brilliant establishment found positions in at the Mughal courts of northern India, and others went to Ottoman Istanbul. Still others remained in Iran and continued to practice their profession by altering their working-processes.

One way of doing so was to extract figures from a typical manuscript composition and repeat them, perhaps on a slightly larger scale, as a single figure on a single page. Images of this kind were, of course, not unknown as a genre in the Timurid period: portraits, shown on rectangular supports of approximately the same size as some of the earliest surviving single-figure images, are the focus of illustrations in key stories in both Firdausi and Nizami [239–42]. And we have seen that true portraits of contemporary personalities were known from the end of the prior century [186–89; Fig. 70].

With such numbers of single sheets of precious images, and words, in circulation in cultured Safavid circles, the quantities of another kind of Safavid book, the *muraqqaʿ*, or "album," can hardly be coincidental. The remains of treasured older manuscripts [103, 203; Fig. 61] or paintings from other places [108, 151, 179]; paintings rejected from manuscripts; portraits [190] and other single-figure compositions [81, 148, 174, 181]; studies, copies (Fig. 74), and working drawings for manuscripts; and decorated objects of all kinds; in addition to calligraphic samples of renowned scribes, or entire documents, from both past and present: all were considered worth saving. Materials were collected and then carefully arranged and mounted, sometimes with surrounds of calligraphy [146, 152] by celebrated scribes that were always vaguely relevant, if not always pointedly apposite, in theme; the folios were occasionally bound in covers no less elaborate in workmanship and materials [Fig. 1] than those of the most costly manuscripts. They are perhaps not a a uniquely Safavid creation but, with a few exceptions (Fig. 88), the most important of carefully assembled and bound albums seem to date from the first half of the sixteenth century, works made in the presence, and then the withdrawal, of Tahmasp's patronage of the arts of the book. The study of these albums, as objects in their own right, is still in its early stages, but its significance for the history of Iranian figural art in the Islamic period is unquestionable.

It seems likely that the genre of the finished single-figure painting or drawing that is not intended as a portrait dates from earlier in the century than Shah Tahmasp's apparent disaffection with painting. Yet the development of this kind of image cannot be unrelated to the attitude that so

affected the second half of Tahmasp's reign, since fully finished single-figure compositions offered one alternative source of income to artists suddenly deprived of regular court employment in the making of illustrated books. Less frequently remarked upon is that fully finished single-figure paintings seem, again, to predate fully finished drawings of similar subjects, as if to confirm the Iranian pattern in which the largest or boldest example of a new pictorial style, or genre, appears first and is then modulated, reduced, or otherwise diminished by continued repetition. For example, one of the earliest single-figure Safavid pictures is 37.5 centimeters high (Fig. 71) (dimensions surpassed only by the size of the folio of Tahmasp's *Shahnama* and the somewhat later *Falnama*) [215, 216]. The picture shows a pair of standing men dressed in early Safavid-style clothing and the *taj-i haydar*, standing in an unremarkable period landscape with a *chenar*, a plane tree, in autumn foliage and a golden sky. The distinctive pose of one figure, moving left but looking over his shoulder to the right with one hand in a pocket, was copied in an only slightly smaller painting (Fig. 72) in which the image was set against a bare paper ground

74. "A Bounding Stag," drawing on paper, Iran or Western Central Asia, late fourteenth century; Berlin, Staatsbibliothek, Diez A, fol. 72, S.10, #1

73. "Hunters in a Mountainous Landscape," drawing on paper, Qazvin or Isfahan, late sixteenth century; New York, the Metropolitan Museum of Art, 45.174.16; New York, The Metropolitan Museum of Art, 45.174.16

with sparse golden floral growth (this may be a later addition). Early Safavid paintings of this size have not survived in any quantity, and dated, or – more frequently – datable, examples appear to be from somewhat later in the century; often they are also finer in quality. Compositions with figures in landscapes, executed as finished drawings rather than fully colored paintings, also seem to appear only from about mid-century; some are truly virtuoso achievements and by rights should be considered as a separate genre of the Iranian figural manifestation (Fig. 73).

Still another genre comprises the drawings that are truly handmaidens to paintings. In Iranian manuscript illustration from its earliest moments, a drawing usually underlies a finished painting of a figural subject; this may only become evident when a painting has flaked away from the paper, but it can be assumed in almost all cases. Drawings also preserve images and transfer them, whether or not the outlines are actually pricked for pouncing. Both figural underdrawing, and copy-drawings (Fig. 74, cf. Fig. 7) are known from as early as the Muzaffarid period in the late fourteenth century; they survive in some quantity from Baysunghur's Herat workshops, and many were collected in later albums whose contents are truly shaped by their presence. Lastly, decorative drawings survive in even greater numbers from the very late fourteenth century and throughout the Timurid period; often they are so fluently executed and beautifully finished that only the peculiarities of their shape reveal their practical function. Thus, while there are relatively few surviving Safavid (or later) drawings of this kind, the designs for myriad practical objects of the Timurid period are documented in especially large numbers. They occur both verbally – as in the *'arz dasht*, the workshop document presumably issuing from Baysunghur's Herat atelier, in which bindings and illuminations for manuscripts, small pieces of furniture, tile designs, tent poles and saddles, textiles for tents, and architectural decoration, are mentioned – and as pictures, in the drawings mounted in some of the same albums that also preserve Timurid working and underdrawings.

That the albums are virtually always to be found in the Ottoman Imperial Library in Istanbul (or originally came from it) illuminates a significant aspect of Safavid sixteenth-century history: the continued menace of the Ottoman Turks at Iran's north-western frontier. Whether these paintings and drawings were originally part of the Timurid library that fell into Safavid hands quite early in the sixteenth century and were then captured by the Turks at Chaldiran in 1514 [Fig. 77], or had instead found their way directly into the Ottoman treasury with Badi' al-Zaman in 1507, they summarize the uncertain security of Safavid

Tabriz in the first half of the century. So much so that by 1548, it was decided to relocate the seat of Safavid government and all the fixed court apparatus and household to Qazvin, a city conveniently located between Azarbayjan and Khurasan, the two theaters of perpetual Safavid conflict with their neighbors.

QAZVIN: PAINTING IN THE SECOND HALF OF THE SIXTEENTH CENTURY

How complete Tahmasp's weariness of the pictorial arts might actually have been in the years after the "Edict of Sincere Repentance" is far from clear. The building activity that appears to have followed the move from Tabriz to Qazvin is one index to this question.

Tented camps, in the Turco-Mongol tradition, may have been the setting for debate on matters of political significance and the making of military decisions: they were located wherever the Shah and his court, his advisors and his secretaries, might have been at the moment. But Tahmasp must also have been preoccupied with establishing the "perquisites that set forth the pomp and grandeur of a sumptuous court" (in the words of the seventeenth-century French jeweller, Jean Chardin), for his new capital of Qazvin. He ordered the erection of a palatial precinct, Sa'databad, in the Ja'farabad district to the east of the city; its completion eventually came to require the services of crafts-men he had earlier dismissed. Regarding the calligraphic decoration, Qadi Ahmad wrote:

> When the Lord of Sultans . . . completed the building of the *daulat-khana* in the capital of Qazvin, and a need was felt for inscrip-tions (*kitaba*), orders were issued that . . .

calligraphers in princely service elsewhere should return to Qazvin.[10]

As regards the painted decoration, the documentation again lies in contemporary poetry, notably in the text of a *Khamsa* written by a certain 'Abdi Beg Shirazi. His *Jannat al-'Adn*, the *Garden of Eden*, was composed between 1557 and 1560. It celebrates the beauties of Tahmasp's new palatial complex and describes some of the painted and tiled decorations in the central building of the complex, the Daulatkhana. These include images of blossoming gardens, and scenes of riding and the chase: leopards and lions, gazelles and birds are men-tioned, as are Turkish archers and other brave huntsmen who vanquish their prey. All are so beautifully painted that they would challenge the work of Mani himself.[11]

Qadi Ahmad also records that Tahmasp himself painted several pic-tures in another building, called the Chihil Sutun, in the new capital. Of the type termed *majlis* – usually meaning "group picture" in such a context, one of these paintings was a scene of Yusuf appearing before Zulaykha and her ladies. Such references to sixteenth-century princely Safavid buildings no longer standing highlight the significance of the mural ensemble of about 1580 discovered in the small palace in Nayin [86, 158, 231], well south of Qazvin near Isfahan. The decoration of the Nayin pavilion echoes the themes of the Qazvin paintings known only by report and by literary reference, while the overall style of the ensemble – even if its technique is different – reflects that being practiced in the capital of the moment. The small "Literary Room" in the Chihil Sutun in Isfahan [249], dating from no earlier than about 1647, is a seventeenth-century example of the sixteenth-century picto-rial tradition exemplified by the Qazvin and Nayin pavilions and reflected in contemporary poetry.

Illustrated manuscripts of high quality made in Qazvin are a rather different matter: in 1929, Sakisian had declared that he knew of no

illustrated manuscript "dated in Qazvin." Nearly thirty years later, Robinson could write that "this period seems particularly barren of manuscripts whose colophons contain statements of their place of origin"[12] – which is not to say that there are no illustrated manuscripts from the second half of the sixteenth century, but rather that they rarely name Qazvin (or any other locale) as their place of production. Notable is that the range of authors whose texts were illustrated seems wide, more varied than was found in Safavid Tabriz, and exceptionally so when a comparison is made with the Shiraz output during the entire century. And it is swelled when, to manuscripts clearly illustrated in the Qazvin style, is added a group of contemporary manuscripts with illustrations in a variant style (sometimes resembling the work of Muhammadi *musawwir*); inscriptions in some of these manuscripts name smaller centers in Khurasan – Bakharz and Sabzavar. Works by Jami, Firdausi and Nizami abound; copies of Amir Khusrau, Hafiz, and Sa'di, and Hatifi, Hilali, Sana'i, and the Timurid historian Mirkhwand, are less frequent. An illustrated copy of the legends of the saints and prophets by al-Nishapuri, a *Qisas al-'Anbiya* of 1565, is perhaps evidence of a mid-sixteenth-century vogue for illustrated volumes of *fal* [215, 216], or fortune-telling.

In all of these manuscripts the illustrations are stylistically unmistak-able, both in figural mannerisms and landscapes, even if our sense of it is built up compositely. A number of single-figure paintings, of dis-sipated youths and beautiful girls, vividly enhance the notion of this style. Perhaps the *locus classicus* of the "Qazvin style" of painting is the illustrations in a splendid manuscript whose place of execution is not one, but many, in Khurasan as well as in the capital itself. It is a copy of Jami's *Haft Aurang*, *Seven Thrones* [41, 85, 111, 217], that was made for Tahmasp's bibliophile nephew Ibrahim-Mirza over a number of years in the middle of the century.

IBRAHIM-MIRZA'S *HAFT AURANG*

Tahmasp had named his nephew governor of Mashhad at the age of sixteen, and Ibrahim and his entourage entered the city just before Nauruz in March 1556; his bride and cousin, Gauhar-Sultan, and her party arrived there in the summer of 1560. The *Haft Aurang* was prob-ably begun in Mashhad in the period between these two dates: one picture in it is surely a pre-marriage portrait of Ibrahim-Mirza, in the guise of the beautiful Yusuf, entertaining at court [41]. In 1564, however, a period of turmoil began in Ibrahim's own life. Shah Tahmasp revoked his nephew's governorship (and presumably also the revenue sustaining his myriad activities), and for much of the next decade he moved from place to place in Khurasan, until about 1574, when Tahmasp invited him back to the court in Qazvin. This last period of reconciliation and favor did not last either for the Shah or his nephew. Tahmasp became seriously ill in the autumn of 1575 and, although in due course he recovered, he died of poison in the spring of 1576; while in the fol-lowing year, Ibrahim-Mirza was murdered at the order of the new Shah, his cousin and brother-in-law Isma'il II.

Qadi Ahmad, whose father had been Ibrahim-Mirza's vizier and who was probably about the same age as this attractive prince, has left a long verbal picture of him, in which a deep affection transmutes the con-ventional phrases of courtly writing. The picture that emerges is of a man of immense and varied talents. His library contained some 3,000 volumes; concerning the arts of the book, his biographer commented that "No sultan or khaqan possessed a more flourishing kitabkhana . . . [in whose service the] majority of excellent calligraphers, painters, artists, gilders, and bookbinders were employed. . . ."[13] Yet most of their

efforts no longer survive, and for the usual variety of reasons. The celebrated album of "the writings of masters and paintings of Maulana Bihzad and others" given to Gauhar-Sultan at their marriage is a grim exemplar: the princess washed it out with water upon Ibrahim-Mirza's murder in 1577, in fear that it should fall into the hands of the fanatic Shah Isma'il II. That the *Haft Aurang* did not suffer the same fate must be because it was not then in her possession.

Ibrahim-Mirza's *Haft Aurang* remains a testament to the taste, style, and pictorial achievements of the second half of the Safavid sixteenth century: in the quality of its calligraphy and of its copious illumination, and in the personal meaning of many of its twenty-eight illustrations. Moreover, it contains information, in its eight colophons and the details of its physical assembly, that has profoundly altered our understanding of the production of fine manuscripts in a princely milieu at this period. And it has survived virtually complete and in surprisingly good condition, given that it almost certainly went to India within little more than half a century after its completion. The manuscript originally had dimensions similar to Tahmasp's *Khamsa* and, like the latter, it also has wide, illuminated margins of paper different from that on which the text is written. It was copied by five different scribes over a period of nine years, from 1556 – the year of Ibrahim's appointment as governor of Mashhad – to 1565, and in three different cities – Mashhad, Herat, and Qazvin. The pictures, and the extraordinary illuminations and decorated borders as well, may be later in date, since the colophons documenting the nine-year span between 1556 and 1565 refer only to the copying of each successive poem. Nearly every page carries some kind of golden ornamentation, at the least as column dividers and borders if not also illuminated headings, rubrics, or triangular panels. It is likely that Ibrahim himself contributed to this aspect of the manuscript, for despite its lavish quantities of illumination, the name of only one – other – illuminator is to be found anywhere within it. And Qadi Ahmad describes Ibrahim as having "golden hands," calling him a master in the various techniques of this fine and exacting art of the book.[14]

The paintings of the *Haft Aurang* are neither signed nor dated, which has engendered much discussion in an effort to assign them to artists known by name or – by stylistic analogy – to other signed paintings or drawings. Their subjects are relatively uncommon, and many were devised from a larger pool of pictorial elements whose antecedents are often evident; Ibrahim-Mirza's artists put them to striking and original uses. Some are based on Timurid compositions and one recalls very early Safavid painting; others are constructed on the examples of the most mature Tabriz compositions with their ample rhythms and gorgeous [85] or intensely lyrical settings. Several are unforgettable images with taut, energetic lines of buildings [41, 85, 111] or tents providing a structure for complex assemblages of personages whose expressions and interactions convey nuances beyond the meaning of the illustrated episode. Some pictures anticipate the distortion of figural proportion and pose that is one of the hallmarks of Qazvin painting and drawing. Another hallmark at the Qazvin style is seen in the settings, in which languidly contorted figures are virtually lost among fantastic rock landscapes, or of tents and canopies in the wilderness [217], or amid the skewed geometry of palace-pavilions. Stchoukine's comment is apt: Qazvin painting, as it is seen in this manuscript, sacrificed the linear clarity of the Tabriz style and replaced it with rich visual confusion and a highly refined chaos.[15]

This moment of "refined chaos" did not last long. A large double-page painting [145], with splendidly executed borders of cavorting beasts drawn in gold and silver, has a tamer and more open landscape setting in which larger figures take a midday rest from hawking in the

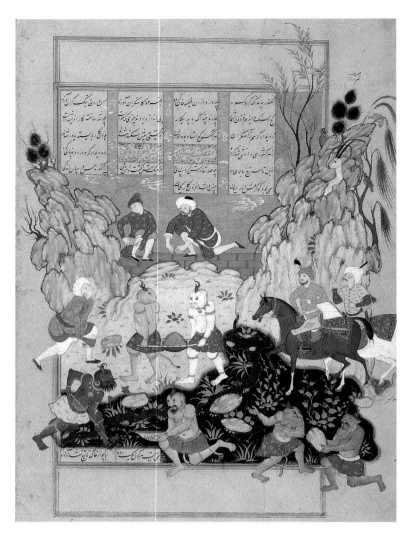

75. "Iskandar Builds a Wall Against Gog and Magog," folio from Isma'il II's *Shahnama*, Qazvin, 1576–77; The Art and History Trust

mountains. Only in the human element can the mannerisms of the classical Qazvin figure still be seen: slender, long-waisted bodies with wide heads on overly slender necks, enormous and heavily lashed eyes, and a silhouette with elbows akimbo and knees sharply bent. This exaggerated figural style would soon yield to a differently exaggerated style, evident by the last years of the century; landscapes and settings would become quieter, less chaotic and mannered, as can be seen in many of the paintings in a now-dispersed *Shahnama* manuscript considered the accession-*Shahnama* of Shah Isma'il II and, therefore, datable to 1576–77 (Fig. 75). Representations of architecture, in paintings from the last years of the sixteenth century and into the seventeenth, remain for the most part only typical constructs, but occasionally a true sense of built reality appears [87, 98, 112], giving a foretaste of turn-of-the-century painting, with a kind of representational reality similar, if not equal, to the settings of the Timurid *Bustan* or the *Haft Aurang*'s "Yusuf Entertains at Court."

SHIRAZ: PAINTING THROUGHOUT THE SIXTEENTH CENTURY

Sixteenth-century Shiraz manuscripts with illustrations are an entirely separate chapter in the history of Iranian painting. Fine volumes had long been made in Shiraz, as is documented by their survival from the first third of the fourteenth century, despite the fact that the only princely bibliophile-governors of Shiraz were Timurids who ruled in the first half of the fifteenth century. The arrival, and departure, of successive Turkman rulers in the second half of the century, and the presence of Safavid governors all through the sixteenth century, did not

affect the vigor and productivity of its long-lived manuscript traditions. To the contrary, Shiraz in this first part of the Safavid period maintained its position as a thriving center for the commercial production of well-calligraphed and finely illuminated manuscripts of all kinds; some of the unillustrated manuscripts, especially Qur'ans, are exceptionally fine.

Illustrated Shiraz manuscripts of the period may also be of good quality, and the best have a certain gaudy grandeur. The works illustrated include all the classical authors, and a number of more unusual texts: a series of copies of Sharaf al-Din's ʿAli Yazdi's *Zafarnama* [110], works by the Timurid historians Mirkhwand and Khwandamir, and several copies of Sultan-Husayn Bayqara's sufi biographies [169, 175]. The pictures in these manuscripts are coloristically unique. The Shiraz sixteenth-century palette is quite different from the balanced bright richness of contemporary Tabriz paintings: it prefers light hues, and secondary rather than primary colors, and it makes much use of shades such as chartreuse and acid pink, yellow-ocher and a taupe-lavender, dramatically juxtaposed and which ought to clash but instead are memorably satisfying. And all Shiraz manuscripts of the sixteenth century, with or without illustrations, have a particularly distinctive appearance because they are produced according to a particular proportional canon operating throughout most of the century.

Determining all aspects of a good mid-sixteenth-century Shiraz manuscript is a set of numerical relationships, essentially 2 (and 3): 5. This ratio controls the size of a folio, and therefore the entire text-block and the binding; it controls the size of the written surface laid down upon a folio, together with the breadth of the columns of text (in the case of poetry) and the width of its colored rulings. Illustrations are part of the canon: this ratio also controls the composition of any pictures in the text. The height of the horizon, the shape and placement of any architectural elements, and the width of the lateral extension beyond the vertical ruling are all "plotted," as if on an implied grid marked at ⅖ and ⅗ of the height and the width of the picture. The extension is also expressed as a proportional measure of the width of the entire picture and, as this is never so high as the written surface, it often results in the picture's peculiar "sideways T" shape. Classical Shiraz paintings of the sixteenth century, thus, often have extremely irregular outlines (which makes them difficult to measure accurately), even when the text and the picture are both contained within the characteristically wide rulings of many colors and gold. The proportional canon also controls the content of the extension: often architecture will be placed in it, the separation between interior and exterior being emphasized by the implied vertical of the unseen marginal ruling.

Why this canon should have developed in so systematic a manner in the sixteenth century in Shiraz but not elsewhere – or hardly to the same extent elsewhere – is unclear – although the reason cannot be unconnected with its tradition of commercial manuscript production. Variables such as the overall size of a manuscript, the quantity of illumination, the number of illustrations, and the amount of gold to be used in both pictures and illumination were, evidently, dependent upon the means of the client (or the sponsor). But the classical shape of a sixteenth-century Shiraz volume, no matter what its size, almost certainly derives from the commercial Turkman manuscripts being made in Shiraz throughout the second half of the fifteenth century. Their basic shape is narrower and somewhat taller than the classical Timurid volume, and a good commercial Turkman manuscript can often be recognized for what it is, even before the volume is opened and its paintings examined. Thus, the question probably better posed is one that focuses on the fifteenth-century commercial Shiraz-Turkman manuscript as the forerunner of Shiraz Safavid volumes.

The primary study of sixteenth-century painting in Shiraz was published over half a century ago, well before Turkman manuscripts, either princely or commercial, had been recognized.[16] The author of this study had noted various earlier page-layouts – she called them "plottings" – and pointed to Timurid examples as precedents for the Shiraz sixteenth-century canonical layout. A functioning Timurid proportional canon does appear to ordain the layout of extraordinary later Timurid manuscripts, for instance Sultan-Husayn's great *Bustan* manuscript [248]. But a great deal more fundamental work – primarily to measure, and record, manuscripts of all kinds and qualities – has yet to be done before broader conclusions can be drawn. Shiraz, then, provides a fascinating, if somewhat isolated, body of evidence for the existence of a canon of integrated and harmonic organization covering every aspect of the art of the Iranian book.

It was not a static canon. Instead, the sixteenth-century Shiraz canon really begins to appear in the 1520s, sometimes in pictures with a certain complexity and crowded grandeur. Some of the best examples of it date from the middle of the century. Not coincidentally, this is also the time when the hand of "refugees" from Tahmasp's Tabriz workshops begin to be evident in the illustrations of Shiraz manuscripts, as elsewhere in the country. During the course of the century, compositions do seem to open up and to exhibit a certain spaciousness, being less densely filled with patterned textiles [110] and architecture; other paintings begin to reflect the smoothed-out provincial Qazvin style in which suavity in the rendering of landscapes replaces the delicate Shiraz spikiness. The absence of the Safavid *kulah*; with its protruding baton, is to be noted by about 1570 in Shiraz, as elsewhere. By about 1580, a modified Qazvin idiom had spread widely throughout Iran, and by the end of the century only the occasional reminiscence of the classical Shiraz "sideways T" shape argues for a Shiraz origin in the case of an otherwise unidentified painting.

QAZVIN AND ISFAHAN: PAINTING IN THE TIME OF SHAH ʿABBAS I

Shah ʿAbbas I, the sixteen-year-old grandson of Shah Tahmasp, came to the throne of Iran in 1577 and ruled for over half a century, as long as his grandfather and even longer than the Sasanian Khusrau I, to whom he was sometimes compared [42]. Khusrau had reigned from 531 to 579, a period considered a high point of Sasanian history. He made significant reforms in social policies and fiscal planning, in agricultural and military affairs; he restored Iran's pre-eminent position in international trade and reasserted the country's political supremacy among her Byzantine, Armenian, and Hephthalite Turkish neighbors; he encouraged justice in the land, and learning among its inhabitants. History accords him the epithet Khusrau Anushirwan, Khusrau of the Immortal Soul, and in certain ways the reign of ʿAbbas I was seen as a Safavid parallel to that of Khusrau Anushirwan. Upon his accession, ʿAbbas had quickly, and finally, put an end to the military domination of the Turkman tribes and largely suppressed tribal squabbling. He made peace with Iran's enemies, with the Ottomans to the west as early as 1590, and also, if only temporarily, with the Uzbeks on his eastern borders; and he expanded Iran's territories by annexing Georgia and Shirwan, in the north, and the territory of Bahrain, in the Gulf. He reorganized state administration and encouraged trade and agriculture, especially sericulture, on which product the far-flung and highly profitable Safavid trade in raw silk was based. He built extensively: he repaired roads and bridges and erected caravanseries all over the country. And he moved his capital to Isfahan beginning in the 1590s, establishing it as an international

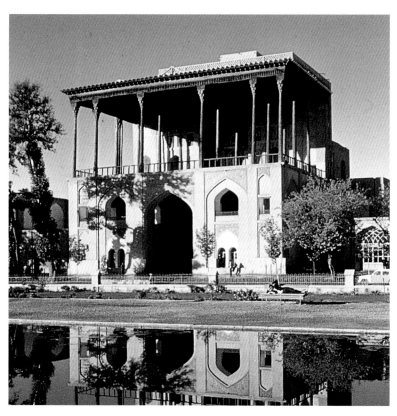

76. The ʿAli Qapu, Isfahan, enlarged in the first decades of the seventeenth

showplace by initiating the construction of mosques, palaces [Figs. 76, 80], and markets [Fig. 83]. In what was by then well understood as a pictorial gesture of homage (if not actually of dynastic propaganda) made in the context of an illustrated manuscript, one picture in an early seventeenth-century copy of Firdausi's *Shahnama* sets the accession of Khusrau I in a contemporary Isfahan milieu that was surely inspired by the terrace of ʿAbbas's great open audience hall in the gateway structure called the ʿAli Qapu, the Lofty Portal (Fig. 76).

ISFAHAN: MANUSCRIPT ILLUSTRATION AND OTHER PAINTING IN THE TRADITIONAL SEVENTEENTH-CENTURY STYLE

It might be argued that large-scale mural painting was the primary figural art in Shah ʿAbbas I's reign, at least at the princely level of patronage, although numerous single-figure paintings and drawings would immediately challenge the argument. But few illustrated manuscripts of princely quality appear to have been made in ʿAbbas's reign and throughout the first half of the seventeenth century. A signal exception is a fragmentary *Shahnama*: it is usually considered to be what remains of a manuscript commissioned by Shah ʿAbbas shortly after his accession in 1587. It only survives as twenty-one leaves with an exquisite illuminated heading and sixteen pictures [80]. The very large folios have splendidly decorated margins and there is much grandeur, and gravitas, to those of its paintings executed in the traditional late sixteenth-century styles. The lack of any statement of date, place, patron, and artist has encouraged speculation, especially about its painters; that it remained incomplete is clear from the two pictures [99] added by the later seventeenth-century artist, Muhammad Zaman ibn Haji Yusuf of Qum, in 1676.

All the paintings in this *Shahnama* are full-page in size: that is, they occupy the full height of the written surface. The lavish margins display golden animals and birds cavorting in luxuriant landscapes, a feature of

only the finest princely manuscripts of the sixteenth century – Shah Tahmasp's *Khamsa* and the double-page Qazvin "Hawking Party." [145] Such margins set off the paintings as a gold mount does a precious stone. None of the pictures is signed, but the two foremost painters of the period, Sadiqi Beg and Riza, presumably contributed to the project, the latter because of his early fame, and the former because of his position. In several pictures may be seen the delicate drawing and execution thought to be typical of the young Riza-i ʿAbbasi [Fig. 78]; fewer have been attributed to Sadiqi Beg, although it would be natural to assume that the artist who headed Shah ʿAbbas I's library, for two decades after his accession in 1577, would have participated in the project. At least one more sixteenth-century painter's hand has been recognized, while Muhammad Zaman's seventeenth-century pictures are in his distinctive and eclectic style.

If princely manuscripts are relatively rare in the period of Shah ʿAbbas I and his successors throughout the century, merely good, or ordinary, manuscripts were produced in some numbers. Firdausi's *Shahnama* was especially popular. A peculiarity of these seventeenth-century copies is that often they are quite large, even if the written surface is not commensurate in size, and they often contain great numbers of illustrations. One, dated 1602, has sixty-two pictures [42, 159, 182]; another, made for a governor of Mashhad in 1648, has 148 [10, 18, 87, 134]; a third, with dates throughout the decade between 1642 and 1652, has 192 contemporary illustrations. Nizami's *Khamsa* was also popular although its pictorial program was never so extensive; the same is true for texts of Amir Khusrau, and other poets – Hilali, ʿAttar, ʿAnwari. The taste for illustrated works by Jami and Saʿdi seems to have waned, but a poem written by Muhammad Riza Khabushan in 1604, a sufi tale of love between a Hindu princess and a Muslim youth, was briefly popular as an illustrated text in the 1650s and 1660s. In the last quarter of the century illustrated works of history, especially Safavid history, seem to have been commissioned in some numbers. These include three copies of a history of Shah Ismaʿil I, composed by the historian Bijan in the 1680s and illustrated by the workshops of Muʿin *musawwir*, each having at least twenty pictures (Fig. 77); a copy of a different history of Shah Ismaʿil I, completed in 1094/1683 with seventeen paintings; an undated, but illustrated history of the dynasty, composed for Shah Sulayman in 1667–68, by the guardian of the Ardabil Shrine, with twenty-two full-page paintings; and an illustrated account of the Safavid retaking of Hurmuz from the Portuguese in 1622, completed toward the end of the century.

A handsome copy of al-Nishapuri's tales of the saints and prophets perhaps throws some light on Shah ʿAbbas I's thinking about the uses of fine illustrated manuscripts, even if he seems not to have commissioned many new ones for himself. This *Qisas al-Anbiya* is defective at the end and thus lacks its colophon, but it still contains twenty illustrations, one signed by Riza (who surely painted others in this manuscript as well) [218, 219]; one has recently been attributed to Sadiqi Beg. Probably therefore made in the royal atelier in Qazvin, the pictures have all the hallmarks of the early Isfahan figural style even though the compositions often recall earlier sixteenth-century *Falnama* pictures. An inscription on the first folio, dated in March of 1615, notes that it was then in the library of the Mughal emperor Jahangir – within only two decades of its completion: might the manuscript have been a gift to his "brother" emperor from Shah ʿAbbas I? Many other manuscripts of this period – not all of them princely – have similar, dated inscriptions recording their presence in the Mughal library; again, the dates are often shortly after the volumes were completed. Whether this throws any light on the state of politics, trade, or personal diplomacy between the two empires remains to be explored elsewhere.

Shah ʿAbbas I's most celebrated offering of an illustrated volume is

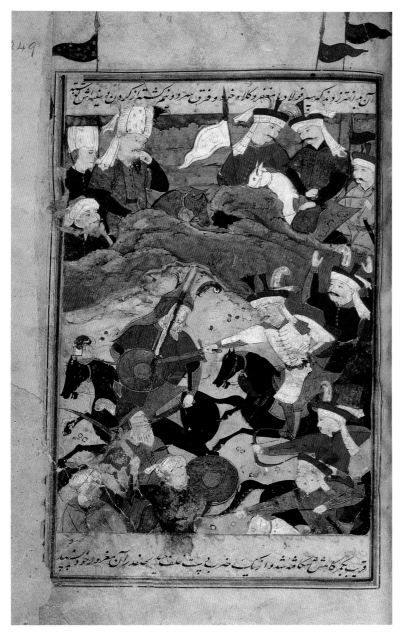

77. "Shah Isma'il I and Sultan Selim I at the Battle of Chaldiran in 1514," from a copy of Bijan's *Tarikh-i Jahangusha-yi Khaqan Sahibqiran*, Isfahan, ca. 1690; London, British Library, Or. 3248, folio 249r

SADIQI AND RIZA: WORDS AND IMAGES II

The Safavid artists responsible for so many of the paintings discussed in this chapter are less anonymous than their Timurid counterparts. This is in part because of the writings, among others, of Dust Muhammad, Sam-Mirza Safavi, Qadi Ahmad, and Iskandar Munshi – their accounts span nearly a century, from 1543 to 1617 – but also because it became more and more usual for Safavid artists to sign their work. For example, Iskandar Munshi commented that during the reign of Isma'il II (1576–77) worked other excellent artists and painters, such as Muhammadi of Herat. Indeed, the name "Muhammadi *musawwir*" occurs on perhaps a dozen or so tinted drawings from the third quarter of the century. His style is delicate, his chosen subjects pastoral and notably uncrowded, and his work is remarkably uncalligraphic in its draughtsmanship. The earliest date connected with Muhammadi, 1568, occurs in a manuscript of Hafiz finished in Bakharz (in Khurasan) which also contains several paintings recently attributed to him. Only two other dates, 1578 and 1584, occur anywhere in the inscriptions on indisputably signed works, and the details of his life are otherwise sparse. Iskandar Munshi's laconic notice and the uninformative inscriptions on Muhammadi's drawings have given rise to continuing speculation, in the attempt to flesh out both the details of his life and to swell his oeuvre. By contrast, Mu'in *musawwir*, the most celebrated practitioner of the traditional style of the seventeenth century, often annotated his paintings and drawings with astonishingly copious and immediate details [193] but appears nowhere in written contemporary sources. Clearly, words are not always sufficient to resolve the questions raised even by signed images; indeed, words sometimes resist the interpretation that seems obvious from a picture.

The lives and careers of Sadiqi-Beg and Riza, two of Shah 'Abbas I's court painters, well exemplify the problem, for interpreting words in the light of images, and vice versa, is the crux of problems that have accumulated around both painters. While the arguments need not be repeated here in detail, the larger issues – the reliability of visual evidence versus the written evidence of texts and signatures, and the extraordinary variations of style in what are supposed to be the works of a single artist – deserve some attention. Especially so since these concerns arise only slightly in advance of the moment when radical stylistic changes begin to occur in the aesthetic of Safavid figural painting, as they will also arise in connection with painters of the eighteenth and the early nineteenth centuries. The younger of the two painters, Riza, represents the first instance of the problem in the literature on Iranian painting; let us turn first to him.

Riza – Aqa Riza, as Qadi Ahmad names him – was the son of 'Ali Asghar of Kashan, a painter in the service of Ibrahim-Mirza and later, Isma'il-Mirza, Shah Isma'il II. He was probably born in the mid-1560s and entered the library, and painting atelier, of 'Abbas I shortly after his accession in 1587. Qadi Ahmad's family was close to 'Ali Asghar's, and while the biographer had not yet met the young "painter of beauty," he could write:

> . . . in the flower of his youth he brought the elegance of his brushwork, portraiture, and likeness to such a degree that, if Mani and Behzad were living today, they would praise his hand and brush a hundred times a day.[17]

A large number of drawings and single-figure paintings [146; Fig. 78], some still mounted in albums, and a few manuscript illustrations, all of them signed either "Riza" or "Aqa Riza," embody the kinds of paintings Qadi Ahmad mentions. The Qazvin mannered figures have given way to larger ones with a sturdier, but still delicate, stance; the

surely that of Sultan-Husayn Bayqara's *Mantiq al-Tayr*. Along with so many other treasured Timurid manuscripts, this had been acquired by the Safavids and remained in their possession for over a century, unfinished and probably untouched. Eight spaces had been left for illustration when the manuscript was copied, but only four Timurid pictures were actually painted [60, 168]. At some time before 1609 it was again taken in hand: the folios were remargined with colored paper, either gold-flecked or marbled, new illuminations were made for the opening of the volume, a new binding prepared, and paintings [98] made for the four blank spaces left in the initial part of the text. The first of the new paintings is signed by Habiballah [250], an artist who had earlier worked for Husayn Khan (the Shamlu governor of Herat) and may have played some part in the revival of the Timurid manner seen in some illustrated manuscripts of the later sixteenth century. All the paintings, and the colophon page, were then stamped with 'Abbas's seal – one falling upon both the new border with its wide rulings and the picture [98]; and the word *waqf*, meaning "inalienable donation," was written onto each picture, as it also was on the colophon page. The refurbished volume made a handsome gift to the Safavid family shrine in Ardabil, perhaps the most splendid of the entire donation of the year 1609 which included other fine manuscripts and an album of mounted paintings.

heads are more oval, the eyes longer, but not so large as the classical Qazvin eyes, and the mouth merely a line with an expressive wriggle in the middle to indicate the bow of the lips (Fig. 78). A constant feature is the fine curling black hair, always shown escaping from the head-coverings of both men and women, unless they are actually shown bareheaded.

What gave rise to controversy, for more than half of the twentieth century, was the existence of a related but distinctly different group of images, again mostly single-figure paintings and drawings signed "Riza-i ʿAbbasi." Not precisely the same name as "Riza" but having one similar element, these pictures also bore later dates than "Riza's" paintings, between about 1603 to about 1635. Because the later paintings were considered to be stylistically coarser and far more mannered than those of "Aqa Riza," they were thought to be the work of a different painter. Lines were always far more pronounced than in works signed "Riza," the curving silhouettes of the very plump standing figures quite exaggerated – almost dangerously so – and the palette placed a peculiar emphasis on deep greens, browns, and purples with some yellow accents, in contradistinction to the strong reds, greens, and blues of "Riza's" paintings. For some decades of the century, the "dualists" and the "unitarians" (as Robinson termed them) could not agree on whether they saw in the entire grouping the work of one, or two, artists. But by 1964 Stchoukine could gather together enough evidence to propose, convincingly, that "Riza," "Aqa Riza," and "Riza-i ʿAbbasi" were all versions of the same painter's name.[18] In hindsight, it seems clear that the comments by both Qadi Ahmad and Iskandar Munshi might well have been accepted as the reliable eyewitnesses they are: the former says that Aqa Riza was appointed to the court of Shah ʿAbbas, while the latter, writing about 1615, comments that Riza

> . . . avoided the society of men of talent and gave himself up to association with such low persons. At the present time he has a little repented of such idle frivolity but pays very little attention to his art, and like Sadiqi Beg he has become ill-tempered, peevish, and unsociable . . .[19]

Today it is difficult to appreciate how the two groups of pictures could not have been seen as issuing from the hand of one painter. Connoisseurship does not account for the lapse, and it is even more at odds with the written documentation relating to Sadiq (also known as Sadiqi Beg or Sadiqi Afshar), the irascible Turkman who eventually became Shah ʿAbbas I's court librarian. A generation older than Riza – he was born in 1533–34 – he figures in both Qadi Ahmad's and Iskandar Munshi's accounts of painters and calligraphers in the last part of the century. During Sadiqi's own lifetime Qadi Ahmad could write that he was unrivalled in painting and portraiture; Iskandar Munshi, writing after Sadiqi's death in 1609–10, is equally complimentary regarding his painting but otherwise comments: "Sadiqi Beg was . . . of a disagreeable, jealous, and suspicious disposition . . . [a] surly, unpleasant character. . . ."[20]

But Iskandar Munshi begins his notice by calling Sadiqi a man of parts, practicing the literary as well as the pictorial arts. He composed a large number of works in both Persian and Chaghatay Turkish, poetry and biography, and he also wrote a treatise on the techniques of painting, the *Qanun al- suwar-i naqqashi*. As an artist, he is known by a small signed corpus of illustrations to epic poetry, single-figure paintings and line drawings with either signatures or attributions, and, perhaps, all 107 illustrations in a volume of animal fables. This corpus has one prevailing characteristic: its utter stylistic dissimilarity. His manuscript illustrations of the 1570s are competent but somewhat boring and compositionally formulaic. His single-figure paintings and drawings are

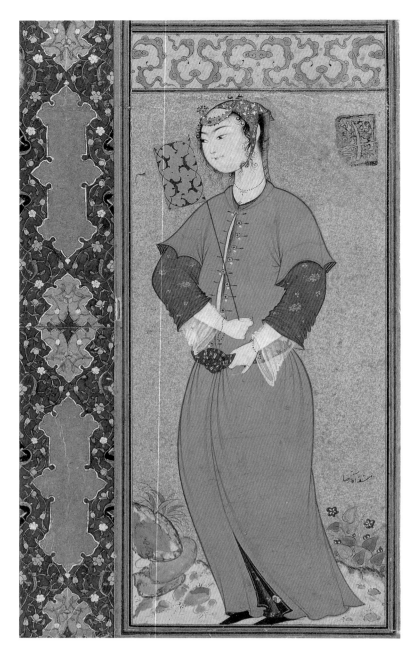

78. "Lady With a Fan," painting on paper by Riza, Isfahan, ca. 1590; Washington, DC, Freer Gallery of Art, 32.9

frequently in the manner associated with Riza, although the faces have not yet metamorphosed into the typical seventeenth-century Isfahan blankness. Indeed, they are all different, if quite stylized, which suggests some uncertainty om the part of the painter as to which style to adopt. The fluent, "electric" line said to be most characteristic of the mature Sadiqi can be seen in very few of these works, and it is notably absent from the 107 paintings in the volume that has acquired the status of a key document in his oeuvre.

The manuscript in question is a smallish copy of the *Anwar-i Suhayli* of 1593. It is hardly a lavish manuscript: it has very little illumination, while the pictures are not large, their palette is limited, the paint is thinly applied, and the finished paintings are only lightly polished [79, 97, 112, 210]. Yet they comprise a fascinating set of interpretations on pictorial themes of some age in the Iranian world. They draw heavily on classical Jalayirid and Timurid versions of certain stories and brilliantly reinterpret others; they develop new and wonderfully compressed images for some of the newer stories added by al-Kashifi, some of which remain unique. The colophon names the scribe (who is otherwise unknown) and the date of completion, and ends with a resounding, if enigmatic, phrase: "It is written as it is ordered by the rare man of the time, the second Mani and the Bihzad of the age, Sadiqi Musawwir."[21]

Nothing in this text actually mentions the paintings, although they have always been published as the work of Sadiqi himself, painted into a manuscript he had commissioned. They are similar enough in scale and scope and sources, in draughtsmanship and color, and in their attitude to life, to leave little doubt that they are the work of one painter only. But they have little in common with Sadiqi's earlier text illustrations, the single-figure drawings and paintings, or anything displaying the "electric" line. And they bear no resemblance whatever to the large and extraordinary "Simurgh Takes Zal to Her Nest . . ." [80], from Shah ʿAbbas I's accession *Shahnama*: its majestic breadth and magnificent stylization are at odds with the realistic observations, the figural mix of contemporary beautiful youth and profiled ugliness, and the overall pictorial economy of the 1593 *Anwar-i Suhayli* [97].

How can this apparent disparity be explained? Can it be that Sadiqi was an artist whose ability was best demonstrated when he was challenged by an exceptionally talented younger rival, such as Riza? Or a pictorial chameleon, taking inspiration wherever it might be found but never really developing a recognizable style of his own? How much better did he paint – or draw, for draughtsmanship lies closer to the surface of later sixteenth- and seventeenth-century painting than it does in earlier periods – when the monetary rewards were especially attractive? And how did his fundamental style – assuming he had one – alter when he was working for himself alone, as is presumably the case with the *Anwar-i Suhayli*? Does nothing in his art reveal his own hand, nothing, such as the "Morellian ear," convey his personal presence in any given work of art? In other words, did painters in this period never really develop personal manners, or mannerisms, leaving no personal pictorial "penmanship" to identify them, no matter what the elaboration, or simplicity, of the work might have been? And did a patron, then, receive only what he paid for?

All of this seems highly unlikely in general; it is especially unlikely for a painter whose personality was as well-defined as Sadiqi's and who seems to have had little difficulty in making others aware of himself, however unpleasantly so. Or could it be, instead, that the colophon of the *Anwar-i Suhayli* has not been correctly interpreted, and all 107 paintings are the work of another painter? For it is close to impossible to accept that these, and the signed (or attributed) single-figure pictures and the manuscript illustrations of the 1570s – let alone the late sixteenth-century "Virgin Mary and the Infant Jesus," [219] recently proposed as another work of Sadiqi – can all be by the same hand; unless the artist in question is so protean as to have no recognizable hand at all. Perhaps, then, this is another instance of the "Riza problem" in Iranian painting, one for the later part of the twentieth century and the early twenty-first, that will eventually also resolve itself.

MUʿIN *MUSAWWIR*

In time, Riza did resume painting, as well as its traditions of transmission from elder to younger practitioner. He lived, and continued to work, until 1635 – coincidentally the year in which also occurs the earliest dated example of his most famous, and most productive, pupil, Muʿin *musawwir*. In that same year, Muʿin started a marvellous portrait of Riza [193], which he later inscribed:

> The portrait of my late master . . . Riza-yi Musavvir ʿAbbasi, known by the name of Riza [-yi] ʿAbbasi Asghar. It was painted in the month of Shawwal 1044. In . . . the same year, he passed from this transient life to the eternal life. And this portrait was finished forty years later . . .[22]

Muʿin, curiously, appears in no written biographical sources of the later Safavid period, but numerous works signed "Muʿin *musawwir*" establish the long span of his activity, from 1635 to 1707. His output includes manuscript illustrations, single-figure paintings, and ink drawings. He was a prolific artist who attracted many followers and whose workshop practices must have dictated the need for many assistants; his distinctive signature, written in spidery black letters (on paintings it is usually placed toward the bottom, centered, and upright), helps to distinguish his own work from those who assisted him. His art is firmly grounded in calligraphy, yet his figures are far less mannered in form, less extravagant in line, and often far more engaged in their facial expressions, than those in the works of his teacher, Riza. His palette is less intense and less deep in tonality than is Riza's, but distinctive, with a strong reliance on a sugary pink and lavender balanced by the acid of yellow and orange. And his figural style – or rather, the facial style of his figures – is almost always recognizable as his work (although the face may be the only part of a painting for which he is responsible, especially in the manuscript programs [Fig. 77] of his later years). He remained impervious to the many foreign influences that shaped seventeenth-century painting in the hands of Muhammad Zaman, Shaykh ʿAbbasi, ʿAli Quli Jabbadar, and others, and there is no evidence that he ever left Isfahan. In the broadest sense, Muʿin is the last major representative of the traditional style of Safavid painting, even though his influence is so very evident in the mid-century traditional-style paintings that decorate the audience hall [Fig. 81] and the smaller reception rooms [36, 153, 161] in the Chihil Sutun, a reception-pavilion erected by Shah ʿAbbas II and decorated between 1642 and 1666.

ISFAHAN: MURAL PAINTING IN THE TRADITIONAL SEVENTEENTH-CENTURY STYLE

Shah ʿAbbas I's new capital of Isfahan had to accommodate a large court in the midst of an urban agglomeration of some size and history. Spaces and amenities for the royal household and the women's quarters, for courtiers and court receptions, for military personnel, for horses and stabling, offices for civil administrators and workshops for artists of all kinds, were laid out in buildings in a large garden zone west of the huge main square, or *maydan*, that quickly became the focal point of the newer part of Isfahan. It was called the *naqsh-i jahan*, the "picture of the world."

The walls and domes of the new religious buildings were coated with glazed tile decoration. The walls and ceilings of the new palaces and pavilions also had a certain amount of tile decoration, on the exteriors of the high walls framing portals or ʿiwans, called *pishtaq*, and on exposed dadoes; but their principal ornament was painting, much of it figural. A surprisingly large amount of painted decoration has survived on Isfahan buildings, testimony to the extraordinary figural component of seventeenth-century Safavid painting on the mural scale; this was echoed in ensembles of tiles with large figural compositions (Fig. 79). It is, now, abundantly clear that all the styles of late sixteenth- and seventeenth-century small-scale painting, as it could be seen in manuscripts and innumerable single-figure paintings and drawings, are matched by the ensembles still visible in, and on, the surviving structures of the seventeenth century: the ʿAli Qapu [147; Fig. 76], the Chihil Sutun [36, 43, 153, 161, 191, 192, 249; Figs. 76, 80, 81], the monumental gate of the new bazaar [Fig. 83], and the Hasht Bihisht. The Ayina Khana and other buildings that no longer stand today were also similarly decorated: the accounts of European visitors – ambassadors, merchants, priests, travelers, and adventurers – are full of descriptions of them. And stylistic echoes of the Isfahan styles of painting and the

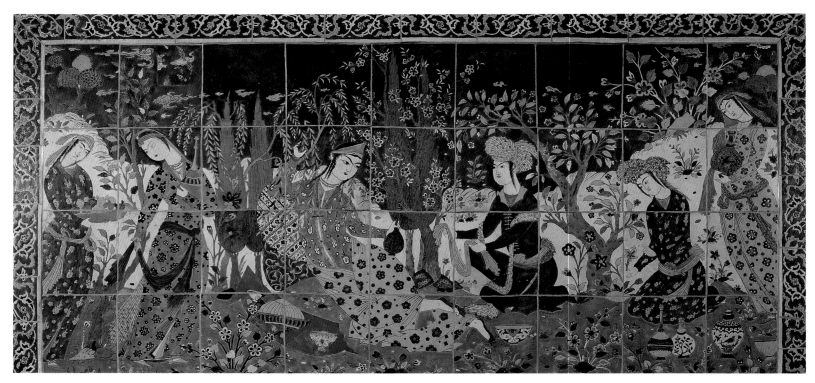

79. "A Gathering in a Garden," composition in glazed tile, Isfahan, first half seventeenth century; London, Victoria & Albert Museum, 139–1891

decorative arts floated back across the river, the Zayanda Rud, from the Armenian quarter of New Julfa. Some of them survive today – still further testimony to the widespread contemporary Iranian fashion for figural decoration. For, if Herat had been the fifteenth-century Paris of the East, in the seventeenth century Safavid Isfahan assumed this role.

The formal entrance to the new palace precinct was a large brick structure erected on one long side of the *maydan*, adjacent to the Shah's grand new mosque and directly across from a smaller Safavid mosque. The building itself quickly became known as the ʿAli Qapu [Fig. 76], the "high gate[way]" or "lofty port[al]" and indeed it is a high and lofty presence, with a large open porch three stories high facing out over the *maydan*, where the shah could not only see but be seen. Deeper into the zone gardens of lying behind the enormous *maydan*, later Safavid monarchs built other palatial structures during the course of the century. The mid-century Chihil Sutun stands in the midst of gardens and served as a formal reception hall. Its ceremonial character is intensified by the approach, on either side of a long pool in which the twenty columns of its large porch, or *talar* (Fig. 80), are doubled in reflection: forty columns – hence the name, Chihil Sutun, which means

just that in English. In comparison with the ʿAli Qapu, a primary difference is that its painted decoration is largely figural: pictures range from the truly monumental to small images resembling framed pictures hung at eye level (Fig. 81). A second difference is that the paintings display the two distinctly different styles characterizing the painting of seventeenth-century Iran, sometimes in the same room. One is traditional, growing imperceptibly out of the Qazvin style of the later sixteenth century and further shaped in Riza's hands [36]. The other is eclectic, a hybrid style formed of imported European influences but equally affected by contemporary Mughal Indian developments in painting [249].

As concerns this stylistic aspect of seventeenth-century, and later, Iranian art, scholars do not yet agree on the chronology of the Chihil Sutun, and therefore, on the dates at which its many pictures (and stylistically similar paintings elsewhere in Isfahan) were executed. All that is incontestable is the fact that the Chihil Sutun is a work of the period of Shah ʿAbbas II, who reigned from 1642 to 1666. Contemporary sources, both Persian and in many of the books written by Europeans who came to Isfahan during the first half of the seventeenth century, confirm this broad dating. Indeed, only one date is found anywhere in the building, equivalent to 1647, occurring in the last couplet of a panegyric poem rewritten on the back wall of the columned porch at the front of the building. No other written source, nor any other date within the overall ensemble of the Chihil Sutun, states or even hints when any area was decorated. Contemporary paintings on a smaller scale, either in illustrated manuscripts or as single-figure paintings or drawings, contribute little information that helps to resolve a fundamental question about the entire painted ensemble: was it created in two stages, separated perhaps by more than a decade of time? or were all the figural paintings executed at one single period, just following the construction of the building in 1647?

The principal programmatic painted decoration of the Chihil Sutun is found in its largest chamber, a triple-domed room twenty-three meters long and over eleven meters wide. Here the transverse vaulting defines three large spaces on each side of the upper level of the room, six in all. In the four outer spaces, two on each wall, were painted the

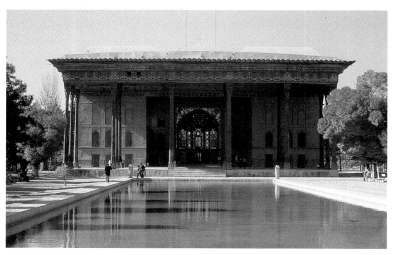

80. The front *talar* of the Chihil Sutun, Isfahan, after 1647

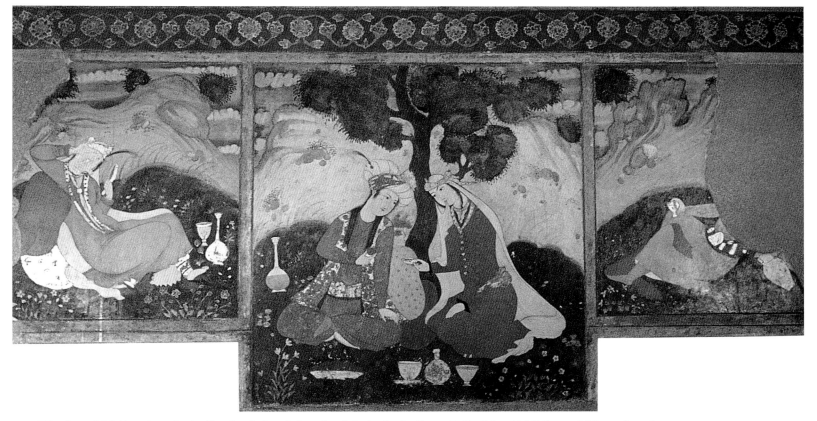

81. "Youths and Maidens in a Garden," wall paintings below the dado in the Audience Hall of the Chihil Sutun, Isfahan, after 1647

four rectangular pictures mentioned by Chardin in 1666; they are the images that originally conveyed the building's primary message. The two center paintings extend the theme, although they have pointed arched tops and are Qajar in date. The original message, and its later extension, would have been evident to all Iranians and was surely understood by visitors from any eastern land: the Safavid court was the refuge of fellow Muslim princes in difficulty, but non-compliance with the Shah's terms might result in defeat in battle, even death. Three of the four rectangular paintings show receptions at court, given by the reigning monarch [43, 191, 192] in honor of a princely visitor from the East. The fourth (but first in the series) pays homage to the military glory achieved by the founder of the dynasty in his rise to power: it shows Shah Isma'il in combat against Shaybani Khan the Uzbek, in 1511, and it is both thematically and stylistically different from the other three, as it is also later in date.

The middle zone displays painting of a very different nature. A frieze of pictures of single figures, or pairs of them, painted in the traditional Isfahan style (Fig. 81), runs around the entire room at just below eye level. The men and women are shown seated or reclining in pastoral landscapes and engaged in leisurely pursuits: they are none other than very large versions of the non-manuscript figural compositions of the period that were so often mounted in albums [146, 148, 160]. The remainder of the vast wall surface, flat walls and vaulted ceilings, is completely covered with floral decoration, painted and gilded in panels the shapes of which emphasizes the architectonic surfaces they decorate.

In front of the audience hall, to either side of the entry *iwan*, lie two smaller reception rooms also richly painted. The "Courtly Room" [36, 153, 161] is placed to the right of the passage; it is mirrored by another, to the left, decorated with a painted program of literary lovers. Each room again has a ceiling of three vaults, resulting from the transverse vaulting that divides the interior unequally into three, two narrow units flanking a central, wider one; the vaults then "flow" seamlessly down onto the longer side walls [cf. 86 and 98]. Like the audience hall, each room is divided horizontally, the uppermost zone extending to the ceiling, and the middle zone comprised of the smallest pictures in the building. Here, they are also rectangular and they are either neatly fitted

into the spaces not occupied by doors and fireplaces, or they are painted on the back walls of small recessed niches. The three upper pictures on the side walls are also recessed, set into larger niches with pointed tops [36]; the pictorial spaces at each end extend across the width of the chamber and are not recessed, although their tops are also pointed. As in the "Music Boxes" of the ʿAli Qapu [147], all have painted frames of floral and abstracted ornament. Below the dado and the zone of small rectangular pictures, the "Courtly Room" is painted with naturalistic clumps of flowers on a red ground, perhaps in imitation of Mughal textiles. Lastly, the vaulted ceilings are completely covered with floral and geometrical decoration, enlivened with molded relief and much gold. In the audience hall the ceilings were also given a red background, while in the "Courtly Room" the ground color is a pale ochery pink.

ISFAHAN: MANUSCRIPT AND MURAL PAINTING IN THE ECLECTIC STYLE

With one exception, all the paintings in both the "Courtly" and the "Literary" Rooms are executed in the traditional painting style; the exception is "The Bride Prepares to Immolate Herself" [249]. It is a very good example of the seventeenth-century Isfahan eclectic style on a monumental scale. The series of male and female figures decorating the exterior of the building are also painted in essentially the same style – at least as can be seen in those that survive today, the majority painted in niches shallowly recessed into the walls on the porches on the short sides of the building. Most are larger-than-life-size single figures; they all have the same face but are dressed in a bewildering variety of costumes mostly inspired by European pictures of various periods, although a few are Indian. They lend an exotic air to the crowd waiting upon the Shah, both inside and outside the Chihil Sutun. In larger niches, the ghostly remains of several group compositions may still be seen, copied from imported images. The same sources also underlie the many European-influenced images in various techniques and scales executed throughout the course of the century (Fig. 82), some in

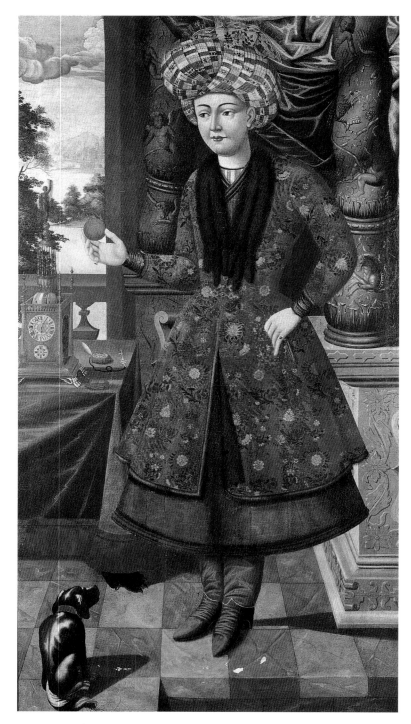

82. "A Youth Standing on a Terrace," oil on canvas, Isfahan, 1650–80; Tehran, Nigaristan Museum

quite public places. For if relatively few seventeenth-century residents of Isfahan could have expected to have seen even the exterior of the Chihil Sutun, most of them would, at one time or another, have passed under the new monumental portal of the bazaar at the northern end of the new *maydan* (Fig. 83), where, high up on the right side, was painted a large group composition in the same eclectic style, whose sources appear to be early seventeenth-century in date and possibly English.

The notion of the single standing figure, multiplied in a variety of costumes, was even adopted as a decorative format by the wealthy Armenians who built houses in New Julfa, no doubt made possible by the profits derived from their part in the silk trade. As in the Chihil Sutun, such figures are painted both inside and on the exterior walls, in the entrance-*iwan*s, of several surviving (in the 1970s at least) houses in this quarter of Isfahan whose plans, and decorative format, reflect the Chihil Sutun in the gardens across the river. Thus, one significant

princely building exemplifies the seventeenth-century Safavid pictorial wealth of figural imagery, realized in quantities of gold and paint that cover its visible surfaces, both inside as well as on its exterior walls.

What of the sources of the European-style painting found in architectural ensembles in Shah 'Abbas's Isfahan? Despite the presence of Europeans, and in some numbers, in Safavid Iran as early as the sixteenth century, the initial manifestation of European influences on Safavid painting is not easy to date with precision. European male dress of the late sixteenth and early seventeenth century – knee-length breeches and especially the black, brimmed hat – appears in a number of Riza's paintings throughout the early seventeenth century but they are often undated; the figure he is drawing, in Mu'in's portrait [193], wears such clothing even though the costume can hardly date from as late as the year the portrait was begun, 1635. A useful event in terms of just this question is the presentation to Shah Safi I, in 1638, of large oil-painted portraits of the English king Charles I and his French wife, Henrietta Maria. No trace of the actual portraits has ever been found in Isfahan, or elsewhere in Iran, nor is the artist named in the King's memorandum of 1637. But details from similar pictures – large canvases painted in oil pigments – produced by artists in the service of the English crown in the 1620s echo throughout the seventeenth century and into the next, in various media and on many scales: the standing pose of the King, the cut of the Queen's dress and her tiny

83. The portal to the *qaysariyya*, the great bazaar of Isfahan, first quarter seventeenth century

coronet [118], the objects, furniture, and architectural details of the formal image, of the type called "a painting with a prospect" (Fig. 82). Far more modest European images were surely also in circulation in Isfahan from the time the city became the Safavid capital in 1598. For instance, the effects left by Nicholas Wilford at his death in Iran, in December 1637, included books on architecture, perspective, and flowers; printed stamps, pictures of the four seasons, of a "Gentlewoman," and of a Spaniard; the pictures in the illustrated books were doubtless prints.

Their presence in seventeenth-century Isfahan is attested in several ways. European printed images might be used directly: pasted onto bookbindings and then lacquered, the covers enclosing texts in Persian or Arabic. The foremost Iranian practitioner of the "Europeanizing" style, Muhammad Zaman ibn Haji Yusuf, also appears to have made such a binding. A European print might be copied: Muhammad Zaman's "Return from the Flight to Egypt" [220] is a colored copy of an early seventeenth-century European print that is itself an intentional copy – albeit reduced in scale – of a large painting by no less celebrated an artist than Peter Paul Rubens. But the usual mode of transmission for foreign images – at least European images – into Iranian painting was the transfer of components from prints: figures and costumes, settings and accoutrements, that were used and reused, as single elements and then combined to make different narrative images or repeated in multiple, especially on the surfaces of decorated objects or in monumental ensembles, such as on ceilings or walls. European reproductive images prove, over and again, to have greatly influenced those Iranian painters ready to look farther than their traditional models for inspiration. This process of isolation, transfer, and reuse is very ancient in the Iranian aesthetic consciousness; only the kinds of images, and the style in which they are presented, are novel developments in the seventeenth century.

"The Return From the Flight to Egypt," dated 1689, also contains many of the landscape elements that recur throughout the oeuvre of Muhammad Zaman, both in single pictures such as this, and in the illustrations he added to, or composed for, two princely manuscripts of the most classical of Persian texts, Firdausi's *Shahnama* [99] and Nizami's *Khamsa* [118, 232]. The jagged tree stump with the alligatored bark and the leafy, broad, upper foliage function almost as "signatures" in his own paintings, but were quickly adopted by later painters, starting with his own relatives [163], the motifs again reduced to formulas and then copied, in various media, for two centuries to come. This is especially evident on the lacquered papier mâché objects that began to appear toward the middle of the seventeenth century, especially containers for writing implements, pen boxes – *qalamdans*.

For the next two and a half centuries, up to the fall of the Qajars in 1924, the possession of a pen box was the mark of a literate Iranian of class and taste; the material of choice was painted and lacquered papier mâché. Painted papier mâché had actually been in use in the Muslim East as early as the late fifteenth century for bookbindings [Fig. 1]. But the medium really came into its own in the mid-seventeenth century for the making of small, useful, shaped objects – jewel boxes [28] and caskets [Fig. 92], bookbindings, mirror cases [119], and especially pen boxes [11, 163]. It remained in favor well into the twentieth century, for it is eminently malleable, quickly yielding a blank three-dimensional form although the decorating process was usually time-consuming. The object would have been made of layers of paper impregnated with a vegetable paste and shaped in a mold, then covered with a priming and whitening layer of gesso, on which decoration would be painted (or otherwise laid down); the entire surface would be finished with coats of varnish or lacquer. In the seventeenth century,

papier mâché objects appear to be primarily pen boxes and mostly large in size: one such [163], in its dimensions as well as the superb quality and the density of its decoration, perfectly epitomizes the significance with which the object was invested in Iran for a period of nearly three centuries.

Nor did its inside decoration remain unnoticed. The luscious floral decoration on the interior of the lift-off lid was copied on innumerable later pen boxes and lacquered book covers, on which a single flower – a rose or an iris, isolated from the overall composition – often serves as the sole decorative element; while an entire composition of growing flowers is often used for the decoration of borders [Fig. 88] for paintings mounted in albums. And the size of the pen box provides another salient example of the Iranian material dynamic: larger, more intrinsically invested, or more audacious examples usually translate as earlier in date.

Muhammad Zaman was undoubtedly the most productive, as well as the most influential, of later seventeenth-century Iranian painters in the eclectic style [28, 99, 118, 220, 232], and while only about two dozen works incontrovertibly signed by him survive, their technical quality, and the fact that the finest were produced in a royal milieu, suggests their significance in the broader story of Iranian painting. But he was hardly the only painter to reflect the many foreign influences eddying around Isfahan in this period. At least one brother and probably also nephews of Muhammad Zaman also produced paintings in his apparently revolutionary but quickly codified manner. Reduced to its essentials, this is comprised of a realism in the depiction of persons and events; cast shadows, perspectively rendered trees or sharply angled buildings to suggest spatial recession, with minute figures in the blued background; and Muhammad Zaman's "signature" landscape details; while the quotation and adaptation of European, and also Indian, images continued to provide exoticisms. Some seventeenth-century painters in the eclectic style, such as Shaykh 'Abbasi and his sons, were more specifically influenced by India, although poses and Indian styles of dress are to be remarked even in Safavid painting of the traditional style from far earlier in the century. And a Georgian strand is also to be remarked, as it had in the later sixteenth century, although it is almost always confined to the artist's name or an inscription in Georgian on an acceptably late Safavid image.

Finally, in some of the paintings created during the reign of Shah Sultan Husayn (1694–1722) a differently oriented type of group picture seems to make its appearance. This is the horizontally aligned single-page court scene crowded with figures [44, 128]; variants include outdoor settings, festive gatherings or an outdoor encounter. A great many of the seventeenth-century examples that today survive were gathered into a large eighteenth-century album of Indian and Iranian paintings; moreover, all of the latter are executed in one or another of the eclectic styles of the seventeenth century. The model for these horizontally aligned paintings surely lies at the heart of monumental Safavid images – the reception scenes painted in the audience hall of Shah 'Abbas II's Chihil Sutun [43, 191].

Throughout the eighteenth century and under dynastic patronage operating in different places – Afshar, Zand [Fig. 86], and even Qajar [194; Fig. 91], in Shiraz, Tehran, and elsewhere – the horizontal court scene with elements of a contemporary setting was reproduced, on paper, and on the monumental scale, in oil pigments on canvas, as indeed the Chihil Sutun paintings were themselves so often copied in the eighteenth [128] and nineteenth centuries. Only toward the middle of the nineteenth century did this type of court picture give way to the plethora of other European models and materials that came to characterize the painting of Qajar Iran.

THE EIGHTEENTH AND NINETEENTH CENTURIES

The eighteenth century in Iran was an exceptionally turbulent period during which no fewer than five dynasties claimed to rule. The Safavids had effectively lost power in 1722 to Sunni invaders from the East, led by a descendant of the last Safavid governor of Afghanistan who, nonetheless, appointed a series of Safavid puppets as nominal rulers in Iran. Yet within a decade, a chief of the Afshar tribe, Nadir, proved so effective in wresting Iranian lands from the occupying Afghans that the Safavid puppet of the day, Tahmasp II, awarded him the governorship of large and influential provinces including his own province of Khurasan, as well as Sistan, Kirman, and Mazandaran. By 1736 Nadir had so successfully re-established control over Iran and its long-troublesome western neighbors, Turkey and Russia, that he could arrange his own proclamation as Nadir Shah Afshar. Forays into India followed in 1738–39; the tribute of gold and gems he exacted from the Mughal emperor Muhammad Shah was so vast that he could exempt the Iranian people from taxes for three years. In a short time, however, the ruthless cruelty of his reign brought the usual attempts at replacement by force, and an Afshar–Qajar alliance finally succeeded in assassinating him in 1747. Both tribal groupings retained power, in Khurasan and Mazandaran respectively, for the rest of the eighteenth century, jockeying for position, making feints at each other, biding time.

In the meantime, Fars and the south came under the beneficent rule of a Lur chief, Muhammad Karim Zand, who ruled from 1750 not as shah but as regent, *wakil*, for the last Safavid puppets. At his death in 1779, strife among his heirs broke out in Shiraz, although the last Zand ruler managed to re-establish personal control by 1789. But the hiatus had enabled the clan of the Qajars to outflank the Afshars. Agha Muhammad (who had been castrated, as a child, by Nadir Shah's nephew, in an effort – vainly, as it happened – to prevent eventual Qajar accession) had actually been crowned in 1785 and, from this position

of strength, was able to extend Qajar hegemony all over Iran, first in Isfahan and, by 1794, over Fars. Murdering the last Zand ruler in that year, Agha Muhammad could at last call himself Shah of all Iran, although it was his nephew and heir, Fath 'Ali, who repopulated the princely landscape and fathered the dynasty that ruled until 1924.

Fath 'Ali Shah's fecundity was one cause of strife among his sixty sons and their descendants. 'Abbas Mirza, Crown Prince and viceroy in Azarbayjan, had predeceased his father in 1833; but long before this date, the Shah had encouraged rivalry between 'Abbas Mirza and those of his half-brothers who had been assigned tenured governorships, with established courts, in Fars and in Kirmanshah. The result was a brief war of succession at Fath 'Ali Shah's death in 1834. His grandson, 'Abbas Mirza's son Muhammad, prevailed over his uncles and their respective supporters, and early in his reign he made a fundamental shift in domestic policy, discontinuing the practice of separate princes' courts. Thenceforward, sovereign power was concentrated in the line of 'Abbas Mirza, with the capital firmly established in Tehran.

If dynastic struggles for hegemony had abounded in eighteenth-century Iran, figural imagery was also abundant, especially from the time of the coronation of Agha Muhammad Shah Qajar in 1785. As if to counter the assertion that Iran, like other cultures within the Islamic community, abhors and forbids the representation of living beings, a host of painted and printed figural images characterizes the art of the late eighteenth and the nineteenth centuries in Iran. They include figures on the tiniest of enamelled and jeweled objects (Fig. 84) and weapons, on formal orders founded in the manner of European decorations, and on golden coins; figures carved in alabaster and ivory, painted on the reverse of glass panels, and on the surfaces of innumerable papier mâché objects; the figures in single-page paintings and illustrated manuscripts, in pictures in printed books, photographs and lithographs, on

84. Lidded gold cup, saucer, and spoon, enamelled with planet and zodiac imagery by Muhammad Baqir, Tehran (?), early nineteenth century; Private Collection

85. "Fath 'Ali Shah," rock relief, Ray, first quarter nineteenth century

86. "Karim Khan Zand and His Kinsmen," oil painting on canvas attributed to Muhammad Sadiq, after 1779; Private Collection

transfer-printed ceramic tiles, and in newspapers. There are oil-painted canvases [154, 194, 195] in very great numbers, and huge paintings on plaster or wood; and – in a revival of one of Iran's most ancient pictorial traditions – there are monumental carvings cut into the living rock, sometimes at sites adjacent to Achaemenid or Sasanian rock-carved friezes (Fig. 85). Rulers are so vividly portrayed that we immediately recognize Karim Khan Zand (Fig. 86), Fath ʿAli Shah, and his ruling descendants and heirs. The buildings and the landscapes of Shiraz, Tehran, and the battlefields of the north-west, where Russian and Iranian forces repeatedly clashed, are realistically represented, whether as interior settings or outdoor backgrounds. The very feel of the times – the brief period of Nadir Shah's restoration of some order; the informality of mid-eighteenth-century Shiraz, where the short-lived Zand dynasty held court; and the atmosphere of claustrophobic, fearful splendor at Fath ʿAli Shah Qajar's court in Tehran: all find pictorial expression in Iranian painting of the eighteenth and nineteenth centuries.

PAINTING IN THE AFSHAR AND ZAND PERIODS (1722–85)

Forms and formulas already developed in the Safavid seventeenth century, especially by the eclectic painters and their families and followers (Fig. 87), are the principal manifestation of painting in the Afshar period. Safavid-inspired imagery can be seen on numerous lacquered papier mâché objects which, increasingly, include bookbindings. Indeed, covers for books, rather than the illustrations inside them, appear to have occupied craftsmen, since in this period few new manuscripts were produced, let alone illustrated: the eighteenth-century Lutf ʿAli Beg Azhar wrote, in a once-famous work entitled *Atashkada*, or *Fire Temple*, that affairs had ". . . reached such a point that no one has the heart to read poetry, let alone to compose it."[1]

One reason for this is, of course, the turbulence and instability of the times: leisure and means were often both lacking. Another is the

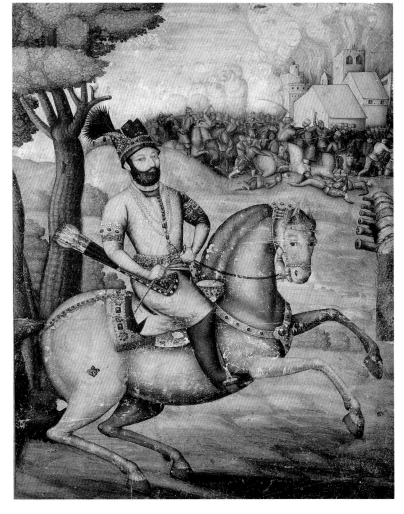

87. "Nadir Shah Afshar on Horseback," painting on paper, Muhammad ʿAli ibn ʿAbd al-Beg ʿAli Quli Jabbadar (?), Isfahan, mid-eighteenth century; Boston, Museum of Fine Arts, 14.646

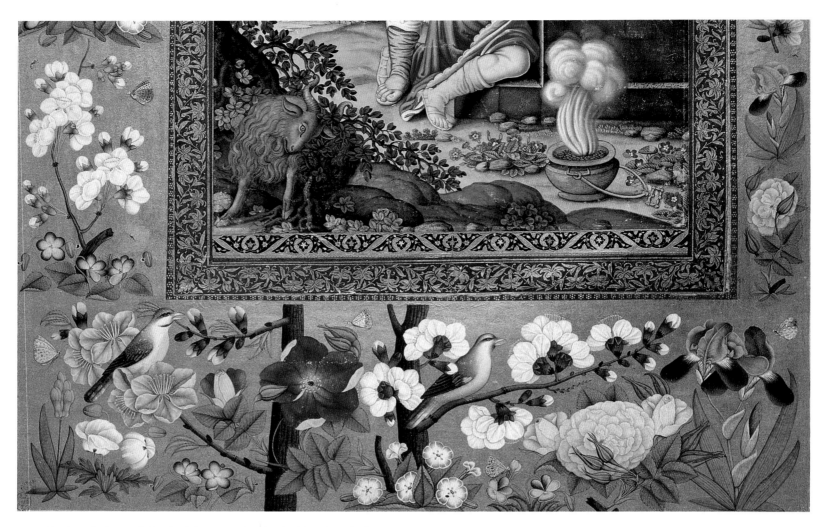

88. "Birds and Flowers," detail of the painted and gilded border of a large album, Isfahan or Tehran, mid-eighteenth century; St Petersburg, Oriental Institute, E. 14, folio 89r

curious continuity provided by the combination of political upheaval and the weight of traditional Iranian patterns of craftsmen's occupations. In the absence of orders to the contrary, artists worked to the method and in the styles with which they were familiar, albeit in a variant medium. This surely accounts for the quantities of painted and lacquered papier mâché of the period, the bookbindings [29], mirror cases [119], caskets [Fig. 92], boxes [28], playing cards, but especially pen boxes [11, 163]. On these objects themes and compositions already developed by the later Safavid eclectic painters were used and reused, copied and adapted innumerable times in greatly varying levels of competence. Some are very fine; others are poor and clearly rely only on the process of sterile repetition, despite the fact that the copying of images was a traditional feature of Iranian painting, and copying a fine work of art considered an honorable activity.

A manual of court administration compiled in 1725 – reflecting the height of Safavid effectiveness – includes a list of Isfahan workshops concerned with the arts of the book: the painters and calligraphers, and the materials used in the library and painting ateliers. Trained in late Safavid traditions and practicing late Safavid styles of painting, some Isfahan artists were evidently appropriated to the service of Nadir Shah when matters of self-glorification arose on his personal horizon. Recently, a number of portraits of him, in both oil on canvas and in the more traditional format of small paintings on paper (Fig. 87), have been published together.[2] They reveal that what most serves to identify Nadir Shah is, just as in the Safavid seventeenth century, the combination of facial hair and costume, especially the Afsharid felt hat with its peaked folds.

The eclectic Safavid manner of applying paint in fine stippling is a characteristic feature of the decorative painting of this period. It is especially evident on lacquered papier mâché but also characterizes enamelling on metal objects such as weapons, jewelry, plate [Fig. 84], and the fittings for qalians – water pipes. As for the repertoire of non-figural and purely decorative painting in this period, the most frequent motifs are floral, or compositions of birds and flowers. Again, these often have late Safavid prototypes (Fig. 88); numerous on bookbindings, especially those for Qur'ans, they also served as patterns for textiles.

Some lacquered objects were more ambitious in scale and in the scope of their decoration. For instance, the scenes on a large casket dated 1776–77, and a related but undated mirror case [119], display that audacious mix of European, Indian, and Iranian elements on objects equal to the best work of the seventeenth century. The assured manner in which personages in Indian and Iranian dress inhabit both the European and the Iranian "halves" of the compositions is evidence of the residual capability of eighteenth-century designers and painters. And a celebrated album offers other evidence of the value then accorded to eclectic Safavid painting, and related contemporary Indian paintings. Someone with taste, means, and the notion of preserving selected materials of the past, gathered together paintings in the eclectic Safavid manner, and a number of works of a well-known Safavid calligrapher known as Mir 'Imad that have dates between 1594–95 and 1615. In 1734–35 a lacquered binding decorated with flowers was commissioned, as the album's cover, by a certain Mirza Mahdi. He is perhaps to be identified as Muhammad Mahdi-Khan Astarabadi, "friend and companion" of Nadir Shah as well as his private secretary and historian. It may also be that the Indian paintings now integral to the materials contained within this floral binding were not originally intended but were thought worthy of inclusion after 1739, having been acquired in

the sack of Delhi. Once all the material was assembled, the paintings and calligraphies were carefully organized in thematic groups and mounted as complementary pairs within new borders, again arranged so that each opening was harmoniously framed by matching pairs of borders (Fig. 88). These are the work of three artists and are dated in the middle of the century: Muhammad Hadi, Muhammad Baqir, and Muhammad Sadiq. The album was finally completed in the Zand period, 1769, according to one source. The borders document another aspect of the continuity of painters' practices, even in this turbulent century: Muhammad Sadiq later worked at the Zand court in Shiraz, and the Shiraz painter Muhammad Baqir also worked there, but for Baba Khan – the future Fath 'Ali Shah Qajar.

Zand painting – properly speaking, that produced in Shiraz between 1750 and 1779 but, more broadly, painting in the second half of the eighteenth century – seems to issue from an entirely different world. The production of manuscripts was still sparse; painterly energy (and patrons' means) seem instead to have been directed at architectural decoration. Ceilings might be covered with vast decorative compositions, like a Kashmir shawl spread across the heaven, and walls were covered with painted figures in architectonic settings. Ensembles of oil-painted canvases must have decorated the walls of innumerable palaces and private houses, to judge from the myriad paintings, with characteristically pointed tops, that must once have comprised suites of multiple images. Again, the formal conception harks back to paintings from the Safavid period, but the style is intimate instead of monumental and the spirit is unusually light-hearted, even frivolous. Subjects typically include the kings of Iranian history and the heroes of its literature – Jamshid, Hurmuzd, and Bahram Gur, Rustam, Yusuf, and Shaykh San'an; princes and beautiful youths; women – acrobats and dancers, often in daringly provocative, semi-transparent clothing or, less often, coquettishly veiled, or mothers with young children, a motif obviously derived from Christian images of the Virgin and Child; and pairs of lovers. Another typical series must have included the standard Safavid "exotics," men in European frock coats and women in transparent Indian gauze skirts. These figures are set in open-air backgrounds with tiny architectural vignettes in the distance, or in simple interiors with a window opening onto a similar landscape, often draped with the curtain introduced by way of European portraiture of the seventeenth century [99, 100]. Interior scenes may include a composition of objects, in the manner of European still lifes: bowls of fruit, vases of flowers, glass bottles and beakers, birds in cages; even a white, long-haired "Persian" cat often placed in the lower part of the painting [119]. Again – with the exception of the cat – the models are seventeenth-century Safavid [43; Fig. 82] and can virtually all be found in the large rectangular pictures in the audience hall of the Chihil Sutun.

Many such Zand-period paintings, especially those intended as architectural decoration, are unsigned; among those that are, the work of Muhammad Sadiq stands out. Trained in Isfahan, he was a principal painter of the period and worked at the Zand court in Shiraz; his works have dates from about the middle of the eighteenth century to at least 1780–81. A penetrating portrait in watercolor on paper, of Karim Khan Zand, is undated and carries the enigmatic phrase *ya sadiq al-va'd*, meaning "O Thou who art True." The image is so similar to the figure of Karim Khan in a larger painting on canvas as to suggest that Muhammad Sadiq might also have been the painter of this group picture, showing the regent in the midst of his court (which exists in several versions, see Fig. 86). Recently described as the "archetypal Zand state image," it retains the traditional late Safavid horizontal format but shows Karim Khan kneeling and smoking a water pipe, surrounded by an informal group of courtiers. All the men are realistically differenti-

ated, and their imposing Zand turbans and the small-patterned textiles of their Safavid style garments convey a contemporary sartorial reality. More typical of Muhammad Sadiq's work are portraits, and pictures of generic subjects: one, of a young Zand prince, which also carries the alternate "signature" *ya sadiq al-va'd*, is an especially fine rendering of soft flesh and fabric, in great contrast to the rougher, almost raw, atmosphere of Karim Khan and his court.

A particularly interesting artist of the last quarter of the century is Abu'l-Hasan Ghaffari Mustaufi Kashani who, with one exception, appears to have worked only on paper; his paintings display a pronounced Safavid historical preoccupation [128]. As he was also a historian, and court secretary to Karim Khan Zand, this is hardly surprising. The corporeal solidity of his images is evidence of a special talent for the visual rendition of figures as well as for the recounting of their deeds in words. Abu'l-Hasan Ghaffari, who came to be styled "the first," also exemplifies a problem peculiar to Iranian eighteenth and nineteenth-century painting: the similarity, over more than a century, of the names of painters who were often related to each other, in veritable dynasties. This has led to a certain need to "suspend disbelief." Accepting the evidence of similar names as referring to the same person, as they appear in signatures – frequent, by this date, on so many objects and paintings – then leads to the proposal that certain artists enjoyed impossibly long careers. It also leads to the corollary that one painter might have been able to paint in an impossibly varied number of styles, not to speak of qualities. This difficulty has already been noted in the case of the two premier painters connected with Shah 'Abbas I, Sadiqi and Riza. Parallel problems such as the true length of Muhammad Sadiq's working career, and the unravelling of the five nineteenth-century artists called Abu'l-Hasan, will also surely come to be resolved with the passage of time, and as the materials of the eighteenth and nineteenth centuries – art as well as the literary sources in Persian and European languages – become more familiar to scholars of literature, history, and the history of material culture.

It is nonetheless the case that some artists of this period do appear to have been comfortable working in several media as well as executing copies of the works of other painters. And many must have continued to work throughout the period when location alone defined the identity of a ruling prince. The variety of painting sponsored – indeed, demanded – by Fath 'Ali Shah Qajar once he acceded to the throne of the Kings of Kings in 1798 is more than ample evidence of the versatility of Iranian painters in turbulent times.

PAINTING IN THE REIGN OF FATH 'ALI SHAH (1798–1834)

Fath 'Ali Shah's reign can be seen as one of glamor and luxury, of glamorous formal court ritual, and as the most glamorously revivalist period in all of Iran's long history. Yet certain contributing features were already in place when he came to the throne, developed by his uncle, the eunuch Agha Muhammad Shah Qajar.

Qajar nobles had served the Safavids in many positions, so perhaps Agha Muhammad considered his tribe to be the legitimate successors to the Safavids. It is no surprise that, as an act of aesthetic propoganda, he returned to the primary pictorial locus of Safavid power, the Chihil Sutun, bracketing the historical sequence of pictures in the audience hall both an earlier and a later Safavid military event. He commissioned two large (but stylistically undistinguished) paintings, to be added in the architectonic spaces between the quartet of Safavid pictures; one is dated 1796, which must also be the approximate date of the other. "Nadir Shah Vic-

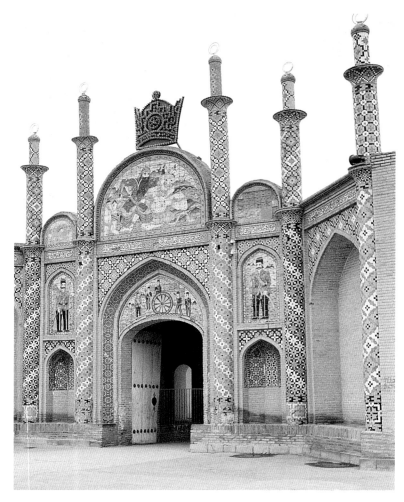

89. "Rustam's Last *Khwan*: He Takes the Liver of the White Div," composition in glazed tiles above the city gates of Semnan, nineteenth century

torious Over the Mughals at Karnal, in 1739" is painted (covering a window) in the center of one long wall; facing it across the room is a picture of Shah Isma'il's encounter with the Ottoman Turks at the battle of Chaldiran [Fig. 77], which had occurred in 1514. Paired images of the military exploits of preceding dynasties were not a new notion of propaganda by decoration for Agha Muhammad: as early as 1781, he had already ordered pictures of the same subjects to be painted in the audience rooms of a palatial residence he built on the Caspian seacoast, in Sari.

Agha Muhammad had additional concerns that expressed themselves in images drawn from Iran's past. His search for new symbols appropriate to the "program" for his new dynasty led him to devise a new crown, the "Kayanid" (Fig. 91). The name comes from Firdausi's *Shahnama*, after the early line of Iranian heroes. And the many popular images of Rustam painted on ceramic tiles and used for public exterior decoration, such as the frieze above the old city gates of Semnan (Fig. 89), are equally drawn from the heroic legends of Iran's past. Thus, the period of his nephew's reign began, in 1798, with pre-Qajar pictorial models of rebuilding, re-creation, and revival that were already well established.

Fath 'Ali Shah had grandiose material plans for his new kingdom. He built extensively – palaces and gardens arose all over Iran. The decorative programs of many of these palaces included large group paintings of significant battles, hunts, and court assemblies – the ancient Iranian themes of *razm u bazm* – as integral parts of their function. Today, however, few remain intact, even the largest of painted canvases. The huge painting of an imaginary Nauruz reception at Fath 'Ali Shah's court, made for the Nigaristan palace, north of Tehran, under

the supervision of 'Abdallah Khan and completed in 1812–13, only survives in a number of reduced painted copies and some early photographs (Fig. 90). Even in reduction, the rows of immobile standing male figures – sons, ministers, courtiers, and foreign envoys – resemble nothing so much as the rows of similar figures carved on the great staircase of Persepolis: the visual parallel was surely intentional.

Many single-figure paintings in oil on canvas show Fath 'Ali Shah alone. Considered as a group, they demonstrate the development of his unique and personal notion of the princely image. The earliest are traditional in their composition: the Shah is shown kneeling, in a three-quarter position and still wearing the Zand turban [194]. Clearly this image was "lifted" from the center of larger, horizontal court scenes; it was often copied both in miniature and on paper (Fig. 91). But in the first years of the nineteenth century Fath 'Ali Shah and his chief painters, first Mirza Baba and then Mihr 'Ali, worked at reshaping the image; what they created was the quintessential princely Iranian icon of the day. It was composed of both oriental and European elements, glamorously stylized and absolutely representative of its time and place [Fig. 5], and its subject never again changed his appearance – at least, his painted appearance – throughout his reign of nearly thirty-five years.

A series of nearly twenty-five oil-painted pictures of this type may presently be documented: they truly function as "state portraits." Occasionally the shah is still shown kneeling; more often he is seated in a European armchair, or standing, holding a staff; and he is almost always alone. He wears the high Kayanid crown, usually enhanced with several towering jeweled aigrettes of black heron feathers. The oriental garments glisten with metal thread; the strings of large pearls and gems are copious, the huge diamonds of the central armbands are the "Sea of Light" and the "Crown of the Moon," the *Darya-i Nur* and the *Taj-i Mah*; and all his other accoutrements are covered with pearls and gemstones. He is the very model of an oriental potentate. The image brilliantly proclaims the antiquity, the renewed splendor, and the contemporary significance, of the Iranian monarchy.

Reproduced many times for gifts to rulers and foreign ambassadors, such pictures were sent all over the world, the aim being to establish Iran's presence on the nineteenth-century world stage. The size and the quantity of the jewels were no less than an advertisement for the wealth of pre-petroleum Iran, and thus an essential part of the public relations formula. The visual signs of his virility – the magnificent beard and the

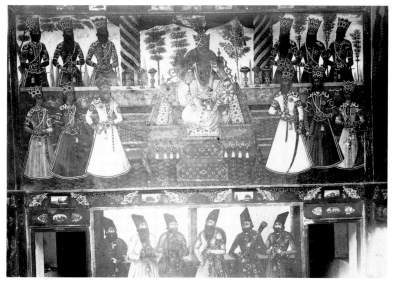

90. "Fath 'Ali Shah and His Sons," salt-print (photograph), Tehran (?), late nineteenth century; Brooklyn, Brooklyn Museum of Art, 1997.3.261

innumerable children – were also a master stroke, countering the withered, sterile appearance of his uncle Agha Muhammad Shah Qajar. His own personal attractiveness, again so different from his uncle, was a third aspect of this positive campaign, both at home and abroad: his fine slender figure, his pale complexion and blazing black eyes under wide black brows, and his long, silky black beard were copied in every material imaginable and are instantly recognizable. As Sir William Ouseley commented: ". . . even the most rudely executed presenting, generally, some similitude."[3]

The overall effect of the monumental images must have been awesome, albeit that even the standing portraits are only slightly larger than life-size, and that contemporary European imperial portraits, for instance of Napoleon [Fig. 6] or Queen Victoria, were equally resplendent with rich robes and fur, gems, and regalia. Certainly the effect on his own citizens was impressive. His ambassador to the English court, Abu'l-Hasan Khan, recorded in his diary for December 29, 1809: "When I beheld the beauty of the Qibleh of the Universe, I bowed my head low until my head was level with his feet."[4] Other contemporary accounts speak of the veneration his subjects accorded to the image of the shah, whether as humble as those painted on cotton cloth and displayed in his camp at Sultaniyya, or as grand as the oil-painted portrait intended for dispatch to the ruler of Sind. Sir John Malcolm recounts seeing its closed container pass through the streets of Tehran, commenting that the unseen portrait in its packing carton was treated with as much respect as was the shah himself. It is thus no surprise to learn that under Fath 'Ali Shah's aegis life-size images were even placed within Shi'a religious shrines and royal mausolea. A poem of 1794–95 recounts that before he acceded to the Qajar throne, the Shah had ordered a life-size image of himself as a gift to the Shrine of the Imam Musa al-Ja'far, in Najaf; four decades later, in the year of his death, he supervised another life-size effigy carved in marble, in which he was shown standing and wearing the Kayanid crown, for his own tomb in a sanctuary in Qum.

Fath 'Ali Shah also made use of the ancient theme of the hunt for images conveying valor and bravery. Hardly the warrior, nor even the hunter, that Agha Muhammad was, he is nonetheless shown countless times demonstrating his personal prowess in the pursuit of dangerous beasts, in monumental scale – on the walls of his palaces, as well as in miniature. Both the upper and the lower covers of the new binding made for the celebrated *Khamsa* of Shah Tahmasp, which was rebound for Fath 'Ali Shah before 1827–28, show him hunting [29]. In both he is surrounded by his sons and – in the ancient oriental manner – he is larger than they are. Thus two important themes, the shah's physical valor and his wealth of progeny, are merged into a single pair of equal images. A different combination of the same themes is seen in the monumental relief panels carved into the rock face of a mountain near the medieval city of Ray. One panel shows the magnificently crowned and bearded shah, alone against a neutral background and spearing a lion; the other shows him seated on a low *takht* – or throne – and surrounded by standing male figures all formally dressed and wearing the Kayanid crown: some of his sixty sons [Fig. 85], Qajar princes all, as they also stand in serried ranks around him in the Nigaristan paintings. Indeed, reflecting on the multiplicity of images of his day, we might wonder whether Fath 'Ali Shah left behind more images or more heirs – over a thousand – at his death in 1834.

At least a dozen artists who painted for Fath 'Ali Shah are known by name, some in several forms, which sometimes makes it difficult to be certain that different names with similar elements refer to the same painter. Many were able to paint in a variety of styles and scales: for instance, Muhammad Baqir could paint stippled landscapes in the

eclectic Safavid manner, execute exquisite enamel-painted figures on gold [Fig. 84], and lay down the watercolor composition that was then lacquered for the rear cover of the Tahmasp *Shahnama* [29]. Painters not only regularly, now, signed and dated their paintings but some added other fascinating details: Mihr 'Ali, signing the St. Petersburg standing portrait of 1809–10 [Fig. 5], added that when the finished painting was shown to the Shah he approved it with no changes.

Some painters could append the title *naqqash-bashi* (literally "chief painter" but carrying a significance more like "painter laureate") to their names. Recent research suggests that the post, at least in the early Qajar period, was not only a recognition of the talent of its holder but also imposed much supervisory activity within the royal painting workshop, or *naqqashkhana*, the "house of painting" (sometimes described as the successors to the Timurid and Safavid *kitabkhana*, or "library workshops"), as well as in the capital, and also in provincial centers or on voyages with the court. Despite the sudden wealth of documentation about painting and many other crafts that characterizes the Qajar period, facts about the position of the *naqqash-bashi*, and the terms on which it might be awarded, still remain unclear: whether each important city – Shiraz and Isfahan, for instance – might have its own, the dates of each *naqqash-bashi*'s tenure, and how many painters might simultaneously be appointed at one time. In any case, as in the period of Shah Tahmasp, a small army of artists – painters, sculptors, jewellers and enamellers, draughtsmen, and craftsmen – must have been employed in Fath 'Ali Shah's court workshops, turning out the thousands of pictures and other accoutrements required by that most picturesque of Qajar monarchs.

PAINTING AFTER FATH 'ALI SHAH TO THE END OF THE NINETEENTH CENTURY

Whether several *naqqash-bashi*s might have held the position simultaneously is no clearer under Fath 'Ali Shah's successor, Muhammad Shah. What is clear is the very different nature of court-sponsored painting from 1834: the stylized oriental brilliance of contemporary court portraiture, and its glorifying function, disappears almost immediately. Muhammad Shah seems to have had little need of, and no interest in, the trappings of dynastic power, or even the personal, pictorial propaganda that had so deeply occupied both Agha Muhammad and Fath 'Ali Shah. His connection with his immediate ancestor, in time, found expression in the wearing of a large oval miniature of Fath 'Ali Shah wearing the Kayanid crown, rimmed with diamonds and surmounted by a miniature Kayanid crown; Nasir al-Din Shah sometimes wore a similarly mounted portrait medallion of Muhammad Shah [195]. No doubt the notion is European, although Iranian traditions easily lent themselves to the making of a miniature image; the creation of the Order of the Lion and Sun, instituted by Fath 'Ali Shah in late 1807, surely also contributed to this new royal fashion.

Instead, oil-painted canvases, with tasteful Empire furnishings, show the new Shah either bust-length or seated, albeit informally. Along with oval portrait miniatures and watercolors, they all reveal the progressive adoption (and adaptation) of European military or civil costume and the invariable black Qajar astrakhan hat: Muhammad Shah was never shown wearing the Kayanid crown. A three-quarter-length oil portrait by Muhammad Hasan Afshar, *naqqash-bashi* to the new Shah (and later to his son, Nasir al-Din Shah [195]) was finished just after Muhammad Shah's accession to the throne. It is a relatively informal image; at the same time, it is also pictorially descriptive of the items from the Crown Jewels now worn by the burly figure on his otherwise sober black *jama*,

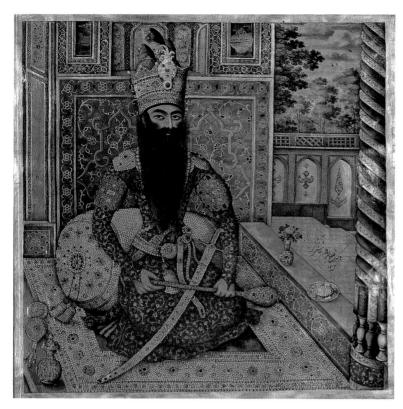

91. "Fath `Ali Shah Wearing the Kayanid Crown," frontispiece to a manuscript of his own poetry, painted by Mirza Baba, Tehran, 1802; Windsor Castle, The Royal Library, Holmes MS A-4/RCIN 1005020

relieved by the cold flash of the white gems, the striped Kashmir shawl twisted at his waist, and the immense cabochon emerald on the sword-belt.

Soon after this picture was painted, Muhammad Shah adopted European military costume. Epaulets, diagonal sash, and the diamond-set portrait medallion of Fath ʿAli Shah henceforward sit upon a red frock coat (it occasionally appears to be a Safavid candy-pink); and white heron feathers spring from the large diamond aigrette ornamenting the black astrakhan Qajar headgear. From the 1840s, not only the shahs, but princes, prime ministers, and other principal advisors and courtiers wore some version of European military or civil garb. Coats are often of the Shiraz woolen brocade called *tirma* (a thicker version of the Kashmir shawl weave); trousers, in early portraits of Nasir al-Din Shah, are brightly eccentric in color: apricot, lavender, malachite green, powder blue; the costume is sometimes completed by gloves and European boots.

Nasir al-Din Shah, who succeeded his father in 1848, ushered in by far the most varied period of painting and the visual arts in all of Iran's long history. The many portraits executed over the half-century of his reign bridge the entire range of nineteenth-century Iranian styles and European techniques: they bring Iranian figural painting from its last truly oriental manifestation into the twentieth century. They range from the early Qajar-style royal icon of a slender youth dressed in a long, pearl-trimmed robe and holding a ceremonial bow, painted in oil on canvas; through a series of dandyish images executed in the 1840s and 1850s in watercolors − all show him with big eyes, huge mustaches, colored European trousers, and white gloves; to Muhammad Hasan Afshar's oil portrait of 1859–60 [195] where the shah stands in a landscape with Tehran and Mount Damavand behind him, dressed in European military garb and weighed down with the diamond regalia and badges that must commemorate his reorganization of the Order of the Lion and Sun. There are portrait miniatures from the 1850s, and another

series of piquant Europeanizing images of the 1850s and 1860s, in which the still-slender shah wears a fur-trimmed, mid-sleeved short coat of *tirma*: seated in a Regency cane chair that rests upon a cloud, leaning on a similar chair in an interior of the period, or standing in front of a huge canon. Photographs of the 1880s and 1890s, and the painted portraits made after them by Kamal al-Mulk Ghaffari, around 1890, show a seated figure of girth and dignified gravitas, European medals and decorations pinned to his chest, and the huge cabochon emerald from the Crown Jewels now mounted on his belt. If Fath ʿAli Shah had created an unchanging Oriental image of antique splendor, Nasir al-Din Shah appears to have embraced the notion of celebrating organic change, capturing the many alterations in the course of his life in all the pictorial modes and techniques possible: we do not easily recognize the beautiful mid-century Qajar boy in the photographs and portraits of the same person made toward the end of the century.

Three developments dating from the decade between 1842 and 1852 would affect Iranian painting in one way or another for the remainder of the century. All are equally fascinating in themselves, while the impact of one would, in the end, complete the alteration of a fundamental aspect of Iranian figural imagery that had characterized it since perhaps the eleventh century − its intimate relationship with words. These developments were the appointment, by Muhammad Shah in 1842, of Abu'l-Hasan Ghaffari II as *naqqash-bashi*, and his immediately subsequent period of study in France and Italy; the founding in Tehran, in 1851, of the military and technical academy that came to be called the Dar al-Funun, the "House of Arts," where the new techniques of photography and lithography were also taught; and the paradoxical rise to prominence, in the middle of the century, of the Isfahani artist Muhammad Ismaʿil, who worked in the traditional medium of painted and lacquered papier mâché and came from the traditional craftsman's milieu. In all of these developments, Nasir al-Din Shah played a significant part. He offered royal patronage; he participated in some of the projects he had commissioned; and he himself became an adept photographer, producing an estimated 20,000 prints in the course of his enthusiasm. Yet while he embraced new styles and techniques, he was clearly not averse to maintaining older pictorial traditions, sustaining artist-craftsmen by commissioning works from them. Notable among them was the talented Muhammad Ismaʿil. That he was worthy of exalted encouragement had been recognized as early as 1847 by the governor of his native city, the redoubtable Manuchihr Khan, Muʿtamad al-Daula.

Manuchihr Khan embodies Safavid customs still being practiced in early Qajar times. A Georgian by birth, he was captured, and castrated, by Agha Muhammad Qajar in 1774; yet he rose to become one of the most powerful men in Iran during the reigns of both Fath ʿAli Shah and Muhammad Shah. The former awarded him the title *Muʿtamad al-Daula*, "Trust of the Government," in 1824. From about 1829 he was viceroy of central and southern Iran, and he was later appointed governor of Isfahan. This semi-independent position afforded him all the appurtenances of his sovereigns, including painters to record his princely valor, and his practice of princely activities. So it may be that to some extent it is he who was, in part, responsible for the extraordinary series of painted and lacquered objects that first appeared around the middle of the century. They are characterized by excessively large numbers of miniature images depicting significant personages and signal events on the surfaces of useful objects.

Muhammad Ismaʿil of Isfahan came from a distinguished, traditional craftsman-painter's milieu. He was the son of a painter called Aqa Baba and the pupil of Najaf ʿAli, the most celebrated of early nineteenth-century Isfahan painters of lacquered objects: scion, brother-in-law,

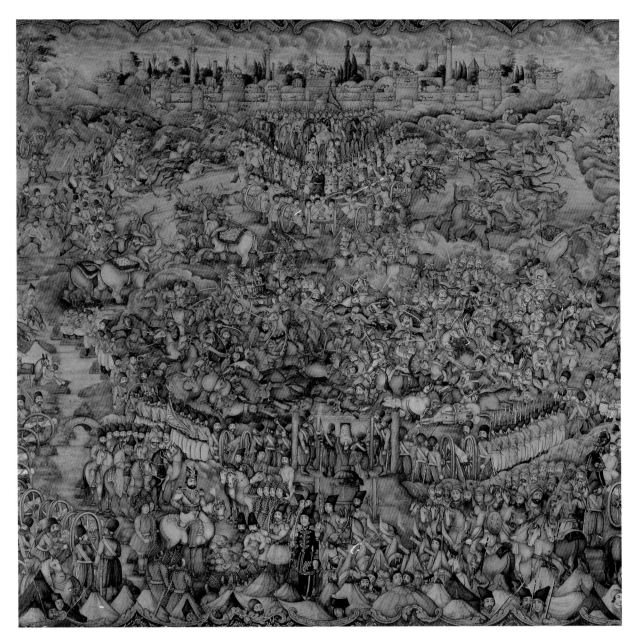

92. "The Siege of Herat,"
detail from the composition
by Muhammad Isma`il
decorating a lacquered
papier-mâché casket,
Isfahan, 1865; Bern,
Historical Museum, 71/13

and uncle of an entire dynasty of painters from Isfahan. He was trained from a very young age to paint on papier-mâché objects and he must have been particularly adept at working on a greatly reduced scale. Manuchihr Khan's first commission to him is a small, sliding pen box finished in 1847; the unmistakable figure of the viceroy in the midst of his court is shown on the lid, the image perfectly in scale with the size of the object. But a second commission for a pen box [11] demonstrates all the new features of Muhammad Isma`il's miniaturizing historical style: an event of significance depicted in breadth and detail, often from the bird's-eye point of view, with figures that might number several hundred, even on a very small object. And although Manuchihr Khan did not live to see it completed, this pen box seems to have been the earliest in the astonishing series of contemporary events painted on lacquered objects by Muhammad Isma`il throughout the next quarter of a century.

Perhaps the most celebrated of Muhammad Isma`il's pieces is a casket completed in 1865. Little wider than a foot and no more than five inches high, it depicts the siege of Herat, in 1838, by Muhammad Shah Qajar: hundreds of figures in truly minute detail cover the top and all four sides (Fig. 92). By 1865, Muhammad Isma`il had been appointed chief painter by Nasir al-Din Shah, which suggests that the Shah had commissioned this breathtaking work of historical painting as one way of honoring the memory of his father; on the casket the painter signed himself as *naqqash-*

bashi. But on the first of his works in this miniature, historicizing style, Manuchihr Khan's pen box of 1849–50, he signs himself ". . . a man from the line of Mani." Invoking the name of the legendary painter in signing a celebration of an event of contemporary significance is not without significance in itself, whether or not Muhammad Isma`il was consciously aware of the meaning of his signature.

Many other painters working within the craftsmen's traditions, usually from family dynasties – in Isfahan, Shiraz, and elsewhere – continued to paint on papier mâché objects throughout the nineteenth century, principally pen boxes, and bindings for manuscripts and albums. To decorate their lacquered works, some continued to use motifs and themes from classical Persian texts, such as the *Shahnama* and the story of Shaykh San`an and the Christian girl [98], extracting elements and infinitely recombining them. European imagery was by this date a stock feature in the craftsman-painter's decorative vocabulary, whether these images were seen through Safavid, or eighteenth-century Iranian lenses, or were drawn directly from the most up-to-date sources; the device of the oval enclosing a head was especially frequent in the construction of a design. Other painters composed and executed magnificent examples of non-figural decoration, using both Islamic and European designs and motifs: these works are an important part of the history of traditional Iranian art of this period for they are often especially fine in quality. Indeed, they are sometimes overlooked among the

quantity of figurally decorated works, of less than superb quality, which gave rise to the pejorative appellation of "chocolate-box" painting. What remained most popular throughout the nineteenth century, however, was the pen box: the demand was so great that even Russia and Japan produced Iranian-style pen boxes for export back to Iran. Japanese boxes were made of wood but the Russian ones were of papier mâché, which was widely used, at that time, all over Europe for small or light-weight objects, and even furniture.

As for that other traditional medium of Iranian painting, the illustrated manuscript, few seem to have been copied after the period of Fath ʿAli Shah; the one notable exception is the mid-century *Thousand and One Nights*. The balance between copying texts by hand and reproducing them mechanically by printing (the printing press had actually been introduced into Iran, by Armenian merchants, as early as the second half of the seventeenth century), appears to have been redressed by the middle of the nineteenth century. As mechanical type-setting became cheaper, easier, and thus widespread, the mechanical reproduction of pictures could hardly be excluded – but the techniques of making pictures were perforce different. This is surely one of the reasons that nineteenth-century painterly energy expressed in the traditional Iranian styles found a continuous outlet in painting on papier mâché. Another outlet for painters who still practiced the traditional craftsmen's techniques was the later nineteenth-century repair of the decorative components of historical buildings, doors and shutters primarily. This is an aspect of nineteenth-century Iranian painting with a certain history of its own.

Another remarkable dynasty of painters, the Ghaffaris, represent a very different aspect of nineteenth-century Iranian painting: they occupy a position diametrically opposed to the craftsmen-painters, in using imported European techniques to depict the Iranian world around them. The pivotal figure is Abu'l-Hasan Ghaffari II. One of those five documented nineteenth-century painters with the same name, he was the grand-nephew of the Zand Abu'l-Hasan Ghaffari and acknowledged the familial and professional relationship in styling himself "the Second." Unlike the apocryphal study trip to Rome that has been associated with the name of the seventeenth-century Muhammad Zaman throughout much of the twentieth century, the Qajar artist actually did go to Rome, and also Paris, after Muhammad Shah appointed him *naqqash-bashi*. To his hand are due a number of portraits of his countrymen executed in a variety of European techniques, all of them astonishing likenesses.

Ghaffari's watercolor drawings on paper – delicate, forthright, immediate – especially call to mind the drawings of the older contemporary French painter Jean-Auguste-Dominique Ingres. Abu'l-Hasan Ghaffari II was born in 1812, more than thirty years after Ingres, and went to Europe only in 1842; but the two painters died within a year of each other, Abu'l-Hasan in 1866, and Ingres in January of 1867. The French painter had made a first, long, trip to Rome in 1806 and was there again, for a shorter time, in 1835. From the first Roman period date Ingres' earliest informal portrait drawings in pencil, subjects placed against the bare and neutral paper, which he continued to do for the rest of his life and which have such striking echoes in the work of the younger Iranian artist. Nothing records that the two met, or even could have met, although by 1842 Ingres was greatly renowned and even his modest pencil drawings were greatly valued, especially where Abu'l-Hasan might have seen them, in Rome and in Paris. A better explanation for the astonishing parallels might, again, be their "similarity of mental texture."

After his return to Tehran, about the time of Nasir al-Din's accession in 1848, Abu'l-Hasan received two major commissions, both rooted

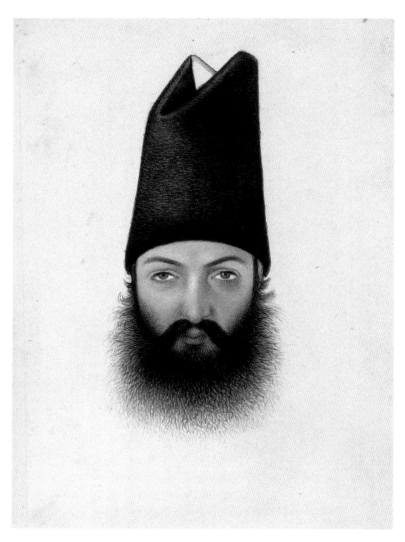

93. "Khusrau Khan Kirmani," watercolor study by Abu'l-Hasan Ghaffari II (Saniʿ al-Mulk), Tehran, 1850–60; London, British Library, Or. 4938, folio 12r

in older Iranian pictorial traditions but very different in mode, style, and significance. One would require his supervisory attention for the next seven years, the production of an illustrated manuscript of the *Thousand and One Nights*, translated into Persian by 1843. The task of illustrating its six immense volumes – ". . . no less than 1134 pages . . ., each page carrying between two and six separate compositions" – occupied forty-two painters and other craftsmen until 1855.[5] Even Nasir al-Din is thought to have contributed sketches for the project, the pictures to which rather suggest an Eastern *Vanity Fair*. In many ways, however, the Qajar *Arabian Nights* represents the end of the classical illustrated Persian manuscript: the very density of its illustrative program overwhelms the text and forever altered the relationship between word and image. It had no posterity – and it is no wonder.

The second large commission was a monumental group painting on plaster, in the manner of Fath ʿAli Shah's imaginary Nauruz assembly executed for the Nigaristan in 1812–13. It was to show Nasir al-Din and his sons, ministers, foreign envoys, and numerous courtiers: over a hundred life-size figures, all true portraits. Some of Abu'l-Hasan's watercolor paintings of male heads, on a neutral background, are no doubt studies for the project; on the back of one is the French notation, "Ressemblance frappante" (Fig. 93). Colleagues and contemporaries, deeply influenced on his return in 1847, began to paint in the same manner – which suggests that they had also begun to conceive altered notions of the "representation" of the people around them. In 1861, Nasir al-Din rewarded Abu'l-Hasan II with the title by which he is

usually known – *Sani' al-Mulk*, "Craftsman of the Kingdom": the revealing title was richly deserved.

Sani' al-Mulk's oeuvre – the monumental court painting, and his studies for it and the many resulting watercolor portraits, and his lithographs – brings to life the entire Qajar milieu of the third quarter of the nineteenth century. His subjects are remarkably individually depicted, if sometimes mercilessly so; this attitude is especially to be noted in his portraits of the clergy. The textures of fur, feathers, and taffeta, ribbing and coarse weaves, hair and leather, are meticulously rendered, as are furnishings and wall decoration. Some subjects sit on European chairs, or stand; such figures are set at the angled corners of well-delineated but partially visible interiors shown in well-achieved perspective. Less often a figure is shown kneeling in a three-quarter pose, in the old-fashioned manner of the well-bred oriental – but wearing white European gloves, as did Nasir al-Din in the portraits of the same years. Even more meticulously depicted is the corporeality of bodies, the bone structure of heads, and the color of eyes: Sani' al-Mulk depicts features and expressions, but also character. Gone is the classical Iranian habit of representing only the ideal personage with the same face; it has been replaced by what appears to be a frank and limpidly rendered depiction of a living, breathing being. Indeed, his subjects seem ready to rise from their seats and step off the page – just as do those in Ingres' pencil portraits.

To what extent the camera contributed to these remarkable portraits by Sani' al-Mulk is difficult to evaluate. It is true that his subjects often look away, or down at an angle; more frequently they gaze directly out of the picture, clues to his working process, in which the camera may have played a part. But many other Qajar artists also relied upon the camera, and their paintings frankly reveal the processes, unlike Sani' al-Mulk's. A nephew, Abu Turab Ghaffari, in a portrait of the chief secretary to the son of Nasir al-Din Shah, Haji Mirza Sulayman Khan, must have made use of a photograph for the head alone, composing the body himself; many of his other paintings are self-evidently reliant on photographs. His brother, Muhammad Ghaffari, the celebrated artist Kamal al-Mulk, made no secret of the photographic basis on which he built some of his most penetrating and interesting paintings. And still other later Qajar painters would do the same, especially if the subject were not one that could be observed from the painter's own life, such as women. Isma'il Jalayir provides a late but telling example.

This fascinating artist was trained as a traditional craftsman but was especially adept at combining older modes with contemporary European techniques. He became an instructor at the Dar al-Funun; never appointed *naqqash-bashi*, he eventually came to sign himself *naqqash-i daulat-i 'aliya*, "painter of the sublime court." Like so many other nineteenth-century Iranian artists, he was extremely versatile: he could render calligraphic texts as if they were composed of myriad flowers – in the classical Islamic manner that subordinates one decorative image to the form or lines of another; and paint portraits, such as a set of pictures of the darvish Nur 'Ali Shah, in oil on canvas as if they were sepia-toned photographs. Perhaps a photograph made after 1873 also served as his model for a remarkable painting of Qajar women gathered on a porch in a garden around a samovar. Two women are unveiled but wear elaborately jeweled headdresses, full short skirts (in imitation of the ballet dancer's tutu, a fashion introduced after Nasir al-Din's first trip to Europe), but no shoes. Others wear headscarves fastened under the chin, and one wears a black *chadur* open at the neck to reveal a great deal of jewelry. The details of dress are precise, and the dark-browed faces of the ladies are neither ideal nor flattering – as if to confirm the photographic basis of the faintly forbidden image. The entire scene, however, is itself effectively "veiled" by Isma'il Jalayir's characteristic paint surface and the dark, heavily flowering, almost moist atmosphere, which he achieved by a virtuoso manipulation of pigments. Few of his works survive today; those that do suggest that he is probably the most original of all late Qajar artists, and one who most effectively spanned the range of nineteenth-century Iranian modes of painting.

His oil paintings of the denizens of Tehran appear toward the end of the nineteenth century, like a mirror reflection of the medium in which were painted the most resplendent of Iranian kingly images, so characteristic of the beginning of that century. The intervening years were not great in number but the significance of the changes wrought in Iranian culture and reflected in its figural painting, especially in the notions of the uses of pictures and the manner in which they function in the presence, or absence, of words, is exceedingly great. Yet both at the beginning and the end of the century, Iranian painters – craftsmen and artists alike – made figural paintings. As Robinson had so astutely observed, as early as 1964: "Persia in the nineteenth century was a land of paintings, as never before or since."[6]

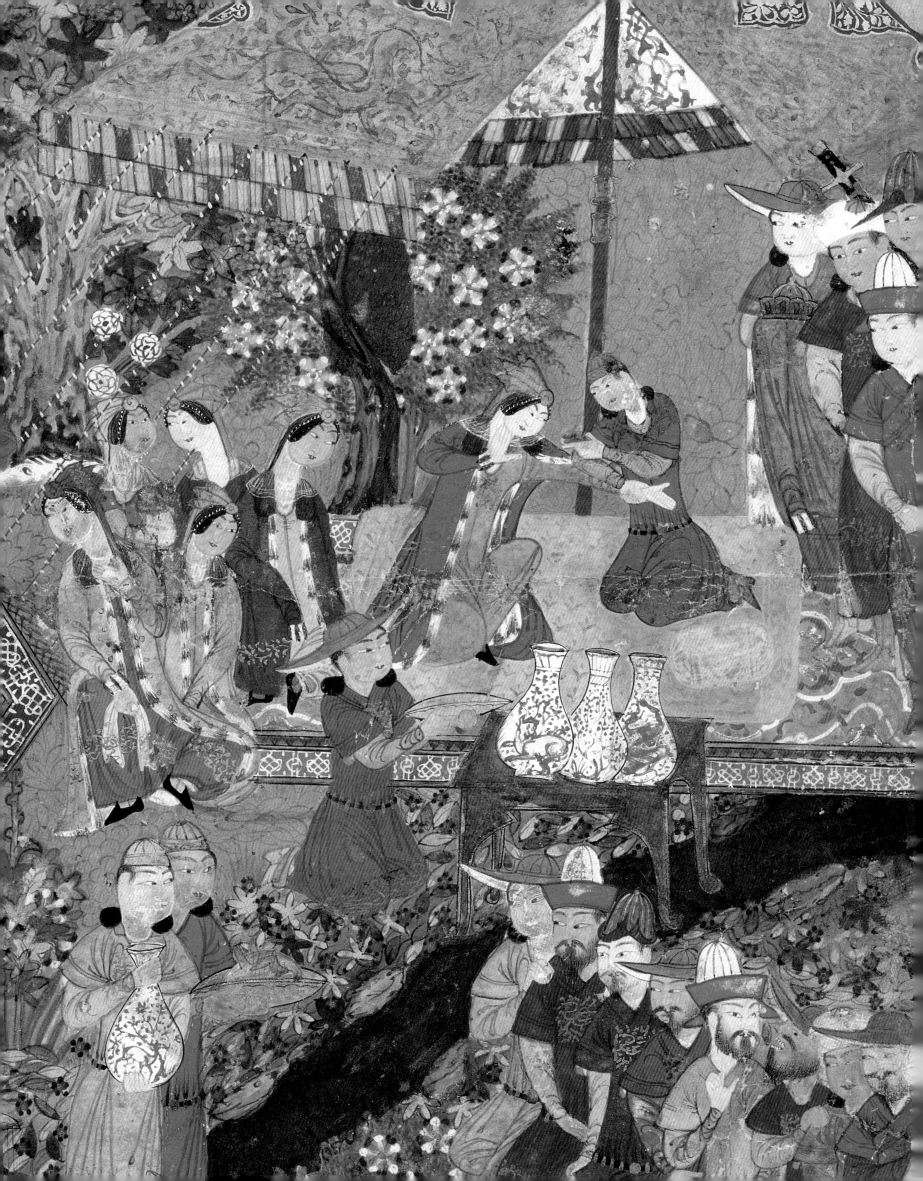

THE PRIMARY THEMES OF IRANIAN IMAGERY

RAZM U BAZM,
 FIGHTING AND FEASTING

FIGHTING: BATTLES

 DUELS

 THE HUNT

FEASTING: OUT-OF-DOORS

 INDOORS

CULT AND CEREMONY

WORSHIP AND CEREMONY

THE FIVE PILLARS OF ISLAM

MOURNING

THE *MI'RAJ* OF THE PROPHET MOHAMMAD

SETTINGS

THE NATURAL WORLD

THE CULTIVATED WORLD OF THE GARDEN

THE BUILT WORLD: EXTERIORS

 INTERIORS

NIGHT SCENES

FIGURAL TYPES

THE PRINCE AND HIS COURT

THE HERO

YOUTH AND AGE

WOMEN

THE LOVER AND THE BELOVED

THE SCHOLAR

PEASANTS AND WORKMEN

NOMADS

SUFIS AND DARVISHES

*DIV*S AND ANGELS

THE EXCEPTION TO TYPE: PORTRAITS

THE ILLUSTRATION OF TEXTS

ANIMALS: IMAGES AND STORIES

BIBLICAL IMAGERY IN MUSLIM GARB

CLASSICAL PERSIAN LITERATURE:

FIRDAUSI'S *SHAHNAMA* AND NIZAMI'S *KHAMSA*

THE LITERARY THEME OF THE PORTRAIT

OTHER CLASSICAL PERSIAN LITERATURE

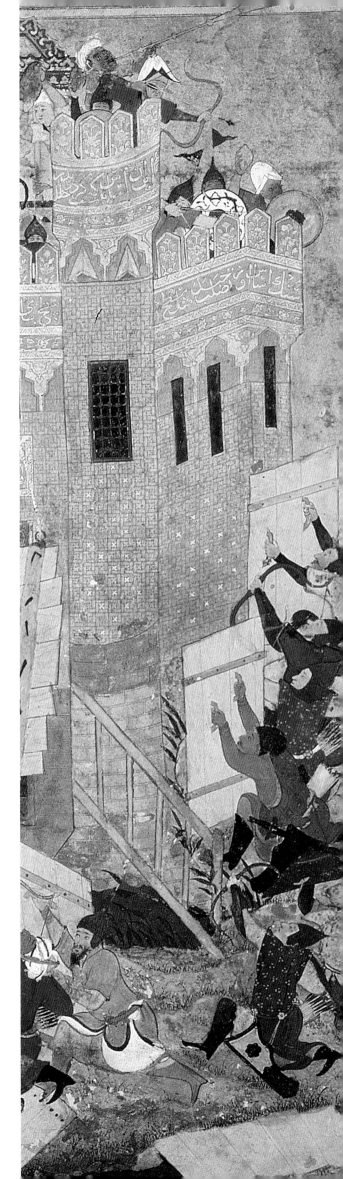

RAZM U BAZM

FIGHTING AND FEASTING
CULT AND CEREMONY

BATTLES

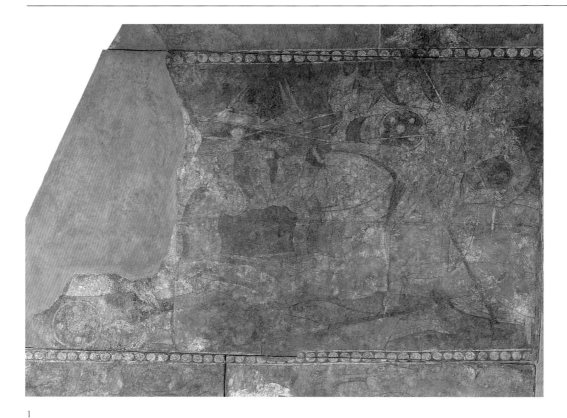

1

1. THE BATTLE OF TWO SQUADRONS

Painted mural in a private house
Panjikent, Sogdia, ca. 740
H: 103 cm
St. Petersburg, State Hermitage Museum,
SA 15903

In the reception room of the house of one of Panjikent's wealthy citizens, a large part of its mural decoration was still relatively intact. The paintings include the now-famous "Rustam cycle" and a narrative frieze situated just above these epic illustrations, of which only small fragments have been preserved.

The battle is joined by two squadrons of opposing warriors of equal rank. They are shown in the heavy armor worn in Sogdia in the seventh and eighth centuries, yet the picture almost certainly did not illustrate a contemporary event but instead some epic that remains unidentified. The heroes of the encounter were probably shown in an adjacent picture that has not survived. Every warrior in this painting is distinguished pictorially in some way — by his position in the line-up, his posture and weaponry, or the color of his horse. Such individualization, even for ordinary persons, is typical for Sogdian art as well as for that of certain nomadic peoples of the area, as can be seen in the Orlat buckles; while it is distinctly not typical of the art of the ancient Near Eastern empires, whose troops are always uniformly presented. Panjikent painters also display a pictorial interest in the change of fortune that could quickly occur on the battlefield: warriors agonizingly wounded, or dead, are often portrayed in Sogdian murals, the sudden loss of power on the part of once brave and dangerous adversaries recalling the transitory nature of human life. In Firdausi's *Shahnama*, scenes of battle and especially of individual combat are often followed by a meditation — a line or perhaps several lines — on just this theme. B.I.M.

2. THE FREER PLATE: THE SIEGE OF A CITADEL

Mina'i ceramic, ca. 1220
D: 45.5 cm
Washington, DC, Freer Gallery of Art, 43.3

A vivid, frenetic, and ambitious image of combat is painted on the face of a large fritware plate or dish with a narrow, flat rim. The scene has been connected with one or another Seljuq historical event; the possibility that it might illustrate an episode from Firdausi's *Shahnama* no longer seems tenable.

At the left stands a high-walled citadel with a zone of open arcades from which three archers shoot at their attacking foes. Round shields are arrayed above them and a vertical pile of armor appears to outline the right wall of a crenellated interior court, the inner structure seen only as a sharply angled horizontal shape in the upper left quadrant of the plate. Inside the court stands a mangonel or a catapult, a ball or missile held in an arm at the ready; and behind the farther wall can be seen a caparisoned elephant, pacing left. Outside the citadel at its lower right wall, some of its defenders are the worse for wear. Having lost both mounts and clothing, they fight on foot with swords and spears, bows and arrows, still engaging the rival army swarming toward them from the right side of the dish. The force includes both cavalry and foot soldiers, armed as are the defenders, and

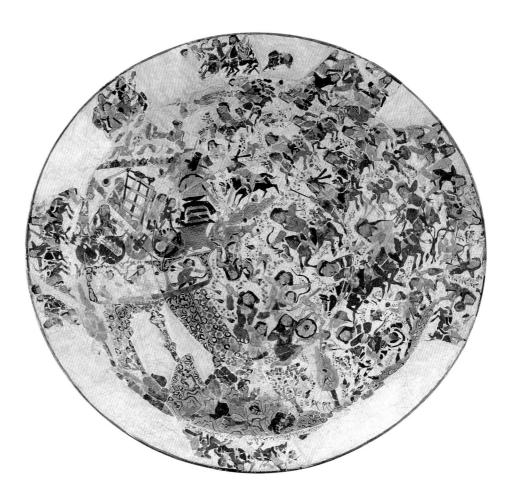

they are roughly arrayed in five rows that might – just – be read as registers. This impression is slightly contradicted by the smaller figures, both mounted and on foot, who race around the flat, narrow rim of the dish.

Many of the attacking figures are named by inscriptions. One, at the center, has been identified as a certain Baha' al-Din Muhammad Shir Barik, ". . . a man of low extraction from Tabriz"[1] who briefly held positions of political importance in the mountains of 'Iraq-i 'Ajam (western Iran, extending westward to the Tigris River), in the second decade of the thirteenth century, just before the Mongol invasion. The entire scene is remarkably detailed, even to his black headgear with a triangular ornament at the front: it is the same as that worn by the central figure in a contemporary Arab painting who is usually identified as Badr al-Din Lu'lu', Zangid vizier in the Jazira until 1259 (Fig. 54).

Such details, and the approximation of registers in which the forces of Baha' al-Din attack the citadel at the left, suggest that someone considered the event of particular importance and wished to commemorate it. He must have looked for models other than the usual combination of figures, *topoi*, and significant motifs symmetrically disposed on the curving surfaces of *mina'i* wares. Indeed, the mode of text illustration underlies the image on this very large plate, especially seen in the zonal disposition of the attackers, and the elaborate citadel. Yet while the three defending archers angle their arrows diagonally down to the right, the circular shape of the plate perforce required eliminating the foes returning fire – even though three discharged arrows are clearly visible in the patterned buttress of the citadel itself. Nonetheless, this celebrated – if still incompletely understood – fritware plate remains the best surviving medieval example of the pictorial tension between the modes of Iranian decoration and illustration, as they are used together on a curvilinear object of potentially practical usage [208, 226].

3. THE IRANIANS LEAVING THE FORTRESS OF FARUD

> *Mina'i* tile painted with an episode from Firdausi's *Shahnama*
> Iran, twelfth or early thirteenth century
> 24 cm point to point
> Boston, Museum of Fine Arts, 31.495

An energetic procession of mounted warriors in the company of drummers and flag-bearers marches over a fragmentary *mina'i* tile (originally having the shape of an eight-pointed star). The primary figures are male, with nimbed heads and large, rounded faces; two in the foreground have thick black beards. Garments and horse trappings are densely patterned, as is the background.

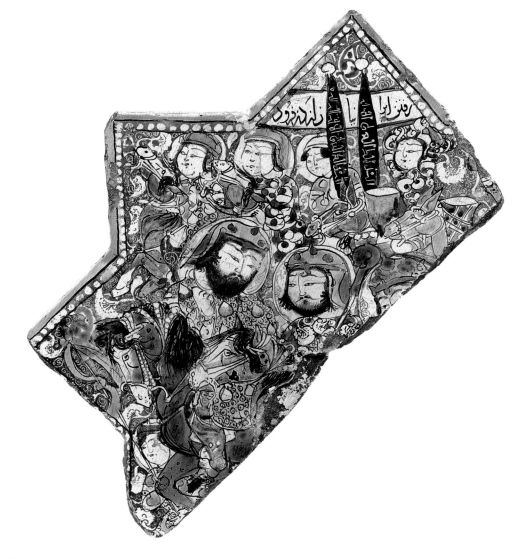

3

The subject is an episode in Firdausi's *Shahnama*. On a band reserved at the top of the composition is written "The Iranians leaving the fortress of Farud:" not a *Shahnama* verse but merely a description of an event – or the rubric in an illustrated manuscript. Farud was the son of Siyavush, grandson of the foolish Kay Ka'us and half-brother of Kay Khusrau [70, 102], an early casualty in the continuous conflict between Iran and Turan that is one of Firdausi's overarching themes. This must have been one of a much larger ensemble of *mina'i* tiles made to decorate some palatial Seljuq residence that no longer exists.

4. GULSHAH SLAYS THE SON OF RABI' IBN ADNAN

> Painting in a manuscript of 'Ayyuqi's *Warqa u Gulshah*
> Anatolia, 1200–1250
> H: 7 cm; W: 18 cm
> Istanbul, Topkapı Saray Museum, H. 841, fol. 23v

The illustrations in this uniquely surviving, provincial Seljuq illustrated manuscript perfectly embody the "Seljuq International figural style" of painting: seen in manuscripts produced in neighboring Arab lands (Figs. 54,

4

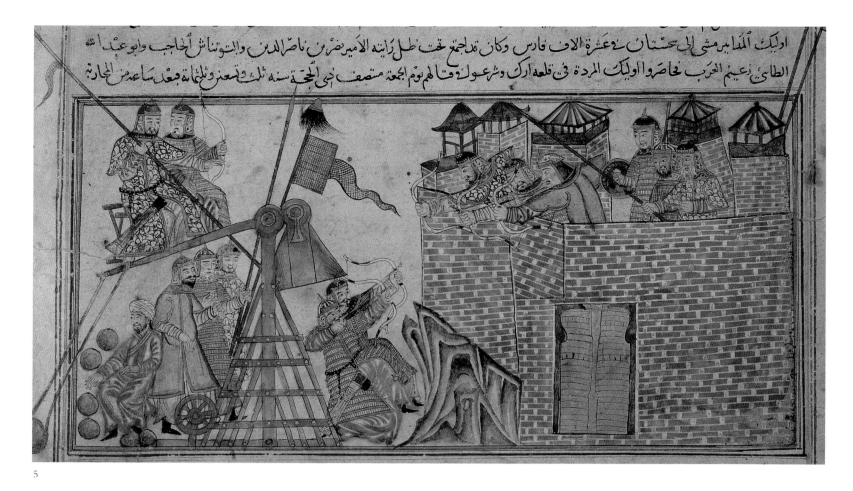

5

55) and on myriad Iranian ceramics [2, 3, 123]. The faces are full and round – the moon face of Buddhist images from Eastern Turkestan; the heads are often nimbed; the poses of figures are varied and energetic, even in their strip-like format and almost simplistic landscapes. Indeed, the entire ensemble of seventy-one paintings can be characterized as an illustration of verbs, as was once observed of the Freer Beaker [135].

This particular picture illustrates a specific episode but the genre is common to ʿAyyuqi's text: battle. Without the identification written in white on the red background of the painting, it would be hard to identify the heroine of the poem as Gulshah, dressed as she is in men's clothing. Such generic pictures are not uncommon for the period and can be paralleled, for example, by the contemporary fragmentary star-tile whose action is described only in a title-like phrase [3].

5. MAHMUD IBN SEBUKTIGIN ATTACKS THE FORTRESS OF ZARANG IN SISTAN

Folio from the Arabic manuscript of Rashid al-Din's *Jamiʿ al-Tavarikh* (*Compendium of Chronicles*)
Tabriz, 1314
H: 33.5 cm; W: 44.5 cm
Edinburgh, University Library, MS Arab 20, fol. 172v

The section of Rashid al-Din's monumental *Jamiʿ al-Tavarikh* devoted to the Ghaznavids is heavily illustrated, with twenty-seven pictures that lay great emphasis on the legitimacy of Ghaznavid rule under its greatest Sultan, Mahmud. Twenty-one of these are vivid images of battle and conquest; this illustration is typical. Stretching the full width of the ruled surface of the folio, its height is about thirteen lines of text. It is drawn against the bare paper and color is then applied, both in bounded solid fields – the tradition for most Islamic text illustrations – and as transparent color-wash – a technique more typical of Chinese painting.

The composition is dramatic: the besieged fortress looms on the right as a solid brick-built mass on a rocky cliff whose defenders rain arrows down on attackers from the ramparts; at the left, the Ghaznavids ready a catapult, the towering wooden structure flying a banner and a yak-tail standard, under the protection of archers.

The essential compositional motif, the fortress on a rock defended by a row of archers aiming down at their attackers, is of some pictorial age; it already appears on the celebrated *minaʾi* "Siege Plate", complete with catapult [2; Fig. 60]. Much of the strength of the image derives from the tension created by the two sets of archers; used horizontally, as it is here, it is very effective. The motif appears several times in the paintings of another fragmentary copy of the *Jamiʿ al-Tavarikh* (Fig. 58), at least once in a taller format; and it lived on into later centuries, for instance in a fifteenth-century Shiraz painting in the more conservative mode [81], and occurs throughout the Safavid period.

6. THE BATTLE OF BADR

Painting in a Persian translation of Rashid al-Din's *Jamiʿ al-Tavarikh* (*Compendium of Chronicles*)
Tabriz, 1314
Istanbul, Topkapı Saray Library, H. 1653, fol. 165r

In the two surviving Persian copies of Rashid al-Din's world history, the illustrations are generally more uniform, in both size and style, than the pictures in the Arabic manuscript [5, 69, 88]. Most are horizontal compositions occupying the full width of the ruled surface. Stylistically, they display a greater cohesion, with very few strong colors – red, black, blue, and gold and silver – played against washier applications of the same tint. The life of the Prophet Muhammad is illustrated by four pictures in the earlier of the two Persian manuscripts: this "Battle of Badr" is one.

Badr was the site of the first great victory of Muhammad and his forces. The Muslims emerged from it with great self-confidence for the new faith as well as the prestige of having routed a rich caravan returning from Syria to Mecca, inflicting great loss of life while suffering minimal casualties themselves. The illustration employs the simplest of means to recount this signal event: four figures and two horses fully shown, and the back of a fifth figure, along with several horses only partially seen, and a severed head and arm. Figures race through the width of the picture in a mist of curling, writhing Chinese-style clouds. No ground line interrupts the deadly chase

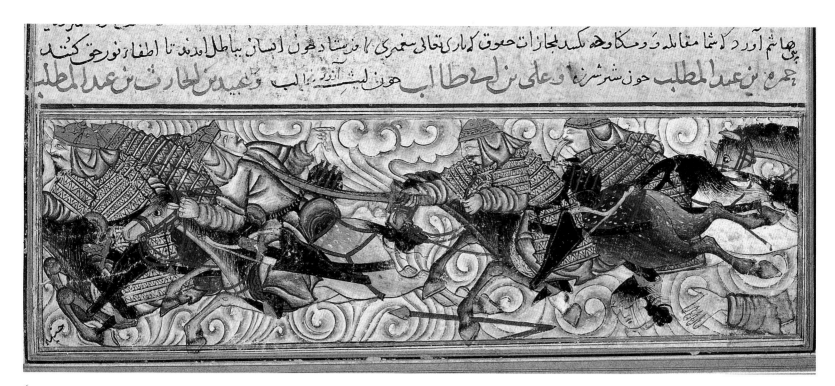

6

of the Prophet Muhammad's forces — a pair of
horsemen just right of center — and the
fleeing caravan — three horsemen, one only
suggested by a different color for his body
armor. Most wear lamellar armor of the East
Asian type, as did some of the Ghaznavids in
the Arabic *Jamiʿ al-Tavarikh*, the only exception
is the pointing figure being struck in the
back. Remarkable throughout this manuscript
is the intense expressiveness of faces, hands,
and entire figures, which occasionally
approaches the grotesque. Mouths are large
and red, eyes are fully drawn with whites and
dark pupils; brows furrow deeply, hands are
over-large and bony. Nothing could be further
from the compact, contained figures and the
rounded moon-faces of Seljuq painting in
whatever medium [123, 177].

7. THE HOSTS OF IRAN AND TURAN
IN BATTLE

> Painting in a manuscript of Firdausi's
> *Shahnama*
> Probably Shiraz, ca. 1405
> H: 10.3 (22.9) cm; W: 14.7 cm
> Dublin, Chester Beatty Library, P. 114,
> fol. 38r

Five sturdy soldiers, a pair of swords
betokening two more behind a hill, and two
caparisoned horses are the simple components
of this vivid image of a battle that bursts from
the wide golden rulings and out into the
margin of a tiny page. The picture illustrates
one of the many occasions in the *Shahnama*
on which the Iranians fight the Turanians [8],
with an added theme, the revenge sought by
the Iranians for Afrasiyab's slaying of prince
Siyawush [100].

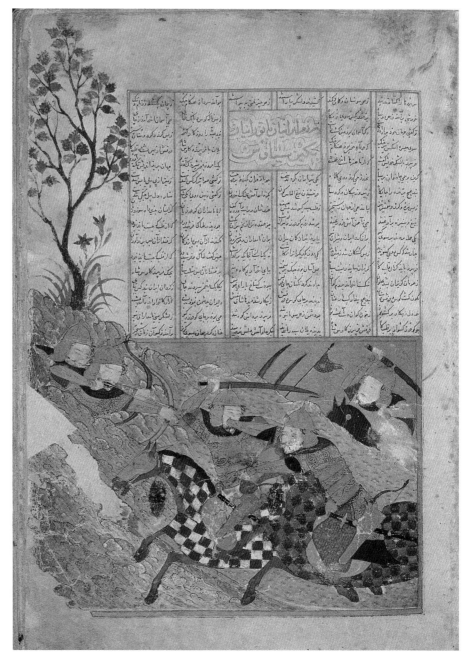

7

The painting is one of fourteen that illustrate a gathering of epic poems that once belonged to the Ottoman Sultan Bayazid II and, later, to the nineteenth-century diplomat and Orientalist, the comte de Gobineau. The volume was later split into two parts, one containing Firdausi's *Shahnama* with five illustrations, and the other having four poetic epics, in the genre of Firdausi, and nine illustrations. When the manuscript was completed, and where it was copied, are nowhere stated in the Firdausi volume; the *Epics*, however, has dates between October and December of 1397, and the Firdausi portion, being originally last in the volume, was surely completed after this date. Its very small size and the style of the calligraphy, as well as its anthological nature, argue that it was made in Timurid Shiraz.

The picture is quite small, and so the few sizeable figures appear even larger than they are in reality and they have large oval heads. They move within a fully painted mountainous landscape, with a brilliant gold sky above the lavender rocks. The action is only partially contained within the wide gold rulings and spreads into the marginal extension at the left, where the tree and a lily with a bent leaf are painted against the bare paper. Movements and positions are varied, even when a pair of figures is depicted "in unison" to give the impression of many from few. The soldier partially seen behind the hill raises his sword, an action that seems completed by the thrust of the soldier in the foreground, shown in a three-quarter back view; he wears a cuirass recalling the lamellar armor in paintings in the Persian *Jamiʿ al-Tavarikh* [6], as well as on the two combatants in "The Duel" [15].

Many aspects of the finest of the unattributed pictures in the Istanbul albums are repeated here: the size of the sturdy figures; the tendency to set them into a dip in the landscape; the edges of the rocky horizon, similar to the dabbed-in quality of the Istanbul paintings [15, 104]. These, and other features, in addition to the palette of the ensemble in which dark intense colors are often "powdered" with overall golden designs, all suggest that some source very close to the Istanbul album pictures underlies the design of these images. Perhaps it was the painter himself – not native to Iran and challenged at finding himself in a milieu like Shiraz [e.g. 70, 71], where the making of fine books was already an old tradition by the late fourteenth century – to whom this new illustrative vision is due. Whatever, in the end, accounts for the amalgamation of a pictorial tradition from the East with a book-making tradition from the Iranian heartland, its first splendid visual experiments are to be found in this tiny volume of epic poems in Persian.

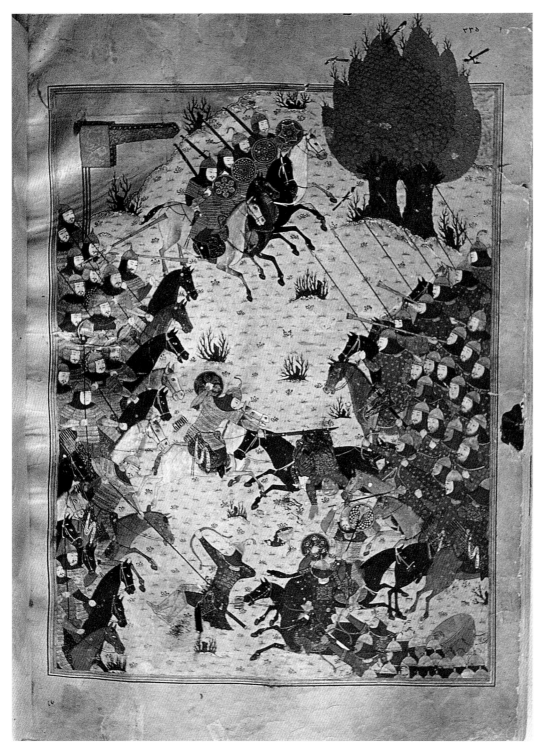

8. THE HOSTS OF IRAN AND TURAN
IN BATTLE

> Painting from Baysunghur's manuscript of Firdausi's *Shahnama*
> Herat, 1430
> Tehran, Gulistan Palace Library, MS 61, p. 355

The illustrations of Baysunghur's majestic *Shahnama* are especially large for Timurid paintings, with large figures well integrated into their settings. One of Firdausi's overarching themes is the conflict between Iran and Turan that flares up at various times and was, at one point, driven by Iranian desire to avenge the murder of prince Siyawush by the Turanian monarch Afrasiyab. More than once [7, 10], the hosts of Afrasiyab and Kay Khusrau, son of Siyawush, met in battle: this painting illustrates one of those occasions.

Firdausi's rhetoric here is given its visual due: the image is truly a clash of hosts. The two mounted armies advance on each other from the opposite corners of a full-page picture, and the diagonal movement of the masses of men and horses creates an even greater sense of precipitate movement. The Turanians wear purple surcoats, and their mounted phalanx charges from the right, lances lowered and trumpets sounding. The Iranians are in golden lamellar armor and mostly still drawn up behind their heroes, Rustam and Barzu, his grandson; one wing, at the upper left meets the Turanian charge with

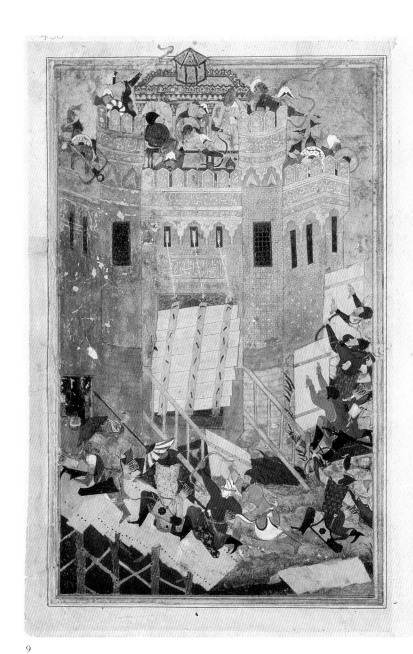
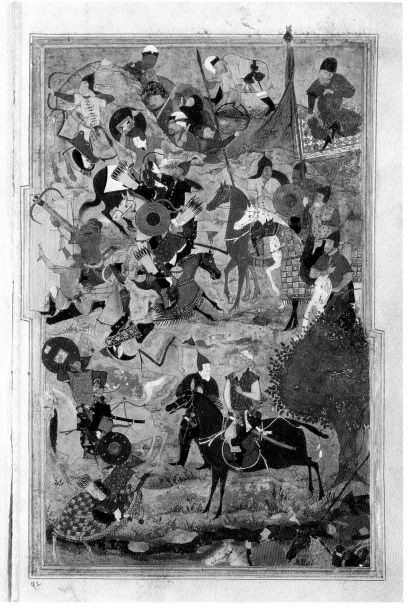

9

swords still at the shoulder. In the lower left, the Turanians are in some disarray: the ranks are split, some Iranians have advanced into their midst, and two soldiers battle at close range, shields and swords both raised. The Turanian archers let arrows fly but one, in the foreground, has been stopped in mid-draw by the lance of none other than Rustam.

The device of multiplying figures, seen to such effect in the little painting of the same subject done in Shiraz perhaps twenty-five years prior, is used throughout this picture as well; but so great is the number of figures – and so large is the field upon which they are disposed – that the eye does not read them as multiple figures but rather as the mass of armed men that is intended. The helmets of both armies are gold, the Turanians' surcoats are "powdered" with golden ornament, and the woven wicker shields provide accents of bright color and whirligig patterns throughout the painting. It is a grand image that thoroughly glorifies the continuing conflict between Iran and Turan.

9. THE FORCES OF TIMUR ATTACK THE KNIGHTS OF ST. JOHN AT SMYRNA IN DECEMBER 1402

> Double-page painting in Sultan-Husayn's manuscript of Sharaf al-Din ʿAli Yazdi's
> *Zafarnama*
> Herat, 1480–85
> 449v H: 20.8 cm, W: 12 cm
> 450r H: 21.1 cm, W: 11.9 cm
> Baltimore, The Milton S. Eisenhower Library of Johns Hopkins University, John Work Garrett Collection, fols 449v–450r

Sultan-Husayn's illustrated copy of Sharaf al-Din ʿAli Yazdi's *Zafarnama*, the *Book of Victory*, was illustrated with six pairs of double-page paintings [33, 93], of which four are battle scenes. Those showing encounters in foreign lands against non-Muslim opponents are directed by Timur himself, as if to underscore the breadth of his conquests.

The capture of the castle of the Knights of St. John, in Smyrna, may not have ranked highest on Timur's list of targets in the Anatolian campaign, but the illustrated event

in Sultan-Husayn's manuscript is vivid and exciting. In one sense, it can be seen as an expanded version of the earlier Shirazi "The Siege of Alamut:" the besieged castle stands on the left, approached by a gangway placed at a sharp angle, while the besiegers move in from the right; archers are prominent among both groups. There, however, the resemblance ends.

The Herat painting shows a castle built of stone – albeit that the inscriptions over its portals are written in Arabic, and the defenders are dressed exactly like the Muslim attackers and armed with the same eastern bows and round decorated wicker shields. The besiegers are both mounted and on foot, and they are spread over both sides of the picture. Shields as large as doors defend the archers; they are held by companions who sit beside the archers or pace beside them as they advance. Horsemen wheel at dizzying angles, turning their horses, dodging arrows and launching them. At the top of the right-hand side, sappers dig, and earth is carried away in buckets. Flag bearers keep the standards in sight and confer, while someone on foot

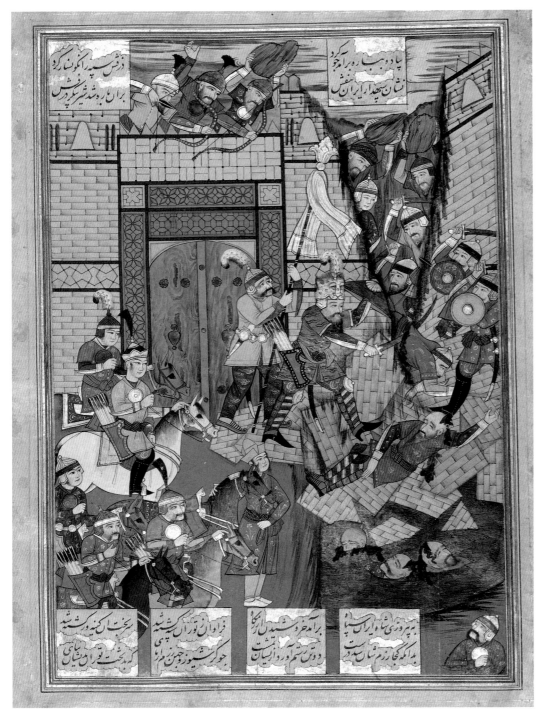

10

10. KAY KHUSRAU, RUSTAM, AND THE
IRANIANS ATTACKING THE FORTRESS OF
GANG BIHISHT

Painting in a manuscript of Firdausi's
Shahnama
Isfahan, 1648
H: 26.2 cm; W: 17.8 cm
Windsor, The Royal Library, MS 1005014,
fol. 376v

The young Kay Khusrau eventually took the
avenging of his father, Siyawush, to the very
stronghold of the Turanian king Afrasiyab.
Twice the Iranians and the Turanians had met
in battle on the open plains, and twice the
outcome was inconclusive; Afrasiyab then
withdrew to his stronghold of Gang Bihisht
north of the Jaxartes River, and thought
himself safe. Gang Bihisht was high and
battlemented, eight leagues long and four
wide, with "provisions, palace, treasure, crown,
/ And majesty, command, and throne and
host." But three weeks later, Kay Khusrau and
his own host, with Rustam at the vanguard,
arrived at Gang Bihisht, whose battlements
called forth the comment from the young
shah: "The builder of these walls built not /
As one expectant of calamity. . . ."

Kay Khusrau then directed a massive
campaign to storm the stronghold: he
commanded a surrounding trench to be dug
and undermined the walls, stationed 200
ballistas – siege engines to hurl boulders –
around the perimeter with elephants to help
move them, smeared black naphtha on the
walls and then fired them: "The walls . . . came
headlong down / From their foundations like
a mount in motion."

The artist of this picture, in a large and
lavishly illustrated mid-seventeenth-century
Shahnama made for Qarajaghay Khan,
governor of Mashhad towards the middle of
the century, has shown us exactly this
moment. The walls being stormed by the
Iranians tumble down into the trench in large
chunks of brick-masonry, although the
mechanisms that made the breach – elephants
and ballistas – are nowhere to be seen, and
the trench is simply a blackened space at the
foot of part of the stronghold. With Rustam at
their head and the young Kay Khusrau
following closely behind, the Iranian attackers
slash their way into Gang Bihisht, dodging the
arrows and stones of the Turanians. Three
defenders are placed above the still-closed
wooden portal; one holds a large boulder high
above his head, in readiness to hurl it down
onto the enemy, but the other two are archers
shooting down to the right at an angle. The
artist has shown them in different stages of
action: one pulls back his bowstring and the
other has just released an arrow. Together the
three Turanian defenders comprise a distinct
and quite traditional pictorial motif, one that
is seen in Iranian painting for at least five
centuries [e.g. 2, 59, 91].

speaks with Timur who is mounted on a
chestnut horse at the lower right of the
picture; he wears a crown and
a light-green *jama* underneath a sleeveless
surcoat.

The action is relentless in the angled
movement of arrows from upper left to lower
right, but there is also a constant circling
motion within the Timurid army. Figures are
lithe, and they move in realistic ways, bending
and running, turning and twisting and
dodging, as if they had been liberated from
the restraints and mannerisms of the painting
of prior centuries. Both of these features
are always ascribed to the hand of Bihzad.
Whether this painting, and others in the same
manuscript, will ever be incontrovertably
identified as his work is almost less important

than it is to appreciate that such freedom in
figural movement is one of the features that
characterizes the best painting of this late
Timurid period [e.g. 33, 34, 93, 94].

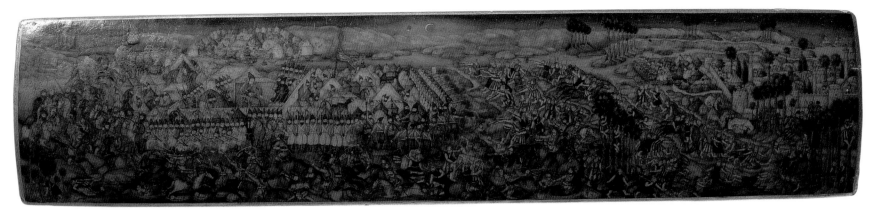

11

11. A BATTLE DIRECTED BY MANUCHIHR KHAN MUʿTAMAD AL-DAULA

> Painted and lacquered papier-mâché pen box (*qalamdan*)
> Isfahan, 1849–50
> L: 30 cm; W: 7.1 cm
> London, Nasser David Khalili Collection, LAQ39

The top of a rectangular pen box with a lift-off lid records a military campaign against the Banu Kaʿb, an Arab tribe with territories lying south-west of Isfahan, which took place in the year equivalent to 1841–42. The Persian verses running around the edges of the lid recount the names of the principal figure and the painter, the event, and when the minutely scaled work depicting probably over 300 figures was completed: several years after the death of the person commanding the battle shown on its top. That person is Manuchihr Khan, the feared, hated, but very effective viceroy and governor of Isfahan, one of the most powerful men in the reign of both Fath ʿAli Shah and Muhammad Shah.

The pen box was decorated for him by Muhammad Isma'il, a painter from a veritable dynasty of lacquer painters in Isfahan. The viceroy is shown on it three times: on the lid, and twice on the sides, riding in the center of a procession of troops, and presiding over a hunt, with dogs and falcons – classic oriental images of princely prerogative.

The battle takes place at night outside a walled city in the midst of irrigation canals and palm plantations. The artist has adopted a bird's-eye point of view, so that both the square, walled town on the right and the square, tented arrangement of the Iranian camp on the left are clearly visible; the commander, Manuchihr Khan, sits in a European armchair at the center of the Iranian enclosure. By this date, many divisions of the Iranian army wore European uniforms and were armed with both muskets and cannon; in their black Qajar astrakhan hats with a distinctive slanting shape, they are clearly distinguishable from the bedouin in striped robes and *kaffiya*, even in the melée of battle before the Qajar camp on the left, or splashing through the canals outside the city.

Stars and a sickle-moon light the night sky, and the myriad tiny details are meticulously executed in stippled paint – landscape, architecture, time of day and atmosphere, accoutrements, and animals, but especially the faces and poses of human figures, many quite individual depite their tiny scale.

Muhammad Isma'il went on to become *naqqash-bashi*, "chief painter," to Nasir al-Din Shah, painting a number of lacquered objects with events of contemporary history in the same excessively miniature and multiple-figured style. On this pen box, the first of the series, he signs himself as a painter not merely from a family of painters but from an ancient line of practitioners of the Iranian pictorial art: "– that tale was depicted upon this surface by a man from the line of Mani, Isma'il by name."[1]

DUELS

12. ARMORED WARRIORS DUELLING
ON FOOT

> Silver plate with *champlevé* decoration and
> gilded details
> Sogdia, seventh century
> Diameter: 21.8 cm
> St. Petersburg, State Hermitage Museum,
> S-33

The duelling scene on this silver plate
illustrates an episode in some heroic Sogdian
epic as yet unidentified; its popularity in the
early medieval period in Sogdia is evident
from its appearance in contemporary Sogdian
mural painting.[1]

In the epic poetry of a large Eurasian area –
from the Balkan Peninsula through Russia and
Persia, to the Turkic and Mongolian Steppes –
the combat of perfect heroes always takes place
according to a formula that emphasizes its
tragic nature. The heroes meet three times,
each encounter being fought with different
weapons; three times neither prevails. In the
end, the heroes must abandon man-made
weapons, draw on their own innate strength,
and wrestle to victory for one, and defeat for
the other: in Firdausi's *Shahnama* [17], in the
Russian *Byliny*, and in Kazakh, Mongol, and
other steppe epics, the duel between heroes is
often decided by a wrestling match.

On this plate, however, the story is not
strictly adhered to, for despite the discarded
weapons on the ground, the heroes carry still
others, as if their duel had only just begun.
The figure on the left pulls a bow, while that
on the right holds his long spear atilt,
although the space between them is already
littered with discarded shields, broken and
useless swords, maces, and battleaxes. Yet the
composition is symmetrical, emphasizing the
fundamental equality of the protagonists, and
the plate well illustrates the tragic collision of
two heroic imperatives: he who wins, in the
end, will prevail because it is his heroic "duty"
and he will do so with no supernatural
assistance, divine or demonic.

Where the story of heroic single combat
sometimes diverges is when an apparently
invulnerable hero succumbs. In a painted
version of the same episode from this as-yet
unidentified epic, one hero is pierced in the
chest by an arrow and must die, his adversary
attaining victory by means of supernatural
assistance. In the *Shahnama*, Rustam slays
Isfandiyar with the help of the *simurgh* (the
magical bird who protects Rustam's family),
after three futile skirmishes in which each
hero's weapons were broken. Rustam's wounds
were healed by the *simurgh's* feathers; she also
told him how to choose an especially straight
branch of tamarisk with which to make an
arrow that would be fatal to Isfandiyar. The
Sogdian stories, on both the plate and in
mural paintings, are not the precursors of
Firdausi's tale of Rustam and Isfandiyar, but it
is quite possible that the episode in both epics
shares a common typology. B.I.M.

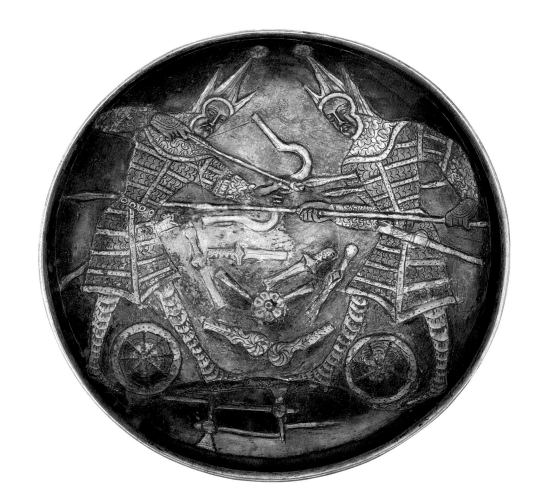

12

13

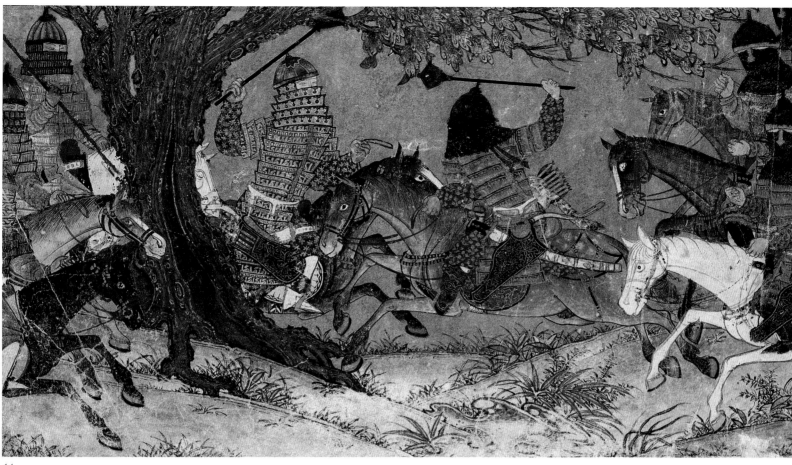

14

13. THE DUEL OF VAG AND THWENAK

Painted mural in a private house
Panjikent, Sogdia, first half eighth century
H: 18.4 cm
St. Petersburg, State Hermitage Museum

This scene is part of a longer narrative frieze
in the reception hall of a private house in
Panjikent. The prior episodes tell of the
combat of two horsemen, which continues
even when one, unsheathing his sword, is
unhorsed and his adversary dashes at him with
a lance. In this next stage, which takes place
outside a fortified house, the adversary has also
dismounted and makes to tie up the opponent
whom he has captured alive. From the flat
roof of the house, two ladies throw something
to the victor. This episode is not the end of
the story – but the conclusion is unknown,
since no further illustrations have survived.

One clue is furnished by the manner in
which the combatants' faces were depicted, for
the usual practice in Panjikent murals is to
show the faces of more ordinary people in
three-quarter view and the hero in full profile
[e.g. 1, 129, 132]. Here the "heroic profile" is
that of the loser while the victor's face is seen
in three-quarter view, but the unusual image
tells us that his destiny will soon alter.

It happens that the names of the two
combatants, Vag and Thwenak, have been
preserved. In a white rectangle painted at the
gate of the house is a Sogdian inscription,
in poor condition but still readable.[1] Its text
suggests that both warriors were trying to
enter the house, and that Vag then tried,

unsuccessfully, to tie up Thwenak. Thus,
while the story is incomplete in the murals of
this reception hall, a brighter future for the
apparently-conquered Thwenak is not only
suggested visually – by the depiction of the
heads of both combatants – but confirmed in
the accompanying text. B.I.M.

14. ARDASHIR FIGHTS WITH BAHMAN, SON OF ARDAWAN

Folio from a dispersed manuscript known
as the "Great Mongol *Shahnama*"
Tabriz, ca. 1325–35
H: 17 cm; W: 29 cm
Detroit, Detroit Institute of Arts, 35.54

The armed encounter of single warriors who
represent two sides of a conflicting force is
an ancient rhetorical device of many cultures.
When Ardashir the Sasanid overcame the
Parthian Artabanus V at the momentous battle
at Hurmuzdigan in 224 – from which dates
the establishment of the Sasanian dynasty –
the victory was commemorated in just this
fashion, in a great rock-relief carved above the
Sasanian road at Firuzabad, in Fars Province.

A millennium later the same event is
visualized. Above the painting is a cartouche
with the title, "The battle of Ardashir with
Ardawan" (Artabanus), but the text above the
picture recounts a prior event, when Bahman,
son of Ardawan, fought Ardashir; a tiny
correction is actually written into the
cartouche.

Firdausi recounts that day had dawned,
when ". . . from the army's centre came
Ardashir;" here the scene is set against the
shining golden sky of midday. Two horsemen
in full lamellar armor advance on each other,
their horses at a flying gallop; they brandish
maces above their heads, swords and arrows
hang at their waists. Only the color of the
armor, and their headgear, distinguishes the
opponents: Ardashir and his troops – three
mounted soldiers – wear an armored face
covering (painted in silver, it has oxidized and
now appears black); Bahman and his troops –
two men, on the left – wear neck armor up
to the eyes, and helmets of red and blue. The
composition is simple, only a central pair of
figures facing each other with accompanying
soldiers behind them (and here cut by the
margin); it was a motif known in the Tabriz
ateliers and had been used in the Arabic *Jami'
al-Tavarikh*. Here the formula is varied by the
placement of the huge gnarled pine tree
partially hiding the figure of Bahman.

15. THE DUEL

Painting mounted in an album
Western Central Asia or Samarqand, late
fourteenth–early fifteenth century
H: 27.5 cm; W: 36.5 cm
Istanbul, Topkapı Saray Museum, H. 2153,
fol. 138v

Mounted on horses with compact bodies and
large heads of impressive shape, two heavily

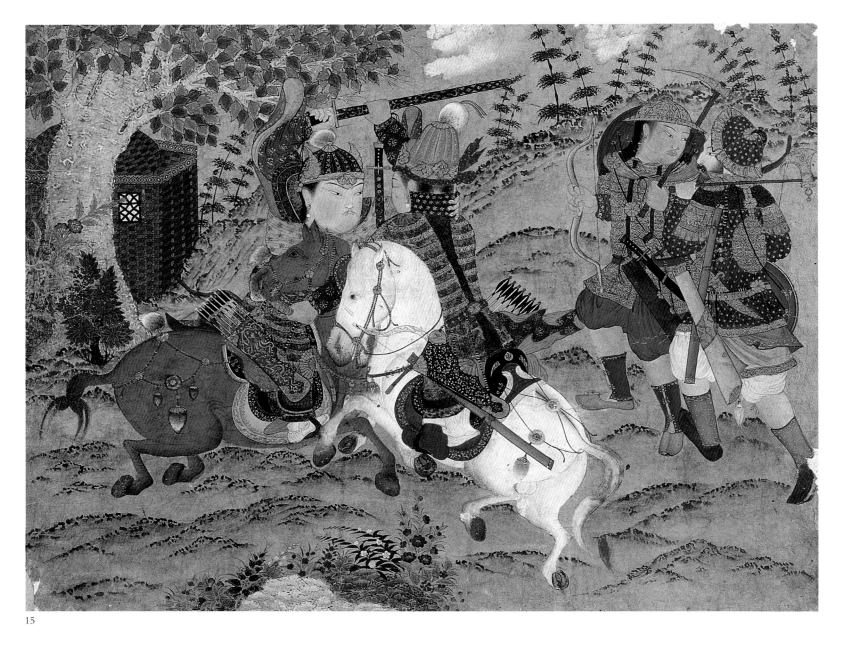

15

armed men are locked in combat, so closely so that one horse must turn its head to avoid a clash with the other. The rider on the dun horse raises his sword arm and with the other clutches the neck of his opponent, seen from the back and mounted on a white stallion; he, in turn, grasps the hilt of the sword raised against him with his bare right hand and the bridle of his opponent with his left. Colors are strong and primary; helmets and clothing, arms and armor and horse trappings, are depicted in astonishing detail, as are those worn and carried by the pair of foot soldiers at the right margin. The helmet of the man on the dun horse appears to have tiny golden wings, or horns, attached to the headband, and his quiver is decorated with a golden dragon; small gold, patterns decorate other garments, as well as helmets and saddles.

The horses "ride" the air – all eight legs bent and hooves off the ground: the engagement is at high speed. Together with the position of the two riders – one seen from the back, and the highly detailed Asian armors, the picture brings to mind the picture of Ardashir and Bahman son of Ardawan [14], from the "Great Mongol *Shahnama.*" Similar, too, is the spreading tree at the left of the picture, its foliage cut by the margin at the

top of the painting; here it is clearly a plane tree or *chenar*, with silvery bark horizontally striated, and large leaves of different green hues. One element seems to set the picture clearly in an eastern Muslim milieu, the small domed brick building in the lee of the hill, partly hidden by the plane tree; the blue interstitial plugs and blue-tiled cresting are typical of buildings in Central Asia and Transoxiana.

The horizon line of the picture is irregular but high, rising above the heads of the foot soldiers. The ground is suggestively modelled, with dabs of reddish color from a loaded brush, in mounds and little hillocks, instead of being fully painted with color; this treatment is reserved for the figures and the building in the background. The figures are large and long-waisted, with large heads; varying shapes of eyes and noses differentiate Asians from a single reddish-haired foot soldier, shown in profile. Considered together, they seem to issue from a world east of Iran, where the material culture of Turkestan and Transoxiana was a matter of daily observation. The landscape style of the painting also appears more eastern, in its high horizon and its suggestively bare sky. A striking picture with an immediacy to the central image of

grappling horsemen, its date and origin remain uncertain. Wherever it was painted, it is a brilliant pastiche of an easterly pictorial subject in what appears to be a more western-Iranian composition.

16. RUSTAM FIGHTS BARZU WITHOUT RECOGNIZING HIM

> Painting from Baysunghur's manuscript of Firdausi's *Shahnama*
> Herat, 1430
> Tehran, Gulistan Palace Library, MS 61, p. 357

Rustam had fathered a son, Suhrab, born of a single marriage-night with Tahmina [108]; he did not recognize his son until he loosened the armor of a young opponent who had rashly engaged him in single combat, only to find the amulet he had given Tahmina. So, in the earliest of the "post-*Shahnama* epics," Suhrab had fathered a son, Barzu, to whose mother Shahru Suhrab had in turn left a token. Barzu prevails upon Shahru to tell him his father's name and vows to avenge his father's death at Rustam's hand; and again Rustam finds himself in single combat with

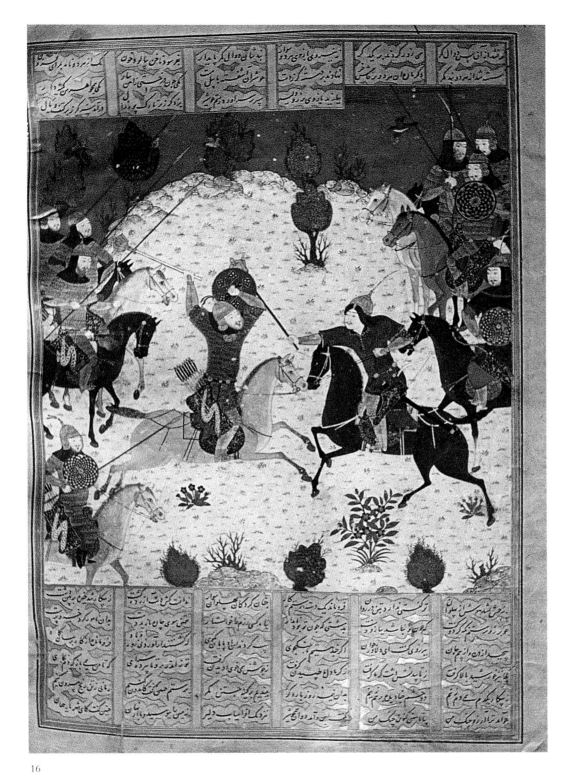

16

::17

Rustam, in tiger-skin coat and leopard's tail over his quiver, and his eager, still unrecognized grandson. They fight with maces, Rustam raising his shield to ward off Barzu's blow. It is Shahru herself who identifies Barzu for Rustam but she is nowhere to be found in the painting which is, instead, an image of the ideal knightly combat fought beneath an ideally blue sky.

Interpolating the Barzu story into his *Shahnama* revisions is one way in which Baysunghur's interest in Firdausi's text manifested itself. He is also credited with composing a new preface for the work; and both are said to appear first in an unillustrated *Shahnama* manuscript dated 1425–26. The *Barzunama* interpolation in Baysunghur's illustrated *Shahnama* suggests that he – or at least writers in his circle – had variant versions of Firdausi's text at hand with which to work, since before this period it seems that no standard Firdausi text was used and accepted all over Iran, whether a text was to be illustrated or not.

17. RUSTAM WRESTLES WITH PULADWAND

Painting from Ibrahim-Sultan's manuscript of Firdausi's *Shahnama*
Shiraz, ca. 1431–35
H: 9.6 cm; w: 14.5 cm
Oxford, Bodleian Library, Ouseley 176, fol. 170r

Ibrahim's *Shahnama* differs visually from that of his brother Baysunghur, especially in the pictures that illustrate Firdausi's text [8, 16, 75, 90]. They are far more numerous – forty-three, as opposed to nineteen; the illustrative program is utterly different from his brother's preoccupation with affairs of state; and stylistically the two manuscripts appear to have virtually nothing in common. *Rustam Wrestling with Puladwand* is a case in point.

A picture of the "old-fashioned" shape and

an unknown youth. This time the youth's identity is disclosed before the *coup de grâce* falls; the two are reunited, and Barzu then joins the Iranian forces to fight at his grandfather's side [8].

The anonymous text of the *Barzunama* is thought to date from the eleventh century but as a work on its own it is encountered infrequently, perhaps because it is even longer than Firdausi's *Shahnama*. Baysunghur included parts of it within his majestic illustrated *Shahnama*; this picture is probably the earliest appearance of Rustam's grandson Barzu in an illustrated Iranian manuscript.

On a high-rising hill under a blue sky, Barzu advances on the great hero. Iranian mounted soldiers, in lamellar armor and carrying round shields, watch from both sides, but the center of the picture is given to

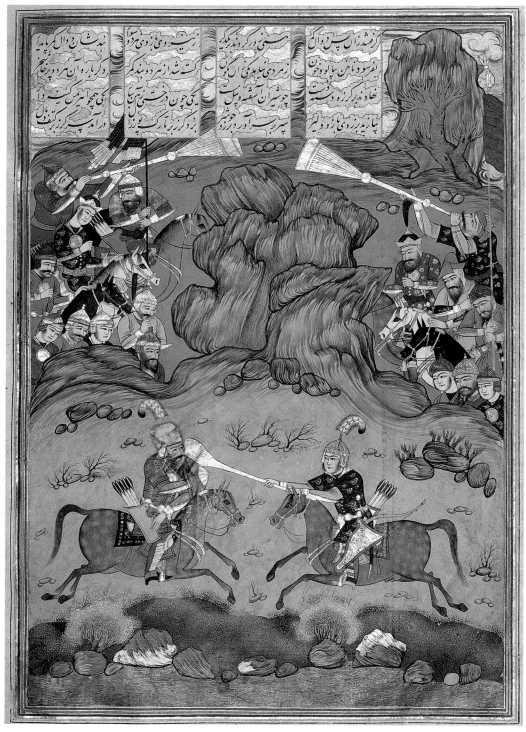

18

18. RUSTAM FIGHTS BARZU WITHOUT
RECOGNIZING HIM

Painting in a manuscript of Firdausi's
Shahnama
Isfahan, 1648
H: 28.7 cm, W: 19.5 cm
Windsor, The Royal Library, MS 1005014,
fol. 279v

In a densely illustrated *Shahnama* manuscript
made for a Safavid governor of Mashhad [10,
6, 134], the interpolated *Barzunama* is
illustrated by a surprisingly large section of
thirteen illustrations. The painter of this
picture has made use of the classical image of
a pair of mounted heroes engaged in what is
surely intended as mortal combat to illustrate
the first meeting between the hero Rustam
and Barzu, the grandson whose existence he
does not even imagine [see 16].

Rustam's appearance alters throughout this
manuscript: here he is appropriately mature
and black-bearded whereas his grandson Barzu
is shown as a beardless youth, his cheeks
covered in fine black down. To make up for
the disparity in age, the painter has given
Barzu a huge golden mace with which he
swings, in vain, at his wily and experienced
grandfather. These two figures are the core of
the illustrated episode, but each is
accompanied by a small army of mounted
companions, each side carrying standards and
blaring trumpets to herald the start of combat.
The forces are, as always, displayed in a fold of
mountains in the background, and the two
sides are emphatically separated by a mass of
rock towering up through the center of the
background, a device developed at least as
early as the Jalayirid period, in the middle of
the fourteenth century [321].

size, it is merely a rectangle placed at the
bottom of the page and entirely contained
within the rulings. Against a high hill with a
regular *semée* – a scattering of grass tufts – and
a few clumps of low flowers, two armed men
wrestle each other; their horses wait apart,
heads facing into the picture from the edge of
the hill near each margin, set against a bit of
golden sky. That one of the opponents is
Rustam we know from his tigerskin *jama*.

Here Rustam is engaged in one more
heroic deed for the Iranians, taking on the
champion Puladwand (Firdausi calls him a *div*,
or demon), whose services had been called
upon by the Turanian king Afrasiyab. Both are
skilled in using the lasso, but Rustam fails to
snare Puladwand; he crashes his mace onto

Puladwand's head but to no avail; they fight
with swords and Puladwand even taunts
Rustam to "change his gear" and discard
his tiger skin, but Rustam refuses. Then
Puladwand said: "Wrestling is the test 'twixt
man and man" and the two dismounted,
". . . made a pact / That none should interfere
from either side," rested, and began again.
Their respective forces drew back half a
league, and ". . . each warrior / Seized his
opponent by the leathern belt." Exactly what
the anonymous Shiraz artist has depicted: two
armed men grabbing each others' belts on
a virtually empty field of combat. The bare,
distinctive Shiraz style – large figures with
large heads, dramatic in silhouette, and dynamic
in action – is used to good advantage.

19. BELT BUCKLE WITH
A HUNTING SCENE

Gold inlaid with glass
Southern Siberian Steppes, fourth–third
century BC
H: 10.2 cm; W: 19.2 cm
From the Siberian Collection of Peter the
Great
St. Petersburg, State Hermitage Museum,
SI-1727-1/70

This impressively large and heavy gold buckle, worked in low relief and enhanced with glass inlay, is one of a pair from the same belt. Two hunters, one mounted but both wearing identical clothing, weapons, and horse harnesses are shown on each buckle. A number of such pairs of buckles forms part of the famous Siberian Collection of Peter the Great. This consists of many gold and silver objects excavated by peasants digging in the early eighteenth century in Southern Siberia (which then included the northern part of Kazakhstan); Peter had issued an edict in 1718, according to which the Siberian governor was to collect such finds and send them to St. Petersburg.

Each buckle of a pair bears the same scene but represented as if viewed from different sides; thus we see swords on one buckle, and quivers and bow-cases on the other. The shape, the style of figures and their size, and some technical characteristics of both buckles are typical for fifth- or fourth-century Saka, or Eastern Scythian, art; yet the weapons depicted on them are slightly later, and the use of inserted glass details, instead of turquoise, is unusual. This pair of buckles was probably made in the fourth or third century by an artisan of some urban Central Asian center for a nomadic patron.

The almost identical figures on this and other Siberian buckles represent the foster brothers, a theme typical of the epic literature of many Asiatic peoples, in which one figure

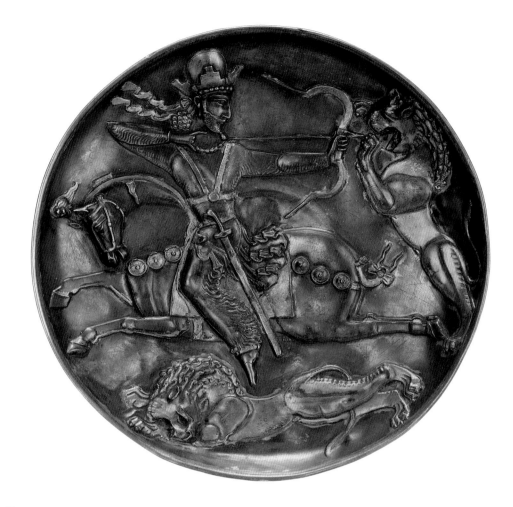

20

acts as befits a hero of almost divine stature while the actions of the other characterize the imperfections of human nature. Here one brother hunts a huge wild boar and the other escapes into a tree in panic. It prefigures the episode on a celebrated ceramic beaker [135] of the twelfth or early thirteenth century, painted with *Shahnama* illustrations, in which the valiant Bizhan fights monstrous wild boars

while his friend Gurgin hides behind a hill; the episode was often illustrated in *Shahnama* manuscripts [136–39]. Other Saka buckles that show the struggle of two warriors on foot and flanked by their standing horses have parallels in illustrated manuscripts from the fourteenth century onward [17]. Such analogous images show us how deeply ingrained, and over what length of time, was the tradition of certain epic representations in the art of the Iranian peoples. B.I.M.

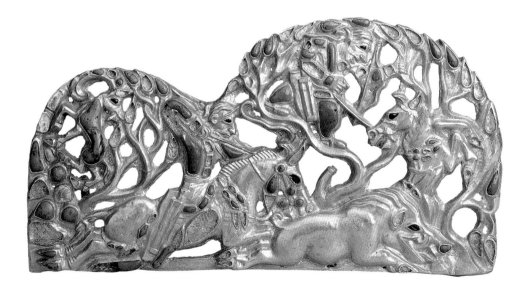

20. SHAPUR II HUNTING LIONS

Silver plate with *champlevé* decoration and details in high relief
Iran, fourth century
Diameter: 22.9 cm
St. Petersburg, State Hermitage Museum,
S-253

The hoard in which this plate was buried, together with another Iranian [224], two Byzantine, and three Sogdian vessels, was found by chance in 1927. It was one of many burials of precious objects discovered in the forests of the Kama and Vyatka Valleys in northern Russia.

Early medieval merchants from the Orient came to this region to buy furs from the local

Finno–Ugrian hunters and trappers, who were happy to exchange their furs for Oriental silver vessels. These were prized by the northern tribesmen and used for sacral feasts; some plates appeared to be serving up the "faces" of their idols, and even today certain Siberian Ugrians only eat sacrificial meat from metal dishes. The State Hermitage Museum acquired its large collection of Sasanian and Sogdian silver vessels from the Imperial (and later, the Soviet) governments, whose practice was rarely, if ever, to reward finders with a sufficient sum of money. Such circumstances discouraged forgers from even attempting to profit in the exercise of their craft; thus there are no forged silver pieces in the Hermitage Collections except for a plate bought in Rawalpindi (at that time in British India, now Pakistan).

This superb plate bears an image of Shapur II (309–79) in victorious combat with a dangerous lion. The king of beasts is shown twice, attacking, and then dying. Shapur shoots backwards, executing the so-called "Parthian shot." Also referred to as "false (or pretended) flight," it was especially effective for a galloping horseman because his arrow could be released directly at the target, avoiding the chance that his horse's head would interrupt the trajectory of his arrow. Shapur thus displays his *farr*, or royal charisma, in executing such a shot.

His crown and breast ornament, the *apezak*, were features of official royal attire, whereas in reality the royal hunter might wear neither crown nor *apezak*, as can be seen in the hunting reliefs at Taq-i Bustan (Fig. 13). Nonetheless, the king's hunt – always victorious – was a manifestation of his *farr*; its success signified his own majesty, and prosperity and luck for himself as well as for his subjects. The owner of a silver plate bearing an image of his victorious monarch probably hoped to partake, in some small part, of his ruler's charisma and fortune.

We know of at least three silver dishes showing Shapur II hunting. They are practically synchronous but stylistically different. The plate in the British Museum belongs to a large group of vessels produced by the masters of some other school with its own artistic traditions. The Freer plate belongs to a different stylistic group; only the Hermitage piece has no direct parallels and seems (at present) unique. However, its technique is typically Sasanian, with areas of high relief executed by crimping in place, and areas of low relief done by carving away the background. B.I.M.

21

21. A HORSEMAN HUNTING WITH HIS HOUND

> Painted mural in a private house
> Panjikent, Sogdia, seventh century
> H: 159 cm; W: 109 cm
> The Rudaki Museum, Panjikent

On the wall in a reception hall on the upper floor of a two-story house belonging to the owner of several large granaries in Panjikent was painted a large hunting frieze. This fragment, with a horseman and his dog, is its best-preserved section, but adjacent areas show other horsemen in pursuit of gazelles and leopards. A bountiful hunt was considered a sign of good fortune in many ancient cultures, especially among the Iranian peoples of the ancient and medieval world, and the image of a hunt would have had a benedictory significance for the person whose house was so decorated.

This Sogdian horseman hunts with bow and arrow, seated on a galloping bay stallion – since Sogdian art, like Sasanian art, depicts

only stallions and never mares. In art as in life: even today, Tajiks from Panjikent and other places in the Zarafshan Valley only ride stallions, unlike their Uzbek neighbors, Turkic in origin, who ride mares and geldings.

The mural was restored at a very early date: the wall was damaged and the owner of the house must have wished to repair the paintings on it. Perhaps because expenses were kept to a minimum he employed a painter to execute the repairs who could paint ornament but not figures. This is evident from the repairs now visible in the well-lit museum: in the lowest zone of the frieze, the ornament was carefully covered with a layer of clay and then new ornament was painted over this layer, but the damage to the figural part of the composition was simply "restored" with three straight stripes of color, executed with a very wide brush. This filled lacunae in the red background, but the tail and the hind legs of the hound, as well as the rocks in front of the figures, disappeared under the fresh color. Today, we may only conjecture that the repairs obliterating certain passages were not so evident when the painting was still in its original location, on an upper story and lit only by a single opening in the center of the ceiling. B.I.M.

22

22. THE LION HUNT

Carved wooden architectural panel from a private house
Panjikent, Sogdia, before 722
H: 39 cm; W: 35 cm
St. Petersburg, State Hermitage Museum, on long-term loan

Some Sogdian houses were decorated not only with extensive wall paintings but also with carved wooden panels which, in the local climate, would have decayed almost completely once the city was abandoned. The preservation of such wooden elements we owe to the Arab invasion of Panjikent in 722, when many houses were put to the torch. The fire following the invasion fortunately preserved a number of the high-relief wooden panels in this house, which belonged to a wealthy citizen; what remains gives us a further sense of the material, as well as the stylistic, variety of Sogdian figural art.

This carbonized fragment was recovered from the ceiling of the reception hall. It had been decorated with a number of similar square wooden panels, all carved in high relief and showing different figures set in roundels; pairs of symmetrical half-palmettes were placed in the corners of the squares. The human figures may have had a subsidiary function as benedictory images, but it is likely that, in view of their small scale and repetitive design, their primary purpose was decorative.

The carver did not depict his Sogdian compatriots hunting, as is the case with all of the mural paintings; instead, he carved a

somewhat simplified but typical Sasarian hunting scene. Perhaps a sense of humor led him to emphasize the "foreign" peculiarities of his model, for this hunter has the wide-open eye typical of late Sasanian images. By contrast, in Sogdian painting of the later seventh and the early eighth century, the ideal eye was narrow with heavy eyelids, following the late Guptan, Indian ideal of beauty; only demons were depicted with large, wide-open eyes.

23. MOUNTED HUNTSMAN WITH A SPEAR

Painted ceramic bowl
Nishapur, tenth century
Present whereabouts unknown

This rider mounted on a horse of impressive silhouette exemplifies the vigorous painting manner of a large class of painted pottery from Nishapur. Before the excavations carried out by the Metropolitan Museum between 1935 and 1940, painted pottery of this style was virtually unknown; since that time, more examples have come to light, as have a number of wares that are technically similar but stylistically different. Their existence suggests that other locales not far from Nishapur, such as Bayhaq (present-day

Sabzavar) or Juvayn, have also been clandestinely excavated for their buried ceramic treasures.[1]

Nishapur figural wares have a uniformly buff-colored pottery body; the decoration is outlined in black and slip-painted in black, yellow, and green over which a transparent glaze, high in lead, was applied. The designs may be either inanimate (with many variations of geometrically based floral patterns) or figural, the latter most frequently being painted on dishes or shallow bowls. The figures are almost always male, sometimes seated; often they are horsemen, some shown in armor, and equally often they will be hunters, as in this fine example.

The huntsman has the typically flat head of the true Nishapur figural group. He is shown in profile; the oval eye, pupil hanging from the upper lid, is elongated by a line drawn out behind the eye itself. His full beard is black; long black hair flies out behind him in the rush of his forward movement. A protective garment, like chaps, covers his legs and he appears to be wearing boots. If there is a belt at the narrow waist it is not of the nomadic, Turkish type, for no thongs or straps appear to hang from it. He is bareheaded, and the absence of headgear is surely a clue to the class and religious grouping for whom these wares were produced: Muslim men usually cover their heads, while Arabs, in

medieval painting, are usually depicted as wearing something recognizable as a turban [196; Fig. 56].

The class of society this figure represents has yet to be satisfactorily interpreted. Several theories have been proposed; while not according with each other, they nonetheless point to the almost purely Iranian sphere from which such wares arose. For some, the single-figure Nishapur images of riders have been seen as a survival, in painted ceramic wares, of Sasanian Persian royal images that had earlier (and elsewhere) been executed in silver. Indeed, a certain quantity of "post-Sasanian" silver has recently been reconsidered as documenting the survival of Sasanian forms and iconography well into the Islamic period in Iran.[2] Countering this interpretation is an unpublished study which suggests that the figural decoration on this type of painted pottery stems from a mix of more popular Iranian and Central Asian myths and folklore, and that the celebration of the Iranian New Year, *Nauruz*, and *Mihragan*, the autumnal celebration, is evoked on certain pieces.[3]

23

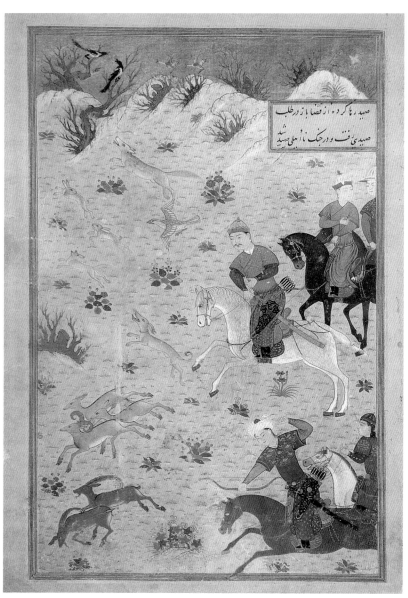

24

24. BAYSUNGHUR WATCHES A HUNT

Illustration in an anthology of prose and poetry
Herat, 1427
H: 19.8 cm; W: 11.8 cm
Florence, I Tatti (Harvard University Center for Renaissance Studies), fol. 30r

The anthology from which this picture comes includes poetry whose themes are love, wine, and roses; as well as prose works on mathematics, chess, music, and a treatise entitled *The Sword and the Pen*: all subjects a well-educated Timurid prince would be expected to have mastered. Among its seven pictures, this is one of two illustrating passages in the poetic texts; the remaining five should be seen as visual counterparts to the texts concerning princely activities [126]. Here the central figure is an idealized "portrait" of Baysunghur himself [compare 185].

The hunt is a *battue*, in which game is driven from a large tract of terrain toward huntsmen in a more central location [26]. The prince is accompanied by attendants, hounds, and a hawk; a companion looses an arrow at a horned goat, and the others watch. Animals and birds flee towards the left; those in pairs bring to mind the ancient Iranian formula in which prey was almost always shown in pairs [20, 224, 228], and perhaps the painter made a conscious attempt to overcome the formulaic habit by showing a group of three ibexes but only a single jackal. The hunters' clothing is of strong colors with much golden ornament; together with the baggy pants worn by the prince and the archer, these details recall the costume typical of Iskandar's Shiraz painting of several decades prior.

Everything about this manuscript – the quality of its paper, its superb illuminations, and its illustrations, including the idealized figure of Baysunghur in four pictures – embodies the intellectual and aesthetic concerns of the prince at whose courts, first in Tabriz and then in the Timurid capital of Herat, the classical style of "Persian miniature painting" took final shape.

25. TIMUR HAWKS NEAR BUKHARA AFTER THE SPRING CAMPAIGN OF 1389

Painting from a now-dispersed manuscript of Sharaf al- Din ʿAli Yazdi's *Zafarnama*
Shiraz, ca. 1434–36
H: 27 cm; W: 16 cm
The Art and History Trust (on deposit at the Sackler Gallery, Smithsonian Institution, Washington, DC)

The *Zafarnama*, the *Book of Victory*, was completed in early 1425 but no copy of this date has survived. Instead, the earliest version with an indisputable date is the illustrated manuscript in which this picture of Timur hunting was formerly to be found: it is over a decade later, the manuscript completed in 1436.

The illustrative program devised for Ibrahim's *Zafarnama* was intended to present Timur, as well as his heirs, as heroic kings in the ancient Iranian mode: victorious in war, courageous in the hunt, generous in providing feasts after victory, powerful in the arrangement of marriage alliances, and favored in the birth of sons. This picture is perhaps the finest of its hunt scenes. Timur is mounted on a horse of Shiraz shape, with an exaggeratedly long body; he is bearded, dressed in ordinary clothing and a felt hat with a high crown, but over his head an attendant holds a parasol [127]. An ancient Asian symbol of kingship, here the parasol is also a sign of the Iranian *farr* – without which no king could rule; sometimes it is shown as a baldachin or a fixed tent rather than a parasol [32–34, 41]. On one hand he wears a heavy leather glove, presumably for the hawk a kneeling attendant presents to him; another hawk chases a crane in the golden sky, in the Shiraz–Timurid manner almost certainly adopted from the decorative vocabulary of *chinoiserie*, decorative designs of East Asian origin.

The heads of other attendants can be seen from behind a hill in the middle-ground.

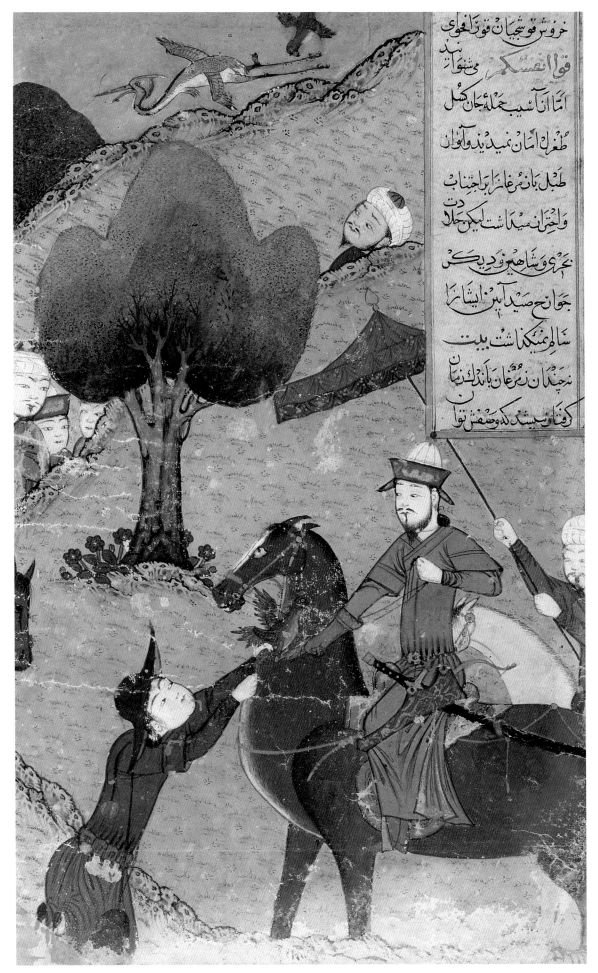

25

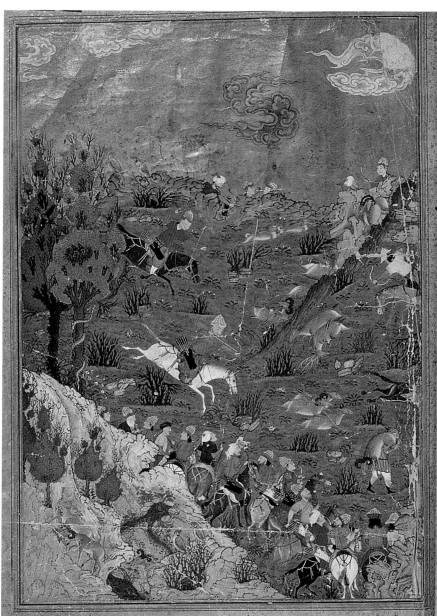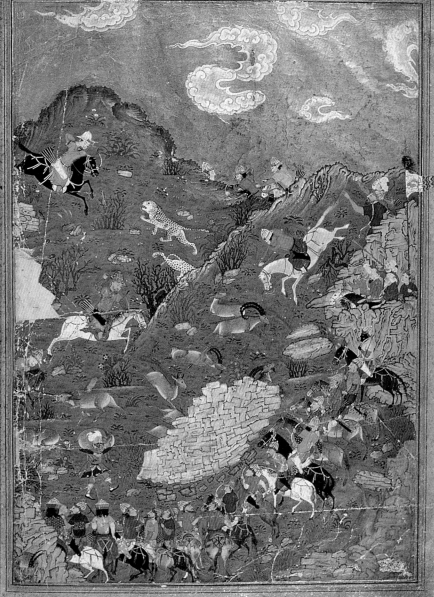

26

26. THE GREAT HUNTING PARTY OF UZUN HASAN

> Double-page painting on facing folios,
> pasted into a sixteenth century
> manuscript of Jami's *Silsilat al-Zahhab*
> Tabriz, between 1467 and 1473
> St. Petersburg
> Russian National Library
> Dorn 434, fols. 81v–82r

In the tradition of the double-page
frontispiece in which a prince displays pomp,
prowess, and generosity, this large double-page
painting of a *battue* in a mountainous
landscape has been connected with Uzun
Hasan Aq Quyunlu, of the White Sheep
Confederation.

The *battue* [24] lends itself to the broad
circular disposition of riders on both sides of
this composition. Five horsemen, including
one who may be Uzun Hasan himself, race
down the slopes of the central field at a
furious gallop, loosing arrows at ibex, goats,
and rams, gazelles and onagers; prey lies dead

upon the field and servants carry animals away
on their shoulders. Another group of mounted
men watches at the right margin; many wear
turbans, whereas most of the men in the
foreground circle wear the Turco-Mongol
high-crowned gored felt hat.

Not surprisingly, animal life abounds: ibex
and deer climb the mountain repoussoir in
front of the circle of attendant horsemen on
both sides of the picture, and pairs of game
birds perch there, as well as at the horizon at
the left; leopards engage a mounted horseman
and two other archers at the rear of the right-
hand side of the picture; and a snake winds
itself around a tree at the lower left [60, 78].
The frenetic human and animal activity is
mirrored by the whirling Chinese-style clouds
in the sky. The areas of bare rock whose
outlines disclose "rock-spirits," or faces, might
be seen as another mirror of inanimate nature
that will prove to be a particular characteristic
of Turkman-style painting toward the end of
the century and of the earliest Safavid
paintings [78, 79]. Whether or not this large

painting was even intended for a manuscript is
uncertain; but the numbers of waiting
attendants of various ranks and classes give the
impression that its purpose is akin to
recording an outdoor audience, an occasion of
witness to the skill and prowess of the
hunters.

27. CAVALIERS HUNTING

> Silk-velvet and metal-thread ogival
> medallion from the so-called "Sanguszko"
> tent
> Tabriz or Kashan, mid-sixteenth century
> H: 60 cm; W: 40 cm
> New York, Metropolitan Museum of Art,
> 1972.189

Just as the patterns of abstract illumination
in Timurid manuscripts had influenced the
decoration of objects of all kinds and in all
media in the fifteenth century, so in the first
half of the sixteenth century figural designs

predominated in the decoration of court-produced knotted carpets and fabrics, especially those used for garments. An ogival medallion, of cut velvet on a satin-weave foundation enriched with precious-metal strips, exemplifies the adaptation of a narrative image of some age in the Iranian world to a luxurious textile of silk and gold.

The principal figure is a cavalier on a galloping horse fending off an attacking lion, its jaws at the rider's leg and claws planted in his horse's flank. Below him and facing in the opposite direction, another cavalier looses an arrow at unseen prey while, between the two horsemen, another lion pounces on a struggling quadruped. At the upper left corner a groom and a hunting dog watch from behind the shelter of rocks, along with a fox and a gazelle; a rabbit and a large partridge take cover in the lower right foreground, and the front legs of a pair of hoofed quadrupeds may be seen in the curve of a lobe at the "upper" edge of the medallion. Whatever the position of the lions' bodies, their heads are turned frontally, in the ancient manner that can be traced back to the relief sculptures at Persepolis [202].

The textile is one of a group of six different silk-and-metal fabrics cut and shaped to decorate a sumptuous tent at some point in the sixteenth century [172]. Another piece of

the same textile was used for the circular ceiling piece of the same tent.[1] About four times as large as this medallion (although admittedly pieced together), it shows that the original pattern included many more figural and animal groups, and that the figures on the textile were woven in repeats that faced opposite directions. In its original state, this hunting-velvet must have been a dense, rich display of human prowess pitted against the powerful magnificence of the animal kingdom.

The tent from which these pieces are considered to have come is known as the "Sanguszko" tent, its Polish name being that of the general into whose hands it fell when the armies of a European coalition defeated the Ottomans at the siege of Vienna in 1683. How and when it passed from the Safavids to the Ottomans is as yet unexplained, although one account holds that it was captured by the Ottoman Sultan Sulayman in the Iranian campaign of 1548. That would mean the textile was made before 1548 – a date considered too early, by some scholars, for both manufacture and Turkish acquisition, even though it is true that none of the six different textiles from the "Sanguszko" tent is actually dated. The high quality of the drawing of the pattern, as well as of the weaving, suggest that this fabric might have been made for Shah Tahmasp himself although, again, just

when is uncertain. His disinterest in the arts of the book was particularly strong in the middle 1540s, but it is unclear to what extent the production of figured textiles was affected by his disinterest. The design does include turbans still wound around the high early Safavid baton (Fig. 71) as well as lower turbans with no baton; and riflemen appear on the larger circular piece of the same textile; both details make a date in the third quarter of the century a plausible one.

Other figural subjects on fabrics from the same tent are Nizami's "Bathing Shirin Discovered by Khusrau," and a standing man, in Safavid court costume (but sometimes identified as Alexander the Great – Iskandar), about to hurl a rock at a dragon. Both subjects, as well as the hunting motif, would have been familiar to Safavid viewers either from popular literature or as older classical *topoi*. All three motifs are quite finely drawn, which argues for the origin of their designs in court workshops where illustrations for manuscripts were also generated. Yet all three are treated as decorative motifs rather than as text illustrations: repeated in staggered rows and further varied by being woven in reverse directions, a technique especially suited to textiles. The shaping of the medallions, on the other hand, is crude: irregular in shape, and some – as is this medallion – even cut so that the design is askew in relation to the woven structure of the fabric. Such details suggest that, wherever the tent was decorated (in Iranian lands or in Turkey), very little care was taken in planning how to cut up the sumptuous figured textiles that had been so carefully designed and woven.

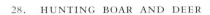

28. HUNTING BOAR AND DEER

Painted on lacquered papier mâché (probably the lid of a circular box)
Isfahan (?), 1662–63
Diameter: ca. 20 cm
Formerly Tehran, Museum of Decorative Arts, No. 27

An energetic and well-composed hunting scene is painted on the surface of a papier-mâché disk and signed, in reddish-purple ink, by "the slave of [His Majesty's] court, Muhammad Zaman" in a year equivalent to 1662–63. The majesty referred to would thus be Shah ʿAbbas II, and the implication is that the painter Muhammad Zaman was in royal service from early in his career [118, 220, 232].

The disk is almost surely the lid of a now-lost circular box, and the painting is one of mixed modes. The composition sets a number of large horsemen in the foreground – they move in vigorous, perspectivally convincing positions. One man seen from the back with his horse's head turned into the picture is counterbalanced by another, charging forward just to the left of the first horse's turned neck; a third is seen in profile as his weapon pierces

the hide of a boar at his feet; and a fourth races into the picture from the lower right with his spear leveled at the side of another beast. Horsemen in the middle distance are both smaller and less distinctly colored. Trees with the dark foliage of a deciduous forest frame the picture on both sides and in the foreground low-growing plants provide an angled repoussoir. The middle distance is closed by a hillock with several tall, slender trees, and in the background tiny and indistinctly rendered buildings dot the open landscape [81, 100, 163].

The Safavid court clothing and Iranian weaponry, the horseman executing the "Parthian shot" [20], and even the style of hunting – the *battue* – do not disguise the fact that the composition derives from a European source, possibly a battle scene, that had also been designed as a circular composition.

A decade later, Muhammad Zaman reused the figural components to decorate the

interior of a large hinged pen box made for Shah Sulayman, but the rectangular format [cf. 163] meant that the figures had to be strung out along the length of the lid and the spaces between each figure, or figural group, punctuated by a tree.

29. FATH ʿALI SHAH HUNTS WITH HIS SONS: HE SPEARS A LION (*BACK*)

Lacquered papier mâché over wooden panels, the binding for Shah Tahmasp's manuscript of Nizami's *Khamsa*
Tehran (?), between ca. 1825 and 1828
H: 36.9 cm; W: 25.5 cm
London, The British Library, Or. 2265

Among the innumerable images of Fath ʿAli Shah commissioned by that most brilliant of Qajar rulers are many scenes of the hunt. The image of the Shah demonstrating his personal

prowess in the pursuit of dangerous beasts was commemorated on every scale, and in all the many materials, of pictorial imagery practiced at this period.

One of the largest examples on lacquered papier mâché, and perhaps the finest, are the two paintings on the front and back covers of Shah Tahmasp's unfinished *Khamsa* of Nizami [35, 67, 96, 109, 118, 127, 172, 232, 234, 242,]. Fath ʿAli Shah had considerable literary interests: he commissioned a poetic history of the early years of Qajar rule and wrote poetry himself, under the pen-name of Khaqan (Fig. 91). So it is hardly surprising that he, too, should have been concerned to refurbish an older, treasured volume of classical Persian poetry, the magisterial *Khamsa* made for one of his princely "ancestors." He ordered that a new binding be made for the manuscript, and two of his court artists, Sayyid Mirza and Muhammad Baqir, were then assigned the task of decorating the new exterior covers with

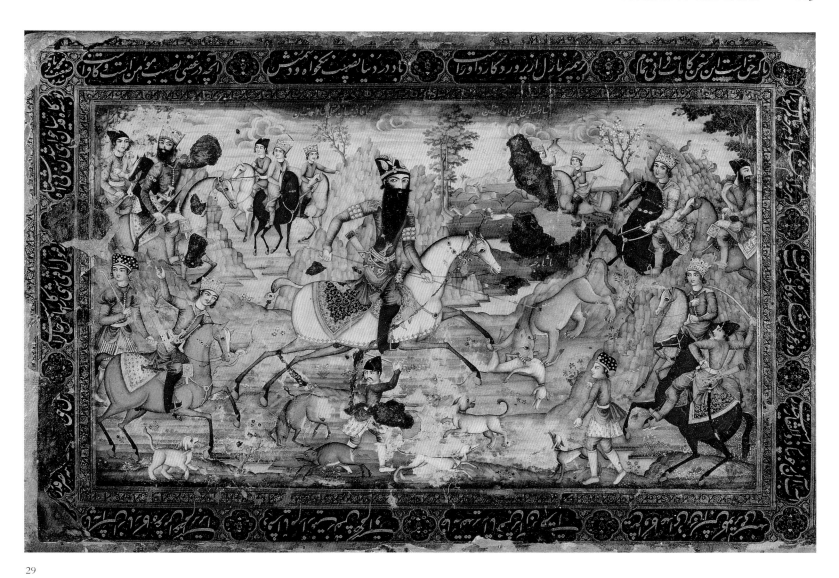

29

hunting scenes in which the Shah was the prominent figure.

Both artists observed the same formula in their paintings. Each is horizontally aligned, and in each Fath 'Ali Shah is mounted on a white horse whose legs and underbelly have been tinted with henna. Shown in profile, he rides to the right at some speed, shown by the magnificent long black beard sweeping out to the left, his head turned to stare out of the picture with level equanimity. As if the beard, and the jeweled armbands, belt, and weapons were not enough to identify him, his princely rank is also indicated by another ancient, Oriental pictorial device – scale. He is larger than anyone else in each picture, and placed slightly left of center but unobscured by any of his crowned offspring or attendants. Both painters also repeat several of the same figural groups, the three princes in the left background, and the two figures in the right

foreground, one – mounted on a rearing horse and brandishing his sword – seen from the back.

Sayyid Mirza's picture, on the front cover (not illustrated), shows Fath 'Ali Shah in the guise of Bahram Gur. The intention was surely to show his transfixing, with a single arrow, a lion and its prey of wild ass, but the arrow seems to have been forgotten; the animal group is a pictorial quotation from the early Safavid picture, on folio 202v in the manuscript itself. Muhammad Baqir's painting on the rear cover shows the Shah spearing a lion whose jaws have closed on the hapless body of a hunting dog, and he has added boar to the hunters' prey. In each picture, most of the surrounding figures are intended as his sons, indicated by the crowns they wear; by contrast, in both pictures their father wears the soft black Qajar lambskin hat with a thin gold diadem circling the base.

Both painters signed their pictures, Sayyid Mirza as "the slave of the court," and Muhammad Baqir as "the feeble slave." They both also surrounded their compositions with poetry in praise of the Shah so as to celebrate, in both word and image, his exploits on the hunting field. Neither painter gives a date by which his picture had been completed [cf. Fig. 84], even though by this time dates were frequently included in the signatures on Iranian pictorial works [Fig. 5]; but it is reasonable to suppose that the two covers were being worked on at the same time. The binding must have been finished by some time in the year equivalent to 1827–28, since the writer of a note on a text-folio says that, at Fath 'Ali Shah's order in that year, the manuscript was deposited in the palace of the princess Taj al Daula. Little more than half a century later, it had been catalogued as a recent acquisition in the library of the British Museum.[1]

30. A MAN AND HIS WIFE FEASTING

Painted ceramic amphora
Marv, sixth–seventh century
H: 47 cm
Ashkabad, State Museum of Turkmenistan,
#3455

This pottery amphora is decorated with four
scenes that exemplify an early medieval Iranian
life well-lived: a feasting couple, man and wife;
a man hunting on horseback; a death scene;
and a funeral procession. The protagonist is
always the same man: his life was happy, as
indicated by the banquet and the hunt, but
inevitably ended in death, and he was suitably
mourned by the wife who survived him.

Painted after firing, the images are
distinguished by boldly traced outlines which
delineate figures with exaggeratedly large
hands and enormous eyes. The simple color
scheme is based on contrasts, and the
background is strewn with heart-shaped flower
petals. Many aspects of the style recall art of
the Parthian period but it also anticipates both
the ninth-century ʿAbbasid style, especially as
it was practiced in Samarra, and that of a large
class of tenth-century figural pottery of
Khurasan, produced in Nishapur [23]. B.I.M.

30

31

31. A PRINCELY RECEPTION AT THE MONGOL COURT

A painting probably from a historical
manuscript
Maragha or Tabriz, about 1315
H: 33.8 cm; W: 25.8 cm
Berlin, State Library, Diez A fol. 70, s.22

Paintings from still another illustrated *Jamiʿ
al-Tavarikh* volume were collected by Heinrich
Friedrich von Diez in Istanbul during his
tenure as Prussian *chargé d'affaires* between
1786 and 1790. Mounted into albums which
were probably made in the Istanbul bazaar,
many of the better illustrations to this text
appear to stand, stylistically, between those in
the Arabic copy of 1314 [5, 50, 69, 88, 212,
213] and those in the Persian copies, dated
1314 [6] and 1317. This scene of a court

reception perfectly exemplifies the genre – its
vertical format and the use of bare paper as an
overall ground for the picture; the thin washy
color in a limited palette, with solid areas of
black, brown, red, gold, and silver; the high
horizon with the ground only suggested by
contours and tufts of grass; the expressiveness
of figures and gestures, but without the
grotesque quality of the Persian copy in
Istanbul [6].

The subject is a Mongol courtly reception
in the out-of-doors. The furnishings, and some
of the garments and headgear, are
unmistakably Mongol – the men's feathered
bonnets [39] and the ladies' *boqtaq*, the high
red headdresses that appear to be fantastic but
were noted by many western observers,
including the Spanish ambassador to the
Turco-Mongol Timur at the very beginning of

the fifteenth century.[1] The composition is a "modern" version of the ancient oriental court image, a gathering of courtiers formally arranged on either side of a prince [Fig. 54] (or princely figures). Several double-page versions are mounted in the same album, and yet more are in other Istanbul albums.[2] The double-page pictures are larger, and also more crowded, the groups of figures often numbering three or more, set closely together and at an angle.

The tenth-century picture of a gathering of the Manichaean elect, painted on the largest paper fragment recovered from Kocho, in Chinese Turkestan, again suggests a prototype on paper for the whole group [49]. This single-page version instead appears to be a carefully selected and integrated example of the *topos*. Its compositional descendents are numerous [34, 35, 110, 120] and can be seen for several centuries henceforward; its format, higher than it is wide, will become the norm for the best illustrated Persian manuscripts.

32. A PRINCELY BANQUET IN A GARDEN

Double-page frontispiece removed from a manuscript of Firdausi's *Shahnama*
Shiraz, 1444
H: 26.3 cm; W: 20.7 cm (45.169)
H: 26.2 cm; W: 20.7 cm (56.10)
Cleveland, Cleveland Museum of Art, 45.169 and 56.10

The double-page picture of a reception in a garden, especially when it functioned as a frontispiece for a princely Timurid manuscript, appears to have settled into its canonical form between about 1425 and 1435, when the manuscripts commissioned by two sons of Shahrukh, Ibrahim-Sultan and Baysunghur, were being produced.

The latter's *Kalila u Dimna* opens with just such a double-page painting: both the presence as well as the absence of certain figures, and the fact that the prince is a "portrait" of Baysunghur [185], suggest that it has a specific meaning, however little we are yet able to read of it. Ibrahim-Sultan's own illustrated *Shahnama* comes closer to the canonical image, in one of three double-page compositions at the beginning of his *Shahnama* manuscript. In his *Zafarnama, Book of Victory*, the first picture – which is also the first of the double-page illustrations, the audience that Timur held upon assuming control over the

Ulus Chaghatay in Balkh in the spring of 1370 – uses many of the same conventions [33].

This double-page frontispiece to a *Shahnama* possibly made for Ibrahim-Sultan's son ʿAbdallah and completed in Shiraz, in 1444, is the ultimate version of the Timurid feast in a garden: virtually everything seen in any of the three earlier princely Timurid frontispieces is depicted within it. The occasion is perhaps the celebration at a marriage, given the cluster of ladies sharing the carpet, the huge ornamented tent under which a male and a female figure sit, and the male musicians in the foreground. That there is some diplomatic purpose to the event seems evident from the kneeling group of three men in the left-hand background, for their black headgear is Chinese.

The painting is particularly large, as the manuscript from which it comes is of exceptional size, and it exhales exuberance. The taste for the angled placement of objects as well as people is evident: three carpets, and several other figural groups, are set at truly precarious angles, and the *bauwab*, the gate-keeper, is the most vertiginously placed of all. The desired effect was probably a perspectival adjustment, however peculiarly it is worked out. As for the carpet of the princely pair, it is precisely placed at a right angle to the picture frame but it has the appearance of being carelessly placed, lying across the stream with no visible means of support – although it was,

once, an Iranian summer practice to lay a
carpet on a low wooden platform standing in
a pool or a mountain stream: perhaps this is
what was intended.

In the figural multiplicity of this picture, in
its inclusion of every element of a Timurid
outdoor diplomatic reception feast-marriage
celebration-picnic, and in the almost slapdash
exuberance of its execution, can be seen
both the pictorial achievement of the
canonical Timurid outdoor feast, as well as its
dissolution. The careful selection, as well as the
care in execution, that typify the paintings in
manuscripts made for the Timurid princes in
whose hands this art was truly shaped seems
to have disappeared in this frontispiece. More
important, in this picture, was the display of
all the personages and features pertaining to a
princely Timurid entertainment in the open
air in one grand and joyously crowded
composition. The Spanish ambassador's account
of the receptions he attended in the gardens
outside Samarqand in the autumn of 1404 is
similar, in spirit, and detail, to the reception so
exuberantly pictured here, even though forty
years had passed.[1]

33. TIMUR HOLDS AN AUDIENCE IN BALKH, IN APRIL 1370, TO REAFFIRM HIS POSITION AS HEAD OF THE ULUS CHAGHATAY

> Double-page painting in Sultan-Husayn's
> manuscript of Sharaf al-Din ʿAli Yazdi's
> *Zafarnama*
> Herat, 1480–85
> 82v: H: 17.9 cm; W: 10.9 cm
> 83r: H: 18.6 cm; W: 10.5 cm
> Baltimore, The Milton S. Eisenhower
> Library of Johns Hopkins University, John
> Work Garrett Collection, fols. 82v–83r

Timur, on establishing himself as head of the
Ulus Chaghatay, held an audience in Balkh to
reaffirm his position: he "placed his foot upon
the throne of rule, and the hand of divine
destiny placed the keys to the realm of the
inhabited quarter of the globe in his hands," as
the later Timurid historian, Khwandamir, put
it.[1] This signal event is the first picture in
both of the illustrated Timurid manuscripts of
Sharaf al-Din ʿAli Yazdi's *Zafarnama* (*Book of
Victory*).

The setting and many of the details are
similar to those of other double-page
reception scenes, especially frontispieces. The
text, of course, provides the precise
identification of the event, while in the hands
of a fine painter the pictorial details precisely
describe the occasion.

Thus, the audience takes place in a garden
to which access was restricted (as is signified
by the brick portal and the wooden door at
the left margin. Sun makes the sky golden,
flowers bloom underfoot, and the obligatory
stream of silver winds through the meadow;
but women and musicians are absent from the

33

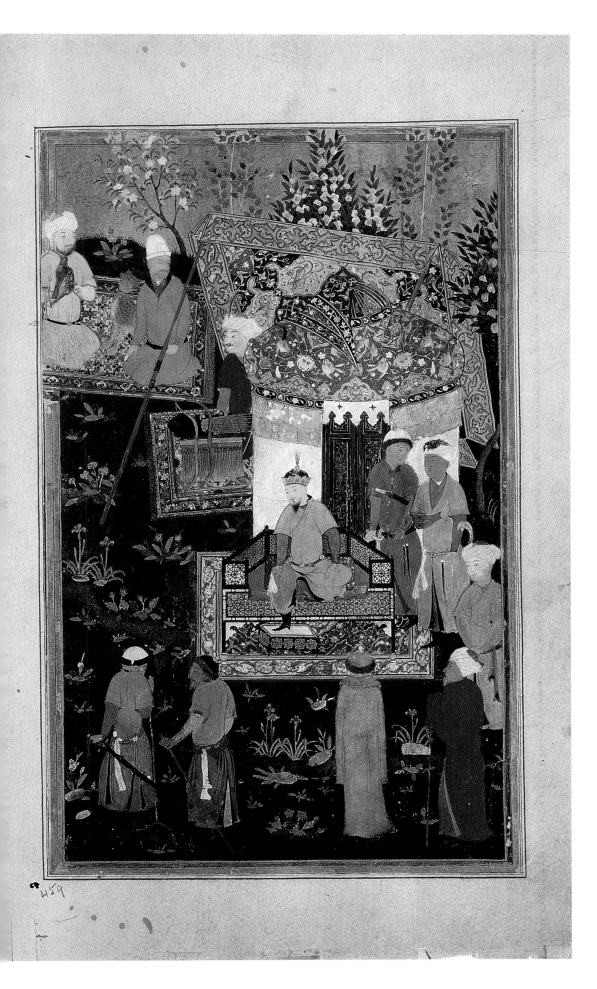

scene. Timur, dressed in green and wearing a crown with a heron-feather aigrette, sits, on the right side of the picture, on a platform-throne placed on a carpet set at a right angle to the picture frame. Behind him is a trellis-tent with a bulbous dome and behind that is a rectangular canopy, both symbols of princely rank. A saddled horse, a falcon, a hunting cheetah, weapons, and trays of gifts — jewels and coins — are arranged on both sides of the picture in a loose diagonal slanting downward from right to left. This line is reinforced, on the left side of the composition, by perhaps the most important addition to the conventional setting, the row of five men who kneel on one knee: chiefs of the Ulus Chaghatay reaffirming Timur's position. Others in attendance are both men of the sword and men of the pen, as ethnically varied in depiction as Timur's following was in reality. Many figures will reappear in other illustrated manuscripts of the period, especially in pictures attributed to Bihzad [93, 94, 117, 168].

34. A CONVIVIAL GATHERING AT THE COURT OF SULTAN-HUSAYN BAYQARA IN HERAT

> Double-page frontispiece in a manuscript of Saʿdi's *Bustan* (*The Orchard*)
> Herat, 1488
> 1V: H: 25.5 cm maximum; W: 16.7 cm maximum
> 2V: H: 24.3 cm maximum; W: 15.5 cm maximum
> Cairo, National Library, Adab Farsi 908, fols 1v–2r

A bibulous party of men only, in an elaborate terrace setting, is the opening double-page illustration in Sultan-Husayn's copy of Saʿdi's *Bustan*. The elements of similar scenes in earlier princely Timurid manuscripts are almost all utilized — the garden setting and the controlled attendance [32, 33], the accoutrements, the wine and the music. As always in manuscripts of particular sponsorship and unlimited means, they are combined in an image uniquely descriptive of its time and place.

This gathering does not appear to be one of literati and it takes place in an architectural setting of unusual complexity; in this it may mirror the architecture of Sultan-Husayn's own Bagh Jahan-Ara, the World-Adorning Garden, in the suburbs outside Herat to the northeast. The party is spread over a pair of adjacent terraces of hexagonal shape, a walled one paved with fine stone, and a service-terrace with hexagonal tiles underfoot and fenced with a lattice through which the garden itself is visible. These small architectural components characterize the Timurid garden; they are a *topos* of the period and reappear frequently in the architecture and the painting, as well as the literature, of both Safavid Iran and Mughal India in the following centuries [35, 82, 85, 126].

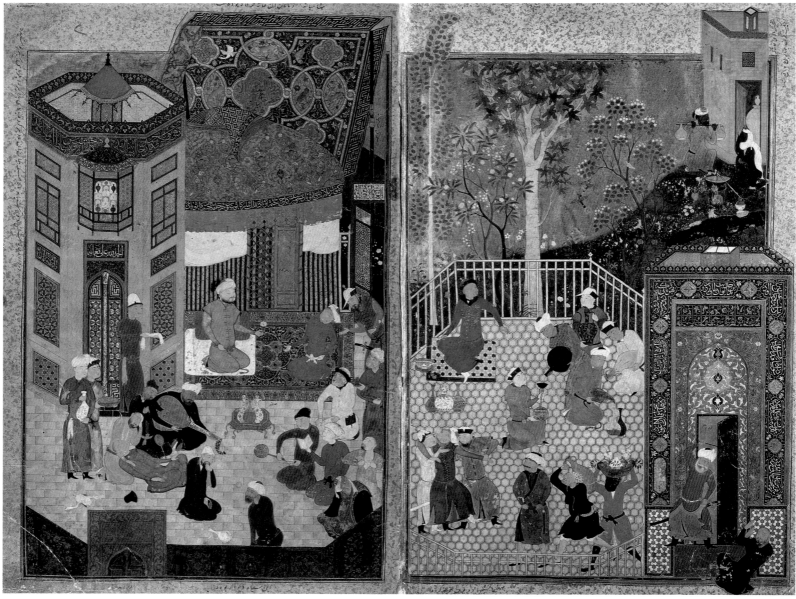

34

On the left side of the picture is a small two-story hexagonal structure of brick; bottles and ewers are set into niches in a projecting balcony, like the Safavid examples of the *chini-khana*, "china-house," which survive in the seventeenth-century additions to the shrine at Ardabil and in the pavilion called the ʿAli Qapu which Shah ʿAbbas I erected on the great square, or *maydan*, in Isfahan (Fig. 76). Beside the building is a trellis-tent, its side-coverings looped up to show the wicker structure; above it, tipped back to reveal an elaborately patterned underside, is a rectangular canopy. Together the two make up a fixed version of the princely parasol already used in an earlier manuscript of this period, the first illustration in Sultan-Husayn's *Zafarnama* [33]. Here the motif is reversed and enlarged; the illumination patterns are even richer than in the *Zafarnama* but the green and gold decoration on the flap is used in both pictures.

Like Baysunghur in his double-page frontispiece for his earlier *Kalila u Dimna* [185], Sultan-Husayn himself is present in the frontispiece of his *Bustan*: in the words inscribed in

one of the cartouches decorating the underside of the canopy, and in the kneeling figure dressed in a green *jama* and a turban with a black heron-feather plume [186] who sits on a mat placed directly under the cartouche. What he presides over might appear to be nothing more than a vinous rout but is instead to be read as a sufi metaphor: the sufi holds that inebriation – with the love of God – leads to the attaining of mystical union – *tauhid* – with God.

The left half of the picture is composed in a loose version of the ancient triangular arrangement in which a primary figure, at the apex, is flanked by two groups of participants, the descending legs of the triangle (Fig. 54). Sultan-Husayn offers a flower to a young companion beside him; they both kneel on an elaborately patterned rug spread before the trellis-tent. Below them to the left, two seated musicians play a large lute and a small stringed instrument; in the facing row of figures, a man recites from an open book he holds up in one hand, behind him another sings (or chants) in some transport, and beside the reader a bareheaded man pulls open his *jama* in a

gesture of abandon, expressing desperation in love as also in mourning. In Saʿdi's own words, "The musician never falls silent . . . when lovers begin the love of wine." Indeed, almost everyone else in the picture, except the doorkeeper – the *bawwab* beating away a would-be entrant – and every other object, is connected in some way with the wine-dark liquid of ecstasy.

In addition to the *chini-khana* in the pavilion on the left, no fewer than twelve vessels of different shapes and materials – from small metal and glazed ceramic cups to large unglazed wine bottles – are in use to carry, pour, and consume wine; eight more bottles and vessels await eager hands; and a white ewer lies on its side in the foreground of the left half of the picture, tipped by the hand of the tipsy kneeling man who looks aghast at what he has done. Behind him, a man reclines with his head in the lap of a friend who mops his own head, his turban fallen to the ground beside him, as has the cap of his reclining friend. Facing them, in the group of the reciter and singer, another man sags forward, his turban about to tumble to the

terrace. Even the sultan's companion on the
carpet slumps to one side with his head
hanging down, and the attendant behind him
gestures solicitously. In the foreground of the
right half of the picture, yet another guest,
unsteady on his feet and with his head held
awry, is helped away by two companions. In
front of them, more wine, and a huge basin of
fruit, is carried into the gathering; above
them, wine is being mixed and decanted. And
in the upper right of the picture, in the
garden outside the princely enclosure, a dark-
skinned couple distills some kind of spirit, in
which the "confused and drunken darvishes"
of the memorable gathering may continue to
immerse themselves in the search for union.

35. KHUSRAU AND SHIRIN, IN A GARDEN AT NIGHT, LISTENING TO SHIRIN'S MAIDS RECITE POETRY

Painting in Shah Tahmasp's manuscript of
Nizami's *Khamsa*
Tabriz, 1539–43
H: 30cm; W: 18cm
London, The British Library, Or. 2265,
fol. 66v

Khusrau and Shirin are two of the three
principal figures in Nizami's great romantic
poem bearing their names, the second work
in the collection of *masnavis* known as the
Khamsa, or *Quintet* (of poems). Khusrau is the
Sasanian Khusrau II, Khusrau Parviz, Khusrau
the Victorious (ruled 591–628), and – for
Nizami – Shirin is the Armenian princess
who became queen of Armenia before
eventually becoming Khusrau's queen.

Their relationship endured vicissitudes that
would have strained lovers of less fortitude
and determination. It is a story that begins
with a dream – of a horse, a kingdom, a
musician, and a promised love. It continues
with an introduction by proxy [77, 239], and
the destined lovers sighting each other, as each
travels – in the wrong direction – in search of
the other. The tale then tells of Shirin's
languishing in the unhealthy Iranian plain
before the distant Khusrau commands the
building of a new palace, at Kirmanshah, for
her, and finally, an ecstatic meeting and
courtship at Shirin's home in Armenia. These
points in the story are punctuated by a
number of events: Shirin's determination not
to yield to Khusrau until they should be
married; the usurpation of Khusrau's throne,
which he reclaimed only with the assistance
of the Byzantine ruler whose terms included
Khusrau's marriage to his daughter, Maryam;
Shirin inheriting the Armenian throne from
her aunt Mihin Banu, and her dawning
realization that Khusrau would always be
prevented from wedding her, not only on
account of the terms of the aid accorded by
his father-in-law but because of the weakness
of his own character, and her growing
jealousy. Chaste diversion is afforded by the

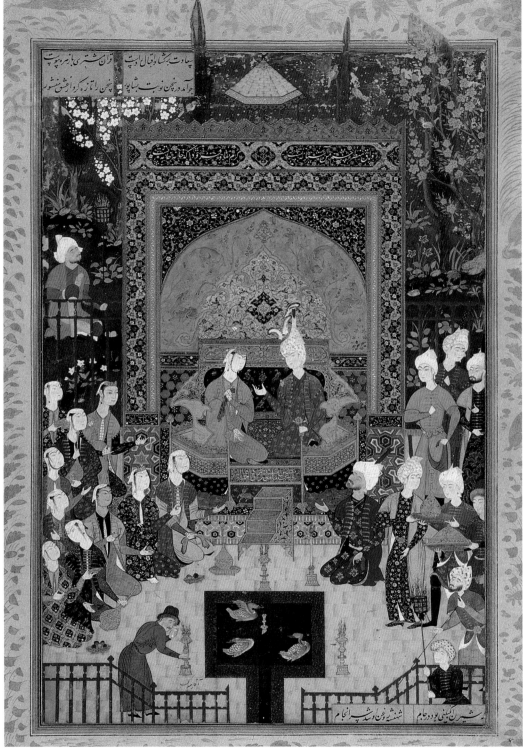

35

sculptor-stonemason Farhad [40], who built
for her at Kirmanshah the channel for milk
[235–37]; he engenders craven jealousy in
Khusrau, whose ruse causes Farhad to commit
suicide; Maryam dies and an Isfahan lady
creates further diversion. Finally there is a long
period of reconciliation [158], assisted by the
songs of the court musicians, Nikisa and the
peerless Barbad [234], and at last, Khusrau and
Shirin are married. But their period of mature
happiness together was not to last: Shiruya,
Khusrau's son by Maryam, stabbed his father,
in an attempt to gain both Khusrau's throne
and wife; Shirin appeared to consent to
marrying her stepson after Khusrau's funeral

but instead she stabbed herself upon his bier,
and the two were eventually buried together.

This magnificent picture of a courtly
entertainment is one of five illustrations to the
marvelous story of loyal and patient love in
Shah Tahmasp's great copy of Nizami's
Khamsa. It occurs relatively early, when the
two young lovers are courting in the palace of
Shirin's aunt, Queen Mihin Banu. They had
met on a day when each was out hunting
with their retinues, and they continued to
hunt by day, while in the evening they feasted,
to the accompaniment of music and the
recitation of poetry. One night, ten of Shirin's
maids gathered to recite poetry celebrating the

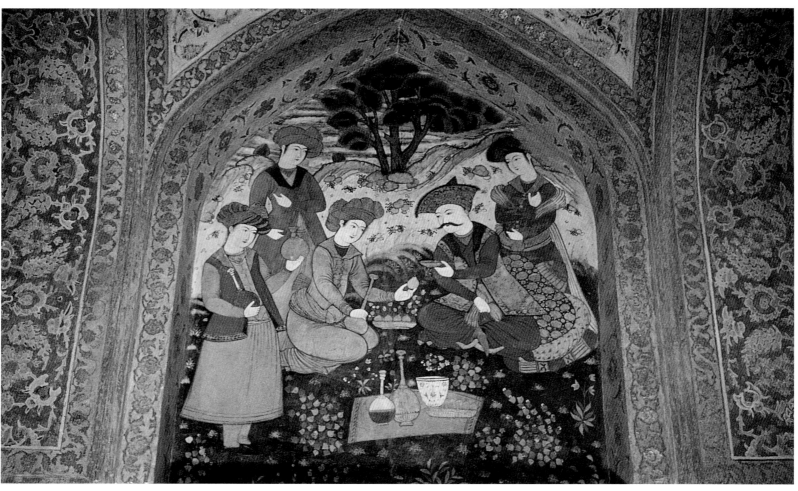

36

love between Shirin and Khusrau. Shapur (Khusrau's friend and confidant, the artist who had first "shown" Khusrau to Shirin by means of the three portraits pinned to the tree), and then Shirin and Khusrau themselves, also join in, each recounting his role in the story and telling of the welter of emotions aroused in the pursuit of this love.

The setting is a garden terrace cooled by a small fountain and open to the spring sky; several small candles and a pair of cresset lamps confirm that it is night, but otherwise the sky is a bright dark-blue and the scene is splendidly visible. Like all the contemporary illustrations in Tahmasp's *Khamsa*, it is a balanced and visually well-paced painting, the figures large, but not crowded together, and differentiated instead of overlapping "in unison." Shirin's ten maids are gathered at her side of the picture, to the left; Shapur kneels at the foot of the throne on Khusrau's side, to the right, where his attendants also stand. Pages bring a platter and a large golden bottle; the maids are already well supplied with bottles and wine cups. At the apex of the picture, the couple sits together on a large and most elaborate golden throne, ornamented with painting and cushioned with brocaded fabrics. The shape of its extravagant back – half a lobed ovoid with curling, extended tails and an interior pattern of abstract illumination – suggests that it is a fantasy drawn from the repertoire of manuscript illumination [242], and it adds even more magnificence to an

already brilliant image of a princely reception held in the out of doors at night.

36. SHAH ʿABBAS I HOSTS A CONVIVIAL GATHERING IN A GARDEN

Painted on a wall in the "Courtly Room" in the palace of the Chihil Sutun Isfahan, after 1647

This image is painted in the center of one of the long walls of the small chamber known as the "Courtly Room" in the reception pavilion called the Chihil Sutun. Shah ʿAbbas I is shown receiving a filled wine cup from a seated companion while three figures stand behind him. It is a fine, if formulaic, example of the traditional style of Iranian painting as it was practiced towards the middle of the century.

The flowering green meadow on which the figures are gathered gives way to a lighter-colored desert, strewn and edged with rocks; a tree with foliage of spade-shaped masses stands at the apex of the painting; blue sky streaked with white spreads out on either side of the yellow-edged green foliage. The Shah leans forward from the three patterned bolsters behind him, in a convincingly natural pose, as the guest settles back from having poured the wine from a long-necked bottle and holds up an indeterminate object, perhaps a piece of fruit. All five figures have the large, full,

undifferentiated faces that are the legacy of the earlier painter Riza [146]; three wear the large seventeenth-century turban with its extravagant silhouette, while the Shah wears the hat seen in so many pictures of him, originally of karakul and shaped with a pointed top and a wide, turned-up brim. This, and one other absolutely defining feature – the Shah's luxuriant, dark, wide mustaches [191] – suggest that this painting in the Chihil Sutun was intended as a kind of posthumous portrait.

The Italian Pietro della Valle, who was in Isfahan between 1617 and 1622, left a vivid description of Shah ʿAbbas I, whom he called the "gran Picinnino:" small in stature but imposing in presence, with a sun-browned complexion and lustrous lively dark eyes, a shaven head, deep black eyebrows, and large drooping mustaches. This very specific image quickly became a type in its own right, the anatomical details reduced to just two elements – the bald head and the enormous mustaches flaring out to each side of the mouth. When such an image is truly intended as a portrait, these two features are usually complemented by his favorite headgear, as here, the hat-brim of brocaded fabric with fur edging. Usually it is shown tipped forward at a jaunty angle, seen in many pictures of him, both Iranian and Indian, that were painted throughout the course of the century.

37. THE FEAST OF THE SOGDIAN MERCHANTS

Painted mural in a private house
Panjikent, Sogdia, ca. 740
H: 122 cm
St. Petersburg, State Hermitage Museum,
on long-term loan

In the largest house excavated in Panjikent, a painted frieze depicting more than thirty men, seated cross-legged at a banquet, was found on the walls of a very large room with a fire-altar. Such halls with altars like fireplaces were used for family celebrations and religious rituals, and most houses typically had a single room so furnished. The owner of this house was a wealthy merchant who possessed a small bazaar of sixteen shops. His house, unusually, had two rooms with fire-altars, and it seems likely that the larger of the two, painted with the murals of which a section is shown here, was a gathering place for his entire clan.

The men in the mural are also of the merchant class – they do not wear swords, which were an attribute of the nobility – and the painted images may well be intended as a kind of group portrait, perhaps of the owner's family and others of the same class who visited his home. Names were actually written in inscriptions placed near their heads, but these have almost completely disappeared, as the heads have also been badly damaged. Thus we cannot judge the extent to which the faces were intended as individuals, or whether they were standard representations of the classic Sogdian male face.

Yet their garments and accoutrements, and the vessels of the banquet, are all shown as having different details and colors; none is exactly alike. The painter of the mural presented the fabrics of their kaftans in meticulous detail. These garments appear to be lightweight textiles patterned with large ornamental roundels; the cuffs, collars, lapels, and borders appear to be made of heavier silk in many colors. Chinese, Persian, and Byzantine styles of textile production can all be recognized – but not the so-called Zandaniji silks, an appellation for an elusive type of textile which was at one time attributed to Sogdiana but is never found in Sogdian murals. It is noteworthy that while the figures whose garments they appear on are represented illusionistically, drawn to convey volume and showing every fold, the roundel ornaments of the kaftans are shown as if they were seen on flat pieces of fabric. Such different approaches to pictorial representation in one and the same composition, treating the outline and the filler-elements in two different ways, is typical of Sogdian painting from the sixth to the eighth centuries, as it was in contemporary Sasanian pictorial representations – for instance, in the hunting reliefs of Taq-i Bustan; and of course, in later illustrated Persian texts. B.I.M.

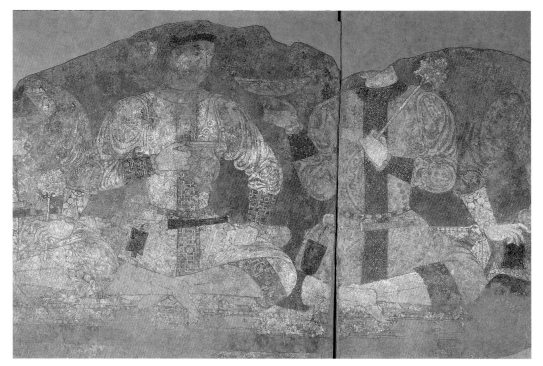

37

38. A PRINCELY ASSEMBLY

One register of a fragmentary wall
painting
Iran, twelfth or thirteenth century
H: 71.5 cm W: 71.8 cm
New York, Metropolitan Museum of Art,
52.20.1

This fragment of figural painting must have flanked some aperture slanting upward to the left. Its best-preserved part is the middle register, which shows a row of seven figures, two standing and the rest seated cross-legged or kneeling. Above it is a register of seven coursing animals, moving to the right; below it are the remains of a third, higher one, in which a pair of mounted hunters is painted, one with a spear while the man facing him wields a sword. Between them is what appears to be an indistinct semicircular object, of irregular width and incurving in the middle: which is, in fact, a snake.

Despite the relatively crude quality of the image, the combination of formally arranged

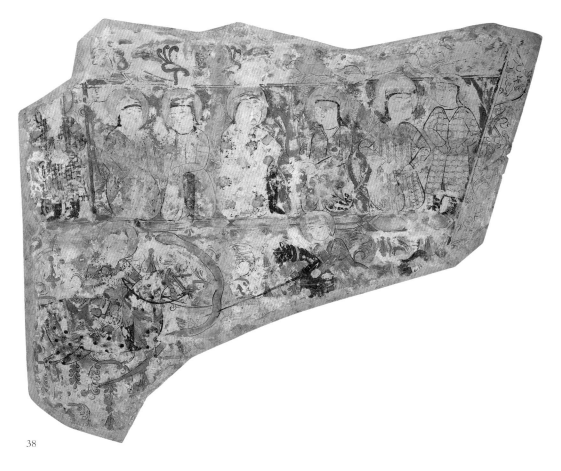

38

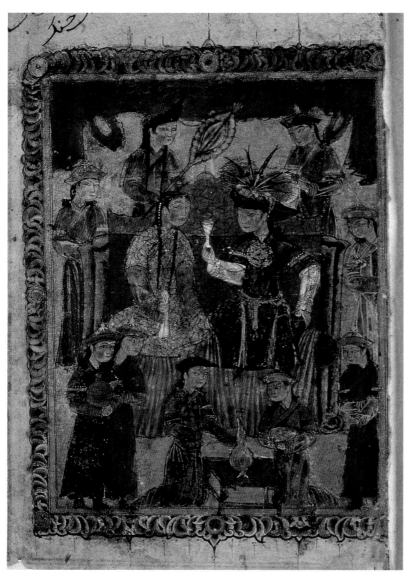

39

figures, in reception-mode or as huntsmen, suggests that its model was princely: images of an enthroned prince and the hunt (or its accoutrements) are usually found together in frontispieces of medieval Islamic manuscripts of any pretension, no matter what the content of the volume might be [39]. Quality apart, the figures display a lively eye contact; heads are large, approaching the moon-faced Seljuq ideal of beauty, and set off by haloes. Garments are varied, in style – closing both in the center and on the right – and in color and pattern, with *tiraz* at the upper arm; caps of various styles are set on long dark hair. The colors are primary and not especially subtle, applied within designs drawn in black. Modulation in the painting depends upon lines drawn over a color field, rather than on the application of one color over another, as will be the case with painting on paper in manuscripts from the early fourteenth century onward. This fragment appears to have been part of a small-scale ensemble, perhaps the wall just to the side of a niche, for at the left side is painted a curving band of foliate arabesque, enclosed within borders.

39. A PRINCELY RECEPTION AND A PRINCELY HUNT

> Double-page frontispiece from a manuscript entitled *Mu'nis al-ahrar fi daqa'iq al-ash'ar* (*The Free Men's Companion to the Subtleties of Poems*)
> Isfahan, 1341
> 1v H: 19.8cm W: 12.5cm
> 2r H: 13.5cm W: 12cm
> Kuwait, Dar al-Athar al-Islamiyya, fols. 1v–2r

An anthology of Persian poetry arranged to exemplify a number of rhetorical devices was compiled in Isfahan by a certain Muhammad ibn Badr al-Din Jajarmi and finished in early 1341. Once the text was copied and the text-illustrations completed, the manuscript was given a double-page frontispiece showing, on the right, several princes hunting, and on the left, a prince and his consort enthroned and surrounded by courtiers.

The right side is damaged, although not so badly that its essentials cannot be seen. Considered together with the left-hand image, it is evident that the frontispiece to Muhammad Jajarmi's modest anthology of poetry is composed according to a formula in use in the princely Seljuq world for well over a century and probably much longer [120]. The best surviving examples of the type are the frontispieces in a series of manuscripts made in the Jazira, possibly in Mosul, late in the twelfth century and in the first quarter of the thirteenth: these all show some pictorial combination of a ruler sitting in state surrounded by courtiers, attendants, and princely accoutrements, together with a hunting scene (Figs. 5, 54, 55), to evoke the notion of princely prowess and strength. Although the formula would be altered in Iranian painting in the following centuries, the essential – the pictorial combination of enthroned prince and hunting prince – remains a frequent feature of frontispieces in illustrated Iranian manuscripts, at least to the end of the sixteenth century. Its appearance in this unique text is fascinating, an image at once formulaic but also rich in contemporary details.

Although Muhammad Jajarmi himself is probably the painter of the charming illustrations to the twenty-ninth chapter of his manuscript [246], for the frontispiece he may have turned to a professional artist [cf. 31]. The left side shows a golden interior draped with a red curtain at the top of the picture.

The prince raises a slender, footed goblet to his consort, as they sit together on a draped and bolstered double throne, she to his right. The details of their garments are carefully drawn: the golden badge on his chest, and his owl- and eagle-feathered bonnet, show him to be a person of very high Mongol rank (although just who remains a matter of some debate); her golden garment is patterned with large Ilkhanid-style lotus flowers, and her headdress with its transparent veil is held in place by a string of pearls. Eight attendants – seven of whom are men – surround them, dressed in the long *jamas* of the day and wearing brimmed felt hats. The drawing of the faces is partly in red – the lines of cheek, chins, and mouths, and the cheeks are shaded with red [cf. 117]; eyes are large, and the Seljuq nimbus has disappeared. The figures have a certain length and elegance, linking them with the Tabriz paintings of the Great Mongol *Shahnama* [124, 150] rather than to the Inju-sponsored *Shahnama* volumes made in Shiraz at about the same time [227, 230].

This comparison does not hold true for the right side of the frontispiece: fine and sprightly as are the hunting figures, the red backgrounds of the registers are archaizing and recall earlier Seljuq wall painting. Instead, the best contemporary parallel is with Inju pictures [177, 227, 230], which in turn may hark back to the mural paintings of Central Asia and probably also to now-lost Sasanian paintings. The conical mountains are another ancient landscape convention retained as late as the middle of the century by painters in Shiraz [68, 70] and Baghdad – and also in Isfahan, to judge from this half of the frontispiece. For whatever reason – perhaps it was the gravely disordered times in which he lived – it suggests that Muhammad Jajarmi's professional painter was only able to finish the hunting half of the frontispiece for his compilation of poetry and then had to abandon it to someone else.

40. SHAPUR BRINGS FARHAD
BEFORE SHIRIN

> Painting from a manuscript of Nizami's
> *Khusrau u Shirin*
> Tabriz, between 1406 and 1410
> H: 27.3 cm; w: 16.2 cm
> Washington, DC, The Freer Gallery of
> Art, 31.34

In Nizami's poem *Khusrau u Shirin*, Shapur is Khusrau's friend and confidant, a painter by training and the invaluable link between the frustrated lovers [77, 239]. Here he introduces to Shirin the sculptor Farhad, who will make her life in the palace near Kirmanshah more healthful and pleasant.

Above a stone floor, the middle zone of the picture shows a richly decorated interior, three sides of an octagon with a long window in each; above is a brick wall, with windows in

the side sections and an apparently octagonal roofed balcony projecting from the central wall. In all three zones – stone floor, chamber, and brick upper storey – the surfaces are carefully adjusted at the two angles where the vertical surfaces abut. The interior decoration echoes the apparent octagon: stone floor, blue and gold tiled dado, crisp gilded borders and blue-decorated white walls; pink brick in a triangular lay with interstitial turquoise stars, and low wooden screens at the windows and at the sides of the balcony. As do the furnishings: the "rug" with its kufic-style borders has both a top – as well as a side –

border (seen at the left angle), suggesting that there are actually three rugs lying upon this floor; the draped red curtains and ruched parti-colored hangings above are shown in triplicate; and each of the three is surmounted by a frame that seems to rise from the dado-border but instead hangs in the air, unsupported. This surface is golden with a bright floral meander; the register just above it, and the corresponding register just above the stone floor, display gold arabesques on a lapis-blue ground arranged in a reciprocating pattern. Both are standard passages of ornamental illumination in the repertoire of

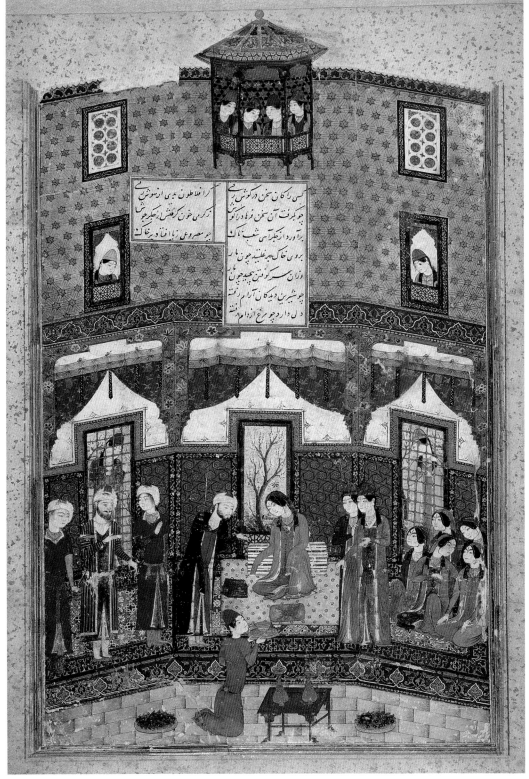

40

fine manuscripts, rather than ornament for the decoration of interiors. Despite the brilliant surfaces in this palatial interior, the structure lacks true architectural and spatial logic and the impression is that of a flat and flimsy stage set. The logical rendition of interior spaces was never really a Jalayirid strong point, even in its best examples [105, 114, 174].

Among which this painting must surely be counted. It comes from a rather mutilated but finely made copy of Nizami's *Khusrau u Shirin*. Although part of the colophon page has been torn away, the name of the scribe – who signs himself *al-sultani*, "in royal service" – remains, as does the information that the manuscript was made in Tabriz, the *dar al-saltanat* – usually translated as "the capital of the kingdom." It would be hard to place this painting (and the other four contemporary pictures in the manuscript) anywhere but in the milieu of Sultan Ahmad Jalayir. The long, elegant silhouettes of both men and women, and the details of the interior surfaces and the princely accoutrements, especially the geometrically patterned rugs and the luxuriant platters of figs, are all features of other paintings made for Sultan Ahmad or in his milieu [105, 114, 171, 179]. The same is true of the white turbans falling to one side, and the typical features of Jalayirid ladies – bluish eyebrows meeting above the nose, and blue "beauty-marks" [156].

Indeed, late in Sultan Ahmad's life he did rule from Tabriz: for a short time in 1406, when he was joyously welcomed as its true sovereign, and then sporadically between the end of that year and his death, in August of 1410. It is, then, of some interest to recall that although, for Nizami, Farhad's presentation to Shirin took place outside Shirin's quarters, this picture may again adapt the text to Sultan Ahmad's own situation. The interview is set in a rich interior in the presence of many attendants, both male and female, and other figures – all men – witness the meeting by looking through the windows and down from the upper story and the balcony.

41. YUSUF ENTERTAINS AT COURT BEFORE HIS MARRIAGE

Painting from Ibrahim Mirza's manuscript of Jami's *Haft Aurang* (*Seven Thrones*)
Mashhad (?), between 1556 and 1567
H: 27 cm; W: 19.4 cm
Washington, DC, Freer Gallery of Art, 46.12, fol. 132r

This picture in one of the most splendid copies of the poet Jami's masterpiece, the *Haft Aurang* (*Seven Thrones*), may be read on several levels. It illustrates a passage of the text, offers a vision of a Safavid court entertainment, and directly relates to an event in the life of its patron, Ibrahim Mirza ibn Bahram Mirza – the marriage (forthcoming, or already celebrated) to his cousin, the daughter of Shah Tahmasp.

An all-male party has gathered on a terrace

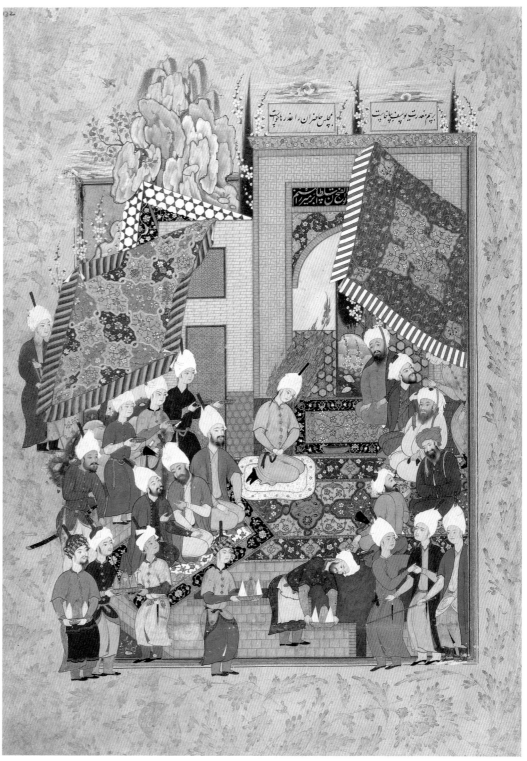

41

adjacent to a substantial brick structure on a blowy spring day. Like many paintings in the manuscript, it breaks out of its rulings: sky, landscape, furnishings, guests, and attendants all spill out onto the wide margin with its brushed golden floral ornament.

The traditional triangular disposition for such princely reception pictures has been abandoned; only on the left side of the picture are courtiers, and servants, arranged in the classical sharp diagonal so literally underlined by the angled carpet. The courtiers appear to be seated behind Yusuf, whereas on his other side five clerics face him, disposed in a loose semicircle that stretches well "above" – that

is, around – him. As host, Yusuf occupies the center of the composition; as the hero of this sufi tale, he is set apart from his guests by his flaming golden halo, and the white cushion on which he modestly kneels, hands crossed in his lap. His guests are varied in physiognomies and builds, racial types, and ages; their discourse is well expressed by movement. The attendants, mostly beardless youths, are less differentiated. They tend to be disposed in groups of three and, standing, they demonstrate a peculiarity of stance characteristic of the single-figure pictures made in the new capital of Qazvin in the second half of the century: loosely bent knees

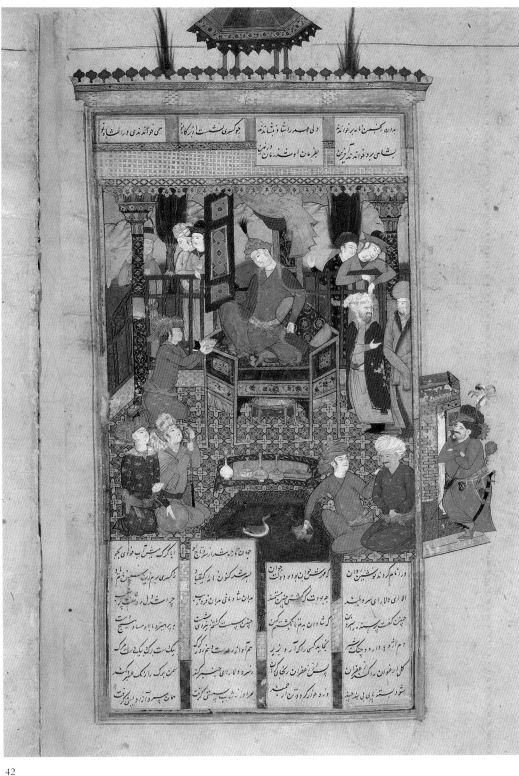

42

42. THE ENTHRONEMENT OF
KHUSRAU ANUSHIRWAN

Painting in a manuscript of Firdausi's
Shahnama
Herat or Isfahan, 1602
H: 29.4 cm; L: 15.9 cm
London, Nasser David Khalili Collection,
MSS 544, fol. 420v

An illustration of the enthronement of Khusrau
Anushirwan in a manuscript of Firdausi's
Shahnama completed in 1602, this picture was
surely also intended as a gesture of homage – if
somewhat belated – to Shah 'Abbas I, who had
acceded to the throne in 1587.

For whom the manuscript was made is
not known, nor is it certain that it was made
in Isfahan itself. But many of its sixty-two
illustrations display the most up-to-date
contemporary architecture and its decoration,
which suggests that this aspect was of some
importance to the anonymous patron of the
manuscript. Copied on large folios, its pictures
are technically only half-page in size but
most transcend this limitation and extend in
all directions beyond the wide rulings that
theoretically contain them; this picture is no
exception [159, 182].

The Shah sits on a raised throne placed
on a high open terrace overlooking a garden
and a hilly landscape; in front of him is a pool
with a porphyry rim, and behind him an open
railing. Shelter from the sun is provided by a
roof supported on two elaborately decorated
columns with *muqarnas* capitals, and their
location defines the rear corners of the terrace.
A pair of painted wooden doors behind the
throne affords access from the outer terrace;
one door stands open to display the decoration
on one side; the other door is partially hidden
by a curtain gathered together and tied up.
Many of the open terraces and porches of
contemporary Isfahan buildings were protected
in this way, just as they were built of fired
brick, which is also visible in several
realistically depicted parts of the throne-terrace.

Perhaps the most unusual aspect of this
picture is its point of view. This gathering
composed of the traditional elements for such
a scene is set in one of the newly constructed
roofed terraces that looked out over the great
central square, the *maydan*, and the garden
zone of Shah 'Abbas' new capital, but it is
shown as if viewed from underneath. Instead
of seeing the courtiers who, traditionally,
would have been shown either in a princely
interior with a glimpse of the garden seen
through a tall narrow window cut into the
back wall [40], or on a completely open
terrace in a garden shaded by a large tent
[242] or canopy, we seem to see them from
deep inside the terrace, facing the shah who
turns his back on the garden, its view and its
air. A curious physical sensation, one that
includes a real sense of dislocation, is the
result of this experiment in combining a
traditional composition with a very real and
specific contemporary setting.

give them all a curiously springy appearance.

The architecture shows a realism that seems
new, in the context of Safavid court painting
in this century. The structures of walls, *iwan*,
and terrace logically relate to each other;
the colors of the architectural fabric seem to
reflect the difference between fired brick, and
terracotta cladding and floor-tiles; and the
ornament of the *iwan* seems appropriate in
scale, color, and design for the ceramic tile-
mosaic it represents. More functionally unreal
are the three rectangular canopies: ostensibly
they shield the company from sun but they are
shown dramatically tipped up, not only so that
the wonderful ornament of their undersides

can be seen but also for the sheer pictorial
drama of the skewed lozenge shapes with the
bold patterns of their flapping awnings.

This picture also is to be read on additional
levels. A sufi meditation on divinity is
embodied in the beautiful figure of Yusuf, his
head set off by the flaming nimbus that curves
up against the blank white wall of the *iwan*.
And the very subject of the picture – a pre-
marriage reception – surely alludes to Ibrahim
Mirza's own marriage, the beautiful Yusuf
being an idealized portrait of Ibrahim himself
and his name and titles written in gold letters
directly over his head, on the black panel of
the *iwan* at the rear of the picture.

43. SHAH TAHMASP RECEIVES HUMAYUN PADISHAH OF INDIA

> One of an ensemble of four large murals, painted on the upper wall of the audience hall of the palace of the Chihil Sutun Isfahan, after 1647

This painting is the second in the series of four large, rectangular Safavid pictures decorating the audience hall of the Chihil Sutun. Such a reception took place at the Iranian court in Tabriz in 1541, when the Mughal emperor had sought temporary refuge with the Safavids.

Like its two compositional companions [191], it is a striking and curious stylistic combination of traditional and foreign elements that may well have been seen in Isfahan for the first time in this painting – if the entire palace was indeed decorated just after 1647. The traditional composition for a princely reception, a wide triangle with the prince at the apex [44], is the foundation on which is built this attempt at the realistic depiction of Indian guests, and Iranian courtiers and entertainers. The window at the rear of the composition, permitting a view of an open landscape, is hardly a novelty; what is new is the treatment of the landscape, its components increasingly diminished in size, both less distinctly painted and "blued" as the eye is led into the background [28, 81, 163].

Lastly, the attempt at historically realistic clothing of the previous century is notable in the Safavid context. Tahmasp and his principal courtiers, at the right of the picture, here wear the early Safavid turban with its prominent baton; less exalted Iranian attendants wear contemporary mid-seventeenth-century headgear, and their clothing makes no other historical concessions [cf. 99]. The Indian turbans worn by the Mughals, at the left of the picture, are less successfully placed in the prior century, although Humayun's courtiers are shown wearing appropriately sixteenth-century Indian dress: vertically striped trousers

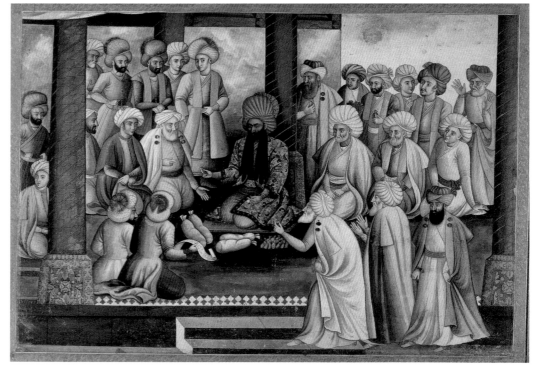

44

and bare-backed slippers. And the distinctive Indian *patka*, the sash, is tied to display its lavishly decorated ends. Humayun himself wears a fur-trimmed robe of honor, which surely would have been a gift from Tahmasp to his exalted guest, although it is, again, shown in the seventeenth-century style and as made of contemporary floral brocade with a large pattern on a gold ground [Fig. 82].

44. THE DISTRIBUTION OF NEW YEAR GIFTS AT THE COURT OF SHAH SULTAN HUSAYN

> Painting once mounted in an album
> Isfahan, probably 1721
> H: 33.1 cm; W: 24.5 cm
> London, British Museum, 1920.9–17.0299

This rather ghostly image of a court reception on the occasion of *Nauruz*, the Iranian New

Year – at the time of the spring equinox on 21 March – is among the last contemporary renderings of Safavid court gatherings, painted as it was in the year of the Afghan invasion of Isfahan, which began in the autumn of 1721.

The subject is the distribution of gifts to members of the court at the arrival of the New Year. The gifts look meager indeed, while the distributor is almost certainly not the last Safavid, Shah Sultan Husayn – to judge from a portrait of him engraved by the Dutch artist, Cornelius le Bruyn, in 1704[1] – but one of his two last grand viziers, either Fath ʿAli Khan Daghestani or Muhammad Quli Khan Shamlu.

Whoever is actually depicted is a fearsome-looking character, with a thick black beard almost indistinguishable from the dark fur collar of his gold brocaded *jama*, and a saturnine complexion set off by the luridly *changeant* lavender and gold of his turban. Moreover, he is the only person depicted in full color, while the courtiers and religious figures seated in front of, or standing in rows flanking, the grand vizier are instead rendered in thinner color-washes with little drawn detail. The painting might be considered unfinished, but the grisaille shading of faces and garments suggests otherwise. The differences in the styles of execution may be accounted for by proposing that more than one painter worked on it – although the inscription only names Muhammad ʿAli ibn Muhammad Zaman. And wherever the New Year ceremony depicted here took place, the columns of the room in which this audience occurs are carefully shown, with an angled golden line twisting continuously around them and trapezoidal carved marble bases.

Everything fundamental in this picture – date, setting, style, and principal subject – contributes to its unsettling effect, naturally intensified by our appreciation of the imminent collapse of effective Safavid power.

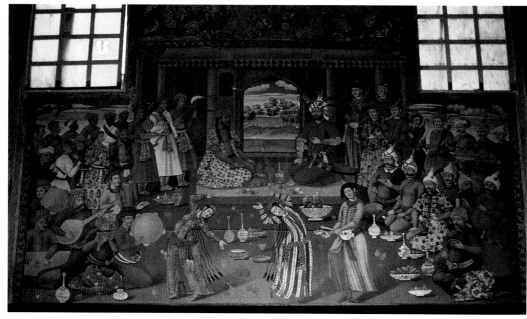

45. A GODDESS

Painted mural on a wall of a small shrine in Temple II
Panjikent, Sogdia, ca. 500
H: 185 cm; W: 160 cm
St. Petersburg, State Hermitage Museum, on long-term loan

This enthroned goddess was discovered in a small fifth-century shrine in the courtyard of Temple II, one of the two large temple complexes at the archaeological site of Panjikent. She is not the primary deity of the shrine but a fragment of a larger painting on its side wall.

The throne on which she is seated is supported by the figures of two fantastic winged animals, their dog-like heads having a single horn. Her crown is adorned with flowers, and broad Sasanian ribbons float above her shoulders. Her right hand is raised and holds a musical instrument with many small bells on it; in her left hand is a banner. On her left stands a female donor offering her a necklace, and on the other side is the figure of a man carrying a portable fire-altar. All these details constitute an iconography of mixed Sogdian and Kushano-Sasanian character. For instance, the pose, and proportions, of the goddess Anahita on fourth-century Kushano-Sasanian coins are very similar to those of the Panjikent goddess, despite the fact that the attributes of the figures in the painting and on coins differ from each other and can hardly represent the same deity.

This mural is the best surviving example of the fifth- to early sixth-century style of painting so far discovered in Panjikent. The color scheme is restrained, being primarily a silvery-ocher with a few spots of dark red. Tonal transitions, highlights, and shading all convey a sense of volume. The style apparently derives from classical models and shows that in Sogdia in the fifth and sixth century, the Hellenistic tradition was still alive, as the picture of a pair of male donors from the same shrine also makes clear [46]. B.I.M.

46. A PAIR OF MALE DONORS

Painted mural on a wall in a small shrine in Temple II
Panjikent, Sogdia, ca. 500
H: 80 cm; W: 140 cm
St. Petersburg, State Hermitage Museum, on long-term loan

This fragment comes from the same side-wall of the small fifth-century shrine in the courtyard of Temple II at Panjikent as the goddess [45]; it shows the best-preserved figures of a longer row of male donors, of whom only details are still visible at the edges. The men are making offerings to the deity; one holds an oval tray and the other a bowl.

They wear short tunics, and wide trousers

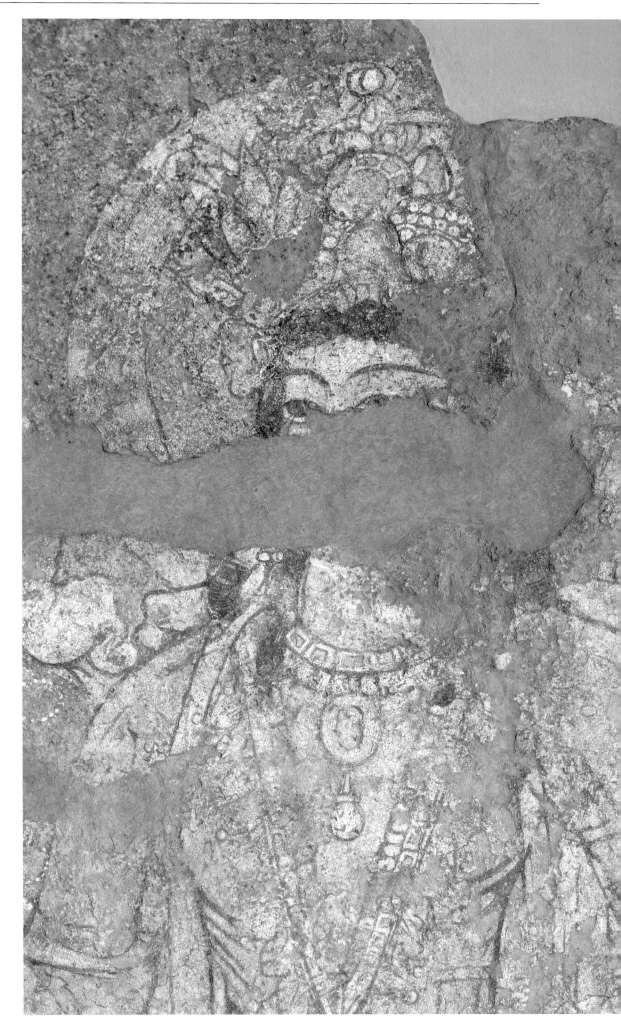

bloused and tucked into narrow boots, a costume typical for what is known of Sogdia in the fifth and sixth centuries. Such clothing may be traced back to the more ancient garments of the Sakas, the Bactrians, the Parthians, and other Iranian peoples. The figures are compact and stocky, with large hands and heavy heads; the beardless faces are shown in profile but the frontally depicted bodies, legs, and feet recall standing figures of donors in Tokharistan paintings of the Kushan period, from Faiaz-Tepe and Kara-Tepe, near Termez. The artist makes use of thick black contours, not only to outline fields of color but as expressive elements in their own right. Yet he also drew upon Hellenistic pictorial traditions and here painted a low horizon and the earth with flowers in bloom; below the figural painting is an ornamental frieze, composed of motifs of Hellenistic origin, "stepped merlons" and an accordion pattern.

The donor figures seem to be more archaic in style than the goddess on the same wall, with her mixed Hellenistic and Sasanian features. Their faces appear to be almost identical, but it is also possible that they were originally painted as representations of real persons, for Sogdian pictorial art tends always to render the norm rather than to represent the individual. B.I.M.

47. FOUR MALE DONORS

Part of a mural painted on the walls of the Cave of the Sixteen Sword-Bearers Qizil (Chinese Turkestan), 600–50
H: 150.5 cm; W: 208 cm
Berlin, Staatliche Museen, Museum für Indische Kunst, III 8426a, b, c

On both the third and the fourth German "Turfan-Expeditions" to Chinese Turkestan, Grünwedel and his team explored the Kucha area. At the site called Qizil, a very large number of cave-temples had been hewn out of the mountainside high above the Muzart River; it was almost inaccessible and – as was the usual Buddhist monastic practice – designed to be so.[1] Numerous caves had been decorated with wall paintings, in styles different from those that had earlier been discovered in the Turfan Oasis further east, and many appeared to be older as well. In a letter of April 1906, Grünwedel wrote:

For years I have been endeavoring to find a credible thesis for the development of Buddhist art, and to trace the ancient route by which the art of imperial Rome . . . reached the Far East. What I have seen here goes beyond my wildest dreams. If only I had enough hands to copy it all, . . . here in the Kizil area are about 300 caves, all containing frescoes, some of them very old and fine.[2]

The number of caves apparently gave rise to the notion of naming them, instead of the

46

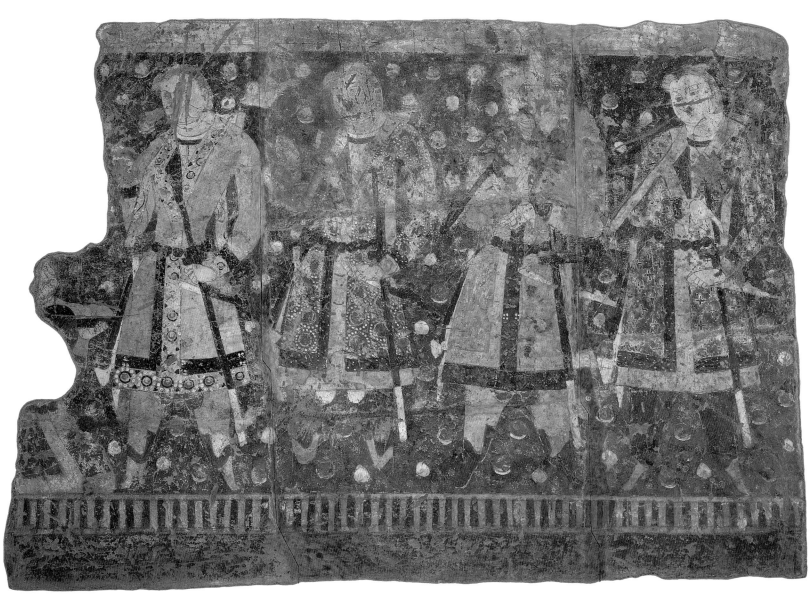

47

number system used at sites discovered on previous expeditions [68]. The "Cave of the Sixteen Sword-Bearers" is thus named for the male donors painted on both walls of the right- and left-hand passages into the cave itself, the figures arranged in four groups of four. Discovered in the summer of 1913, it counts among the most important at Qizil, for both its architectural and its artistic qualities.

The figures are remarkable for their physical characteristics and their dress, especially in the context of a Buddhist temple complex in Central Asia: red-headed and light-eyed, with short hair parted in the center, they are neither East Asians nor Indians, but "Western." All are garbed in the same manner: they wear tight trousers tucked into boots and fitted, knee-length, front-closing coats with lapels that clearly show the right-to-left closing [122]. The fabrics depicted are different in color, with various colored designs and edgings, the patterns predominantly repeating circular motifs of a medium size; the belts that close the garments tightly at the waist are of overlapping metal disks, from which hang very long swords, and other useful objects. Boots, trousers, fitted front-opening garments and

waist-slung paraphernalia are, of course, features of the dress of horse-riding peoples [Fig. 38]: indeed, these sword-bearers have been identified as Tokharian knights, Tokharistan being the eastern Iranian province formerly called Bactria.[3] In style and details, their coats are very close to the garments worn by Khusrau II, Khusrau Parviz, and some of his attendants in the stone reliefs carved into the side walls of the grotto at Taq-i Bustan [Fig. 13], garments otherwise unusual in the Sasanian context. Instead, the front-opening robe with lapels, and the belt of disk-like elements with similarly composed hanging straps, are both typical for nomadic, or steppe-dwelling, peoples and are usually considered characteristically Turkish; their presence in the Taq-i Bustan reliefs has been interpreted as an Eastern sartorial influence reflecting the political reality of the time. Given Khusrau's regnal dates of 591 to 628, the hunting reliefs in the grotto of Taq-i Bustan could be virtually contemporary with the painted sword-bearers of Qizil, murals usually dated to the first half of the seventh century.

The figures are formally aligned, but while they stand in a row and face in the same

direction, their arms are held in varying positions and the space between them is loose and open. The arrangement of subsidiary figures in rows continues to characterize Iranian painting in the following centuries, both mural and miniature in scale; but the "breathing" spaces between figures will tend to disappear and they will instead overlap, giving rise to a kind of formula to suggest many figures, even a multitude, within a relatively small space [8, 49, 59, 89].

Apart from the historical aesthetic of painting, however, the fact that Iranians in rich and unmistakably nomadic-Turkish dress should have offered paintings to a Buddhist temple complex on the Northern Silk Route is testimony to the strong Iranian presence east of Iran proper at this time; it well exemplifies the cosmopolitan mix of cultures throughout Central Asia in the centuries immediately preceding the advent of Islam.

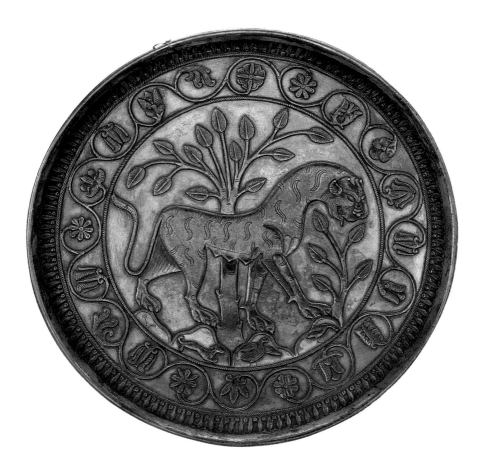

sketching. The primary finds of a rather short campaign, however, are among the richest and most interesting of the four German expeditions: manuscripts, including all the fragments of Manichaean sacred texts now in the Berlin State Collections, among which is this two-sided fragment. It is still the largest piece of Manichaean painted paper known to have survived, and it bears perhaps the most impressive, and evocative, Manichaean images ever discovered.

This side shows a ceremony held in a richly furnished setting, conducted by a white-haired, white-robed figure with a golden stole. He is attended by a host of smaller figures also dressed in white (the customary garb of Manichaean adherents) whose headgear, or lack of it, distinguishes their relative positions within the community, as either the Elect, or the Auditors; some of their names – mostly Iranian – are written in red letters on their robes, and no other text accompanies this image. But the reverse side of the fragment [Fig. 26] displays vertical columns of text, written in red and black inks, flanking the central image, with additional illumination and more text to the left of it. The picture shows a large priestly figure in white, this time wearing a red stole; he grasps with his right

48

48. A NURSING TIGRESS IN A LANDSCAPE

Silver plate with *champlevé* decoration and gilded details
Iran, sixth–seventh century
Diameter: 22.8 cm
St. Petersburg, State Hermitage Museum, S-41

The figure of a tigress (or lioness) with pendant breasts full of milk occurs on a number of Sasanian silver vessels and is a benedictory image. Iranian culture often likened noble warriors to the most ferocious animals – lions, tigers, wolves, even dragons: Suhrab, in the *Shahnama*, surveys the Iranian camp with Hajir and sees among the champions' standards some bearing an elephant, a dragon, a lion, and a wolf (II, pp. 153–55). A silver plate so decorated might be presented as a wedding gift to a woman whose primary obligation was to give birth to a future hero and nurse him; its significance was virtually the same if the gift were made after the birth of a male child.

Images of benediction occur on many other late Sasanian silver vessels, among which may now be distinguished gifts to young boys, and *Nauruz* – New Year's – presents. After the Arabs conquered Iran, between 633 and 651, benedictory phrases written in Arabic letters began to replace pre-Islamic Persian benedictory imagery on vessels of metal and ceramic made in Iran; thus very few silver plates with figural images from the early

Islamic period have survived.

In addition to the tigress, the plate displays a dog and two birds, hills and trees, and a fantastic scroll with many kinds of flowers: its rich decoration symbolizes all vegetal growth and all the creatures of the universe. Its space is dense and embroidery-like, its figures and floral motifs highly stylized, a characteristic it shares with a number of similar late Sasanian silver vessels. Such intensity of decoration seems to have been as important for the artists who produced these vessels and for the clients who commissioned them as was the richly allegorical meaning of these compositions. Yet the technique of their execution is relatively simple, the flat relief being executed by carving away the background from around the figures. B.I.M.

49. THE FEAST OF BEMA

Fragmentary folio, painted on both sides, from a Manichaean manuscript
Found in the ruins of Temple Alpha at Kocho
Chinese Turkestan, eighth–ninth century
H: 12.4 cm; W: 25.5 cm
Berlin, Staatliche Museen, Museum für Indische Kunst, III 4979

The second German expedition to Central Asia arrived in Turfan in late 1904 and continued its work in the ruins of the large, ancient city of Kocho, inventorying and

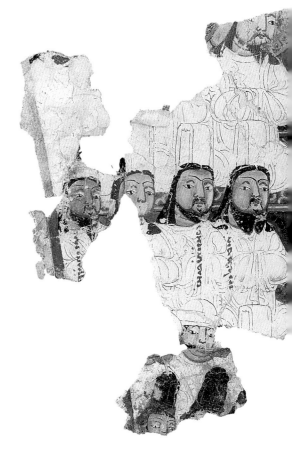

hand (or is held by) the right hand of a princely figure in lamellar armor and a helmet. Both are nimbed, the priest's halo being red and the prince's violet; each is flanked by three attendants, the priest by two clerics and a layman in Central Asian garb, the prince by three "knights." Below them are six extraordinary figures. A pair of deities or angels, also nimbed (one in violet and the other in red), faces a row of four figures who are probably Hindu gods – Ganesha, Vishnu, Brahma, and Shiva – but equally perhaps a Central Asian, Hindu-influenced vision of the Manichaean "Four-Fold" God.

Large, detailed, and richly colored, the images, in whatever text they once illustrated, must have had a signal importance for the Manichaean community that produced them – not to speak of their scholarly interpreters in the twentieth century and later. The ceremony attended by the host of white-robed figures is thought to represent the "Feast of Bema" which commemorated the martyrdom of Mani, put to death in the spring of 276; while the picture of the priest and the prince may refer, to the conversion of the Uyghur ruler Bögü Khan, who had adopted the "religion of light" in 762–63 and declared it to be the Uyghur state religion.

For our purposes, aspects other than the arcana of Manichaean doctrine call for comment. Most important are the striking visual similarities between these two pictures (and so many other Manichaean manuscript fragments) and the images painted on medieval ceramic vessels and tiles [123, 135], as well as those illustrating the unique copy of Ayyuqi's *Warqa u Gulshah* [4, 57, 140, 166].

In the "Feast of Bema," the attendants (all male) are seated close together in overlapping ranks. This, and their faint angling, both clearly adumbrate the later Iranian pictorial mannerism of using a few figures placed "in unison" to represent many. All the men (save those in helmets) wear their black hair falling to the shoulders and apparently parted in the middle, a male style almost universally depicted in the Seljuq period. Unlike the Hellenistic-derived convention so often used in Sasanian and Sogdian wall paintings, painting men with unmodelled reddish-brown faces, here the men's pinkish faces are modelled with shading in red or white; the noses and mouths are drawn in red, and the eyes are an almond shape, with a black line above and below the pupil which is enlivened with white, so that a subtle variety of looks and expression is obtained. This, too, will

prove to be typical of Iranian manuscript painting from the Ilkhanid period onward [177]. The red stool in the foreground reappears in some of the earliest Ilkhanid painting that has come down to us [31], as does its illusionistic, angled position. The three-footed form of the dish of fruit (fruit has a Manichaean significance, being "light-filled") also occurs in a painting in the *Warqa u Gulshah* manuscript [140]: it must have travelled nearly as far west as did the red Chinese-style folding stool, for it is seen on a luster-painted Iranian fritware tile made as late as 1339.[1]

Lastly, the elaborate floor coverings seen in the paintings on both sides of this extraordinary folio are also to be found in later manuscript illustration, even used in the same way – underscoring the placement of both principal and secondary figures [32, 33, 40]. How many more aspects of the later art of painting in the Islamic period in Persia might also have been anticipated by other Manichaean illustrations made in Turfan is something we shall never be able to say, so vast was the scale of careless, haphazard, or wanton destruction of the rich libraries and religious institutions in Kocho and the neighboring areas.

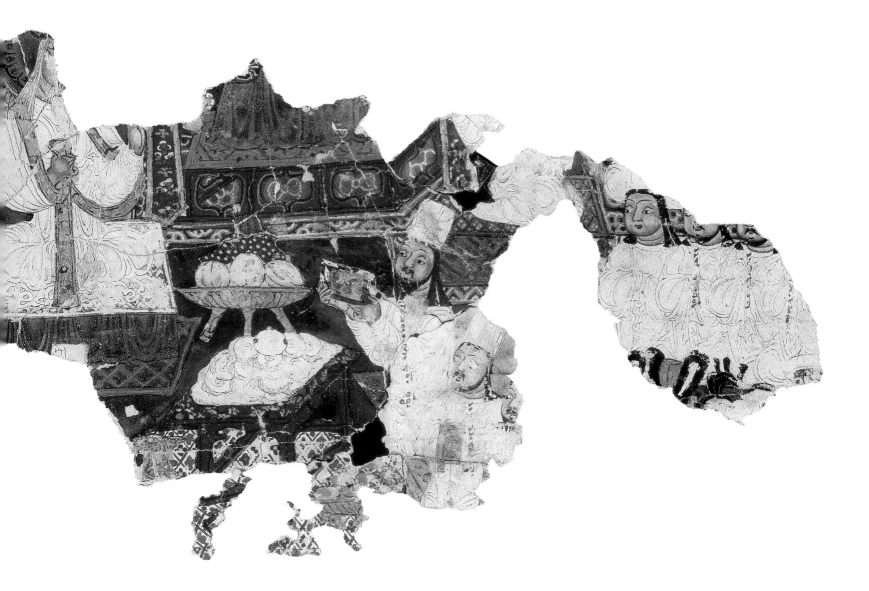

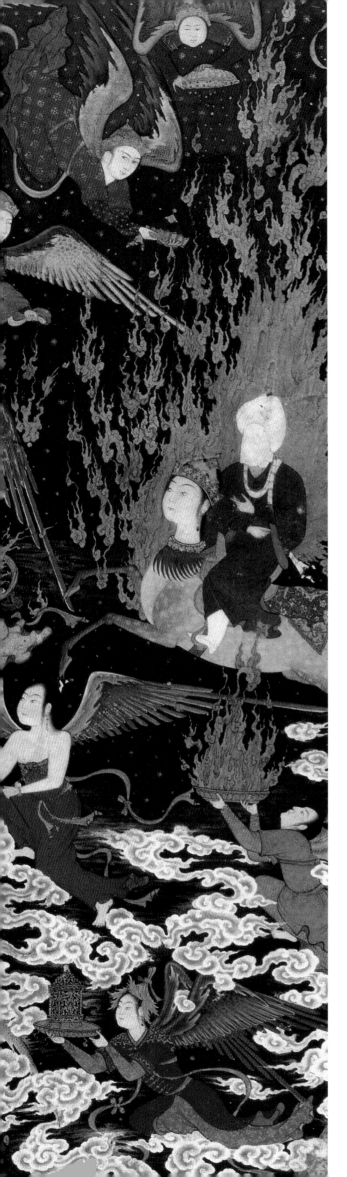

RELIGIOUS PAINTING
IN THE ISLAMIC PERIOD

Ernst J. Grube

Religious themes abound in Islamic art. Christian and Muslim subjects were often illustrated in manuscripts as well as on objects. Biblical subjects, both from the Old [211, 214, 217, 218] and the New [213, 219, 220] Testaments, are frequent in illustrated Persian historical texts, since the genre of the universal world history was a recognized scholarly discipline in the Persian-speaking world from as early as Bal'ami's translation of the chronicle of al-Tabari [180], in the mid-tenth century. Rashid al-Din's *Jami' al-Tawarikh* [212–13] is the most famous, but by no means the only example, of this genre of illustrated Persian historical writing. Nor should we ignore Muslim pictures reflecting Biblical derivation in Islamic garb, or even aspects of popular piety, especially when they are as magnificently rendered as are those in an extraordinary mid-16th-century manuscript of augury called the *Falnama* [215, 216].

While Christian subjects appear primarily on objects made in Syria and Egypt rather than in the Iranian world, there are exceptions. Jesus was recognized as one of the pre-Muslim Prophets, and the story of his life is treated as a historical subject in some illustrated Persian histories and single paintings [220]. Yet for many reasons, a fully developed Muslim religious iconography – in the sense that the West would understand it – never emerged in Islamic culture, although representations of the Prophet Muhammad comprise a special category of Muslim religious painting that developed within the framework of Islamic art. They, too, often appear in the larger context of a general world history. And however unexpectedly the image may appear, there are also illustrated Muslim texts that deal specifically with the life of the Prophet and, even more astonishingly, with the metaphysical and highly mysterious *mi'raj*, the journey made by the Prophet during the course of just one night through all the Heavens and into Hell. Such paintings bear comparison with the cycles of the Life of Christ in Christian churches or manuscripts.

A number of illustrations whose subject is the life of the Prophet Muhammad (or fragments from such texts) have survived [61–63], but only one complete illustrated manuscript describing the Night Journey has come down to us [53, 54, 64, 65]. It was composed in Chaghatay Turkish, written in the Eastern Turkish (or Uighur) script, and produced in Herat in the second quarter of the 15th century for Shah Rukh, Timur's son and successor. The *Mi'rajnama* shows that Turkish language and culture were of great significance in Timurid Iran, and it should be recalled that the Turks had long been a major force in the eastern Iranian world, both as administrators, and as writers of history and hagiography. Indeed, it is from Ottoman Turkey that the most elaborately illustrated history of the Prophet's life has survived, the six-volume *Siyar-i Nabi*, *Life of the Prophet*, started for Sultan Murad III

(1574–95) and finished in the reign of his son Mehmed III (1595–1603); the Timurid *Mi'rajnama* is clearly an accidental survivor of an ancient Turkish tradition adopted by the Iranian world.

The most striking image of the Prophet's Night Journey shows him riding the mysterious winged human-headed beast, *al-buraq*, and ascending to Heaven. Both Buraq and the rider are enveloped in a flaming golden halo whose immediate parallels are in East Asian, Buddhist art, which had also long been an important source for the development of religious imagery in the Muslim world. In a fourteenth-century drawing, the halo encircling the head of the Prophet is a chinoiserie of lobed form [cf. 54]. This image of Muhammad on *al-buraq* was probably first developed in painting cycles of a purely religious nature, but it was then adopted for use in other contexts and became an almost icon-like image, especially as a "frontispiece" in illustrated Persian texts of Nizami's *Khamsa* [66, 67]. There it functions symbolically at the opening of a poetical text which, at first reading, would appear to have no religious connotations, but which is fundamentally imbued with religious, almost mystical significance.

This leads to one of the crucial problems in the identification of "religious" art in Islam. Jewish art, which was largely aniconic (even though the third-century wall paintings in the Synagogue of Dura-Europos, and the seventh-century mosaics of Beth Alpha, in northern Israel, show that a figurative tradition was one strand in Jewish art of the late Classical and early medieval periods), usually expressed religious themes by way of visual symbols. Early Christianity also developed a symbolic language, probably due more to official persecution, and the need for secrecy or – at the least – great caution, than actual choice; for after the acceptance of Christianity by Rome in the fourth century, under Constantine, the change from pure symbol to unmistakably Christian imagery was fairly rapid.

Islam, by contrast, never officially adopted a figural religious iconography; indeed, the very lawfulness of images was hotly debated in the early Islamic centuries. In mosques there are no cycles of paintings illustrating the Prophet's life and his deeds comparable to those of the life of Christ or the saints in Christian churches or, for that matter, the life of the Buddha in Buddhist temples. Thus, that one of the most extraordinary images of the Prophet's Night Journey should appear in poetic texts written in Persian, where it is apparently "out of context," suggests that such pictures comprise a highly elusive form of religious imagery: one that alludes to a religious theme not in form – that is in signs or symbols – but by context. In other words, the illustrations of Nizami's *Khamsa* may all be considered as having a religious significance, although it is hidden under the guise of "text illustration," or overshadowed by the narrative sequence.

For instance, in Nizami's *Haft Paykar*, Bahram Gur visits the Seven Princesses in their Seven Pavilions of Seven Different Colors [115, 118], which represent the Seven Regions from which the princesses come, and consequently the Seven Climes of the World; the series is sometimes depicted in its entirety. These pictures ultimately represent the Seven Spheres of Heaven and the Seven Stages of the Mystical Journey of the individual to Divine Knowledge, even though on the surface they seem no more than illustrations of "romantic" poetry. To the contrary, they have a deeply symbolic, mystical, and therefore ultimately religious significance. Another example of such "hidden" religious meaning in what would appear to be illustrations to an elaborate narrative are the paintings illustrating 'Attar's *Mantiq al-tayr*, *The Language of the Birds*, especially the "Assembly of the Birds" [250]. Here the search of the birds for a leader brings them face-to-face with the *simurgh*, meaning "Thirty Birds," in whom – being a group of thirty – the birds come to recognize themselves and, in that recognition, understand that they are one with the divine. The painting is a beautiful rendering of a landscape with a fresh watercourse making its way through the rocks, in which the birds (all highly accurate depictions of members of the species) gather around their momentary leader – the hoopoe – in anticipation of meeting their destiny. A subtlety of the picture is that the *simurgh* is not actually shown. It is an image that well exemplifies the ambiguity – surely intentional – of some of the finest of Iranian "religious" paintings.

This "hidden" form of religious Islamic art is far more frequent than has generally been recognized, but it is a phenomenon almost totally inaccessible to the non-Persian reader or the non-Muslim; or to anyone not initiated into the subtleties of sufism [173–76], the eastern version of what, in the West, is known as mysticism. Western Christian mysticism had developed a complex imagery of its own and, although it is equally difficult of access to the non-initiated, it is more easily identified and understood than is the equivalent language of mystical images in the Muslim world.

The word used in Islam for mysticism is *tasawwuf*. Derived from the Arabic for "wool," *suf*, it is usually said to refer to the early Muslim mystics' habit of wearing coarse woolen garments to proclaim their rejection of worldly goods, in emulation of ascetic Christian practices. The sufi holds that his mystical union with God needs no intermediary, and that many practices will aid this union, as will a determined renunciation. Sufism grew within the community of Islam from its earliest years, spreading from the Arabian Peninsula to the Indian subcontinent; its adherents were kings, princes, and educated men and women, as well as the poor and uneducated; its literature is vast and has immeasurably enriched Muslim culture, not to speak of the non-Muslim world wherever the

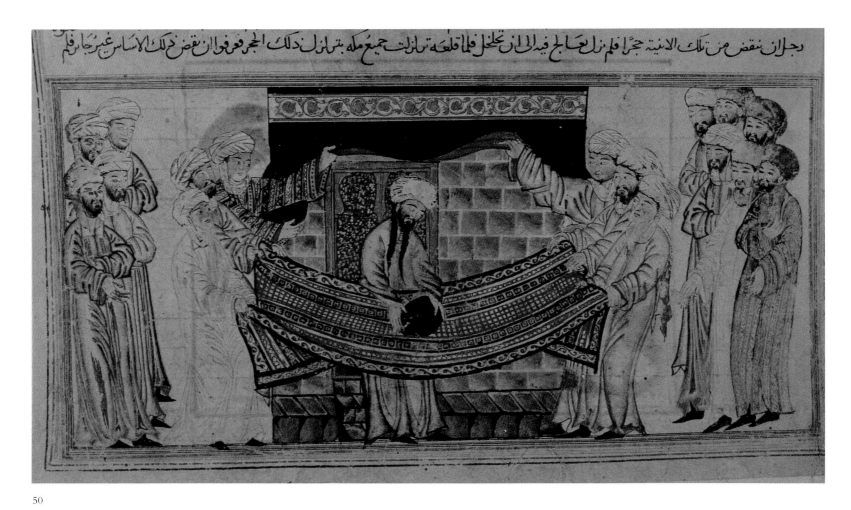

50

works of writers such as Jalal al-Din Rumi, and others, have been translated. Yet paintings recognizably depicting sufis and darvishes seem to appear in the Iranian figural repertoire only in the later fourteenth century. They become a regular feature in the fifteenth and sixteenth centuries [174], at which time a number of individual renderings of devotees impressively convey the spiritual force of the sufi movement.

50. THE PROPHET MUHAMMAD SOLVES A DISPUTE

> Painting in the Arabic manuscript of
> Rashid al-Din's *Jami' al-Tavarikh*
> (*Compendium of Chronicles*)
> Tabriz, 1314
> H: 33.5 cm; W: 44 cm
> Edinburgh, University Library, MS Arab
> 20, fol. 47r

This picture is a unique illustration of the ceremonial resolution to a dispute that threatened to mar the completion of the rebuilt Ka'ba, the structure that was the focus of Muslim pilgrimage to Mecca.

The Prophet Muhammad was "of man's estate" when a fire destroyed the first Ka'ba. It was rebuilt, in alternating courses of stone and wood, its height doubled, and a roof constructed. But when it was time to reset the celebrated Black Stone in the wall, the Meccans quarreled among themselves as to who should be given the honor; passing by, Muhammad is said to have put the stone onto his cloak and invited the quarreling elders each to carry a corner of the cloak to the Ka'ba, where he himself then repositioned the Black Stone.

The drama of this picture is both inherent and formal, and its composition appears to have been developed expressly for the subject. Groups of men, Meccan Arabs in turbans and very long robes, anchor the picture at both sides, watching Muhammad who is placed just off-center and in front of the greenish stone structure; two men lift the Kiswa, the black cover with gold embroidery which is draped over the Ka'ba, to expose the place in the wall where the Black Stone was to be replaced near a door (as it is today). Muhammad holds the Black Stone over the red and blue textile, whose corners are held by four Meccans. Its curving length and strong colors sweep dramatically through the center of the picture, and its drooping ends form arresting triangular shapes against the sketchily painted white robes of the Meccans.

In the illustrations of the Arabic version of the *Jami' al-Tavarikh* figures are often elegantly long, as are hands and fingers; faces are varied in forms, beards, and expressions, with none of the expressive grotesquerie approached by the smaller figures in one of the Persian copies of the text [6].

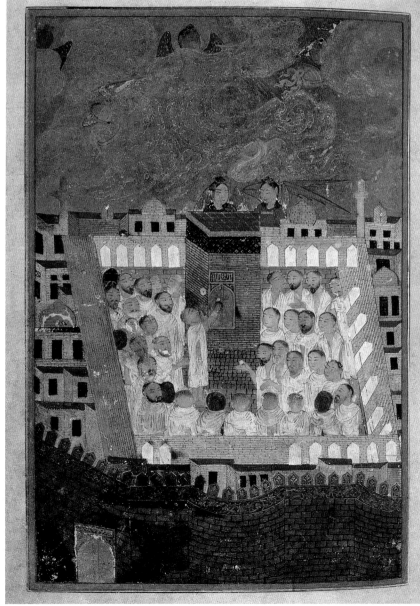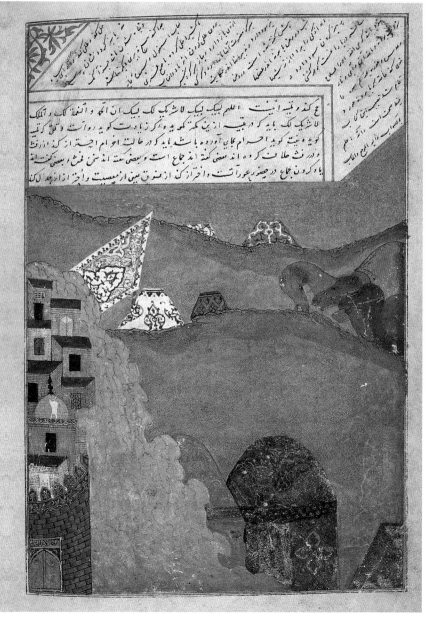

51. PILGRIMS AT THE KAʿBA

Double-page painting in an anthology of various texts
Shiraz, 1410–11
Each half: H: 15.5 cm; W: 9.8 cm
London, The British Library, Add. 27261, fols 362v–363r

The *Hajj*, or pilgrimage, to Mecca is one of the five obligatory duties of an observant Muslim, one of the "Five Pillars of Islam." A vision of Mecca and the Kaʿba is spread over two pages of this celebrated tiny anthology commissioned by Iskandar, governor in Shiraz between 1410 and 1414. The enclosure around the Kaʿba is filled with *hajj* pilgrims dressed in white; outside the walls of the city their camels are tethered and their tents are pitched.

The parent volume is a compendium of literary and scientific texts and includes a treatise on religious observances, in which this picture occurs. The manuscript is also a kind of stylistic compendium, with twenty full-page paintings in the new Shiraz–Timurid style [239] developed in Shiraz in the course of the prior decade, and numerous pages of chinoiserie and marginal illustrations; this is its only double-page picture. Several worlds meet within it: the mundane world of the pilgrims, who would have traveled long distances and undoubtedly finished the journey by camel, even if they did not begin it that way; the heightened world of the *hajj*, when Muslims from the entire community of believers shed the concerns and trappings of daily life to join with each other in the ritual circumabulation of the Kaʿba itself; and the angelic exaltation of that moment, presided over by divine beings in a swirl of golden clouds against a golden sky.

The heart of the image is the left side, painted on the recto of the folio, with a daylight view of the Kaʿba and the walled city, pilgrims in their white garments (symbolizing the purity of intention with which they approach the holy place), and angels peeping from behind the swirling golden clouds. The right side, painted on the verso of the preceding folio, lends human interest: large fuzzy Bactrian camels and colorful tents and yurts are nestled in the three planes of the landscape. The city wall continues from the left half of the picture to the right, with a second golden door set in its wall to match the one in the left half; houses perch on the cliff inside the wall and outside the precinct of the Kaʿba itself; but little in it is truly necessary to convey a sense of the crowded exaltation of the *hajj*. Not so large as the left side of the picture and peculiarly shaped at the upper right, the right side is perhaps an afterthought, added when the copying of text on the verso of the folio left free a rather large space, in which just such an extended view of this grand religious gathering could be painted. It is a unique image, standing at the nexus of the material and the spiritual worlds.

52. THE VIZIER AT THE KING'S PALACE

Painting from Baysunghur's manuscript of
Sa'di's *Gulistan*
Herat, 1427
H: 20.2 (maximum) cm; W: 13.3 cm
Dublin, The Chester Beatty Library, P.
119, fol. 9r

The giving of alms to the needy is another of
the "Five Pillars of Islam." This picture – not
precisely an image in which charity is given,
but one in which he who offers believes he is
doing so – is one of eight pictures in an
exquisite manuscript made for Baysunghur in
Herat. Illustrated is Sa'di's story of the vizier
who, reduced to destitution and darvishhood,
sat begging in front of the royal palace; when

his royal master offered to reinstate him he
refused, saying "Better disgrace than favor."

This copy of the *Gulistan* finished in the
Hijri year equivalent to 1426–27 is the earliest
of the illustrated manuscripts completed for
Baysunghur in Herat. Architectural settings
are found in half of the paintings now within
it, and the workshop document called the
'arz-dasht, or "review," mentions work being
done on one such "architectural" picture
for a *Gulistan* manuscript, and on another
architectural picture needing repair.[1] The
picture, then, embodies one aspect of the
original program of settings for the episodes
illustrated in Baysunghur's *Gulistan*.

Its left half is, in fact, dominated by
architecture, the tall screen-like form of the
palace facade being a particularly strong

orange color only faintly modulated by the
turquoise interstitial elements. Other aspects of
the composition keep this orange from
overwhelming the picture, both the placement
of the text-passage intruding into it, as well
as the coloristic balance achieved by the
placement of colors throughout it. The orange
façade is also tempered by the rather hard
light-turquoise color of the ground, on which
the vizier-turned-darvish sits and raises his
hand to decline the king's offer.

As in the best Jalayirid painting, the figures
here are elongated and slender, and relatively
small in terms of the overall picture space.
Other Jalayirid features – the men's white
turbans that fall to the side, the turquoise tile-
elements studding the brick, and its screen-like
rendition – were also seen in the last of
Sultan Ahmad Jalayir's paintings [40]. Unlike
even the finest of late Jalayirid manuscripts,
however, Baysunghur's *Gulistan* already
demonstrates one of the distinctive
characteristics of all the manuscripts produced
in his Herat workshop – the integration of
calligraphy, stunningly sophisticated abstract
illumination, and fine illustrations that were
carefully chosen, executed, and finished. The
calligraphy by Mir Ja'far – who here adds the
epithet *baysunghuri*, "in the service of
Baysunghur," to his name – is especially
beautiful, and the illumination in the written
surface on this folio is extremely refined.

53. THE PROPHET MUHAMMAD PROSTRATES HIMSELF BEFORE THE ETERNAL

Painting in a manuscript of Mir Haydar's
Mi'rajnama
Herat or Samarqand, between 1420–40
H: 19.7 cm; W: 16 cm
Paris, Bibliothèque nationale de France,
Suppl. turc 190, fol. 36v

The first "Pillar of Islam" is the recitation of
the Muslim profession of faith, the *shahada*.
The least pictorial of human religious
activities, nonetheless it takes a visual
expression in one of the most unusual of all
illustrated Islamic manuscripts, the *Mi'rajnama*,
the *Book of the Mi'raj*. Written in Uyghur, an
Eastern Turkish script and language, it was
illustrated at some point in the second quarter
of the fifteenth century, in either Herat or
Samarqand; for whom it was produced is still
unknown.

Mi'raj means literally, "an ascent" and, by
extension, the ascension to heaven by the
Prophet which occurred in a single night and
took him through the heavens to Paradise, to
Hell, beginning in the "farthest place," the Aqsa
in Jerusalem [54]. There he finds himself in the
presence of God, and he prostrates himself
in adoration. This painting of so signal an event
shows the Prophet face to face with
the Almighty. He is alone and isolated, with
neither his guide, the archangel Gabriel, nor the

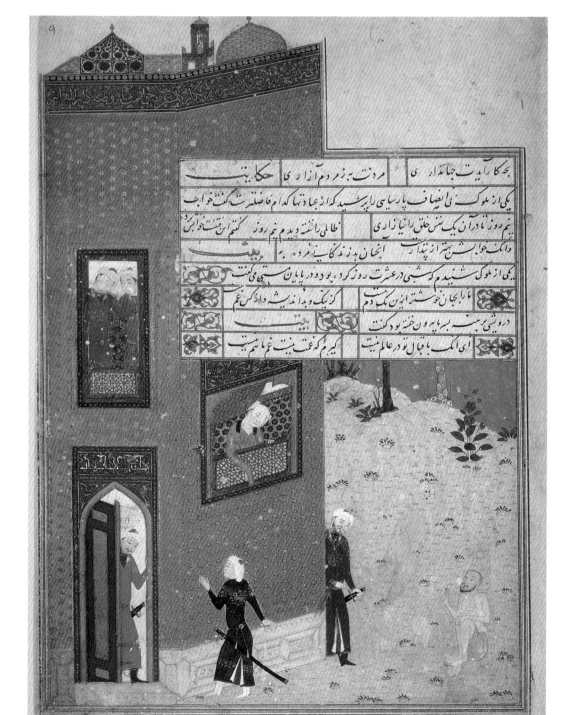

52

وصول النبى صلى الله عليه وسلم الى مقام القربة واشارة جبريل انه مقام القربة
وقال له اسجد فسجد صلى الله عليه وسلم وقال رايت الحق تعالى وجل جلاله بعين قلبى

حضرت محمد عليه السلام مقام قربه اولدى وجبرئيل عليه السلام دوى مقام قرب در ديوانه ابرادى و سجن ابرد رده حضر رسول صلى الله عليه ش
دغيجقه سجده ايدوب كردل كورى باسحى يعالى حضرتلرى كوره م ديد وكى جلد

54

Painting in a manuscript of Mir Haydar's
Mi'rajnama
Herat or Samarqand, between 1420–40
H: 16.6 cm; W: 19.4 cm
Paris, Bibliothèque nationale de France,
Suppl. turc 190, fol. 7r

Prayer, carried out at five appointed times of
the day, is the second of the Five Pillars of
Islam. Illustrated is a most significant moment
in the Prophet's Night Journey, when his
angelic guide, Gabriel, leads him to the
Mosque of the Aqsa, the "farthest place." This
is traditionally identified as the location from
which the Prophet departed on the *mi'raj*. In
the Aqsa he is ushered into the company of
the prophets who have preceded him, led by
Ibrahim (Abraham), Musa (Moses), and 'Isa
(Jesus). The Archangel utters the call for
prayer, and Abraham appoints the Prophet as
imam, to lead the prayer.

Muhammad is shown kneeling on a prayer
rug placed between two rows of kneeling men
who raise their hands, the Muslim gesture of
prayer. Both gesture and pose indicate that the
prayer is in progress: kneeling is one of the
positions between the acts of prostration
which mark the beginning and end of each
section of the prayer ritual. The Prophet's head
is surrounded by a flaming halo; he turns
towards the three figures kneeling to his right
who are dressed in long brown robes with
heads covered by full-length scarves, a form of
garment almost exclusively worn, in the
illustrations of this text, by the prophets of the
Old Testament. The three men kneeling to the
Prophet's left are dressed in traditional Eastern
garb, with white turbans covering their head;
they may be identified as prophets of Islam.

The interior of the mosque is decorated in
the contemporary Timurid manner: the floor
is of polished bluish-green stone, the walls in
the background are covered with green, blue,
and black tilework painted with abstract floral
motifs in gold, and golden lamps hang in
niches above the panel of text. As this is
a manuscript produced within the orbit
of Timurid culture – whether it was in
Shahrukh's capital of Herat, or the older
capital of Samarqand where his son Ulugh
Begh was governor – such details surely
convey the material reality of contemporary
Timurid buildings and furnishings. E.J.G.

companionship of his fellow prophets: in fact,
The Prophet is shown alone only twice within
this densely illustrated manuscript, although the
text accompanying this picture clearly mentions
angels who surround him. Awed by the
Prophet's closeness to the divinity, these angels
bear witness by reciting the *shahada*: "There is
no God but God (Allah), and Muhammad is
the Messenger of God."

Picturing such an event is a rare occurence
– perhaps unique: an "illustration" of the first
act of religious observance performed by the
practicing Muslim. The small figure of the
Prophet prostrate on an enormous golden
flaming cloud, surrounded by four large
undulating cloud-bands emanating from a

larger central cloud, effectively and beautifully
conveys the solitude of man in the face of
God. Rarely has Iranian painting achieved so
powerful a metaphysical effect by such simple
means; rarely has the word of Islam been
rendered in an image of such profound
significance, amounting to nothing less than
the investiture of the Prophet Muhammad by
the Almighty himself. A more dramatic image,
the Prophet traversing the heavens on the
steed called Buraq [64–67], has become the
Muslim religious scene par excellence; yet
this humbler rendition more directly
communicates the essence of the message of
Islam – submission, to the will of God – to
both believer and non-believer alike. E.J.G.

55

55. THE SIGHTING OF THE NEW MOON AFTER RAMADAN

Folio from a manuscript of the *Divan* of
Hafiz
Tabriz, 1525–29
H: 20 cm; W: 15 cm
The Art and History Trust (on deposit at
the Sackler Museum, Smithsonian
Institution, Washington, DC)

Another Pillar of Islam is the obligation to fast
during the month of Ramadan: when the
new, crescent moon of the month of Shawwal
has been seen, and verified, the fasting month
is officially concluded and the feast of the ʿId
al-Fitr may begin.

In a manuscript of the collected works of
the fourteenth-century poet Hafiz is an early
Safavid picture of just such a celebration at
the turn of Ramadan. It is also an image
eloquently testifying to the sophisticated taste
of literate Iranian society in what is surely
its most refined setting, the court of Shah
Tahmasp.

The court is assembled around a prince
who is handed a wine cup, as everyone awaits
word that the new moon has been sighted.
Men on a balcony watch the sky, pray, or
glance at their neighbors; the rest of the
company sits outside on the terrace of a
pavilion, where music is being played and
wine bottles handed around; courtiers at the
rear, outside the low balustrade, gather white
roses to be offered to the select company
gathered around the prince. Superbly written,
in white letters on the gold cartouches just
beneath the balcony, is a pair of couplets from
a panegyric of Hafiz written in praise of the
Muzaffarid Shah Shujaʿ in about 1376, a
particularly apposite quotation:

Friends, eagerly wait, for it is the time of
 ʿId and roses.
Saqi! Behold the refulgent moon in the
 king's resplendent face and bring wine!
He is fortunate, a noble ruler, Oh God,
 spare him from the evil eye.[1]

Wine, roses, the thinnest of sickle-moons, and
the resplendent full-moon face of the young
prince: everything in the poetry written
directly above the prince's head also has its
place within the picture. It is clearly to be
understood as an implied panegyric on the
prince who commissioned it.

Just who that was is uncertain, although the
quality of the entire manuscript from which
the picture comes should leave little doubt that
it was probably Tahmasp, the connoisseur-prince
who had succeeded his father, the charismatic
Ismaʿil, in 1524. The extreme fineness of the
white paper suggests that it may have come
from Herat, in the east, where the finest papers
of the period were still being made. The
superlative quality of the decorative passages,
the illumination decorating the architecture, and
the finesse of detail, all suggest the court
workshops of Safavid Tabriz; while the painting
itself is signed "the work of Sultan
Muhammad," whom Dust Muhammad lists first
among the painters of the Safavid royal library
[67, 78, 223]. For anyone other than Tahmasp to
have marshaled these resources would have
been difficult; yet there is also an inscription
above the doorway at the left margin that reads
al-hadi abu'l-muzaffar sam mirza, "the guide, the
victorious" (a phrase usually used to refer to
Shah Tahmasp alone) "Sam Mirza" – who was
Tahmasp's next younger brother. The question
remains unresolved.

As does that of its date, for the manuscript
has no colophon, and nowhere in it has a
date been discovered. A time of year – early
summer – might be deduced from the absence
of blossoming fruit trees and the presence of
rose bushes full of white blooms. Not only are
they called for in the panegyric poem above
the prince's head, but they may also suggest a
date, at least for this one painting in which the
flowers add to the ideal setting and also reflect
a specific internal, verbal reference. Tabriz lies
in a temperate zone of Iran, where roses do
not blossom until the summer, and in the years
between 1525 and 1529, Shawwal – and the ʿId
al-Fitr – fell in the summer months.

56

56. A PAINTED OSSUARY

Paint on gypsum
Khwarazm, Tok-Qala, seventh–eighth
century
H: 49 cm; L: 55 cm; W: 31 cm
St. Petersburg, State Hermitage Museum,
SA 15708

Ossuaries, containers for human bones cleaned
of their flesh by dogs or birds according to
Zoroastrian funeral rites, have been found at
many Sogdian and Khwarazmian sites. The
form of this example, a gypsum box with
four legs, was typical for Khwarazm in the
seventh–eighth centuries; it was discovered in
Tok-Qala, in northern Khwarazm (north-west
of Bukhara near the Aral Sea). Some of
the more interesting box-ossuaries bear
Khwarazmian inscriptions with Avestan terms,
but the subjects painted on others shows an
ecstatic mourning that was strictly prohibited
in Zoroastrian texts. This suggests that folk

traditions for mourning, as for so many other
aspects of life, were more adhered to than was
religious orthopraxia.

The paintings on the ossuaries of Tok-Qala
are similar but never identical. Here mourners
are grouped around the bed of the deceased,
who is clad in his usual clothing. The widow,
children, and other relatives weep, tearing their
clothing, scratching their faces, beating their
heads. The painter's repertoire of human forms
was so poor that, even though he drew the
dead man in a horizontal position, all of the
other details suggest that the deceased might
still stand up, alive. Like other Khwarazmian
ossuaries, this is truly an example of folk
art, with its simple black outlines, clumsy
proportions, and the simplest of palettes, black
and white. Yet the faces, in three-quarter view,
the posture of certain figures, and the balanced
composition also reveal some knowledge of
the work of professional painters. B.I.M.

57. GULSHAH ARRIVES AT WARQA'S TOMB

Folio from a manuscript of ʿAyyuqi's
Warqa u Gulshah
Anatolia, 1200–1250
H: 7 cm; W: 18 cm
Istanbul, Topkapı Saray Museum, H. 841,
fol. 65v

Unlike other images from the same rare
Seljuq manuscript [4, 140, 166], this picture
illustrates precisely the text in the midst of
which it is set: "When they arrived at Warqa's
tomb, . . . She fell to the ground from her
palanquin."[1]

The weeping heroine, tearing her hair and
rending her garments, lies in the center of the
strip-like composition. The brick tomb, like a
small ziggurat, weights the picture to the
right; and to the left it is balanced by a horse,
shown in a pose unusual for this date – from
the rear, its head turned to face into the

57

composition. Other attendants, and horses still yoked to the palanquin, fill the interstices; above Gulshah, at the center of the picture, the palanquin towers over her and breaks through the simple double-line margin into the wide space between the text-columns. Every figure faces right, creating an immediate, urgent, and effective composition: it translates ʿAyyuqi's text directly into visual imagery by the simplest of means that appears to rely on no prior model.

Nevertheless, the painter has kept to an ancient practice: the names of the primary characters and places, and even a digest of the action, are often inscribed directly onto the picture surfaces in the manuscript [2, 4, 13].

58. MOURNING OVER THE BIER OF ISKANDAR

> Folio from a dispersed manuscript known as the "Great Mongol *Shahnama*"
> Tabriz, ca. 1325–35
> H: 24.9 cm; W: 28 cm
> Washington, DC, Freer Gallery of Art, 38.3

The scene depicted here is the lamentation of the Greek elders over the bier of Iskandar – Alexander the Great. Firdausi actually sets the scene in open country and it is sometimes so depicted. But there are few, if any, images of mourning over the bier of Iskandar that are any earlier than the *Shahnama* manuscript from which comes this painting with its richly furnished interior. Indeed, it has been said to reflect with some accuracy the details of a princely funeral in Ilkhanid Iran. Drawing on

his own surroundings and practices to create a new picture, the artist has built up an image of great immediacy that might instead be considered a kind of "visual counterpoint" to Firdausi's text, one never intended to illustrate his precise words.

On a raised bier placed on a large textile (perhaps a rug of geometrical pattern) stands the coffin, its golden covering pushed back to allow the embrace of a gray-haired mourning woman, Iskandar's mother. Two pairs of large metal candlesticks stand at its head and foot, and over it hangs a large jeweled metal lamp; a pair of smaller lamps hang in the niches at the sides of the composition.

At the front – and mostly shown from the rear – wailing women in shades of blue, with transparent veils falling from their heads, tear their hair and pull at their clothes. At the head and foot of the coffin, crowds of bareheaded men tear open their clothing or cross their hands over their breast; many are also dressed in blue, the ancient color of mourning in Iran, as the rending of clothing is an ancient mourning gesture. Facial expressions, and hands, are expressively contorted, as was the case with the Arabic *Jamiʿ al-Tavarikh* but less striking in effect here, no doubt because of the more naturalistic palette, as well as the appropriateness of gesture to subject. The picture remains unique in the repertoire of illustrated Iranian manuscripts for its realistic setting and its emotional immediacy.

59. MOURNING OVER THE CATAFALQUE OF MUHAMMAD–SULTAN IBN JAHANGIR, TIMUR'S GRANDSON AND HEIR–APPARENT

> Double-page painting from a now-dispersed manuscript of Sharaf al-Din ʿAli Yazdi's *Zafarnama*
> Shiraz, ca. 1434–36
> Right half: H: 14.9 cm; W: 11.1 cm
> Left half: H: 15 cm; W: 11.5 cm
> Genoa, The Bruschettini Collection

Among the unusual images needed for Ibrahim-Sultan's program of illustration in the *Zafarnama*, a panegyric history of the exploits of his grandfather Timur, was one that would focus on the death of Timur's heir-apparent, Muhammad-Sultan ibn Jahangir.

The occasion was not only one of personal grief but also marked the collapse of the cornerstone of policies long pursued by Timur. He had adhered to the Yasa, the code of Chinghiz Khan, and to Chingizid policies in the administration of his empire; he himself never ruled as anything but *amir* nor styled himself other than *kuragan*, "son-in-law [of the khan]" – that is, a Turco-Mongol khan of direct Chinghizid descent. Instead he married Chinghizid princesses whose children would have Chinghizid blood, and he sought Chinghizid marriage-alliances for his sons as well. Jahangir, Timur's eldest son born of a free-born Chinghizid mother, had been designated as Timur's heir-apparent. He was married to Sevin Beg Khanzada (meaning "born of a khan"), daughter of a descendent of Chinghiz Khan in the Juchid line; that event was also illustrated in Ibrahim-Sultan's *Zafarnama*, by a single-page image of Timur

59

sitting in front of a tent receiving guests. Jahangir unfortunately predeceased his father; his son, Muhammad-Sultan, also being the son of a free-born princess with Chinghizid blood, was then made the new heir-apparent. Had he lived longer, he would no doubt have been the focus of the struggle for position that followed Timur's own death in 1405.

Muhammad-Sultan had been injured during the Anatolian campaign, in March of 1403, and succumbed to his wounds shortly thereafter: he was not yet twenty years of age. Timur's grief was excessive, according to Sharaf al-Din, and his entire following donned clothing of black and blue, threw earth upon their heads and stones inside their clothing, wept, and slept on beds of straw and ash; the young widow of Muhammad-Sultan fainted and eventually lost her reason from grief. From this text, and from the simplest of stock elements of the Shiraz painter's repertoire, an original double-page painting was constructed for the *Zafarnama* that conveys the grief of Timur, his family, and their followers simply but most effectively.

The right side of the painting shows the coffin, laid on a carpet spread upon the ground – not a flowering meadow – and watered only by a stream at the edge of

which not even a blade of grass can be seen. The coffin is covered with cloths of black and blue, and at its head, a bearded figure in blue wearing a fur cap kneels on a smaller carpet, holding a huge white cloth to his face: this is presumably Timur. Three women in black garments open at the neck bend over the coffin and tear at their loosened hair. On the left-hand side of the painting, two men in black garments and bare heads move toward the coffin and a third tears open his garment; a small "crowd" of men – six – at the left margin also weep into large white cloths. Each half of the painting has the same background, the high, rounded, Shiraz-style mound, and in each half a single tree marks the background. A disparaging comparison could be made with the most elaborate of mourning scenes known in Iranian painting of this period, the "Mourning Over the Bier of Iskandar," from the "Great Mongol *Shahnama*." But, Ibrahim-Sultan's painters have truly illustrated their subject – a princely death on campaign in the early spring in Anatolia. Within the possibilities of the Shiraz repertoire, this double-page image has as much "verism" as it has of Shiraz mannerism and simplified convention.

60. THE SON WHO MOURNED HIS FATHER

Painting in a manuscript of Farid al-Din ʿAttar's *Mantiq al-Tayr* (*Language of the Birds*)
Herat, 1487
H: 23.5 cm; W: 13.7 cm
New York, Metropolitan Museum of Art, 63.210.35

One of the Timurid paintings in a celebrated copy of Farid al-Din ʿAttar's *Mantiq al-Tayr*, the *Language of the Birds*, "The Son Who Mourned His Father" is an apposite pictorial comment on ʿAttar's short but pithy text. The setting is a burial milieu, and the picture well describes the funerary practices of Khurasan and Transoxiana in the fifteenth century. Even the tombs of the most significant personages, princes and sufis alike, were by preference no more than a place on an open platform surrounded by some kind of enclosure, usually a lattice-work fence. The construction was known as a *hazirah*.

A funeral procession arrives at the gate of a cemetery; inside workmen are preparing the grave of the man whose coffin is preceded by his weeping son. The son bewails his fate: "O my father, nothing like this soul-wounding day

has ever occurred in my life." A white-bearded sufi standing at the portal of the cemetery is moved to reply, "Nor to your father, and his fate is a good deal more difficult than yours!"[1] The weeping bareheaded son, clothes torn from his upper body, is placed in the vertical center of the picture, on the direct axis supplied by one corner of the platform where his father's grave is being dug – the large stone being handed to a workman standing inside it – and the base of the gnarled tree to which pious visitors have attached funerary banners and in which birds flutter and nest. The secondary axis of the picture is the horizontal line of the cemetery wall, effectively dividing the two parts of the picture. Outside the portal, where the funeral procession approaches and the sufi rebukes the weeping son, is where 'Attar's verse is actually illustrated, whereas inside the cemetery, with its two platforms and the preparation of a fresh grave, is the space for the painter's comment on the story: that death comes to us all.

As always in the finest of these paintings, the inscriptions in Arabic and Persian elaborate on the picture's underlying theme and the text it illustrates or comments upon. The inscription over the portal of the cemetery itself calls the tomb the portal through which all human beings must pass; written on the banner carried by a weeping older man at the left are Qur'anic verses proclaiming that God is sufficient, the perfect protector and bringer of victory, and that those slain in the cause of the Lord are not dead but living in Paradise. On the small banners placed on the tree, and also one planted at the head of the tomb enclosed within the simple open railing, are the words of the simple invocation, *ya allah*, pronounced during funeral prayers. Several sly pictorial comments also occur in this part of the picture: the nest in the tree contains eggs but a snake winds its way up the tree trunk, while the cat curled up on the railed platform seems dangerously close to the open cage and the birds fluttering in the lower branches of the tree. The painting is not signed but is probably by Amir Ruh Allah Mirak *naqqash*, "Mirak the painter," by compositional and stylistic analogy with a signed painting in the same manuscript.[2]

Mirak is one of the two or three late Timurid artists discussed by contemporary writers, including the historian Khwandamir and Mirza Haydar, a sixteenth-century Timurid writing in India, as well as the Safavid librarian Dust Muhammad.[3] In language that is never precise enough to allow modern eyes to distinguish the stylistic differences between these painters, we are nonetheless told that Mirak was a master calligrapher and illuminator, as well as a painter; that he was attached to Sultan-Husayn's court and worked wherever his prince went – both in his dwellings and in the open air – and that he became the administrator of Sultan-Husayn's library. He was also Bihzad's teacher but his compositions

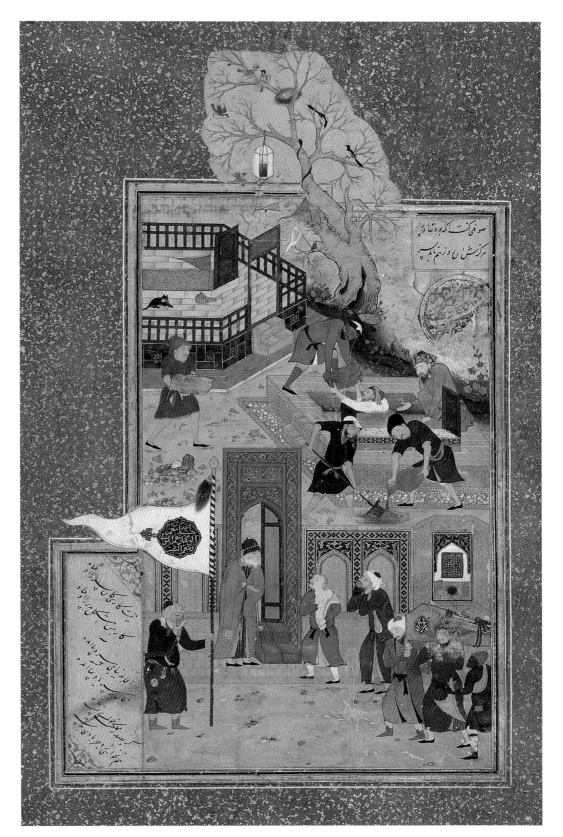

60

were always more accomplished than Bihzad's although his output was smaller. Lastly, this fine painter also practiced wrestling and other violent sports – a most singular combination of talents, opines Mirza Haydar.

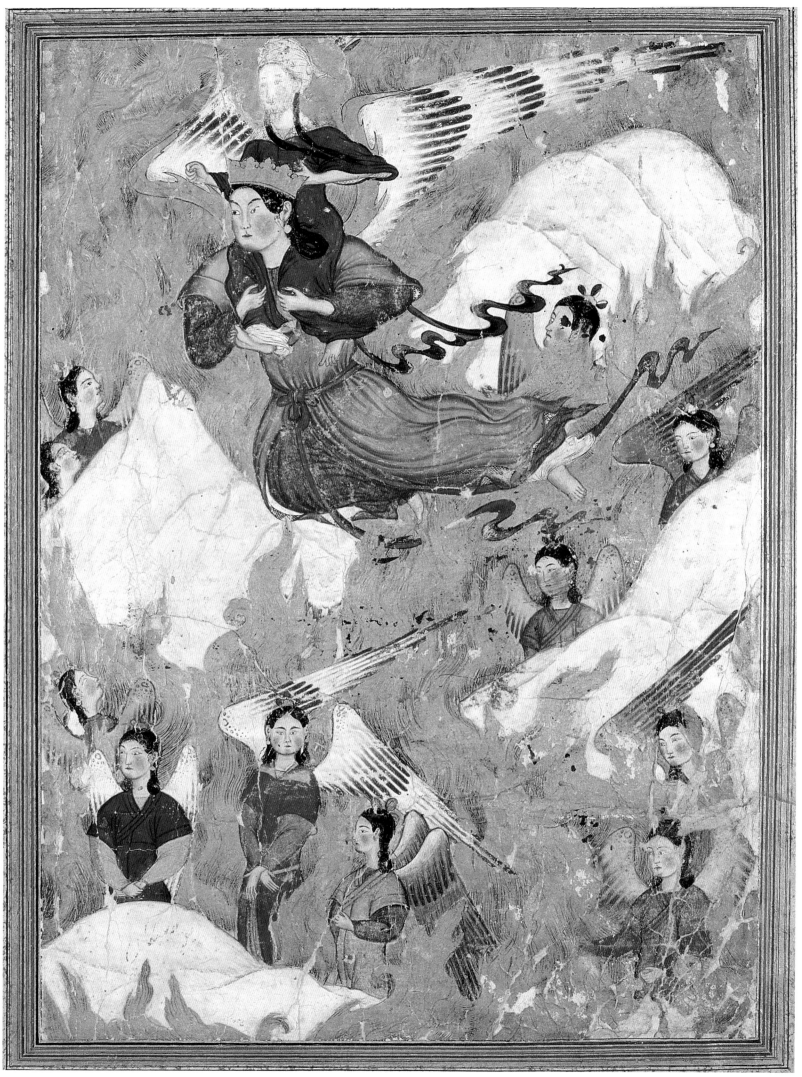

61. THE PROPHET MUHAMMAD CARRIED ON GABRIEL'S SHOULDERS

> Painting from a dispersed or never completed manuscript, perhaps a *Life of the Prophet* or a *Mi'rajnama*, mounted in the Bahram Mirza Album
> Tabriz or Baghdad, about 1325–50
> H: 34.5 cm; W: 24.2 cm
> Istanbul, Topkapı Saray Museum, H. 2154, fol. 42v

The Night Journey of the Prophet Muhammad through the Seven Heavens, Paradise, and Hell – his *mi'raj* – is a subject not often represented in the earliest periods from which Iranian manuscript painting survives. This extraordinary vision is one of eight contemporary pictures mounted in the same album. Their themes are the marvels of the *mi'raj*: the Prophet Muhammad travelling above the land and the waters on the shoulders of the angel Jibra'il – (Gabriel); or in the Aqsa (the farthest place of his journey) in Jerusalem; or in heaven surrounded by angelic beings. Several of the paintings are labeled, in beautifully calligraphed letters on an illuminated ground in the best sixteenth-century style; others, including this, are not, although it, and the following two paintings, are three of the finest in the entire cycle. They are so similar in shape and size that they must be from the same manuscript, now lost and known only through the illustrations mounted in this album.

Later images of the Prophet Muhammad guided by the archangel Gabriel as he traverses the skies generally show him riding a curious and composite steed, Buraq [64–67]; here he travels instead on the shoulders of an enormous crowned angel. The concept is unique to this cycle of paintings; it occurs in three other pictures but this is the most dramatic.

The Prophet seems almost dwarfed by the huge figure of Gabriel, who flies in an upright position under his precious burden; only the angel's sash of red and green, and strands of long black hair, ripple out behind him to suggest air-borne speed. The sky and land around them are filled with golden flames, through which cone-shaped mountains with snow-covered tops emerge; smaller angels appear to stand behind the mountain tops rather than flying above them, respectfully watching the Prophet and Gabriel. It is an image entirely without parallel. E.J.G.

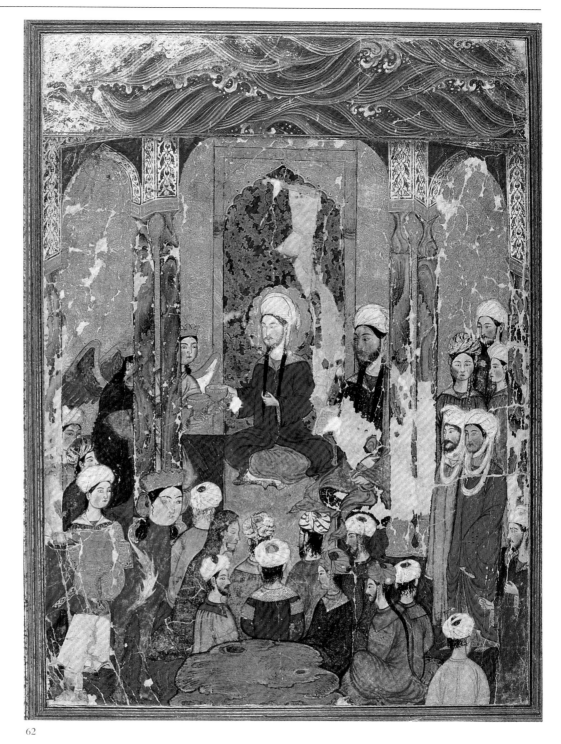

62

62. THE PRESENTATION OF CUPS TO THE PROPHET MUHAMMAD

> Painting from a dispersed or never completed manuscript, perhaps a *Life of the Prophet* or a *Mi'rajnama*, mounted in the Bahram Mirza Album
> Tabriz or Baghdad, about 1325–50
> H: 30.2 cm; W: 24.1 cm
> Istanbul, Topkapı Saray Museum, H. 2154, fol. 62r

The Prophet Muhammad is shown seated on the ground in the center of a round or polygonal building, in another original and apparently unique picture surviving from this fourteenth-century fragmentary manuscript of surpassing interest [61, 63].

During his Night Journey, the Prophet Muhammad encountered a group of angels who offered him three cups filled with liquid. The scene takes place in a setting with certain specific architectural features: tall slender pairs of green marble columns carry ornamented arches that probably support a dome – although it is not visible. The building seems not to be a mosque although a large *mihrab* lined with the same green marble appears behind the Prophet's head, pictorially framing him. A figure is seated on the ground next to him – surprisingly, as large as the Prophet himself; a number of smaller men, dressed in long robes and wearing turbans, stand to his right and left; still others are seated in a circle in front of him, "turning their backs" to the beholder. This is an extremely unusual feature in Iranian painting of so early a date, but

the same grouping of figures is seen in other pictures from the same dispersed manuscript and mounted in the same album.

A pair of crowned angels approach the Prophet from the left, and while they are partially hidden by the pair of columns, the three large golden bowls which they offer him are quite visible. They contain, respectively, milk, wine, and honey, and the Prophet chooses to drink only from the bowl of milk. Gabriel is curiously absent from the scene – unless the tall figure seated next to the Prophet is to be identified as the Archangel. This seems highly unlikely, even though Gabriel is often shown in considerable size – even larger than the Prophet himself, in paintings in which he carries the Prophet on his shoulders – and he always wears a crown, never a turban. Even stranger is the steed, Buraq, standing in the left foreground. The creature's body is bright red, the face a pale white moon under a large gold crown, and the long black hair is arranged in braids looped just below its very large green ears. This image of Muhammad's steed, like so many other aspects of this cycle, is without parallel in any of the surviving paintings, from any period, that depict phases of the *mi'raj*.

As is the setting of the event. The architectural interior might be identified as the Dome of the Rock, the octagonal Muslim sanctuary on the platform in the Haram al-Sharif in Jerusalem, which is the original site of the Solomonic Temple. The large mass of dark rock in the foreground of the picture might allude to this significant and sacred location; both it, and the Aqsa Mosque [54], have been identified as the place from which the Prophet departed for his Night Journey. Indeed, this painting well conveys the sense of the extraordinary event; the presence of Buraq, so prominent in the foreground, and the angels make clear that the event is a visionary one. E.J.G.

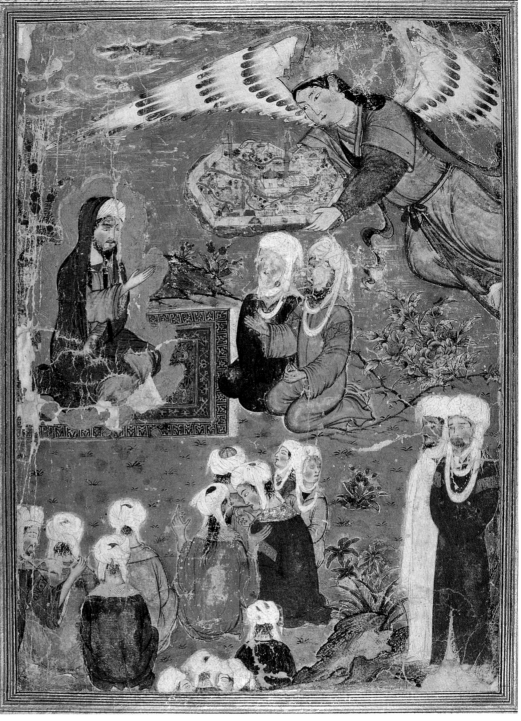

63

63. THE PRESENTATION OF A CITY TO THE PROPHET MUHAMMAD

> Painting from a dispersed or never completed manuscript, perhaps a *Life of the Prophet* or a *Mi'rajnama*, mounted in the
> Bahram Mirza Album
> Tabriz or Baghdad, about 1325–50
> H: 35.6 cm; W: 25.2 cm
> Istanbul, Topkapı Saray Museum, H. 2154, fol. 107r

A third painting from this *mi'raj* cycle mounted in the Bahram Mirza album shows the Prophet Muhammad kneeling on a small rug as a winged, crowned angel offers him a model of an Islamic city.

The actual subject of this picture still defies identification. One suggestion is that it was inspired by a *hadith* (a traditional saying ascribed to the Prophet) in which the conquest of Constantinople by a great Islamic ruler was foretold by the Prophet. Three minarets are shown– but why minarets should appear in a city whose submission to Islam still lay a century in the future is unclear; nor does the river that winds through the city inside its walls accord with the geography of Constantinople. Jerusalem is another possibility but again the topography is mismatched. That the principal figure is the Prophet Muhammad, however, is evident from the flaming golden cloud surrounding his entire body; that his companions are intended as Arabs seems clear from the white turbans with falling loops at the neck [Fig. 56].

Most of the kneeling figures arranged in a loose curve at the front of the picture are shown from the back; one is in profile and another turns his head only. The kneeling pair next to the Prophet, and a standing pair at the right margin, seem to be pictorial elements from a somewhat different source: they add quantity to the scene but each pair represents a stock figural group, and the number of figures could be easily increased or decreased merely by changing the details of dress and headgear. All the faces are shaded with red, and some of the hands are expressive, in the manner of the Arabic *Jami' al-Tavarikh* [6, 213]; gold Chinese-style clouds float in the upper left. The horizon is high but dips down, near the right margin, and on it grow the plants and shrubs that will be found in the landscapes of illustrations to Persian texts for

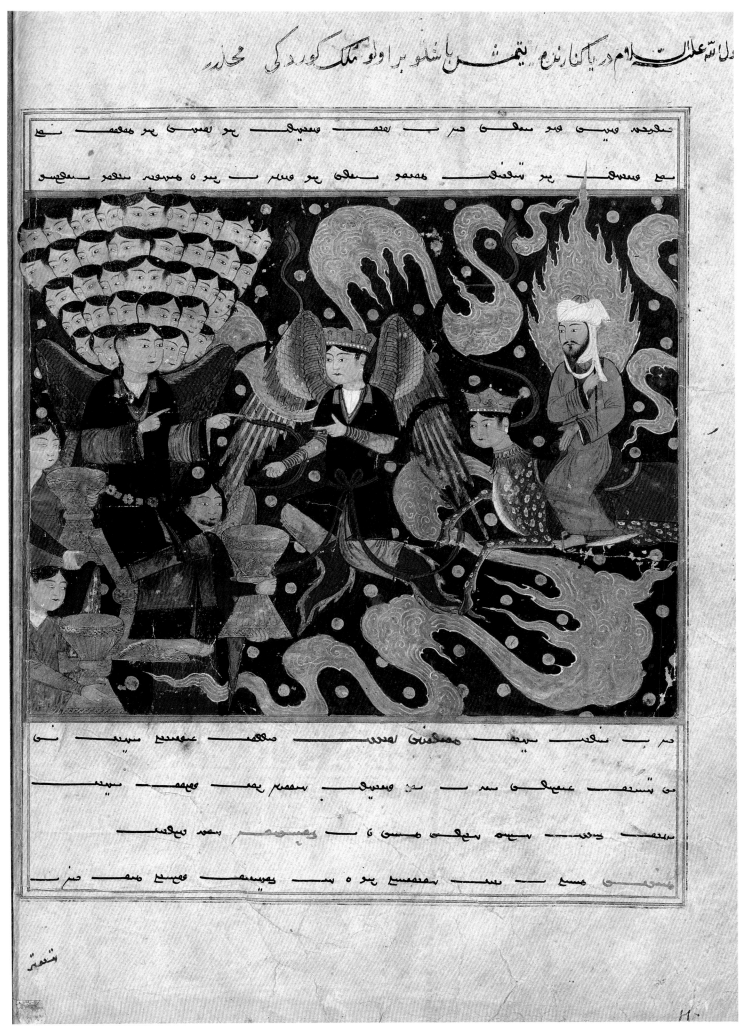

the next several centuries. One leaf in the foliage of the purple and orange day-lilies in the right foreground is bent, as if trodden upon; it recurs as a standard landscape element throughout the century and becomes one of those "diagnostic" features that helps to trace the Jalayirid content in painting from later in the century and well into the next [78, 156].

64. THE PROPHET MUHAMMAD MOUNTED ON BURAQ SEES THE ANGEL WITH SEVENTY HEADS

> Painting in a manuscript of Mir Haydar's *Mi'rajnama*
> Herat or Samarqand, between 1420–40
> H: 13.6 cm (14.5 maximum); W: 18 cm
> Paris, Bibliothèque nationale de France, Suppl. turc 190, fol. 19v

During his Night Journey the Prophet Muhammad has a series of extraordinary visions, none more striking than that of the angel with seventy heads. According to the text, each head has seventy tongues with which to utter seventy forms of praise. This apparition is seated on a golden throne at the left of the picture, surrounded by more conventionally headed angels carrying golden stools. The angel Gabriel, flying ahead of Muhammad, points out the entire angelic group to the Prophet, mounted on Buraq.

The moment marks a pause in the Prophet's progress during the night, between his visions of the Seven Heavens and Paradise [83] and before his descent into Hell [65]. The many-headed angel has been linked to Buddhist images of a similar kind; indeed, much of the iconography in this manuscript derives from East Asian, Buddhist art. Buddhism had enormous importance for the development of medieval Central Asian art which in turn, was one of the principal sources of inspiration for artists at the Timurid courts, so well exemplified by every feature of this volume. E.J.G.

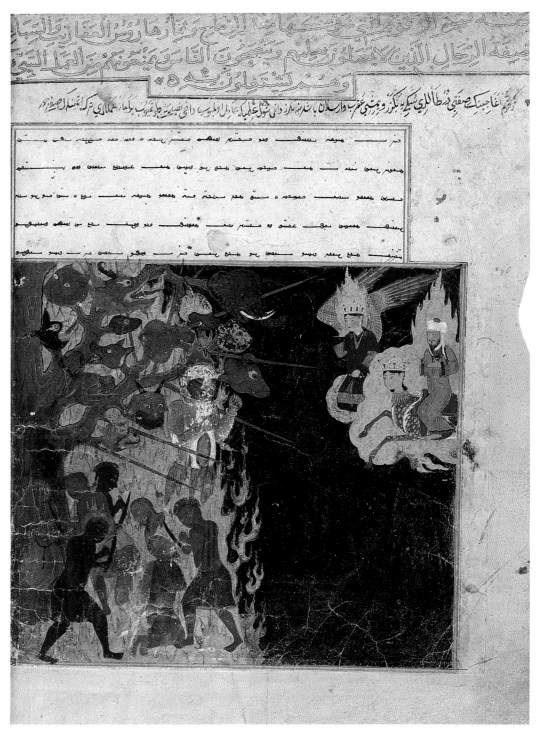

65

65. THE PROPHET MUHAMMAD ON BURAQ SEES THE INFERNAL TREE

> Painting in a manuscript of Mir Haydar's *Mi'rajnama*
> Herat or Samarqand, between 1420–40
> H: 19.2 cm; W: 20.7 cm
> Paris, Bibliothèque nationale de France, Suppl. turc 190, fol. 53v

On his Night Journey, the Prophet Muhammad is granted visions of both Paradise and the various heavens, and given horrifying evidence of the tortures of Hell. Here he is shown the punishment meted out to those who have been untrue to the faith, drinking wine and committing fornication. Under the supervision of a fearsome blue-bodied *div*, their tongues are cut out of their mouths by red devils standing in flames below a giant tree "That springs out / of the bottom of Hell-fire" (Qur'an, XXXVII, 64–65). "Its thorns like spears, and the ends of its branches turning into monsters' and monstrous animals' heads." Indeed, the branches of this tree do terminate in the heads of wolves, lions, hyenas, and a camel, as well as dragons. This feature is curiously reminiscent of the "talking tree" that Iskandar – Alexander the Great – finds at the end of the world, when the various heads warn that he should go no further in his travels.

Unlike the golden skies under which the angels bear witness that Muhammad is the Prophet of God [53], or the celestial blue sky of the Garden of Kauthar [83], the scene of this most horrendous punishment takes place against the lurid red-edged flames of Hell and the blackness of the void through which Muhammad and his angelic guide and steed are traveling. The entire scene derives from Central Asian and Chinese renderings of the torments of Hell, for in the Muslim pictorial tradition, depictions of Hell are rare. Yet in this manuscript no fewer than sixteen paintings are dedicated to terrible but picturesque images of Hell; they constitute a unique series, in stark contrast to the manuscript's five pictures of Paradise. E.J.G.

66. THE *MI⁣ʿRAJ* OF THE PROPHET MUHAMMAD

Painting from a manuscript of the *Khamsa* of Nizami
Tabriz, 1505
H: 28 cm; W: 19 cm
London (Ham), The Keir Collection, III. 207

Of the recorded paintings illustrating the Prophet's ascent to Heaven, this is among the most unusual conceptions of the scene as well as one of the most spectacular. The Prophet rides the Buraq in the center of a mass of flaming, golden, wildly undulating clouds that fill the entire night sky. A multitude of angels flies freely through the billows, or clusters along the edges; still others ride the crests of the clouds as if they were huge waves in the sky. A circular opening at the upper left of the picture, like a gateway to Heaven in the dense cloud formation, is encircled by angels peering down through the precariously tipped oculus to gaze upon the Prophet and his galloping steed. Underneath the night sky can be seen the Great Mosque in Mecca, the Ka⁣ʿba in the courtyard to the right and, next to it, a smaller domed building; this is perhaps a vision of the Prophet's tomb. A sandy, hilly, desert landscape is painted in the margins of the page, above the architectural complex and around the rectangle of the written surface that defines the space of the heavens; it suggests oases, with tall palm trees, tamarisks, and small structures with tiled domes.

This painting is unique: immense and original in conception but tiny in scale, unbelievably crisp and jewel-like in its details. It was originally the first picture of the first poem, the *Makhzan al-asrar*, the *Treasury of Mysteries*, of a much-traveled copy of Nizami's *Khamsa*. Its long and complex history extends for over half a century, from before 1457 to 1505. Started for a Timurid prince and worked on, successively, by four Turkman princes, it then came into the possession of Shah Isma⁣ʿil I at whose command another nine paintings were added. Several have been attributed to his greatest court painter, Sultan-Muhammad, including this vision, dated in 1505 (written in minute gold letters on the portal of the small building on a terrace, behind the mound of rock in the left foreground).

Illustrated copies of Nizami's *Khamsa* often open with this image: it underscores the profoundly religious significance of the celebrated poet's verses. This, however, is an exceptional picture that ties together the earth and the heavens, and then punctuates the celestial regions with an oculus that must derive from a contemporary European painting. E.J.G.

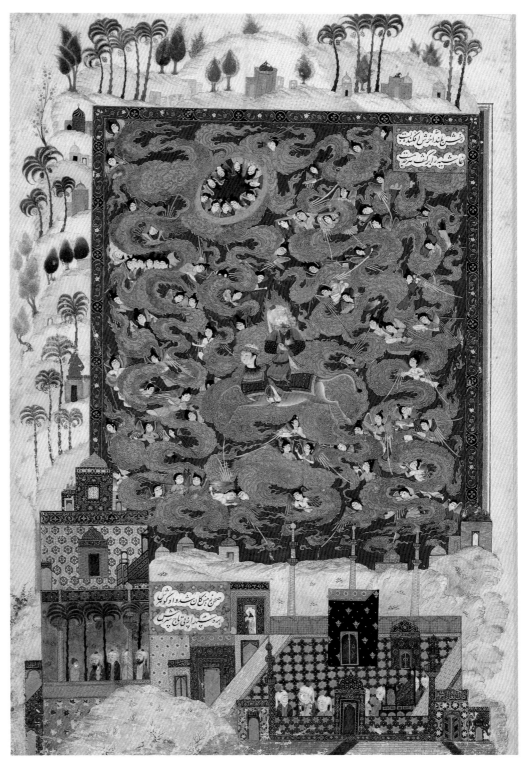

66

67. THE *MI⁣ʿRAJ* OF THE PROPHET MUHAMMAD

Painting in Shah Tahmasp's manuscript of Nizami's *Khamsa*
Tabriz, 1539–43
H: 30 cm; W: 18 cm
London, The British Library, Or. 2265, fol. 195r

The Prophet Muhammad riding through the night sky on the Buraq is the most frequently encountered, and also the most immediately recognizable, of religious images in Muslim religious culture. It has a special place in Iranian manuscript illustration. Other than in a narrative context – illustrating the Prophet's Night Journey in a text called the *Mi⁣ʿrajnama* – from the fifteenth century onward, this image is often found as a non-narrative picture placed near the front of Nizami's *Khamsa*. Almost icon-like, it symbolizes the supernatural quality of Muhammad's position as the human link between the absolute infinity of God's universe and the finite, physical reality of the natural world of men. In such a poetic context, the surreal vision of the Prophet is often rendered in the most astonishingly "real" fashion.

Shah Tahmasp's magisterial manuscript of Nizami's great poems opens with this particularly splendid painting. The Prophet

is shown astride the Buraq in the center of the dark-blue night sky, his body enveloped by a huge flaming aureole matched only by the somewhat smaller but still magnificent flaming halo of the archangel Gabriel who leads him on his way. Angels surrounding the Prophet offer him gifts, including a large golden dish filled with golden fire. Another angel, just below Gabriel, carries a lamp that swings from a long red pole; from the lamp blazes the huge flame lighting the Prophet's way through the dark sky, for the veiled moon, hardly visible behind white clouds, provides only ghostly white light.

The size of this painting and its rich detail make it an especially impressive religious painting, one which embodies all natural and supernatural elements. The night sky with its multitude of stars and the clouds partly obscuring the golden moon; the large golden dishes, the huge censer, and the large decorated portfolio carried by the angels; the lithe and agile body of Buraq, like a thoroughbred horse; the Prophet's costume – a green cloak over a brown undergarment – and the rich embroidery or brocade of the saddlecloth: all these things occur in the real world. Their transposition to the celestial regions, where angels dwell and spiritual forces manifest themselves in vast bursts of flaming energy, evokes the metaphysical reality of the event in a manner rarely paralleled. This painting is not only a masterpiece of the Safavid period: it is an enduring masterpiece of Muslim religious painting of any period.

E.J.G.

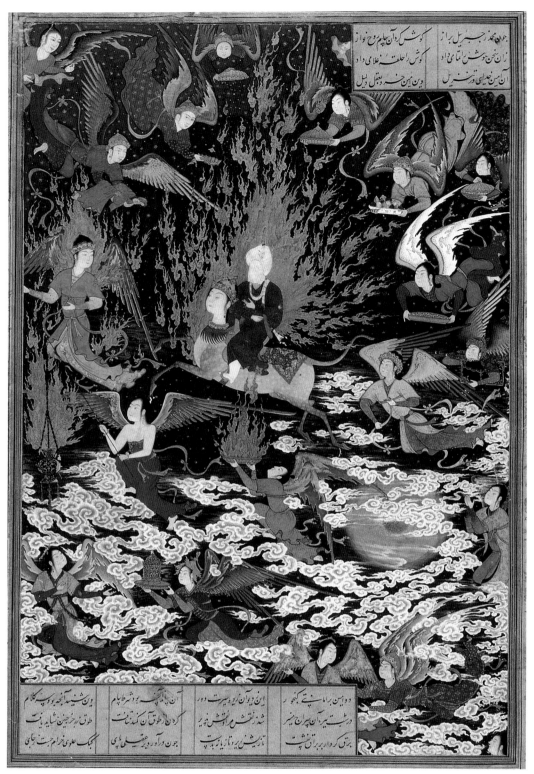

67

SETTINGS

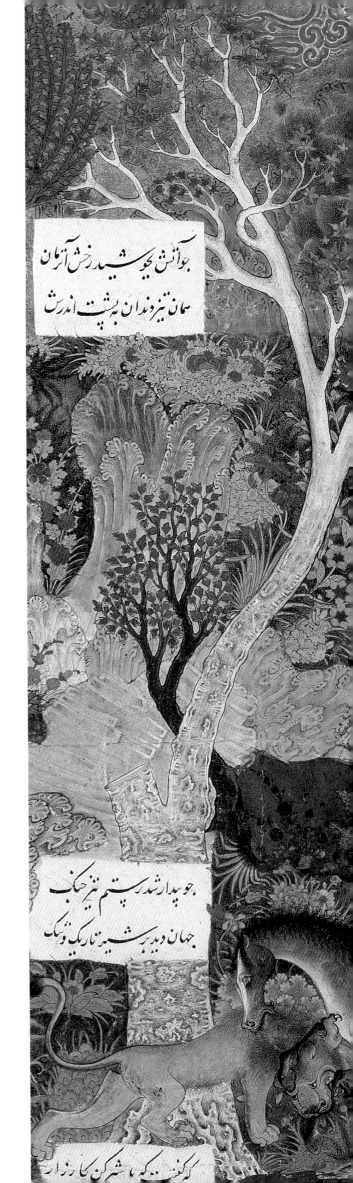

68. DRAGON IN A LAKE

Mural painting from Temple 19
Bezeklik (Chinese Turkestan),
eighth–ninth century
H: 66 cm; W: 56 cm
Berlin, Staatliche Museen, Museum für
Indische Kunst, III, 8383

Bezeklik, in the Turfan oasis on the northern
Silk Route, is a Buddhist monastic complex
set high above the Sengim River and, as
always in Buddhist Central Asia, very well
hidden. At a bend in the river, a large terrace
had been hewn out of the soft local stone,
and a number of the several hundred temples
at the site were within caves cut into the wall
behind the terrace.[1] As elsewhere in Buddhist
Central Asia, the caves had been decorated
with mural paintings: indeed, the word

bezeklik, in eastern Turkish, means "place
where there are paintings and ornaments." A
great number of the Bezeklik caves still had
intact mural paintings when the second
German "Turfan Expedition," led by Albert
von Le Coq, arrived there in the late summer
of 1905.

At Bezeklik, it is Chinese and Iranian
elements that predominate in the paintings,
whereas Indian influences are rarer. This
fragment of painting from Temple 19 is
exemplary: a Chinese-derived dragon emerges
from a lake surrounded by Iranian-like
mountains of a distinctive sugar-cone shape.

Temple 19 is a long narrow barrel-vaulted
cave cut into the soft stone of the terrace[2] and
in it, unusually, the cult image on its pedestal
was set towards the middle of the temple.
Painted on the pedestal was a landscape, of

which this dragon emerging from the lake is
a fragment: it appears to be an illustration of
some legend that has not yet been identified.
The Iranian landscape element is quite strong
in a number of paintings found at Bezeklik
and here the scrollwork on the surface of the
water is also Iranian in derivation. As for the
stylized mountains, they have always been said
to be Sasanian Persian in origin, despite the
fact that virtually no Sasanian mural painting
actually survives in Iran itself (with the
possible exception of the remains at Kuh-i
Khwaja, in Sistan; Fig. 24).

The same treatment of mountains, of sugar-
loaf shape with contours indicated by different
colors, is frequent in the landscapes of a series
of illustrated manuscripts of the Islamic
period, from fourteenth-century Tabriz [61],
Shiraz [70], and also Isfahan [39]. These are
executed in the same techniques as seen here,
behind the dragon: stripes of color describe
the contour, the color applied as if with a full
brush, increasing in intensity through the
stripe and deepest at the edge next to a
contrasting color. As for the Iranian source of
the landscape, it almost surely did not come
directly from Iran but from another Central
Asian site, perhaps by way of Kucha, another
major site in the Tarim Basin further west but
also on the Northern Silk Route.[3] Its
startlingly similar occurrence in Iranian
manuscript painting, at least half a millennium
later, has been well described as a "backwash
into Iran of a current that started out in that
country."[4]

69. THE MOUNTAINS OF INDIA

Folio from the Arabic manuscript of
Rashid al-Din's *Jami' al-Tavarikh*
(*Compendium of Chronicles*)
Tabriz, 1314
H: 12 cm; W: 14 cm
London, Nasser David Khalili Collection,
MSS727, fol. 261r

Even more than the Chinese-style mountains
seen in *The Annunciation* do these "mountains
of India" derive from Chinese landscape-
models. Here, the contours are colored with
greater variety, the surface more elaborately
drawn, more richly shaded on the interior;
and the profile against the sky suggests a
forest. On the other hand, the modulation of
color, shading to white, recalls the tenth-
century painted mountains in one of the caves
at the site of Bezeklik, in Chinese Turkestan,
for which an Iranian origin – albeit
unidentified – has always been suggested. Like
the Bezeklik wall painting, there is water at
the foot of the mountains; here, too, is seen a
Chinese convention for water, the scale-
patterned waves that foam in bubbles, shown
as white dots against a blue ground. But
instead of a dragon, a pair of fish cavort and a
pair of ducks paddle in the waves.

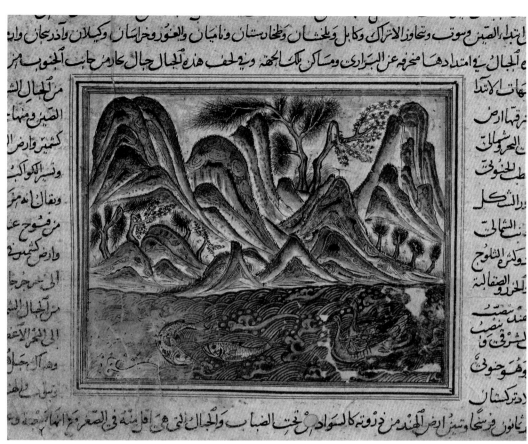

them and they yielded up sweet life." Thus perished Giv and Bizhan, Tus, Fariburz, and Gustahham.

This illustration in the earliest of the recorded Inju *Shahnama* manuscripts depicts only four of the celebrated heroes – Tus, Fariburz, Giv, and Bizhan (named in the title above the picture) – in the midst of the blizzard. Whitened beards and brows suggest the snow that sent them to sleep forever, but the predominant feature in this picture is the mountains. They rise in steep cones of shaded reds, blues, and yellows; strings of white dots articulate some surfaces, and peculiar large painted fringes sweep against the horizon – as if to copy the bristling pine foliage of certain pictures in the "Great Mongol *Shahnama*." But their shape is far older and can be found in landscapes engraved on Sasanian silver dishes,[1] as well as in Central Asian wall paintings [68] that are themselves derived from pre-Islamic Iranian models.

69

70. THE PALADINS OF KAY KHUSRAU
DEAD IN THE MOUNTAINS

> Folio from a manuscript of Firdausi's
> *Shahnama*
> Shiraz, 1331
> H: 11 cm; W: 22.5 cm
> Istanbul, Topkapı Saray Museum, H. 1479,
> fol. 126r

Kay Khusrau's reign was long and just, and he was wise enough to know when to withdraw from the world with his good name intact. "I have avenged my sire, / And have adorned the world with goodliness, / . . . now I deem it better to depart / . . . while I still am flourishing. . . ." He closed his court, convened the Iranian forces for the last time and addressed them, and he gave patents to Rustam, Giv, and Tus; he ordained that Luhrasp should succeed him as shah and said farewell to his women, commending them to Luhrasp's care. He then set forth for the mountains, in the company of Zal and Rustam and Gudarz, Giv and Bizhan, Tus, Fariburz, and Gustahham. At the mountain-top the first three acceded to his wishes and turned back but the other five would not. That night Kay Khusrau bathed in a spring and prayed, and warned the paladins ". . . be not / Here on the morrow . . .": for snow would fall and obscure the track to Iran. The next morning he had indeed disappeared, and while they lingered near the spring the promised snowstorm arose and buried them. "They tarried in the snow, . . . / And under it they struggled for a while, / And made a hollow space, but at the last / Strength failed

71. RUSTAM DISCOVERS HE HAS SLAIN HIS SON SUHRAB

Painting in a manuscript of Firdausi's
Shahnama
Shiraz, 1371
H: 11.8 cm; W: 10.9 (13) cm
Istanbul, Topkapı Saray Museum, H. 1511,
fol. 45v

In a small square picture in a manuscript completed in 1371 in Shiraz, some of the landscape mannerisms of Iranian manuscript painting for at least the next century are already marshaled with verve and a sense of decorative coloring that sometimes belies the subject of the picture.

The painting is inserted into the middle of the page with the text, in six columns of poetry, above and below it. The horizon is exceptionally high: the landscape rises nearly to the top of the picture as a pair of dun-colored mounds. The shape of the right mounded hill suggests the froth of an overfilled soufflé spilling over the side of its container; it falls down the right side of the composition, to break through the ruling at the lower left of the picture and settle, in the shape of a large boulder, at the lower right of the picture. At the edges grows a pair of trees, a deciduous tree in leaf and a tall, pointed cypress tree, painted onto the bare paper of the margin. The ground inside the picture-space is marked with regular clumps of purple-tipped green foliage, and small reddish stumps with smaller bare branches growing from the base of the tree trunks; both are so regular in form that they might have been stenciled. Golden lines of articulation at the edges of the mounded landscape suggest the glinting of sun on the dun-colored desert, but the overall effect is rather more of frivolity than it is of stark, unbearable tragedy.

For the subject is a crucial event in the life of the hero Rustam: he has just discovered that the rash young opponent who challenged him to a duel is none other than his son Suhrab, fruit of his union with Tahmina, daughter of the king of Samangan [108].

72. ISFANDIYAR'S FIRST *KHWAN*: HE SLAYS THE WOLF-MONSTERS

Folio from a lost manuscript of Firdausi's
Shahnama, preserved in an album
assembled later
Baghdad or Tabriz, ca. 1385
H: 32.5 cm; W: 28.5 cm
Istanbul, Topkapı Saray Museum, H. 2153,
fol. 73v

Prince Isfandiyar, like Rustam, was set a series of seven feats to perform; the slaying of a pair of wolf-monsters was the first. He was told the beasts would be "each like a lusty elephant, / A male and female, having horns like stags / . . . and monstrous elephants' tusks," Here, both have tusks and one

71

(presumably the male) sprouts a single staghorn from its forehead.

This beautiful painting is one of a small group of perhaps ten, all that survive of what must have been a particularly impressive copy of Firdausi's *Shahnama* dating from sometime late in the fourteenth century. Higher than it is wide, it sets Isfandiyar — who here functions visually as hero as well as crown prince (his father is Gushtasp [90]) — so that his silhouette is echoed by the shape of the mountain behind him. Horse, rider, and attacking beasts are perfectly integrated into the landscape that stretches out broadly behind them all. Only the moderately cone-shaped mountains retain a fourteenth-century aspect [161].

Again, it is Bahram Mirza Safavi's librarian, Dust Muhammad, who puts this painting and its companions into context when he writes of Shams al-Din, a pupil of the celebrated Ahmad Musa: Shams al-Din illustrated pictures of square format in a *Shahnama*, a comment that surely signals a difference in the picture-shape from the usual format then in use. In addition to the feature of shape, the quality of "Isfandiyar Slays the Wolf-Monsters" and its companion pictures is a persuasive argument for all having originally been part of the large manuscript that has come to be known as the "Shams al-Din *Shahnama*." It must have been executed before 1374, since Dust Muhammad further writes that Shams al-Din remained loyal to his patron's memory and, after his death in 1374, accepted no further commissions. But these pictures have more to

tell, which also suggests how perfectly they had come to embody the visualization of Firdausi's *Shahnama*: they served later generations of princely bibliophiles as models for their own copies. Especially for Baysunghur, Firdausi's *Shahnama* must have been seen as a supremely significant instrument by which to assert the right of his Turco–Mongol line to rule in Iran; this manuscript must have been one he revered especially by reasons of its quality and aesthetic lineage. Baysunghur's *Shahnama* repeats several of Shams al-Din's compositions so exactly that the surviving paintings are also occasionally referred to as the "Proto-Baysunghur" *Shahnama* [75]. Not only pictorially but also in the matter of the text-layout, in six columns, did Baysunghur render homage to the achievements of a prior generation of artists of the book: his *Shahnama* of 1430 is also copied in a format of six columns of text, even though it was by that date an archaic layout.

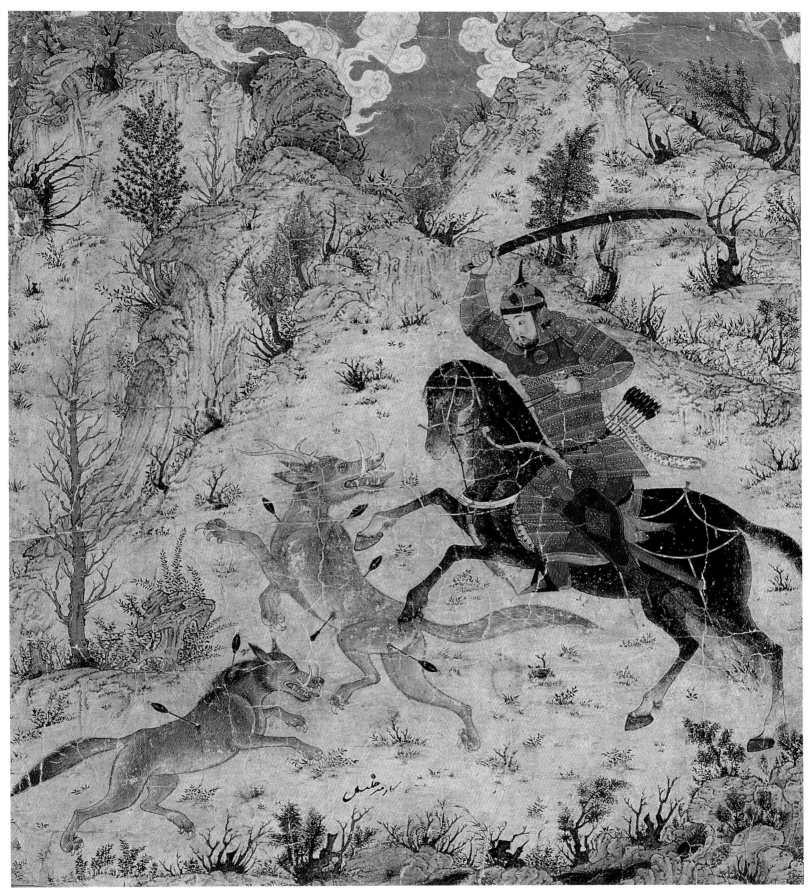

73. MALIKSHAH ACCOSTED BY A POOR WOMAN

Painting from a manuscript of the
Masnavis of Khwaju Kirmani
Baghdad, 1396
H: 26.7 cm; W: 17.3 cm
London, The British Library, Add. 18113,
fol. 85r

The poet known as Khwaju Kirmani – the
little master of Kirman – lived from 1290
through the first half of the fourteenth
century and worked in south-western Iran.
The romantic poems on which his fame
largely rests were much influenced by both
Sa'di and Hafiz; Nizami was also an influence.
Indeed, the third poem of Khwaju's *Masnavis*,
the *Rauzat al-anvar*, or *Garden of Lights*, owes
its form and subject matter – twenty ethical
discourses interspersed with stories – to the
form and subject of Nizami's *Makhzan al-asrar*,
The Treasury of Mysteries, the first work of the
Khamsa.

One story often pictured in Nizami's
Makhzan al-asrar concerns the Great Seljuq
sultan Sanjar, once accosted by an old woman
complaining of oppression [127]. In Khwaju
Kirmani's poem the sultan is Malikshah I, an
ancestor of Sanjar, and the woman complains
that the sultan's soldiers have chased her cow,
on which the health of her four fatherless
children depends. This picture is a remarkable
example of the classical landscape in a classical
Iranian manuscript painting, already fully
developed by the end of the fourteenth
century, in which all the elements of the ideal
outdoor setting for episodes of classical Persian
poetry are present and perfectly integrated.

The subject of this painting should probably
also be seen as pictorial homage to Nizami,
to the tradition developing around the
illustrating of his *Khamsa* in Baghdad in the
late fourteenth century. The only (presently
known) earlier illustration of this episode from
Nizami's poem was also made in Baghdad
between 1386 and 1388, yet the difference
between the two Jalayirid paintings is striking
evidence of an aesthetic revolution that
manifested itself in the space of a decade.

The earlier Nizami picture is a horizontal
rectangle about half the height of the written
surface and contained at the sides by the
rulings. Three long narrow figures and a horse
are set in a landscape that is merely a high,
shallowly rounded, lavender hill covered with
grass tufts; trees and flowers are confined to
the outer edges of the composition, and the
sky above the high horizon is gold.

This later painting is a large vertical
rectangle, much larger than the size of the
written surface; the relevant text "hangs" in
front of the picture and effectively interrupts
the line of the horizon at the right. The tops
of all the trees growing on the far side of the
silver river – six different varieties, including
blossoming fruit trees – break up the
burnished golden surface of the sky in which
birds are flying; the farther shore is dotted

73

with low flowering plants all the way down to
the verdant green bank of the river. This rises
behind an outcropping of fancifully colored
rock – pink, blue, and lavender – and then
winds horizontally through the picture at a
shallow angle; the near bank is as verdant as
the farther one but then the desert takes over,
covered with a sparse regular growth of grasses
shown in a tuft-like pattern that is sometimes
still referred to as *semée*, "a scattering." At the
lower left a bare twisted tree grows from a
larger outcropping of rock, again pink and
blue, lavender and grey, that functions as a
kind of repoussoir inviting us to look down
into the picture as if from a height. We might
well wonder what the true subject of the

painting is intended to be, the old woman's
interruption of the sultan's recreation with a
grave complaint, or the wondrousness of the
setting.

The answer is implied by the fact that the
primary figures are set in the sandy-colored
desert zone, as if for maximum clarity. The
woman in her long blue garment occupies the
center of the composition, silhouetted against
the ground; she bends to grasp the sultan's
bridle and gestures with the other hand, her
back to the sultan's *payk* – his groom – who
holds a round-headed axe and who precedes
the sultan but turns to look over his shoulder.
These are the three essential figures, but many
more crowd this version, and vision, of the

story, and the painter has disposed them in a broad curve across the foreground and up through the left of the picture, fully integrating them into all the features of his landscape.

The landscape elements – golden sky and silvery river, the desert *semée*, the flowering shrubs and the fruit trees in blossom, the massing of rocks and their unreal colors – comprise virtually all the standard components of the landscape in which the dramas of illustrated Persian poetry will take place, for several centuries to come. The sky may instead be a brilliant day-time blue and white clouds may hang in it, but the implication is that the sun always shines. The silver river may meander more energetically, or descend in a series of falls, but it is always present – even if it may have tarnished black over centuries of exposure to the air. If there is desert, it may be colored differently but it will always be *semée*; more important, it will always be a fully painted ground, however pale its hue. Flowering clumps will have different shapes and colors – useful "diagnostic tools" for determining differing times and places of execution – but they are always part of the ground-cover and virtually always thicker at the edges of streams and pools; the dead tree may be replaced by a tree stump with bare branches. Living trees may be fewer in kind, and again typical of certain times and places, such as the *chenar*, the plane tree with autumn foliage [80] or the spade-shaped tamarisk [75]; the blossoming tree – if not more than one – is always present and goes far to create the impression that the episode illustrated takes place in a perpetual, and ideal, springtime that is rarely, if ever, disturbed by heat or frost, rain or snow, or indeed bad weather of any kind [cf. 79]. And the rocks are a wonderfully malleable component of the classical landscape of an Iranian manuscript illustration, their colors seemingly unreal and their shapes apparently fantastic: yet traveling through the desert in Iran, rocky outcrops emerge from nowhere and often reveal just such shapes and colors.

74

74. A LANDSCAPE UNDER RAINCLOUDS

Painting in an anthology of Persian poetic texts
Fars Province, 1398
H: 20.2 cm; W: 12.6 cm
Istanbul, Museum of Turkish and Islamic Art, MS 1950, fol. 250v

Cypress trees, a pomegranate bush, and a date palm laden with fruit grow around a pool in the foreground of this exceptionally beautiful painting. It is one half of a double-page landscape composition that appears to have no specific reference to the texts between which it is placed – two poems from Nizami's *Khamsa* – let alone to any work in the entire anthology of poetry. The same manuscript has

another full-page "double-page" landscape, again painted in the blank spaces between a second pair of Nizami's poems. Smaller blank spaces have also been filled with landscapes – two full-page paintings and five smaller vignettes; one of these was probably never finished, since it has no golden detail. In all of the larger pictures streams and pools of water are significant features and, unusually, the sky is full of rain clouds.

The manuscript was completed in 1398 by a scribe from the mountainous town of Bihbahan, perhaps 150 miles north-west of Shiraz. Its format and layout, however – a primary text in the central vertical rectangular field, with a second text in the margins and

written on the diagonal – are typical of Shiraz volumes of this date, both illustrated and without pictures. That it is an anthology, together with other material features – the paper, the style of the calligraphy, and the many illuminated headings (one for each of the seven texts it contains) – and the style of the mysteriously uninhabited landscapes, all add weight to the proposal that the volume was actually made in Shiraz. Its pictures are certainly the finest surviving examples of Shiraz painting of the late fourteenth century as it was practiced under the Muzaffarid rulers of Fars. They are also among the most apparently inexplicable: no human beings nor even animals are depicted in them, with

the exception of the birds in the first of the ensemble (of contemporary pictures).

The positions of the images – between, or at the end, of texts – makes clear that they were not originally planned; they must have been added after the copying of the text was complete, but very soon afterward. They are extraordinarily delicate in style and they also display a tendency toward the decorative depiction of flora. These elements tend to be unoutlined, as is the floral growth so typical of contemporary Shiraz illumination; much of the drawing of the trunks and branches of trees, and the stems of shrubs, is executed in a particular brownish-red hue that is also characteristic of later fourteenth-century Shiraz painting [71].

More than half a century ago, a persuasive suggestion was made that the entire ensemble of landscapes in this anthology of Persian poetry should be interpreted as a vision of the Mazdaean creation-myth, corresponding to the account set out in the *Bundahishn*.[1] Sections of the text were quoted, to show how closely the pictures, especially the full-page paintings, paralleled the text describing the creation of the oceans and rivers, the mountains, and their covering of green and growing flora, in particular the cypress tree, holy to Zarathustra. The suggestion has lain in abeyance since then, historians of the Iranian Islamic period seeming disinclined, for whatever reason, to accept these superb Shiraz-style landscapes as a manifestation of a far earlier period of Iranian culture within the context of a manuscript of the Islamic period. Yet their vision is one of the vegetal richness of an earth as yet uninhabited, the cloudy skies so clearly a sign of life-giving water; and the consistent presence of the cypress tree and the date palm argue still more significantly for a Zoroastrian origin. The manuscript itself has neither dedication nor final colophon, and perhaps it was not even a commission but a manuscript produced for the open market in Shiraz, the center of the ancient Persian heartland, Fars. Shiraz remained an important Zoroastrian center throughout the Islamic period, and thus it is not inconceivable that the first owner of this fine anthology was an adherent of the ancient faith. He might have wished to embellish his new anthology of classical Persian poetry with visions of the creation as it was recounted in a text of his own persuasion; and so he had them painted into the only blank spaces he could find in the manuscript – around the ends of, and on the pages between, the separate poems. For whatever reason, this task was not finished; had it been, more such superb landscape visions might have been painted into a later section of the text where other blank pages offered a temptation similar to the blanks in the Nizami text.

75

75. ISFANDIYAR'S FIRST *KHWAN*: HE SLAYS THE WOLF-MONSTER

Painting from Baysunghur's manuscript of Firdausi's *Shahnama*
Herat, 1430
Tehran, Gulistan Palace Library, MS 61, p. 393

Among the surviving pictures of the fourteenth-century "Proto-Baysunghur Shahnama," two in particular illuminate the way in which the earlier manuscript served the greatest of Timurid bibliophiles as a model. This painting in Baysunghur's very large fifteenth-century *Shahnama* was copied almost exactly from the earlier manuscript [72].

Small but subtle adjustments were made by Baysunghur's painters: Isfandiyar is moved more toward the center of the picture and his horse reduced somewhat in size; the wolf-monsters are perhaps larger and their position has been altered, the female moved toward the center, directly below the left rear leg of the male and well below the body of the horse; Isfandiyar leans more forward from his saddle and appears more eager to finish off the beasts with his slashing sword. The greatest change is to the landscape and the sky: perhaps they seemed to represent the most old-fashioned of settings in the aesthetic context of Baysunghur's Herat. The white curls of Chinese-style clouds are gone, as are the

cone-shaped mountains of ancient Iranian origin. Instead, the bare and prickly horizon of the earlier painting has been softened, and sweetened, by a far gentler shape of hill with a meringue-like outline. In the dips between the hills and from one hilltop, trees spread green foliage upward (some of their branches cut off by two panels of text at the right); a fruit tree and floral shrubs now bloom against the blue sky where birds are flying, undisturbed by the ferocious carnage beneath them. The foreground landscape is heightened and now functions like a repoussoir over which we peer down, and into, the landscape, and on its crest are several smaller trees with typically spade-shaped foliage and a few unruly straggling branches.

In commissioning this very personal and illustrated manuscript of Firdausi's great epic, Baysunghur adhered in many ways to the Jalayirid illustrated model that must have been in his workshop in Herat. He even retained the old-fashioned format on which the text was copied in six columns of verses, and it seems a unique occurrence among the volumes of his library (insofar as it survives today). Dust Muhammad's later comment – that Baysunghur ordered his craftsmen to produce a book that exactly copied an earlier one made for Sultan Ahmad, in its format, size, and pictures – is apposite because it confirms that such apparently technical matters as the size and shape of a manuscript were of aesthetic importance in Baysunghur's time: making a manuscript with an old-fashioned format was a conscious form of bibliophilic homage to masterworks of the past. Almost a century later, the greatest of Safavid bibliophiles, Shah Tahmasp, would also choose to base at least one painting in his own *Shahnama* on a model that ultimately derives from the "Proto-Baysunghur *Shahnama*."

76. THE PALADINS IN THE SNOW

Painting from Muhammad Juki's manuscript of Firdausi's *Shahnama*
Herat, ca. 1440
H: 12 cm; W: 12.5 cm
London, Royal Asiatic Society, Morley 239, fol. 243r

The paintings in the *Shahnama* commissioned by Shahrukh's youngest son, Muhammad Juki, probably comprise the most beautiful ensemble of such illustrations that has ever been painted: they are the supreme example of "the Persian miniature," exquisite in coloring and unimaginably perfect in forms, like fairy-tales come to life.

The ordeal of Kay Khusrau's paladins lost in the snow was interpreted in a very different way by Muhammad Juki's anonymous artists than by the Inju artists of the previous century [70]. The Timurid picture is one of action, however vain, in the face of nature and impending tragedy. The snowstorm has begun:

76

white clouds blot out most of the sky and powder the ground with snow, and the spring has started to ice at the edges. The heroes have already provided their horses with nosebags, and now they try to protect themselves, huddling on small, brightly colored carpets spread on the ground. There are seven figures, and seven horses: perhaps two are servants, although it would be hard to deduce this fact from their dress. Style and costume vary among them but show no evident distinction of rank. The different colors of the garments, the horse-trappings, and the carpets spread throughout the composition contribute equally to the effect of bright colors against the grayed landscape and the lowering gray storm clouds in the sky. An occasional glimpse of blue sky sharpens the upper zone of the painting and confirms how recently the storm has arisen.

77

77. THE PORTRAIT OF KHUSRAU SHOWN TO SHIRIN

Painting in a manuscript of Nizami's
Khamsa
Herat, 1494–95
H: 17.2 (21.9 max) cm; W: 13.3 cm
London, The British Library, Or. 6810, fol.
39v

This image is a reworking of a favorite older
subject [239], one of several new versions of
older compositions to be found in this late
fifteenth-century *Khamsa* of Nizami made for
a distant relative of Sultan-Husayn, Sultan ʿAli
Mirza Barlas. Its originality lies primarily in its
landscape setting.

Illustrated is the moment when the first
of Shapur's three portraits of Khusrau finds
its way into Shirin's hands. She and her
companions are listening to music in a green
meadow, Shirin reclining against a pile of
bolsters spread on a rug. A maid brings the
painting, and Shirin reaches for the white
rectangle on which is painted a seated prince
holding a wine cup in one hand. Khusrau's
picture is similar in size and shape to those in
earlier versions of the same subject; likewise
the painter Shapur is here nowhere to be
seen. The verdant flowering meadow has the
appearance of a *millefleurs* tapestry, and the
silvery stream winds in the background of the
picture, so that the foreground may be given
over to Shirin, her companions, and their
servants and the musicians. An unusual detail
at this time – although it is a geological reality
of Iran that will become a kind of *topos* in
seventeenth-century Safavid painting – is the
sudden eruption of a rusty-pink spur of rock
from the green floor of the meadow [79, 147].

78. RUSTAM'S FIRST *KHWAN*: HE SLEEPS WHILE RAKHSH KILLS A LION ("THE SLEEPING RUSTAM")

Folio from a manuscript of the *Shahnama*
now almost entirely lost or never
executed
Tabriz, ca. 1510–20
H: 31.8 cm; W: 20.8 cm
London, The British Museum,
1948.12.11.023

This most striking of all illustrations ever
made for a classical Persian text remains
unfinished; the manuscript for which it was
destined is unknown – if it ever existed – and
even the date at which it was painted remains
uncertain. None of this detracts from its
extraordinary appeal.

The first of Rustam's seven feats, or rather,
the feat of his marvellous horse Rakhsh, is its
subject. Fatigued from making two stages of the
journey to Mazandaran in a single day, Rustam
had lain down to sleep in a bed of reeds that
was the lair of a lion; Rakhsh defended both
himself and his master by sinking his teeth into
the lion's back and then dashing it to death.

For once, the feline is the prey; yet even in this dense and rich new vision of the episode, the lion's pose is centuries old [202], its body in profile but its head turned so that the muzzle and both eyes are visible.

The true subject of the painting, however, is really the landscape in which the horse, the lion, and the hero sleeping on a striped mat are set. In Rustam's case, "suspended" is a better description, even though his gear serves him as a pillow firmly placed on the grassy ground. The shah Rustam served in these early days was Kay Ka'us, usually called "the foolish Ka'us." Early in his reign he had been seduced by the song of a minstrel from Mazandaran and conceived the idea that he must invade and rule that fertile land; Rustam assisted him in clearing the land of *div*s. Lying along the Caspian shore, protected by the high range of the Alburz mountains on the south, Mazandaran still supports crops such as rice and citrus, sugarcane and tea. Its moist humidity and dense green color is beautifully captured in this verdant painting.

But the landscape has qualities beyond well-watered fertility: a frantic pictorial dynamism in which trees and plants and rocks are charged with writhing energy. Reeds and flowers sway, the foliage of trees blows in a strong breeze, tree trunks bend deeply or curl around straighter trees. A snake slithers up a tree trunk in search of birds' eggs; the blue whorls of Chinese cloud-bands seethe in the golden sky; even the edges of the rocks are alive with rock-spirits [178]. This last, and the motif of the lily with the bent leaf [156], are both elements of western Iranian painting of some age, underlining the Tabriz milieu from which this picture arose, even if it was not actually painted there.

Such supercharged energy in the depiction of natural and mineral forms is associated with the painter Sultan-Muhammad. No written evidence – signatures or texts – links him with late fifteenth-century painting at the Aq Quyunlu court in Tabriz, but he may have worked on the much earlier picture usually called "The Hunting Party of Uzun Hasan" [26]" both display the same kind of over-abundant energy and the dynamism of natural forms, and the same snake winds its way up a tree trunk in the lower left of each picture. His sixteenth-century career is a very different matter: he is the first-named of Dust Muhammad's "portraitists and painters" of the Safavid library in Tabriz in the time of Shah Tahmasp. When Tahmasp's *Shahnama* entered the arena of scholarship in the 1970s, "The Sleeping Rustam" engendered the unlikely proposition that it too must have been intended for this manuscript. But Tahmasp's manuscript actually has an illustration of the same subject (although at a different point in the text); the Tahmasp *Shahnama* is copied in a very different hand from that seen on "The Sleeping Rustam;" and the size of the written surfaces does not accord.

Less questionable is that the painter of "The Sleeping Rustam" painted other pictures for

Tahmasp's *Shahnama* [223]: his vibrant foliate, animal, and mineral forms, and an extraordinary palette that includes an almost electric pale turquoise, all give evidence of his presence in Tabriz in the early part of Tahmasp's reign, and Dust Muhammad speaks of his work for "His Majesty's *Shahnama*." This single painting (one of four from the same manuscript still extant early in the twentieth century) instead seems a vivid testimony to an earlier, and transitional, moment between Aq Quyunlu Turkman painting and Safavid painting at the princely level.

79. BAZINDA AND THE SUDDEN STORM

Painting in a manuscript of Husayn ibn ʿAli al-Vaʿiz al-Kashifi's *Anwar-i Suhayli*
(*The Lights of Canopus*)
Qazvin or Isfahan, 1593
H: 30 cm; W: 21 cm (folio)
Geneva, Collection of Prince Sadruddin
Aga Khan, fol. 22r

A rare and striking picture of a thunderstorm illustrates one of the stories added to Nasrullah's twelfth-century translation into Persian of the Arabic *Kalila wa Dimna*, the expanded text named in honor of Sultan-Husayn Bayqara's vizier Ahmad Suhayl [97, 112, 210]. The picture occurs in a late sixteenth-century manuscript connected with Sadiqi Beg Afshar, Shah ʿAbbas I's sometime court librarian.

The story is told to a king by his vizier, who wished to persuade his master not to embark upon an arduous voyage. A pair of pigeons, Bazinda and Nawazinda, dwell together in peace. But their contentment is suddenly disturbed by Bazinda's desire to travel, and Nawazinda cannot dissuade her mate from setting off for parts unknown. Disasters multiply: Bazinda is caught in a thunderstorm, after which a falcon is about to pounce when an eagle disputes the falcon's claim, allowing Bazinda to take refuge under a rock; but hunger lures him from his hiding place and leads him to the grain strewn as a snare for another pigeon; escaping the snare, he is then hit by a sling-shot pellet and eludes his unthinking tormentor by falling into a deep well. In exhaustion he returns to the neighborhood of his old nest where Nawazinda hears the fluttering of her mate and rescues him.

In a flowering mountain meadow where rock-edged silver ponds are fringed with low shrubs, Bazinda – looking more like a bluebird than a sober grey pigeon – huddles on a branch in the lower right. Rocky outcrops, weird shapes of yellow and purple inhabited by grotesques, or rock-spirits, rise precipitately from the floor of the clearing into the center of the picture. Diagonal black lines of driving rain beat down from the darker purple sky above the rocks, and yellow lightning, shown as connected bracket-like lines, traces counter-

diagonals across the purple sky.

This representation of extreme weather is effectively achieved with means both extremely simple, and firmly grounded in the traditional Iranian visual language for depicting landscapes. All that actually conveys the impression of the thunderstorm and its attendant lightning flashes are the diagonal dark lines descending from the purple sky above the towering rocks, and the bracket-like yellow lines running across the black of the rain: rain does not even fall into the lower half of the picture, and the limbs of the small shrubs are no more wind-blown than they appear in other pictures. In fact, the landscape in the lower part of the picture is unobscured by the ephemeral effects of inclement weather: no rain falls upon the purple iris and red lilies at the edge of the water at the bottom of the painting, nor on the ubiquitous large rocks fringed with flowers and foliage that border the pond, nor even on the towering purple rock mass with its ghostly big-eyed rock-spirits peering out of the center of the painting. Yet so well-observed is the event of the storm, and so effectively painted, that we "read" it as a storm raining down over the entire picture and blowing fiercely over the shrubs and flowering plants.

80. THE SIMURGH TAKES ZAL TO HER NEST IN THE MOUNTAINS

Painting from a fragmentary copy of the *Shahnama* of Firdausi, probably commissioned by Shah ʿAbbas I on his accession
Qazvin or/and Isfahan, ca. 1590–1600
H: 40.6 cm; W: 26.2 cm
Dublin, Chester Beatty Library, P. 277, fol. 12r

Perhaps the most spectacular vision of a mountainous landscape known in Iranian painting, this picture is one of only sixteen remaining from a princely *Shahnama* that once ranked among the truly magnificent royal manuscripts of any culture.

Iran's foremost hero, Rustam, was protected by a supernatural being whose form – at least, as represented in the pre-Islamic painting of Sogdian Panjikent [129, 132] – was that of a winged lion with a dragon's tail. By the time Firdausi was writing the *Shahnama*, this protective being was called either ʿanqa, or *simurgh*, a fabulous bird (one meaning for *simurgh*, in Persian, is "thirty birds" [250]). In Firdausi's poem, the *simurgh* aided not only Rustam but his father, Zal, before him: when Zal's father repudiated his newborn son – because his snow-white hair was thought to be a sign of demonic blood – and exposed him on a mountain-top to perish, the infant was rescued by the *simurgh* who reared him with her own fledglings in her nest in the fastness of the Alburz Mountains, until Zal's father repented and reclaimed his son.

Already in late thirteenth-century Iranian painting, the *simurgh*'s form had merged with that of the Chinese phoenix and henceforth, in most later manuscript paintings, the *simurgh* would be shown with a raptor's curved beak and brilliantly colored plumage, short curling feathers in its crest and tail, and longer flame-like tail feathers. In this picture that transcends its ruled margins on all four sides, the *simurgh*'s tail is an extravagant swathe of orange and iridescent turquoise feathers trailing behind her as she holds the infant Zal in her claws and ascends to her enormous nest at the top of a mountain crag.

Both patron, and painters, of the fragmentary *Shahnama* from which this painting comes remain unidentified; this fact has long encouraged speculation. Yet the likelihood that the manuscript was commissioned by Shah ʿAbbas I shortly after his accession to the throne in 1587 is strong, given the size of the folios, the quality of the paintings, and the one illuminated heading. The paintings are all full-page, and the margins are lavishly painted with golden animals and birds in luxuriant landscapes, something found in only the finest of princely manuscripts of this period [111, 127, 145]; here they set off the paintings as a gold setting does a precious stone.

None is signed, but at least three, if not more, hands seem evident within the manuscript, including perhaps the young Riza-i ʿAbbasi. A more recent suggestion is that Sadiqi Beg is also responsible for several paintings – including this image – inasmuch as he was head of Shah ʿAbbas I's library for a decade, from the shah's accession in 1587. If indeed he did paint this towering mountain vision, then little in the 1593 *Anwar-i Suhayli* compares with this accomplishment, with the possible exception of "Bazinda and the Sudden Storm."

In the *Shahnama* painting, the forms of the rock are both jagged and soft, and their surfaces flicker with contrasts of color that bring to mind Sultan-Muhammad's great "Court of Gayumarth" [223]. Frivolous white Chinese-style cloud bands float in a dark-blue sky, but they are ominously overshadowed by the stylized hanging curls of grey storm clouds thick with snow that cluster below the craggy peak of the mountain where the *simurgh* has her nest. The entire natural year is evoked by both the blossoming fruit trees and the plane tree in early autumnal foliage; the tamarisk trees, with their spade-shaped mass of foliage, miniature shoots, and bare extruding branches, are quite unlike the tamarisks in "Bazinda and the Sudden Storm." The overall sense of natural observation that distinguishes so many of the *Anwar-i Suhayli* pictures, especially "Bazinda and the Sudden Storm," seems alien to the magnificent stylization of "The Simurgh Takes Zal to Her Nest." Such differences seem to argue not only for different means – not merely those of time, expectations, and available materials – but for a completely different hand for the two paintings.

81. A COURTIER ON A TERRACE

Painting mounted in an album
Late seventeenth century
H: 28 cm; W: 18.6 cm
St. Petersburg, Oriental Institute, D-181,
fol. 42r

The Europeanizing mode of painting that began to appear in Iran towards the middle of the seventeenth century was well established by the end of the century, as this picture of a fashionably dressed courtier seated on a terrace attests.

His clothing is beautifully detailed and meticulously painted, and his face is that of a real person, not just the type of the mature bearded man. The mountainous hills in the background are blued and suggestive of distance, an illusion sustained by the small skiffs with tiny passengers floating on the lake in the middle distance, and the silhouettes of small and indistinctly seen buildings on its far side; the mass of white cumulus clouds in the blue sky finishes the composition in a suitably European manner. What is, then, fascinating to realize is that the depiction of illusionistic perspective and distance had by this date already become as formulaic as earlier landscape formulas; while in the foreground the components of the terrace setting – a floral-patterned floor covering and the openwork wooden balustrade – are rendered just as formulaically, but in the older, traditional manner [105, 107], as horizontal rectangles filling the width of the painting.

This picture is signed by a certain Muhammad *sultani*; the epithet *sultani*, "in royal service," suggests that he must have been connected with the last of the recognized Safavid rulers, Shah Sultan Husayn (1694–1722). Another work with the same signature mounted in the same early eighteenth-century album is dated early in this shah's reign, to the equivalent of 1697–98. Clearly Muhammad *sultani* was influenced by the work of his somewhat older contemporary, Muhammad Zaman, for several of the latter's "signature" landscape elements, the oak tree "glued" to the right margin [220, 232], and the taller, slender tree with broader clumps of foliage at the top [28], are prominent in this picture. At first sight, the shape of the mountainous hills in the background appear to derive from some European image. Yet on a clear day in Isfahan, especially from a high vantage point, such as the upper terrace of the ʿAli Qapu, the distant landscape beyond the city includes bare mountainous hills of astonishing shape that are not at all dissimilar to those in the background of Muhammad *sultani*'s painting.

81

82. HUMAY AND HUMAYUN IN A GARDEN

Painting from an unidentified manuscript
of Khwaju Kirmani's Masnawi *Humay u
Humayun*
Herat, ca. 1425–30
H: 29 cm; W: 17.5 cm
Paris, Musée des Arts décoratifs, Inv. 3727

In a flowering garden enclosed within a
green stone wall topped by red palings, four
figures stand under a night sky lit by stars and
the crescent moon. The drama of whatever
meeting has brought them together is
expressed in the most economical of gestures:
an inclined head, an extended hand, arms
crossed at the breast. This painting is one of
breathtaking and magical quality, one that
embodies all early Timurid princely pictures
of the subject, in the dress of its dramatis
personae, in its garden setting, and in its
richness of paint and precious-metal pigments.
Moreover, mystery surrounds it: the picture
remains unassociated with any personality or
patron, or any surviving manuscript of Khwaju
Kirmani's *masnawi* entitled *Humay u Humayun.*

The subject is probably the meeting of
Humay – the turbanned figure at the right –
and the Princess Humayun – crowned and
flanked by a serving-woman – in a garden in
the cool of the night, when the fragrance of
the flowers underfoot and overhead would be
most intense. Flowers and blossoming trees,
and watercourses fed by a fountain, are all
enclosed within a fence: these are the
essentials of the ideal garden in Iranian
painting in the Islamic period, and they
should all be understood to symbolize paradise
both on earth and in heaven.

Indeed, the *topos* of the Iranian garden in
these centuries is "watered" by two streams:
the pre-Islamic Iranian tradition, documented
from as early as the sixth-century BC garden
pavilion of Cyrus the Great at Pasargadae; and
the Islamic garden, the primary metaphor for
the Garden of Paradise, which the Prophet
Muhammad had visited in his *mi'raj*, and in
which every devout Muslim hopes to awaken
after death. In both traditions, water was an
essential feature, as can be imagined for
geographical zones that are naturally arid or
scorchingly hot – or both. That water enabled
grass to grow, flowers to blossom, and fruit
to ripen helps to explain the prevalence of
flowering meadows and bearing fruit trees in
Iranian art; because water was so precious a
commodity, a watered garden is often enclosed
within walls or other boundaries, as it is here.

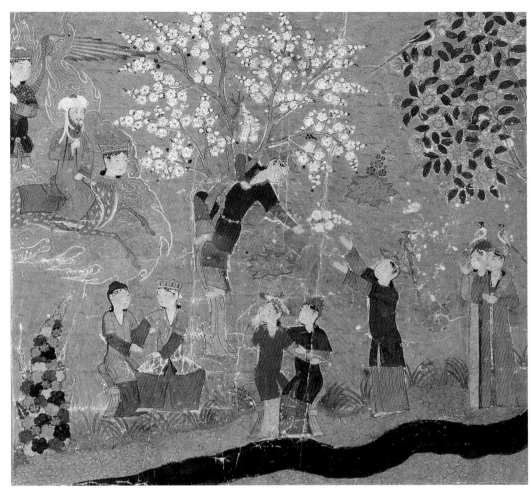

83

83. THE PROPHET IS SHOWN PARADISE

Painting in a manuscript of Mir Haydar's
Mi'rajnama
Herat or Samarqand, between 1420–40
H: 19.7 cm; W: 16 cm
Paris, Bibliothèque nationale de France,
Suppl. turc 190, fol. 49v

In the course of his Night Journey, the *mi'ra'*,
the Prophet Muhammad travels through the
heavens to the terrifying regions of Hell and
also passes through Paradise. Five paintings in
this manuscript picture the Muslim paradise,
and two show the Garden of Paradise itself.
Here it is depicted as a blossoming garden,
just as the Qur'an describes it.

Verdant lawns edged with flowering trees
and bushes, and a silvery stream winding
through the evergreen meadows greet the eyes
of the Prophet as he enters the Garden of
Kauthar. A couple is seated under a tree in
full bloom; a "Companion of the Garden"
picks blossoms from the tree to pass to
another Companion; birds sing in the trees.
That it is to be understood as a vision of
Paradise is evident in the presence of
Muhammad mounted on the Buraq with the
Angel Gabriel behind him, explaining to the
Prophet:

> . . . give glad tidings
> To those who believe
> And work righteousness,

That their portion is Gardens,
Beneath which rivers flow.
Every time they are fed
With fruits therefrom,
they say: "Why this is
What we were fed from before,"
For they are given things in similitude;
And they have therein
Companions pure (and holy);
And they abide therein (for ever).
(Qur'an, II, 25)
E.J.G.

84. FIRDAUSI AND THE COURT POETS OF SULTAN MAHMUD

Painting from Muhammad Juki's
manuscript of Firdausi's *Shahnama*
Herat, ca. 1440
H: 16.5 cm; W: 15 cm
London, Royal Asiatic Society, Morley
239, fol. 7r

The story of Firdausi besting three of the
court poets of Sultan Mahmud, in a test of
poetic skill held in a garden outside the city
of Ghazna, is another of the additions made
by Baysunghur in his revised preface to the
Shahnama. Four men sitting in a garden, three
together and another somewhat apart from
them, is the unremarkable way in which the

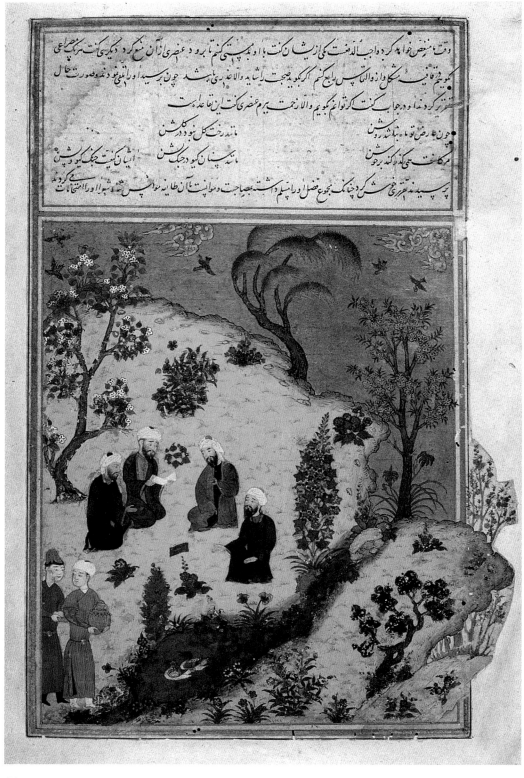

84

resulted in Firdausi's introduction to Sultan Mahmud.

Here Firdausi's triumph takes place in an open garden in which everything is at its springtime ideal: a flowering meadow, a silver pond with swimming ducks, a breeze turning the feathery leaves of a tree, fluttering birds and floating white clouds in the sun of a golden sky.

85. A FATHER'S DISCOURSE ON LOVE

Painting from Ibrahim Mirza's manuscript of Jami's *Haft Aurang* (*Seven Thrones*)
Mashhad (?), between 1556 and 1567
H: 23.6 cm; W: 16.8 cm
Washington, DC, Freer Gallery of Art, 46.12, fol. 52r

The text in which this picture is embedded concerns a father's reply to the query of his son, a beautiful youth beset by suitors: how to choose from among them all, and what to look for in the chosen one. The garden setting is a classical Iranian one in which the theme of love is often explored, both verbally and visually [82, 86]. This picture in Ibrahim Mirza's *Haft Aurang* recasts all the formulaic elements of the *topos* and splendidly reinterprets them, providing a vivid and unusual image for an important sufi theme to which Jami devotes some attention in the first poem of the *Haft Aurang*, called *Silsilat al-zahab*, the *Chain of Gold* [111].

A group of noblemen and their entourage, men of all ages and mischievous boys, have gathered in a garden pavilion on a grassy hilltop during the season of roses and poppies. They converse, they eat and read, meditate or simply relax; they play chess and listen to music; the boys filch eggs from the large bird's-nest in the plane tree. The pavilion presumably stands in one part of a much larger garden, since no walls or railings are visible anywhere in the grassy meadow which is watered by a pair of streams descending from a rocky height, at the left rear of the picture. The pavilion has three architectural elements: the terrace – a raised brick octagon paved with patterned tiles, a single *iwan* with a porphyry dado and a tiled *pishtaq*, and a staircase, or walkway, with low wooden railings, entered under a portal, like a frame from which no doors are hung.

The two streams in the background have been joined together to feed the small round pool on the terrace, where five ducks paddle and preen; two channels flow out of it in opposite directions, dropping off the terrace into two diverging streams. The pool and the channels are all edged in a reciprocating pattern of red porphyry and green stone. Together with the large-scale interlaced strapwork designs of the pavement, they offer a hard-edged visual contrast to the natural landscape surrounding the pavilion and the human activities taking place on and around

event is always illustrated; the image was surely developed in response to additional text. It appears for the first time in Baysunghur's majestic *Shahnama* of 1430, and then in the illustrated copies of the *Shahnama* made for Baysunghur's brothers, Ibrahim-Sultan and Muhammad Juki, within a period of perhaps only ten years. In many later manuscripts it is the opening image of choice.

Arriving in Ghazna travel-stained and alone, Firdausi entered a garden in which the poet 'Unsuri, having won a contest in the composition of epic verse, was celebrating

with two companions, Farrukhi and 'Asjadi. Firdausi wished to join them, but the three were not pleased at the intrusion. Two would have insulted him but 'Unsuri was more polite: he said that all three were poets and then proposed an extempore rhyming contest. The three chose a rhyme which they felt certain the stranger would not be able to match, and each recited one line of a quatrain, leaving Firdausi to finish the poem; he did so, brilliantly and with erudition, his rhyme having an allusion to a story from the legends of the Iranian kings. The event is said to have

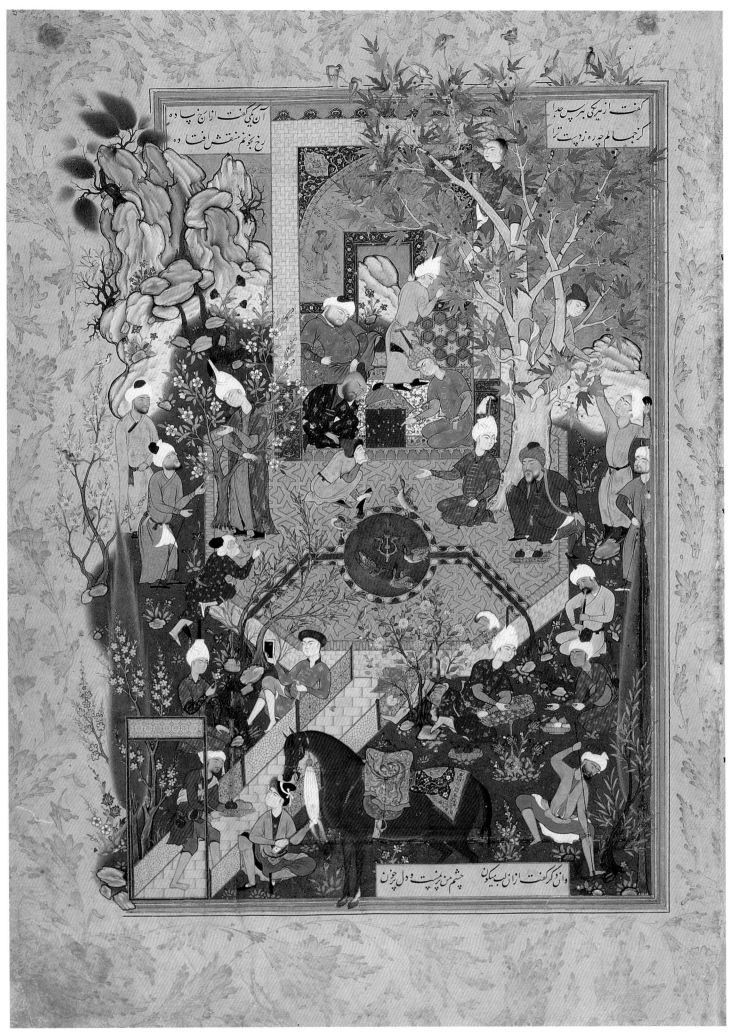

85

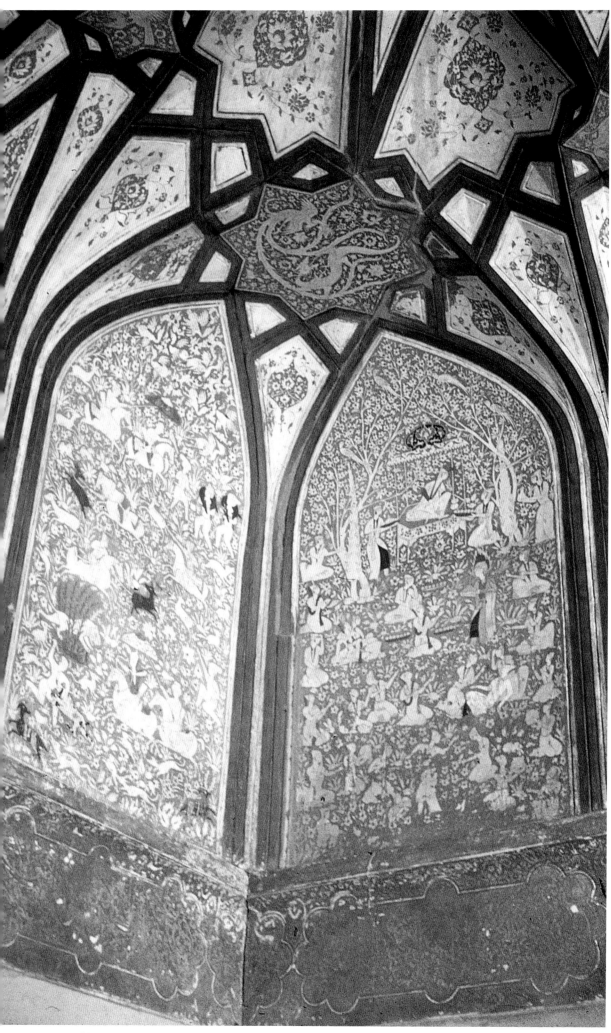

86

it. They also focus attention on the two diverging channels of water, almost certainly an allegorical comment on the sufi's everlasting quest for union and the inevitability of separation. The strong diagonal of the staircase is another contrasting straight-edged element with a particular function: it directs the eye toward the beautiful youth and his father, seated underneath the plane tree at the upper right.

The two figures do not, otherwise, stand out as the textual protagonists, so deeply are they involved with questions on the nature of a lover's attachment and the depth of his devotion, on the triviality of what appears to be and the importance of seeing below the surface. The youth wears an early Safavid court turban, with a large feather and strings of jewels, but so do four other youths engaged in conversations elsewhere in the picture; the father's simpler dress and the informality of his posture, robes hitched up to reveal one red-stockinged leg hanging over the side of the terrace, mask their intimate relationship.

Visual comments on their conversation are made in the *iwan* behind the terrace. A youth wearing a striped court turban plays chess with an older bearded man whose headgear is laid beside the chessboard, chess being a metaphor for life and its vicissitudes. Behind them all, on the surprisingly intense pink of the wall of the *iwan*, a poem, a picture, and a suffering lover all further expand the themes of Jami's text. The picture shows yet another youth, perhaps the beloved of the man in yellow who, armed with a pen box and an inkwell (stuck under his belt), is inscribing the following poem on the wall:

> I have written on the door and wall of
> every house about the grief of my love
> for you.
> That perhaps you might pass by one day
> and read the explanation of my
> condition.
> In my heart I had his face before me.
> With this face before me I saw that which
> I had in my heart.[1]

86. ZULAYKHA AND HER LADIES, WITH YUSUF, IN A GARDEN

Carved and painted decoration on the upper zone of a large *iwan*
Nayin, about 1580
H: ca. 155 cm; W: ca. 80 cm

In a quarter not far from the principal mosque of the small town of Nayin, about 125 kilometers east of Isfahan and near the edge of the desert, the remains of a small palace of the later sixteenth century were discovered in the late 1960s. Several rooms were found to have decoration in an uncommon technique, pictorial and ornamental designs cut through a white-painted surface into the underlying mud-plaster; occasional touches of color on the surface relieve the cool austerity of

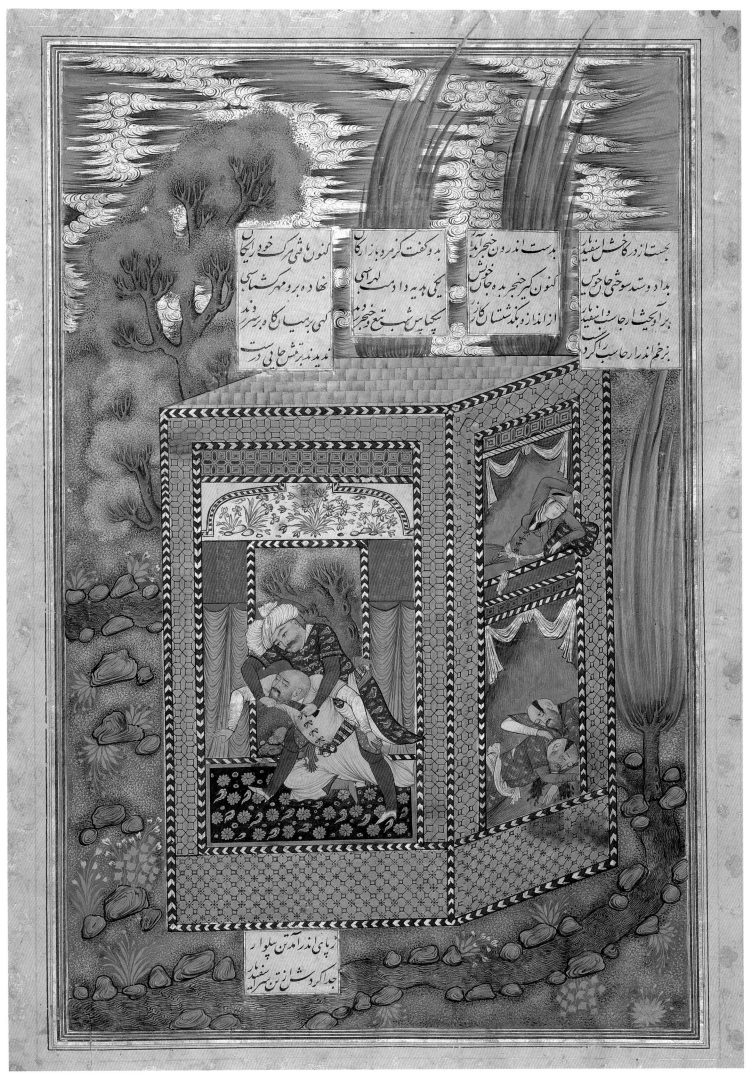

predominantly white and gray-brown. The areas so decorated are all in the upper walls and ceilings of the rooms, and paradise is the primary theme: the paradise of verdant gardens inhabited by lovers, and the paradise of the enclosed garden, in which the hunt and the polo game may take place. This is conveyed both by the content of the pictorial decoration and the accompanying poetry, where it has survived.

The large *iwan* opening onto a garden-courtyard surrounding a large tank, or pool, of water retains most of its original decoration. In the largest panels on each of the three walls are images of lovers from the most well-loved, and popular, of Persian poetry, stylistically related to contemporary Qazvin-style illustrations in manuscripts and single-figure studies. All are set against leafy and flowering backgrounds, in gardens where birds sing in the trees, or in a hunting ground thick with birds overhead and lions half hidden in reed thickets; attendants, servants, and hunting animals swell the numbers of figures in the compositions. In star-shaped compartments on the ceiling of the same *iwan*, angels, bears and monkeys, waterbirds, and the fantastic *simurgh*, are likewise set against a paradise of flowering trees.

The corner panel on the left wall shows Zulaykha and her ladies. They kneel or recline, while servants offer platters of fruit, music is played, and dancers perform. Seated alone on a hexagonal dais, Zulaykha bends gracefully and yearningly, toward Yusuf; he stands well below her, a flaming nimbus around his head, and carries a platter of fruit. The nimbus instantly makes clear just what story is intended by this otherwise unspecific scene of princely garden entertainment. Those who were themselves entertained in so enchanting an *iwan* looking out onto a verdant garden, fragrant with flowers and cooled by running water, would immediately recognize the subject and fill in the details of the story, as well as all the paradisiacal and mystical overtones of Jami's great poem.

87. ISFANDIYAR SLAYS ARJASP IN THE BRAZEN HOLD

Painting in a manuscript of Firdausi's
Shahnama
Isfahan, 1648
H: 225 cm, W: 203 cm
Windsor, The Royal Library, MS 1005014, fol. 445v

This apparent scene of ambush and murder, set in an isolated garden pavilion in early spring, could not contrast more dramatically with the image of precisely the same episode in the Timurid *Shahnama* of the bibliophile Baysunghur [90] – a manuscript made slightly more than two centuries prior to the densely-illustrated copy commissioned for a Safavid governor of Mashhad, Qarajaghay Khan.

Baysunghur's picture adheres to Firdausi's recounting of the text and brilliantly interprets the sense of urban chaos effected by Isfandiyar's ruse and his carefully laid plans to smuggle armed men into the Brazen Hold. Qarajaghay Khan's is similar in only two ways: Isfandiyar slays Arjasp by slitting his throat, as Firdausi writes, and the setting again reflects contemporary architecture. Otherwise, this picture is strikingly unfaithful to the text, setting the assassination in a square, two-story pavilion in the midst of a bucolic spring-green wilderness where tulips bloom in clumps at the edges of a winding silver stream.

The walls of the brick structure are completely opened up as galleries, or *iwans*. One of these faces out of the picture and is of full height, while on the side wall is a two-story opening. In the upper story a woman sleeps, reclining on a large purple bolster with one arm flung out of the opening; in the gallery below her, two men, heads gashed open, sleep forever. These two figures are the only evidence of Isfandiyar's well-laid campaign to penetrate the Hold, dupe Arjasp into accepting him as a wandering merchant with hospitably deep pockets, and stage a feast at which he drinks his guests into a stupor, thus enabling him to call his own men to the

attack and follow Arjasp into the very heart of his fortified Hold, where he can cut the Turanian's throat. Still in merchant's garb – as is Arjasp – Isfandiyar stands behind Arjasp with perfect access to his unprotected throat; the men seem to have wrestled with each other [17], the Iranian appearing to cling to his opponent's back.

It is a dynamic and dramatic image of one man overpowering another by stealth and skill, rather than by a ruse permitting a speedy frontal attack. The isolated position of the pavilion in its garden, shaded by towering cypress trees and cooled by the flowing silver stream, increases the peculiarity of the picture, in which text and image seem to be telling different stories. Indeed, without a knowledge of Firdausi's text, this impressive picture would surely be open to an entirely different interpretation.

88

Painting from Shahrukh's manuscript of
Nizami's *Khamsa*
Herat, 1431
H: 17 cm; W: 10.3 cm
St. Petersburg, State Hermitage Museum,
VR-1000, fol. 251r

At the same time as Baysunghur's workshop
in Herat was producing illustrated manuscripts
of classical Persian texts [52]to standards, and
in styles, that would remain a benchmark in
the Muslim East for nearly two centuries, his
father Shahrukh was also having made in the
same city an illustrated and illuminated copy
of Nizami's *Khamsa* [236, 240]. Different in
every aspect from the large illustrated
historical manuscripts he also commissioned,
Shahrukh's *Khamsa* exemplifies the classicism
of the Baysunghuri achievement. The
differences obtained by the manipulation of
classical elements are extraordinary.

88. KUSHINAGARA, WHERE THE
BUDDHA ACHIEVED NIRVANA

Painting from the Arabic manuscript of
Rashid al-Din's *Jamiʿ al-Tavarikh*
(*Compendium of Chronicles*)
Tabriz, 1314
H: 10.8 cm; W: 15.8 cm
London, The Nasser David Khalili
Collection, MSS727, fol. 277v

In the Arabic *Jamiʿ al-Tavarikh*, the last picture
in the section on India is a rectangular
composition set at the bottom of the page. Its
painter used no particular pictorial model but
instead illustrated a type of contemporary
Iranian building to represent the domed
crystal edifice in which the Buddha achieved
his aim of annihilation – *nirvana*.

The focus of the composition is the domed
structure and the brick-work portal. The
long windows with metal grilles, the stone
pediments, the double doors with a central
impost-block, and the lion-headed door
knockers: all have parallels in architecture in
Tabriz and throughout the Ilkhanid realm and
would have been familiar to the painter. Other
features – the lunettes above the windows,
the cornice, and the capitals – are designs
that come from contemporary illumination,
from the floral and geometrical passages of
ornament found in contemporary manuscripts
such as the Qur'ans being produced in Tabriz,
Baghdad, Hamadan, and other Ilkhanid
centers. That such ornament also found its way into
actual Ilkhanid buildings, most notably the
monumental mausoleum that Oljaytu was
constructing in the same years at Sultaniyyah
[cf. 102], indicates how closely interrelated
were the crafts, and craftsmen, of this period.
Only the space beyond the building to the
right carries a non-architectural motif, an
attendant figure and a tree decoratively bent
to occupy the pictorial space above the figure.

89

Shahrukh's *Khamsa* also exemplifies the now well-developed Timurid dynamic by which an illustrative program for a manuscript of classical Persian poetry was organized. Some episodes are conveyed in "traditional" formulations – Nizami's *Khamsa* having been illustrated for at least half a century and probably much more; others are variations on a *topos*, a traditional stock setting, of a non-specific situation that lends itself to adaptation, such as two persons conversing in an interior; yet others are original compositions for episodes already having some representational history; and one, or perhaps two, will be entirely original compositions for episodes or text-points not previously illustrated. "The Crowd Admires the Castle of Khwarnaq" is just such a new composition for a new text-point: developed for this manuscript, it remains (so far as we know) unique [cf. 94].

The Sasanian king Bahram V (Varahran), son of Yazdigird I and – as Bahram Gur – the hero of Nizami's *Haft Paykar*, or *Seven Portraits*, was raised in the Yemen by the vassal king Nuʿman. At a particular point in his youth, the Yemeni air being dry and the land hot, King Nuʿman and his son went

> Seeking a high and spacious place,
> from noxious heat and all harm safe.
> That region boasted no such fort,
> and useless were all other sorts.[1]

So Nuʿman searched for a master-builder and eventually persuaded the Greek Simnar to build the wondrous palace of Khwarnaq,

> A palace with a heavenly dome
> round which the heavens' nine spheres turned.[2]

When it was completed,

> . . . earth judged it Chinese painters' work.
> Hearing of it, from near and far
> flocked thousands just to gaze and stare.[3]

Indeed a crowd – ten men – is gathered on one side of the picture, gazing, staring, pointing at the structure "towering" up to the top ruling on the other side of the picture. This palace stands on a high plinth of greenish stone, its pink brick facade studded with interstitial turquoise ceramic tiles and a ceramic-tile cornice bearing an inscription in praise of a "mighty sultan." Its seven domes, each a different color, are no doubt what the crowd stares at most. The painter has interpreted Nizami's text in an highly original composition whose source must lie in a later part of the poem. Instead of a single dome around which heaven's nine spheres turned – the medieval computation of the sun and the planets – the artist has drawn upon the description of the palatial structure proposed to Bahram by an apprentice of the architect Simnar, a building of

> seven strong forts, seven fair domes,
> Each of a different hue . . .[4]

These, of course, are the seven domed

chambers in which Bahram will then install the Seven Princesses of the Seven Climates, whose hands he has obtained in marriage; he visits them on seven successive days of the week, and they tell him stories. Black, yellow, green, red, turquoise, sandalwood, and white are the colors of Nizami's domes, although here the series substitutes blue, with illuminated ornament, for sandalwood. Each dome is lovingly painted, and each is different: two are ribbed, a third has lotuses on a turquoise ground; the green dome shows reciprocating three-pronged figures called *diqmaq*, a pattern long used in small-scale metalwork decoration; the red and yellow domes display interlocking ogival designs, and the illuminated patterns on the blue dome (only partially seen), are sensitively placed on the dome's curve and on the building's cornice, *pishtaq*, and cresting.

90. ISFANDIYAR SLAYS ARJASP IN THE BRAZEN HOLD

> Painting from Baysunghur's manuscript of Firdausi's *Shahnama*
> Herat, 1430
> Tehran, Gulistan Palace Library, MS 61, p. 401

Isfandiyar's role in the *Shahnama* is that of both prince and hero. His position parallels but surpasses Rustam's, and the growing rivalry leads eventually to a tragic end for both. Isfandiyar's earlier life is marked by achievement as well as disappointment: his father Gushtasp consistently promises him – and in public – that he will crown him shah in his own stead [124], but just as consistently he delays and prevaricates, and instead he sets Isfandiyar new tasks and responsibilities. Isfandiyar is sent forth to establish the faith of Zardusht – Zoroaster – in Asia; he is then set a series of seven supernatural trials – *khwans* – on the model of those performed by Rustam and Rakhsh, which he accomplishes by himself with open-eyed intelligence and skill; Gushtasp especially requires Isfandiyar's princely presence and his bodily strength in the conflict against Turan. Turan is now ruled by Arjasp and his abode is an impregnable fortress called the Brazen Hold. He has taken prisoner the sisters of Isfandiyar, and Gushtasp pledges that if his son will

> . . . go without disaster to Turan,
> Courageously confront the Dragons's breath,
> and free thy sisters from the Turkmans, I
> Will yield to thee the crown . . .

And Isfandiyar does go a second time to Turan, performing his seven *khwans* [72, 75] on the way to the Brazen Hold.

The Hold is ringed by an iron rampart so broad that four horsemen might ride abreast around its walls; it has only two gates, one facing in the direction of Iran and the other

towards China; and its garrison of 100,000 cavaliers willingly serves the Turanian ruler like slaves. Isfandiyar resorts to a ruse: disguised as a merchant, he smuggles eightscore men with weapons into the city in his chests of merchandise and seeks an audience with Arjasp. Finding favor, he then invites the king and his nobles to a great feast on the ramparts, offers wine in plenty, and when the company is drunk and night draws on, he kindles a great fire – the signal to his army outside to charge the Hold. Armed himself and with his smuggled men now also armed, he goes to Arjasp's palace, frees his sisters, and beheads Arjasp [cf. 87].

Baysunghur's artist(s) achieved a tour de force in their design for the Brazen Hold, setting Arjasp's throne room squarely in the upper right corner but deliberately angling the inner wall, a series of adjacent structures, and the outer rampart. The effect is extraordinary: not only may we see into all of these different parts of the Hold, but the tilted and skewed architecture vividly conveys the physical dislocation and the terror of armed invasion.

The effect is all the greater when we realize that the only figure actually using his weapon is Isfandiyar, as he cuts Arjasp down from his throne. The architecture in the lower half of the composition – moat, city wall, angled gangway, and a congeries of urban structures – can probably be traced back to paintings in one of Rashid al-Din's illustrated histories that survives only in fragmentary form [Fig. 58]. What, there, looked compositionally unsteady, here is taut and has the rock-solid assurance of intentionally tight, firm design; even the most haphazardly placed red railing, tilted tower, or overturned tile panel contributes to the disturbing atmosphere of a city under siege. The sisters, however calmly they appear to sit in their chamber – placed in the very center of the painting – also sit at a skewed angle, and the rug, the walls, the window, and the *pishtaq* of their chamber are equally skewed.

The decoration of the brick architecture is remarkable. Drawn again from the illuminator's repertoire, it is placed in just the areas that were, in Herat at that time, actually decorated with glazed tiles – portals, cornices, buttresses and towers. Moreover, because the structures within the painting are already so large, and because Timurid architectural decoration by this date was so profoundly influenced by the forms and patterns of the illuminator, the effect – for anyone who knew Herat before the destruction of the 1980s – is one of surprising reality, despite the tilted forms to which the decoration is applied. The appearance of the inscriptions written on the "glazed tile" decoration just below the cornice increases the sense of reality, but their content is surely intended for Baysunghur and is not especially appropriate to the episode. On the outer wall is the phrase "This is a depicted fort, . . . May God grant good life to its ruler, may the kingdom of its prince last forever;"[1] but Firdausi writes that, after Isfandiyar had

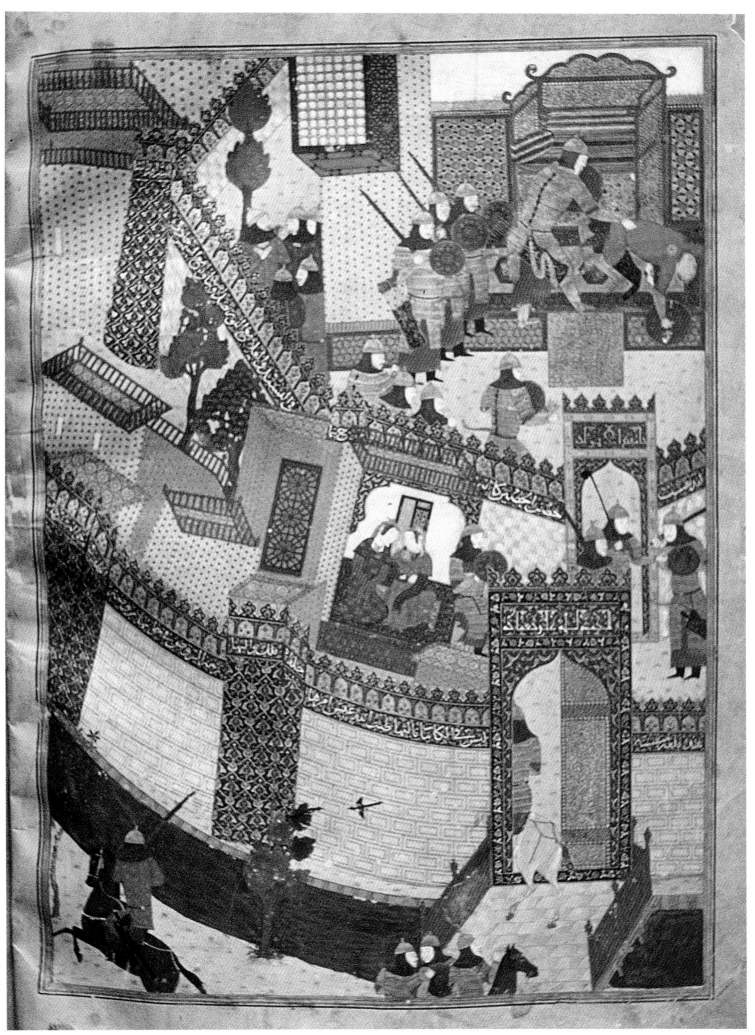

90

rescued his sisters, sealed the Treasury door, and taken horses for his men, he set fire to the Hold.

As for the other figures, Baysunghur's artist(s) observed the same sartorial convention used in "The Hosts of Iran and Turan" [8]: Turanians wear purple surcoats and Iranians golden lamellar cuirasses. Thus we know that it is a Turanian who gallops around the rampart at the bottom left, and Turanians who gather outside the palace; that an Iranian rides over the gangway into the Hold, and Iranians who see to the releasing of Isfandiyar's sisters, confer outside the palace, and accompany Isfandiyar into the throne room. The artist has left us the final word in the inscription on the cornice of the palace, anonymous although it remains: "I drew this well-fortified fortress . . . rivalling the sun in its exaltedness."[2] Indeed the painting was never rivaled by repetition: it is unique.

91. HULAGU AND THE MONGOLS BESIEGE ALAMUT

Painting from a partially dispersed manuscript of 'Ala al-Din 'Ata Malik Juwayni's *Tarikh-i Jahangusha* (*History of the World Conqueror*)
Shiraz, 1438
H: 18.7 (maximum 21.3) cm; W: 12 cm
Paris, Bibliothèque nationale, Suppl. pers. 206, fol. 149r

In the intellectual climate of Ibrahim-Sultan's Shiraz, where relatively recent Turco-Mongol history was being poured into the Persian literary mold of Sharaf al-Din's *Zafarnama* [25, 59], and then illustrated in a style that was itself a Turco-Iranian development unique to Fars Province, it is not surprising that Juwayni's *Tarikh-i Jahangusha* should also have been illustrated in the same city. The text is a great Persian literary work, a model of historical writing devoted to the exploits of Chinghiz Khan and the first Turco-Mongol invasion of Iran [198].

Just who at that time might have commissioned such a manuscript, and one with pictures, is unknown: today the volume is partially dispersed and its opening no longer survives although, on the colophon page, the scribe signs his name and tells us that the copying was completed in the year equivalent to 1438. Thus it was probably made for someone connected with Ibrahim-Sultan in some way, but without either the taste, the resources, or both, to command the making of an illustrated manuscript of the impressive size of Ibrahim-Sultan's *Zafarnama*. Instead, Juwayni's fine prose-history is here illustrated by a charming, mannered, and almost toy-like version of Ibrahim's large, stark, spare illustrative style, with pictures that rarely approach the entire text-surface within the rulings. This image is the exception.

The subject is the Mongol attack on the

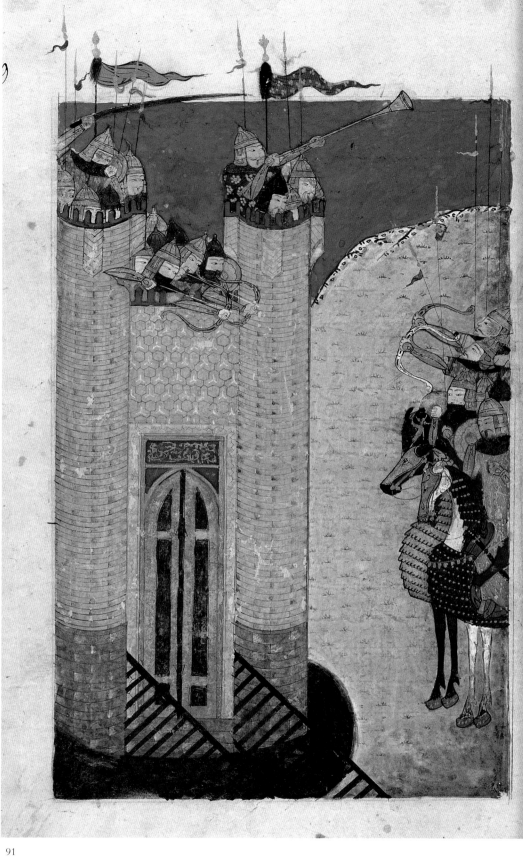

91

fortress of Alamut, the stronghold of Hasan al-Sabbah, leader of the Isma'ili sect known as the Assassins. Spare in esthetic and simplified in its elements, the picture consists of a castle, on the left, being defended by an army at the ramparts and besieged by a mounted army at the right. In true Shiraz-Timurid fashion, few represent many: the besieging "army" is three mounted men and two archers, and the defenders comprise three archers above the portal, and a trumpeter, and several flag-

bearers on the flanking towers, the ranks then apparently swelled by a number of helmeted heads.

The fortress is of the usual orange-pink brick with a stone foundation, a moat, and an angled gangway; it appears to stand in a hollow behind the usual high Shiraz-Timurid horizon line, although in reality the fortress of Alamut stands at the summit of a towering mountainous spur and the approaches are steep and covered with scree. Again, the source

of the composition is at least as old as the
thirteenth century [2]; that it should emerge
in Shiraz, by then the scene of several
centuries of intense pictorial activity in
manuscripts, is probably one more indicator of
the persistence of certain Iranian visual
formulations within the imagination of Shiraz
painters.

92. THE CITY OF BAGHDAD

Painting from a manuscript containing
selected lyrical poetry of contemporary
poets
Shamakha (Shirwan), 1468
H: 23 cm; w: 12.7 cm
London, The British Library, Add. 16561,
fol. 60r

A small Turkman-style anthology consists
of selections from the works of eleven
fourteenth- and fifteenth-century poets,
including Hafiz and Jami. It is a splendid
example of the art of the fifteenth-century
Iranian book, written on brightly colored,
highly polished, gold-spattered paper in
alternating colors of lavender, fuschia, and
chartreuse, with nine small and finely executed
pictures. Being localized, in Shamakha
(Shirwan, in Azarbayjan), and dated in the year
1468, it testifies to the currency of literary
culture in Turkman Azarbayjan, to the
spread of Timurid notions of the beautiful
manuscript, and to the reach of the Turkman
variations on the themes of Timurid painting
[26, 95].

Baghdad, the former capital of the
Caliphate and still the premier city of Iranian
'Iraq, figures in a painting accompanying
poetry by a certain Nasir, a darvish from
Bukhara. Visiting Salman Savaji in Baghdad in
the reign of the Jalayirid Sultan Uways,
between 1356 and 1374, at a moment when
the Tigris was in flood, he was moved to
write a *ghazal*, a lyrical poem, on the event.
The painting does not really show Baghdad at
flood tide but simply the city itself, with its
brick and tiled architecture, the river, and
especially the famous bridge of boats. Other
vessels ply the river leisurely, and people swim
in it, piling their clothing neatly on the shore;
a man in a looped white Arab-style turban sits
on a tiled bench outside a house on the
riverfront and converses with someone in the
doorway.

The buildings on the near side of the shore
are remarkable. The brick architecture is a
sandy tone, which is already different from
the pinky-orange brick of generically Iranian
buildings; the tile decoration is predominantly
turquoise and white – the turquoise of a
greener hue than on Iranian or Central Asian
buildings in Iranian painting. The shapes of
the domes, and the typical Baghdadi minarets
with white exterior *muqarnas* surfaces, both
convey the "foreign" atmosphere of the
ancient city on the Tigris.

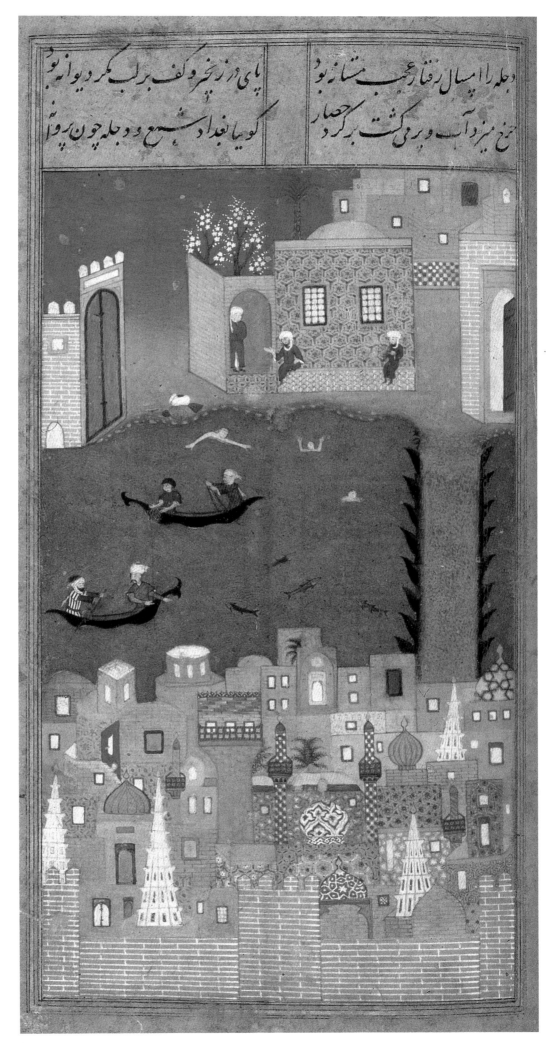

92

93. THE BUILDING OF THE GREAT MOSQUE OF SAMARQAND

Double-page painting in Sultan-Husayn's manuscript of Sharaf al-Din 'Ali Yazdi's *Zafarnama*
359v H: 19.9 cm; W: 12.1 cm
360r H: 20 cm; W: 12.5 cm
Herat, 1480–85
Baltimore, The Milton S. Eisenhower Library of Johns Hopkins University, John Work Garrett Collection, fols. 359v–360r

Returning victorious from a campaign of conquest in northern India in early 1399, Timur was already planning the construction of a huge mosque in Samarqand. He had brought back with him stonecutters, and ninety-five elephants, in anticipation of hauling stone from quarries to the building site. The foundations for one of the largest mosques ever built anywhere in the Muslim world were laid in May of the same year.

Progress was not unhindered: changes were made during the course of construction and, once the edifice appeared to be finished, work was restarted in 1404, at Timur's orders. Clavijo describes Timur in that autumn, no longer able to ride but being carried to the mosque every morning; he would stay for the best part of the day, feeding the workmen himself, and only ceased to visit when the snow began to fall. What Sultan-Husayn's painter depicts is drawn from Sharaf al-Din's textual description; what he also paints is the very process of building itself, all the kinds of manual labor that went into making Timur's "lofty, blessed" mosque. It is no surprise that the anonymous painter is usually assumed to be the "second Mani," Kamal al-Din Bihzad, and at a stage quite early in his career [33].

An open courtyard, with a portal in the course of construction and an arcade resting on white marble columns behind it, is shown in a kind of perspective. The walls to the left of the portal are only several courses high, so that the left side of the arcade can also be seen, at the top left of the left-hand picture. What looks like the stump of a minaret of the classical Timurid kind, of brick and decorated with alternating staggered rows of ogival

glazed tiles, seems inexplicable until Sharaf al-Din's comment is recalled – that four lofty minarets stood in each of the four corners of the building: a part of one was painted into what is, after all, the corner of the building.

To the right of the arcade in the left half of the picture is the bare brick wall of the *mihrab*, or prayer niche, to be faced with the white marble slabs being cut and carved inside the courtyard. More marble arrives in the left foreground, on a cart dragged by a horse and on the back of one of the mountainous elephants from India; slabs already unloaded are being carried through the foreground to the portal area. There, workmen mix mortar and carry bricks up a ladder, where other masons lay bricks into place above the portal arch. Five well-dressed men stand under the arcade at the left side of the picture, or in the courtyard; one holds a staff, standing beside a younger man in a crown who carries a *mandil*, or handkerchief. Sharaf al-Din again provides the clue: they are the Timurid princes and amirs, whose job it was to supervise the building of Timur's lofty, blessed mosque.

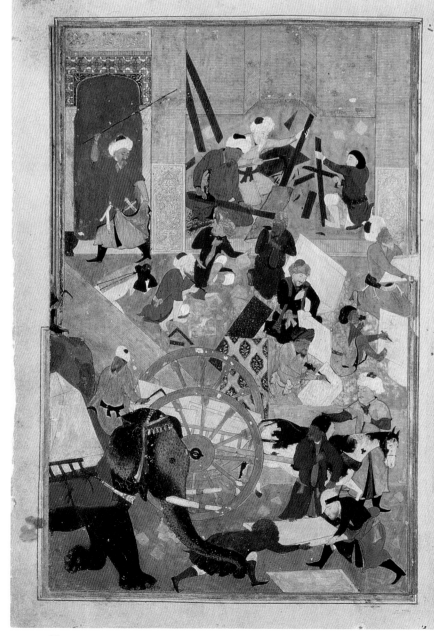

94. THE BUILDING OF THE CASTLE
OF KHWARNAQ

> Painting in a manuscript of Nizami's
> *Khamsa*
> Herat, 1494–95
> H: 17 cm; W: 12.4 cm
> London, The British Library, Or. 6810, fol.
> 154v

The double-page picture in Sultan-Husayn's
illustrated *Zafarnama*, "The Building of the
Great Mosque of Samarqand," was compressed
into a single-page painting to illustrate "The
Building of the Castle of Khwarnaq" in Sultan
'Ali Mirza Barlas' *Khamsa*.

This image lacks the specific architectural
setting of the *Zafarnama* picture, in the same
way that it is without the specific textual
program of the *Zafarnama*. Here, the central
focus is instead the hexagonally portal whose
pishtaq is being completed; it is still in the
midst of construction and nothing
recognizable as ornament is anywhere to be
seen, nor is there any suggestion of even a
single dome – let alone seven [89]. Lacking
any real textual connection, the true subject of
this picture is the ordinary workmen who
build Simnar's "silvery palace of stone and
clay."[1] They mix mortar and cut stone, haul
and drag the shaped pieces, lay bricks at the
top of the portal, which they reach by
climbing a ladder leading to a scaffold of tree
trunks lashed together.

The groups of men laying bricks and
mixing mortar repeat groups already worked
out in "The Building of the Great Mosque
. . . ," although the figures themselves have
been adjusted and their clothing altered. Some
display a lack of finish but others are quite
individualized: the man in the striped turban
standing at the top of the scaffold cutting
stone, the bricklayer at the top margin of
the picture, the man below him who hauls
up a load by means of a striped rope, the
stonecutter at the left margin, and the water-
carrier at the bottom. On the other hand, the
stones being cut at the base of the building
are quite indistinct and it is hard to imagine
just where, on the building here portrayed,
they might eventually be placed.

Such divergencies in finish suggest that
while the pictorial idea, and its formal
composition, have as a source the artist who
so exuberantly illustrated Sharaf al-Din's "The
Building of the Great Mosque" – whether or
not it was Kamal al-Din Bihzad, this picture
was not fully executed by him.

94

95. JALAL SEATED BEFORE JAMAL'S
CASTLE ON MOUNT KAF

> Painting in a manuscript of Asafi's *Dastan*
> *Jamal u Jalal*
> Tabriz, around 1504
> H: 30.8 cm; W: 19.6 cm
> Uppsala, University Library, O Nova 2,
> fol. 70r

Muhammad of Sabzavar, whose pen-name was
Asafi, was another of the Herat circle of poets
and men of letters at the court of Sultan-
Husayn. His *Tale of Jamal and Jalal* exists in
a unique illustrated manuscript copied in
Herat and completed in the years 1502–3.

The *Tale of Jalal and Jamal* is faintly infused
with the sufi search for unity in the form of
a beloved, but it seems far from the exalted
seriousness of a contemporary sufi poet such
as Jami. Jalal's beloved Jamal is the daughter
of the king of the fairies, and long before

he reaches her abode on Mount Kaf, she
encourages his quest by visiting him in the
guise of a series of birds – a turtle-dove, a
parrot, a peahen. He is assisted by a servant
called Faylasuf, "philosophy," and his path is
hindered by all the wonders and the obstacles
of romantic literature: he must slay poisonous
birds and demons, some in the form of
dragons; travel to deserts and wastelands, pass
by mountains of metal and trees whose leaves
all bear the name of Jamal, converse with
talking flowers and a drum; and even kill
hostile members of his own family, before he
obtains the hand and love of Jamal, the object
of his desire.

Jamal's castle is a splendid red-brick
structure forbiddingly closed by a pair of
narrow doors at ground level but blossoming
into open loggias, shuttered balconies, and a
turret surmounting the roof-pavilion. As
always in the best of Turkman painting, a

structural logic underlies the unreal appearance of the building, and Jamal and her suite of winged attendants seem perfectly ensconced in the loggia and on the roof-pavilion.

The manuscript's fine calligraphy is the work of a certain "Sultan ʿAli," and because the colophon explicitly names the *dar al-sultanat, herat*, only faint doubts have been expressed that the scribe could not have been the celebrated Sultan ʿAli *al-mashhadi*, who worked for both Sultan-Husayn and Mir ʿAli Shir, and who copied, among other splendid late Timurid manuscripts, Sultan-Husayn's

illustrated copies of the *Mantiq al-tayr* [60, 168] and the *Bustan* [248].

Yet the exuberant and dynamic landscape of many paintings throughout the manuscript proclaims the western Iranian provenance of this poetical work composed in Khurasan, in the east. None of the thirty-four paintings is signed, but the hand of the foremost of early Safavid painters, Sultan-Muhammad, has been discerned in the most striking of them; while a double-page battle scene clearly derives from the more provincial Shiraz-Turkman tradition of the second half of the fifteenth century.

96. NUSHIRWAN AND THE OWLS

Painting in Shah Tahmasp's manuscript of Nizami's *Khamsa*
Tabriz, 1539–43
H: 30.4 cm; W: 19.4 cm
London, The British Library, Or. 2265, fol. 15v

The opening illustration in Shah Tahmasp's magisterial copy of Nizami's *Khamsa* is a vision of the fragility of mankind's creations: it shows a once-splendid structure of brick, with once-glistening tiled revetments on its interior courts, falling into pieces from neglect, bad management, and oppressive taxation.

The opening poem of Nizami's *Khamsa* is entitled *Makhzan al-asrar*, a *Treasury of Mysteries*, and it is a series of twenty ethical discourses each followed by an illustrative moralizing tale. The second discourse advises kings to uphold justice and ends with an account of the Sasanian shah Nushirwan, who became separated from his hunting party with only his vizier for company. Finding themselves in a ruined village, they hear bird-sounds and the shah asks what the argument might be. The vizier replies that the pair of birds is discussing the marriage settlement that the daughter of one would bring to the other, who then says that if the present governance of the shah should continue unchanged, not only would this ruined village revert to the birds but a hundred thousand more. Nushirwan is duly remorseful and changes his ways, and "the hope of kindness spread over the country."

In the best of courtly Safavid visual traditions, instead of a humble ruined mud-brick village, Mir *musawwir* (the painter), who signed and dated the painting in 1539–40, has painted a large and splendid palace, although it is now abandoned to snakes and owls, stray dogs and grazing deer. Grass and weeds grow inside the octagonal pavilion, water pours through the crumbling outer walls, chunks of the exterior brick and tiled wall lie at the foot of the pavilion, and a family of storks has made a huge nest at the summit of the broken wall. On the cresting of the pavilion, just inside the left margin and silhouetted against the cloud-streaked sky, sit the owls whose conversation is the point of the tale.

The ruined palace occupies virtually the entire left half of the picture. The questioning, gesturing shah, mounted on a chestnut horse, dressed in bright orange and wearing a golden crown, is placed in the virtual center of the picture, above his more soberly dressed vizier, mounted on a dappled ass. The landscape at the right includes all the classical features – the piled-up mass of boulders with their humanoid silhouettes, the silver stream that emerges from the rock and falls gently down to a rock-bound pool from which it flows quietly until the next declivity, the clumps of flowering vegetation at its banks, and the purplish unwatered desert ground. At the top right of the picture, a bending fruit tree in

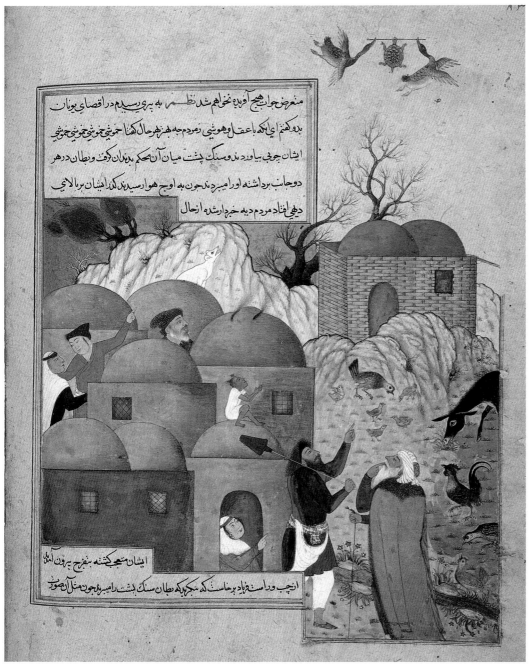

who look up to point at the avian oddity; sixteenth-century versions usually expand the image with a generic architectural setting.

A princely variation – unusual for this story – is found in Ibrahim Mirza's somewhat earlier *Haft Aurang*: well-dressed nomads in Safavid court turbans, in front of a large and richly patterned tent with a bulbous top, stare at the ducks and the tortoise flapping lazily in a golden sky at the upper right of the picture.[1] By contrast, this small *Anvar-i Suhayli* manuscript sets the scene in a contemporary Iranian village of mud-brick houses with domed roofs, but the picture retains the kernel of the composition: a crowd staring at the same flying group, in the same position within the picture.

The village is rendered in dun, brown, and grey, the various tones differentiating the similar buildings, all with small latticed windows set high in their walls; smoke rises from the roof of one, no doubt the village bakehouse. In the distant upper right is a fired-brick structure with two domes. A donkey grazes in the fields beyond the village, and chickens scratch at its feet, but every other living being gazes upwards at the ducks and the tortoise in the bare margin of the page. Two white-veiled women, one young and the other an old crone; a white-bearded elder leaning on a stick; a middle-aged man with a greying beard; a black-bearded farmer, and a youth; even the child perched on a dome in the foreground and a howling white dog on another dome at the far end of the village: each one, by this date, a standard figure in the broad repertoire of the Iranian painter's human comedy.

If this "Flying Tortoise" can be seen as a paraphrase of a picture in one of the great princely manuscripts of the previous generation, it is also clearly one in which the full range of human types is set in a modular assemblage of smaller motifs also already used for several centuries by Iranian manuscript illustrators. The domed brick building in the lee of the hills in the background of a picture [15], and the white dog on a domed roof of a village [109] can both be easily paralleled; while all the elements of the landscape – the rock-edged stream running at a shallow diagonal in the fields, the spade-shaped tamarisks at the upper left, and the bare branching tree behind the two-domed building – are typical of Iranian painting for well over a century, and also unremarkable.

What makes the image memorable is the subtle handling by a skilled painter who was also a true pictorial narrator, comfortable working within the conventions of Iranian landscape painting but also able to manipulate spaces both within and outside of the marginal rulings of a manuscript illustration. He avoids bright colors and includes no passages of architectural ornamentation inappropriate to a village setting. He scales figures to the architecture they inhabit, so that the entire scene is a coherent and believable picture of a contemporary Iranian village that

97

blossom suggests that all is not ruin and desolation, even though, in the foreground, a pair of woodsmen – no doubt from the court party, judging by their donkey's saddle-cloth – cut down living trees for firewood.

97. THE FLYING TORTOISE

Painting in a manuscript of Husayn ibn ʿAli al-Vaʿiz al-Kashifi's *Anvar-i Suhayli* (*The Lights of Canopus*)
Qazvin or Isfahan, 1593
H: 30 cm; w: 21 cm (folio)
Geneva, Collection of Prince Sadruddin Aga Khan, fol. 89v

There is no doubt that all the illustrations of the *Anvar-i Suhayli* of 1593 [79, 112, 210] are the work of one person, whether or not it was the court librarian of Shah ʿAbbas I,

Sadiqi Beg. Whoever the artist, he did provide settings of great visual immediacy that convey the humbler side of contemporary Iranian town and village life. "The Flying Tortoise" is an excellent example.

The pithy moral of this core story of the *Kalila u Dimna* cycle – that silence may preserve one's life – is contained in the tale of the tortoise who was devastated when the two ducks in her pond decided to seek wetter waters. As they would fly to their new home, they offered to take the tortoise with them by carrying in their beaks a stick onto which she could firmly fasten her jaws. This curious trio rose into the air, to the visible astonishment of the villagers they were leaving behind; the foolish tortoise opened her mouth to salute them – and fell to her death. The flapping ducks and their shelly cargo on a stick are the fundamental image of this ancient story, with at least one, if not several, amazed spectators

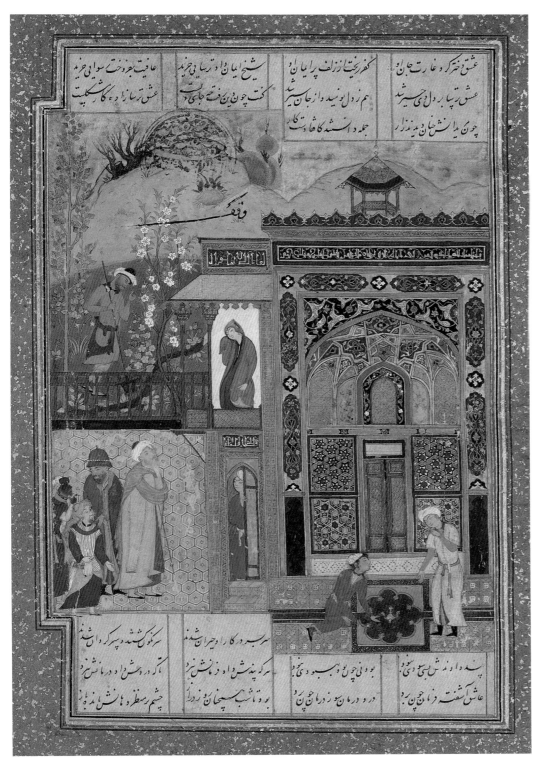

98

comment pictorially upon this encounter [60, 168]. More straightforwardly narrative are three of the four pictures painted in the blank spaces left in the manuscript when, sometime before 1609, it was refurbished at the order of Shah ʿAbbas I, to prepare it for donation to the Safavid family shrine at Ardabil.

The story of Shaykh Sanʾan of Mecca and the beautiful Christian maiden is the last parable told by the hoopoe to the thirty birds before they set off on their journey, and it is told at some length. In Sultan-Husayn's copy, this is perhaps reflected in the fact that two illustrations were planned for it: one for the event – when the shaykh sees the Christian maiden, whose beauty instantly causes him to fall in love with her and for whom he abandons Islam and his saintly status in Mecca; and one for the denouement – the maiden's death in the company of the shaykh and his disciples.

The Meccan party has traveled to Rome, in hope of resolving the mysteries of a dream recurring, night after night, to the shaykh. There they encounter the dark-haired maiden, at the sight of whom the shaykh is struck dumb with love. His disciples are equally stricken:

> They stared, confounded by his frantic
> grief,
> And strove to call him back to his belief.
> Their remonstrations fell on deafened ears;
> Advice has no effect when no one hears.
> In turn the sheikh's disciples had their say;
> Love has no cure, and he could not obey.[1]

The Roman scene is given a contemporary Iranian urban setting, the shaykh and his party standing on a terrace beside a red-fenced garden [82, 126] surrounding the large and handsome building where the maiden stands at an upper balcony. She is carefully placed: framed, above and below, by Sultan ʿAli *al-mashhadi*'s beautiful calligraphy in the classical arrangement of four columns of poetry. The pictorial space is organized so that the building occupies the width of three full columns of text, and the maiden, dressed in red and standing against an unadorned white ground, stands just to the left of the horizontal center of the picture and just above its vertical center.

The two-story structure is presented as a large *iwan*. Inside it, on the lower level is a wall with a wooden door at its center; on the upper level is a deep open hall with a low balustrade. The architectonic composition of the interior at both levels is precisely that of the small sixteenth-century palace in Nayin [86]; while the structure, and the coloristic effect of golden ribbing separating brightly colored geometrical shapes, both call to mind the grander Safavid palaces built in Isfahan in the seventeenth century.

might be anywhere in the land. Lastly, the slight decrease in the size of the fired-brick building in the background lends an impression of distance, as elsewhere the painter is able to approach the perspectival depiction of an architectural background [112].

98. SHAYKH SANʾAN SEES THE CHRISTIAN MAIDEN

Painting added to a late fifteenth-century copy of Farid al-Din ʿAttar's *Mantiq al-Tayr* (*Language of the Birds*)
Isfahan, before 1609
H: 18.8 cm; W: 11.5 cm
New York, Metropolitan Museum of Art, 63.210.18

The four fifteenth-century paintings in Sultan-Husayn Bayqara's copy of ʿAttar's great mystical poem are all composed on a particular pattern: they illustrate a brief verbal exchange between two persons, and they then

99. THE HEAD OF IRAJ PRESENTED TO HIS BROTHERS SALM AND TUR

Painting added to a late sixteenth-century copy of the *Shahnama* of Firdausi probably commissioned by Shah ʿAbbas I on his accession
Isfahan or Ashraf, 1675–76
H: 24.9 cm; W: 19 cm
Dublin, Chester Beatty Library, P. 277, fol. 10

This remarkable picture, neither signed nor dated, is one of two paintings added to a fragmentary copy of a *Shahnama* associated with Shah ʿAbbas I [80], nearly a century after the (presumed) date of the parent manuscript. The other picture has the signature of Muhammad Zaman and a date equivalent to 1675–76, so it is reasonable to assume the same hand and a similar date for this most original depiction of an early episode in Firdausi's text.

The subject is the deed from which springs, for Firdausi, the primal conflict between the Iranians and the Turanians – the slaying of their youngest sibling by his two elder brothers. Salm, Tur, and Iraj were the sons of Faridun, who had overcome the evil tyrant Zahhak and bound him in chains for eternity in a narrow gorge on Mount Damavand. In due course, Faridun's sons married the three beautiful daughters of the Arab king of Yemen, and Faridun divided the realms over which he held sway between the three. To Salm was given "Rum," Rome, and the west. To Tur went the land of the Turks – which historically lay east of Iran – and Chin. But to Iraj went Iran and Arabia, and "the throne / Of majesty and crown of chiefs he gave, / Perceiving that Iraj deserved to rule." Time passed: Salm and Tur grew jealous of Iraj's pre-eminent position and wrote to their father to complain but, displeased with his answer, they convened a parley among the three brothers. Discussion gave way to action: Tur's temper flared and he attacked Iraj, first smiting him with his massive golden throne and then cutting off his head, which the brothers then wrapped in painted silk and sent to their father. In this way does Firdausi embody the historical fact of the enmity between Iran and Turan [7, 8]: it expresses itself in constant conflict over the issues of sovereignty and territoriality, language and culture which still characterize relations between Iranian and Turanian peoples, notwithstanding centuries of intermarriage and coexistence.

Muhammad Zaman's version of this most significant event ignores Firdausi's text and looks elsewhere for a pictorial model in which a severed head also appears. The true originality of the picture lies in the brilliant combination of Iranian and European features in one image. Iranian clothing is worn by the protagonists of what is an Iranian story; the architectural setting – underneath its apparent Italian sixteenth-century lines – actually affords a view of the Chihil Sutun and its columned porch, or *talar* [Fig. 80], with a small pool on

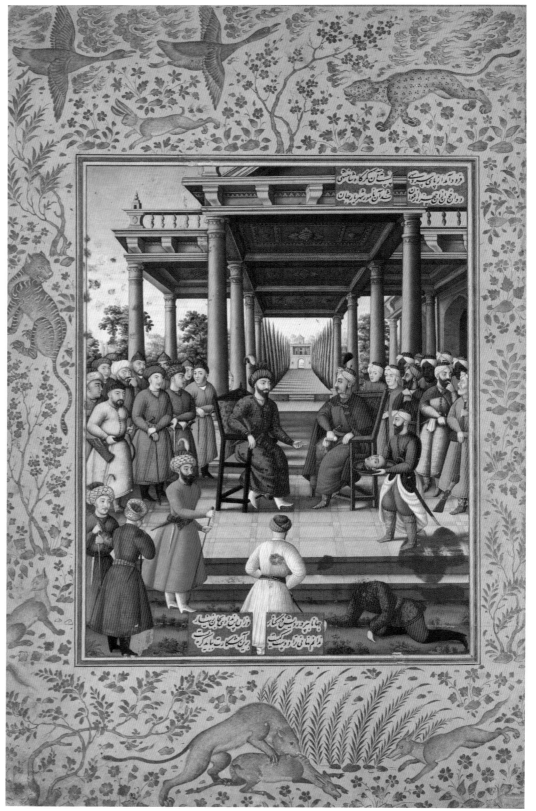

99

the platform, set in the midst of gardens as it must have looked in the later part of the seventeenth century. The composition is European, as is, surely, the underlying image of the head of Iraj on a platter, just as the head of St. John the Baptist is sometimes shown in Mannerist Italian and Flemish art of the sixteenth century; as well as the view of the executioner, in the foreground but seen from the rear. The architectural decoration is European, and so are the pictorial conventions of blue sky and green earth, the cast shadows,

long vistas, and the diminution of objects in the background, as well as the hazy bluing of these objects and the lightening of the sky at the horizon. The overall palette is light and brilliant – surprisingly similar to that of Italian Mannerist paintings; the unpatterned garments of the attendant crowd provide accents of solid color in the middle zone of the picture.

The clothing should be noted: few figures save the three protagonists wear truly fashionable Iranian attire of the later seventeenth century; instead, turbans and *jama*s

are simplified and cast in a kind of archaic mode, as if to acknowledge that the event took place in the very distant past. But the uncanny resemblance of this columned and balustraded porch to the Chihil Sutun *talar* and its gardens, with the long double row of cypress trees leading to the pavilion at the rear, brings us back to seventeenth-century Isfahan; while the building abutting the Italianate loggia, just visible at the right of the picture, confirms the Iranian setting: it appears to be an *iwan*, tall and with a pointed arch.

100. SIYAWUSH CAPTIVE
BEFORE AFRASIYAB

Painting from a manuscript of Firdausi's *Shahnama* copied and illustrated between 1663 and 1669
Isfahan (?), 1696
H: 47 cm; w: 28.3 cm (folio)
New York, The Metropolitan Museum of Art, 13.228.17, fol. 110v

It is not unusual for Persian manuscripts with illustrations to have been copied, illustrated – or both – over a long period of time. The volume in which this interesting picture occurs is a good example: the text has dates between 1663 and 1669 but its forty-two illustrations seem only to have been painted three decades later. They display a dissimilarity of styles and qualities whose coexistence, acceptable in the seventeenth century in Iran, seems jarring to the modern eye.

This picture of the Iranian prince Siyawush standing, in the right foreground with his hands bound, captive before the Turanian king Afrasiyab, is not signed in the strict sense of the word. But together with the date of 1107, equivalent to 1696, is written the phrase *ya sahib al-zaman*, "O lord of time," that is often associated with Muhammad Zaman. The same phrase is also found on two other paintings in the same manuscript, although the features most consistently associated with paintings indisputably signed "Muhammad Zaman" are only found in this picture.

Most of these features are landscape elements: the large tree with oak-like foliage in the left middle distance [220], and the more slender tree in the distance, with "clouds" of foliage clumped more broadly at the top. A European feature broadly adopted as an "exoticism" by Iranian painters in this century and later is the red drapery at the top of the painting, with a heavy red tassel; this motif had no doubt been circulating in Isfahan from the time of the presentation of oil-painted state portraits of King Charles I of England and his consort in 1638.

It is true that the composition is based on Muhammad Zaman's "Head of Iraj Presented to Salm and Tur," whence come also the double row of cypress trees leading to a two-story pavilion in the distance viewed from the shelter of a columned terrace, the pool of water in the middle distance, and the figures gathered in the middle of the painting and dressed in unpatterned clothing of strong colors and stylistically simplified lines. What is disturbingly unlike Muhammad Zaman's pictures is the quality of this painting, with its mediocre drawing, muddy colors, unaligned perspective, and the absence of blue-hued distances: it is hard to accept that such a picture could be any more than lightly influenced by this most important of later Safavid artists.

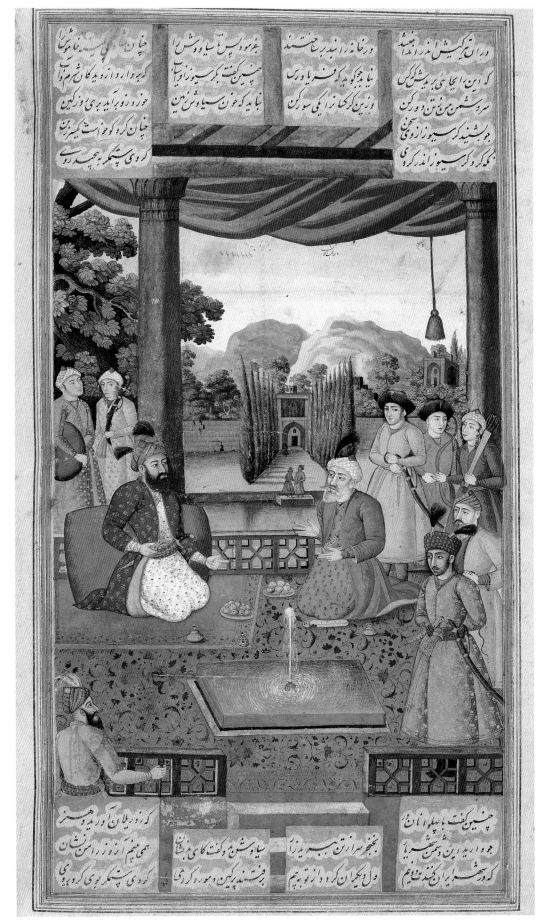

100

101. FIGURES IN AN INTERIOR

Fragment of a wall painting, lost and
probably destroyed during World War II
Iran, twelfth–thirteenth century

Ten men stand in an elaborate architectural
interior apparently built of brick, with arches
of several shapes and sizes, a balustrade, and
some kind of large circular panel. This panel,
curiously, is set below the level of the heads
of the large group to the right; at least one
more head, smaller than the others, is
silhouetted against it. Possibly two more
figures, kneeling, may be discerned in the area
above the balustrade, at the upper left, where
the niche appears to have a broken profile
such as is known from the fourteenth-century
mausoleum of Oljaytu at Sultaniyya.

The standing figures wear knee-length
front-closing garments, sashed at the waist and
with *tiraz* on the forearm; the headgear is
indistinct but seems to be caps rather than
turbans, and the footwear is high black boots.
The faces are quite round; the heads, often
inclined towards the next figure, create a sense
of dialogue despite the badly damaged paint
surface. Perhaps the painting was never
finished: the head of the figure at the lower
left shows only the rounded face, set off by a
small nimbus, which is typical for all the
figures on this extremely ruined but
suggestively detailed picture of an elaborate
interior.

The architectural decoration is rendered in
great detail. The palette is lost forever, but
the drawing is precise and shows a number
of decorative motifs on a major scale. The
spandrel at the right of the large circular shape
may have been of stucco; the hexagons in
the circle might have been glazed tiles; a
geometrical pattern that could be interpreted
either as tiles or brick seems to fill the round-
headed arch roughly in the center of the
composition, while the brick pilaster just
to the left has some kind of a foliate capital
whose material is uncertain.

Yet of the quantity of brick-built Seljuq
architecture still standing in Iran (despite the
Mongol invasions of the middle thirteenth
century), and of many post-Seljuq buildings,
none suggests an immediate parallel for any of
the features so carefully drawn in this ruined
wall painting; especially unusual is the round-
headed arch. Whether it was an architectural
fantasy, or a picture of a kind of Seljuq palatial
interior that simply no longer survives, is
impossible to say.

Nonetheless, even in so fragmentary a state,
this picture adds considerably to our
appreciation of the figural arts of Seljuq Iran,
including the notion of qualitative variation.
It is very specific in its representation of an
elaborate interior, very broad in the
disposition of its figures, and much finer in its
figural draughtsmanship than are the few other
fragments [38; Fig. 53] known to survive from
this period.

101

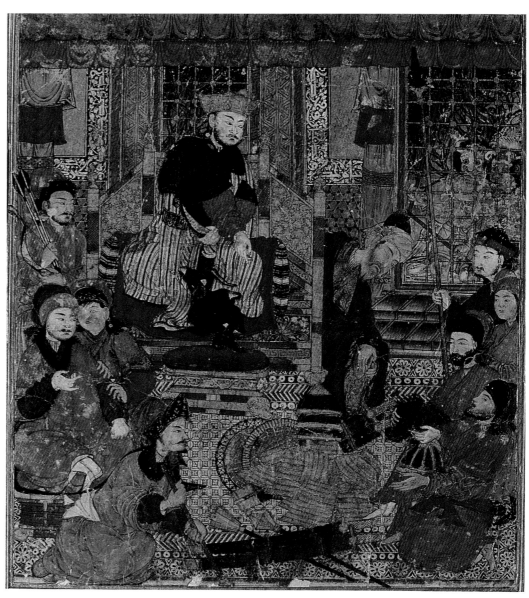

102

102. KAY KHUSRAU VICTORIOUS OVER THE *DIVS*

Painting removed from a manuscript of
Firdausi's *Shahnama*, now mounted in an
album
Tabriz or Baghdad (?), ca. 1325–35
H: 22 cm; W: 19 cm
Istanbul, Topkapı Saray Museum, H. 2153,
fol. 55r

An extraordinarily detailed Ilkhanid princely
interior is the setting for a subject rarely, if
ever, illustrated in copies of the *Shahnama*: Kay
Khusrau victorious over Ahriman and the *divs*
at the castle of Bahman. Firdausi writes that
Kay Khusrau then erected the fire-temple of
Azargushasp beside the castle, returning there
for ceremonial events several times during his
long reign.

A crowned prince on a throne decorated
with large golden lotus blooms leans forward
to acknowledge the presentation of arms and
armor taken in battle: casques and lamellar
body armor, shields, swords, and maces. An
attendant at the left carries two arrows, and a
man leaning into the picture at the right
holds a lance. At the window behind him two
divs peer through the grille and one also holds
a broken lance, symbolizing defeat. Their
presence, and the verses from the *Shahnama*
written in large, fine white letters on the blue
frieze surrounding the window niche in
which the throne is placed, have together
permitted the true subject to be identified.[1]

The setting is visually descriptive, almost as
if a specific princely interior were reproduced.
The window is long, with a low stone or
brick sill; its grille is composed of short bars
set at cross-directions and held together by
round metal balls at each juncture. The lower
part of the wall is covered with interlocking
six-pointed stars in two colors, hexagonal tiles
in staggered rows with shared points
composed of the interstitial triangles. Above it
is the painted blue and white inscription-
frieze running around the throne window,
framed with part-opened shutters of an
apparently geometrical pattern. Virtually all this
architectural decoration can be paralleled
in the interior of the most monumental
of surviving Ilkhanid princely buildings, the
mausoleum of Oljaytu at Sultaniyya. Textiles
hung above the throne and around the
windows, and the floor-textile thick with
guard bands, enhance the richness of the
setting. Again, as with certain paintings from
the "Great Mongol *Shahnama*" [58, 124, 150],
the impression is that the painter drew on the
kind of royal buildings he knew in creating
this impressive image.

Recent scholarly work has increased still
more the "charge" carried by this picture. The
texts in white on the blue frieze are, at the
right, the opening verses of the *Shahnama*,
and at the left, an abridgment of a verse
close to its end: in essence a verbal summation
of Firdausi's great work, which the same
scholar has documented as a work of the most

profound importance in Ilkhanid Iran's
intellectual and religious life. From the days
of Abaqa Khan, the men of greatest influence
over the Ilkhanid rulers of their land were
highly educated Iranians of remarkable talents,
especially the Juvaynis, and Rashid al-Din. It
was surely 'Ala' al-Din Juvayni [91, 198], vizier
to Abaqa Khan, who suggested the rebuilding
of a palatial structure at the ruins of the
ancient fire-temple of Azargushasp, Sasanian
Shiz but called, by the Ilkhanids, Takht-i
Sulayman. Excavations there have uncovered
not only seals confirming that it was the site
of the Sasanian fire-temple, but also many
Ilkhanid luster-painted tiles with *Shahnama*
inscriptions, or figural compositions deriving
from it.

More recently, the painting has been
proposed as having originally been intended
for the "Great Mongol *Shahnama*" – a
manuscript now widely dispersed and with
many gaps, it should be recalled. According
to this interpretation, its illustrations are to be
understood as a pointed visual commentary
on the entire Ilkhanid reign, this picture being
uniquely apropos for Abaqa Khan, who had
re-established an Iranian princely presence at
the site of the great Sasanian fire-temple.

103. THE THIEF IN THE BEDCHAMBER

Painting from a manuscript of Abu'l-
Ma'ali Nasr Allah's animal fables called
Kalila u Dimna, preserved in an album
made for Shah Tahmasp
Baghdad or Tabriz, ca. 1360
H: 32.7 cm; W: 22.8 cm
Istanbul, Istanbul University Library,
F. 1422, fol. 24r

Fifty pictures from a mid-fourteenth-century
copy of Nasr Allah's Persian translation of
the animal tales called *Kalila u Dimna* are
mounted in Shah Tahmasp's celebrated album.
They may be all that remains of an equally
celebrated manuscript [203; Fig. 61], painted
by the legendary fourteenth-century painter
Ahmad Musa, who is mentioned in the
written preface to another album made for
the shah's brother, Bahram Mirza, by its
compiler, Dust Muhammad.

Many of the fragments are mounted
two to a page; this splendid picture and its
accompanying text represent the only
surviving complete page and it was mounted
by itself in the album. The text recounts the
end of the story of the rich man and the
thief: a thief on the roof of the house of a

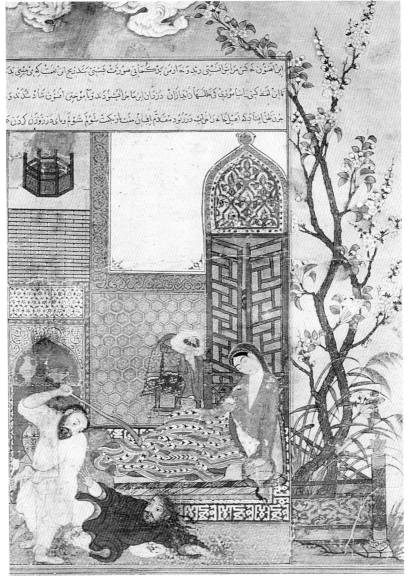

103

rich merchant overheard the merchant telling his wife, as a ruse to snare the thief (the sound of whose feet he had heard on the roof), that the secret of his wealth was a magic formula enabling him to make solid the rays of the moon, on which he could then enter people's houses from above and rob them. The thief pronounced the formula but of course fell into the bedchamber, where he was thoroughly beaten by the rich merchant.

The setting wonderfully reflects the rich merchant's means. It is a tall, highly decorated inner chamber with a lantern (or a kind of chimney) in the ceiling, through which the thief has presumably fallen. The floor and the lower walls, are covered in gold-decorated turquoise hexagonal tiles, and the upper wall is white with a wide border of gold and red palmettes; the same decoration surrounds the tympanum of what appears to be molded plaster above the shuttered window; the railing in front of the window is lacquered red and gold. The niche at the left side, in which stand several brass vessels, is framed by spandrels of blue arabesque scrolls, and it is surmounted by what appears to be small-scale decorative painting in blue on white, a scheme frequently used in fourteenth- and fifteenth-century Iranian interiors [102, 104].

The bedclothes are as richly colorful as the chamber walls. The bedding is spread upon what appears to be a small carpet, to judge from the white border of square Kufic on a dark-red ground [58, 105]. Several layers, suggesting quilts, come next, the topmost being yellow with a gold-patterned chestnut-brown border; the cover is striped in alternating gold and blue and black-and-white arrowheads, with a red lining; the blue and green bolsters are patterned in floral gold. A pile of clothing, topped by the merchant's turban, is draped on a low stand to the left of the window.

The figures, large and expressive, are set in the lower part of the painting. The thief, his clothing in disarray and sprawled on one bloody hand, reaches with the other toward the merchant, wearing rumpled white; he holds the thief by one bare ankle and raises the other arm to rain blows down upon the hapless intruder. The merchant's pose, leaning back upon one foot turned out for support with the other turned in the opposite direction, is unusual, even in this period, and must have been observed from life. His face is a classical oval while the thief's seems bonier and more irregular, his raised brows conveying distress. The lady, by contrast, is a classical Jalayirid female beauty, oval face, strong curved brows meeting in the center above the nose, and blue beauty mark above them [40, 51, 156]. The string of beads holding her headdress has not been disturbed by the scuffle, and only the deep inclination of the head, as she sits up to watch the mêlée, conveys shock or surprise.

The manuscript from which this painting comes must date from the second third of the century and may be attributed to a

successor dynasty to the Ilkhanids in Tabriz and Baghdad, the Jalayirids. Not only politically but in the area of bibliophily Hasan Buzurg's family succeeded the Mongol Ilkhans, from about 1335. Jalayirid-sponsored painting developed marvellously flexible canons of composition, and a very particular color sense, over the course of the second half of the fourteenth century. Such paintings provided a firm foundation for metropolitan painting of the next century [105–108].

104. A CHRISTIAN MONASTERY

Painting mounted in an album
Western Central Asia or Samarqand, late fourteenth–early fifteenth century
H: 33.7 cm; W: 47.8 cm
Istanbul, Topkapı Saray Museum, H. 2153, fol. 131v

Even more impressive a painting from the same group as the duelling men on their splendid horses [15] is this picture of a Christian monastery. The brightly colored scene is painted in full color on the same bare paper, and the high and irregular ground line established with the same dabs of magenta pigment; there is even a comparable small brick-built domed tomb with blue interstitial plugs set in a similar place, low at the horizon at the left of the picture. Here, however, the monastery itself is the true subject of this composition crowded with figures from west and east.

A large hexagonal building with open galleries on two stories is crowned by a large, bulbous, tiled dome rising from a flat roof; a smaller green-tiled dome sits on the roof at its right, and a green-tiled open pavilion, a *guldasta*, at the left. Behind this rises a smaller hexagonal tower, its shuttered interior space reached by means of a ladder standing behind the larger dome. Wooden openwork balustrades screen the balconies, inscriptions written on tiled panels run around the cresting and over the portal at the right; and a wealth of tiled and painted surfaces suggests the richness of the Christian monastery – for so the building is designated, in two inscriptions at the top of the central tower. The portal is set in a wall of hexagonally patterned bricklay with blue plugs; the doors are double, and possibly of metal (although it is hard to be certain just what was intended by their color, silver-grey and uneven yellow), inset with coffered panels and protected by a flat wooden overhang that appears to be made of geometrically patterned woodwork. Banners, pennants, and dyed yak-tails fly gaily over it; an attendant outside the building, in the service area at the left, leans on the bell rope to sound the bells strung along the outside of the central tower and massed at the portal.

As the building is crowded with a generally prosperous-looking multitude, so it is virtually encrusted with surface decoration. On the

ground floor a dado of blue hexagonal tiles with wide shared borders is surmounted by a frieze of wall paintings, in which Christian subjects have been identified. The dado of the second story is tiled in the same manner, and the wall above it has simpler blue decoration on a white wall – the better to show off the gold-color lamps hanging from its ceiling. The inscription with the Christian references, at the top of the central tower, is in white letters on a blue and gold background; the inscription in large white letters at the base of the largest dome is written on a gold ground. Its tiled surface is a net of white strapwork star-shaped compartments with golden ornament on a blue ground, and it is very carefully executed, the pattern diminishing in size toward the top of the dome. On the third-story level, the upper walls are also decorated with figural paintings; the outer surface above them is hexagonally tiled with yet another variation of the schemes seen in the central tower, and the broken spandrels on all four stories are either gold, or painted with floral decoration.

Where, in the Eastern Islamic world, might such a building have existed, one peopled with so many different types and whose models have actually been shown to come from a wealth of manuscript sources, mostly Eastern Christian but also late fourteenth-century Jalayirid manuscripts? The answer is almost surely "nowhere but in the painter's imagination." Like "The Duel," this picture is probably also a pastiche. In it are combined real architectural forms and decorative ideas from buildings in Transoxiana and Khurasan. A representation of a hexagonal, balconied building in which people sat and read, or copied, manuscripts was taken from a late thirteenth-century manuscript made in Baghdad [Fig. 56]; and combined with the notion of a towered, belled, balconied, pagoda from somewhere along the Silk Route, such as at Kanzhou or Zhouzhi. The resulting creation was then set in a landscape merely suggested by the simplest dabbing of paint on bare paper. It is a highly sophisticated picture that brilliantly renders the idea of an Eastern Christian monastery in the visual terms of eastern Iranian painting of the earliest Timurid period.

105. NUSHIRWAN AND BUZURJMIHR IN CONVERSATION

Painting from a manuscript of the *Masnavis* of Khwaju Kirmani
H: 26.7 cm; W: 17.9 cm
London, The British Library, Add. 18113, fol. 91r

Another painting in Sultan Ahmad Jalayir's copy of Khwaju Kirmani's Masnavis is set in an interior throne chamber, a conversation between the Sasanian king Nushirwan and his great vizier Buzurjmihr. The *topos* of the wise vizier and his monarch who quests after

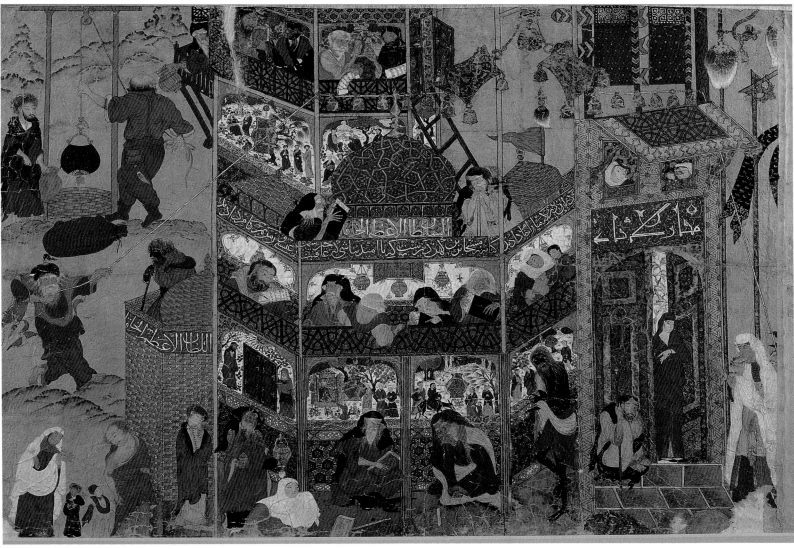

104

knowledge is frequent in Iranian art, as it is in literature. For Khwaju it was probably directly inspired by a similar episode in another Nizami poem, *Khusrau u Shirin*. Here the poet writes:

In the assembly the golden-throned king,
 To show the wisdom of his vizier,
Put a question to Buzurjmihr,
 Saying: Wise one, who knows the secret
 of the heavens?[1]

Nushirwan and his minister are seated in a grand interior, high of ceiling and rich in wall decoration and furnishings. The chamber has a stone floor extending the width of the picture, with a fountain and a round pool let into the floor; right of the pool is a platter of fruit, perhaps figs, surrounded by green leaves. The king's golden throne is of the high-backed high-seated type known from Ilkhanid pictures [102]. This could be read as a mass of vertical rectangles of faintly different light colors and textures set on a stack of more intensely colored horizontal rectangles; it should, however, be understood as a cloth-hung gold-backed throne reached by a set of steps standing on a knotted pile carpet spread on the floor toward the outer edge of the large recess, or *iwan*, in which the throne itself is placed. In front of the carpet is the outer zone of the *iwan*-floor, tiled in blue and

turquoise hexagons; above it the dado has rich tile decoration in blue, turquoise, and gold; above the dado and two very rich borders, the walls are gilded. Lastly, the entire *iwan* is topped by what looks like the proscenium arch of a European theater but is an element of Iranian architecture called a *pishtaq* in Persian, literally a "fore-arch." This demarcates the space of the *iwan* at the ceiling and spatially echoes the floor-level plan of the recess. The *pishtaq* of a building is often quite elaborately decorated, since it is often its most visible part. In this picture the *pishtaq* is also the most elaborate decorative element, almost certainly because it reflects a line of poetry in the text contained within the painting: "The corner of his canopy passed the moon in height."[2] Its background is a spangled dark blue, like the night sky, and in the spandrels are angels with long, rippling sashes, their wings beautifully fitted into the angled corners. A disk with a moon-face is set at the apex of the arch, visually echoing Khwaju's text.

Nonetheless, beautiful as these decorated areas are, enchanting as the fluttering angels in the arch above the scene, and apposite to the text is the intent of the entire ensemble, overall the picture disappoints: it feels empty, and it is only schematically composed. This is underscored by the groups of courtiers and

soldiers at the left, in three stiff angled rows each having three tall, stiff figures closely set together, gesturing among themselves as if in conversation of their own; squeezed into the right margin is another group of three, less schematically shown but still an almost negligible presence.

Offsetting the overall visual emptiness of the picture is the very large carpet beneath the feet of Nushirwan and Buzurjmihr. It has a red ground with a widely-spaced geometric pattern of staggered and alternating eight-pointed stars, squares, and knots; of its two contrasting border patterns, one is of ochery-gold kufic elements in which the letters *lam-alif*, "l" and "a," can be read. These features gave rise some decades ago to the proposition that, in this dated manuscript known to have been made in Baghdad in 1398, a type of Iranian carpet known only from later surviving examples could be "documented" as having been in existence in the late fourteenth century. The type is the so-called "small-pattern Holbein." The fact that surviving examples are considered to be Turkish instead of Iranian, smaller in size, and not much earlier than late in the fifteenth century, suggests the extent of the problem. The broader argument is therefore a fairly complex one but it hinges on one

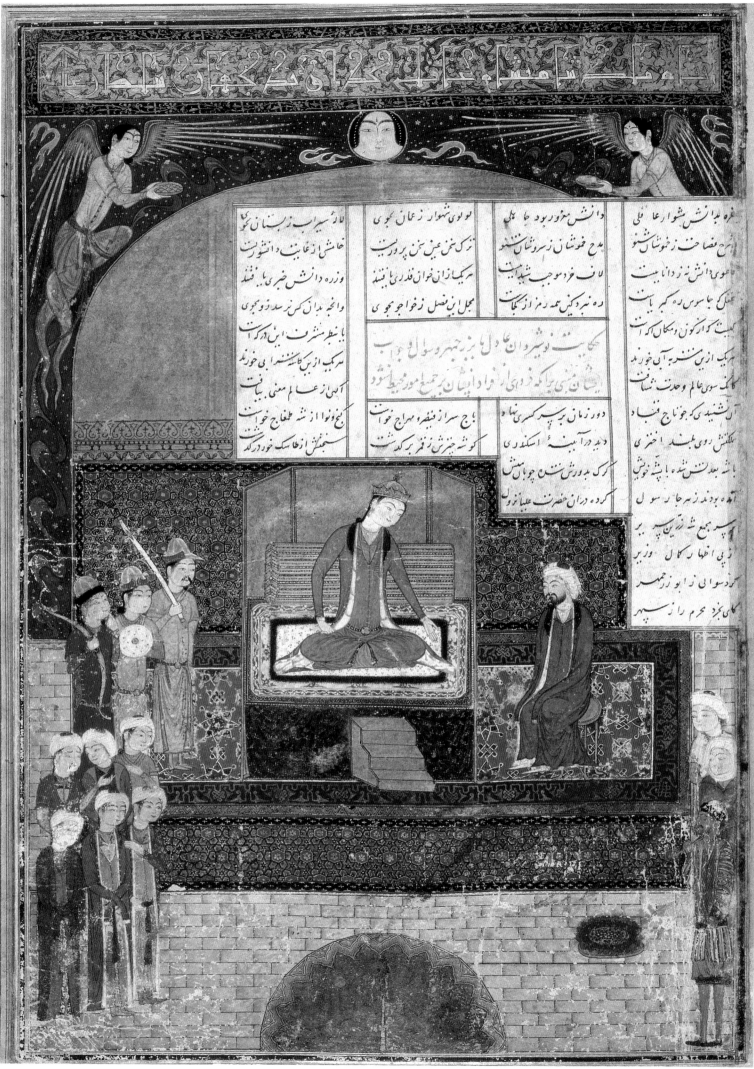

fundamental question: whether the aesthetics of one distinctive and sophisticated art form – a woven one – could ever be found truly reproduced in an utterly different, and even more sophisticated art form, whose purpose was highly formal, whose mode was archetypal, and whose practitioners did not necessarily choose to reproduce anything – much less literally so – unless it served the internal aesthetics of painting.

106. THE SHOEMAKER'S WIFE RELEASED BY HER FRIEND THE BARBER'S WIFE

Painting from Baysunghur's manuscript of Nasr Allah's *Kalila u Dimna*
Herat, 1429
H: 11.8 (21.6) cm; W: 16.3 cm
Istanbul, Topkapı Saray Museum, R. 1022, fol. 31v

This painting comes from the *Kalila u Dimna* manuscript made entirely in Baysunghur's Herat atelier [185, 205]. The story is deeply embedded in the structure of Nasr Allah's text and occurs in the course of the developing friendship between the lion and the bull, as the jackal Dimna begins to grow jealous.

Kalila tells Dimna of the adventures of the pious man in pursuit of his stolen robe of honor: he is a guest in the home of a shoemaker whose wife had taken a lover, with whom she was preoccupied when her husband returned, unexpectedly early, from a drinking party. Enraged, the husband beat his wife and tied her to a pillar in the bedroom, but he then collapsed in a stuporous sleep; a friend of the shoemaker's wife, the wife of a barber, offered to take her place at the pillar, so that the shoemaker's wife could go to console her lover. The pious man witnesses these events, and what follows, so that eventually he is able to enlighten the judge before whom this cast of characters eventually appears in a drama of domestic violence.

Illustrated is the moment when the barber's wife unties her friend, and it seems an image unique to this manuscript. The shoemaker's house is a wonderful adaptation of the classic Timurid interior. It has a stone floor, a tiled dado, white walls above a red and gold painted border; a long window with a lower wooden grille is cut through the back wall, to display a garden and a bearing fruit tree against a golden sky. That the story needed a pillar or a post must have brought the artist to add the implied *iwan*, which rests on two pillars, as well as the *pishtaq* (its lower edges shown against the white walls, under the text); both are splendidly decorated with passages of illumination ornament, however out of keeping this may be for the home of a shoemaker. At the right is a brick-faced structure whose architectural logic is uncertain but whose pictorial function is evident: the

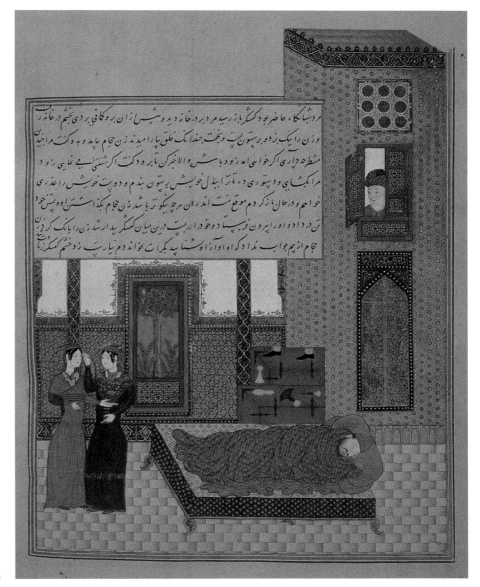

106

carved wooden door leads to an upper story with a window, one wooden shutter open, from which the pious man observes the goings-on. Above this is a window set with round panes in a stucco frame, and the structure has tiled cresting, again executed as a passage of illumination ornament. To the left of the brick structure stands the shoemaker's workbench, identified by the boots lying on top of it and the half-moon-shaped knife that will figure in the next stage of the drama.

The prevailing palette of the animal pictures in this manuscript – the majority of the images [205] – is hard and metallic, dominated by icy blues, sharp purples, and turquoise. Here a notable amount of warm red is used: the ladies wear red shoes and headdresses; the shoemaker's wife has an ornament suspended from a red ribbon around her neck, and even the rope with which she is tied is red. As is the somewhat rumpled quilt underneath which the shoemaker sleeps, furnishing a large red counterpoint to the smaller quantities of red in the ladies' toilette. The color almost surely anticipates the next stage of the drama, when blood actually flows. Altogether,

this picture is a wonderful exercise in the color-balancing technique that was another development in the illustration of manuscripts in Baysunghur's Herat workshop.

107. THE SECRETARY OF THE CALIPH DISTURBED BY HIS MAIDSERVANT

Painting in a copy of Nizami 'Arudi's *Chahar Maqala (Four Discourses)*
Herat, 1431
H: 10.2 cm; W: 8 cm
Istanbul, Museum of Turkish and Islamic Arts, MS 1954, fol. 12r

The "four discourses" of this manuscript refers to the counsel a medieval Muslim prince could expect to receive from the four advisors he could not do without: the vizier, the poet, the astrologer, and the physician. Written in the middle of the twelfth century in Samarqand, the *Four Discourses* is a series of four sets of thematically linked anecdotes; it falls somewhere between *belles lettres* and the genre of admonishing advice for rulers, usually

called the "mirror for princes." A long illustrative tradition lies behind some of these texts, the most famous being the *Kalila and Dimna* stories. That is not the case with Nizami ʿArudi's *Four Discourses*, and Baysunghur's personal copy still appears to be the only known illustrated version: perhaps it was his own idea. It was also the last illustrated manuscript to issue from his workshop – at least so far as we know.

Its pictures vary in size but none occupies the entire page. All are distinguished by the Baysunghuri clarity and polish in execution, but they also display a very strong reliance on prior traditions contributing to the painting in the Herat manuscripts made for Baysunghur [106], and for his father Shah Rukh. All depict specific anecdotes and are thus intrinsically text illustrations, but the text had never previously been illustrated. Each picture therefore had to be developed specifically for each episode illustrated. As these were not usually dramatic incidents whose action could visually recount the story, stock settings, sometimes adopted directly from earlier pictures, together with a few generic figures, were instead used to suggest a milieu and an action. Most are only to be understood by reading the text itself.

This does not in the least detract from the qualities of the paintings: strong in palette, limpidly polished of surface, crystalline in the vision of the Timurid world they provide. And most carry an implicit admonition to the prince who might read the accompanying text and consider the import of each illustration. *The Secretary of the Caliph Disturbed* recounts the story of the official whose household stock of flour had been depleted and who was interrupted, in the midst of writing a letter for the caliph, by his maidservant announcing that fact. He was so flustered that he wrote down her words – "there is no flour left" – in his official letter. The caliph was unable to make sense of the phrase until the secretary explained and apologized, whereupon the secretary's salary was increased so that he need never be concerned by household problems when he was engaged upon the caliph's affairs.

The relevant phrase is actually written upon the secretary's letter shown in the picture; otherwise the image accompanying this anecdote is essentially composed of a series of horizontal rectangles. This format had been in use in Baghdad for at least four decades [40, 105]. Each meticulously painted zone represents a different surface in the secretary's chamber and each extends fully across the picture, with no attempt at perspectival adjustment. It is thus unclear whether the niche where the secretary kneels is to be understood as being on a different level from that where his slippers neatly sit. Moving from the bottom of the picture upward, what appears to be a stone floor has objects standing on it – the slippers, a ewer and basin, and a vase of flowers; a zone of hexagonal tiles with a contrasting border follows, and

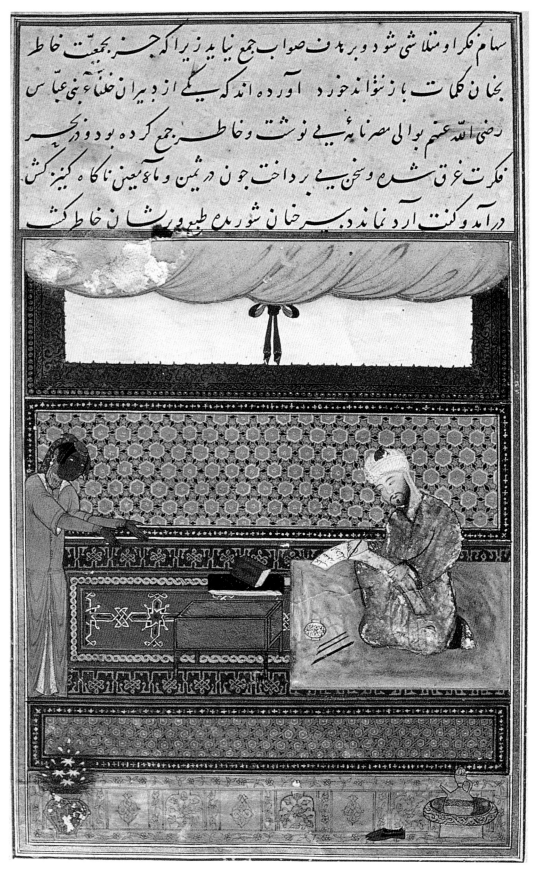

207

then a carpet with a red, geometrically patterned field and two contrasting borders. This, too, reads as a floor surface, since it is here that the secretary kneels (on a large felt mat or a cushion placed over the rug), here his writing desk stands, and here his maidservant approaches. Above it is the dado, another zone of larger hexagonal tiles, again

with a contrasting border; and then a white wall with a wide border that turns the corners at each side of the picture. At the top is a yellow zone that appears to be a curtain looped up in puffy folds and somehow – decoratively – secured with a bow whose surfaces display at least three different colors.

In the end, of course, it is not truly

necessary to know whether the carpet is spread upon a raised surface; far more important is that each of these zones is meticulously painted and the colors carefully spread throughout the picture, even through so simple and almost schematic a composition.

108. TAHMINA COMES TO RUSTAM'S BEDCHAMBER

> Painting from a lost, or never executed, manuscript of Firdausi's *Shahnama*
> Herat, ca. 1415
> H: 21 cm; W: 10.8 cm
> Cambridge, Mass., Harvard University Art Museums, 1939.225

Nothing could contrast more greatly with the simplicity of the Baysunghuri painting in which the Caliph's secretary was disturbed than this picture, showing the night visit paid by the daughter of the king of Samangan to the hero Rustam. It is probably among the most beautiful, and beautifully detailed, of any early Timurid painting; certainly it is one of the most bewitchingly romantic versions of this famous episode in the *Shahnama*. Tahmina had long nursed a passion for Rustam and, hearing that he is a guest in her father's palace, she comes to his chamber at night to declare her love. Rustam marries her at once, and from their union is born Suhrab, the son whom Rustam never meets until the fatal day they meet in combat when Rustam overcomes – and slays – Suhrab [71].

For its height this picture is rather narrow, and in this it recalls paintings in Sultan Ahmad Jalayir's volume of *Masnavi*s, as does the device of a vertical division separating the *iwan*, where Rustam lies, from the doorway where Tahmina enters [114]. Here the spatial division is unequal, the *iwan* approximately twice the width of the entry wall, and the figures are few but large and sturdy. They also recall other contemporary paintings: Tahmina covers her mouth with her cloak, as does the "Maiden" [151], who in turn recalls "The Lady Travelling" [113]; the servant's hat can be seen in the same picture, while his strapped bodice originates in other paintings of the same Istanbul group but can then be seen in paintings made for Iskandar-Sultan [235].

The interior space of the *iwan* is exquisitely logical. The outer *pishtaq* is supported on the side walls of the rectangular space where Rustam's bedding is spread, and beyond is a projecting bay with three walls, where his clothing and weapons have been laid; each wall is pierced by a long window echoed by an arched plaster panel in the upper zone. The floor of the entire chamber extends the full width of the painting and effectively ties the composition together at its base; its angled edge is repeated by the angle of the entry wall, by the line at the top of the doorway where the tiled surface gives way to a white-painted wall, and again by the decorative

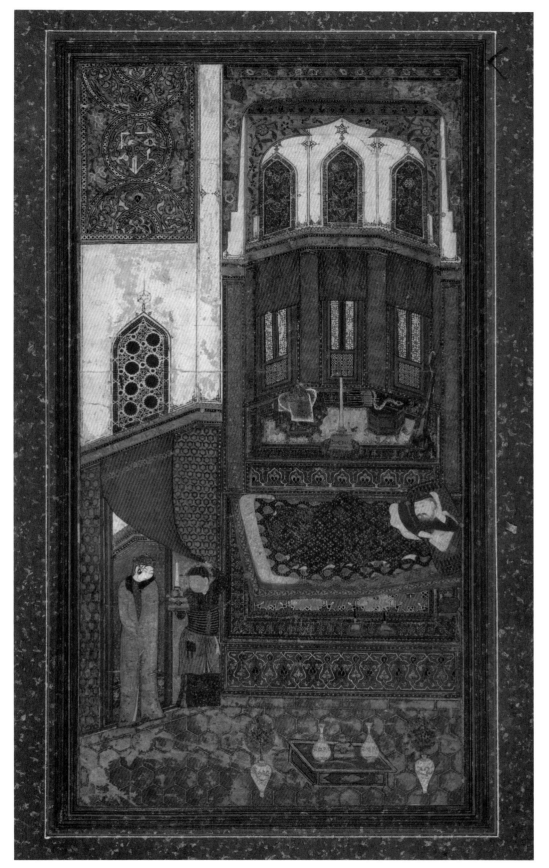

108

arched panel above it. Only the rectangular panel in the top left corner disturbs the perspectival logic on this side of the picture.

Surfaces are densely detailed. Some represent true architectural and textile surfaces – glazed or polished tiles, wooden lattices, painted plaster, the weight of quilted coverings and flat heavy rugs, and the flimsier curtain at the door; others are "merely" brilliant passages of ornament borrowed from the repertoire of manuscript illumination – the two zones below and above the carpet on which Rustam's bedding has been spread, the outer *pishtaq* above the *iwan* as well as an inner one framing the bay, and the rectangular passage at the upper left of the painting. Even the

placing of objects has the logic of use: on the low wooden table are two blue and white ceramic bottles and a covered metal container, and two vases of flowers stand on the floor to either side of it; two candlesticks and a covered jar are close at hand for Rustam, at the edge of the carpet; and a large candlestick and two tabourets, for his clothing and gear, stand in the bay on what appears to be a shaped rug.

Altogether, a mood of mysterious portent is conveyed by this picture of Tahmina's night visit, as a mystery also surrounds its date and the very reasons for its existence. The picture was, at some time in the past, mounted into an album from which it has now been removed, and it therefore lacks whatever context it might once have had. Only an inscription, written in cursive blue letters on the shiny golden register over the doorway where Tahmina enters, provides a clue: once thought to reproduce the name and titles of Iskandar-Sultan, more recently the name of Baysunghur's son 'Ala al-Daula, born in 1417, has been deciphered in it. Moreover, the particular size and shape of the painting, twice as high as it is wide, rules out any surviving manuscript for which it might have been intended: Firdausi's *Shahnama* was illustrated only three times for princes of the house of Timur, but all three have pictures of a different size, shape, and style, as each also has its own pictorial program. Lastly, the painting has a pictorial intensity that is quite remarkable, and the question has been posed whether the same intensity could have been maintained throughout the entire process of illustrating a *Shahnama*, even one with a restricted pictorial program.

One explanation for all these subtle features is that this painting was never intended for a manuscript but instead for an album, perhaps (or perhaps not) the album of miscellaneous works started by Baysunghur in imitation of one formed by Sultan Ahmad Jalayir; it was left unfinished at his death in 1433 and only completed by his son 'Ala al-Daula. The subject is especially appropriate for a wedding, a fact that, together with the stylistically earlier figures of Tahmina and the servant who ushers her into the hero's chamber, might further suggest that the picture was painted several decades earlier, perhaps in celebration of a wedding of Baysunghur's. Significant in his life, and treasured for this reason as well as for its superb quality, it would have been mounted into the miscellany described by Dust Muhammad and, after his death in 1433, his son wrote his own name onto the wall above the door where Tahmina enters to tell her love.

109. LIFE IN TOWN

Painting probably intended for Shah Tahmasp's manuscript of Nizami's *Khamsa*
Tabriz, 1539–43
H: 28.3 cm; W: 20 cm
Cambridge (Mass.), Harvard University Art Museums, 1958.76

Darkness approaches a small town, and evening tasks and pleasures occupy its inhabitants, young and old, rich and poor. No better evocation of urban life in a sixteenth-century Iranian town has ever been painted than this dense image presumably intended to illustrate a scene in Shah Tahmasp's great *Khamsa* of Nizami.

Candles, oil lamps, and cresset lamps light the various parts of the quarter over which we have a bird's-eye view, from the palatial foreground, through the markets and the mosque, and the private houses, to the bare hills beyond the town. At the lowest zone of the picture, a prince hosts a reception for noblemen on a tiled terrace opening off a richly revetted *iwan*. His guests pour and pass cups of wine; out of a domed structure at the lower right step servants bringing more platters of fruit and cones of sugar; and on the other side of a porphyry-edged water channel musicians play and a dancer performs the handkerchief-dance. The sedate festivities may take place behind blank walls but the men are not unnoticed: on a terrace above the *iwan* three ladies watch the proceedings accompanied by two servants holding a candle and a lamp, and from the parapet of the domed structure at the lower right a pair of urchins gestures in amusement.

Beyond the angled wall is the commercial zone of the quarter, where provisions are gathered or purchased. The architecture is accordingly simpler, built of bare brick, with modest tiled panels over doorways, and unpainted wooden shutters and flaps to the stalls. A young woman fills a pitcher with water flowing from an animal-headed tap in a domed covered fountain while a youth holding two large earthenware vessels waits his turn. A well-dressed young nobleman purchases something in a deep blue and white bowl, and a more modestly dressed youth searches in his wallet for coins to pay for a melon being weighed by an Indian fruitseller; another purchase of foodstuffs is being weighed in a stall beside one of the portals to the town, where a woodseller enters with a load of kindling on his back.

The mosque, to the right, has the richest exterior decoration. On its handsome stone and tiled steps, a boy speaks with a bent and white-bearded man leaning on a stick and holding a smoking oil lamp; an inscription is written in the tiled register above the doorway; the dado of the entry wall, the cresting and the parapet, the balcony of the short, stubby minaret, and the bulbous dome are all covered with tiles, some patterned with strong geometric design and others clearly

derived from book-illumination. A domestic interior occupies the upper left corner: a young woman and an older man converse in a simply furnished room lit by a flaming oil lamp mounted on a wall stand; and in a wooden balcony, a young woman leans over the edge to watch the evening's activities, as does the white dog [97] perched on the ledge of the domed portal below her.

The apparent lack of formal compositional organization in this picture is remarkable. Instead it appears to be a series of urban and genre-like architectural vignettes comfortably fitted together, even if at times the spatial logic would have us accept that a blossoming fruit tree can grow on a public walkway beside a high brick wall in the midst of a market, and that behind the palatial *iwan* – where the market is depicted – a green and verdant garden may be glimpsed through the window at the back.

What has never been evident is just which poem of Nizami's *Khamsa*, or story within a poem, this wonderful picture illustrates. Its companion [172], sometimes called "Life in the Country," seems more evidently an illustration intended for *Layla u Majnun*. Both pictures have been trimmed, as well as cut in two, at some point in their independent history. Neither bears any text that identifies the poem – let alone the manuscript – from which they might have come, but both have repaired patches of the size and shape that would once have accommodated a couplet of poetry; in this picture the repaired block is at the lower left corner. Its milieu is Iranian, both princely and urban. The inscriptions – over the portal of the mosque, a saying ascribed by tradition to the Prophet Muhammad on the blessedness of building a mosque, and a couplet of Hafiz over the doorway at the lower right – provide no further clues. Lacking both signature and attribution, "Life in Town" has been ascribed to Mir Sayyid 'Ali, whose scrawled name appears at the top of "Life in the Country," and who may have painted other pictures in, and for, Tahmasp's *Khamsa*.

110. TIMUR HOLDS A GREAT FEAST WITH AMIR HUSAYN, AFTER THEY HAVE RAISED A CHINGHISID TO THE RANK OF GREAT KHAN

Painting from a manuscript of Sharaf al-Din 'Ali Yazdi's *Zafarnama*
Shiraz, 1552
H: 20.2 cm; W: 15.6 cm
London, The British Library, Or. 1359, fol. 35v

A reception feast staged by Timur in Samarqand in 1363, well before he had consolidated his power over the entire *ulus* Chaghatay [33] and while he and Amir Husayn of the Qara'unas clan were still allies,

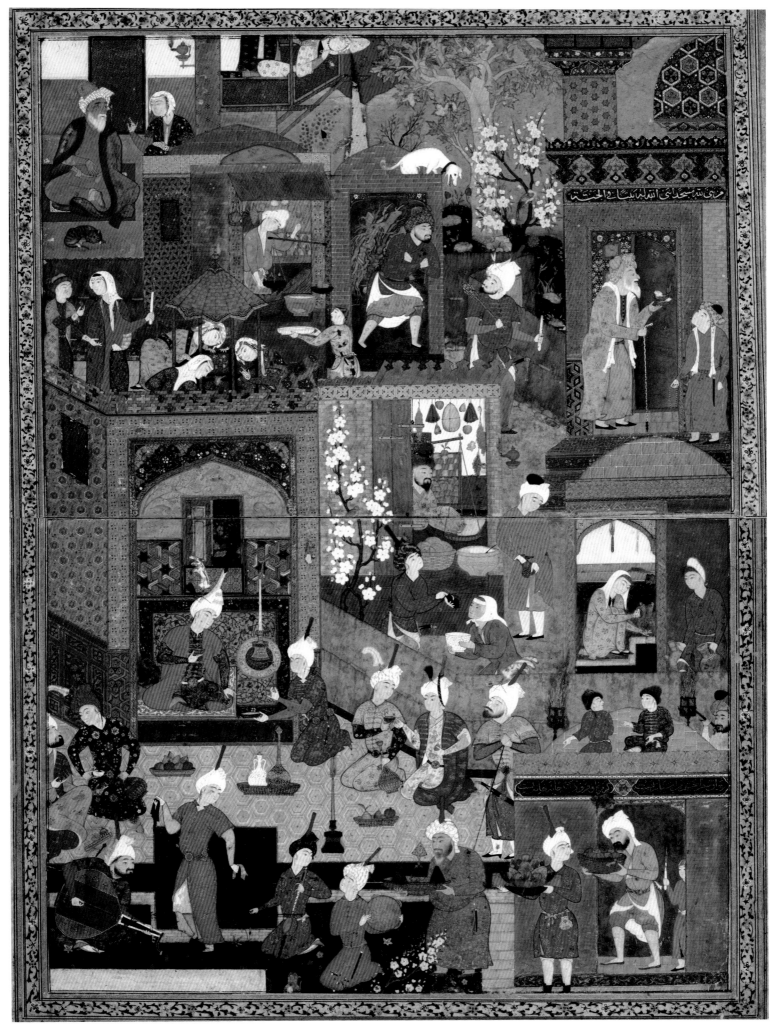

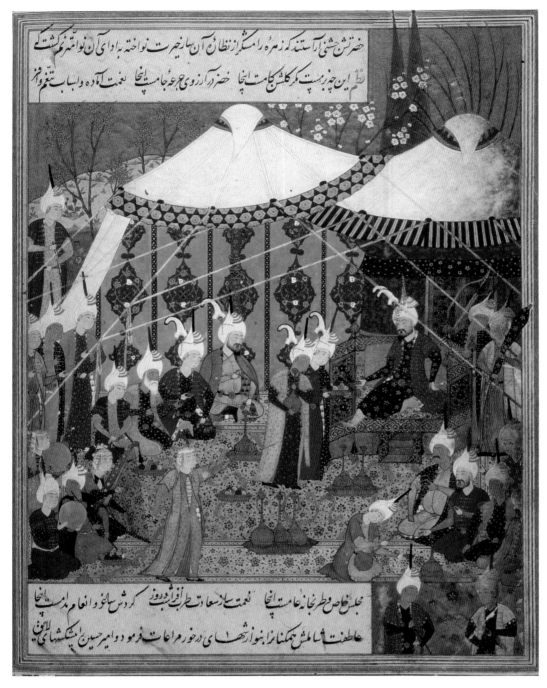

110

with white exterior walls in vertical sections, a pointed top, and a central large pole, the superb tent appears prominently in the so-called "Life in the Country" [172], a painting almost certainly removed from Tahmasp's great *Khamsa*, and twice more in other illustrations still within Tahmasp's *Khamsa*. In the *Zafarnama* picture the tent's interior is pale blue; the vertical panels have large ogival medallions with smaller extensions above and below, in dark blue with floral arabesques; and its flap is a contrasting fabric of staggered six-pointed stars with shared points. In the *Khamsa* pictures, the color and design are almost identical, and only the flap of the tent differs, subtly: it has a more complex design, in three colors, with a smaller six-pointed star inserted into the pattern. Clearly this tent was an image current in Tahmasp's Tabriz workshops, and the design came to Shiraz with a Tabrizi painter after Tahmasp's "Edict of Sincere Repentance" led him to dismiss painters from his court and cause them to seek their livelihood elsewhere in the land, or abroad.

111. THE SUFI IN THE HAMMAM

Painting from Ibrahim Mirza's manuscript of Jami's *Haft Aurang* (*Seven Thrones*)
Mashhad (?), between 1556 and 1567
H: 30.1 cm; W: 19 cm
Washington, DC, Freer Gallery of Art, 46.12, fol. 59r

Another illustration to the first poem of the *Haft Aurang*, the *Silsilat al-zahab* [85], accompanies the story of the proud and beautiful youth who unwittingly, and unwantedly, found himself the object of a poor darvish's love. The latter's devotion took him so far as to collect every hair from his beloved's head as he was being shaven in the *hammam*. Outside the bath-house, when the darvish despairingly asked the youth what he might do to attract his beloved's attention, the answer was: "Die in front of me;" the darvish did so, but the youth merely went on his way. That night he had a dream in which the darvish rebuked him for his disregard. It caused the youth to repent of his pride, become a darvish himself, and abase himself upon the grave of the old darvish who had only sought union with God in his adoration of youthful beauty.

Illustrated is the episode in the *hammam*, when the darvish lovingly collects the shorn hairs of his beloved. The story's protagonists are in the foreground; but it would be hard to point to a more detailed depiction of a bath-house in classical Iranian manuscript illustration, or to one so lavishly decorated and so well stocked with fine towels and matching bath buckets. Indeed it is hard to escape feeling that the *hammam* is the true subject of this splendid architectural creation that shows us the entire building, from the exterior dome

is illustrated as if it were a princely Safavid reception.

A pair of large and luxurious tents is pitched in a springtime garden. A throne is set up and the ground spread with carpets, wine and fruit are plentiful, and a female dancer performs to the music played by three musicians seated at the lower left of the picture. Timur, to the right, sits at the apex of the human complement of the picture; courtiers are seated in angled rows to right and left of him, those at the left backed by a row of standing courtiers. All the men wear the *taj-i haydar*, and the clan leaders have splendid white feathers stuck into their turbans – Timur three of them.

That he is apparently placed away from the center of the composition is hardly by chance; it accords perfectly with the compositional

canon of Shiraz painting operating throughout most of the sixteenth century [169]. This was based on a proportional system which controlled all the spatial aspects of the picture and made use of the vertical ruling nearest to the pictorial extension as well. Here the implied vertical emphasizes Timur's position, at a point two-thirds of the width of the picture; this is also visually enhanced by the pattern of the guy ropes crossing over his head.

At least six illustrated copies of Sharaf al-Din ʿAli Yazdi's *Zafarnama* were made in Shiraz workshops between 1523 and 1552; the manuscript in which this painting occurs is the last of the series and one of the finer of the entire group. That this should be so is one manifestation of the change in Shah Tahmasp's interests, in the early 1540s, and it is embodied in the tent to the left in this picture. Circular,

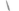

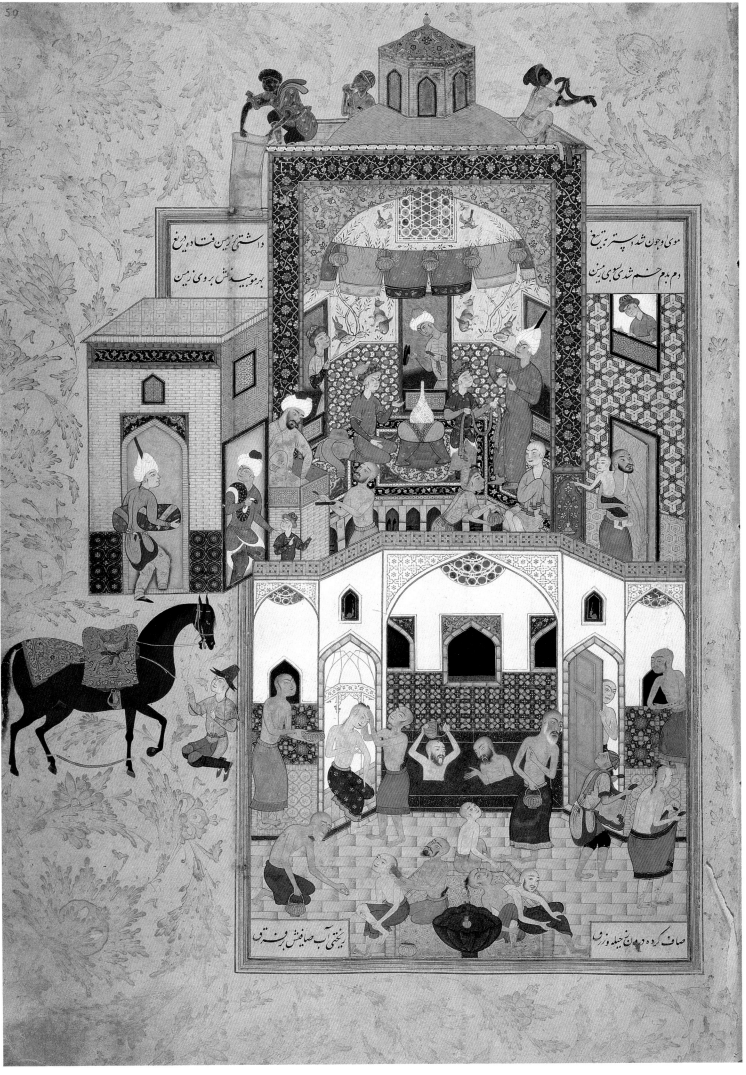

and entry portal to the luxurious interior changing and bathing chambers.

The rulings of the picture define, more or less, the interior spaces of the *hammam*, so that the marginal extensions on the page truly represent exterior structures: the brick and tiled portal block at the left side of the painting, and the dome with its lantern that rises over the large *iwan* of the changing room. Human activity gives scale to these structures: a well-dressed courtier carrying two bundles, one under each arm, steps into the doorway and his groom waits outside with his hobbled horse, while on the parapet around the dome several dark-skinned attendants wring out towels and spread them to dry.

The portal is the fulcrum on which entry to the *hammam* turns – visual as well as actual. Just ahead of the courtier another man, accompanied by a child, has come through the structure and turned right, entering the interior space of the picture within the rulings – the changing room. This is a large *iwan* with lavish and colorful interior decoration of carved stone and tile mosaic, painted plaster, colored glass, and openwork wooden screening. Red-framed windows, with low wooden screens, pierce the three walls; above a dado tiled in a complex pattern of interlocking hexagons and six-pointed stars, the wall is painted in blue with pairs of rabbits and jackals in a garden; high on the back wall is a window of colored panes of glass set in a stucco frame. A raised and carpeted platform stands above a row of small niches for shoes; at the left side, just inside the entry, is a smaller but higher platform of brick screened with low wooden grilles, where the doorkeeper sits. The changing room is crowded with men in various stages of preparation for bathing, or dressing after bathing: a courtier starts to undo the fastenings of his *jama*, another patron sits at the edge of the platform with a towel over his shoulders, a third, wrapped in a towel and carrying a small boy also wrapped in a towel, walks down an angled, richly tiled corridor that must lead to the bath chamber. Neat piles of clothes and pairs of shoes in their niches speak of bathers; strings of fresh towels, and bath buckets, await new patrons.

The bath chamber is a large hall off which a series of rooms open under arches with a pointed profile. Perhaps it is underground: the only windows are circular and set with panes of colored glass, visible just under the points of the arches, and oil lamps in niches high on the walls are lit. This area is predominantly white although the side rooms and the pool room, with its large porphyry-edged tank, have tiled dadoes of large and strongly colored geometrical patterns, and the pointed niches have tiled surrounds. The floors of the side rooms are tiled in brick and terra cotta; that of the main room seems to be of stone, and the floor of a small vaulted niche opening off it, at the left, appears to be stone of a contrasting color. At the lower margin is a

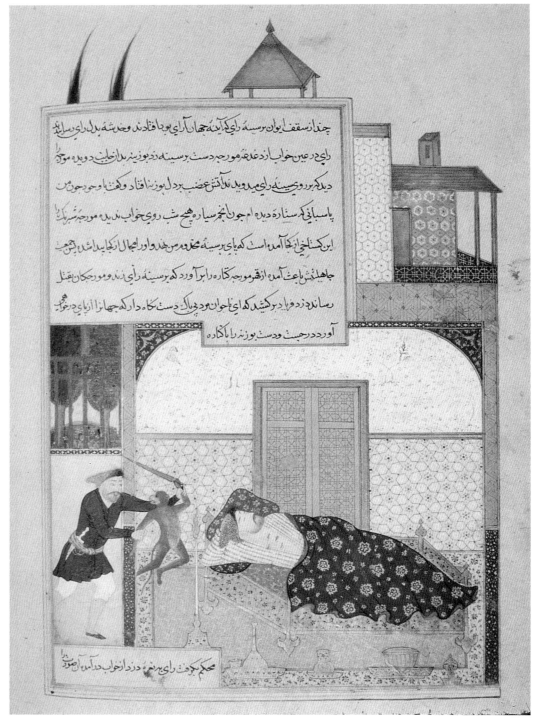

112

small raised octagonal platform on which stands a lobed basin on a pedestal, spouting cool water: on, and around, this platform are grouped the protagonists of Jami's tale.

The beautiful youth sits on the edge of the platform, one leg crossed over his knee, as his head is being shaven; the darvish, bent, bald, and white-bearded, kneels on the stone floor at the left and carefully picks up something between his thumb and forefinger. The narrator of the tale, Shaykh Rudabari, is probably the more imposing bald and white-bearded man who stands at the right of the platform holding his bath bucket in one hand, gesturing upwards with the other as he asks a question of an attendant. These three figures, however, are no more prominent in

appearance nor in activity than any of the other patrons – the pair in the pool, the men being massaged, or shaven, or who steam or wrap themselves in a towel, or any of the others. Without knowing the story, we would be hard put to identify this brilliant genre scene for what it actually illustrates: *the story of the witnessing by Shaykh Abu ʿAli Rudabari . . . of the death of that agitated darvish from love of that youth proud of his beauty.*

112. THE WISE THIEF RESTRAINS THE GUARDIAN MONKEY AND SAVES THE LIFE OF THE KING OF KASHMIR

Painting in a manuscript of Husayn ibn ʿAli al-Vaʿiz al-Kashifi's *Anwar-i Suhayli* (*The Lights of Canopus*)
Qazvin or Isfahan, 1593
H: 30 cm; W: 21 cm (folio)
Geneva, Collection of Prince Sadruddin Aga Khan, fol. 213v

Most of the 107 illustrations in this late sixteenth-century copy of al-Kashifi's elaborated Persian *Kalila u Dimna* text extend in some way to the margins beyond the rulings of the written surface, as does this picture for an episode added by al-Kashifi.

The tale is inserted into the older core story of the monkey and the tortoise and concerns a pair of thieves, one wise and the other foolish. One night, the wise thief finds himself in the bedchamber of the king of Kashmir, who has trained a monkey to guard the safety of his sleep at night. The thief arrives just in time to restrain the monkey's use of a sharp knife to destroy the ants crawling over the king's bare chest, and when the king awakens and realizes that his life has been saved from his well-meaning guardian, he richly rewards the thief.

The compact picture makes no reference to the exotic milieu of Kashmir: it is merely set in the king's bedchamber which is shown as an *iwan* in a brick structure adjacent to a terrace and a garden. The thief, the monkey, and the sleeping king are placed within the margins of the written surface, while the bedchamber spreads beyond it; both the upper

story and the tops of the cypress trees growing in the garden wrap around the written surface of the text-panel, lending breadth to the picture. But the scale of the architectural forms, and the lack of decoration, suggest instead a domestic structure; only the bedchamber is distinguished as princely, with a porphyry dado on the exterior, a golden bedstead, and golden accoutrements – candlestick, bottles, bowls, platters, and cups – arranged in a row in the foreground, for maximum visibility.

Otherwise, the palace appears to be a good urban building, subtly toned in color, with subtle surface patterns on the exterior pink brick and the interior tiled dado. The blue wall painting – a garden inhabited with birds and animals – on the white wall above the dado, is faint in texture, and the spandrels of the bedchamber have the most restrained of golden patterns on a dark-blue surface. As to the upper story in the marginal extension, it is the exterior surfaces we see: a pink brick outer wall below a geometrical wooden balustrade, and a sheltered wall surface, presumably tiled, under a slatted wooden overhang above which is a small, square wind tower. Above the text-panel rises a set of pointed forms: they visually "complete" the impression of a larger structure merely interrupted by the text, a square open *guldasta* with a pointed roof and finial, and the tops of the cypress trees, bending slightly as if blown in a soft night breeze. This simple set of forms becomes itself a repeatable motif and was much used in manuscript illustrations of the seventeenth century [42].

113. THE LADY TRAVELLING

Painting cut into sections and mounted in two albums
Western Central Asia or Samarqand, late fourteenth–early fifteenth century
H: 33 cm; W: 67 cm
Istanbul, Topkapı Saray Museum, H. 2153, fols 3v–4rL

Among the Istanbul album paintings whose origin remains mysterious, perhaps the most detailed of the compositions peopled with sturdy Chinese-looking figures is this image of a noblewoman traveling with her suite at night. Too long even for the large album into which it was pasted, the section at the left – a pair of female dancers – was cut away and mounted into another album in the same collection. The division was sensitively made, and this larger section survives as a suggestive unit with a narrative content that seems to hover just beyond positive identification.

A richly appareled and accoutered procession, two women riding on docile ponies and attended by solders, footmen, and pages, moves left along a level ground. That they travel at night is clear from the flaming lamps carried by three attendants; the intensely deep-blue sky seen above the horizon line underscores the unusual hour and suggests that the night setting was important to the story depicted; for the usual practice of the painter(s) of this group of pictures was to leave sky and earth as bare paper, with only the horizon and the interior contours indicated with dabs of magenta pigment.

Garments, weapons, horse trappings, the bird cage, and the lamps are all depicted in

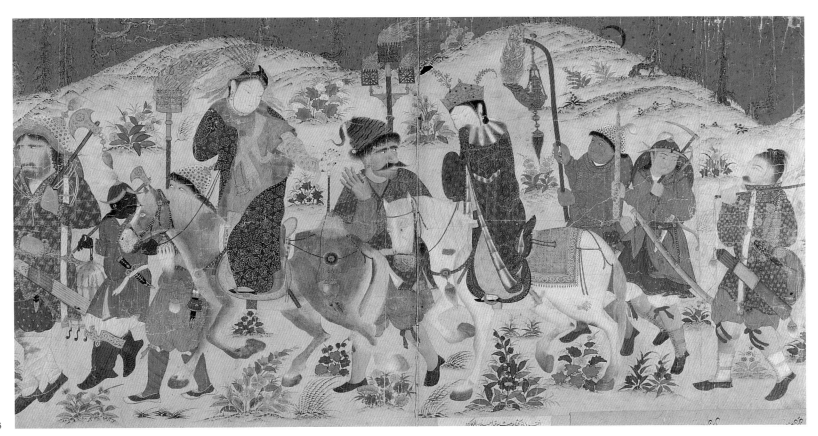

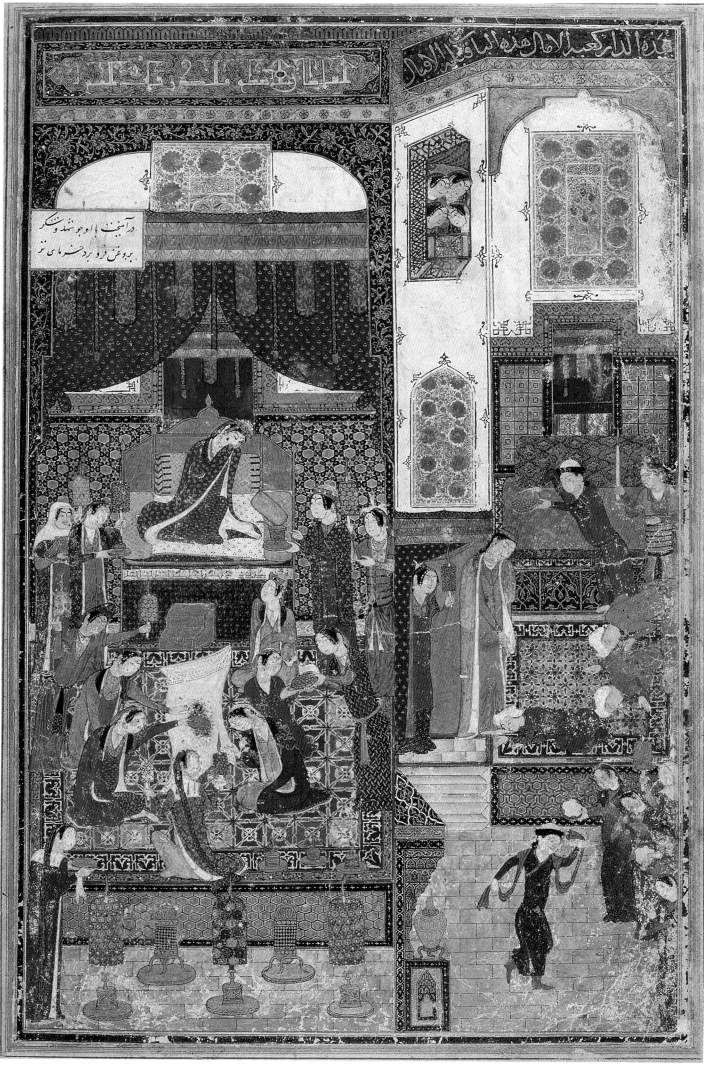

wondrous detail. The sources of light are of two types and three models; all are carried on red poles and all flame to the right, as if a wind were blowing. The spouted oil lamp is suspended by three chains from a kind of metal canopy which then hangs from a staff by a single chain; a red-dyed yak-tail and several golden elements hang beneath it. The others are cresset lamps, openwork baskets made of some heat-resistant metal into which oil-soaked cloth, paper, or straw was placed, and lighted; the container could be fixed to the side of a building or fitted on a pole and carried. Here, one is a single large basket, carried by the small page walking in front of the older woman; the other is a triple lamp with three smaller baskets mounted on a single brace and carried (in some invisible manner) by the big-nosed beetle-browed "westerner."

He turns back toward the younger woman in the ermine-lined blue cloak who, in turn shields her mouth with her cloak – she would be speaking to a man who is not a family member; the older woman also turns and gestures, joining the conversation. The discussion may concern their arrival and perhaps the forthcoming celebrations; the separated fragment of the painting, let us recall, shows a pair of dancers wildly spinning – their garments and scarves ripple in the wind and heavier ornaments fly out away from them.

Some decades ago, this picture was proposed as an image of the Chinese lady Wen-Chi returning from her exile in Mongolia. Or perhaps it comes from some other Asian story in which a princess or woman of rank travels at night. A contemporary event is a third possibility: the marriage of Timur to Dilshad Aqa in 1375. She was the daughter of a subject khan, and she and her mother had to be escorted by Timurid soldiers through enemy territory and dangerous mountain regions, to the borders of their own country near Uzkand, where the ceremony took place. Certainly the extreme whiteness of the ladies' faces recalls the Spanish ambassador Clavijo's observations of the complexion of Timur's "Great Khanum" in Samarqand in 1404.[1]

It may be that this tantalizingly narrative scene will forever elude precise identification, just as the many objects in it (and the larger group of composite paintings to which it belongs) have also proven resistant to identification. The architecture, the clothing and many of its apparently precise details, and most of the objects have all been shown to be pastiches: fantasies, caprices, or even caricatures of a reality that never truly existed.

114. GOLD COINS POURED OVER THE HEAD OF HUMAYUN

Painting from a manuscript of the
Masnavis of Khwaju Kirmani
Baghdad, 1396
H: 28.4 cm; W: 17.8 cm
London, The British Library, Add. 18113, fol. 45v

The wedding ceremony is over, the marriage has been consummated, and Humayun leaves Humay's chamber to be greeted by a shower of *nithar*, golden coins, and by servants prostrating themselves.

His exit is at night: numerous candles and lanterns "illuminate" the scene to show us both the beautifully decorated women's quarters, the *andarun*, and the outer chamber or *birun*, even more richly decorated. Single candles with shades fitted over their shafts are held by women, including the maid who ushers Humayun out of the *andarun*; a page behind the attendant who pours the coins from a small flat golden dish holds a longer, unshaded taper; and on the floor in the foreground inside the women's quarters are two tall incense-burners and three much larger shaded candles in candlesticks. None of these instruments actually provide the light by which we see everything in this crowded painting: the entire page would be as brightly lit without them, as it is with their presence. But they are there to signal that this festive occasion occured at night.

The architectural setting is one of the most complex known in any illustration to a classical Persian text, let alone at so early a date. That the two zones result from a simple division down the center of the picture space is beautifully obscured by the extraordinary richness of each side. Moreover, the picture is quite tall and the figures fairly small, despite their elegantly long bodies; this permits a great many of them to be believably disposed throughout the painting, each with something to contribute to the festivities. Every architectural surface is decorated, with tiles or paint or carved woodwork, gilding and stucco; every surface capable of being spread or shaded, hung, looped, or piled with decorated textiles is so decorated; and red – the festive color of marriage trappings in many Asian cultures – is especially prominent in the palette, from Humay's robes to the central candle in the foreground.

It happens that the painter of this beautifully designed picture has signed it, in red letters written on the stucco window screen in the *andarun*, and also identified himself as *junayd naqqash al-sultani*, "Junayd the painter in the service of the sultan." It also happens that Junayd "of Baghdad" is one of the few painters mentioned by Dust Muhammad in his preface to the Bahram-Mirza album, as another of the students of Shams al-Din; he had worked in the time of Shaykh Uways Jalayir, father of Sultan Ahmad – for whom this manuscript was made.

Mannered though the painting may seem at first glance to the unaccustomed eye, it is in fact a splendid and vivid image that takes the text of a literary event, in China, and recreates it in a princely Jalayirid milieu. A finer, more interesting, and more beautiful contemporary painting would be hard to conceive of – except by ʿAbd al-Hayy, a fellow pupil of Junayd, who also contributed a painting to the same manuscript for Sultan Ahmad.

115. BAHRAM GUR AND THE INDIAN PRINCESS IN THE BLACK PAVILION ON SATURDAY

Painting from a manuscript of Nizami's
Khamsa
Herat, ca. 1435–40
H: 21.5 cm; W: 11.9 cm
New York, Metropolitan Museum of Art,
13.228.13, fol. 23v

Bahram Gur, as a young man, having seen a room hung with Seven Portraits – *haft paykar* – of the princesses of the Seven Climates of the world, and having secured their hands in marriage, ordered the building of a palace with seven domes [89], one for each of the princesses who brought the world into his hands. They hailed from India, China (Chinese Turkestan), Khwarazm, Russia, Byzantium, North Africa, and lastly, from Iran itself. Each dome was built, and decorated, in the color associated with a planet which governed each day of the week:[1] black for Saturn, yellow for the sun, green for the moon, red for Mars, turquoise for Mercury, sandalwood for Jupiter, and white for Venus.

Once the domed palace was built, Bahram began a series of visits which took place on successive nights of the week. He commenced with the Indian princess in the Black Dome on Saturday, for a day and a night of love and of storytelling: "The dome of Saturn, as was fit, / was veiled in musky black . . . ,"[2] In a dark and richly furnished *iwan* under a dark dome, Bahram props himself against a bolster and listens to the tale told by the Indian princess:

. . . everything within it made
the selfsame hue the dome displayed. . . .
To drink his cup of wine, he'd don
robes the same colour as the dome.[3]

Just as Nizami writes, the dome and its decoration, and all the furnishings and garments, are painted in dark tones of purple, dark grey, dark blue, and silver: a painter's fantasy on a single color. "Bahram With the Indian Princess in the Black Pavilion on Saturday" is often illustrated in fine Timurid manuscripts of the first half of the century,[4] but this painting, from an otherwise unidentified manuscript of about 1435–40, adds something to the canonical image. It brings the heavens above into the coloristic sphere of Nizami's Saturday: the intensely blue night sky, spangled with stars and a crescent

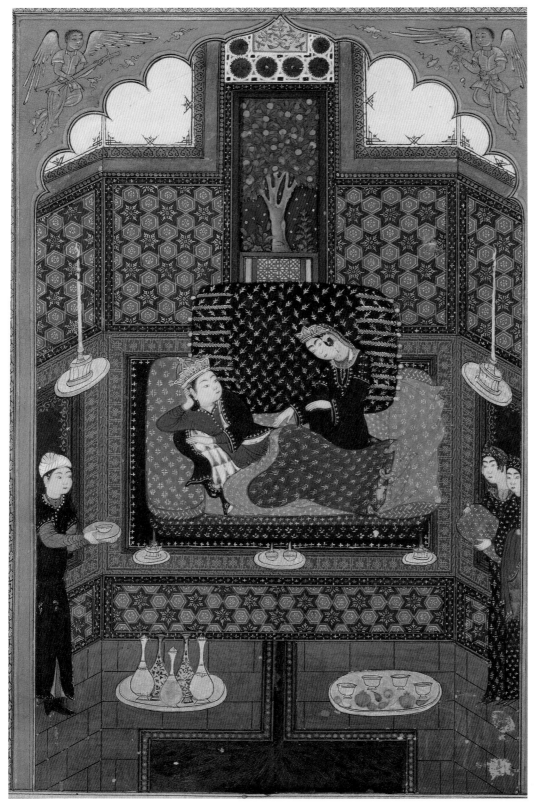

115

coloristic fantasies on the same compositional theme did not always appeal. Indeed the entire series is not always represented, even in the finest manuscripts made for the most thoughtful of clients or patrons; "Bahram Visits the Indian Princess in the Black Pavilion on Saturday" is often the only image in the series [118]. It then serves as a pictorial summary of the entire week of entertainments, with all the attendant mystical overtones of a spiritual journey through the seven days, climes, colors, and stages of the attainment of wisdom.

116. RUSTAM RESCUES BIZHAN FROM THE WELL

> Painting from Muhammad Juki's
> manuscript of Firdausi's *Shahnama*
> Herat, ca. 1440
> H: 19 cm; W: 15.5 cm
> London, Royal Asiatic Society, Morley
> 239, fol. 180r

Rustam's rescue of the Iranian paladin Bizhan from the pit where Afrasiyab confined him – for daring to love the Turanian princess Manizha – was a favorite *Shahnama* story and often illustrated; such pictures survive in manuscripts from the middle of the fourteenth century. The version in Muhammad Juki's mid-fifteenth-century *Shahnama* is especially enchanting.

The Turanian king Afrasiyab was incensed with rage at discovering the relationship between his daughter and the Iranian hero Bizhan. Dissuaded from killing him outright, he imprisoned Bizhan inside a pit closed by a mighty boulder, chained from head to foot, with only his beloved Manizha to bring him food and water. Word of his captivity eventually reached Iran and Bizhan's father, Giv, Kay Khusrau, the shah, and Rustam, who was Bizhan's kinsman; eventually the great hero departed for Turan and the city of Khotan, near to Bizhan's place of confinement. Rustam disguised himself as an Iranian jewel merchant; Manizha sought him out, told the story, and received food for Bizhan from Rustam as well as his signet ring. From Bizhan, in turn, she received a message for Rustam, and when she delivered it, Rustam told her he would come that evening to rescue her love, and asking her to set a fire around the pit, as a guide for him and his companions. This is the background to the point in the story so often illustrated: the night-time rescue.

In eastern illustrations to eastern texts, night scenes are rare unless the scene in question does occur at night. For the Iranian painter in the fifteenth century, the conventions of his art decreed that anything difficult to see would be represented without the slightest regard to the diminished visibility of night-time. He had several recourses: he could color the sky a darker shade of blue, spangle it with stars and a crescent moon, paint devices to

moon, even shows through the open window at the back of the *iwan*.

In his poem, Nizami built a series of symbolic edifices in his seven domes of seven colors. Each dome is associated with a planet and a day of the week; both also symbolize the path man must traverse in pursuit of knowledge and of spiritual awareness. Thus Bahram's journey begins on Saturday, the day associated with Saturn, the planet farthest from the earth and veiled in black, as human ignorance can be considered as veiled in

darkness; it ends with a visit to the Iranian princess on Friday, the day associated with Venus, the planet nearest the earth, whose color is white, symbolizing purity and spiritual awareness, and whose traditional association with love is, in Nizami's terms, to be understood as both human and divine love.

But to illustrate this part of the *Haft Paykar* with seven similar pictures, of seven princesses entertaining Bahram in their seven differently colored chambers, was perhaps a different matter; the executing of seven different

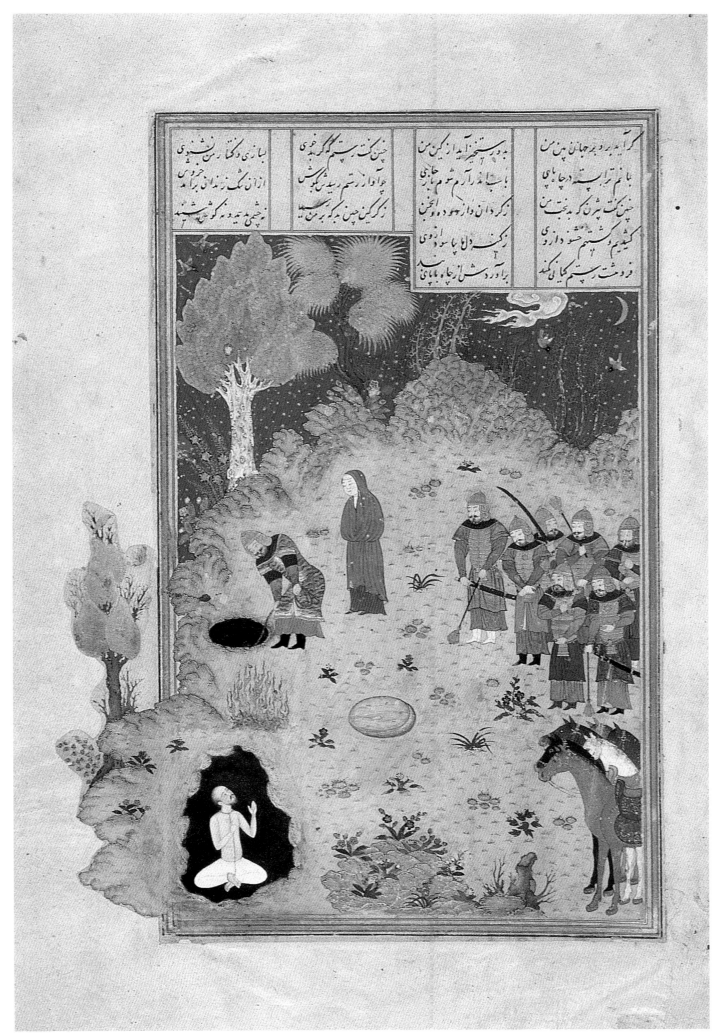

light the scene – the cresset lamp, candles, a fire; but what he shows us is always seen as clearly as if it were taking place under the brightest noonday sun.

Here, it is the stars and the moon, and the blazing fire, that ostensibly light the scene for Rustam to move away the boulder, and to haul the prisoner up from his pit. That we also see Bizhan under the earth, at the same time as we see Manizha, Rustam, and the rest of the rescue party standing upon it, imparts the daring charm of omniscience to the scene: another consistent feature of Iranian painting in this classical period. More than any other episode of classical Persian literature, the story of this romantic night-time escape challenged painters to develop ways of dealing with all the visual obstacles it presents.

117. ISKANDAR VISITS THE SAGE

Painting in a manuscript of Nizami's *Khamsa*
Herat, 1494–95
H: 22 cm; W: 14.8 cm
London, The British Library, Or. 6810, fol. 273r

The last painting in Sultan 'Ali Mirza Barlas' *Khamsa* [77, 94], this is a truly wondrous image. It illustrates the visit of Iskandar – Alexander the Great – to a hermit in a distant cave. Here the cave is located in the midst of a rocky slope that appears to fall away from the ramparts of a city high on the cliffs above. The visit takes place at night, under a midnight-blue sky palely lit by a crescent moon.

Loosely organized in an upper and a lower zone, as were several of the contemporary illustrations in Sultan-Husayn's 'Attar manuscript [60, 168], Iskandar and his suite stand in a clearing in the rocky lower part of the picture. The cave is a night-dark space at the lower right, and it is beautifully framed by the curving form of a huge plane tree in full autumnal foliage, and the rocky repoussoir at the left, behind which some of Iskandar's followers can be seen. The hermit with his white hair and long white beard is, in turn, framed by the darkness of the cave. In front of him Iskandar kneels respectfully; he is dressed in a green *jama* and with a full black beard, surely intended – in a graceful gesture of homage – as a portrait of Sultan-Husayn [186]. At the very bottom of the picture an attendant holds a cresset lamp on a long pole but its flame flares golden against the sandy ground of the clearing, so this formal indicator of a night scene is not clearly seen.

The night setting does not in any way modulate our perception of the walled city at the upper zone of the picture, surely a loving picture of Herat itself. Instead we clearly see its pink brick bastions with large seal-Kufic letters set into the brickwork, merlons of brick and glazed tile panels, and the cornices of the buildings with inscriptions in white on

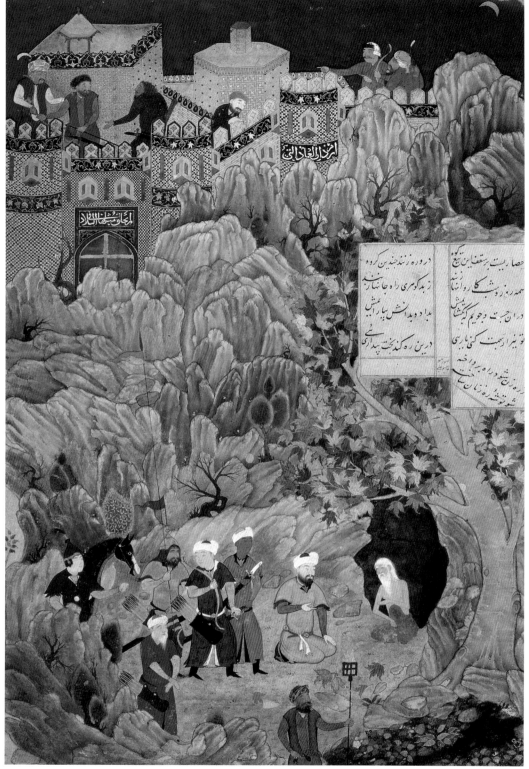

117

a blue or floral ground that praise the unique wonders of the building they adorn. Men stand on the ramparts apparently in conversation; again they are not the princes and nobles of Sultan-Husayn's circle but ordinary men who might truly have manned the ramparts of the capital of the Timurid empire in its own autumnal days.

118. BAHRAM GUR AND THE INDIAN PRINCESS

Painting added to Shah Tahmasp's manuscript of Nizami's *Khamsa*
Ashraf, 1675
H: 25.6 cm; W: 17.3 cm
London, The British Library, Or. 2265, fol. 221v

This moonlit vision is perhaps the most audacious Iranian picture ever created for the first of Bahram Gur's visits to the Seven Princesses of the Seven Climes of the world. It is one of three painted by Muhammad

Zaman for the unfinished *Khamsa* of Nizami begun for Shah Tahmasp over a century earlier [232].

In the summer of 1675, Shah Sulayman must have taken himself, a large entourage, and some of the most precious manuscripts of the Royal Library, to the Safavid princely establishment at Ashraf (in Mazandaran, on the Caspian seacoast), where parts of the hot Iranian summers were spent. Not only Shah Tahmasp's *Khamsa*, but also Shah ʿAbbas I's accession *Shahnama* [99], contains pictures with dates in the same year, 1086, equivalent to 1675–76, and inscriptions saying that they were made for the shah by Muhammad Zaman. This picture carries the note that it was done in "the delicious town of Ashraf."

Instead of a dark-hued richly furnished chamber in a palace [115], the scene takes place on an open terrace under a full moon partly obscured by clouds and lit by lamps and candles. Instead of a princess who is recognizably Indian in type and dressed in Indian garments, the lady is Muhammad Zaman's version of Charles I's Queen, Henrietta Maria. Images of her crown, jewels, and pink dress trimmed with lace and ribbon rosettes had come to Iran in 1638, in one of the "pictures of or selfes, or Queene and children"[1] presented to Shah Safi I by an agent of the English East India Company (although Muhammad Zaman has shown the princess kneeling, as would any polite Iranian of high rank). Instead of a uniformly visible picture surface, the dramatic light cast by the row of lamps and candles in the foreground throws only a broad oval of light onto the otherwise dark scene; it leaves in shadow the backs of Bahram Gur, the lady, and her attendants, and lights just the front of the huge tree with the alligator-like bark.

119. LESSONS ON A TERRACE AT NIGHT

Painted on the outer front shutter of a lacquered papier-mâché mirror case
Iran, late eighteenth or early nineteenth century
H: 19 cm; W: 11.8 cm (shutter only)
London, Nasser David Khalili Collection, LAQ18

Given the quantity of lacquered papier-mâché objects made in Iran between the later seventeenth and the early twentieth centuries, it is hardly surprising that the same figural motifs, as well as entire scenes, should appear on many of them as copies, "quotations," or adaptations. The outer cover of this finely painted but undated mirror case, a picture of youths attending lessons on a richly furnished terrace at night, exemplifies the creative reuse of an image documented on a number of other contemporary painted and lacquered objects.

The core of the scene is a frontally shown

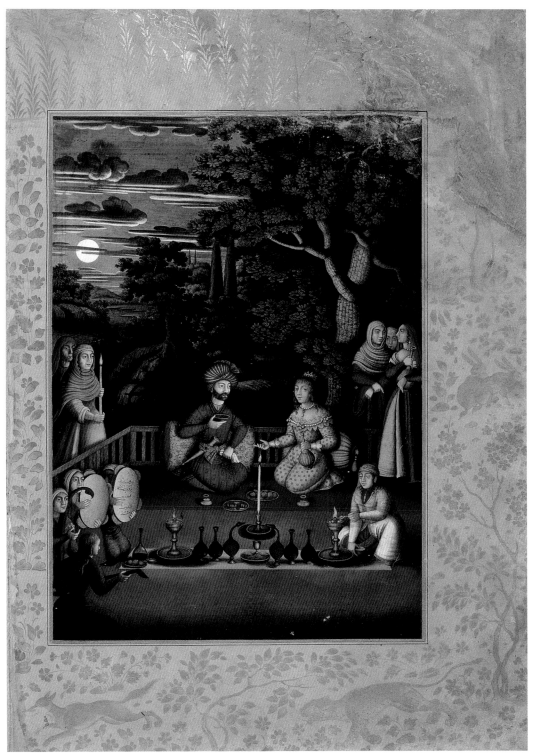

118

figure flanked by others in profile: a white-bearded, bespectacled old man in a low white turban sitting cross-legged, his head bent down as he writes on an oblong tablet, and two well-dressed pupils who kneel and listen, or discuss – the youth at the right raises two fingers while the left figure gestures with an outstretched hand. The youth at the right is dressed in the Iranian manner of the later seventeenth-century but wears a long Indian sash and a smaller rounded turban; the youth at the left wears a version of an Akbari turban and an Indian *jama*, scarf, and sash. The same figural group appears on the covers of a number of contemporary pen boxes, always

set on an open terrace; and sometimes lit by blazing candlesticks and a full moon illuminating a cloud-streaked night sky, or even shown in broad daylight. By far the most complex and elaborate version is that on the lid of a very large lacquered casket, where the group on the shutter of the mirror case serves as the right half of what has been interpreted as an allegory of the Muslim and Christian worlds living in peace.[1] The casket is dated to the equivalent of 1776–77. Its painter must have had in front of him a number of objects with figural decoration, and perhaps also European reproductive prints or printed books. From them he constructed a rather

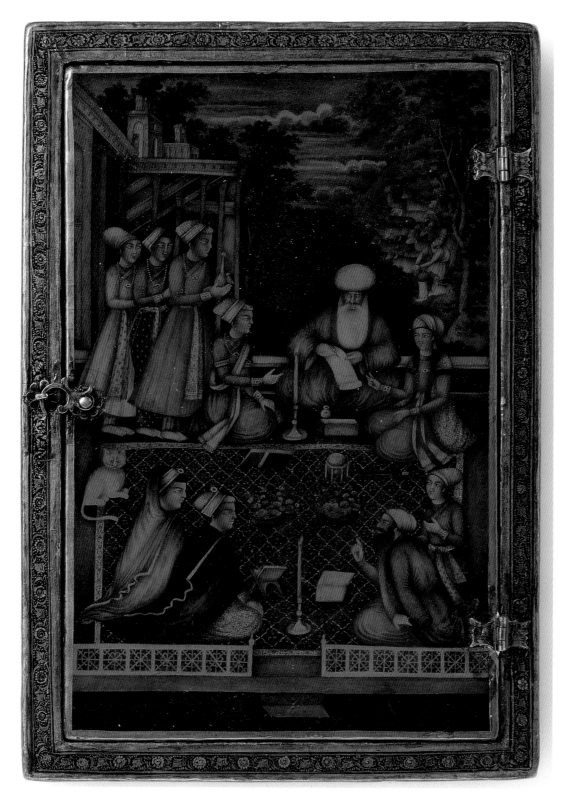

casket lid this figural group is to the right of the old man, and all the figures face left. On the mirror case, four figures in the foreground comprise another scene of instruction: a dark-bearded cleric to the right of the entrance to the terrace raises a finger over an open book, and a youth behind him echoes the gesture, while at the left a pair of youths in similar Indian turbans partly hidden by enveloping shawls kneel attentively. The figures have been spatially adjusted to suit the different shape of the terrace on the mirror case; the white cat has simply been reversed and now sits at the edge of the carpet at the left of the picture. In both scenes, the accoutrements of study – books and a bookstand, a globe, an open pen case or ink-pots – stand on the carpet; on the mirror case, a pair of fruit bowls also divides the two groups.

The other primary change in the scene as it appears on the mirror case is the hour: on it, the lesson takes place in the cool of the night. Candles in small stands light the front and back of the terrace, and streaky clouds provide a ghostly light in the sky that also lights the shepherd and his flock in a leafy clearing in the right background, and touches the top of the towers and the arcade on the left.

The painter has neither signed nor dated his work but his hand seems remarkably individual, even though his techniques of highlighting and shading differ depending on his pictorial models – Iranian, as on the front of the shutter, European (the back of the case), or Indian (on the inner face of the shutter). He makes consistent use of exceptionally fine stippling in all three scenes, however, and he paints eyes in a very particular manner, showing the whites as well as shading the upper eyelid in white under lowered lids: this gives a curiously intent look to all the figures on the front shutter, especially those seen in profile.

119

grand figural pastiche, with a European-derived architectural setting and a landscape vista opening up between the Christian group, gathered on the steps of a large stone building at the left, and the Muslim group of youths around the white-bearded old man on the large carpeted terrace at the right.

The painter of the slightly later mirror case has reused this composition but broken it down into what were surely its two original parts – the "Christian" group for the back of the case, and the "Muslim" grouping of youths and their teacher on its front outer cover.[2] He has also reversed this half of the composition.

And as the casket lid is more than twice as large as the mirror case, neither scene could have been transferred directly.

On both lid and shutter, the lesson takes place on a large and richly carpeted terrace surrounded by a low openwork wooden balustrade [81, 100, 194]. The bespectacled old man faces front, as always, and while the mirror-case painter has reversed this scene as it appears on the casket lid, the old man also always writes with his right hand. The single youth on the left, in Indian clothing, is accompanied by three similarly dressed youths with bare feet who stand behind him; on the

FIGURAL TYPES

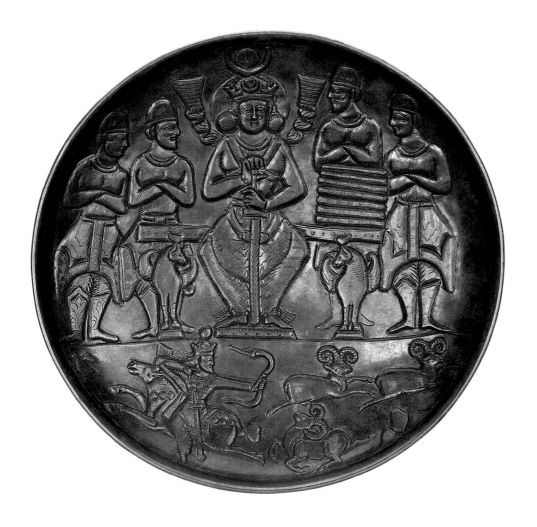

120

120. AN ENTHRONED KING, AND A PRINCELY HUNT

Silver plate with champlevé reliefs and
gilded details
Iran, sixth century
Diameter: 26 cm
St. Petersburg, State Hermitage Museum,
S-250

Two scenes decorate this plate: in the upper
zone is an enthroned king, and below is a
prince hunting wild rams. Beside the throne
in the upper zone are four men, two on each
side, with their arms crossed over the breast.
The throne itself resembles descriptions of
Mithra's chariot, said to be drawn by winged
horses; two, here, support the front of the
throne. The same throne is depicted on the
famous "Cup of Khusrau" (in the
Bibliothèque nationale in Paris), carved on a
piece of rock crystal serving as the base of a
golden vessel with glass-paste medallions set
into its walls. The crown might be that of any
Sasanian monarch from Peroz (459–84) to
Khusrau II (591–628).

Some scholars have proposed that the king
on the plate is Khusrau I (531–79), who
divided his state into four military districts: the
four attendants would then be the generals
commanding these districts; others note that
according to the *Shahnama*, this reform was
instead the work of Khusrau II. The four
figures could also be vassal rulers, the crossed
arms denoting submission: Tigran, king of
Armenia in the first century BC, followed
Iranian custom and placed four conquered
kings beside him, their arms crossed to
symbolize that they had become his slaves.

Details of the attire, especially the peculiar
rendering of the boots of the figure at the far
right, with one upper leg shown frontally but
both feet in profile, can be found in murals
of the Hephthalite period from Dilberjin, in
Tokharistan (formerly kept in the Kabul
Museum but now destroyed). This plate, then,
was probably made in the reign of Kavad
(488–97, 499–531), who was a tributary and
ally of the Hephthalites. The hunting figure in
the lower zone would be his heir Khusrau I,
while still a prince: the crown worn by the
hunter bears no crescent, even though this had
become a standard feature of the crown of the
King of Kings from the early fifth century. A
Bactrian (Hephthalite) inscription on the
outside of the plate conveys the name and
title of a later owner. B.I.M.

121. A BATTLE SHIELD

Wood covered with painted parchment
Sogdia, early eighth century
H: 23 cm; W: 61.1 cm
St Petersburg, State Hermitage Museum,
SA-9093

This fragment of a round shield was found in
the castle of the Panjikent prince Dewastich on
Mount Mug in the Zarafshan Valley. Dewastich
was captured there, in 722, by Arab invaders
who crucified him later in the same year.

The shield is made of light wooden planks
each measuring nine centimeters in width; it
had a metal border, which has not survived.
Close to the center are two round holes, by
which the handle was attached, and near one
on the inside is the imprint of a buckle,
probably for a long strap so that the shield
could be hung around the neck, leaving its
wearer the use of both hands [1]. The Mug
shield is larger than those in the Panjikent
mural paintings and has no metal bosses. Its
owner was a military leader, perhaps Dewastich
himself – everything found in the castle had
belonged to Dewastich and his companions.
Certainly it had been used in battle: there are
dents made by arrows on its surface.

Inside, it is also covered with parchment,
painted to resemble the spotted skin of a
snow leopard. It seems that in Sogdia, painted
parchment was not only used for shields but
also for manuscripts, and illustrated ones were
evidently made but are no longer extant.

On the outer surface is painted the figure
of a mounted warrior, serving its wearer as
a badge of identity, like the coat of arms
of a Western medieval knight. He was clearly
a military leader: his horse wore trappings
of ball-like ornaments above the head and
at the neck, of the kind that, in surviving
contemporary mural paintings, are only worn
by commanders. He is clad in full armor
and equipped with a mace (or a battleaxe), a
sword, a dagger, a bow case with two bows,
and a quiver of arrows. Though the horse's
neck is bent deeply forward, the rider's finely
drawn fingers hold the reins lightly. Firdausi
evokes just this mastery when he tells of
the particularly "fine hand with his reins" of
Rustam's father, Zal, "more beautiful than
those depicted on palace walls." Indeed,
Sogdian murals confirm that the manner in
which a man held his horse's reins is an
attribute of masculine beauty. On the shield, as
always in Sogdian painting, the horse is a
stallion and his eyes express his mettle. Tajik
folklore holds that the stallion has something
demonic in his nature and is able to protect its
rider against demons because he is partly a *div*
himself. Sogdian artists always emphasized the
contrast between the light figure of the rider
and his proud, powerful horse. So, while at first
glance, it is hard to accept that the slim-
waisted man on the shield could master such
an animal, for the Sogdian, the strength of a
true hero was expressed in his training and
skill, and never by his inert weight. B.I.M.

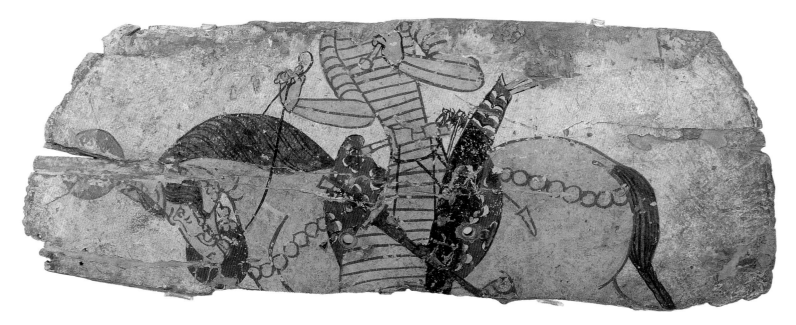

121

122. PALACE GUARDS

Fragmentary panel of wall painting from the audience hall of the South Palace at Lashkari Bazar
South-central Afghanistan, early eleventh century

Lashkari Bazar, in Ghaznavid times, was a princely suburb of the medieval city of Bust, at the confluence of the Helmand and the Arghandab Rivers in south-central Afghanistan. The name suggests its origin as a military "camp" – *lashkargah* – and it served the sultans of Ghazni as a winter retreat. French excavations there in the late 1940s uncovered the remains of several palace structures built on the curving cliff above the Helmand River.

The South Palace included a large audience hall situated so that it overlooked the river. The upper zone of the walls was decorated with epigraphic brick panels and carved stucco; a water basin in its center was fed by a small channel running laterally through the chamber, eventually emptying over the cliff into the river. The lowest zone of the chamber wall was decorated with a painted frieze of standing Turkish guards; forty-four were still recognizable *in situ* in 1948, of a number that might once have been as many as sixty. They seem to have been over a meter in height and would have presented the appearance of a life-size procession of guards whose presence was permanent.

From the time the paintings were first published in 1952, their Turkish origin was recognized. Their dress is virtually identical to that of the donors in the Cave of the Sixteen Sword Bearers from Qizil [47] (by then well known to scholars), and the Turkish context is furnished by both ruler and army alike. An account of Sultan Mahmud's Turkish slave corps – said to number 4,000 – related that

on the days of audience, the sultan ranged them on either side of his throne, 2,000 on each side, and that they wore plumed headgear and carried arms of gold and silver.[1] Such a number may well be an exaggeration, although Mahmud's army has been called the most effective military machine of its age. This

painted guard was perhaps intended as an everlasting evocation of the Sultan's power.

What today remains of the Lashkari Bazar frieze of painted guards clearly shows the Turkish dress: front-closing, lapelled coats, or kaftans, with contrasting borders and the belts with hanging thongs, from which are

122

suspended a sword and perhaps a money purse (left figure), and a series of hanging strips of metal or cloth (right figure) – the same details that are so unusual at Taq-i Bustan but so uniform on the "Tokharian knights" from Qizil. The differences between the two ensembles are relatively small: at Lashkari Bazar, the robes are longer and some of the decorative patterns are quite large, with the distinctive *tiraz* on the upper sleeve; the footgear can no longer be distinguished but was said to be boots. The heads are virtually all destroyed, and it is not clear whether all the figures, or only some, held something long in both hands – a sword or staff that rests on the right shoulder. But they were surely meant to be read as many individuals rather than a massed group: the costumes are differentiated by color and design, there are spaces between the figures, and a single falcon can be seen to the right of the figure in the dotted kaftan, suggesting the presence of a falconer among their ranks [127].

The "descendants" of these painted Turkish guards in the Ghaznavid audience hall at Lashkari Bazar may be seen in Iranian painting for many centuries to come [73, 89, 91], although in later examples they will begin to take on a more formulaic appearance and may be shown as overlapping figures differentiated only by the details of their clothing. To what extent the details of the fabrics can be taken as renditions of actual textiles remains an issue of debate. Nonetheless, it is clear that by the early eleventh century, the Turkish element from Central Asia was well ensconced within the Islamic world, both in reality and in the rendition of reality – as painting in this context may be understood.

123. AN AGED PRINCE IN THE MIDST OF COURTIERS

> Luster-painted bowl
> Kashan, Jumada II 607/ November 1210
> Diameter: 30 cm
> New York, Metropolitan Museum of Art,
> 41.119.1

This large luster-painted fritware bowl exemplifies the expressive pictorial potential of metallic overglaze painting in the presentation of an apparently princely image.

An aged ruler sits cross-legged, surrounded by twelve courtiers. He is shown full-face and his beard is white; the other figures are beardless, shown in three-quarter view, the eye and curve of the cheek visible at the edge of the rounded, moon-shaped faces, and they have small mouths and brows that meet at the top of the nose. A brilliant white nimbus encircles each head. Two areas formed by a line drawn across the curve of the bowl's side counter the indistinctness of the setting, merely an "awning" at the top of the composition and what seems to have been a

123

fish pond at the bottom; the large foliate decoration of the "awning" gives the impression that the setting is a garden of some sort. Garments, furnishings, and background alike are densely patterned, in a multitude of scrolls, whirls, leaves, and dots, whose function is actually to impede the movement of the eye over the glazed surface of the bowl, interposing passages of metallic luster pigment to catch and reflect the light. Only the large moon-faces, the encircling haloes, the dark cap of the prince and the courtiers' dark hair, and their expressive – if boneless – hands present solid surfaces to contrast with the dense shining net of lustrously reflecting painted patterns.

Ordered rows of attendants surrounding an enthroned figure have many parallels in Asian art, and two immediately come to mind. The first is the virtually contemporary frontispiece to the *Kitab al-Aghani* (Fig. 54); the second is earlier, seen in the ordered rows of attendants flanking both the white-bearded priest and the prince, painted on the reverse sides of a large paper fragment of a Manichaean manuscript found at Kocho [49]. Indeed, the prince on this Seljuq luster-painted bowl, and his twelve attendants, have been said to recall the Manichaean ruler of the Kingdom of Light, the Father of Greatness, who is surrounded by twelve gods, or "Beings of Light."

The suggestion is highly evocative: what could better express so fundamentally Manichaean a concept as the ruler of the primeval, eternal Paradise of Light, and his

twelve "Beings of Light," than metallic luster-painting, a technique which "dissolves" the dross of physical matter under shining, light-reflecting metallic glaze? The faces, and poses, of the twelve courtiers are exceptionally similar and far less varied in details of coiffure and dress, even in the subtleties of pose, than are those in the *Kitab al-Aghani* frontispiece, or the multitudes of attending figures on other Seljuq luster-painted vessels and tiles. Yet the *tiraz* bands on all the forearm sleeves are a contemporary feature; worn all over the medieval Islamic world, here they reinforce the notion of a Seljuq "present day" for the gathering painted on the curved surface of this large bowl.

124. ISFANDIYAR APPROACHES GUSHTASP

> Folio from a dispersed manuscript known as the "Great Mongol *Shahnama*"
> Tabriz, ca. 1325–35
> H: 23.8 cm; W: 29 cm
> Florence, I Tatti (Harvard University Center for Renaissance Studies)

Despite the long gap just preceding this picture in the manuscript, there is no doubt that it was expressly designed to illustrate the text here at this point: written in gold letters in the cartouche just above the king's throne is the phrase "Picture of Gushtasp and the Coming of Isfandiyar to Him."

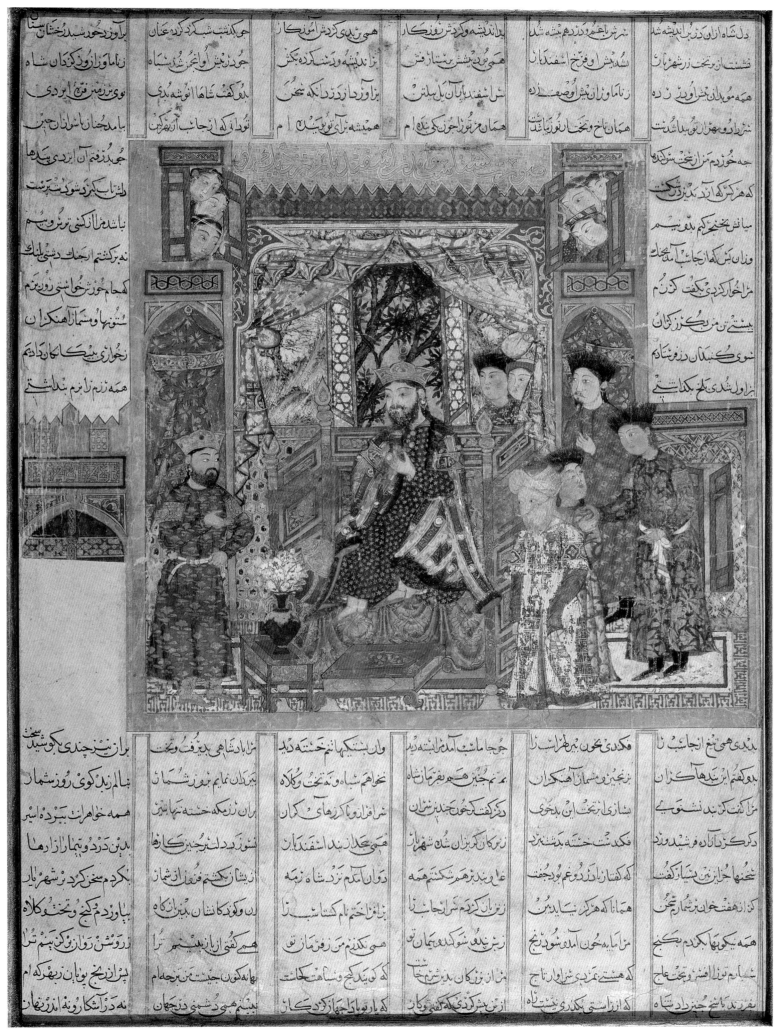

The essence of the image, the enthroned ruler surrounded by attendants, serves perfectly for an episode in which a prince makes bold to inquire of his father the king how long he will delay his promised abdication. The setting again reflects an Ilkhanid courtly interior: the tiled dado, carved woodwork, and wooden shutters; the carpet with its pseudo kufic border on which stands the red-lacquered throne; the brocaded hangings, and the garments of deep color with large golden floral patterns of the kind shown in other contemporary examples [102, 150]. In a formula often used in this manuscript, women peer down onto the scene from a pair of windows whose shutters are partially ajar; one, on the right, is crowned, and the others wear transparent white veils. In the lower zone, however, the placement of the figures underscores the drama of the interview. Six male attendants stand, loosely grouped, at the right side, while the king, in the center, faces Isfandiyar, who stands alone in the doorway at the left, hand on his hip. The conversation between them is well conveyed by posture, gestures, and the focus of their eyes. Both are crowned, as if to echo the word Firdausi uses at the end of this episode: "Now therefore set the crown on thy son's head / As thine own father crowned thee in his stead."

125. CAESAR GIVES HIS DAUGHTER KATAYUN TO GUSHTASP

Painting from a dispersed manuscript of Firdausi's *Shahnama*
Isfahan (?), ca. 1335–40
H: 20.5 cm; W: 13.5 cm
New York, Metropolitan Museum of Art, 1974.290.22r

The prior illustration, in which a slighted son dares to approach his father and demand his rights, is a grand version of the topos of the princely interview: it is a complex picture in a very rich setting, with many witnesses of both sexes. In this small, and strip-like, painting (also later, although perhaps by only fifteen years) the princely focus of the composition has been pushed to one side and the

attendants reduced to three. The central figure is instead the daughter of Caesar, who has seen the Iranian prince Gushtasp in a dream and will have no other for her mate: Firdausi lets her assert her will, and the painter echoes the text. He balances his picture, however, by setting another princely figure – perhaps Gushtasp himself – in a doorway to the right.

126. THE GAMES OF BACKGAMMON AND CHESS

Painting in an anthology of prose and poetry
Herat, 1427
H: 19 cm; W: 11.9 cm
Florence, I Tatti (Harvard University Center for Renaissance Studies), fol. 50v

Baysunghur's illustrated compendium of subjects a Timurid prince should master includes a treatise entitled *The Refutation of Chess*. This picture of a princely gathering, men playing both chess and backgammon on an outdoor terrace in a garden, offers a visual commentary on the text.

Seated on a rug, a prince plays backgammon. He is bearded and wears a white turban, and he is dressed in an ermine-lined green cloak and a blue *jama*, both with golden cloud collars around the neck. His courtiers are from many lands: one is black in color but wears the turban with one end pulled under the chin in Arab style. The headgear and garments of the others vary in details, such as the manner of their fastenings, but all have golden decoration at the shoulder or the knee, or *tiraz* on the sleeves of ermine-lined cloaks. The setting is composed of a simple series of horizontal zones: stone floor, carpet, flowering garden seen through the red palings of a fence, and the golden sunny sky, where birds flutter or perch in the branches of the trees. But the painting is filled with figures – ten, of reasonable size, are assembled on the terrace to play and to join in the disputation, presumably on the respective merits of the two games – and the human element is perfectly integrated into its space. The debate is essentially expressed by the gestures of

hands, less so by the direction of glances. It is a superb image of "the game of kings" played in an ideal setting that is realized in a particularly beautiful manner; it is also the best preserved of all the paintings in Baysunghur's anthology of princely pursuits.

127. SULTAN SANJAR AND THE OLD WOMAN

Painting in Shah Tahmasp's manuscript of Nizami's *Khamsa*
Tabriz, 1539–43
H: 26.5 cm; W: 20.5 cm
London, The British Library, Or. 2265, fol. 18r

The fourth discourse of Nizami's *Makhzan al-asrar*, the *Treasury of Mysteries*, concerns the behavior of kings to their subjects. The moralizing tale with which it ends recounts the meeting of the Seljuq sultan Sanjar with the old woman who complains of abuse meted out to the poor by his officials and police: "Thou art a king to lessen tyranny, and if others wound, thou shouldst heal."

The subject was even more popular an illustration than "Nushirwan and the Owls" [96]. In Tahmasp's great *Khamsa*, this image, whose subject is the direct contact between the governed and the governor, equally embodies that moment in the history of Iranian manuscript illustration when Timurid classicism could seamlessly adopt high Safavid garb in the creation of a perfect picture.

The core of the composition is the group of three figures, the mounted shah and the old crone – the only characters in Nizami's text – and the groom on foot who turns back at the interruption, an element of the episode since at least the beginning of the fifteenth century [73]. Each is perfectly in scale within the very large painting. The open and uncrowded composition breathes a stateliness and even a kind of serenity, despite the tension of the encounter and the apposite morale of its message. The groom is a slender, dandyish figure in bright clothing and a striped turban cloth; Sanjar's other companions are relatively few, not extravagantly dressed and wearing white turbans. Almost all would be logical participants in a hunting party in the wilderness: the attendant who holds the parasol [25], two who carry bows and a third with a cloth bow-case, a falconer, a cup-bearer, and another man on foot barely seen behind the rocky outcrop at the top of the picture. Also large figures with space around them, they are placed believably throughout the vertical space of the large picture, despite being formally spread along its right margin, as if to anchor a kind of open "C-shape" in the landscape. This is formed by the rocky outcrop and the rock bed of the flower-fringed silver stream that flows and drops down the right side of the picture to the bottom margin, where ducks paddle on a

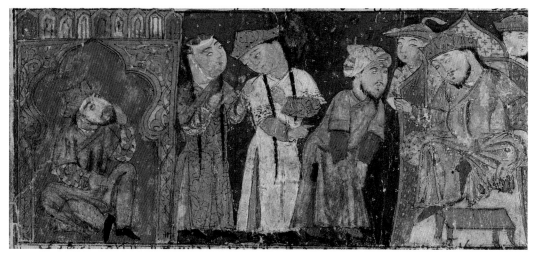

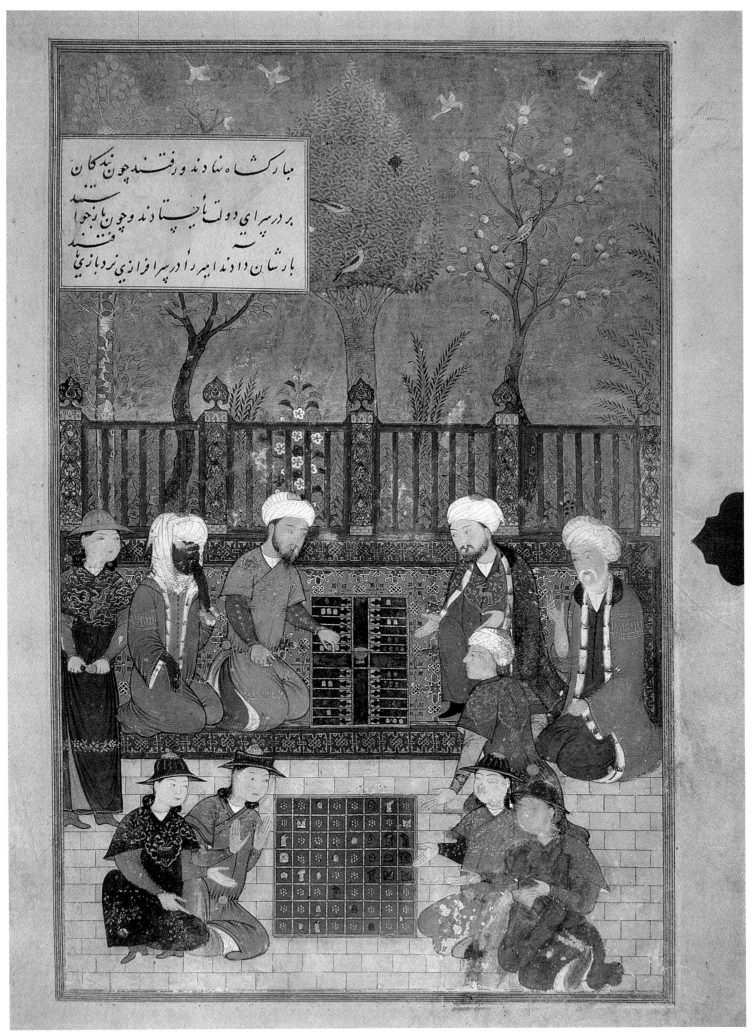

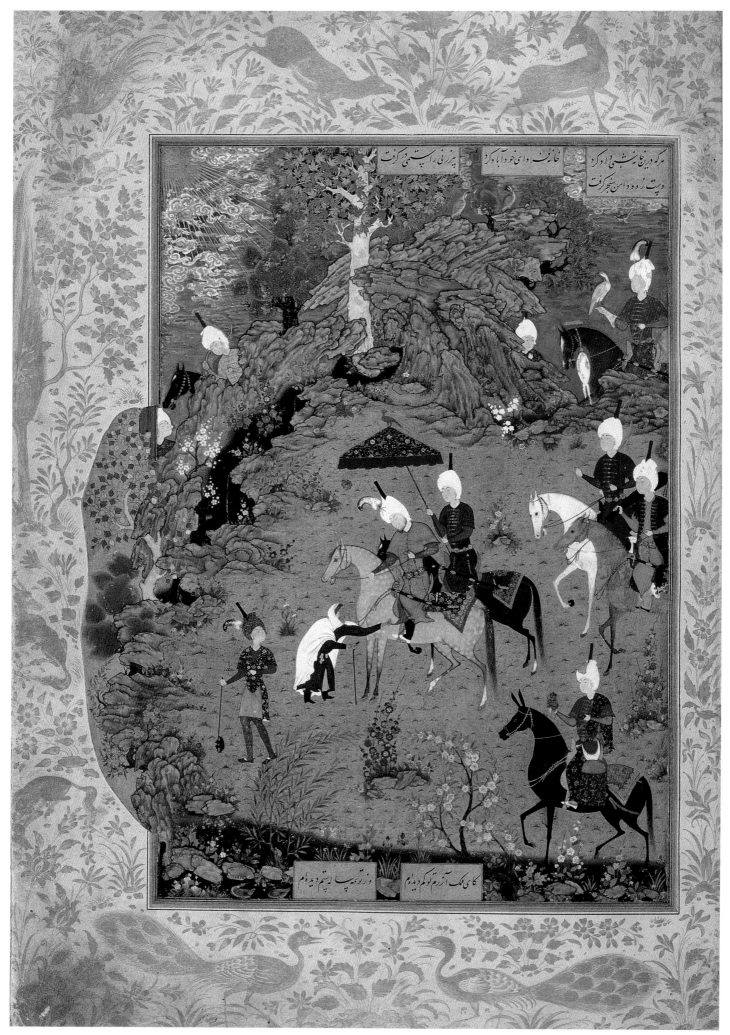

calmer stretch of water. At the center is the barer desert ground where the old woman lays hold of Sanjar's skirt, just as Nizami writes.

The shah on his dappled grey horse, a finely illuminated parasol held over his head, again occupies the center of the composition. The plane tree at the top center, its foliage cut by the upper margin, is an echo of an older, Timurid compositional formula [73, 239]. Another stock element of even greater age is the pair of red-legged partridges perched on the edge of the rocks to the right of the plane tree, an apparently naturalistic motif already several centuries old, by this date. Formulaic in their position, one placed slightly above the other with its head turned to look back at its mate, they are almost more noticeable when one has been omitted, as in "Nushirwan and the Owls" [96].

128. SHAH ʿABBAS II RECEIVES A MUGHAL AMBASSADOR

> Painting intended for mounting in an album
> Shiraz, late eighteenth century
> H: 33.5 cm; W: 24.5 cm
> Geneva, Prince Sadruddin Aga Khan Collection

The architectural inscription in white on blue that runs around the *iwan* in the background

of this picture proclaims its subject to be the "victorious" Shah ʿAbbas II and ends with a phrase suggesting that he is still alive: *khalladallah [mulkahu]*, "may God preserve [his kingdom]."

The image of the shah conforms, in most features, to the formula by which ʿAbbas II is usually depicted: wearing a gold-frogged pink *jama* and a striped Safavid turban of extravagant bulk, with jeweled ornaments. Different, here, is the fine fuzz of chestnut-color facial hair that gives him the appearance of a youth, instead of the thick dark beard and mustache that entirely enveloped his lower face in later years. Otherwise, the clothing of the central figure closely resembles that of ʿAbbas II [192] as he appears on the wall in the audience hall in the Chihil Sutun (built during his reign). The subject and composition of this formal reception of an Indian ambassador at the Safavid court is also modelled on the Chihil Sutun painting, itself a formula of far greater age in the Iranian world [120].

This picture has always been dated to the middle of the seventeenth century, in the reign of ʿAbbas II, on several counts: because its subject so faithfully depicts mid-seventeenth-century Safavid dress and accessories, furnishings and architecture; because the faces seem similar to those in some of the other late Safavid pictures of court assemblies; and because another contemporary court painter (who worked in

an Indian-influenced eclectic style) did paint a similar subject in 1663. More recently, however, it has been proposed as a work of the later eighteenth century and attributed to the Zand painter Abu'l-Hasan Ghaffari. The now-compelling reasons are the similarity of its pose and features to a historicizing portrait of Shah Safi I (1629–42) dated in 1794, and the use of the white inscription-frieze on a blue ground that also runs around a two-story setting for a portrait dated several decades earlier.[1] Details such as the perfectly adjusted perspective of the rugs and the mat on which the shah sits, the drawing of the two deep bowls of blue and white ceramic in front of him and the carefully reproduced decoration of the tile spandrels on the *iwan* behind him, the vigorous height of the black heron-feather aigrettes in the courtiers' turbans, and the shah's surprisingly youthful appearance: all lend credence to this suggestion.

Such historicizing painting is not entirely unknown in the eighteenth and nineteenth centuries – there are numerous later copies of the Chihil Sutun audience hall paintings. But the exceptional quality of the execution of this image and the details that so carefully reproduce its Safavid setting, in addition to the text referring to a living ruler, all suggest that a Safavid seventeenth-century image actually lay before Abu'l-Hasan Ghaffari as he was painting this picture in Shiraz, toward the end of the eighteenth century.

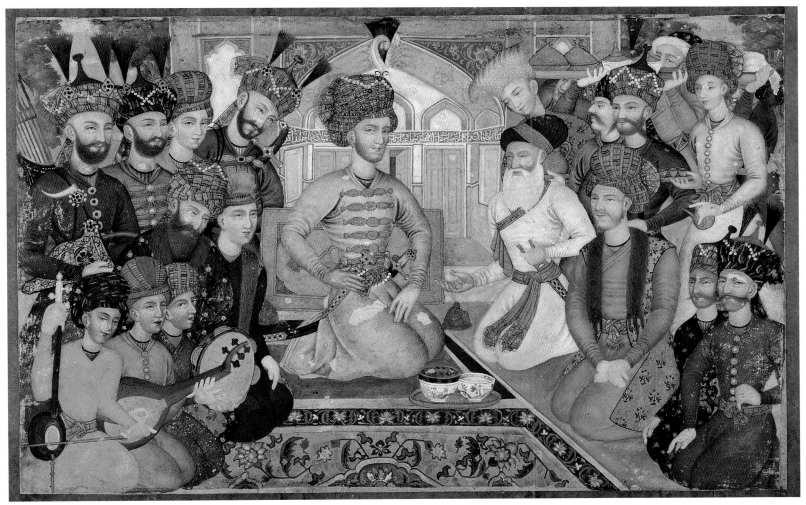

128

THE HERO

129. RUSTAM VICTORIOUS

Painted mural in a private house
Panjikent, Sogdia, ca. 740
H: 102 cm
St Petersburg, State Hermitage Museum,
SA 15902

A large cycle of murals devoted to the Eastern Iranian hero Rustam of Sistan (a region south of Khurasan, straddling the border between present-day Iran and Afghanistan) and Zabul (to the east of Sistan), was the primary decoration of the reception hall in one of the larger private houses in eighth-century Panjikent. The sequence here differs from that on the wall, where the fight with a dragon [132] is placed after the duel [133] and before "Rustam Victorious" [129].

Here Rustam rides his famous charger, Rakhsh. They move peacefully away from a combat in which the hero has prevailed over a supernatural foe. Rustam is the image of heroic energy gathered together in rest, latently energetic but not inert. He is portrayed according to the Sogdian ideal [121] of the heroic male physique: from a narrow waist

rises a broadening body with powerful but rounded shoulders; muscular arms taper, from the broad shoulders, to light and mobile hands; a strong neck supports a light head.

Indeed, this Sogdian Rustam perfectly exemplifies a contradiction in the very concept of the hero: heroic feats appear so impressive because they are performed by a mortal, yet they are too much for a mere mortal to accomplish without some supernatural assistance, from his own power or from elsewhere. The painter well portrayed both aspects of this paradox. The mortal Rustam nearly perished in his fight against the dragon, and both he and Rakhsh are shown as only slightly larger than ordinary warriors and their horses. Yet his formidable face is very different from more ordinary Sogdian male faces, beautiful but standardized. Here, Rustam has a heavy chin, a pointed skull, and raised eyebrows. These features recall instead the faces of painted *div*s – Rustam's constant enemies – and the terrible gods of Shiva-like visage.

The Sogdian painter did not invent this visage but more probably borrowed it from

the pictorial imagery of the Hephthalite state, in which the profile portrait of the ruler, found on coins in particular, had a similarly fiery appearance. This aspect may be traced to the fact that the early sixth-century king Mihirakula and his relatives were worshippers of Shiva, and his artists introduced some features of Shivaite iconography into their monarch's images. As for the pointed shape of the skull, it is typically Hephthalite [183], and Zabulistan – Rustam's land of origin – was an important part of the Hephthalite dominions. It seems plausible to suppose that the earliest illustrations of the cycle of Rustam stories were produced there, perhaps in scroll form, for the use of a professional story teller. When Sogdiana fell under Hephthalite sway in the early sixth century, it is equally plausible that such scrolls with illustrated Rustam stories came into the hands of Sogdian listeners; they, or later Sogdian generations, then commissioned artists to illustrate the same cycle on a larger scale and in a more public context.

Painted near Rustam's head is his own supernatural protector, the flying beast which,

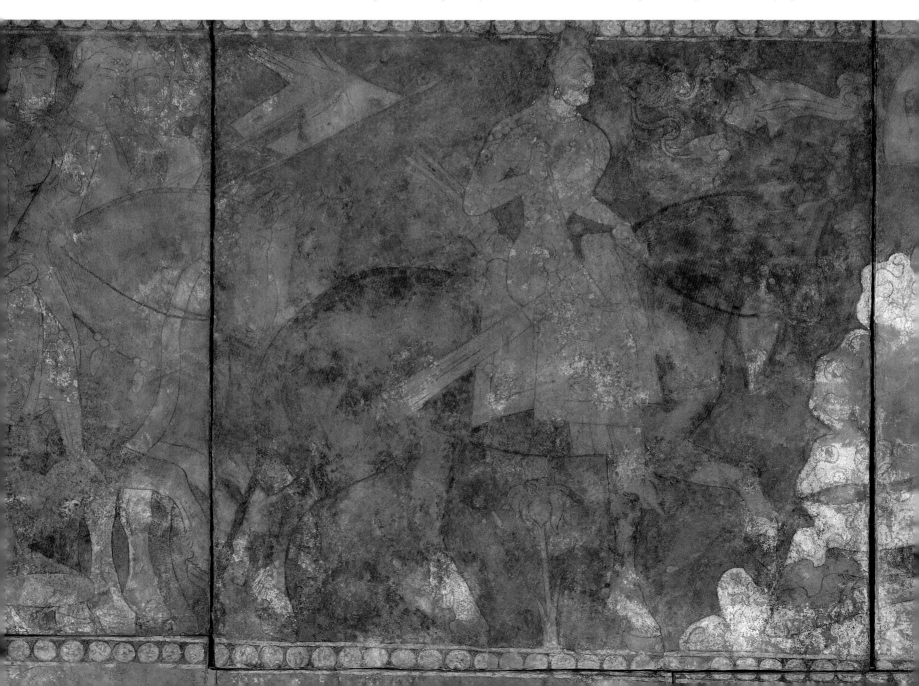

130

in Firdausi's later text, is a divine bird called the *simurgh* that afforded protection to Zal and his son Rustam [80]. Here, the Sogdian *simurgh* is a winged lion with a dragon's tail (and entirely different from the Sasanian creature sometimes and perhaps wrongly called the *senmurv*, like a dog-bird and occurring on stucco, silver vessels, and textiles).

"Rustam Victorious" is composed on a vertical axis, varied by the S-like curves of Rustam and Rakhsh and the flame-like termination of all forms; the lower part of the axis is provided by a flower on a straight stem. This is not only a compositional element but a symbolic one as well: in many folk cultures, dragons guard the waters, and the breaking of a drought, one result of which is verdant blooms, is sometimes expressed as slaying a dragon. The foliage of this flower also offers information about the colorism of Sogdian painting, for its stem and leaves are greyish yellow, not green. Green was a color deliberately avoided by Sogdian painters; their preferred palette was shades of red, blue, and yellow – the primary colors – and the achromatic black and white, colors which, when juxtaposed, would not destroy the overall harmony of the composition. But their choices were limited to the harmonious shades

that could also be compounded from the few mineral pigments at their disposal. Thus they seem to have rejected all risky juxtapositions of reds and greens, or blues and greens, because they could only be beautiful if the adjacent hues were fortunately selected. For instance, some greens and reds are complementary, saturating each other. One might think that Sogdian painters simply had no proper green pigments, whereas in fact they disliked blending paints. B.I.M.

130. A HERO IN A TIGER–SKIN GARMENT WRESTLING A BLACK *DIV*

Painting mounted in a later album
Western Iran or Central Asia, late
fourteenth–fifteenth century
H: 18 cm; W: 23.5 cm
Istanbul, Topkapı Saray Museum, H. 2153,
fol. 64r

This dramatic picture of a sturdy man in a tiger-skin skirt and a leopard-skin hat wrestling a *div* to the ground immediately brings to mind Firdausi's great hero Rustam, and his encounters with *div*s – demons – especially with Puladwand [17].

For Firdausi, the Black Div appears very early in the epic, named as the son of Ahriman who personifies sin and evil. Engaged in combat by Gayumarth, first of the Iranian kings, the Black Div slew Gayumarth's son Siyamak; the *div* was, in turn, slain in revenge by his son Hushang, who flayed him, lopped off his head, and trampled the corpse. Rustam appears in the *Shahnama* somewhat later, and he never fights the Black Div but is compared with him, in the course of completing his seven feats of strength and cunning, his *haft khwan* [182].

The *div* in this picture conforms to the vision of demons always seen in this group of paintings [Fig. 64] – which are, in turn, similar to those in Iranian text illustration from as early as it survives, in the fourteenth century [102]: a spotted skin, a horned head with fang-like teeth, five-fingered hands and toes, and a hairy tail; the golden rings around arms, legs, and neck are not ornaments but tokens of servitude. Wrestled to an upside-down position, the *div* twists his adversary's foot in both hands, and the disengaged little finger shows a distinct fingernail. The hero has pushed his sleeves up for bare-armed combat; he grasps the necklet of the *div* in one hand and one upper thigh in the other. He is seen

131

131. RUSTAM UNHORSES AFRASIYAB

Painting from Ibrahim-Sultan's manuscript
of Firdausi's *Shahnama*
Shiraz, ca. 1431–35
H: 23.4 cm; W: 16.5 cm
Oxford, Bodleian Library, Ouseley 176,
fol. 63v

The deeds of heroes are among the themes
given particular pictorial stress in Ibrahim-
Sultan's *Shahnama*: over half of its pictures
have heroic subjects, and this is one of the
earliest in the manuscript.

Rustam's first encounter with Afrasiyab
was when the great hero was still a youth,
eager to know what war was. His father Zal
advised against his participation but Rustam,
headstrong, charged the Turanian on Rakhsh's
back with his great mace flying, amid the
blare of trumpets. As he had promised, he
grasped Afrasiyab by the belt and lifted him
from his saddle. Firdausi writes that he then
hung the mace on his saddle, but in this full-
page painting in Ibrahim-Sultan's *Shahnama* it
has dropped to the ground beneath Afrasiyab's
horse.

Almost surely by the same hand as that of
Rustam's wrestling with Puladwand [17], this
is, again, a picture in which a few large figures
with dynamic and dramatic silhouettes are
disposed in the foreground. The horses more
than fill the picture-space: Shiraz horses,
especially from Ibrahim's atelier, are very large
creatures with long bodies, and the full armor
they wear increases the sense of their size.
The effect of two armies closely drawn up is
achieved by techniques seen in earlier Shiraz-
Timurid painting [7]: at the right, three moun-
ted soldiers, two archers, and the trumpeter,
and three mounted archers on the left; the
device of cutting three horses by the margin,
to show only the rumps or the head [91],
increases the sense of the battle's confusion.
Behind the high hill float two pairs of pennons,
suggesting that the main armies of both Iran
and Turan are assembled just out of sight.

132. RUSTAM FIGHTS A DRAGON

Painted mural in a private house
Panjikent, Sogdia, ca. 740
H: 100 cm
St Petersburg, State Hermitage Museum,
SA 15902

Rustam and Rakhsh fight a she-dragon,
perhaps adumbrating Firdausi's story of
Rustam's third *khwan*. The image is altogether
more dramatic than that of Rustam's encoun-
ter with Aulad, in the preceding episode of
the frieze [133], and Rustam appears to be
even more helpless than Aulad. The dragon is
shown as a sinuous beast with a female head,
and arms but no hind legs. Her serpent-like
tail is coiled around Rakhsh's four legs; she
grasps Rustam's forearms and tries to drag his
head into her jaws. As always in this ensemble,
Rustam wears the leopard-skin coat [129]

in rear profile, so that the hooked shape of his
nose and the heavy eyebrow over a large eye
are evident – not a beautiful East Asian type,
but a westerner. His tunic is made of the
distinctive tiger skin later associated with
Rustam, while his upper and lower garments
are shown as lined with leopard skin: Siyamak,
in sallying forth to fight the Black Div, had
arrayed himself "In leopard skin, for mail was
yet unworn." And in the Sogdian murals in
Panjikent [129, 132, 133] Rustam seems to
wear a leopard skin as the lower part of his
garment; such a description is also attested in
Sogdian texts. It is only later, in fourteenth-
century manuscript painting onward, that his

customary garb will be the tiger-skin surcoat;
the leopard-skin casque first became a standard
element of his costume in fifteenth-century
Shiraz painting.

Again, this image seems to come from a
locale in which very skilled painters had but
an incomplete appreciation of Iranian literary
culture. Yet it is a striking and dynamic fantasy
on the strength and invincibility of Iran's
greatest legendary hero.

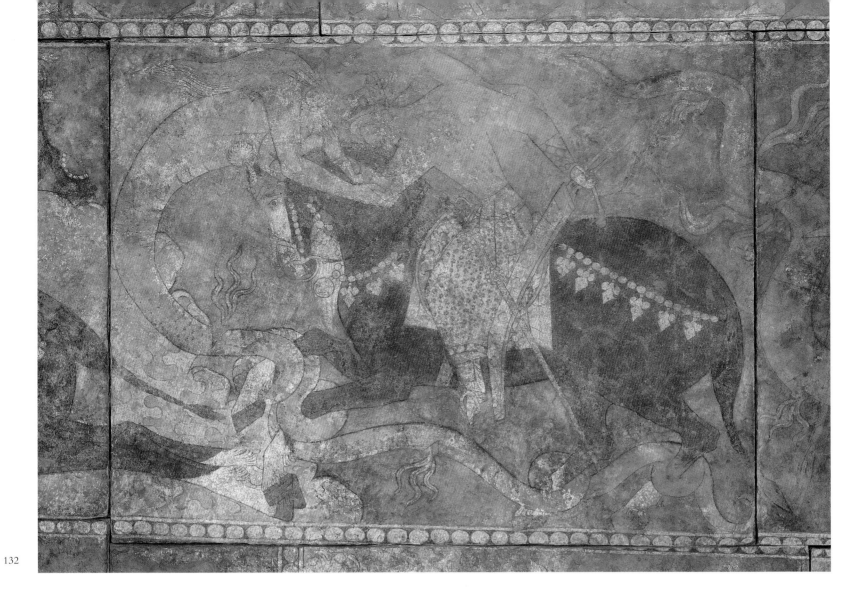

132

133

mentioned in the surviving Sogdian text of the story, but his other attributes of good fortune, and glory, are not shown, and no divine protector flies at his shoulder.

The depiction of his arms and weapons demonstrates a surprising logic on the part of the painter. As Rustam is seen from the back, the rich pectoral seen in other episodes is invisible. His left arm is close to the front of the picture-plane, and his right is apparently further to the rear but it is shown as if pulled behind his back, which brings it closer to the front of the picture. Rustam's weapons were always chosen for the task at hand: here it is with an axe that he has inflicted damage on the dragon – two slashing cuts on its tail, from which spurt flames, to show the fiery nature of the beast. Yet the painter chose not to show the axe itself (hanging down from the right hand and mostly hidden by the massive curve of Rakhsh's crupper); instead, pictorial stress is laid on the peril of the moment, when an apparently defenseless Rustam was most in danger from the monster. Thus, the empty left hand is raised in a helpless gesture; while the right hand partly rests on the bow case (which would actually have been worn at the left side) and holds the virtually hidden, but potentially damaging, axe. Such reluctance to relegate to the background any element of primary importance is typical for Sogdian painting.

Another typical feature is the inclusion in one episode of details from a previous one, as here, when Rakhsh's front hooves overlap the rear hooves of the next episode. What mattered more to the Sogdian painter was the sequence of events, not the spatial relationship between elements. And in the eighth century, a background space full of diverse objects held no interest for the painter or the viewer (unlike the painting on a certain class of Nishapur pottery of the tenth century [23]). Indeed, the empty background conveys the impression that Sogdian figures move freely in their surrounding space, whereas its immaterial abstractness permits the painter to focus on the narrative sequence of his pictures and to dispose, in the most pictorially effective manner, of the crucial components of his picture – the right hand and its impossible position in front of the left-mounted bow case. B.I.M.

133. RUSTAM LASSOES AULAD

Painted mural in a private house
Panjikent, Sogdia, ca. 740
H: 101 cm
St Petersburg, State Hermitage Museum,
SA 15902

For the Sogdian artist an architectural corner presented no visual obstacle. Thus the picture of Rustam's capture of Aulad was spread over two adjacent corners of the large reception hall on whose walls many other episodes from the Rustam cycle were painted.

As Firdausi tells the story, Aulad is the only human adversary who figures in Rustam's seven feats of prowess, or *khwans*, among the *div*s. In the *Shahnama*, Rustam lassoes Aulad after defeating him and his men [134]: "When Rakhsh neared Aulad, the day became dark like night. / Threw Rustam his long lasso, [and Aulad] bent [his] proud head."[1] The Sogdian legend diverges somewhat, and the painting depicts the initial encounter between the two: Aulad, in full armor and mounted on horseback, raises a long sword against Rustam.

Nonetheless, Aulad is an image of utter helplessness, shown in the moment just after the noose of the lasso has landed over his neck, his back already bent in response to the tightening rope. Moreover, he and his horse are smaller than Rustam and his Rakhsh, and he is placed in front of a high mountain that further diminishes his importance, in comparison with Rustam. A beautiful girl, partly hidden behind a second, lower mountain, raises her hand in admiration. Rustam is accompanied by his symbol of divine protection, the *simurgh* in the form of a winged lion with a dragon's tail, who brings ribbons to the hero; the girl is protected by a flower-skirted female who offers her a necklace.

For the Sogdian painter, all the pictorial elements relating to Rustam are associated with his ability to move without hindrance: his powerful body, Rakhsh's flying gallop, and the empty sky-blue space around them both. As in so many other Sogdian murals, the

figures are three-dimensional and foreshortened, and convex curves are mostly used for outlines. This treatment, together with the warm ocher palette, produces a corporeal impression when the paintings are viewed from a close vantage point, even though from a great distance the entire wall, with its evenly disposed contrasting color zones, is more suggestive of a flat but richly colored carpet. B.I.M.

134. RUSTAM LASSOES AULAD

Painting in a manuscript of Firdausi's
Shahnama
Isfahan, 1648
H: 29.2 (30.6) cm, W: 19.6 cm
Windsor, The Royal Library, MS 1005014, fol. 94r

The third of the seven feats, or *khwan*s, which Rustam performed as a young hero in the service of the foolish Shah Kay Ka'us was to capture the youth, Aulad, who was in league with the *div*s. He could not only direct Rustam to the lairs of Arzhang, and the White Div [182], but also to where Kay Ka'us was kept as a blinded prisoner.

In this mid-seventeenth-century picture – as is always the case in manuscript illustrations of the episode – Rustam captures Aulad with a mighty lasso. Firdausi writes that Rustam rode forth to combat with Aulad having sixty coils of rope looped over his elephantine arm. Yet the story of Rustam's feats among the *div*s is far older in the Iranian world. Possibly derived from folk stories, it was circulating in Sistan some centuries earlier, perhaps as a Middle Persian *Saga of Rustam*, which was also known in a Sogdian version. Indeed, Rustam's lassoing of Aulad figures among the deeds of Rustam painted on the walls of an eighth-century private house in Panjikent [133].

Rustam had fought his way through Aulad's army: ". . . The troops . . . / Fled in dismay, and wilderness and dale / Were filled with dust clouds by the cavaliers / As they dispersed among the rocks and hollows." Aulad's troops have scattered to the safety of the mountainous outcroppings of the background, where they watch their commander struggle with the lasso that has landed neatly around his body. Aulad's helmet has apparently fallen off in the fray and he is shown as bald, as are many other men throughout this manuscript, even though Firdausi calls him a youth. This is almost surely an instance of visual homage to Shah 'Abbas I [36, 128]: both Iranian images and European descriptions attest to this fact. 'Abbas I had died in 1629, but pictures of young and vigorous bald men, often with large and luxuriant mustaches, continue to appear in Iranian painting throughout the course of the seventeenth century and well into the eighteenth.

135. BIZHAN SLAYS THE BOARS OF IRMAN

A scene painted on the Freer Beaker, a *mina'i* drinking-vessel
Iran, twelfth or early thirteenthth century
H: 12 cm; W: 11.2 cm
Washington, DC, Freer Gallery of Art, 28.2

A series of twelve narrative scenes recounting the romance of the Iranian hero Bizhan and the Turanian princess Manizha is painted in three registers on the flaring walls of this drinking vessel known as the "Freer Beaker."

The Bizhan-and-Manizha cycle is today best known as it appears in Firdausi's *Shahnama* [116] but, like other celebrated Iranian legends that acquired literary fame in medieval times and were used in the decoration of metal or ceramic objects of many periods – Bahram Gur and Azada [224-228], or Shirin and Farhad [235-37], it well pre-dates Firdausi's tenth-century text. Firdausi himself calls it "a tale of yore . . . [whose] theme is love, spell, war, and stratagem," and says that it is drawn "out of the book of ancient legendry" (a Pahlavi book). He concludes ". . . the story of Bizhan is told / As I have heard it in the tales of old."

In Firdausi's narrative, Bizhan is the hero appointed by the shah Kay Khusrau to rid the land of Irman – Armenia – from an infestation of wild boars. The shah sent another hero, Gurgin, with Bizhan "To show him the way and be his help in need." When the pair reached the forest where the boars roamed free, Gurgin turned sullen and refused to assist Bizhan, who "undaunted strung his bow" and slew the beasts himself [136–39].

A panel in the top register of the beaker's decoration appears to show just this event by the simple means of four figures – a pair of horsemen setting out to hunt, and a single horseman slashing at a single beast on the ground while his companion looks on.

Firdausi says, in his prologue, that he will turn the ancient story of Bizhan and Manizha into verse; it must already have been circulating in one or another versified version by the later tenth century. These, and whatever pre-Islamic, Pahlavi source he worked from, were all based on far older components, including the story of the hero and his companion seen on a large Scythian gold buckle [19] in the treasury of Peter the Great of the fourth or third century BC, where the hero performs heroically while his companion hides in panic. Firdausi completes the transformation of these components when he makes Gurgin's jealousy the fulcrum on which the larger story – the continuing blood feud between Iran and Turan – advances: "Gurgin for his own profit and renown / Spread out his nets upon the young man's path." Events then proceed inexorably: the snare posed by the beautiful princess, the inevitable attraction between Iranian boy and Turanian girl, the father's rage and his imprisonment of the foreigner, Manizha's plot and her enlisting of Rustam, greatest of the Iranian heroes, to rescue Bizhan at night. All lead, ultimately, to one of the great battles between the Iranians and the Turanians; as well as to the quietly resolved, but happy, conclusion to the romance. On the beaker, however, the final painted panel on the beaker is Bizhan's rescue from the well [cf. 116].

That most of the episodes of one of Firdausi's great love stories should have been so meticulously painted in three registers of

135

relatively small scenes on a fragile ceramic drinking vessel, to "read" which the drinker, or viewer, would have had to rotate the beaker three times while holding it at eye level, makes us wonder for what use the "Freer Beaker" was intended. And what were its pictorial sources? An oral version, either truncated or a variant, of Firdausi's Bizhan and Manizha? a now-lost but illustrated manuscript? or several, from which a selection of images was made? a pictorial scroll? or a format deriving from painted domestic interiors such as those brought to light in sixth- to eighth-century Panjikent? Convincing arguments could be made both for, and against, all of these possibilities. For the moment, the "Freer Beaker" remains unique in the larger repertoire of Seljuq objects with pictorial decoration.

136–38. BIZHAN SLAYS THE BOARS OF IRMAN

Paintings from three different, dispersed fourteenth-century manuscripts of Firdausi's *Shahnama*
New York, Metropolitan Museum of Art
136: Isfahan (?), ca. 1335–40;
 H: 20.5 cm; W: 13.5 cm
 1974.290.18v
137: Date and place uncertain;
 H: 37.4 cm; W: 28.3 cm
 25.68.1
138: Shiraz, 1341; H: 31.8 cm; W: 26.7 cm
 29.160.22

In contrast to the textually observant rendering of Bizhan slaying the boars of Irman on the "Freer Beaker" [135] the illustration of the episode in three fourteenth-century copies

of the *Shahnama* departs in several ways from the story as Firdausi relates it.

The picture from a small manuscript now attributed to Isfahan early in the fifth decade of the fourteenth century [136] is farthest from Firdausi's text: Bizhan has dismounted from his horse but he is armed, shown as a mature warrior with a dark beard and mustache, and the sullen Gurgin is nowhere to be seen. In the painting from the "First Small *Shahnama*" (and also in a related manuscript, the "Second Small *Shahnama*" [137]), he is both bearded and mounted, on an unarmored horse; but his clothing reflects the styles of the Ilkhanid court – the *jama* patterned with large Mongol-style flowers and a hat with a split, turned-up brim. The third contemporary version, from the Inju *Shahnama* of 1341 [138], varies these details: it shows Bizhan mounted and in full armor, as is his horse but, like the other two fourteenth-century illustrations, it also shows the young hero bearded and unaccompanied by the treacherous Gurgin.

The textual diversity among fourteenth-century copies of Firdausi has long been recognized, but their pictorial diversity is only now beginning to be noted. For Firdausi, Bizhan kills boars as Gurgin looks on from safety: his text, or its source, is followed in this detail by the painter of the "Freer Beaker" but not in the three fourteenth-century illustrated books. Their illustrations accord only in their presentation of Bizhan as a solitary slayer of multiple boars. Since the manuscripts from which they all come were made in at least three different places in western Iran, it is not surprising that each, materially, differs from the others: in size and in the number of text-columns on a folio (the exceptions being the "First" and "Second" smaller manuscripts [137], almost surely made in the same, if still unidentified, center); and likewise in pictorial conception.

Still other possibilities deriving from yet other poetic sources also exist: for instance, the eleventh-century panegyrist Azraqi describes Bizhan as slaying a single, enormous boar in the company of cavalry.[1] Thus, what Firdausi writes – in whatever textual recension – is not always matched in visual terms in the

136

137

138

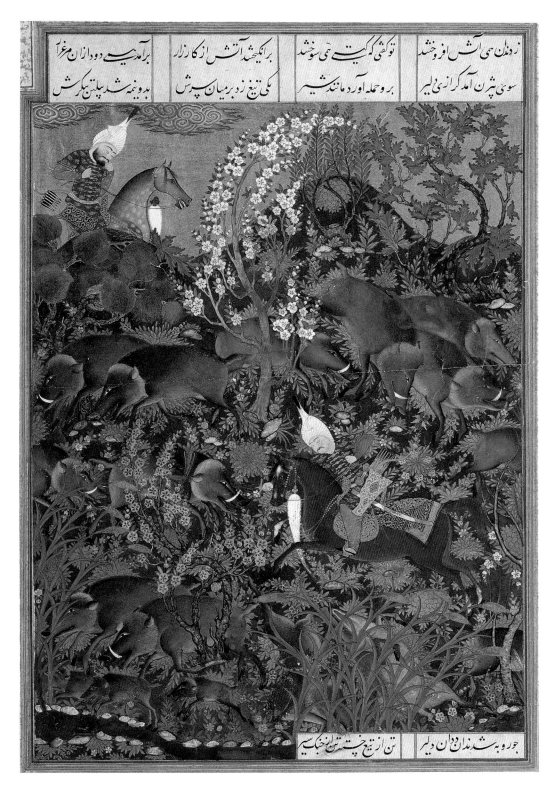

زمانی سی آتش افروخند | توکشی که کیت سی سوخند | براینکه جد آتش از کارزار | برآمد سی دودازان مغرا

سوسی پتهرن آمد کرانسی ئیمر | بر وحمله آورد مانتد شیر | یکی تیغ زد برمیان سورش | بدو نیمه شد پلتن نیکرکش

تن از تیغ چست تن ابن خاک سیر | جورویه شدندان ودان دلیر

139

illustration of manuscripts in the pictorially formative fourteenth century, especially when the subject is a composite one that has lain for so very long in the Iranian subconscious.

139. BIZHAN SLAYS THE BOARS OF IRMAN

Painting from the dispersed manuscript of Shah Tahmasp's *Shahnama* of Firdausi, folio 299r
Tabriz, between 1525–35
H: 24 cm; W: 17.5 cm
London (Ham), The Keir Collection, PP12

The same heroic episode, as it is depicted in a celebrated sixteenth-century manuscript, might be the image of any princely hunt or feat of prowess performed against wild animals: a hero slashes through foliage in the mid-zone of the picture, watched by another male figure biting his finger, the classical Persian gesture of wonder or astonishment, in the upper zone. Bizhan, again, is shown as old enough to sport a black mustache, and he wears no protective armor; the astonished Gurgin watches from the safety of the high horizon.

The boars immediately identify the subject. The ancient Iranian pictorial formula [19] – one who acts and one who watches – takes on wonderful specificity with the sheer quantity of ravening beasts and the verdant green and flowering landscape. The distant exoticism of Irman is evoked by the combination of the tamarisk, a shrub of the desert, at the top left and the cattails fringing the stream in the lower part of the picture. On the other hand, the two men are dressed as if to appear at court, in gold-embroidered, color-balanced garments. The crisp folds of their tall white turbans are executed in thick impasto and stand out in high relief.

140

140. GULSHAH'S PARENTS DISCUSS THE POSSIBILITY OF HER MARRIAGE TO WARQA

> Painting in a manuscript of 'Ayyuqi's
> *Warqa u Gulshah*
> Anatolia, 1200–1250
> H: 7 cm; W: 18 cm
> Istanbul, Topkapı Saray Museum, H. 841,
> fol. 31r

Seated cross-legged in a rich interior, Gulshah's parents consider whether to accede at last to the young couple's desires and approve of their marriage. Warqa has already pleaded his case with the mother, but the father is disinclined to the match, given Warqa's present lack of means. The strip-format and the figural simplicity of this picture – with its two figures inclined toward each other, the all-important conversation indicated only by outstretched hands – is countered by the architectural setting and the furnishings. We may imagine the interior of the niche where the parents sit as being hung with watered silk – effected by the rippling pattern of dark blue on a lighter hue – the exterior woodwork as carved and gilded, and the niche capped with gaily colored merlons. The father is a venerable white-bearded man seated on a golden chair; the mother could be Gulshah herself – bareheaded, with very long hair falling to her knees, for it has been noted that this painter knew only one female type. Both heads are set off by a golden nimbus.

This illustration is as vivid, and effective, as that of Gulshah's arrival at the tomb of Warqa [57], but it actually has a number of sources. The pictorial *topos* for this crucial moment is the princely interview; here it has been adapted to the textual purpose by substituting a white-bearded figure (itself a type of authority-figure) for the prince. The textile background of the interior in which the couple confer is known from book illustrations probably made in Mosul, in the Jazira, in the late twelfth and early thirteenth centuries, as well as in fourteenth-century Mamluk Egypt. The sole object, a large platter standing on three high, tapering legs and piled

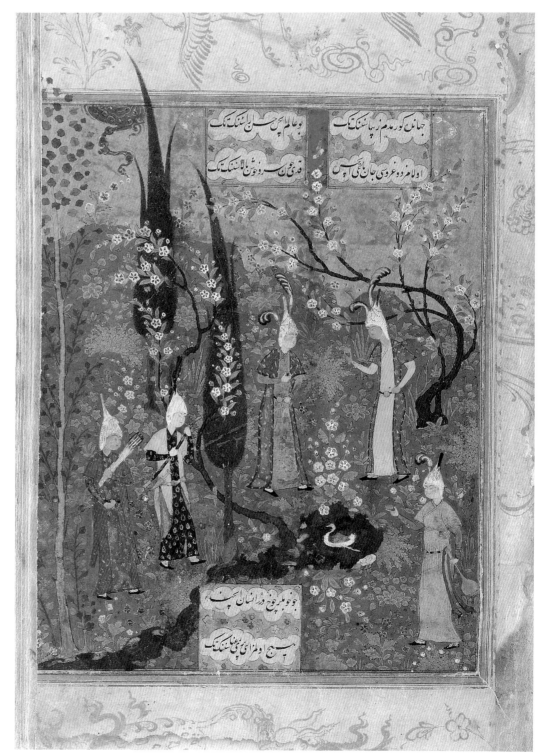

high with fruit, has been compared with somewhat earlier stone objects found in Nishapur, but it also has an even earlier painted parallel. The same three-footed fruit bowl appears in "The Feast of Bema" [49], a painting on one side of the largest of Manichaean book fragments found at Kocho, in Chinese Turkestan.

141. FIVE YOUTHS IN A GARDEN

Painting in a manuscript of the *Diwan* of Khata'i (the pen-name of Shah Isma'il Safavi)
Tabriz, ca. 1520
H: 15.2 cm; W: 12.1 cm
Washington, DC, The Arthur Sackler Gallery, S86.0060, fol. 2r

This charming manuscript of Shah Isma'il Safavi's *Diwan*, his collected poetry in Turkman Turkish, has no colophon page to tell us who copied the text, or when and where. But the inscription painted on the façade of a building in one of its three illustrations suggests that it was made for the shah during his lifetime: thus it must date before 1524. The three pictures do not illustrate stories but the themes of his love poetry, at once youthfully exuberant in tone and overflowing with the standard images of poetry in the Persian style – no matter the actual language.

"Five Youths in a Garden" could not convey more perfectly in images the stock vocabulary of love poetry in the Persian style, nor more beautifully exemplify its intimate relationship between images and words. A verdant, flowering meadow is the setting in which five beautiful youths stand; fruit trees are in full blossom and ducks swim in a pool from which a silver stream flows. A princely pair, distinguished by the elaborate plumes in their tall elegant Safavid turbans, stands above the pool; they are lover and beloved. The others are servants: a cup-bearer carrying a long-necked bottle, and a pair of arms bearers, one holding a quiver of arrows.

All the youths are tall and slender, beardless and having the tiniest of features. All nature, each figure, and every accoutrement, reflects the words of the poem adjacent to the text:

Truly, within the garden of the soul, there can be no stature so elegant as your tall, slender cypress.[1]

The elegant forms of the two princely figures are echoed by the two tall, slightly swaying cypress trees; that they are each entwined by a bending, flowering fruit tree is an additional visual image typical for this genre of painting. Other poems in the *Diwan* include words also pictured here: the long-necked bottle is a reference to the straight, slender figure of the beloved; the arrows refer to the keen gaze of the beloved that pierce the lover's heart; the pool and stream collect tears shed by the lover that collect at his feet and water the cypress.

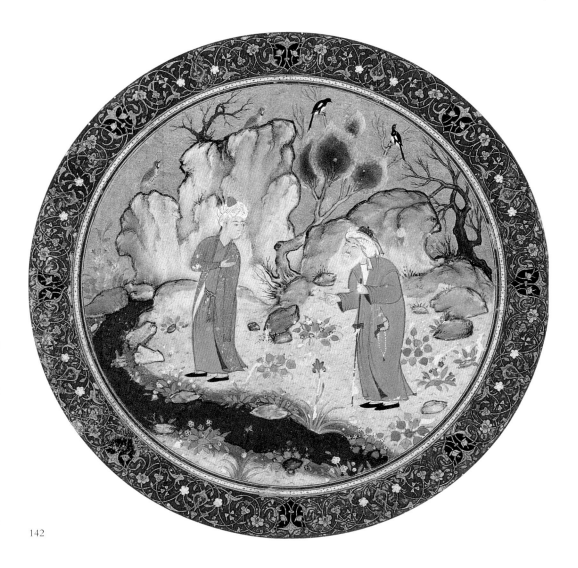

142

142. YOUTH AND OLD AGE

Painting mounted on an opening folio of an anthology of poetry
Herat, 1524
Diameter: 8.3 cm
Washington, DC, Freer Gallery of Art, 44.48, fol. 3r

This small roundel shows two men in a flowering landscape watered by a silvery stream. It is mounted, in the manner of an illuminated *shamsa*, at the beginning of an album of poetic extracts assembled in Herat for the Safavid vizier Khwaja Malik Ahmad. He himself chose some of the leading scribes of the day to copy the excerpts he had selected, requested another craftsman to design the volume, and placed a painting ascribed to Bihzad on an opening folio; a preface includes the information that the volume was completed in May of 1524.

Even so brief a description of this charming roundel raises questions concerning which much ink has already flowed. Can this small and simple painting truly be the work of the most celebrated of Iranian painters, notwithstanding the inscriptions in the margins, and the later comments by the Mughal rulers Jahangir and Shah Jahan, to the same effect? And when was it done, given the low headgear around which the mens' turbans are wrapped?

If the date of 1524 is accepted, how can it be explained as being painted by Bihzad in Herat, in the east, when the decree of Shah Tahmasp naming him as head of the Safavid royal manuscript workshop in Tabriz, in the west, is dated two years prior, in 1522 (or even earlier, in 1519)? When, then, did Bihzad actually move to Tabriz? And if all of these questions should be resolved in favor of Bihzad's hand, how may we then account for the fact that this charming but stylistically undistinguished painting seems to bear no visual relationship to earlier, fifteenth-century manuscript paintings, some of truly superlative quality, that are usually now considered his work [33, 68, 248]?

Still more ink has flowed in proposing explanations to account for the stylistic divergences, but for our purposes it is the subject and its setting, rather than the painter, that is of interest. A white-bearded man leaning on a stick, soberly dressed and with a string of prayer beads at his waist, converses with a beautiful youth; the latter is ahead of him on the path by the stream and turns backward, to answer the older man. The text above and below the roundel elaborates on the image, referring to the older man as a sage and the younger a prince; the youth is cautioned to recall, despite his highborn state, just how he came into the world, and that he will eventually leave it behind. The two figural

types summarize in one image the human condition; and the landscape echoes the juxtaposition of youth and age, combining both blossoming flowers and bare, twisted, dead trees in the same tiny setting.

143. RECLINING PRINCE READING

Painting mounted on an album page
Tabriz, ca. 1530
H: 15.6 cm; W: 12.6 cm
Washington, DC, Arthur Sackler Gallery, S86.0300

A beautiful prince, young and beardless, appears to have been interrupted in reading the small oblong volume he holds in one hand. Reclining on – indeed, almost embracing – a large bolster, he turns his head to look at the unseen source of the interruption, a pose which provided the artist with an opportunity to paint a gently curving figural study in blue and salmon-color touched with gold and black.

The palette is particularly harmonious and decorative, while the face of the princely youth seems decoratively anonymous. Indeed, the true subject is the discreet and tasteful luxury of rich garments, jewels, and ornaments adorning an ideally beautiful and youthful male figure, and the verse in the prince's hand echoes the picture in which it figures:

Fate granted such beauty to the face of Yusuf. Try to draw such [beauty] for your face, O slave.[1]

The high Safavid style of the turban must have been one aspect of this painting that led to an early suggestion that its subject was an idealized picture of Shah Tahmasp himself. More recent thinking has instead focused not on the image but on the artist, attributing it to the hand of Aqa Mirak. One of the seven painters named by Dust Muhammad as working in Tahmasp's atelier in the early 1540s, Aqa Mirak is also one of only two who are specifically named as having worked on Tahmasp's two most impressive manuscripts, the *Shahnama* and the magisterial *Khamsa* [35, 96]: "These two matchless sayyids . . . have mixed such colors and painted such faces . . . [that] the pen would . . . be incapable of describing them."[2]

Yet the face of this reclining prince is precisely what seems anonymous and weak: it is a vacuous image of youthful male beauty, rather than one of the many interesting and subtly varied youthful princes to be found throughout the *Khamsa* paintings. This weakness in the face, and the curiously truncated felt mat on which the figure sits, suggest instead that this painting is not original, let alone a portrait, but a copy of such a single-figure painting, however much it is conceived in the spirit of the poet Jami's beautiful Yusuf [41].

144. GRAYBEARD WITH A LION

Fragment of a painting
Qazvin or Mashhad, ca. 1560
H: 24.5 cm; W: 16 cm
Cambridge, Mass., Harvard University Art Museums, 1961.57

This fragmentary painting, now cut down but possibly the illustration to some unidentified

manuscript, either lost or never completed, offers a clear idea of the "building blocks" of classical Iranian manuscript illustration, the basic elements from which some of the most wondrous, beautiful, and compelling images have been composed.

The large fragment shows a middle-aged man and a lion in a landscape, and it conveys a very palpable sense of story. A dignified man

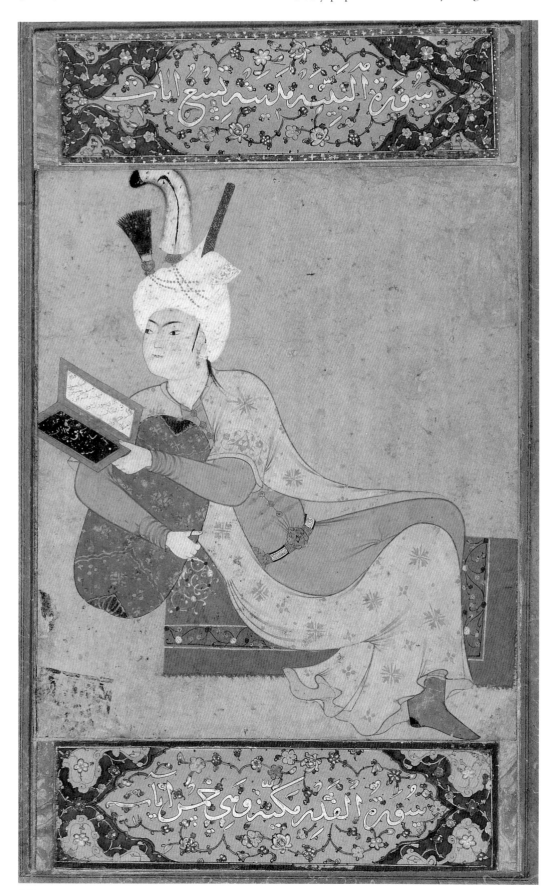

143

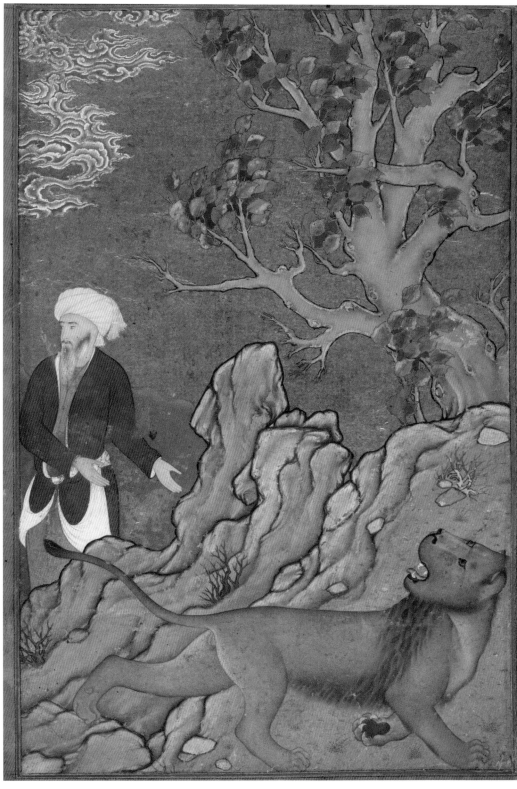

144

145. HAWKING PARTY IN THE MOUNTAINS

Double-page composition mounted on
marbled paper
Qazvin or Mashhad, ca. 1575
Right half: H: 49.9 cm; W: ca. 32.8 cm
 Boston, Museum of Fine Arts, 14.624
Left half: H: 49.9 cm; W: 32.8 cm
 New York, Metropolitan Museum of
 Art, 12.223.1

In a rocky glade a courtly hawking party has
dismounted to rest, while some of the catch
already roasts on a spit. The prince kneels on
a spur at the center of the right half of the
picture; this raises him, slightly, above the rest
of his party. The sense of a midday halt comes
from the brilliant golden midday sky, in which
a wispy cloud floats to lend a sense of
atmosphere.

This double-page painting has pictorial
features that link it to the manuscript of the
Haft Aurang but also place it at the forefront
of the next stylistic subchapter of Iranian
figural painting. As in "Yusuf Entertains at
Court Before his Marriage" [41], the older
men here are shown with well-differentiated
features and expressions, while the younger
figures of the prince and his attendants are all
types, examples of the beautiful young man.
But in the intervening period between the
painting of the *Haft Aurang* pictures and this
composition – that is, between 1556 and
about 1570 – the ideal of the beautiful male
youth, at least in its painted representations,
was changing; by the time this double-page
composition was completed, a rather different
type was prevalent. It is a prominent feature
of what is conveniently called the "Qazvin"
style, a name reflecting Shah Tahmasp's re-
establishment of the Safavid capital in that city
in 1548. A number of single-page paintings
[182] and drawings exemplify the aesthetic of
the Qazvin figural style, but many versions of
the type appear together in this double-page
picture of a princely hunt: the prince, his
beardless companions, and his attendants
perfectly embody the altered notion of
personal beauty typical of the best Qazvin
painting.

Bodies are slim and often sway-backed, and
standing figures appear to sag at the knees,
giving them that curiously spongy look
already seen in some of the *Haft Aurang*
paintings. Faces, too, are unmistakable, the eyes
large and long-lashed, sometimes smudgy in
outline, and widely set in faces broader than
they are high, often with marked double
chins. Heads give the appearance of being too
heavy for the necks on which they sit,
bending at improbable angles, and knees and
elbows protrude sharply from the outline of
the body, heretofore more contained in
silhouette.

These paintings have been proposed as the
double-page opening of a lost, or never
completed, manuscript jointly undertaken by
Tahmasp and Ibrahim-Mirza upon the latter's

– his gray beard suggests age but his carriage
is straight and strong – faces left and gestures
to the right, with open hands, towards a
pacing lion that turns its head back to the left
– and to the man. He is dressed in several
layers of simple and unornamented clothing,
the outer *jama* pulled up and tucked into his
belt. His turban is white and appears to have a
white loop hanging under the chin, a detail
that ought to identify him as an Arab, in the
pictorial conventions of Iranian manuscript
painting [62, 63, 126]. He stands behind the

edge of a mass of boulders gently sliding
downhill; the lion moves away from the rocks
and onto a grassier hillside; undulating clouds
of decorative shape float in the golden sky;
behind the rocky horizon grows a large
gnarled tree with autumn foliage of yellow
and orange.

From such simple elements – a remarkable
setting and an expressive character of a certain
age – a sense of pictorial "event" emerges,
however dimly we are yet able to understand
the event being depicted.

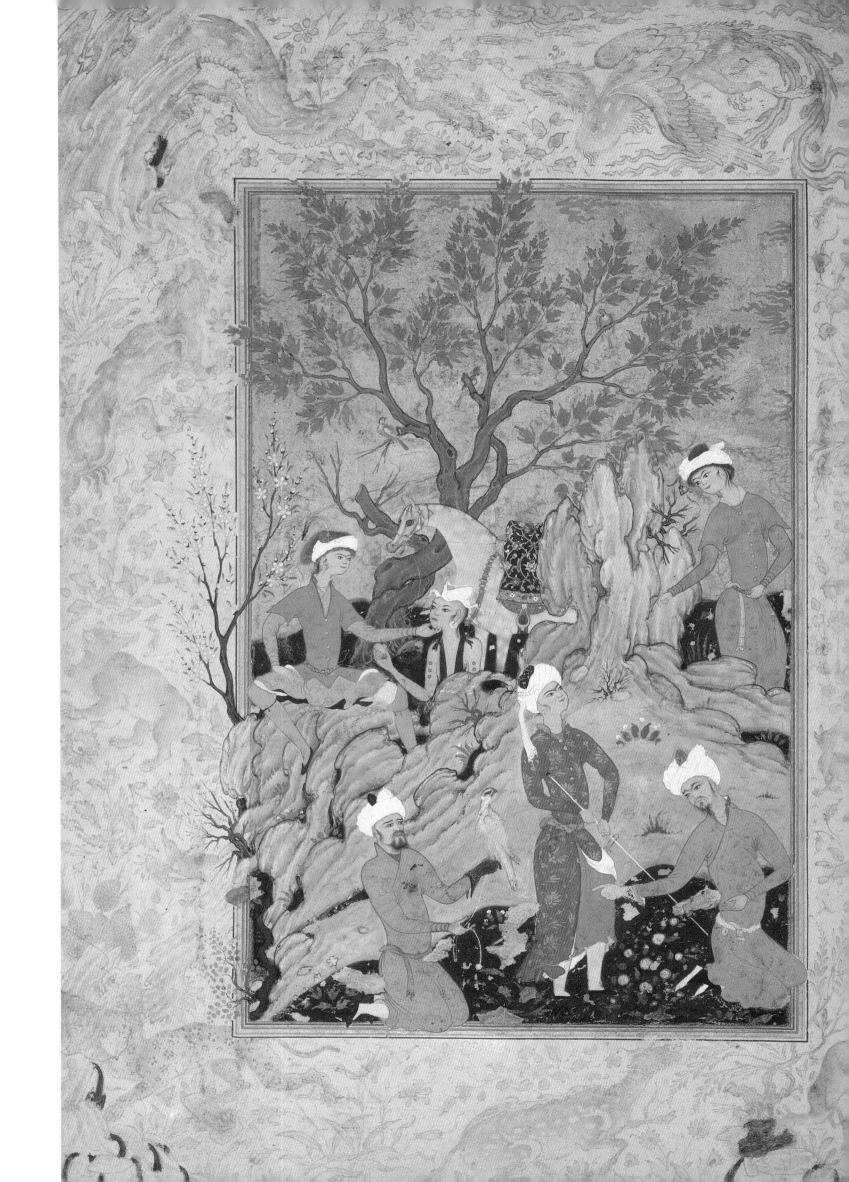

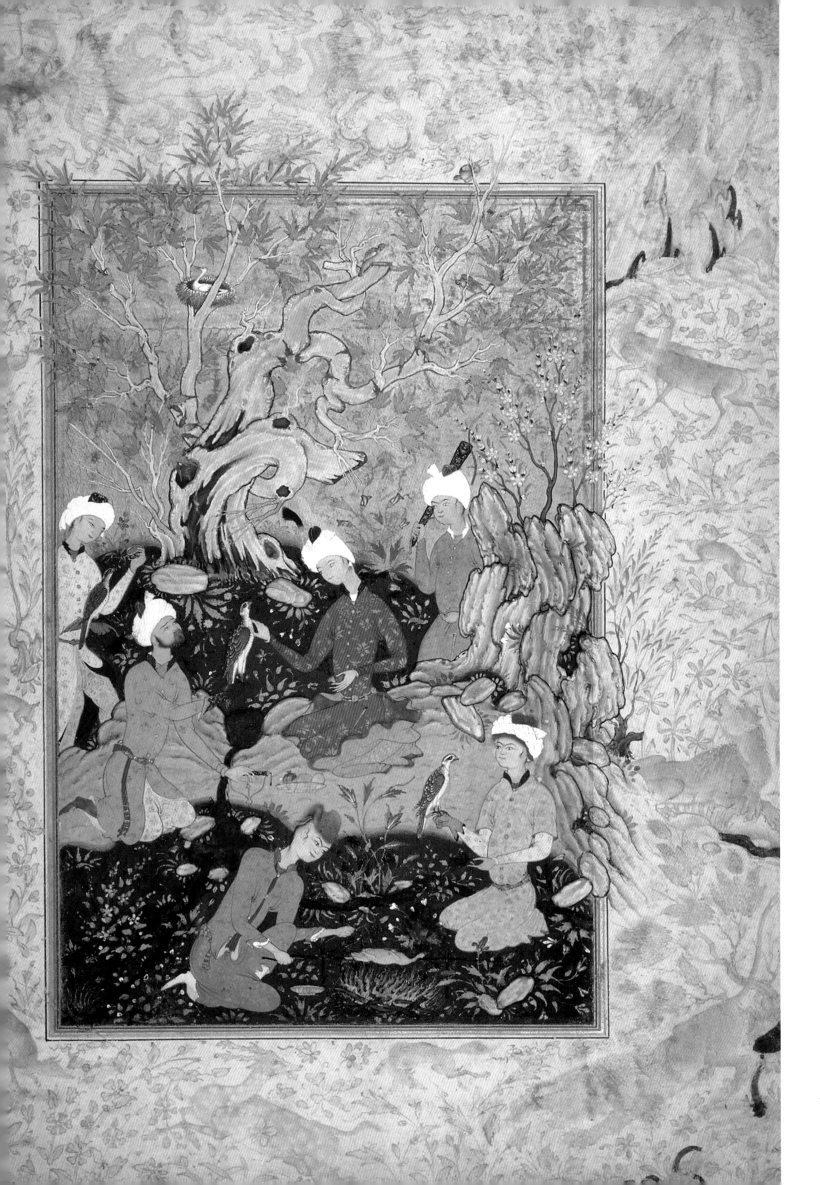

return to the Qazvin court about 1574. Yet neither half is signed or dated, nor is it certain that the composition was intended for a manuscript, although it shares certain technical features with other superb sixteenth-century Safavid manuscripts, primarily in the contrasting gold-drawn borders of the pictures: Tahmasp's great *Khamsa* [127, 234, 242], Ibrahim's own *Haft Aurang* [41], and ʿAbbas I's accession *Shahnama* [80]. The polychrome landscape of the painting gives way to framing golden landscapes through which silver streams trickle in the same multiplicity as in the right half of the painting itself. The gold-painted borders are even more elaborate than those in the *Haft Aurang*, and they extend the theme of the hunt into the realm of imagination: fantastic *simurgh*s, dragons, and *chi'lin*s, as well as leopards and wolves, bears and hawks, here prey upon gazelles, rabbits, and birds.

146. A TURBANED YOUTH LEANING AGAINST A BOLSTER

> Painting mounted in an album
> Isfahan, ca. 1600
> H: 14 cm; W: 7.5 cm
> Washington, DC, The Art and History Trust (on deposit at the Sackler Gallery, Smithsonian Institution)

Seated on an indeterminate ground, one arm barely propped against a pair of large bolsters and one knee drawn up as a rest for the other arm, a barefoot youth looks at nothing in particular, apparently lost in thought. He wears a splendid example of the large, loosely wrapped seventeenth-century turban, of white cloth delicately striped in mauve. Small black heron-feather aigrettes stuck into its folds echo the fine curling locks escaping from the confines of the turban, and his face is beardless, boneless, and pale. He is one version (of so many) of the beautiful youth so frequently encountered in Persian poetry; here he is clad in the latest fashion of early seventeenth-century Safavid Isfahan.

The large stuffed bolster, often covered in a figured or patterned fabric, was already a "prop" in certain sixteenth-century single-figure paintings [143] but it seems an indispensable accoutrement of the seventeenth century [159], appearing in manuscript illustrations [160] and single-figure paintings, as well as in paintings on another scale particularly well known from this period, the painted walls in contemporary buildings [146, 153]. Sixteenth-century Safavid wall painting survives in very few places anywhere, which makes the pavilion in Nayin [86, 158, 231] so important. The concentration of surviving seventeenth-century buildings in Shah ʿAbbas I's new capital of Isfahan partially reverses this state of affairs: they make clear that Safavid wall painting stemmed from exactly the same sources and stylistic impulses as did contemporary manuscript painting, single-figure drawings, and paintings for albums. This beautiful picture of a beardless youth exemplifies the genre, a fully colored image with a few colored "props" set against an outdoor background only faintly delineated in gold: sprays of willow-like foliage, lower clumps of broad-leafed foliage, and several of the ubiquitous small boulders behind which grasses and flowers sprout.

A brief inscription in black pen at the bottom of the picture avers that the drawing is the work of "the least [of the slaves, or painters] Riza." Known first as Aqa Riza (ibn ʿAli Asghar), and as Riza-i ʿAbbasi, "Riza in the service of ʿAbbas," in his later years, he is considered the pre-eminent painter of the early seventeenth century. His name has almost come to be synonymous with the style of human figure depicted here: large, round-headed, fleshy-bodied figures with fine, curling black hair and exaggeratedly bending or curving poses, languidly engaged in doing little but gorgeously attired for the occasion.

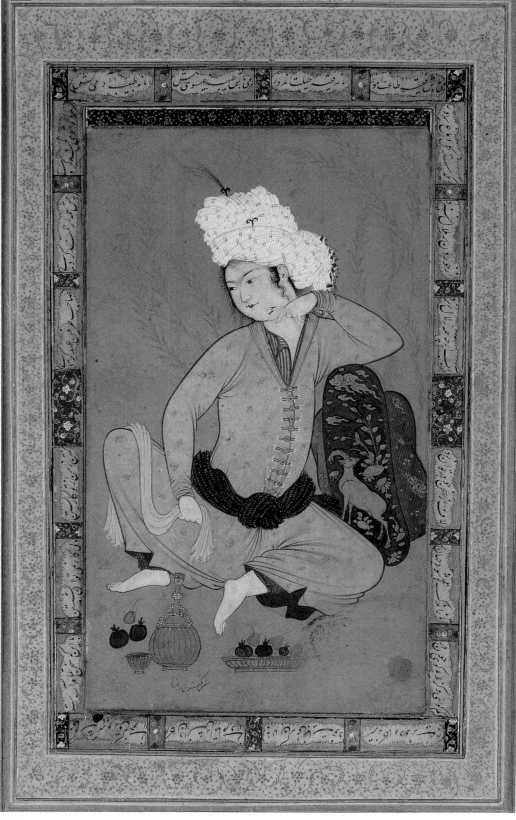

146

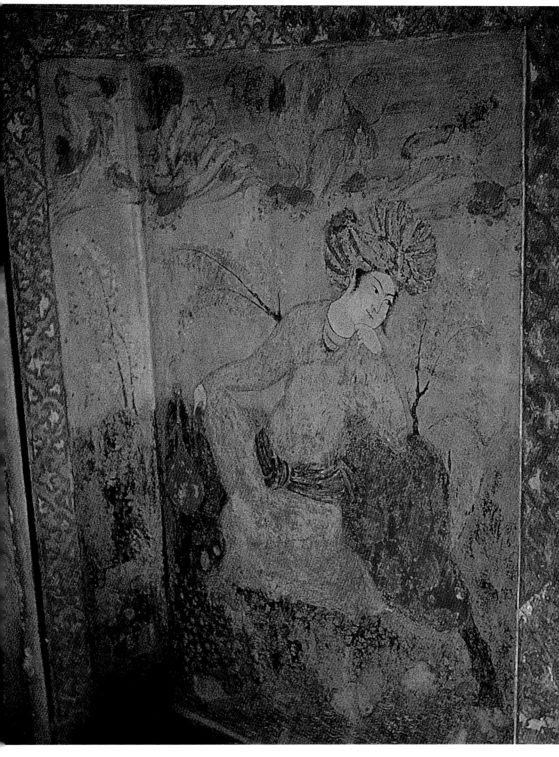

147

figures, nor the details of the landscapes in which they are placed, are the pictures appreciatively different from the smaller contemporary single-figure paintings on paper, save for their color schemes, which are strong instead of subtle. Here, the predominant tones are a pale green, red, and blue, and the borders are dark blue with raised ornament which was originally gold (now flaked away), in sharp contrast to the overall pink-ocher tonality of the rest of the building.

The youth in this picture offers a striking parallel to the Riza "Turbaned Youth" [145] – he is by no means an enlarged copy but so clearly derives from the same model. Seated on the ground, one knee drawn up as a support for one hand and leaning, in earnest, on a large bolster, he wears the same kind of huge, loosely wound turban and turns away from us, staring into the middle distance at nothing in particular, with a faint smile playing around his mouth.

148. YOUNG MAN WITH A MUSKET ON HIS SHOULDER

> Painting mounted in an album
> Isfahan (?), ca. 1610–20
> H: 18.1 cm; W: 9.5 cm
> Berlin, Staatliche Museen, Museum für Islamische Kunst, I.4589, fol. 11r

Another beardless youth, a musket held over one shoulder and the other hand reaching for something in a pouch slung beside the powder horn at his waist, strides purposefully into the lower right of the page on which he has been painted; his destination is unclear from the neutral background of clumps of golden flowering plants and a swath of cloud whorls trailing tails.

He has been called both an officer of the guard, and a huntsman, but he is dressed in clothing of extraordinarily contrasting color and pattern which would make him a most colorfully – not to say fancifully – dressed guardsman or hunter. His legs are wound to the knee in dark-blue cloth edged in gold as if diagonally striped; he wears brown breeches with a large golden floral pattern, a white sash striped in rust and blue and tied in a huge bow at the waist, and a black and gold striped cloth loosely wound around a pointed karakul cap – as if it were a rudimentary seventeenth-century turban, with a loosely plumed feather stuck into the front. Most remarkable of all is the frogged rust-color moiré shirt clinging tightly to his arms and torso.

The painting is signed by "Habiballah al-Mashhadi," an artist known from perhaps six other single-figure paintings, none dated but all probably from early in the seventeenth century. Before 1609, he also painted a remarkable picture (in which a musket also occurs) [250], in a manuscript refurbished at the order of Shah 'Abbas I and given to the Safavid shrine at Ardabil as part of a large

147. A TURBANED YOUTH LEANING AGAINST A BOLSTER

> Painting on a wall of one of the so-called "Music Boxes" in the 'Ali Qapu
> Isfahan, ca. 1610

The 'Ali Qapu, the "high gate[way]" or "lofty port[al]," by which the seventeenth-century palace precinct of Shah 'Abbas I's new capital was entered, houses several audience chambers at different levels. These are reached by traversing a number of vaulted rooms and passages; they are neutral in function and decoration, their walls painted with geometrical and floral designs organized to emphasize the architectonic features of the building. A signal exception is a pair of small rooms cut into the fabric of the upper floor and looking down onto a large interior audience chamber; they were almost certainly intended for musicians, whose sounds would waft through arched openings into the larger room below.

The walls of the "Music Boxes" were painted with several tiers of pictures – figures set in landscapes, each picture framed by floral ornament. Their subjects are single men, single women, or couples; this beardless youth wearing a striped turban of many colors and leaning on a large bolster is one of the better-preserved figures, in the better preserved of the two rooms. In neither the style of the

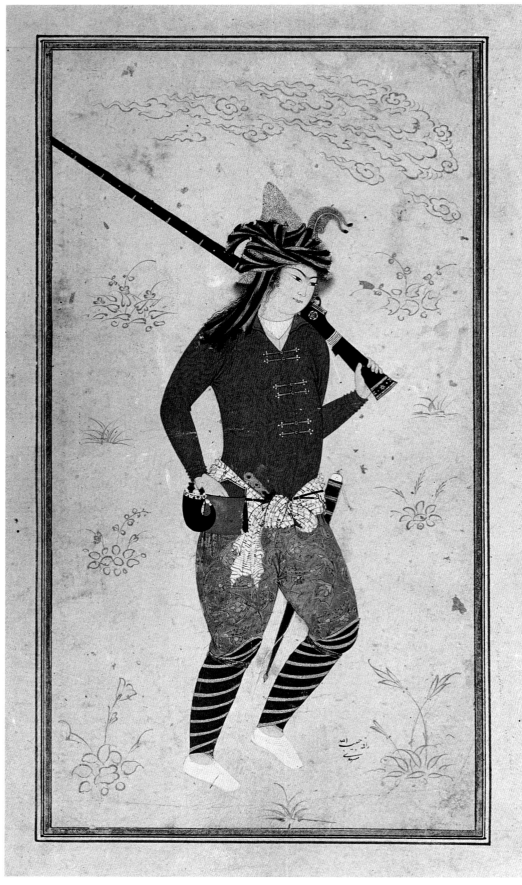

waqf, an inalienable donation. Given his royal service, as well as the rich, if slightly bohemian, dress and accoutrements of this young musketeer, it is difficult to accept that Habiballah was the provincial, non-Isfahani, artist he has previously been called.

Indeed, this striking young man is entirely of the figural type of the first half of the seventeenth century, large and fairly fleshy with a well-observed anatomy, although his pose is not so mannered as the typical Riza-style figure. His garb is as dandyish, and fanciful, as any of the other extravagantly dressed males that are a characteristic type of image in this half of the seventeenth century. He might well be considered a variation on the theme of the well-dressed *jeunesse d'orée* who languidly does nothing but is elegantly attired in doing it; this figure, however, has a purpose to his appearance, even if his expression affords us no hint of what this purpose may be.

148

149. THE HEAVENLY MAIDENS

Painted mural in a private house
Panjikent, Sogdia, first half eighth century
H: 117 cm; W: 257 cm
St Petersburg, State Hermitage Museum,
on long-term loan

On the vault over a short corridor in a very modest house in Panjikent a master-painter executed this charming mural. Such a situation is typically Sogdian, a culture in which the quality of an object or an ensemble had little to do with the social standing of the patrons who commissioned it. In addition, nude women are rarely represented in Panjikent wall painting, so this picture allows for an assessment of the Sogdian ideal of female beauty.

The upper part of the barrel vault is painted black, but where the vault joins the vertical wall its color is pearl-gray; the irregular, wavy juxtaposition of the two colors conveys the impression of a night sky partly obscured by cloud. Constellations or perhaps luminaries – a galloping horse and a lion – are painted on the dark field; several nude (or almost nude) young women, most probably personifications of clouds, are painted lower down, on the pearl-gray areas.

In the section illustrated here, a seated nude girl holds the edge of her cloak above her head. Her gesture derives from the representation of many Greco-Roman Nereids, shown with cloaks billowing out as if they were being blown away by a gust of wind. Another girl rocks on a swing (although its ropes are not shown as taut). Both gesture gracefully and delicately, and they both have rounded breasts, the most obvious feature, in Sogdian mural painting, that differentiates men and women. B.I.M.

150. RUDABA DISCOVERED BY HER MOTHER

Folio from a dispersed manuscript known as the "Great Mongol *Shahnama*"
Tabriz, ca. 1325–35
H: 24.6 cm; W: 19.6 cm
Washington, DC, Arthur Sackler Gallery,
S86.0102

A rich Ilkhanid chamber with latticed windows, the walls decorated with tiles and carved stucco, and the floor spread with a textile, is the setting in which a princess in love with a hero is upbraided by her mother for daring to meet him secretly. The maid has been the intermediary and the princess has rewarded her service – but the mother has discovered the affair. Firdausi's words are not illustrated exactly: instead of speaking with her daughter alone, the mother accosts the young women together, forcing the maid to disclose the princess's rewards of clothing and jewelry – the crown and a necklace of large golden

elements set on a pile of white clothing between the ladies.

The princess is none other than Rudaba, daughter of Sindukht and Sam, the king of Kabul; eventually Rudaba will marry her lover, the Iranian paladin Zal, and their son will be Iran's greatest hero, Rustam [16, 182, 241]. Delicious details abound in the dress and ornament of the three women. Sindukht's hands are hennaed; Rudaba's eyes are rimmed with kohl and her underdress is brightly striped. Rudaba and her mother wear transparent, white veils ruffled, or embroidered, at the hem; that of the maid is shorter but arranged in the same way, to bare the face; and none truly covers the long dark hair or the golden earrings hanging at the ears of all three women.

150

151. THE MAIDEN, HER DUENNA,
HER LOVER, AND HIS PAGE

> Painting on silk
> Samarqand or Herat, early fifteenth
> century
> H: 19 cm; W: 28 cm
> Kuwait, Dar al-Athar al-Islamiyyah,
> LNS 77 MS

The aesthetic of this large painting on fine
silk, showing four figures set in a "landscape"
– a large tree, an iris, and a hollyhock –
derives from that of "The Lady Travelling"
[113] and other paintings in the same group.
Here the ground line is less prominent but it
is executed in essentially the same manner, its
contours dabbed with a brush onto the bare
silk. The figures, too, derive from a painting
such as "The Lady Travelling;" they are large,
and their beautifully decorated garments are as
immaculately painted. But they convey far
less of the sense of narrative than did the
procession travelling through the night: these
figures are almost motionless, contained in
their own silhouettes, and their placement
could hardly be more formal and balanced
– even to the tree set squarely between the
princely couple.

Because the maiden's pose is evidently
related to that of the lady travelling, we may
compare the two. Here the maiden wears a
yellow outer garment lined with grey fur; the
lady's is blue lined with ermine. Both have
very white faces and have pulled their collars
up over their chins – they face men who are
not kin. But other details of the headdress are
different: the maiden's black hair also exposes
her ears but the hair at the back of the head
is hidden, her diadem has a white cloth
crown, and no string of beads secures the
headdress under the chin. Moreover, her
features in general are more firmly drawn, her
brows meet in the middle, at the nose, and
above it is a blue mark, in the Jalayirid
manner of western Iran. And of course, she
merely stands, almost motionless, while the
lady travelling was mounted and active. In
sum, she is in no way an image copied from
"The Lady Travelling" but represents another
step, and no doubt another generation, in the
process of selecting and manipulating elements
which will be so characteristic of Iranian
painting in the Timurid century. She and her
companions were probably painted a decade
or two after "The Lady Travelling," and
possibly in another locale.

The complexion of the maiden's "duenna"
– surely she is no older than her mistress and,
more probably, only an attendant – has a more
natural color than the chalk-white face of
the maiden; and her garments have a western
Iranian look to them, with their center
fastening, although their golden decoration
is as lavish, and the golden "cloud-collar" as
large, as the ladies' clothing in "The Lady
Travelling." Her white head-covering is cut
like that of Rudaba's maid [150], but some
enticing strands of black curls peep out at the
chin. The posture of both ladies is subtly
varied: the maiden's head is bent in a faintly
coquettish pose, while her attendant leans
slightly backward from the waist and gazes
intently at the princely couple. The men are
stiffer and absolutely vertical in pose, and only
the lover's head inclines toward the maiden.

152. SEATED PRINCESS WITH
A FANTASTIC HEADDRESS

> Painting once mounted in an album
> Tabriz, 1540–50
> H: 18.1 cm; W: 10.8 cm
> Cambridge, Mass., Harvard University
> Art Museums, 1958.60

The compact figure of a kneeling princess
with one knee drawn up, as if to support the
forearm of the hand delicately holding a spray
of blossom, is crowned by the dramatic shape

151

152

which the Armenian princess Shirin, and Nushaba, Queen of Barda', are seated.

The source of the diadem remains unidentified, although current thinking considers it Chinese in inspiration, possibly Liao, the Chinese name for a nomadic dynasty, the Khitai, that ruled parts of China between the tenth and the twelfth centuries. Whatever its origin may prove to be, it is an unusual feminine accoutrement in the painting issuing from Tahmasp's atelier in Tabriz at this period. It can hardly be coincidence that, in Tahmasp's *Khamsa*, the thrones on which Shirin and Nushaba sit also breathe that same sense of decorative fantasy drawn from other media; or that one painter, Mirza 'Ali, has been postulated as the artist of both this picture and the *Khamsa's* "Nushaba Shows Iskandar His Own Portrait."

While the best-represented examples of this tailed diadem appear in the early Safavid court milieu, a small number of simpler copies appear in later sixteenth-century manuscripts of lesser quality. It is also seen in the next century, in at least two seventeenth-century manuscripts of quite different dates; but in each it is depicted in less detail than in this beautiful, and slightly mysterious painting.

153. SEATED LADY WEARING A EUROPEAN HAT

> Painted on a wall in the "courtly room" in the palace of the Chihil Sutun Isfahan, after 1647

To the left of the painting of "Shah 'Abbas I Hosts a Convivial Gathering in a Garden" [36] in the "courtly room" of Shah 'Abbas II's reception pavilion, the Chihil Sutun, is this beautiful picture of a melancholy woman wearing a black European hat with a plume. In the shape of the picture and its location – recessed in a niche, in the style of drawing, and in the details of the landscape into which she is set, it differs little from her companion pictures on the same wall. The subject sets it apart: the lady's pose, garments, and jewels make her an "exotic."

She does not seem to have begun her life in this way: she seems originally to have worn a headdress in the Iranian style [160], and from the midriff down she is still wrapped in an enveloping brown veil, even though she is barefooted. At some point (but presumably not long after she was first painted) she was given her "exotic" clothing: a brimmed black European hat, complete with a gold ribbon and a fluffy white plume at the back, strings of beads around her neck, and a delicately patterned transparent white upper garment with a V-shaped neckline and short, loose, wide sleeves.

This is quite unlike the usual representation of women in any of the Chihil Sutun paintings, where they are always fully dressed, even if they are not enveloped in a veil [161]

of her headdress. Another early Safavid single-figure image fully painted and set against a neutral ground [Fig. 72], she too was later mounted on an album page with surrounds of colored paper, and poetry in praise of an unidentified sultan.

Her clothing is tasteful and discreetly luxurious. The dark fur lining of the outer garment is only glimpsed at its edges, fine golden flowers are strewn over the tomato-red fabric, and the arabesques of the black "cloud-collar" – the four-lobed collar of contrasting color that spreads outwards from the neck to lie over the shoulders, back, and breast – are fine in scale with beautifully attenuated forms. But it is the unusual headdress that accords a

special interest to the image.

It is well articulated and beautifully painted. It consists of a high cloth-cap with a golden finial, set over a jeweled ornament curving down over the forehead; a colored scarf hangs down behind the head, and under the chin runs the string of pearls, like a jeweled strap, seen in Iranian painting for nearly two centuries [103, 150, 156]. Encircling all of this is a jeweled metal diadem with an extravagantly elongated and curved tailpiece ending in a split palmette. The tailpiece has the same quality, that of a fantastic object derived from the forms and vocabulary of a different medium, as the thrones of extravagant silhouette in two paintings in Tahmasp's *Khamsa* [35, 242], on

153

above her head with one leg *en attitude*, and a pyramid of red fruit in front of her echoes the theme of balance. The garments above her waist obey the law of gravity and cascade down around her, but one wide leg of her trousers remains decorously – if impossibly – in place so that only the hennaed sole of her left foot is exposed.

This is one picture from at least two surviving similar sets of Qajar oil paintings showing female performers. It is hard to decide what aspect about them is most astonishing: the representation of unveiled and beguiling women, the lavish jewels and their garments heavy with pearl trim, or the incredible flexibility and skill they exhibit, so brilliantly captured on canvas. The painting appears to be a riot of pattern but all its intricacy, and the almost bewildering variety of fabric, is kept under the strictest control. Areas of solid color are set next to bold forms; small-scale patterns with minimal contrast weight the opposite ends of the picture; no detail is overwhelmed.

The solid purple velvet of the acrobat's bodice is set off by the extravagance of the pearl-embroidered cloud-collar, and the white *kashmiri* shawl tied around her waist has wide ends of dense, small-scale floral design. The golden floral pattern on the wide red trousers, almost monochrome in effect, contrasts with the wide hems of pearl and gemstones, which trace two definitive lines – one vertical and the other horizontal – in the upper part of the picture. In its lower part are very thin black lines, her long curling braids: they fall to the ground beside her face and are set off by the white masses of the pearl embroidery on her cuffs and headdress, and the pearl jewelry hanging about her head, face, and neck. This concentrated area of forms and lines is, in turn, balanced by the golden floral pattern on the rusty-red carpet at the bottom of the picture, which repeats the forms and color of her trousers in its upper half.

Like the subject of this painting, the lady in the pendant picture bends her legs similarly although the opposite knee is drawn up, and she stands on her hands instead of her elbows, but the folds of the similarly wide trousers are similarly handled. Neither the superb linearity of the composition, nor the stylization of form and figure, obscure the reality of fabrics and jewels. Yet the imperturbable facial expressions exemplify a centuries-old Iranian tradition that favors formal neutrality over displays of human emotion. These Qajar oil-painted ladies are stunning, daring, and aesthetically balanced images.

from head to toe; even the dancing women in two of the large reception scenes in the audience hall [43, 191] are quite decorously garbed. Moreover, while the plump arm on which she rests her head is in turn resting on that usual Iranian acoutrement, a large patterned bolster [146, 147], her pose seems unusual. The model for the position must have been provided by an imported image, possibly European and deriving from a picture in which a seat appears, or, even more likely, by an image of Indian origin.[1] The hat was the item of European clothing most easily seen in seventeenth-century Isfahan and had early been adopted into Iranian painting as a stock foreign motif. In these features, and in the fine transparency of the upper garment, she was undoubtedly intended as an exotic, and

delicately erotic, accent within the overall courtly program of the small chamber on whose walls she is painted.

154. A FEMALE ACROBAT

Oil on canvas
Tehran, about 1815
H: 151.5 cm; W: 80.4 cm
London, Victoria & Albert Museum,
719-1876 6

The subject of this picture, one of a pair of women in poses requiring almost unbelievable agility, stands on her elbows and imperturbably looks out of the picture. Hennaed hands flutter in front of her, hennaed feet kick up

154

155. A HERO AND HIS SWEETHEART

Painted mural in a private house
Panjikent, Sogdia, first half eighth century
H: 112.5 cm; W: 95.5 cm
St Petersburg, State Hermitage Museum,
SA 14864

This fragment of mural is all that survives *in situ* from a larger picture. It was discovered in the secondary room of a house whose wealthy owner had commissioned highly colored figural paintings set against a background of lapis lazuli for his large reception room. In the secondary room the colors are more restricted in range: the figures are drawn in a sooty black, and the only other colors are two different shades of ocher, a bright red, used for the background, and yellow, for the fence in the upper register; the flesh of the figures is white and they stand out against the red background. Notwithstanding so limited a palette, the execution of this illustration to some romantic episode is of excellent quality.

The hero and his beautiful companion ride on horseback; that she is young, and possibly still unmarried, is evident from the many braids in which her hair is arranged. The couple is followed by a group of horsemen, and before the entire group rises a mountain. A fallen spear near the legs of the horses suggests that a battle has recently taken place before the peaceful moment in the picture. In Sogdian painting, mountains usually symbolize hostile territory, and thus the visual implication is that the hero and his companions have recently defended the lady, perhaps the hero's bride, from some hostile adversary. This particular fragment also informs us that, for the Sogdian artist, draughtsmanship was more important than coloring: far from being flat images, the figures in this painting of quite limited palette have volume and a three-dimensional quality. B.I.M.

156. A PRINCELY COUPLE

Large painting on paper
Baghdad, ca. 1400–5
H: 49.2 cm; W: 32.7 cm
New York, Metropolitan Museum of Art,
57.51.20

Like another large painting on paper, "Jonah and the Whale" [214] this large picture appears to belong in the general category of Western Iranian painting around the year 1400, but why it was executed on so large a scale remains unclear.

A well-dressed young couple stands in a flowering meadow. They do not exactly embrace, but she has one hand around his neck and he reaches both arms out to her, one hand under her chin. They appear to gaze into each other's eyes, and she inclines her head toward him, gathering up the sleeve of her mantle with the other hand.

She is a Jalayirid beauty, bluish brows meeting just above the nose and blue scrolling marks on her cheeks and chin. A double chain of beads and pearls running under the chin secures her headdress, and she wears an ermine-lined mantle over several layers of clothing that fasten down the center, falling in gentle folds to her feet and emphasizing the elegant length of the figure. He wears a long outer *jama* also closing in the center and his white turban, wound around a short red turban-cap (*kulah*), falls in a mass of soft folds

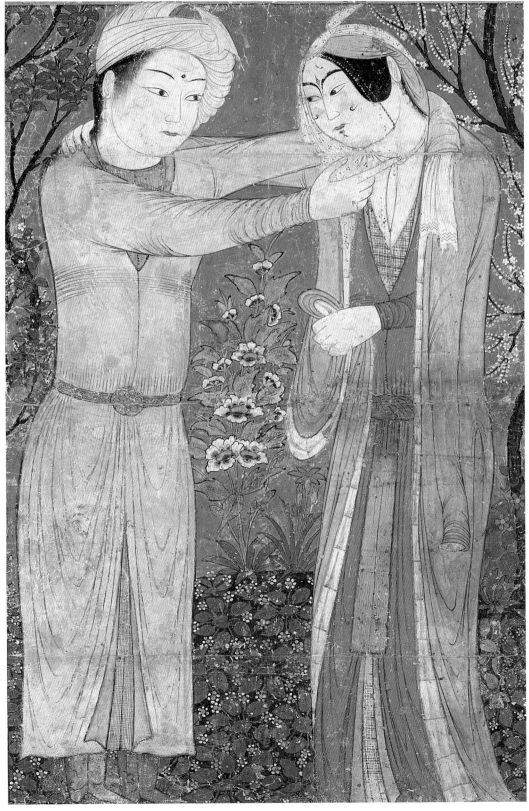

to one side, in a shape and manner more typical of turbans [40] as they are seen in contemporary painting. They stand amid flowering plants; larger ones stud the horizon, including the lily with the bent leaf [63, 78, 178], and blossoming fruit trees frame them against a vivid daytime-blue sky.

That they are lover and beloved in an ideal setting is evident; that the painting was made somewhere in Western Iran and around 1400 is equally apparent. The scale seems appropriate to a wall painting, but this very large image

on paper seems far too fine to have been made merely as a pattern, or even a painter's guide, for such a purpose. And while wall paintings are documented for approximately the same period, fully colored ones tend, at this approximate date, to occur in works connected with Samarqand and the east [104].

As to its origin, a clue is perhaps to be found in one of the very beautiful marginal drawings in a unique copy of Sultan Ahmad's *diwan* of poetry [cf. 171]. On a recto folio at the bottom of the page is a man dressed in a long ermine-lined mantle and a Shiraz-style turban falling in soft folds; he reaches to the right toward a woman in Jalayirid headdress and a long ermine-lined cloak; with one hand she holds her sleeve up to her face and a large handkerchief in the other, in a position similar to the large painted lady in this picture.[1] One of a set of images inspired by the sufi poet 'Attar and conceived as visual commentaries on the poetry of Sultan Ahmad, the artist has turned to the standard Persian metaphor for spiritual love, human lovers in an ideal earthly setting. This large painting is by no means a copy of the drawing in Sultan Ahmad's *diwan*

but it is similar in certain details, and perhaps derives from the same model despite its great difference in size and technique.

157. LAYLA AND MAJNUN SWOON AT THEIR LAST MEETING

Painting from a manuscript of Nizami's
Khamsa made for the wife of Muhammad
Juki ibn Shah Rukh
Herat, 1445–46
H: 14.5 cm; W: 10.2 cm
Istanbul, Topkapı Saray Library, H. 781,
fol. 138r

No lovers in all of the literature of the Islamic world are more famous than the Arab children of the heads of rival tribes, the youth Qays and the maiden Layla. The poem derives from tales current in the Arabian Peninsula about the time of the Prophet Muhammad, early in the seventh century; it may also be that the figure of Qays, who went mad – *majnun* – with the depth and intensity of his love for Layla, is based on the figure of the poet Qays

ibn al-Mulawwa, who lived during the second half of the same century.

The story of these Arab lovers – their youth, their parents' opposition to their marriage, and the tragic end to their undying love and devotion to each other – has a parallel in European literature, in Shakespeare's *Romeo and Juliet*. The Arab tale became popular in Iran during the early centuries of Islam, and when a ruler in the Caucasus toward the end of the twelfth century commissioned a romantic poem from Nizami of Ganja, he asked that it should be based on this story, rather than on a Persian epic theme. Nizami's beautiful version invests the story of fervent, determined, but ultimately hopeless love with such understanding of the human heart and psyche that it has become a universally read story, beloved throughout the classical world of Islamic culture from the Atlantic to the Pacific Oceans.

The two lovers meet as children, sent to the same school by their fathers. They fell in love at first sight, and while they are silent about this state of mind, they cannot hide their devotion and Qays soon becomes distraught with the force of his love and the effort of hiding it. He recites Layla's name in school instead of his lessons and runs through the bazaar of the town shouting her name, which causes people to call him mad, *majnun*. Layla's father hears of it and, thinking that such behavior insults his daughter and her entire tribe, withdraws her from school. At this, Qays does go mad, with love and longing for Layla, grief at her absence, and disdain for his position in the world; his love engenders exquisite poetry, which in various ways reaches the eyes and ears of his beloved. Majnun's father takes him on pilgrimage to Mecca, to ask for a blessing and to pray that his son should be cured of this affliction of love; instead, Majnun asks a blessing on Layla but for himself he prays only that his passion will increase.

All Arabia buzzes with the scandal, which makes Layla's father complain to the sultan, that Majnun continues to dishonor his tribe, and ask for his death. Majnun flees to the desert wilderness for refuge, gradually forsaking friends and family for the comfort of mute animals. Eventually, Layla's father marries her to a nobleman but Layla remains faithful to Majnun, who abides in the desert alone, save for his beloved beasts and an occasional visitor. One, an old man, brings a letter from Layla, whom he has met as she pines in a garden, and Majnun writes an answer for the old man to give to her. Another visitor is a youth who learns Majnun's love songs from him and takes them back to Baghdad and elsewhere: as the entire Peninsula had once buzzed with the scandal of his love for Layla, now the poetry engendered by this love resounds through the entire Arabic-speaking world. When only Majnun's letter reaches Layla, a meeting is arranged, but so great is the emotion of the lovers at seeing

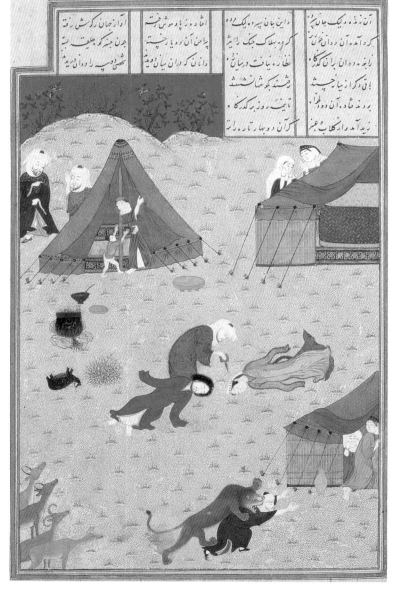

157

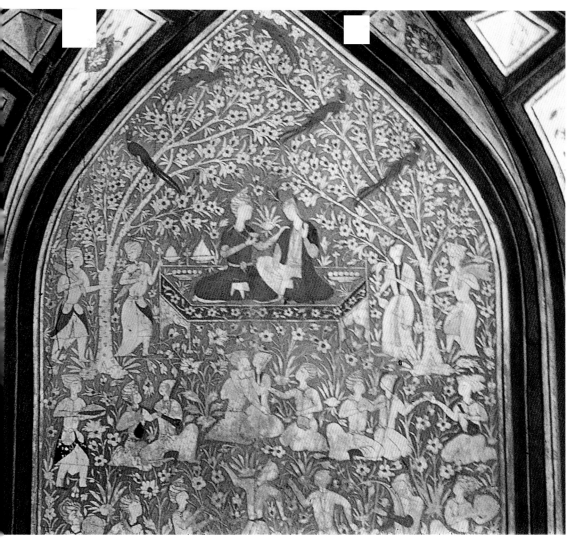

158

each other that, instead of taking pleasure in each other's company, they are overwhelmed and swoon. Revived, Majnun recites the most beautiful of his poems to his beloved, but again emotion overwhelms the pair and they flee from each other. When Layla's husband dies she appears to mourn him for the statutory two years, but her mourning is for Majnun alone, and she dies in her bridal robes, knowing that the living Majnun will come to mourn at her tomb and that eventually they will be buried together.

This mid-fifteenth-century picture of the lovers swooning at their last meeting repeats a composition of earlier in the century, in which the event takes place not in Nizami's thickly forested oasis garden but in a desert encampment. The black tents of the bedouin set the sandy scene: men, women, and children go about their business or peer out of tents at the swooning lovers being sprinkled with rose water. The uncertainty of all human life is evoked by the lion mauling a man in the foreground. In the lower left, some of Majnun's faithful animal companions nose their way into the picture, as if to prefigure the moment of his own death when they stand guard over his body, as he himself had stayed at Layla's tomb.

158. KHUSRAU AND SHIRIN IN A GARDEN

Detail of a panel of carved and painted decoration on the ceiling and the upper zone of a large *iwan*
Nayin, ca. 1580
H: ca. 155 cm; w: ca. 80 cm

Another set of lovers celebrated in Persian poetry who are evoked on the walls of the large *iwan* in the little Safavid palace in Nayin is Yusuf and Zulaykha [86]. The second panel on the left wall, showing a princely pair seated on an open dais presiding over a courtly entertainment in a garden, is surely to be interpreted as Khusrau and Shirin in the early stages of their courtship [35], inasmuch as a later episode of the story is the subject of another panel in the same ensemble [235].

The drawing of the figural component of the entire ensemble is rather provincial, but the technique is highly sophisticated: the background is cut away from the surface and into the wall, leaving the figures and the setting in white on the wall surface. Here the cool white figures and the garden in which the entertainment takes place have retained some of their original color highlighting: the outer garments of the lovers, details of the clothing of the guests and servants, and the long-tailed birds in the canopy of trees above the dais, are all painted an olive-green.

159. ZAL AND RUDABA CELEBRATE THEIR WEDDING AT NIGHT IN THE SUMMERHOUSE

Painting in a manuscript of Firdausi's *Shahnama*
Herat or Isfahan, 1602
H: 30.3 cm; w: 19.4 cm
London, Nasser David Khalili Collection, MSS544, fol. 36r

All the traditional elements of a princely reception in a garden at night are here gathered into an image of special charm: the young couple on a hexagonal throne, the attendant ladies bringing platters of fruit or playing music, the pool reflecting the myriad candles set around its rim, and the other night-time illuminations, tall candle stands and a flaming cresset lamp.

Firdausi writes at great length of the wooing by Zal of Rudaba (daughter of the idolatrous king of Kabul), of the obstacles placed before them by both fathers and Rudaba's mother [150], and of their eventual wedding, perhaps because their son Rustam plays so signal a part throughout his story. Finishing with his account of the month of joyous festivities celebrating the wedding, the poet sets the scene in "that chamber arabesqued with gold" where Rudaba had once entertained Zal; nowhere is a garden in the soft summer night mentioned. Once again, the painter has surely drawn on both the notion of a tended wilderness, and on contemporary practices with which he was familiar, to create a picture of an evening wedding celebration in the out-of-doors, ablaze with candles flickering in the night air. Perhaps he makes some reference to a contemporary event of which we remain in ignorance.

The lovers' throne is set in a verdant open space, wild enough for a huge twisting plane tree and several rocky outcrops, but also tended enough for an octagonal pool with a fine metal water spout and a porphyry rim. The same mixture of artifice and naturalism can be seen in the attendant women. Their heads are notably inclined, in unified positions of gentle deference to the princely pair, or – in the case of the musicians – in conversation with each other, but their expressions are surprisingly varied, even within the conventions of seventeenth-century Iranian painting; and at least one wears the newly fashionable short brocaded golden jacket [191].

As for the lovers themselves, their passion is reflected in both their poses and in their expressions – clearly visible in the underdrawing that shows where the paint surface has flaked. That they should display an interest in each other is unusual, since so often lovers in the carefully finished single-figure paintings of the period are usually remarkable for their blank and uninvolved faces [160]. The posture of the embrace also has the appearance of being drawn from observation rather than repeating a formal, patterned

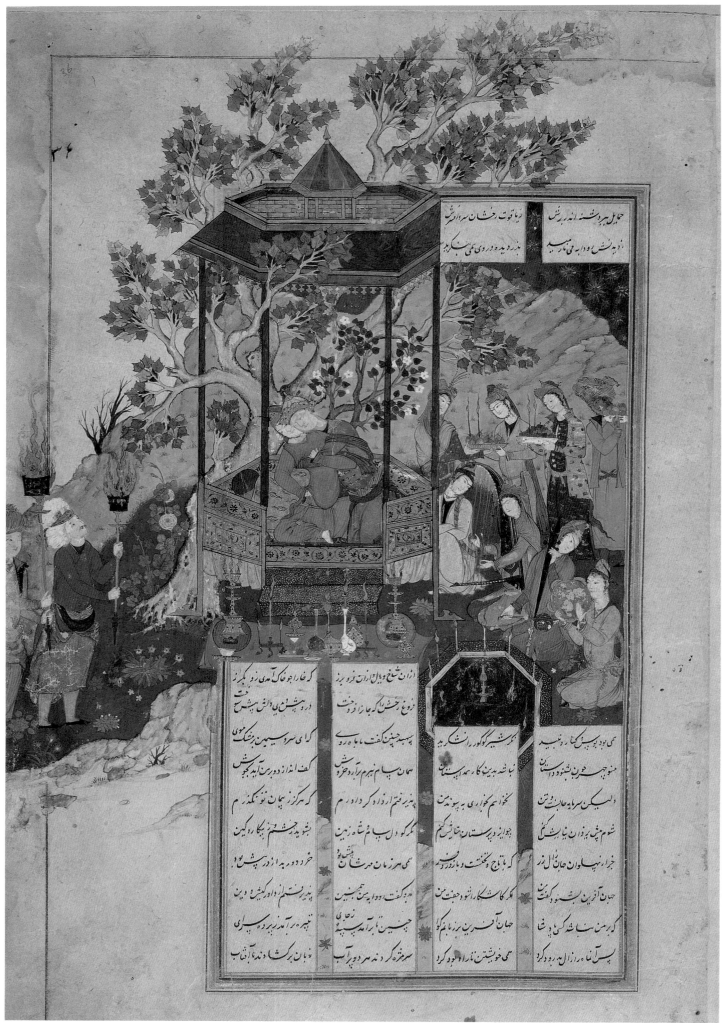

notional embrace of newly-wed lovers, even though the bolster against which she leans is a stock element in certain Safavid paintings.

160. LOVERS EMBRACING

Painting once mounted in an album
Isfahan, ca. 1610–20
H: 10.5 cm; W: 16.5 cm
Minneapolis, Minneapolis Institute of Arts, 51.37.38

Stretched out against bolsters, a pair of lovers embraces. They are still almost fully dressed but she has thrown back the white veil that would, when standing, cover her from head to toe, her sash is untied and has caught under his knee, and she is barefooted; his turban is nowhere to be seen. Their limbs are engaged and entwined in a pose that is both specific and visually arresting: one of her arms is curled around his head and the other reaches down to support herself; he caresses her chin and embraces her, one hand just appearing between the bolster and the white veil, at the right.

Formally, this is a picture of intense colors and of gatherings of fabric – the veil, and their disordered *jama*s and waist-sashes. The clothing is strong and dark in color – red, green, dark blue, and ochery yellow – varied

by small-scale patterns of checks, chevrons, and the faintest of gold rosette patterns on her green *jama*. Apart from this and the buttons down their fronts, there is little gold on the garments, and she wears no jewels save a golden ornament that secures her headdress at the forehead. The strength of the coloristic impression is heightened by the dark blue-green tint of the background, and the gold-drawn clumps of flowering plants suggest that the scene takes place in a secluded glade. So classical a seventeenth-century picture of lovers is completed by their apparent expressions of calm disengagement: she looks away from him and down, to the right, and while his head is inclined in her direction, he does not really look at her. Yet such an image should really be seen not only as two lovers intent upon the physical expression of their passion, but also as a visual metaphor for the soul's passionate longing for union with God [163, 248].

In its present state, the painting has been permanently separated from the additional borders that would originally have surrounded it. They would almost surely have been of contrasting colored paper, and in all likelihood one border would have been composed of panels in which were written couplets of sufi-tinged poetry [cf. 146] that might have made verbal allusion to the theme of the quest for union that is so eloquently conveyed by the painted figures.

161. LOVERS UNDER A TREE

Painted on a wall in the "courtly room" in the palace of the Chihil Sutun Isfahan, after 1647

To the right of "Shah 'Abbas I Hosts a Convivial Gathering in a Garden" [36] in the small vaulted room in the Chihil Sutun, the third painting on that wall shows a couple in a landscape. The lady is dressed in Iranian clothing of unremarkable cut and her pointed golden diadem, a feather stuck into its front, secures the ends of the long brown veil that is almost entirely thrown back but caught, by one edge, under her arm.

This, as well as her pose – one foot resting on the other knee – echoes the lady in the European hat [153], whose pose, in turn, may well be Indian in origin. Here it is clear that the lady's seat is a rocky outcrop; one red slipper, on the raised foot, has fallen to the ground between the two figures. That she writes on a piece of paper placed on her knee, with a small cup of ink in the other hand, increases the underlying sense of the recollection of certain Indian paintings. It also provides an internal logic for the pose, and it sets up the intimation of dialogue, even if it is hardly a full story: her male companion kneels on the ground in front of her, and the wine bottle and cup he holds out suggest entreaty, on his part, that she should abandon

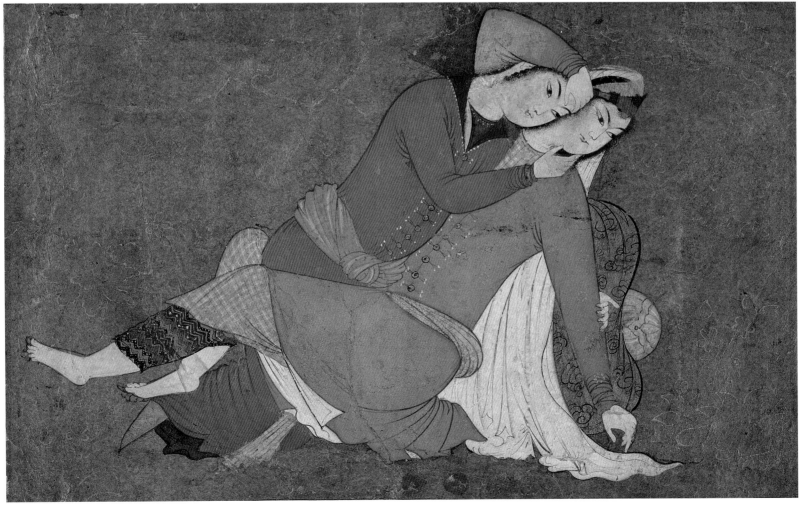

160

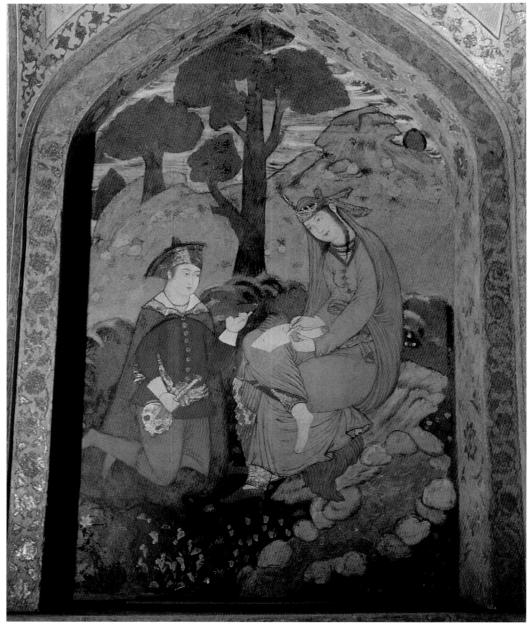

161

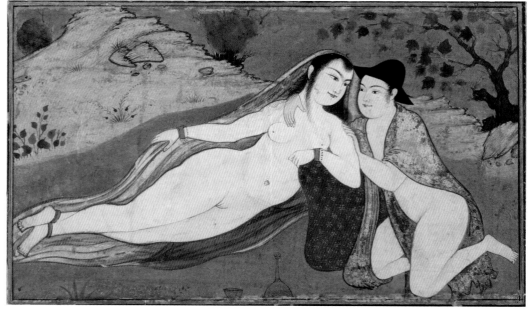

162

such activity and turn her attentions instead to him.

In this painting, the man is the exotic. His clothing is a wonderful mix of Iranian and European styles: soft high boots of gray with breeches tucked into them, and a black European cloak underneath a short front-buttoning tunic with a wide golden sash, the whole ensemble topped off by the ʿAbbasi hat [36] with a wide cloth brim edged in fur. Thus, the three pictures on one wall in one of the small rooms in the Chihil Sutun are subtly linked by pose, clothing, and accoutrements, in addition to the overall theme of courtly entertainments in an outdoor setting which infuses the entire chamber.

162. NUDE LOVERS

Painting once mounted in an album (or intended for one)
Isfahan, ca. 1650–60
H: 12.2 cm; W: 20.7 cm
Cambridge, Mass., Harvard University Art Museums, 1950.130

This painting of a nude couple, the woman reclining on a bolster, with only her long veil between her and the grassy ground on which she lies looking with some satisfaction toward the man who kneels at her elbow, remains an astonishing image within the broader body of Iranian painting. It is as unusual as it is realistic.

The realism with which her body is depicted, the kneeling ease of his pose, and their mutual gaze, are all the more astonishing because other elements of the picture are so formulaically rendered. Their features and the fine fuzzy curls of their black hair, the details and the execution of the landscape around them, the cup and long-necked bottle in front of them, even the exotic black European felt hat perched on his head: all are typical of mid-seventeenth-century painting in general. Yet the delicate but forthright lines of her body convey the painter's clear-eyed observation. Translated into drawing, the image remains free of both the Iranian tendency towards the linear, and the virtuoso play of calligraphic line so often underlying a painted figure or an object.

Thus it is curious that so little passion, let alone eroticism, emanates from this image, despite the frankness of the subject – always to be interpreted as a sufi metaphor for spiritual union.

163. "THE TRIUMPH OF SPIRITUAL LOVE"

Painted and lacquered papier-mâché pen box (*qalamdan*)
Isfahan, 1712–13
L: 36.5 cm; w: 8.8 cm
London, Nasser David Khalili Collection, LAQ361

The outer lid of this large and superbly painted papier-mâché pen box with a lift-off lid is decorated with a figural scene embodying one of the most pervasive themes of Iranian culture in the Islamic period: that human lovers may symbolize the attainment of mystical union with God.

Three couples, in three different amorous positions, represent three stages of love, from the physical attempt at union to the spiritual achievement of union. As Persian is read from right to left, so the three images must be interpreted by moving from right to left. That they are not the same couple is evident from their different garments; that they are ideal and beautiful human beings is also evident from the overall similarity of the youthful faces, the hairstyles of the women, and the growth and style of the men's beards and mustaches. And that they represent personages of late-Safavid Iran in the early eighteenth century is apparent from their adornments and their clothing, of which cut and pattern, color and texture are so beautifully rendered that they could almost be reconstructed from the lid of this pen box.

The couple on the right seems to prepare: seated on the ground facing each other, her legs are spread to either side of him, and her garments appropriately adjusted. But he seems hesitant and has not similarly adjusted his own dress; instead he holds a lock of her hair, while she leans back, supporting herself on her hands and looking away from him and out of the picture, an intent but unengaged expression on her face. The second man enfolds a woman in his lap, with one arm around her limp reclining form and a shallow wine cup in the other hand. Her head is thrown back against his supporting arm, her eyes open and focused somewhere above him, while he gazes intently at her throat from under lowered eyelids. The expression of the third couple, on the left, is little more engaged than lovers are ever shown in Iranian painting

but they are shown in positions of equality and as mutually engrossed with each other, looking into each other's eyes, her hand clasping his with fingers interlaced. His fingering of a lock of her hair recalls the hesitancy of the first couple, but they appear to have reached an entirely different stage of their progress on the path toward mystical union.

The execution of the painting is exquisite, the modeling of faces and the play of light and shadow on their bodies and clothing done in the finest of watercolor stippling that matches any European *sfumatura* in oil. The landscape is equally fine, the illusion of distances in the vignettes between each of the three couples maintained in a masterly manner and the component buildings large and complex.

The signature accompanying the date on the lid is now rather damaged, but it has been interpreted as reading "painted by Haji Muhammad." The stylistic similarities – indeed, the virtual quotation of passages from Muhammad Zaman's finest paintings – have led to the suggestion that Haji Muhammad was his brother. Figures, architectural vignettes, and elements known from Muhammad Zaman's landscapes include the pair of maids at the right of the lid [118], the row of cypress trees leading perspectively to a two-story arched pavilion [99], and the broken tree snapped at its base [220]. It seems clear that Haji Muhammad was intimately acquainted with Muhammad Zaman's work, including earlier painted examples of the large hinged pen box. Yet the hand responsible for this example is a different one, especially evident in the shape of eyes, here both more varied and more realistic, less mannered and perhaps more beautiful, than those of most of Muhammad Zaman's figures.

As on the earlier large pen boxes, every surface of this box is dense with painted decoration. In addition to the figures with their implied narrative on the outer lid, there are oval vignettes alternating with illusionistic landscapes showing both Iranian and European buildings on the sides, naturalistic large scale bird and flower compositions on the interior of the lid (Fig. 88), and smaller decorative vegetal compositions in the traditional manner, outlined in gold against a red ground, on the base.

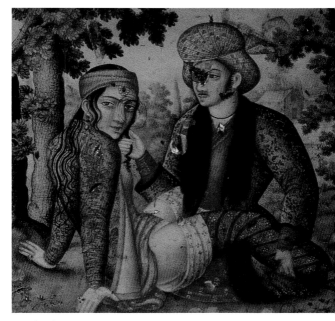

163 detail

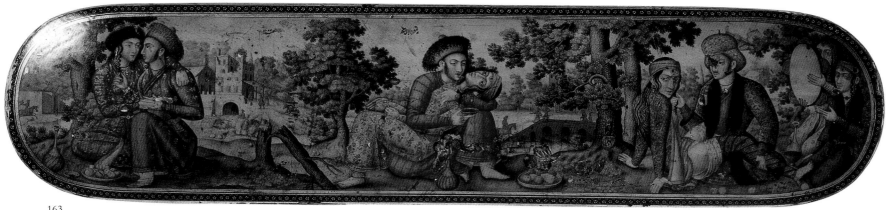

163

THE SCHOLAR

164. SA'DI AND THE YOUTH OF KASHGHAR

Double-page illustration in a late Timurid
manuscript of Sa'di's *Gulistan*
Bukhara, 1547
H: 21.6 cm; W: 13.3 cm (each picture)
Geneva, Bibliotheca Bodmeriana, fols
62v–63r

One of the finest late-Timurid manuscripts
copied in Herat but finished elsewhere is a
large *Gulistan* of Sa'di. Its text was completed
at the end of July 1500, in the Timurid
capital, but its four pairs of paintings were
only added to the manuscript in 1547, at the
court of 'Abd al-Aziz Khan in Bukhara.

His librarian, a certain Sultan Mirak,
appended to the colophon of the manuscript
a long inscription which tells us that the
volume was "perfected and completed by the
decoration of the most eminent artists of
the time and by the adornment of the greatest
illuminators of the world during the happy
reign of . . . 'Abd al-Aziz Bahadur Khan. . . ."[1]
Its eight pictures, arranged as double-pages,
are entirely Bukhara creations painted in the
Bihzadian idiom of Sultan-Husayn's Herat.
Not true double-page paintings, each "pair"
instead illustrates two distinct moments in the
apologue being illustrated.

This "pair" recounts the story Sa'di tells of
his encounter with a beautiful youth whom
he met in the court of the Great Mosque in
Kashghar. Here, the painter has reversed the
process of spatial compression: the architectural
setting of an earlier single-page picture has
been opened up and spread over two pages.
The composition appears to function as a
single, unified image even though the two
scenes depicted in it occur at successive
moments. The fifteenth-century picture on
which it is based had let the viewer peer over
the fence of a courtyard with an *iwan* at its
back, where lessons take place in a rather
helter-skelter atmosphere and the students are
of varying ages, sex, and scholastic dispositions;
the beautiful youth and the traveling scholar
stand in the shade of a plane tree outside the
doorway to the courtyard at the left of the
picture, where the fence meets the building.

In this sixteenth-century Bukhara painting,
the left side of the picture retains the same
viewpoint. It shows the angled wall and places
Sa'di and the youth in the same position – at
the left, outside the courtyard under the shade
of a large plane tree. The right half of the
picture tells the earlier part of the story: the
inhabitants of the court are a sober row of
two scholars, two pupils, and Sa'di, all sitting
on their heels in an angled row. The poet has
just caught his first sight of the beautiful
youth next to him – he holds a bound
volume in his hand, just as in Sa'di's text –
and he gestures in entreaty.

In both halves of the picture, the youth has
the round, unbearded face of the young male
beauty, with raised brows and a tiny mouth,

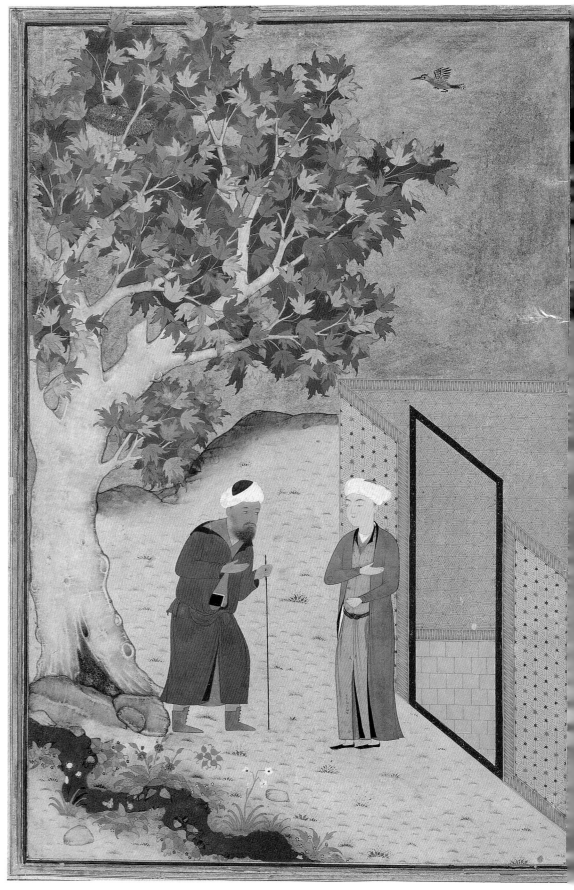

164

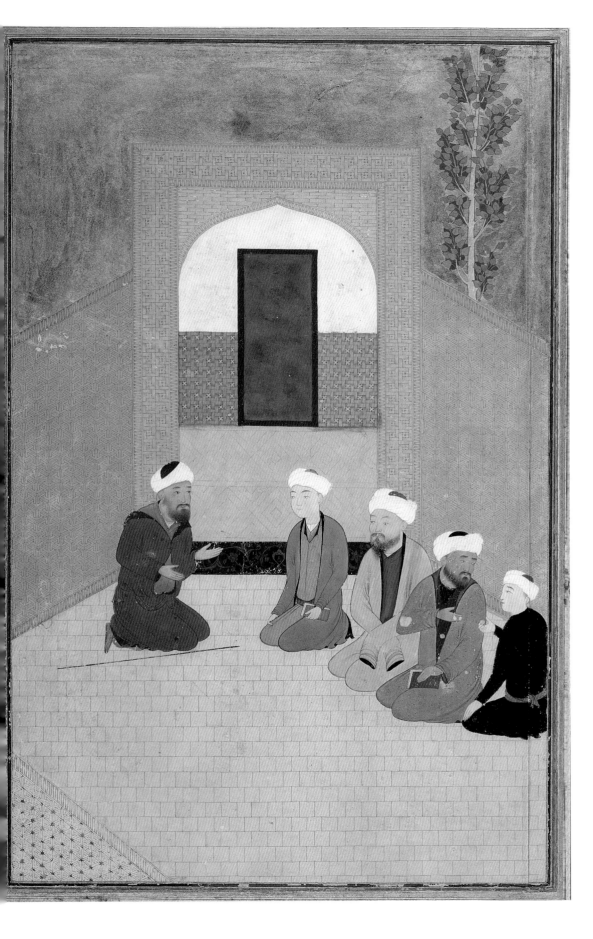

while Saʿdi has the head of a more observed (perhaps Bihzadian) personage, the bone structure differentiated from the faces of the two elder scholars so decorously seated in the courtyard of the mosque. All the men are simply dressed, in layers of unadorned clothing in sober colors; they wear low white turbans, as befits their scholarly status and their non-Safavid allegiance; the older men are bearded.

The brick architecture is punctuated with minimal glazed tile; it is as sober in its forms and decoration as are the scholarly inhabitants of the courtyard. It is so carefully painted that the decoratively laid brickwork can be distinguished from ordinary bricklay, and it conveys a sense of architectural reality, in contrast to the gorgeously tiled courtyard in the fifteenth-century Saʿdi picture. Yet this painting also displays the characteristically formal emptiness of much Bukhara painting, especially in the right half, so open and "aerated" as to seem almost deserted. This is not uncommon in Bukhara pictures in the sixteenth century: its painters were not always fully capable of recreating the Timurid canon at which they aimed, even though their standards of execution were high and their access to the finest of minerals for pigments unparalleled.

165. THE DISTRIBUTION OF THE
NEW CROP

> Painted mural in a private house
> Panjikent, Sogdia, first quarter of the
> eighth century
> H: 112 cm; W: 115 cm
> St Petersburg, State Hermitage Museum,
> on long-term loan

One of the large houses in Panjikent was found to have at least three vaulted granaries on its ground floor, and three additional granaries on the first floor: their overall capacity was fifty to sixty tons of grain. Three walls of the reception hall in this house were decorated with elaborate murals whose subjects allude with pertinence to one of the occupations of the householder, distributing the new crop of grain. He might have been a rich landowner, or a collector of taxes that were paid in kind, or perhaps a grain retailer.

The large composition is organized in two registers. On the side walls are painted royal banquets, the hosts being several kings who symbolize all the monarchs of the earth; the kings and their attendants are depicted in the upper register, and in the lower can be seen the kings' subjects, mostly rich men. On a wall with a door, instead of another picture of a king was painted the reason for the celebratory feast – the distribution of grain after harvesting. The lower zone on this wall depicts several figures, noblemen or merchants feasting (not illustrated in this detail).

In the central picture was painted the image of an enthroned deity, whose head is decorated with a wreath of stalks of grain. He is aged, and his raised eyebrows impart a sorrowful look to his face; he is surely an agricultural god, perhaps Baba-i Dihqan, the "Grandfather Tiller" of the mountain Tajiks. The seasonal cycle, of an autumnal "death" and a rebirth in the spring, would then account for his sorrowful appearance after the harvest; indeed, ethnographers of Tajik culture record that an oblong heap of winnowed grain was called "the Grandfather Tiller's grave."

To the left of the deity the grain is being measured in a pail by a man with a plump face; near him a peasant ties up a tall grain sack. Above them is a man in a blue silk kaftan; an inkpot is attached to his belt, and he holds a document written on a willow stick, while two more lie at his feet. He could be a scribe keeping records of the crop distribution but his posture is lazy; in this, and

in his rich attire, he presents a contrast to the simple clothing and the energetic activity of the peasants. Their faces are much more individualized than those of the feasting nobles in the lower zone of the mural: their eyes are narrow, as was dictated by the Guptan Indian ideal of beauty in early medieval Central Asia, while the peasants' eyes are wider, as if anthropologically reflecting the local population. B.I.M.

165

166. THE BAZAAR OF THE VILLAGE OF
THE BANI SHAYBA

> Painting in a manuscript of 'Ayyuqi's
> *Warqa u Gulshah*
> Anatolia, 1200–1250
> H: 7 cm; W: 18 cm
> Istanbul, Topkapı Saray Museum, H. 841,
> fol. 3v

The illustrations in the uniquely surviving Seljuq copy of 'Ayyuqi's romance [4, 57, 140] are constructed from many contemporary sources and serve their text in different ways. The opening picture in the manuscript is not necessary for an understanding of the story but it sets the scene. Textually, it amplifies the richness of the Arab country in which the story is purportedly set, while pictorially it provides a wonderful glimpse of non-princely life in the Turco-Iranian Seljuq world.

A caption written above the picture tells us that this is "a description of the image of the tribe of the Bani Shayba," to which both Warqa and Gulshah belong. The image is

actually that of a bazaar and four of the most essential of medieval professions: the money changer, the perfumer-cum-druggist, the butcher, and the baker. Each is shown in his own niche, a column and decorated spandrels rising between them; each is dressed according to the needs of his trade; tools, accoutrements, and products surround each man.

The money changer wears a long garment and a cap, and he kneels facing someone, perhaps a client, in a striped robe; his counting devices are suspended from the ceiling of his stall. The perfumer also wears a long garment and a turban; he works surrounded by large containers standing on the floor, and two more shelves above him are filled with smaller covered repositories, squat in shape and with knopped lids. The butcher and the baker, by contrast, are nude to the waist and barefooted; the butcher wears only a loincloth as he slaughters a sheep, while the baker, in white trousers, reaches into the oven and holds a finished loaf with the other hand. Fourteen rounds of bread hang from the roof

166

of his stall, and four joints are suspended from the roof of the butcher's booth. This is a true genre scene, wonderfully fresh and unusual within the context of Seljuq manuscript painting, given how little of it has survived. Yet it accords stylistically with the more general canons of Seljuq painting – the heads are set off by golden haloes; the figures are virtually all shown in profile; the architectural structure has the same gaily colored merlons as in the picture of Gulshah's parents [140].

167. BAHRAM GUR IN THE PEASANT'S HOUSE

Painting from a dispersed manuscript known as the "Great Mongol *Shahnama*"
Tabriz, ca. 1325–35
H: 20 cm; W: 20 cm
Montreal, McGill University Library, on loan to the Montreal Museum of Fine Arts

The *topos* of the king in disguise – or at least unrecognized – and questioning his subjects is used by a painter in this manuscript for an unforgettable picture. Bahram Gur is unmistakably the king, even in the humble setting of the peasant's house: crowned and nimbed and garbed in spangled blue, he sits on a wide throne pillowed with bolsters inside a niche with a tiled dado, and blue and white painted walls. Outside it are two of his subjects: a woman, dressed in a simple brown garment with a white head-covering, milks her cow and her husband, in striped clothing of black, red, and white, looks on from under furrowed brows. But they do not recognize him (or his princely setting) and he does not reveal himself, so the story may proceed.

The peasants had offered him water, food, and rest after his victorious encounter with the dragon [229–31]. Unable to sleep at night he asked the woman to tell him a tale, giving her "Free speech about the Shah for praise or blame." The woman replied that it is the shah's men who bring trouble upon her neighborhood, by extortion, false accusations, and rape. Troubled at the loss of his reputation, Bahram Gur resolved to ". . . play the tyrant for a while that love / And justice may grow

manifest from ill." But these harsh thoughts had an instant, and deleterious, effect upon his subjects: in the morning the cow would not give milk, and Bahram overheard the woman's comment that the reason must be that the shah had become unjust. He forthwith repented, praying, as did the woman who tried her cow again: and "the milk flowed forth."

Represented is the moment when all discover that the cow's milk will not flow; both men stare fixedly at the unconcerned beast, a beautifully drawn white-splotched black animal with velvety large eyes cropping the grass that grows on a slanting hill outside the structure. Figures, royal throne niche, and animal fill the picture almost to its frame; the empty space at the upper right is occupied by a tree with dark, heavy foliage and the cow

grazes on a fungus-like plant (of Chinese derivation) growing at the base of a gnarled tree that twists out of the picture at the lower left.

168. THE MAN DROWNED BY MISTAKING THE LENGTH OF HIS BEARD FOR THE DEPTH OF HIS WISDOM

Painting in a manuscript of Farid al-Din ʿAttar's *Mantiq al-Tayr* (*Language of the Birds*)
Herat, 1487
H: 18.7 cm; W: 13 cm
New York, Metropolitan Museum of Art, 63.210.44

What appears to be a coherently composed genre scene, of a disaster in a woodland

watered by a river beside which men are gathering firewood, is actually to be apprehended as another original painting in which ʿAttar's text and a pictorial comment upon it are seamlessly integrated. As did "The Son Who Mourned His Father" [60], this picture in Sultan-Husayn's *Language of the Birds* both illustrates the parable and expands upon it.

ʿAttar's text is terse: a fool with a large beard suddenly fell into a river, whereupon a sufi standing on the shore called to him to abandon the "bag" around his neck and he would then be able to rescue himself from his watery predicament. The two parts of the picture are tied together by the river winding below the rocky outcrop at the left margin of the picture and re-emerging in the upper half, completely enclosing the woodland where the pictorial comment is staged. A detail in the lower left of the picture might suggest that the fool had entered the water by choice, the neatly folded clothing in a pile by the riverbank.

In the upper part of the picture, the river is a swirling and swift-moving flood, against which the greybeard struggles in vain. On the farther shore stands the sufi, gesturing at the drowning man, who replies that at his neck is not a bag but his own beard; the sufi then offers the advice that the time has come to divest himself of the splendid growth which, otherwise, will be the cause of his demise. In the lower half of the picture three men cut firewood and load it onto a donkey, and a fourth – another graybeard – sits and watches. They are dressed in workmens' clothing, with low shoes and bare or wrapped legs, and only the leopard-skin cap of one and the belt of the seated man suggests that the scene might be more than a vignette of ordinary life. That the men appear to be woodcutters is the crux of the commentary: for hardly anything is more ephemeral than firewood, a natural element that must already be dead to be burned, in the process of which it is consumed entirely and reduced to fragile ash that blows away in the wind, annihilated – as is to be the fate of the drowning fool.

169. KHWAJA ʿABDALLAH ANSARI AT THE BOOKSELLER'S

Painting in a manuscript of the *Majalis al-ʿUshshaq* (Lover's Meetings)
Shiraz, ca. 1560
H: 13.7 cm; W: 16.7 cm
Paris, Bibliothèque nationale, Suppl. persan 775, fol. 152v

The *Majalis al-ʿUshshaq* is a collection of biographies of great mystics, unhappy lovers, and princes. It is traditionally ascribed to the last great Timurid ruler, Sultan-Husayn Bayqara, but is more probably the work of a religious official who served him, Kamal al-Din Gazurgahi. Its prose is pompous in tone but romantic in style and interwoven with

169

poetry. The text had some popularity in mid-sixteenth-century Shiraz [175]; this copy has only five illustrations but rich illuminations.

Khwaja ʿAbdallah Ansari was the great eleventh-century mystic of Herat. The shrine that grew up around his burial place, at Gazurgah to the north-east of the city, was especially important to Sultan Husayn, who reburied his father on a funerary platform within the shrine after he had retaken Herat.

The illustration to his biography in this sixteenth-century Shiraz manuscript recounts the story of Khwaja ʿAbdallah in a bookseller's establishment when a prisoner in a wooden pillory passed along the street, in the company of his jailers. A drummer pounds on his instrument to call attention to the barefooted wretch, and life on the street comes to a halt: passersby stop, watch, and gabble among themselves, or bite their fingers in

astonishment, or point; men in a balcony above lean over the parapet in similar gestures of amazement, and even the youths burnishing paper in the stall behind the bookseller, turbans removed as they work, lean out of the window to watch the unfortunate man proceeding on his unhappy way. Khwaja ʿAbdallah, however, continues his inspection of books, unperturbed by the din in the street.

This lively genre scene makes original use of the sixteenth-century Shiraz proportional canon of 2:5 and 3:5. The greater width of the written surface shows the bookshop, in whose window Khwaja ʿAbdallah calmly sits; in the extension is the workshop of the bookseller's establishment, its occupied roof set at an angle that recalls earlier Shiraz diagonal margins [239]. Below, the street runs the width of the picture unifying the image.

170

170. 'NOMADS' WITH A DONKEY

 Painting mounted in an album
 Western Central Asia, late
 fourteenth–fifteenth century
 H: 14 cm; W: 26 cm
 Istanbul, Topkapı Saray Museum, H. 2153,
 fol. 55r

An image of five men with a donkey is a perfect example of the "nomad" genre among the larger group of unattributed pictures in the Istanbul albums. The figures are painted directly onto the coarse, soft, unpolished paper; the palette is limited – red, black, gray, a chestnut brown, and white – and usually applied as transparent washes; and the drawing is brilliantly assured, even if the forms are decidedly unappealing. A taste for the depiction of folds, whether of cloth or skin or underlying bone structure, is a mannerism of the entire group [130, 204].

 "Nomads" is the usual description of these figures, but no self-respecting nomad would claim these animals, usually shown in a state of physical dilapidation. Moreover, neither nomad tent nor yurt is ever shown, while the clothing – especially the heavy open coats and loose trousers of the men – is not typical of a riding people, and their huge feet are often unshod. Faces, features, and skin are heavy and lined or wrinkled, often resembling those of the demons in pictures related in style and techniques [Fig. 64]. Ocasionally a bell-shaped hat will have an ornamental finial at the crown, as on the man at the right, but in general, the world of these "nomads" is

materially poor, although they themselves do not look undernourished.

 In this picture, the man with the longest beard (in the center of the composition) is being assisted to mount a donkey in the face of a rival claim to transportation, demonstrated by the old person of indeterminate sex being carried on the back of a younger man standing at the left. An unmistakable sense of an altercation is conveyed: everyone but the long-bearded man looks back toward the youth, dismay on faces and in gestures, and desperation in the way one man clutches at the donkey's tail while he helps the older man to mount it. In this, too, the picture is typical of the genre to which it belongs; some specific event, some precise human transaction, is usually presented, even if the event is nothing more than a child yowling for attention or the feeding of a donkey. What world these pictures depict, and where they were painted, remains unresolved, as does their larger connection with the demon-monster-Chinese-people group of paintings [15, 104, 151].

171. A NOMAD ENCAMPMENT:
'THE VALE OF DETACHMENT'

 Drawing touched with color, on a folio
 in a *Diwan* of poetry written by Sultan
 Ahmad Jalayir
 Baghdad, ca. 1400–03
 H: 31.8 cm; W: 22.7 cm
 Washington, DC, Freer Gallery of Art,
 32.34

A unique manuscript of Sultan Ahmad Jalayir's own poetry poignantly reflects the turbulence of the last years of his life. The manuscript itself has no colophon. A smudged note on the last page says that the handwriting is that of "*khwaja* Mir ʿAli, mercy be upon him"; Mir ʿAli had also copied Sultan Ahmad's *masnavi*s of Khwaju Kirmani completed in Baghdad in 1396 [73, 105, 114, 179]. A longer inscription on the same page gives the date of completion as Ramadan in the year "508" – surely a mistake for the Hijri date of 805; Ramadan 805 fell in late March and early April of 1403. Six full-page blanks, probably for illustrations never executed, and a disorder in the sequence of pages as it is now bound, suggest that the manuscript's progress was interrupted: indeed, reading any account of the continuing conflict between Timur and the small principalities of Western Iran confirms that the years between 1393 and 1403 were a time of great trouble for Sultan Ahmad.

 Thus, instead of full-page illustrations, the text of his *diwan* is embellished with drawings. Some pages have a series of virtuoso compositions in black ink, some touched with

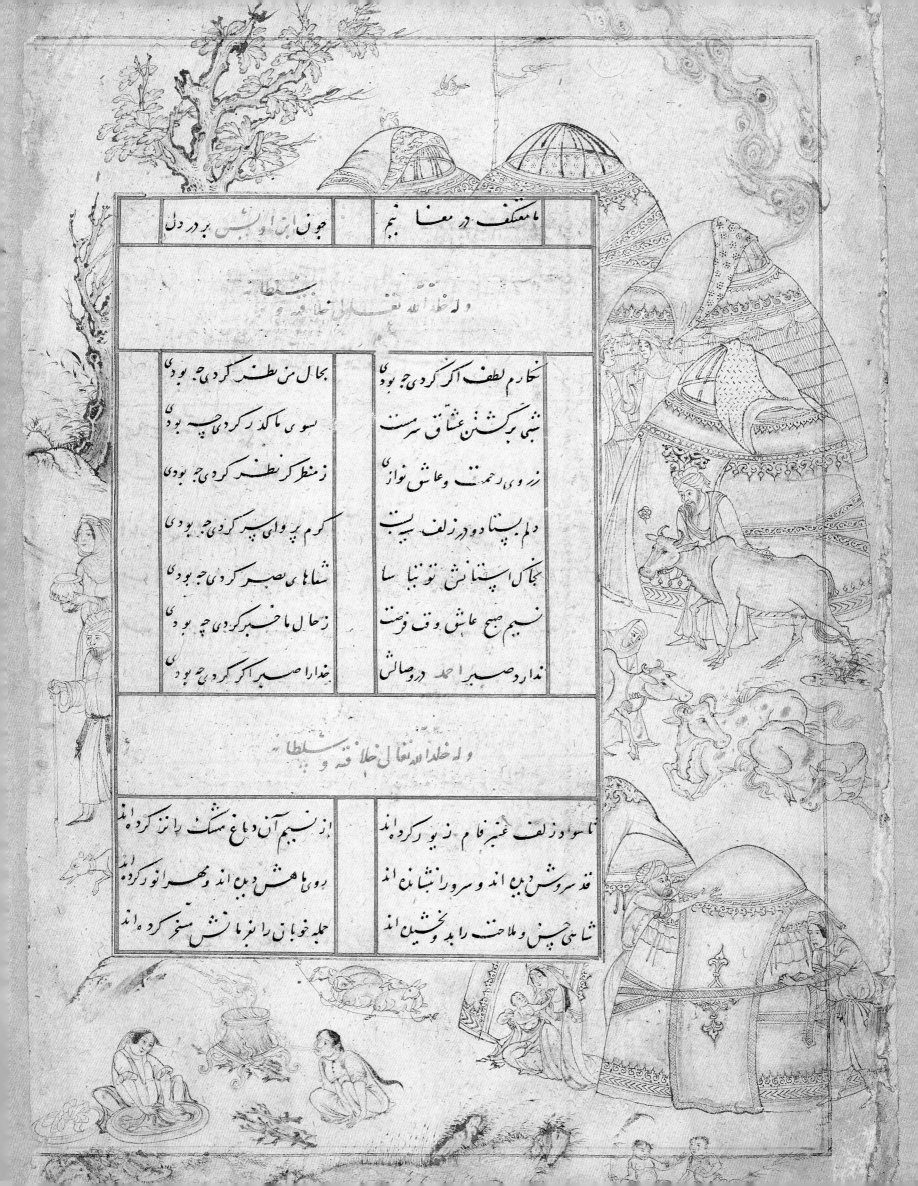

| جون ابن او بس بر در دل | ما معتکف در معنا نیم |

وله خلد الله تعالی خلافته و سلطانه

بحال من نظر کردی چه بودی	نگارم لطف اگر کردی چه بودی
سوی ما گذر کردی چه بودی	شبی بر کشتن عشاق سرمست
ز منظر کر نظر کردی چه بودی	ز روی رحمت و عاشق نواز
کرم بر وای سر کردی چه بودی	دلم بنهادم و در زلف لیب
شبها به صبر کردی چه بودی	بجال اسپنانش نو بنا سا
ز حال ما خبر کردی چه بودی	نسیم صبح عاشق وقت فرصت
خدا را صبر اگر کردی چه بودی	ندارد صبر احمد در وصالش

وله خلد الله تعالی خلافته و سلطانه

از نسیم آن دماغ مشک رانز کرده اند	تا سواد زلف غنبر فام زیور کرده اند
روی ماهش دبیند و دهوانو کرده اند	قد سروش دیده اند و سرورا نشان اند
جمله خوبان را بوز مانش مسخر کرده اند	تا سی حس و ملاحت را بدید بخشیده اند

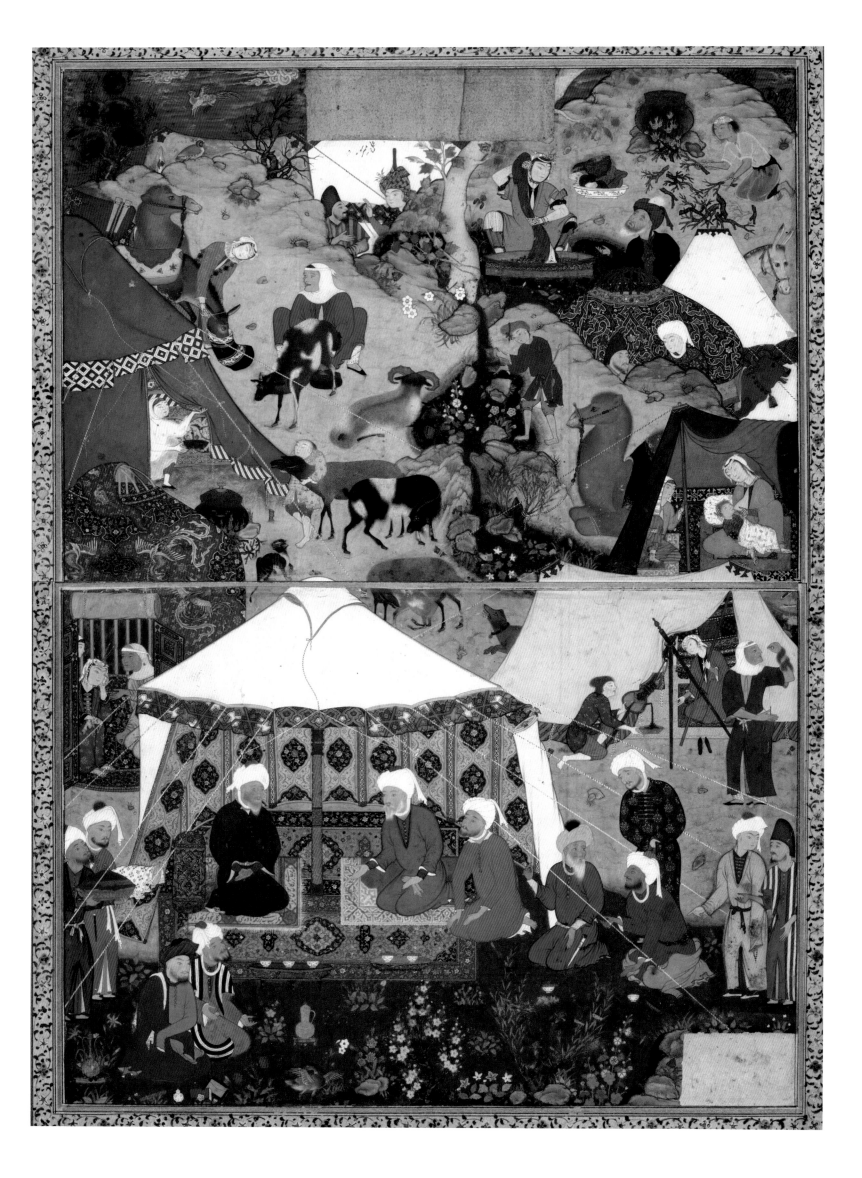

pale green, intense blue, and gold. Their stylistic coherence suggests they are the work of one person: Sultan Ahmad himself is one possibility, since Dust Muhammad says that ʿAbd al-Hayy instructed him in painting and then speaks of his executing a work in "black pen," *qalamsiyahi* – to be understood as pen-drawing. Whoever the artist, these ink-drawings are extraordinary: virtuoso in their execution and unusual, in the context of then-current notions of combining a classical Persian text with pictures, as well as in their use of the entire page as a canvas. They are drawn in ink on the bare polished white paper, instead of being painted in mineral pigments in discrete outlined spaces; their subjects do not illustrate the text but are a visual commentary on the poetry, while they also make references to Iranian life at the turn of the fourteenth century. And their themes derive from the work of a very great poet, the twelfth-century sufi Farid al-Din ʿAttar.

ʿAttar's *Language of the Birds* is a parable on mankind's quest for spiritual knowledge and peace, in which thirty birds undertake a journey in hopes of reaching God, represented by the mythical Iranian bird, the *simurgh* [250]. The journey will be long, and they must traverse seven valleys before they may even hope to find the *simurgh*. The ink-drawings in Sultan Ahmad's own *diwan* "illustrate" the first six of the seven valleys: the "Nomad Encampment" is a vision of the fourth valley described by ʿAttar, the "Vale of Detachment."

It has been called a picture in which man, animals, and inanimate nature are at rest and in equilibrium, neither seeking nor resisting the superficial things of this world. It is, then, a slight paradox that this picture is so very full of things specific to the world of the Turco-Mongol nomads, in particular the trellis-tents called *yurts* – notably absent from the group of so-called "Nomad" drawings [170]. All the details of their construction and decoration are carefully depicted: the wicker framework, the coverings of large decorated textiles, the narrow woven bands, with shallow Y-shaped braces, wound around the structures for stability; and the smoke-holes at the top, whether covered, uncovered, or partially covered where a fire has been kindled inside and smoke floats out in decorative whorls.

Nomadic humankind is also beautifully depicted: erecting a tent, tending cattle, dandling infants, washing clothes, carrying food in a covered pot. And if the facing page in the manuscript is considered as the left half of a double-page painting of which the "Nomad Encampment" is the right-hand part, gathering wood, and pasturing sheep, goats, and horses could be added to the list of details that so well capture the atmosphere of the nomads' halting place. Certain figures, such as a squatting person washing clothes in a large basin, and the woman with a small child on her lap, would become stock-images in later Iranian pictures with pastoral or nomadic settings.

172. LIFE IN THE COUNTRY: THE NOMAD ENCAMPMENT OF LAYLA'S TRIBE

> Painting probably intended for Shah Tahmasp's manuscript of Nizami's *Khamsa*
> Tabriz, 1539–43
> H: 27.8 cm; W: 19.3 cm
> Cambridge (Mass.), Harvard University Art Museums, 1958.75

This picture has shared the vicissitudes of a companion painting "Life in Town" [109]: both have been cut in two and trimmed, and their accompanying text has also been cut away. But unlike "Life in Town," here the narrative subject seems obvious, given the profusion of tents, the Arab-style turbans worn by the principal men seated around the largest tent in the foreground, and the lovely girl who listens to the men's conversation. It must have been an illustration to Nizami's *Layla u Majnun* and
was perhaps its first picture, of Layla's father receiving the father of Qays – Majnun – who has come to the encampment of Layla's tribe to propose a marriage between her and his son.

The image is as dense in separate vignettes, and as lovingly detailed in its evocation of nomad life, as "Life in Town" is evocative of the texture of urban life. "Life in the Country" even shares an overall compositional formula with its companion painting. In the lower half of the picture, both show men seated to either side of a male figure at the apex of a triangular shape – a tent or *iwan*; in the middle zone of each painting the eye is led diagonally left, along the line of the tents, or the wall of the terrace, where it may then pause at any one of a number of vignettes that expand the perceived experience of nomad, or urban, life: there are thirteen in this picture. "Life in the Country" also has more open-air space, as there is no solid brick architecture. Instead it provides a deliciously varied spectacle of tents: nine, in three quite different styles, whose lines are exactly rendered but whose walls and roofs mingle observation, imitation, and fantasy in their decoration.

At the right middle margin, where a young mother nurses a child watched by a girl with hennaed hands and feet, is a low black tent lined in green and supported on two thin poles; in shape and color it is of Arabian *bedu* origin, and it is repeated just below, in white with a striped edging of blue and white; the lining, squares of red and blue geometrical patterns edged in black and white, appears to be of Turkman origin. A third version, in the upper left of the picture, is in tan in color with reddish corners. A second type of tent is circular and supported by guy-ropes, with outer walls in vertical sections, a pointed top with a colored flap, and a central large pole; the picture shows three in white, and a green variation, at the upper left. In the foreground, the momentous conference between the two

fathers takes place in the largest tent of this shape. Its front panels are folded back, to allow us to see the meeting and also to display the splendid interior decoration on the vertical panels – large ogival medallions in deep contrasting colors set against reciprocal ogival shapes in several shades of light blue. Most striking are the two trellis-tents, not only for their shape but for their decoration. That in the right background, just in front of the celebrated image of the washerwoman who piles her wet laundry in a large dish of blue-and-white ceramic (that may – or may not – be Chinese porcelain), is patterned in large, vigorous arabesques of red and dark blue edged in white. That in which Layla sits with her companion is a superlative but fantastic creation. It is decorated with designs associated with contemporary Ottoman Turkish carpets, of large lobed geometrical forms of dark blue filled with flowers and arabesques, between which are several images more usual to contemporary woven textiles and manuscript illumination: these are large *simurghs* (the mythical bird that assisted at Rustam's birth and afforded him protection at moments of danger), with typically trailing tail-feathers.

The many figures throughout the picture are wonderfully lively and the details of dress and ornament, accoutrements and implements, presented in loving detail; domesticated animals and nomad livestock are equally lovingly portrayed. Only when the eye has worked its way up and through, around and down the human and animal surfaces of the picture does it perceive that the landscape setting for this most civilized of nomad encampments is the classical, formulaic Iranian landscape: hills edging a sparse purple desert, a life-giving silver stream with flowers growing at its edges, and a well-watered green and flowering meadow, where the conference between the fathers is situated. There is even a tree at the center background, not growing straight up in the Timurid manner, but twisting to the right, behind the block where a couplet of text must once have been. Beneath the blue paper repair, scrawled on the conical top of a small white tent, are the words "work of Mir Sayyid ʿAli." The attribution argues persuasively that "Life in Town" [109] was also painted by the same artist.

173. WRESTLERS

Star-shaped tile painted in luster
Iran, thirteenth century
H: 12.2 cm; W: 12.2 cm
Baltimore, Walters Art Gallery, 48.1283

This tile is one of a larger series of star-shaped luster-painted tiles probably made in the city of Kashan. Despite the figural imagery, which in this case is also apparently a blatantly secular image, tiles showing wrestlers could have been used either in the decoration of a palace or in the tomb of a notable sufi. Two such tombs are known to have had luster-tile decoration: the Khangah (the house of a darvish order, or monastery) of Pir-i Husayn in Baku, its tiles dated between 1282 and 1285, and that of the Imamzada of Shaykh Yusuf in Sarvistan, which once bore tile decoration with dates ranging from 1281 to 1314.

In ancient cultures as well as in traditional ones, and even up to recent times, wrestling was far from being a mere display of mindless physical force. Firdausi's champions resort to wrestling as an encounter in which the combatants' sole weapons would be their own strength and skill. Sa'di's story of the wrestling master who withheld the last of 360 holds from even his favorite student incidentally confirms it was practiced at medieval Muslim royal courts.[1] And in Iran in the thirteenth and fourteenth centuries, wrestling was especially associated with the emergence of popular Sufism, which at just this period began permeating craftsmen's associations. The Kashan potters, the manufacturers of so many luster-painted tiles with figural decoration, might have been especially appreciative of this apparently secular image that, to the initiated, would readily be understood as having an underlying sufi significance.

174. A SEATED SUFI HUGGING HIS KNEES

> Painting once mounted in an album
> Western Central Asia, sixteenth–
> seventeenth century
> H: 22.4 cm; W: 14.9 cm
> New York, Metropolitan Museum of Art,
> 57.51.30

This painting of a sufi, or darvish, hugging his knees is remarkable for many reasons, not least its matte brown background and portrait-like presentation. The man looks downward at an angle, into a place beyond our vision. Thin but hardly emaciated, well-groomed but barefoot, he wears an earring, and a sheepskin around his shoulders tied with a knot at the neck. A reed flute (or bamboo stick) lies in front of him, and a small wooden bowl to his side; an inscription above the bowl invokes the Prophet from whom comes all aid.

The structure of the bony skull is sensitively rendered, as are the lines around the eye and beside the mouth, and the wrinkles of the brow that convey an interior focus and concentration. The anonymous painter has captured the latent energy of legs and arms tightly held in a compact, ovoid silhouette, and the curly texture of the sheepskin balancing the smooth outline of the shaven skull. So sensitive and observant a picture, with its sophisticated dark background, suggests Mughal Indian influence on a painter who might well have been from Bukhara or elsewhere in Central Asia rather than from Iran.

175. THE POET FAKHR AL-DIN ʿIRAQI WITH DEVOTEES

> Painting in a manuscript called *Majalis
> al-ʿUshshaq* (*Lover's Meetings*), probably by
> Kamal al-Din Gazurgahi
> Shiraz, 1552
> H: 12.5 cm; W: 10 cm
> Oxford, Bodleian Library, Ouseley Add.
> 24, fol. 79v

The *Majalis al-ʿUshshaq* has been attributed to Sultan-Husayn Bayqara but, according to his nephew Babur, is actually the work of an official in his employ, Kamal al-Din of Gazurgah, a suburb of Sultan-Husayn's capital, Herat. This copy is exceptional in that it has an illustration for each of its seventy-six subjects.

The works of the thirteenth-century sufi Fakhr al-Din ʾIraqi focus on mystical love, on what has been called the sufi trinity of love, lover, and beloved. In this "meeting of lovers," Fakhr al-Din is soberly dressed, in several long garments, a turban, and scarf, but he is surrounded by devotees of one or another of the mendicant darvish orders who provide a startling contrast to the mystic poet. They are bare-legged and some are barefoot, and

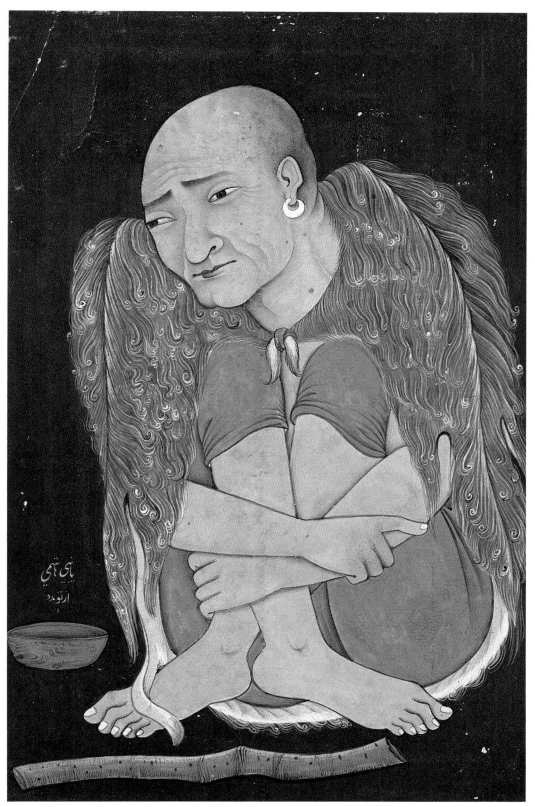

174

many are also naked to the waist, so that the Nubian among them is striking. Much of their clothing is of animal skin – the more decorative skins of leopard and tiger, rather than ordinary sheepskin. Some are bare-headed, with shaven skulls and a golden earring, while others wear the tall darvish hat: again, one is made of tigerskin. They carry some of the accoutrements of the darvish orders, including a large two-prowed boat-shaped vessel, and short sticks and spears; a

banner has been affixed to one. Altogether, they are a decoratively motley crew.

Recalling that the manuscript has a painting for each of the seventy-six biographies it contains, it is hardly surprising that this picture should display the simplified proportional canon of mid-sixteenth-century Shiraz [cf. 110, 169]. Yet one of the standard pictorial details of pictures of middling quality, the surprised observer at the rear, is still present: thus a pair of courtiers wearing Safavid baton-

175

turbans peers at the procession of the mystic
poet and his devotees from behind the steeply
descending hill at one side of the picture.

176. A GATHERING OF DARVISHES

Painting mounted in an album
Herat, ca. 1580–90
H: 25.5 cm; W: 14.5 cm
St. Petersburg, Oriental Institute, D-181,
fol. 36r

In a mountain meadow, a group of darvishes
seeks mystical union – *tauhid* – with God by
the medium of some alcoholic beverage [34].
Some have reached their goal; others are
happily engaged in its pursuit; all must be
finding some measure of enjoyment in the
activity.

This tinted drawing, with washes of color
and certain areas of a more intense hue, gives
the impression of a keenly observed, lively,
and varied group of men, despite the fact
that almost all are types and occur in other
contemporary (and earlier) paintings and
drawings. Headgear is varied, as if to suggest a
locale where Iran, Central Asia, and India are
equally near. The obligatory leopard-skin is
draped around a man at the left margin; a
hide of some sort is knotted at the shoulders
of the relaxed figure at the lower right.
Especially striking is the size of the blue and
white ceramic vessels holding the means of
their mystical transport: even the drinking
cups are large bowls, and a small man could
happily drown in the huge jar in the
foreground.

The landscape in the upper part of the
picture is a beautiful example of the *nim qalam*
manner practiced in Mughal Indian painting
around the same time – the term means "half-
pen" but "lightly colored" better conveys the

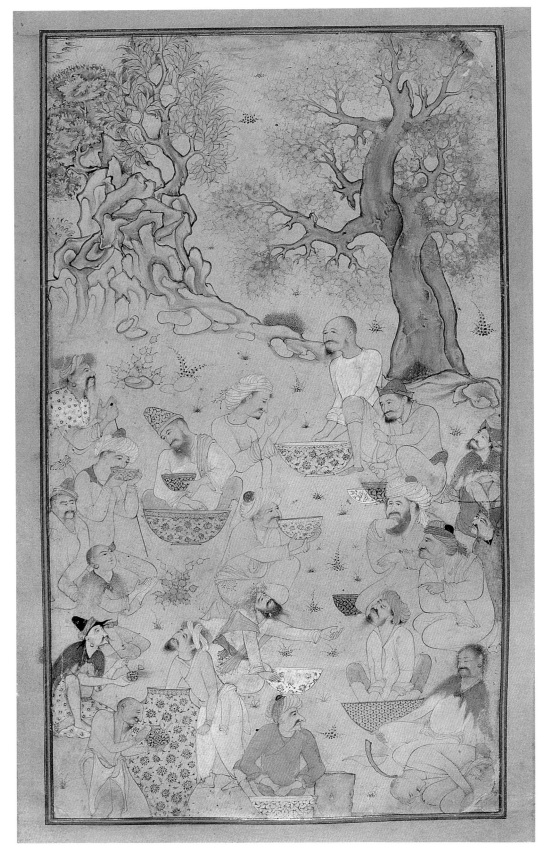

176

meaning. On the other hand, the uneven
color of the ceramic vessels suggests that "half-
finished" more aptly describes this drawing.
Some wares are crisply white with blue
ornament, while others have a paler
background that is probably nothing more
than the color of the paper itself. A pair of
figures at the right margin appears to have
more densely colored garments, while only

the turbans of the pair below them are in
color; the man bending over his knees, in the
lower right, is entirely untouched by color.
Perhaps this picture is a kind of study piece,
versions of figures taken from many sources
and united on paper by the theme of the sufi
search in an eternally pleasant out-of-door
setting.

177

177. SHAMS LISTENS TO THE CONVERSATION OF SHAMAT AND THE PERIS

Painting in a manuscript of Sadaqa ibn
Abu'l-Qasim Shirazi's *Kitab-i Samak ʿAyyar*
(*Book of Samak ʿAyyar*)
Shiraz, ca. 1330–40
H: 14 cm; W: 14.7 cm
Oxford, Bodleian Library, Ouseley 381,
fol. 166v

Only one copy of Iran's oldest prose work of
belles-lettres, the *Kitab-i Samak ʿAyyar*, is known
to have illustrations. It is in three volumes, and
its pictures suggest that it was made in Shiraz
for someone in the ruling circle of that city in
the early fourteenth century. Qivam al-Din,
vizier of Abu Ishaq, the last Inju ruler, is one
possibility. He was a man of politics, letters,
and the arts [Fig. 63], and patron of the great
poet Hafiz, and he also commissioned at least
one other illustrated manuscript, a *Shahnama*
completed in 1341 [138].

The text is a mix of adventure and
romance with much fantasy in which fairies
and demons, *div*s, are an important element.
Many episodes concern the knightly pursuit of
the daughter of the Emperor of China.
"Shams and the Fairies" exemplifies the best
aspects of the Inju style of painting: the
background is red [200]; the trees have trunks
but their foliage confirms that the shrub-like

plants of Seljuq painting are more than a
memory [226]; the heads of the two fairies are
not only crowned in gold but nimbed as well.
Seated cross-legged on the grass beside a
stream, their garments are patterned with
small, outlined images resembling those seen
on the fragments of Seljuq wall painting [38;
Fig. 53], while the larger designs on the cuffs
and border of the left figure, and the great
many colored wings of both, are known from
Seljuq manuscript illustration and from myriad
other materials. Their silhouettes are compact
and their faces devoid of expression, and their
conversation is conveyed by gesture. Their
faces still approach the ideal of the Seljuq
moon-face, although they are vigorously
modeled in red, a newer, fourteenth-century
mannerism [39]. The men in the water call to
mind another swimming figure, on a luster-
painted plate dated 1210,[1] but here the faces
are longer and less round, remarkably similar
to those appearing in pictures painted in
Shiraz around a century later.

178. ANGELS ATTACKING A NEST OF DRAGONS

Painting mounted in an album
Western Iran (or Central Asia?), late
fourteenth–fifteenth century
H: 27.5 cm; W: 37 cm
Istanbul, Topkapı Saray museum, H. 2153,
fol. 5v

Almost buried in a rocky outcrop is a nest of
dragons, a mass of horned heads and writhing
spines, grasping golden claws and curling
tongues. The more closely one looks, the
more heads one sees but there are at least
nine creatures. A band of six flying angels has
attacked them; ropes are looped around heads
and over bodies, and the angels hover
overhead and tug at the ropes, taut with the
strain of the struggle.

The composition is a brilliant one, the
angels fanning out in the clear upper
atmosphere (supplied by the polished white
of the paper), the ropes directing the eye
downward to the silvery-grey mound of
slithering dragons' bodies which are almost
indistinguishable from the rocks in which
they nest. The palette suggests fantasy rather
than menace: the angels are painted in pale,
transparent color, with touches of gold, and
the dragons in black and grey, with much
silver and some golden touches; the rocks are
of dark greys and a brownish red, purple and
blues; and a few flowering plants bloom at the
foot of the rocky outcrop, below the dragons'
nest. The picture has long been described as
an East Asian folk-tale from a Buddhist milieu
but beyond this it remains unidentified. As
does the locale of its execution.

The built-up rock forms are dense with
eye-like formations that sometimes become
full faces: an almost demon-like face hunches
in the red-purple rock near the left margin,
and toward the bottom right a silvery grey
head is hard to separate from that of another
dragon. Such rock-faces would become a
particular hallmark of some of the painting in
princely Turkman manuscripts of the later
fifteenth century [26] and others in the
sixteenth [78, 79]. The angels' garments, and
their topknots of dark hair, are not unlike
those of Buddhist angels, and their flying
sashes and fluttering garments also appear in
some of the late fourteenth- or early
fifteenth-century unattributed paintings in the
albums; the calyx-like headdress occurs as
early, and as far eastward, as the Manichaean
text-fragments found in Kocho.

The inscription written in black ink
between two angels at the upper left lends no
help: it reads *kar ustadh muhammad*, "the work
of master Muhammad," and is one among
many scribbled on certain album paintings
[Fig. 64] at some time after they had entered
the Ottoman library in Istanbul, perhaps by
the young Ahmad I early in the seventeenth
century. On the other hand, there are
Buddhist architectural remains in north-

178

western Iran that testify to the Buddhism practiced in the Ilkhanid realm before the end of the thirteenth century, when Ghazan Khan formally converted to Islam. Tabriz or some other such cosmopolitan place in the Iranian west, at a time in the fourteenth century when the memory of Buddhist literary culture was ebbing, seems the correct Iranian locale to which this marvellous composition should be attributed.

179. KHWAJU KIRMANI VISITED BY THE ANGEL OF INSPIRATION

Painting on a folio removed from a manuscript of the *Masnavis* of Khwaju Kirmani, and mounted in the Bahram Mirza Album
Baghdad (or Samarqand), between 1396 and 1401
H: 28.4 cm; W: 19.4 cm
Istanbul, Topkapı Saray Library, H. 2154, fol. 20v

Perhaps the most beautiful of all of the paintings illustrating Sultan Ahmad Jalayir's *Masnavi*s of Khwaju Kirmani [73, 105, 114] shows a youth sleeping in a handsome interior chamber, and a phalanx of angels in the sky outside. The painting was removed from the parent manuscript (just when is unclear), and mounted in the introductory part of the album Dust Muhammad compiled for the Safavid prince Bahram Mirza between 1543 and 1545.

This is the album, let us recall, in the preface to which Dust Muhammad writes that "the painting which is current at the present time" was invented by Ahmad Musa; his pupil was Shams al-Din, who in turn trained 'Abd al-Hayy. When Timur conquered Baghdad, among the artists and artisans taken to Samarqand was Shams al-Din's pupil 'Abd al-Hayy, to whom this painting is attributed, albeit in a Safavid inscription pasted just above the picture. Also unclear is upon just which of Timur's two invasions of Baghdad – in 1393, or in 1401 – 'Abd al-Hayy was among the

human booty but the latter seems more likely, in light of other details of the parent manuscript's production.

Now established as a missing folio from Sultan Ahmad's manuscript, and with its subject identified as the poet himself, dreaming of a visit from an angelic emissary from "The Exalted One," this picture can be appreciated for what it truly is – a brilliant work in the style of Sultan Ahmad's atelier in Baghdad with overlays from Timur's Samarqand. It is divided vertically in the proportion of approximately two to one, the *iwan* of the sleeping poet being the wider section. This is shown as if it were a folded piece of cardboard – a typical Jalayirid construct [40] – but its surfaces are as luxuriously revetted, and as beautifully executed, as can be found anywhere else in the manuscript: the pool with its lobed outline set in the stone floor, the tiled dado and the elaborate, borders above, the ruched-up many colored curtains in the *iwan* and at the window, and the stucco window-screen

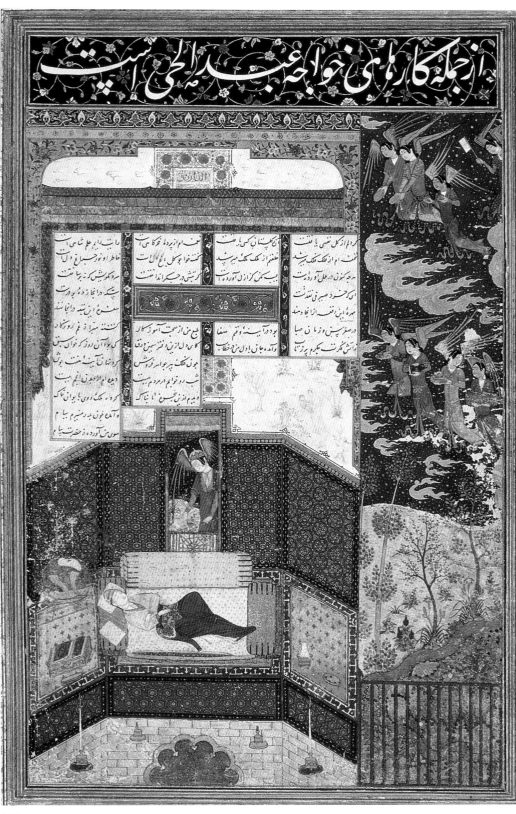

179

seen in contemporary paintings that are presumably of more easterly origin, as "The Duel" [15] and "The Lady Travelling" [113]. Another more easterly feature in this painting would seem to be the blue line-drawings, or paintings, on the white wall above the dado to either side of the window where the emissary angel has alighted; they, too, have an eastern parallel in the paintings on the walls of the Christian monastery, in the same group of pictures [104]. Lastly, the overall palette of this painting seems to echo that of this entire group of pictures possibly from Samarqand and perhaps only faintly earlier in date. All three display a fairly balanced mix of red and yellow, blue and green, with much gold, some silver (usually reserved for water), and the usual touches of black and white, as does this vision of angelic inspiration. The palette of the other paintings in Sultan Ahmad's *Masnavi*s is quite different: not dominated by primary colors but rather by pinks and lavender, light green, pale turquoise and a very dark blue; the exception, perhaps, is the wedding scene [114], in which the emphatic use of red is explained by its subject. In this feature, as well as in the presence of the wall-paintings, seems the silent but unmistakable evidence that 'Abd al-Hayy composed his painting in Sultan Ahmad's Baghdad but finished it in Timur's Samarqand.

180. ADAM AND THE ANGELS WATCHED BY IBLIS

> Painting from a manuscript of the *Annals* of al-Tabari, in a volume of historical texts
> Herat, 1415–16
> H: 19.5 (20.4 maximum) cm; W: 27.2 cm
> Istanbul, Topkapı Saray Museum, B. 282, fol. 16r

After God had created the first man, Adam, he ordered the angels to pay homage to him; Satan – Iblis – refused to obey. This painting shows Adam standing on a royal throne to the right while four crowned angels to the left bow down to him. They prostrate themselves fully, their hands extended towards Adam with palms up, a gesture usually reserved for one of the acts of Muslim prayer [54].

Behind the angels, under a tree whose branches bend over them and visually echo their act of homage, stands a dark-skinned figure with a white beard and wings. A monstrous head with flaming eyes and horns, a tail and clawed feet, scant corporeal covering and golden anklets, all identify it as an evil spirit, a *div*, not dissimilar to the infernal blue guardian in a contemporary manuscript of the *Mi'rajnama* [65]. An Ottoman Turkish inscription, written in red in the margin slightly above the dark figure, identifies it as *shaytan*: Satan – or Iblis, to Muslims.

The figure holds its long white beard with his right hand and with the other points to Adam on the throne; rigid and stubbornly

high in the wall. Lit candles and the star-spangled sky tell us it is night, and in the sky above the full glory of Khwaju's dream is revealed.

A flutter of angels in the midst of flaming golden clouds approaches the chamber in which the poet lies asleep. They are dressed in brightly colored robes, with pearl chains holding their hair in place. An emissary angel, winged and also crowned, has alighted in the window and looks down upon the sleeping poet. The others tread the air behind, their

sashes rippling extravagantly, wings banked at skewed angles, toes spread out on tiny feet; and they carry gifts – a crown, a manuscript, a banner, and golden dishes and boxes.

The entire flutter is wonderfully Jalayirid, with narrow, long figures and heavy eyebrows that meet just above the nose. They wear short-sleeved robes over a contrasting undergarment but the clothing is stylistically mixed: some wear a knee-length overgarment, and some fabrics are plain while others are dotted with tiny golden patterns of the kind

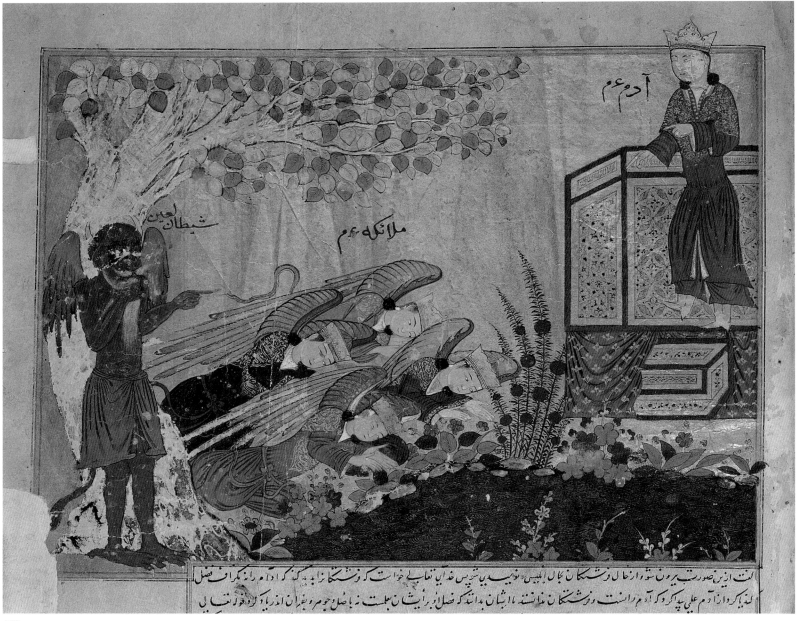

180

upright, he stands in stark contrast to the group of angels prostrating themselves before him. Apart from the fairly realistic tree and the equally naturalistic rendering of the pool flanked by lush vegetation in the foreground, the scene is set against a brilliant golden ground that emphasizes the supernatural quality of the event. This is a memorable painting, wider than the width of the written surface, and quite large. The empty, golden space of the sky almost vibrates, playing a paradoxically positive pictorial role in an art form in which voids are relatively infrequent.

181. A SEATED ANGEL

Painting once mounted in a now-dispersed album
Qazvin, ca. 1575
H: 13.8 cm; W: 11 cm
Washington, DC, The Art and History Trust (on deposit at the Sackler Gallery, Smithsonian Institution)

This picture of a seated angel holding a large pink rose in full bloom is both brilliantly painted and beautifully preserved – so well that the silver of the belt has not tarnished. It is drawn in lines both delicate and audacious, the coloring is strong and contrasting, yet it is tied together visually by the gold-brocaded overgarment with its pattern of song birds within a floral arabesque. The burnished, lustrous surface is a perfect example of the exquisite finish accorded to the finest Iranian paintings of this classical period.

Fully colored but placed against a neutral uncolored ground, the drawing of the head and face is astonishing for its fine, black lines

and the delicacy of features. In this it is rather different from the Qazvin type of youthful beauty, but the dramatic angled outline of the wings and the outstretched leg are typical aspects of the Qazvin style that help to place it around 1575 [145]. The stippling of paint, seen inside the brocaded cloak and at the edges of the wings, is a technical feature that would become more frequent in Iranian painting in the following centuries.

182. RUSTAM'S LAST *KHWAN*: HE SLAYS THE WHITE DIV

Painting in a manuscript of Firdausi's *Shahnama*
Herat or Isfahan, 1602
H: 14.8 cm (max. 32.2 cm); W: 19.2 cm
London, Nasser David Khalili Collection, MSS544, fol. 71v

Rustam's ferocious battle with the White Div is the *Shahnama* story most frequently

182

On this last occasion, Aulad counselled waiting until noon, when the sun would be hot and the *div*s somnolent. Rustam again bound Aulad to a tree with his lasso, and

> . . . he went to seek
> The White Div, found a pit like Hell . . .
> Enraged he struck full at the div and lopped
> From that enormous bulk a hand and foot. . .
> Then with a dagger stabbed him to the heart
> And plucked the liver from his swarthy form.

The scene is virtually always set in the midst of a wild, rocky landscape, and the dark cave is an effective foil for Rustam's famous striped tigerskin garment and for the awful, spotted whiteness of the *div*. Given the weight of both textual and pictorial tradition, it is surprising to consider how different can be the illustrations to this story. Here, the mouth of the cave is wreathed in sharp-edged boulders, the grazing Rakhsh is tethered to another in the foreground, and a well-dressed Aulad is tied to a tree where he may at least look upon Rustam and his monstrous adversary, who appear to be engaged in a decorous dance rather than a fight to a bloody finish.

The *div*, however, could not be more traditionally *div*-like [102, 130]: short branching horns grow from between large pointed ears set, in a feline fashion, toward the top of the skull. Flames flicker from its eyes, and fangs protrude from his mouth, over a short wispy beard. Bare to the waist and wearing only a short wrapped garment, its gruesomely spotted skin, the hairy growth on its limbs, and its long flexible tail are all too visible. Its arms and legs end in a clawed parody of fingers and toes, with an avian counter-claw at the back of the foot. The gold "adornments" – necklet, armlets, leg and ankle rings – are actually signs of servitude: *div*s, in Iranian painting, always wear them, even though it is Sulayman, the Biblical Solomon, who is credited with reducing the *div*s to the state of servitude. Unusual, but consistent in this particular manuscript, is the detail of the dragon's head at the end of the *div*'s tail [cf. Fig. 64].

illustrated in Iranian manuscripts of Firdausi's text from as early as they survive (the fourteenth century). The episode perfectly summarizes the theme of heroic victory over monstrous and gratuitous evil, while the details of the story lend themselves to the most dramatic visualization.

To slay the White Div and pluck out its liver is the seventh, and last, of Rustam's feats of strength and cunning. Mostly they had been performed in Mazandaran [78], the green and fertile land lying beyond the Alburz mountains next to the Caspian Sea. In the early part of the *Shahnama* this province was the realm of *div*s, and Rustam's last two feats not only destroy their hegemony but also restore the sight of the misguided Shah Kay Ka'us, blood from the White Div's liver being a sovereign remedy for blindness brought about by supernatural causes. Accordingly, Rustam had captured Aulad [133, 134], a young marchlord of the region, and forced him to guide the hero to the lairs of Arzhang, and then of the White Div, dragging the youth with him and tying him to a tree during each of these bloody encounters.

THE EXCEPTION TO TYPE:
PORTRAITS

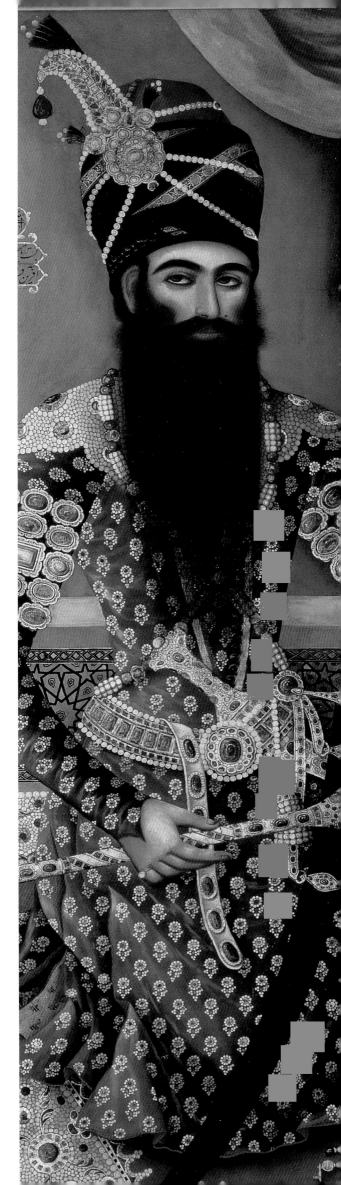

183. A HEPHTHALITE RULER AND HIS WIVES

Silver bowl with *champlevé* decoration
The Hindu Kush region, fifth century
Diameter: 18.3 cm
Samarqand, The Museum Complex,
KP-2934/2

This silver bowl was found in Chilek, near Samarqand, together with a Sasanian silver plate showing Peroz (459–84) hunting, and two sixth-century Sogdian silver bowls. Its shape – a segment of a sphere – and its exterior decoration of *champlevé* relief are typical of "Bactrian" silver bowls of the third to the seventh centuries, a genre that developed from Hellenistic silver vessels.

This example has lost almost all the Hellenistic elements of its model. The portrait medallion on the bottom of the exterior is instead similar to busts on early Hephthalite coins: the massive face, the notably pointed shape towards the top of the head, and the strong neck are all features found in portraits of the earlier Kushan kings. The ladies on the exterior are placed under arcades and resemble those on a number of Sasanian silver bottles and ewers, but the decorative details are all non-Sasanian in character. The figures are disposed as two identical groups, a dancer flanked by a lady with a wreath and another carrying a mirror. The rich floral ornament of the background is in the fifth-century Guptan style of India; the bull capitals are of Gandharan origin.

Another silver bowl in the British Museum

[Fig. 17] must have been produced in the same center, for it shows the same mix of themes, forms, and decorative elements. At the center of the base is a portrait of a nobleman in a medallion, surrounded by three typically Guptan stylized birds with ornamental crests, wings and tails. On its exterior four horsemen hunt: two Kidarite kings, the early Hephthalite ruler (identified by portraits on coins bearing the phrase ΑΛΧΟΝΟ, written in Bactrian letters derived from the Greek script), and, perhaps, the man whose portrait occurs in the exterior medallion.

Bowls such as these, and many other silver wares from Central Asia, clearly demonstrate that, in the lands adjoining Iran to the East, Sasanian motifs reworked by local silversmiths were relatively few in number, with the result that even provincial Sasanian silver vessels differ markedly from the silver vessels made in centers further to the East of Iran. B.I.M.

184. PORTRAIT OF A WORSHIPPER

Painted mural in a private house
Panjikent, Sogdia, first half eighth century
H: 70 cm; w: 50 cm
St. Petersburg, State Hermitage Museum,
on long-term loan

This depiction of a worshipper was discovered on the side wall of a recess in the reception hall of a private house. A man sits on his heels in front of a portable fire-altar, a bowl with offerings in his left hand and a spoon in his

184

right, with which he puts something into the flames rising from the altar. The background of the painting is bluish grey, against which the altar is only partially preserved – enough to see that it was of the usual Sogdian type (also used in Tokharistan), with a conical support, an umbrella with small bells, and the bowl with the burning substance.

Other paintings in the recess included a mural showing religious images, among them that of the great goddess Nanaia, and several other worshipping figures; on the side wall was another group of at least three worshippers. It is therefore difficult to decide whether the man kneeling before the altar was the owner of the house, or one of his relatives. Whoever he was, the painter appears to have known him well enough to represent his bald head and his extremely long mustache. This is unusual because for the most part, the individuality of a represented personage was not important for Sogdian artists. Indeed, in later Panjikent murals, male figures are presented as images largely similar in their posture and bodily proportions, in the line of the neck and shoulders, and in the beautiful oval face seen in three-quarter view. Only the most obvious peculiarities represented a rare departure from the norm of the ideal Sogdian male face and figure.

The same tendency characterizes the portraits of donors, always shown in profile, of earlier Sogdian painting of the fifth and sixth centuries [46]. This facial uniformity seems strange, given that Sogdian artists avoided repeating identical figures; they always varied the postures of their subjects, and of clothing and weaponry as well (which also underscores the wealth of the represented community).

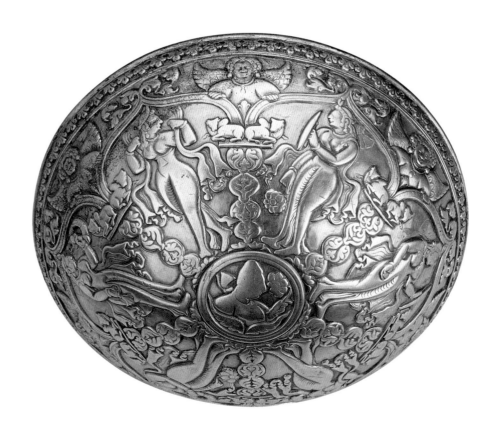

183

Nevertheless, an ideal of human beauty usually prevails in the figures painted by Sogdian artists, and perhaps it also corresponded to an ideal of human behavior. Certainly the paintings in this recess represent a gathering of worthy but ordinary men and women, for the representation of heroes, of peasants [165] and comic figures, and of supernatural demons is always more individualized. B.I.M.

185. THE PRINCE AT AN OUTDOOR RECEPTION: BAYSUNGHUR MIRZA IBN SHAHRUKH IBN TIMUR

Right half of the double-page frontispiece in Baysunghur's manuscript of Nasr Allah's *Kalila u Dimna*
Herat, 1429
H: 22 cm; W: 13.7 cm
Istanbul, Topkapı Saray Museum, R. 1022, fol. IV

Whether it is because more illustrated manuscripts of Baysunghur's patronage have survived, or because of his notion that a princely manuscript issuing from his workshop ought to contain his own likeness in some appropriate place, the fact remains that even by the idealized norms of Iranian painting in the fifteenth century, Baysunghur's is a face that can be recognized. Here, in the opening double-page painting for his own illustrated *Kalila u Dimna*, he presides over a reception held in the out-of-doors.

Baysunghur's appearance is not recorded in words. It is instead the sameness of the round, unbearded face with a thin mustache that permits our recognizing him in significant paintings issuing from his own workshop. If confirmation were needed, his clothing and his position within this picture provide it: he wears a golden crown and a green *jama*, and he sits on a cushion placed on a carpet, one knee drawn up and a wine cup in one hand; he is the focus of attention in both sides of the composition.

Moreover, the reception is not an idealized image of any Timurid garden reception: no women are present, the three men at the right appear to present gifts, and quantities of wine in large bowls are being carried towards the prince by servants approaching in the left half of the picture. These facts, together with Baysunghur's recognizable self, suggest not only that he personally presided over the event but that he had a hand in designing its image.

It is built up of the repertoire of elements that contribute to the princely reception in an outdoor setting: the ruler's pose, the rich but portable furnishings, the presence of courtiers with special accoutrements, and musicians, as well as the setting, a flowering meadow watered by a silvery brook under a golden sky. These are repeated in manuscripts of many levels of achievement throughout the century, whether or not the princely figure is intended

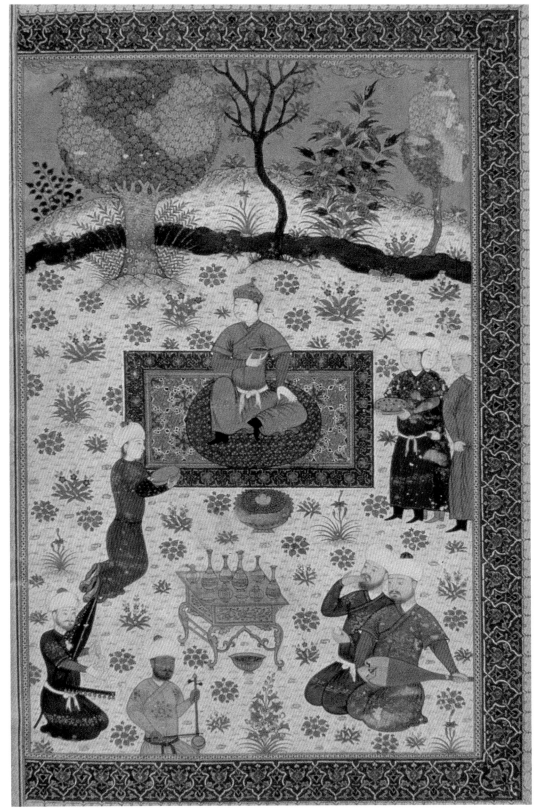

185

as a true portrait [33, 34; cf. 186], and whether or not the painting is a frontispiece, or even a double-page picture. Perhaps this picture of an outdoor reception in Baysunghur's own *Kalila u Dimna* manuscript records a specific event, given his personal presence, and his manipulation of the stock elements of the Timurid garden-reception.

186. SULTAN–HUSAYN MIRZA BAYQARA

Painting formerly mounted in the Bahram Mirza Album
Herat, ca. 1500
H: 18 cm; W: 10.9 cm
Cambridge, Mass., Harvard University Art Museums, 1958.59

The image of Sultan-Husayn is the largest, and in many ways the most impressive, of the stylistically dissimilar group of portraits of

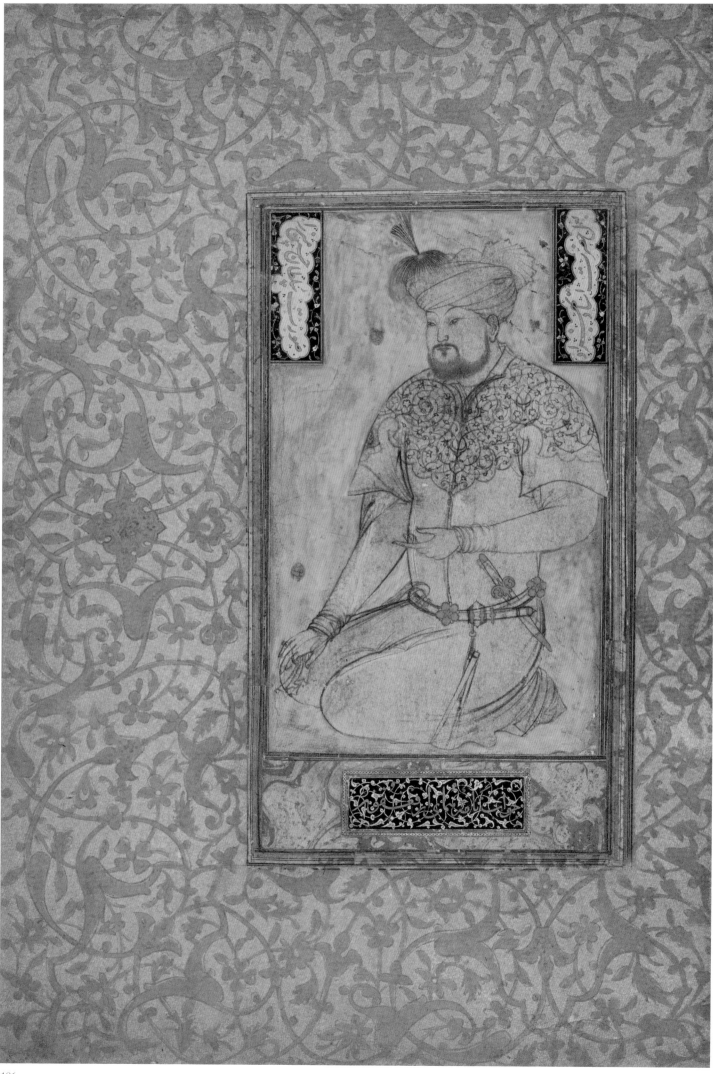

Timurid notables once gathered together on the pages of the Bahram Mirza Album. The unfinished drawing has a background of solid color, probably added when the portrait was mounted in the album. It remains the most immediate of these representations of later Timurid personages, despite its linear quality and some later alterations, to disguise which the earlier lines were once covered with white pigment.

The sultan sits on his heels, one hand holding a *mandil*, or handkerchief, on his knee and the other in front of him with a forefinger extended in a speaking gesture; he wears a turban with a plume of black heron feathers. The pose is similar to that in the frontispiece to his *Bustan* manuscript [34] even though here the image is much larger and faces the opposite direction. Moreover, it remarkably captures the details of the verbal portrait drawn of Sultan-Husayn by his nephew Babur:

He was slant-eyed . . . and lion-bodied, being slender from the waist downwards. Even when old and white-bearded, he wore silken garments . . . on a Feast day would sometimes set up a little three-fold turban, wound broad and badly, stick a heron's plume in it and so go to Prayers.[1]

The inscriptions in "boxes" at each side of the painting identify the subject as Sultan-Husayn as well as the artist − *ustadh bihzad*; they are stylistically typical of the inscriptions identifying other pictures still remaining in the Bahram Mirza album [62−64], in which this large drawing may well have occupied a single
page, given its marbled paper extension at the bottom. It was removed from the album at some point in the early twentieth century: literally peeled off the page, as evidenced by the cracks in the background color that run diagonally from the upper left to the lower right above the sultan's head, in a manner similar to the portrait of Hatifi [188], also once mounted in the same album.

187. MIR ʿALI SHIR

Painting mounted in an album
Bukhara, mid-sixteenth century
H: 16 cm; W: 7 cm
Mashhad, Museum of the Shrine of the Imam Riza

Perhaps the most significant person in Sultan-Husayn's capital with the exception of the sultan himself, Mir ʿAli Shir was a man of both politics and the pen. Descended from a family with links to the earliest Timurid period and, specifically, to Sultan-Husayn's great-grandfather ʿUmar Shaykh, Mir ʿAli Shir was Sultan-Husayn's foster brother and his political career dates from the very beginning of Sultan-Husayn's rule in Herat. He was appointed keeper of

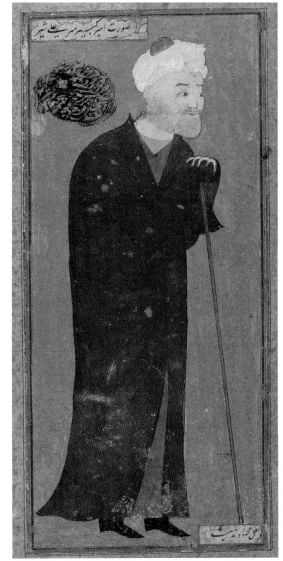

187

the seal in 1469, and by 1472 he was made an amir in the supreme *diwan*, or council. Caught up in court intrigue several years after that, he spent a year as governor in Astarabad, and when he returned to Herat he relinquished governmental posts. Instead he spent his time and his considerable wealth on building in Herat and the neighboring districts − more than 135 structures are listed in a contemporary source. As to cultural matters, his contemporaries considered him the arbiter of taste and of the highly formal etiquette of the day; and Sultan-Husayn praised him greatly for the poetry he composed in both Persian and in Chaghatay Turkish.

Mir ʿAli Shir's pre-eminent position in Herat society is quite belied by this image of an elderly man of apparently meek position and modest demeanor, wearing a low white turban and leaning on a staff. Presented as a fully painted picture, the chestnut-color robe flutters at the rear hem, as if the subject had just paused to lean upon his long stick, even though the solid gold ground lends the figure an abstracted and timeless quality. Two small panels with writing reserved in gold clouds identify "the great amir, Mir ʿAli Shir," and the painting as being "the work of Mahmud

the gilder (*muzahhib*)." This small portrait must have been executed in Bukhara toward the middle of the sixteenth century, where Mahmud *muzahhib* was then working; it may be a later copy of a portrait made during Mir ʿAli Shir's lifetime that showed him standing in a garden leaning on a cane − possibly that painted by Bihzad and spoken of by the contemporary poet Wasifi.[1] It well conveys Mir ʿAli Shir's stance and slightly stooped posture, the bone structure of the head, and the nuances of his expression. No date is given, but the handwriting is similar to other accepted examples of Mahmud *muzahhib*'s own writing and thus accords with an attribution to the mid-sixteenth century, when many paintings in Timurid style were being made at the Uzbek courts of ʿUbaydallah Khan and ʿAbd al-Aziz Khan [164].

188. HATIFI

Painting once mounted in the Bahram Mirza Album
Herat, second quarter of the sixteenth century
H: 9.4 cm; W: 6 cm
Geneva, Collection of Prince Sadruddin Aga Khan

Like the portrait of Sultan-Husayn once mounted in the Bahram Mirza album, this small portrait of the nephew of the great poet Maulana ʿAbdallah Jami, known as Hatifi, was also once found in the same album. Mounted on a page with four other paintings and drawings (including a portrait of the Uzbek Shaybani Khan [Fig. 70], who had taken Herat from Timurid hands and who was, in turn, slain by Shah Ismaʿil), it was part of a composition of portraits that was perhaps

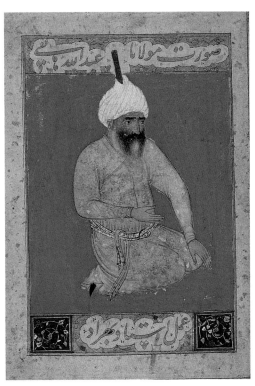

188

placed facing the larger portrait of Sultan-Husayn.

Like that picture, its uniform blue background was almost surely painted around it when the picture was mounted into the album in the early 1540s. And like the "Sultan-Husayn," the "Hatifi" too is essentially a drawing, although the head, the turban, and the striped sash at the waist are painted in full color. That the background was colored when the inscriptions above and below the picture were also added is confirmed by the fact that the baton of the Safavid headgear, the Crown of Haydar or *ta-ji haydar* – the red stick protruding from the white turban – extends into the space in which is written "portrait of Maulana ʿAbdallah Hatifi."

Hatifi was a son of Jami's sister. Not so prolific and never so well known as his uncle, nonetheless he was one of the many poets of Sultan-Husayn's court and his epic poem on Timur's exploits was an intended compliment to the Timurid dynasty. Having survived the fall of the Timurids and the brief Uzbek interregnum in Herat, he embraced Safavid Shiʿism and was visited there by the charismatic Shah Ismaʿil in 1511, who was returning from the successful Khurasan campaign. Inasmuch as the middle-aged poet wears the new Safavid turban, the assumption has always been that this portrait was made after the Shah's visit in 1511; a further assumption is that it was made from life and therefore dates before 1521, the date of his death.

This may, or may not, be the case, since the painting is accompanied by an attribution to Bihzad, and the details of the celebrated painter's life during this turbulent period are uncertain, although it now seems generally agreed that he remained in Herat until 1522. The appearance of the inscription under the picture is stylistically similar to that above it; the phrase "the work of *ustadh* (master) Bihzad," is couched in terms of the respect accorded to the artist by someone else. Thus, it is not certain whether this image of Hatifi is actually in Bihzad's hand and made during Hatifi's lifetime, or whether it was a copy after Bihzad and therefore dates from any time between 1511 – when Shah Ismaʿil came to Herat – and 1543, by which time it was mounted into the Bahram Mirza Album in Tabriz. The painting of the hands has elicited favorable comment, but they seem boneless and schematic in contrast to the face, which renders the details of Hatifi's visage: the bone structure, the shape of the nose, the texture of the heavy eyebrows and the full beard, patchy white in places. It seems more likely that this portrait is a composite image, a well-observed portrayal of Hatifi's head that was drawn from life, very possibly by Bihzad, set onto a more ordinary stock image of a man seated on his heels, as any well-bred Muslim male would have done. Whichever is the case, this picture of Hatifi well illustrates the peculiarity of the early sixteenth-century Safavid turban

189. BIHZAD

Painting mounted in the Shah Tahmasp Album
Herat or Tabriz, 1520–25
H: 13.8 cm; w: 7 cm
Istanbul, Istanbul University Library, F. 1422, fol. 32v

An inscription on either side of the figure's head identifies this small painting as a "portrait of *ustadh* (master) Bihzad." The usual assumption is that the celebrated painter Kamal al-Din Bihzad is its subject, even though *bihzad*, in Persian, simply means "well-born."

Three pages in the Shah Tahmasp Album are each composed of four small and relatively simple paintings of single figures, set against a plain paper background and carrying unadorned inscriptions beginning, "portrait of. . . ." Presumably these identify the subjects as personalities at the Safavid court, and no doubt they did at the time the album was compiled. Today, however, few can actually be connected with Safavid historical personages because the inscriptions are familiar terms, rather than formal names. Bihzad, or Master Bihzad as he is called in the inscription, is one of the few paintings of this series in which the inscribed name accords with a celebrated figure known from so many contemporary written sources.

The black-bearded figure in a Safavid turban and modest unornamented clothing has a portfolio under one arm and holds what

189

could be a book with the other hand; it would be a suitable set of attributes for the head of the Safavid royal library, a post to which he was appointed in 1522.

Nice as it would be to think that the portrait is that of the most celebrated painter of Iran's long history this art, the image has something of the type about it. It is true that the head has a weak chin and a scrawny neck, and the body seems boneless and is narrow at the shoulders but overlong to the knees – all rather personal physical characteristics; the very small feet, on the other hand, seem typical of many figures in text-illustrations. Moreover, while the date of Bihzad's birth is unknown, the usual supposition is that he was born at some time in the decade between 1450 and 1460. This painting, albeit undated, is sixteenth-century in date – the subject wears the Safavid headgear and could actually date from anywhere between 1511 and the mid-1550s. By the time Bihzad entered Tahmasp's service in Tabriz (whenever this was, since the date, and even the decade, are contested), he would have been middle-aged but the black beard in this painting seems inexplicably youthful. It is hard to accept that this picture is a true portrait of "the second Mani;" certainly it was not painted from life.

190. A TATAR KHAN

Painting once mounted in an album
Tabriz or Qazvin, mid-sixteenth century
H: 10.3 cm; w: 6.2 cm
London, British Museum, 1948-10-9-056

A robust man sits cross-legged in a posture of alert attention as he looks down toward the left, from beneath lowered eyelids; his arms are akimbo, hands resting on his knees, and he holds a *mandil* (a handkerchief) in one hand and something indistinct in the other. Over a skullcap is a small hat with a black fur edging pulled down to one eyebrow. He wears a short-sleeved *jama* with buttons down the middle over another long-sleeved garment that bunches at the wrists; a cloth or leather belt with metal elements cinches his ample waist, and he wears low, soft black boots. All these sartorial details typify the dress of men of elevated social stature in the Iranian milieu from the later fourteenth century until at least early in the seventeenth, men who wielded the sword but neither the pen nor the Qurʾan.

Fully colored against a neutral ground, the painting was mounted within colored floral borders, and it was almost certainly intended for an album. The inscription above the picture identifies the sitter as a Tatar khan, the "padishah" (emperor) of Dasht-i Qipchaq, but gives no personal name. Dasht-i Qipchaq is an area in the northern Caucasus, where a confederation of Turkish Qipchaq peoples, allied to the Georgians, had been established from at least the early twelfth century until Timur crushed them late in the fourteenth

190

century. Qipchaq is also a family name, or that of a small unit, found at a slightly later date among the Uzbeks and other Turkic tribal peoples.

If the identification of the subject is thus unclear, the image is not. The strong head with its full face and short neck, the angled position of the fur-edged cap, and the sense of alert cogitation, suggest instead that this is a painting done from life, despite the formulaic pose and our ignorance of just who is represented. The pose is strikingly similar to

a painting ascribed to "the slave Bihzad," the subject identified as Shaybani Khan (Fig. 70) (the Uzbek who so briefly ousted the Timurids from Herat in 1507 and tried to cast himself in the mold of a cultured Timurid prince, only to be captured himself by Shah Isma'il Safavi and put to death in 1510). Despite coloristic differences, the similarity is remarkable and suggests that both pictures derive from the same tradition. The Shaybani portrait was mounted on a now-dismantled folio from the Bahram Mirza Album, indirectly also connecting this picture to the Safavid library in Tabriz, if at a somewhat later date. Together, both pictures document the consistent Iranian use of types, or typical poses, and the traditional pictorial practice of mingling true representation and formulaic presentation in the same image.

191. SHAH ʿABBAS I RECEIVES THE
VALI MUHAMMAD KHAN

> One of an ensemble of four large murals,
> painted on the upper wall of the
> audience hall of the palace of the Chihil
> Sutun
> Isfahan, after 1647

The princely reception held by Shah ʿAbbas I to entertain an Uzbek ruler of Turkestan, Muhammad Khan, is the second of three large reception scenes painted on the upper walls of the audience hall in the Chihil Sutun. In style and composition all three are very similar. The differences between the last two, and the first painting [43] are two: the relatively contemporary clothing worn by Iranians and Uzbeks alike, and the

backgrounds, where no painted window "opens up" the rear of the picture behind the Shah and his guest [109, 242]. Otherwise, all three are built up in the same broad triangle, the Shah at its apex, with guests, courtiers, and servants arranged in lines descending to each side, and entertainers, dancers and musicians in the foreground.

Shah ʿAbbas I kneels, as a well-bred Easterner, on a small richly-patterned carpet. He is magnificently dressed in a frogged golden *jama* brocaded with a large floral pattern; on his head is an equally splendid turban of seventeenth-century shape, striped in gold and many colors with an aigrette of feathers; a double row of pearls encircles his neck, and the hand that offers the shallow wine cup to his guest bears a large archer's thumbring. As he is kneeling, it would be hard to estimate his stature, but the two essential features of his true appearance are evident: his baldness – for no hair trails from underneath the large, loosely wound turban – and the enormous, stiff black mustache, jutting out horizontally, above his upper lip.

The eyes are rendered very differently from those in the other representation of Shah ʿAbbas I in the Chihil Sutun [36]: here the pupils seem to dominate while the formulaic lines of upper and lower lid are virtually absent, and he seems to stare directly out of the picture at the spectator. This is utterly unlike the formula used for all the other figures in the three large reception scenes, and those in at least one of the largest paintings in one of the small rooms [249] beside the entry to the palace. These figures are almost uniformly shown with oval faces, pointed chins, and large dark pupils in large eyes (often set closely together); moreover, both lids

191

are firmly drawn, and overall they have a peculiarly puffy appearance, indicated by another line under the eye. The rendering of Shah ʿAbbas I's face was evidently intended to set him apart visually, beyond the formal reference to his rank and position indicated by his rich garments and his placement within the painting.

192. SHAH ʿABBAS II RECEIVES AN UZBEK AMBASSADOR

One of an ensemble of four large murals, painted on the upper wall of the audience hall of the palace of the Chihil Sutun
Isfahan, after 1647

The last of the three large pictures of princely receptions in the audience hall of the Chihil Sutun has essentially the same composition and is painted in the eclectic stylistic mode of the other two [43, 191]. Again, the visitor is an Uzbek ruler (although just *who* is not yet a matter of specialists' accord, just as the date of its execution remains open to interpretation). But the painting was made in the lifetime of the Shah who is depicted at the apex of the triangular composition and, not surprisingly, it is richer in distinguishing details than are the other two in the series.

The details conveying the physical appearance of Shah ʿAbbas II are to be noted: indeed, if this picture is to be dated close to the construction of the building, in the late 1640s, it is the first instance of the distinctive set of features and dress that would henceforth identify him, just as his grandfather ʿAbbas I is immediately recognizable by his mustache, together with the karakul hat worn at a jaunty angle [36, 192]. ʿAbbas II also kneels on a rich floor covering and stares out of the picture, with a faint air of truculence; he also wears a magnificently frogged garment of a solid salmon-pink color, a large striped turban, and a double row of pearls at his neck; adorning the turban is a jeweled aigrette strung on three short loops of large pearls, and a sword and a dagger are stuck into his belt. Most notable, however, is his beard – thick, black, and full, with short mustaches, it completely encircles the mouth. The chin below is clean-shaven, perhaps to permit a certain mobility of expression but the effect, nonetheless, is that the lower face is entirely covered with thick black hair – a precocious growth for a man still in his teens, if the painting was indeed done in the late 1640s.

It is then interesting to consider the faces of the courtiers and attendants in the picture. With three exceptions, those with facial hair wear the broad, thick ʿAbbasi mustaches, in what is surely a gesture of homage to Shah ʿAbbas I, and are otherwise clean-shaven. Just as in the case of Shah ʿAbbas I, a particular personal feature – the style and color of the Shah's facial hair, together with his clothing, in this case the large striped turban and the light-pink, frogged *jama* – will come to identify Shah ʿAbbas II in contemporary, and later, representations [125] where a written identification is lacking.

193. RIZA-I ʿABBASI PAINTING A PICTURE OF A EUROPEAN MAN

Painting intended for mounting in an album
Isfahan, started in 1635 and finished in 1673
H: 18.8 cm; W: 10.4 cm
Princeton, University Library, Garrett Collection, 96G

Two important persons, and a number of themes salient to the history of figural painting in seventeenth-century Iran, are embodied in this modest portrait of the painter Riza-i ʿAbbasi made by his most accomplished and long-lived pupil Muʿin, known as Muʿin *musawwir*, "Muʿin the painter." The two painters span the entire century and more. The classical figural style of seventeenth-century Iranian painting can be said to have been shaped in Riza's hands [146; Fig. 78]; while Muʿin's firmly traditional version of the Iranian manner is first seen in this very portrait dating from 1635, while his last signed work is from 1707.

Muʿin's manuscript illustrations and many of his single-page compositions are peopled with types, and he sets them in landscapes in which everything is clearly seen, and in which atmosphere and illusion are entirely absent. Yet Muʿin also painted portraits that have left us an unforgettable vision of Safavid life, both at court and elsewhere. These, and a number of his vivid drawings, are often annotated with long, chatty, and very detailed inscriptions that tell us when, why, and under what circumstances a painting or a drawing was made. Such interest in recounting ephemeral details, coupled with a concern for the specific features, expression, or build of the person depicted, is a fascinating testimony to certain fundamental changes in Iranian attitudes toward pictorial art, even when the style of the image on the same page remains firmly rooted in the traditions of the past centuries. Thus, we know that Muʿin started work on this portrait of Riza in 1635 but that the subject's death occurred before the painting

192

provides a timelessly neutral background, and the image thus becomes a universal one, of an aging painter plying his craft.

194. FATH ʿALI SHAH

Oil on canvas
Tehran, 1798–99
H: 188 cm; W: 107 cm
London, Oriental and India Office Library Collections, Foster 116

The most recognizable, and historically verifiable, personage of any Iranian monarch up to the age of photography is the second of the Qajar rulers, Fath ʿAli, who did so much to establish Iran's presence on the nineteenth-century European scene. His fine slender figure, his pale complexion and blazing black eyes under wide black brows, and especially his long and magnificent black beard, are instantly recognizable, whether they are on the tiniest of enameled gold pendants or the largest of oil-painted canvases and rock reliefs [Fig. 85]. Especially did he make use of the medium of oil on canvas for a number of large paintings of himself that might well be termed "state portraits." Those with dates range between 1798 and at least 1815: painted in the year after his accession in 1797, this is the earliest large canvas so far recorded.

It is signed by Mirza Baba, Fath ʿAli Shah's chief painter from the very beginning of his reign. His series of pictures of this most picturesque personage had begun with a very large oil painting[1] showing Fath ʿAli Shah enthroned in the midst of courtiers; "enthroned" is perhaps a euphemism, since he kneels on an open platform, or *takht*, with a low wooden balustrade separating him from that of the kneeling courtiers who surround him. There, the central figure of the Shah, the horizontal format, the sharply angled lines of the *takht*, and the angled rows of courtiers, with the Shah at the apex (if not the center) of the composition, derive from the conventions of much earlier images of court receptions [191]. The turbans are still in the Zand style, although it is evident that full mustaches and enveloping black beards have been widely adopted, in frank imitation of the new Shah who consciously emphasized the virility of his looks (his deeds spoke for themselves).

For the first of the large single-figure oil paintings, Mirza Baba appears to have isolated the Shah from the midst of his courtiers and subtly reworked the image for a very different effect. Fath ʿAli Shah still kneels, in the old-fashioned position, on a carpet spread on a *takht* with a low wooden balustrade behind him, but his posture is more erect, his Zand-style turban is higher and strung with chains of pearls hooked to a towering jeweled aigrette, and he holds a jeweled mace: the effect is of greater majesty. All his accoutrements are jeweled: the belt, the dagger stuck into it, the long curved sword hanging

193

was finished, and that forty years later, he finished it at the urging of his son. He shows Riza as an older man with a graying mustache, wearing spectacles and a turban of the elaborate seventeenth-century shape but of a simple fabric. He sits on the ground with a low stand in front of him, but the picture is propped on a bent knee, as if to bring it closer to his face. *His* subject is a European

man in a cape and a black brimmed hat: nothing could be more representative of the European presence in seventeenth-century Iran [153]. The feathery fronds of foliage curving over his head are equally typical of the "landscapes" in which Riza and his followers set such figures [160]. Other than the stand, a few books, and pens and an inkwell on the ground before him, the tan-gold paper

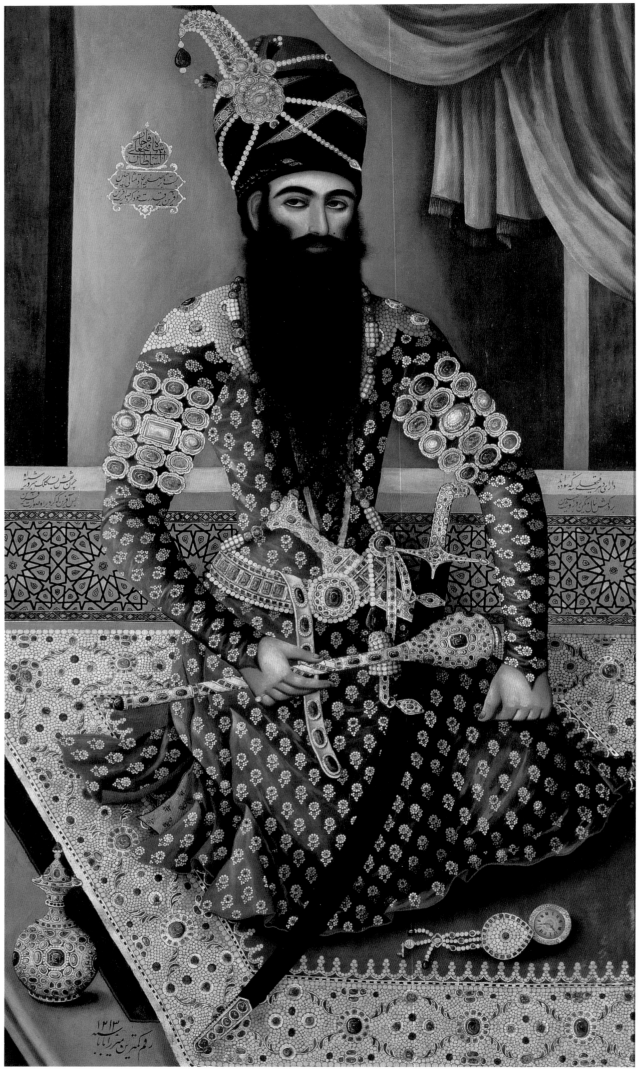

from it, the bottle at the left, and the watch in front of him. The "cloud-collar" lying over his breast, back, and shoulders is of pearls, strings of pearls interspersed with gems hang around his neck and cross over his chest (they are partly hidden by the long beard), and he wears five armbands on each arm, composed of huge emeralds and rubies that effectively set off the central diamonds in each middle row. These must surely be the stones called, respectively, the Darya-i Nur, the "sea of light," and the Taj-i Mah, the "crown of the moon," looted Indian gems that had been set in armbands for Aqa Muhammad in 1791 and are almost as celebrated as the Kuh-i Nur, the "Mountain of Light," inveigled by Nadir Shah Afshar from the unfortunate Mughal emperor in 1739. The seventeenth-century European prop of the draped curtain on one side of the picture is retained [100], but the background is essentially a neutral shadowed space that increases the majestic isolation of this commanding figure whose level gaze engages the viewer in a permanent affirmation of the princely presence.

Mirza Baba repeated this kneeling image of the Shah at least once again, in a miniature painted for Fath ʿAli Shah's own *Diwan*, illustrated at the Shah's order and then sent as a gift to his "brother" George III [Fig. 91]. It was further repeated by others, and on different scales, although later portraits by other painters made more use of the standing pose, or seated the shah in a European armchair-throne. Nonetheless, patron and painter together seem to have set in motion one of the pictorial processes which would assist Fath ʿAli Shah in proclaiming the significance of his reign and the fecundity of his line.

It has been suggested that, as the Qajars had come to power with neither the religious aura nor the temporal power of their Safavid predecessors, it fell to Fath ʿAli Shah to create his own mystique of princely power and splendor. The wealth of Qajar monumental pictorial imagery in all possible media, enhanced by the wealth of jewels that came to Iran after Nadir Shah's sack of Delhi in 1739, were two important elements in Fath ʿAli Shah's shrewd campaign to create a public image of a prince who was in every way the worthy heir of his distant "ancestors," the Sasanian and the Achaemenid Kings of Kings.

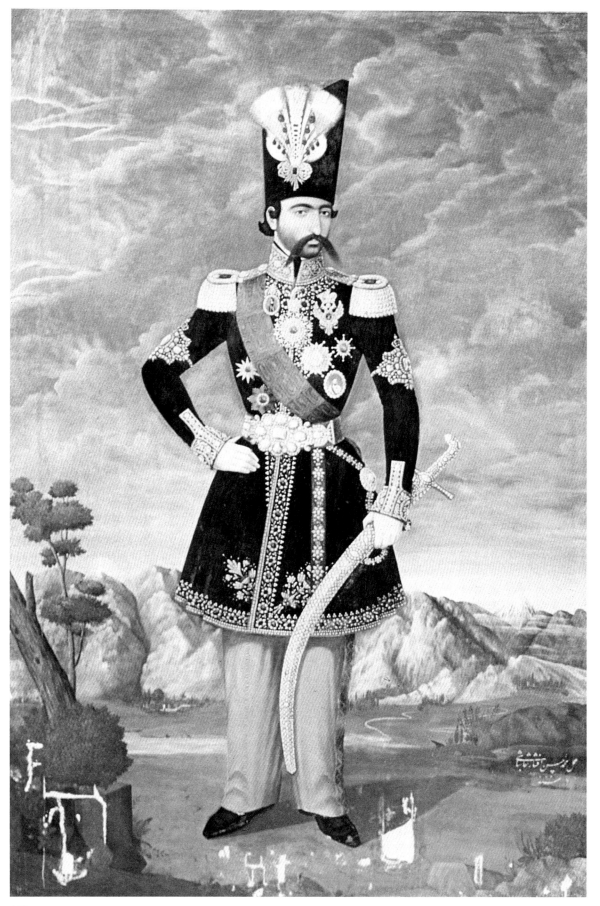

195

195. NASIR AL-DIN SHAH

Oil on canvas
Tehran, 1859–60
Isfahan, formerly in the Chihil Sutun

This portrait of the fourth Qajar ruler of Iran is the work of Muhammad Husayn Afshar. The young Shah, at age 27 as slender and handsome as his great-grandfather Fath ʿAli Shah, stands with one white-gloved hand on his hip and the other lightly touching his sword. He is placed in the open air on level ground with a shallow repoussoir at the left. A river winds in the middle distance from the Alburz Mountains, seen low on the horizon behind him, and in their foothills are several settlements, one walled – most likely Tehran; above the lower peaks towers Mount Damavand, white with snow. The sky is an immense expanse filled with grey cumulus clouds, with a patch of blue toward the upper left of the picture; the overall light is cool but

sun is implied by the shadows cast to the right and behind him.

As impressively jeweled as Fath ʿAli in any of his "state portraits," Nasir al-Din Shah is literally encrusted with diamond accoutrements and badges. He wears the high Qajar astrakhan hat and wide diamond armbands on the sleeves of a version of a European military uniform – a black frock coat with a high stiff collar and epaulets of diamonds, and light-blue trousers with a ribbon down the side. His only weapon is a saber in a diamond-encrusted scabbard, and his huge aigrette of white heron feathers and Indian cabochon emeralds is held in a diamond bow set with a large rectangular emerald. The light-blue moiré sash, reserved for the Shah alone, is secured diagonally under the tab of the left epaulet and at the right by the wide belt with its huge diamond-crusted clasp.

The badges are Iranian and European, and most are set in mounts thick with diamonds. Uppermost on his left side and closest to his heart is pinned an oval portrait miniature of his father, Muhammad Shah, wearing a traditional coat made of Shiraz *tirma*, or brocade, and a white-feathered aigrette on a black astrakhan hat; the portrait is framed in large diamonds set in gold. He also wears four badges with circular images of the Lion and Sun, the Iranian order created during the reign of Fath ʿAli Shah. The largest, just underneath the miniature of his father, is surmounted by the Kayanid crown and aigrette also worked in diamonds; two have smaller mounts of diamond stars, and one is set in gold alone. Flanking the largest lion and sun is a Russian double-headed eagle also surmounted by a large crown; it is made entirely of diamonds save for the monogram in white Cyrillic script on black, reading *N I*, for "Nicholas I" (1825–55). Below this is a large diamond badge with an inscription in French surrounding a falcon on a perch, probably that of the French Légion d'Honneur. Just above the sash-end tucked into the belt is an oval portrait miniature of a youth in a white military coat, perhaps of the young Austrian emperor Franz Joseph I (1848–1916).

Technique, presentation, and atmosphere are all derived from European painting; the details and ornament are equally descriptive and realistic, and the landscape is clearly meant to set the Shah outside of the Qajar capital, Tehran. The European badges, probably gifts from the respective sovereigns, may refer to a moment when Russia, France, and Austria were favored allies of Iran but when Britain was in a period of disfavor. The plethora of badges of the Lion and Sun may equally refer to Nasir al-Din Shah's own institution of new, intermediary grades of the order, created in about 1860; that with the Kayanid crown is probably Nasir al-Din's own diamond-set example of its highest grade.

Two far older landscape conventions, at the very bottom of the picture, vie with the otherwise realistic setting, space, and light of the background. To the left of the Shah are two trees, one tall and slender with foliage growing in interrupted clumps, and in front of it a much larger bare tree set at a precarious angle, as if it were falling. Both are "signature" motifs of the seventeenth-century painter Muhammad Zaman [28, 118, 232]. Even stranger, in this mid-nineteenth-century context, are the rocks in the lower right foreground, behind which grow both a low green shrub and a low bare shrub. These are versions of motifs that occur in Iranian painting by late in the fourteenth century and appear – continuously until about the middle of the seventeenth century, when they were replaced by the mannerisms of Muhammad Zaman.

THE ILLUSTRATION OF TEXTS

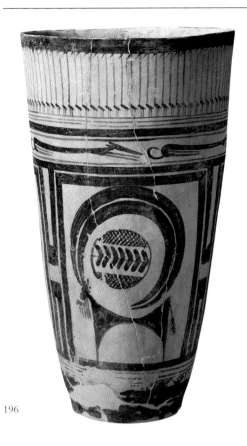

196

196. CERAMIC BEAKER DECORATED WITH STYLIZED ANIMALS

Susa, second half fourth millennium BC
H: 29 cm
Paris, Musée du Louvre, SB 3174

Pottery is one of the oldest technologies of Iran and was made from as early as the 8th millennium BC. By the late Chalcolithic period, finely made and fired ceramics were being produced in great numbers, to judge from the quantities that have been recovered from sites all over western Iran. A beaker excavated from a tomb in a necropolis low on the Susa mound is perhaps the most perfectly potted and decorated of all known prehistoric Iranian ceramic wares: it would be hard to find a better example than this beaker decorated with a stylized mountain goat, racing dogs, and waterbirds.

Recovered in excavations in 1902, it is one of a large group of similar wares usually known as "Susa I," so called to distinguish them from those of later periods also found in the rich city of Susa, ancient Shush. Susa I ceramics have very hard bodies with extremely thin walls, and they were always painted, before firing, in a black pigment that becomes lustrous in the firing process. The decoration consists of abstract geometrical motifs, and birds and animals of a particularly elegant stylization that was hardly ever surpassed, anywhere, at any time. Features are elongated to the point of abstraction, like the long necks of the water-birds pacing around the rim and the bodies of the hounds, perpetually pursuing themselves in the next register. Natural shapes are exaggerated, as seen in the extravagantly

curved horns of the bearded mountain goat in the widest register of the beaker.

The exaggeration, but especially the stylizing, of natural animal features continued to be a characteristic of Iranian art for centuries to come. Thus the curved horns of caprids and ovines appear in Iron Age faience sculptures, and in great quantity in the horse trappings of Luristan, dated in the early first millennium. These have been described as ". . . the last prehistoric manifestation of the Elamite genius for taking an animal form and then playing with it until it is reduced to a decorative abstraction – a trait seen three thousand years earlier in late Chalcolithic pottery . . ."[1] and are beautifully exemplified by this Susa beaker.

Equally significant is that the most remarkable examples of this tendency toward extreme stylization are very early but seem to appear almost perfectly formed, while later examples are often less exaggerated, or less strikingly beautiful, sometimes smaller and often fussier – as is the case with Luristan bronzes. This dynamic of aesthetic creation recurs at key moments and is well exemplified in the "Great Mongol *Shahnama*" [e.g. 229]. The extreme stylization of horns also recurs, in Sasanian metalwork [120] and at various times in the arts of the book [145, 197, 250].

197. BUTTING MOUNTAIN RAMS

From a manuscript of Ibn Bakhtishu's
Manafi al-Hayawan
Maragha, 1291
H: 33.5 cm; W: 25 cm
New York, Pierpont Morgan Library,
M500, fol. 37r

This Persian translation of an Arabic work on the usefulness of animals was copied and

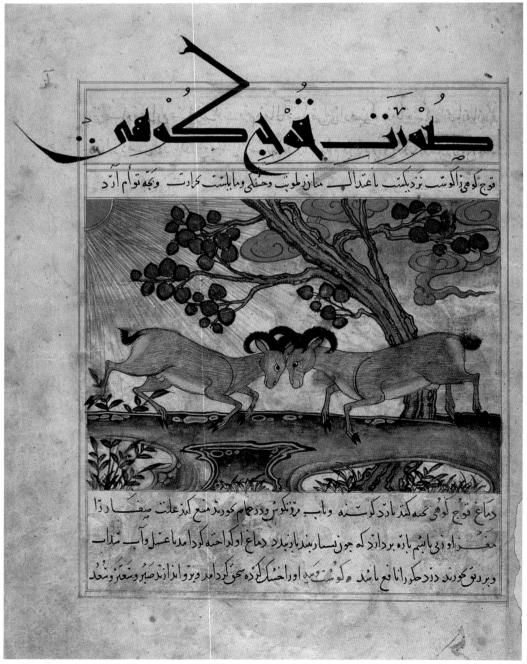

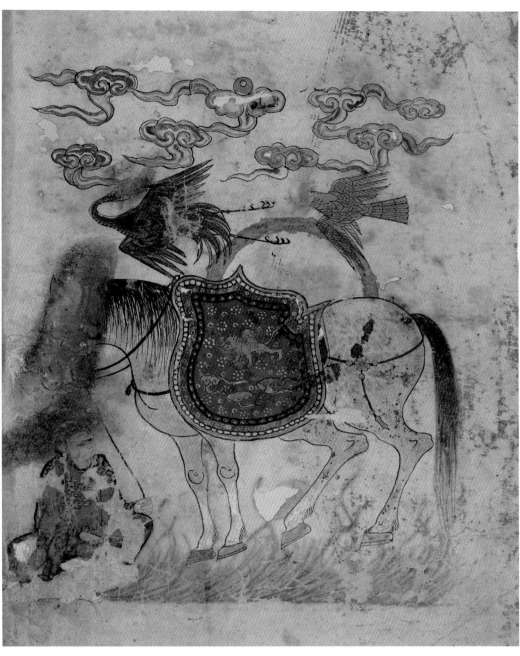

198

198. ʿALAʾ AL-DIN JUVAYNI'S HORSE
AND GROOM

Painting on a folio of ʿAla al-Din ʿAta
Malik Juvayni's *Tarikh-i Jahangusha* (*History
of the World Conqueror*)
Maragha (?), 1290
H: 33 cm; W: 25.5 cm
Paris, Bibliothèque nationale de France,
Suppl. persan 205, fol. 1v

Among the surviving secular manuscripts
copied in the first Ilkhanid center in Iran is
an important historical work, a copy of ʿAlaʾ
al-Din ʿAta Malik Juvayni's history of the
founder of the Mongol empire, Chinghiz
Khan.

The prose text recounts his rise to power,
his reign, and those of his first three
successors; it ends with the conquest of the
Ismaʿili stronghold of Alamut in 1256 [91], to
which the author was a witness. Employed in
Mongol service from about 1246, he had
observed many of the events of which he
wrote; his history was begun in Qara-Qorum
about 1253 and finished in Baghdad where,
after 1260, he was appointed governor.

Facing the horse and groom on the first
folio of this late thirteenth-century copy of
the text is the author, writing, with a page in
attendance. The heads of men and beast have
been rubbed and smeared − considered by
some Muslims as a way of taking life from
the image of a living being without entirely
destroying it. Fortunately the rubbing has not
obscured the features of this frontispiece that
make it so interestingly typical for its period.

The composition is painted in strong colors
directly on the bare paper of the manuscript-
surface, but it is not enclosed within defining
lines, as were the pictures in another Ilkhanid
manuscript completed just a year later [197]
and possibly in the same place. Accoutrements
are carefully depicted, and the golden lion-
and-sun on the saddle are clearly visible.
Other details are Chinese-inspired − the
clouds, whose whorls and tails will be found
in the skies of innumerable paintings for the
next several centuries [26, 80]; and the flying
heron, real − here pursued by a falcon − but
also a decorative motif, of the kind known as
chinoiserie. Moreover, this very large painting
is also higher than it is wide, a detail surely
derived from the model of a Chinese hand-
scroll, rather than from the illustrations in
earlier manuscripts (whether in Arabic or
Persian) whose models were Seljuq. This
essentially East Asian feature will be seen
sporadically, in the illustration of Persian texts
[61], during the fourteenth century; in the last
years of the century it became the norm for
Iranian manuscript-painting in all but the
most old-fashioned of books.

illustrated in Maragha and completed in the
year equivalent to 1291; the translation was
(allegedly) made at the order of Ghazan Khan.
Ibn Bakhtishu's text is a composite work of
natural history and medicine. It consists of a
description of animals − humans, quadrupeds,
birds, reptiles, and insects − followed by a
discussion of the ways in which their parts or
products might be used to treat human
illnesses and conditions. It is illustrated with
nearly one hundred pictures, of which the
larger and more ambitious, as well as the most
sympathetically treated, are those of
quadrupeds.

The pictorial formula is usually a
rectangular space, with a border, a distinct
ground line, and some kind of vegetation in
the midst of which the animals are set. The
landscapes are the work of several painters,
from Arab Baghdad and elsewhere in the
Seljuq world of the Middle East, and also
from places where the Chinese landscape
idiom was circulating.

Several pictures show the male and female
of the species, among them the lion, the
elephant, deer, and oryx; many others are
of single animals, often copied from earlier
illustrated Arabic works of natural history.
Still another variant is this pair of male sheep
charging at each other. They are about the
same size and shown in profile; they are
sympathetically and rather naturalistically
drawn; the distinct recurving of the horns of
both animals is prominent but not unnaturally
so. Yet despite the contemporary details of the
landscape − the curving gnarled tree placed
well off-center to the right, the Chinese
cloud-bands, and the brightly shining sun at
the upper left − there is more than a whiff
in this picture of some very ancient image of
confronted horned animals. The exaggerated
curve of the horns painted on the Susa I
beaker is millennia distant from this painting,
but a post-Sasanian plate in the Hermitage,
with a pair of confronted rams on either side
of a tree is a striking intermediary image.[1]

199. SCENE FROM A KHOTANESE RELIGIOUS LEGEND

Painted wooden votive panel from
Sanctuary D VIII
Dandan Oiluq, Khotan (Chinese
Turkestan), seventh–eighth century
H: 38 cm; W: 16.6 cm
London, British Museum, 1907.11–11.70
[Stein number (D.VII.5)]

In December of 1900, at a site called Dandan
Oiluq some 60 miles north of the Khotan
oasis, Aurel Stein discovered many Buddhist
relics, including this shaped votive panel of
wood. The painting shows two mounted
figures, both nimbed and carrying vessels in
their right hands. The scene is still considered
to represent a Khotanese religious legend that
has not yet been identified.

In the remains of another Buddhist shrine
at the same site of Dandan Oiluq – its name
means "the place of houses with ivory" –
Stein later wrote that he discovered more
painted wooden panels "still resting against the
foot of the pedestal [of the Buddha] just as
pious hands had placed them as votive
offerings." The site was abandoned before 791;
everything found there must evidently predate
the late eighth century.

From the first century AD, the material
culture of Khotan stood out as a distinctive
entity in Central Asia. Its location, south of
the Takla Makan desert on the southern arm
of the Silk Route, made it receptive to
influences from both India and from the
Iranian west. Its language belonged to the East
Iranian group and, despite Han Chinese
pressure, Khotan always managed to maintain
close ties with the Indo-Afghan Kushan
empire. Its Buddhism was Mahayana;
reflections of the figural sculpture and
architecture of Gandhara are also to be
remarked, and the style of its Buddhist
painting displays a vaguely Guptan influence.
Altogether, Khotanese culture is considered
quite original, even within the context of the
Central Asian stylistic melting-pot.

The painting on this panel is among the
best-preserved of the Dandan Oiluq group,
although the face of the lower figure is
rubbed and partly indistinct. The details of the
figures, and the lively and expressive quality of
its execution, are remarkable for the way they
anticipate medieval Iranian painting of
perhaps five centuries – and more – later. The
technique is one of drawing, in black stylus-
like lines, and filling in the primary areas with
color; details were added, in a vigorous hand,
over the color. Both heads are nimbed; scarves
trail out – and fly up – behind them. Both
are booted and trousered, riding with stirrups;
their swords are straight and worn on the left;
and both carry vessels with flaring walls, each
held by the foot. The upper figure wears a
diadem with a large oval medallion at the
front; the face is full, the line of the upper
eyelid only is shown but it is elongated, as

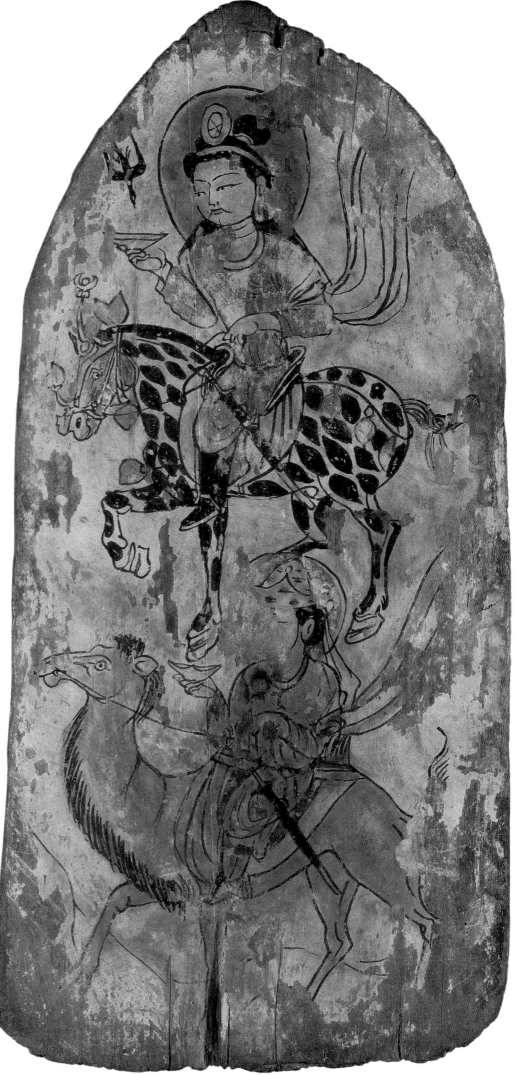

will later be the manner of drawing eyes on medieval Iranian ceramics [3]. The black hair is dressed with a topknot at the crown of the head while behind it, loose hair falls down over the shoulders. The lower figure appears to have shorter black hair, or it may be tucked up underneath a tigerskin hat with a high crown and a turned-up brim, of the shape that will also occur widely in Iranian manuscript painting from the early fourteenth century onward [25]. His steed is a single-humped camel; the upper figure rides a white horse spotted with black.

This spotted, or piebald, horse is distinctive and will recur, as a stock image, in the pictorial repertoire of the Islamic world in centuries to come – in the Seljuq international style of text illustration [200], on Syrian enameled glass [201], and in text illustrations from the Ilkhanid [167] through the Safavid periods [Fig. 68]. It is notable, then, that while the effect is naturalistic, the black "spots" are actually a stylized pattern, virtually all being ogival shapes that swell or diminish in size but run in the same direction, from the horse's neck down toward its rump.

200. THE LION KILLS SHANZABA

Folio from a manuscript of Abu'l-Ma'ali Nasr Allah's animal fables called *Kalila u Dimna*
Anatolia, northern 'Iraq, or Iran (?), late thirteenth or early fourteenth century
H: 7 cm; W: 11 cm
Istanbul, Topkapı Saray Museum, H. 363, fol. 72v

124 pictures are found in the manuscript from which comes this illustration of one of the fundamental *Kalila and Dimna* stories. Many have the same solid red ground, a feature that brings to mind a famous frontispiece in a thirteenth-century Arabic manuscript illustrated in the Jazira (Fig. 55), as well as paintings in a number of fourteenth-century manuscripts made both in Shiraz and in Isfahan. On the other hand, the "shot-silk" patterning of textiles, a device also used for water and rocks (as seen here), suggests affinities with whatever place the unique copy of *Warqa u Gulshah* [39] might have been made – Anatolia, or northern 'Iraq or Azarbayjan.

The story of the lion, the bull, and the jackals is a core story as old as the Indian *Pancatantra*, in which it comprises the first chapter. The lion was king of the beasts with an entourage that included the crafty jackals, Kalila and Dimna. The lion had never met the bull Shanzaba but feared him by reason of the noise of his bellowing. Dimna had become the lion's confidant, and he suggested that the lion meet Shanzaba to allay his fear. The lion and bull did so and *they* became confidants; at which Dimna became jealous and incited the lion to turn upon, and then to kill, his former

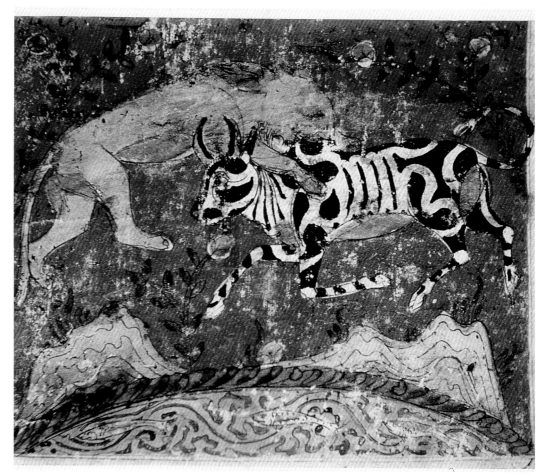

200

friend. The lion did so but instantly regretted his deed, and Dimna was put on trial for treachery to his king.

Whether the ancient Indian tale of the lion killing the bull is in any way related to the ancient Persian image of the lion slaying the bull is a possibility – but equally impossible to resolve with certainty. Not all illustrated *Kalila and Dimna* manuscripts contain this image – but at least twenty-five do.[1] Illustrated here is a painting that may be from the earliest surviving illustrated copy of Nasr Allah's Persian translation.

Shanzaba's black-and-white hide is another Seljuq example of the black-and-white, or piebald, animal whose origin is probably some centuries earlier in Iranian Buddhist lands but that appears occasionally in Seljuq figural art, as it does at least twice in this manuscript.[2]

201. A HORSEMAN ON A BLACK-SPECKLED WHITE HORSE

Painted on an enameled glass bottle
Probably Syria, c. 1270
H: 43.5 cm; maximum D: cm
New York, Metropolitan Museum of Art, 41.150

A painted frieze, horsemen armed with various weapons and possibly out to hunt

fowl, decorates the belly of a large Mamluk blown and enameled glass bottle. Among them is a helmeted figure on a black-speckled white horse, a version of the piebald horse already seen on the painted wooden panel from Dandan Oiluq.

Despite the wealth of painted figures on Mamluk glass vessels of many shapes and sizes,[1] this black-speckled white animal stands out. The piebald horse – indeed, any black-spotted white animal – is intrinsically striking within the broader Seljuq pictorial repertoire, despite the fact that in this period the cultural and linguistic frontiers of the Middle East were consistently transcended, and objects of many materials might be decorated in variants of the Seljuq international figural style.

The frieze on this impressive Syrian bottle is surely adapted from a more conventional painted image, again most likely in a manuscript. Whether this was Arab or Mongol in origin is difficult to say: the horsemen wear the headgear of different contemporary peoples – Arab turbans, generically Middle Eastern metal battle helmets, and Mongol feathered bonnets. But in surviving Arabic manuscripts, black-speckled, or spotted, white animals are rare. The piebald animal seems instead to be an image of East Asian origin that was absorbed into the visual language of the Seljuq Middle East. As an area of black and white in a polychrome context, it enlivens

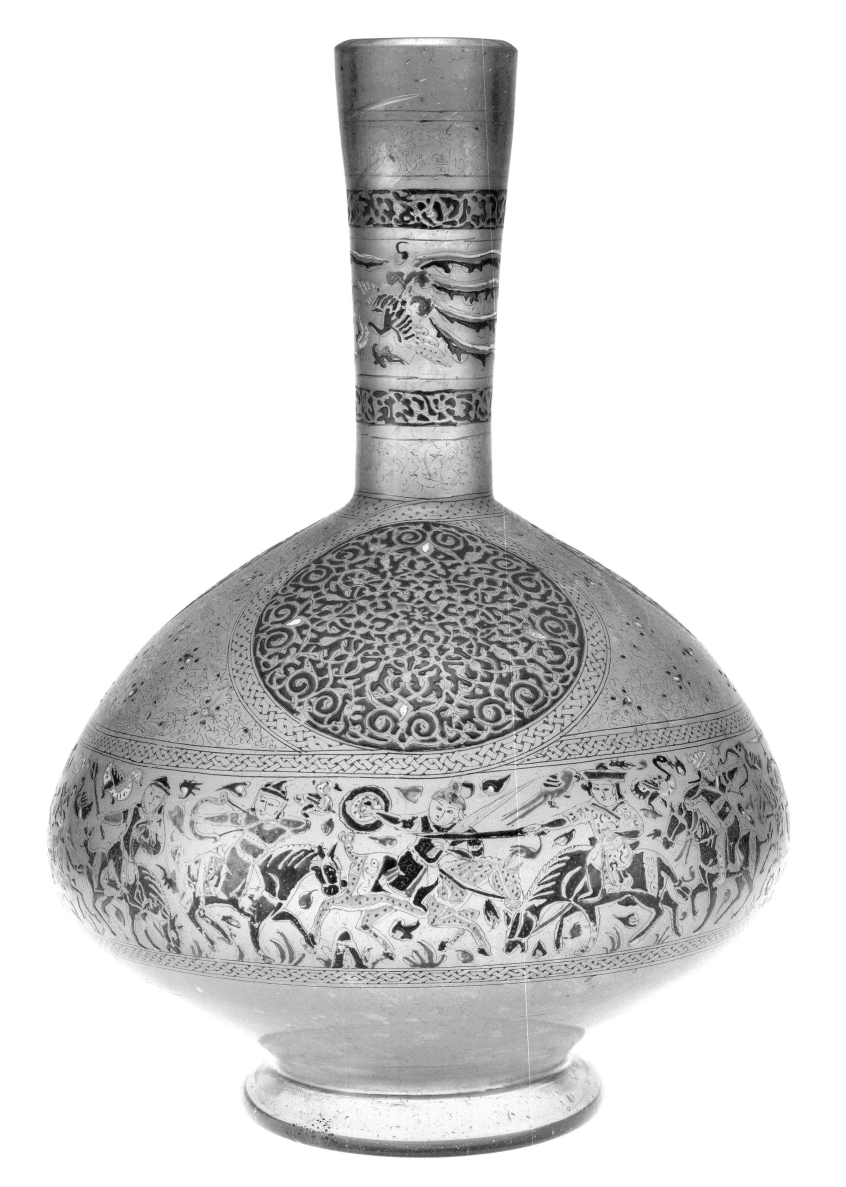

a small number of book illustrations produced in non-Arab milieus; and it appears on a very few *mina'i* objects, and even in the "monochrome" luster medium, where its contrasting scheme of dots or flecks on a solid background made it effective in the decoration of luster-painted tiles [Fig. 42] and vessels.

202. A LION SLAYING A BULL

Carved stone relief on the facade of the eastern staircase of the Apadana
Persepolis, first half fifth century BC

A pair of panels, each showing a powerful lion sinking claws and jaws into the haunch of a bull, is carved on the east front of the stone staircase leading to the majestic platform of the palace at Persepolis. The image of a lion attacking a bull was already a potent symbol of kingship and power in the ancient Near Eastern world and well predates Achaemenid Persia;[1] at Persepolis an additional layer of meaning appears to have been added.

Darius (521–485 BC), toward the end of his reign, erected a complex of buildings on a terrace at the eastern edge of the Marv Dasht plain. Elamite inscriptions call the site "Parsa" but "Persepolis," its Greek name, is the way it has been known for centuries. The function of Darius' vast, columned complex is unclear but

may have been seasonally ritual. Suggestions have been made of a sacred meaning for the entire Persepolis region, perhaps akin to a kind of national sanctuary, where religious archives, or the fire sacred to Zoroastrians, might have been kept. The terrace at Persepolis has also been shown to be solstitial, its buildings precisely aligned with the rising of the sun at the summer solstice.[2] Indeed, astral images have been proposed as one source of the Persepolis lion-bull representations – the constellations Leo and Taurus. These constellations had already been accorded special importance by early settlers on the Marv Dasht plain, and their positions in the heavens were especially prominent in the Persepolis area in the spring.

The Persepolis lion-bull panels beautifully reveal the animals' natural musculature in legs and ribs, sinews and veins. At the same time, the carvings are quite stylized: the crisp curls of hair on the bull's hide resemble a jeweled belt or harness; the lion's body is seen in profile but its head is turned squarely to the front, and its ears and eyes, muzzle and whiskers given a formulaic treatment. The image occurs several times in the carved decoration of Persepolis and, despite variations in the scale of different reliefs, the lion's head, mane, and foreleg are always rendered in the same way, while the head of the bull is always turned backward toward its attacker. The

symbolic importance of the lion-bull image at Persepolis seems undeniable, even though the precise nature of its meaning may elude us so many centuries later.

In the Islamic period, this image of raw animal power appears in a number of painted versions on paper, sometimes alone but more often in the context of a literary creation, the animal fables that first appeared in Sasanian Iran as an import from India. The tales are known in the Islamic world as *Kalila and Dimna*, and the episode of the lion and the bull (the first chapter of the Indian *Pancatantra*) became the core story, of the lion and the bull Shanzaba, in medieval Arabic and Persian texts of this work [200, 203–5]. When this episode of the story is illustrated – and some twenty-five versions are presently known – the image of the lion killing Shanzaba is often seen to be astonishingly similar to the stone lion-bull reliefs of Achaemenid Persepolis, with a similarly formulaic body shown in profile but with the head turned frontwards. Even when this formula is not adhered to, the subconscious memory of the Persepolis stone image usually underlies any later painting, lending the weight of an extremely ancient Iranian cultural theme to a text illustration of the Islamic period.

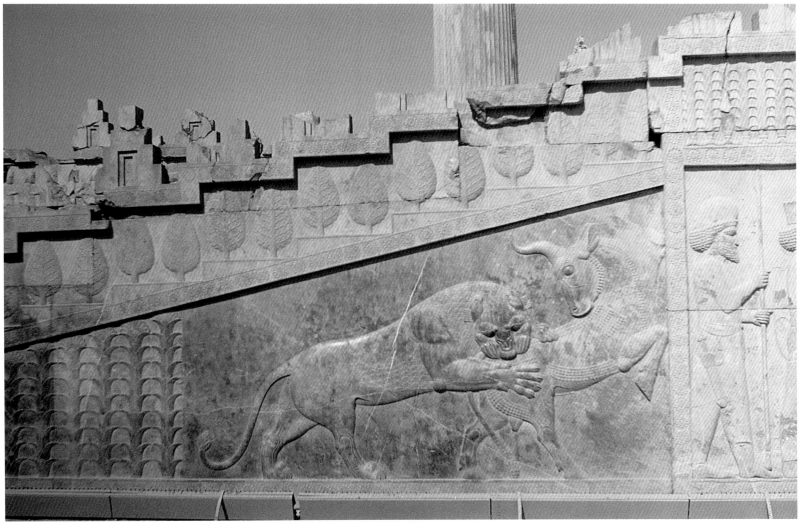

203. THE LION ATTACKS SHANZABA

Painting from a manuscript of Abu'l-
Maʿali Nasr Allah's animal fables called
Kalila u Dimna, preserved in an album
made for Shah Tahmasp
Baghdad or Tabriz, ca. 1360
H: 15.5 cm (33.1 max); W: 17.6 cm
Istanbul, Istanbul University Library,
F. 1422, fol. 6v

In any illustrated copy of the *Kalila and Dimna*
tales, most pictures illustrate animals; the
fragments of the large Jalayirid volume
preserved in Shah Tahmasp's album are no
exception.

 In the original manuscript, the lion and
the bull were set in a rocky landscape at the
bottom of a verso page; in the album the
painting was also mounted on a verso but
the contiguous text above it was cut away [cf.
Fig. 61] and a smaller picture, from the
same manuscript, set into the resulting right-angled
space. Both paintings now pasted on this folio
reveal another aspect of the combination of
text and picture in the finest classically
illustrated manuscripts that was already fully
developed by the middle of the fourteenth
century: the extension of a picture into the
margin beyond the rectangle of the text-
surface, giving it a highly irregular shape and
dimension [103].

 In "The Lion Attacks Shanzaba," the
composition simply continues to the right,
sweeping up and out into the margin where
the jackals – Kalila and Dimna – sit watching
the result of their plotting. Blue sky is painted
above the high horizon at the left of the
picture; in the marginal extension, the spiky
foliage, and the tree with its shoots and
branches are simply painted against bare paper.

 This painting illustrates the moment when
the lion attacks his former friend. He pounces
sideways, and back through the picture space;
one paw is planted on Shanzaba's flank while
the other mauls his head, and he bites into
the bull's soft side; his head is seen in three-
quarter view, unlike the formulaic frontal
position, the head twisting from a body shown
in profile. The bull is an extraordinary image:
the tail curls in agony over the back-leg
stretched out at the top of the picture; its
body splays out down the side of the picture;
and at the bottom one foreleg crumples under
its breast and its muzzle rests on the other. As
elsewhere in the magnificent paintings of this
fragmentary manuscript, the impression that
the artist reproduced what he truly observed
is very strong. The combination of pose and
execution conveys the sense of Shanzaba's
vulnerability, rather than a meeting of two
beasts equal in power and menace [204].

 Surface-textures are beautifully rendered: the
wrinkled velvety hide of the bull, the coarse
fur of the lion, the shorter hair of the avidly
watching jackals. Indeed, the rendition of
beasts and birds throughout this manuscript is
among the finest painting of animals by any
artist, anywhere, at any time.

203

204. A LION AND A BULL CIRCLING EACH OTHER

Painting mounted in an album
Western Central Asia or Iran, late
fourteenth century
H: 14.5 mm; W: 25.5 cm
Istanbul, Topkapı Saray Museum, H. 2160,
fol. 90v

The raw force that emanates from these
painted beasts circling each other on an
indistinct ground of unpainted paper is
tangible. A bull paces down the left side of the
composition; it is black from nose to hooves,
the only coloristic relief being the yellowish
whites of its eyes, and the grayish underside of
its horns and ears. On the right is a prowling
lion, head at the top of the composition and
turned to face the bull; its jaws are barely
apart and its gaze intent, and the right foreleg
is drawn back so that the underside is visible.
The bull's eyes almost flame with quiet
menace; the lion is a mass of tensile strength
barely contained and poised to strike: grievous
harm will ensue from the inevitable
encounter.

Far more than do most *Kalila and Dimna*
text-illustrations of the lion attacking, or
killing, Shanzaba does this mysterious painting
convey the sense of power residing in the
ancient image of a lion confronting a bull.
The musculature and the typical movements
of each beast have evidently been observed
from life, and the texture of hide and hair
wonderfully captured in paint: most striking
are the solidity of the bull's ribs under the
wrinkling hide, the striations over back and
spine, neck and muzzle, and the thin wispy
hairs at the end of its tail. Just as beautifully
rendered are the lion's fur rounding over the
curve of the ribcage, the bunching of skin
on the underside of the paws, the black hairs
springing from the muzzle, and the thicker,
curling mass of the mane. Indeed, it is only
here that the eye notes a series of rather
stylized – if hairy – spirals running down the
neck, before returning to the figure of the
bull, to take account of the extreme stylization
that marks the treatment of both animals. This
is Asian painting of a very high order.

 As to the subject of this picture, it is almost
impossible to say whether it comes from a

204

milieu in which copies of the Kalila and
Dimna stories were circulating, either in
writing or orally; or whether the artist had
seen the encounter of a lion and a bull and
then imposed his own observations, and his
stylized notions of painting on the image he
eventually made. However it may have been,
the weighty, menacing animal-power of this
painting vibrates on the page.

205. THE LION KILLS SHANZABA

Folio from Baysunghur's manuscript of
Abu'l-Ma'ali Nasr Allah's animal fables
called *Kalila u Dimna*
Herat, 1429
H: 15 (15.5) cm; W: 16.9 cm
Istanbul, Topkapı Saray Museum, R. 1022,
fol. 46v

This icy-hard painting of the lion killing
Shanzaba is found in a copy of the *Kalila u
Dimna* tales that Baysunghur had commis-
sioned from his own atelier in Herat [106,
185]. The bull's deep blackness is relieved by
the white blaze down the muzzle, his hooves
and horns are gilded, and he wears princely
golden ornaments of a necklace and anklets:
these have not helped to save him from the
impetuous turning of his former friend the
lion, and blood flows from the wounds under
the lion's maw and paws.

The lion's pose is remarkably like that of
the Persepolis lion [202], shown horizontally

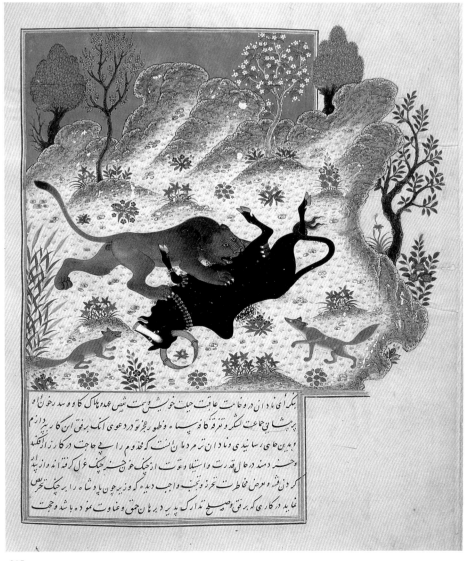

205

206

with one back-leg in opposition to the other; its head is turned almost frontally, so that muzzle and eyes nearly form a single element. The bull is quite different. Here it is the humped Asian variety, called the zebu, with almost circular horns unlike the double-curved horns of the Persepolis bull; moreover, the pose is different: it is shown on its back. The head has a surprising resemblance to a yet another
model, for despite its white blaze, the almost rectangular shape of the muzzle and the closely set almond-shaped eyes are strikingly similar to that of the bull in the powerful image whose origin remains mysterious [204].

206. THE LION AND THE HARE AT THE WELL

Painted mural in a private house
Panjikent, Sogdia, ca. 740
H: 45 cm; W: 58 cm
St. Petersburg, State Hermitage Museum, on long-term loan

This very ruined painting is a panel from the lowest register of the reception room in one of the two largest dwellings in Panjikent. Unlike subjects depicted in the same zone in other houses, the pictures here symbolically praise the exercise of wisdom in place of stupidity, of sagacity in place of improvidence.

The owner of this house was one of the most powerful men of the city in that difficult period when the Arab garrison lived in the stronghold of Panjikent, in barracks built from the ruined palace of the last prince of the city,

Dewastich [121]. During the 740s Sogdian citizens rebuilt, and redecorated, their houses in an attempt to remain faithful to their cultural and moral values and to retain their way of life. The visitor to this house would thus have seen, in the paintings on the walls of the large room in which he was received, that his host was not only wealthy but politically aware, and that he and his compatriots must never forget how crucial to their survival were both wisdom and discretion.

The story of the lion and the hare is found in the earliest Indian *Pancatantra* and then appears in many other versions of these celebrated Asian animal fables. A clever hare fooled a stupid lion into his destruction: the hare showed the lion his own reflection in a well but told him it was a rival; the lion jumped into the well in order to kill the rival but perished himself.

In the Islamic period, these animal tales are of course known as *Kalila and Dimna*. Both Arabic and Persian manuscripts survive from the thirteenth century onward but few, in the earlier periods, illustrate the exact moment when the lion jumps, as does this mural. One, in an Arabic manuscript made in Syria early in the thirteenth century does so, and the figure of the lion is so similar to the lion at the left of the Sogdian painting as to suggest that both derive from the same iconographical prototype. It appears elsewhere, and later, in another Muslim context: the same image of the leaping lion, only its rear paws and tail seen at the rim of the well, is found in a Mughal Indian manuscript of the very end of the 16th century.[1] The Islamic paintings all suggest that

this Panjikent picture and others in the same zone in this house (and in other dwellings as well) also reproduce a book illustration. In turn, this could suggest that the Middle Persian version of the Indian *Pancatantra*, the source of the murals in Panjikent, might have exemplified the same earlier tradition of illustrating this text, from which the paintings in Panjikent then derive. B.I.M.

207. THE LION AND THE HARE AT THE WELL

Painting illustrating Abu'l Maʿali Nasr Allah's *Kalila u Dimna*
Tabriz, between ca. 1410 and 1425; paintings later pasted into a manuscript made for Baysunghur in Herat in 1431
H: 6 (16.5) cm; W: 7.7 (11.8) cm
Istanbul, Topkapı Saray Museum, H. 362, fol. 40v

This painting does not illustrate the lion's jump into a well and to his death, but a prior moment, when the seed of his self-destruction is sown by the clever hare, here pictured huddling underneath the body of the lion as both stand peering into a pond.

It is one of nineteen small paintings in a superb example of the Jalayirid style [209] as it had been developed by Sultan Ahmad Jalayir. All nineteen have been cut from their original context and mounted into a manuscript copied for Baysunghur by one of his favorite scribes, Jaʿfar (who does not add here "in the service of Baysunghur"). The text is written on polished coffee-colored paper with fine illumination throughout the volume, in the same style as in the earlier *Gulistan* of 1427 [52]; it bears the completion date of 1431. The pictures are often not quite so wide as the new written surface and, to fill the gaps, abstract ornament in white and gold was painted around them, like an additional frame. The marginal extensions are a Jalayirid feature dating from the middle of the previous century [103]; they have either been cut from the original pages, or were created anew when the Baysunghuri manuscript was being copied. Here, the marginal extension is original to the primary part of the picture and was pasted onto the new margin.

The story of the lion and the hare is one that the jackals tell each other as they scheme to create a rift between the lion and the bull, Shanzaba. Its age within the *Kalila and Dimna* framework may be judged by the fact that it is one of the eighth-century painted episodes still surviving on the wall of a house in Panjikent: indeed, its source is the Indian *Pancatantra*. Like the story of the lion slaying the bull, it too developed over the centuries a nuanced visual component in which not just one, but a series of consecutive moments in the narrative have come to be illustrated.

In Sogdian Samarqand the story was "told" at the dramatic moment of the jump [206].

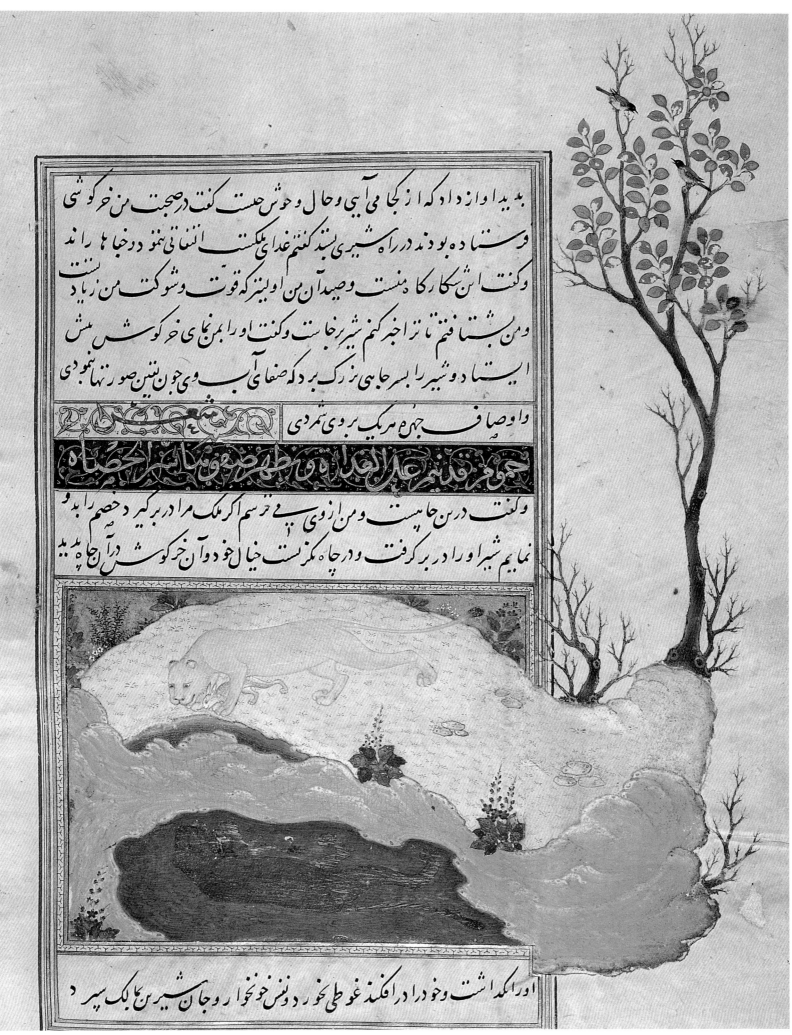

The tradition was still adhered to in some of the fourteenth-century illustrated copies of Nasr Allah's Persian recension (albeit provincial in style), and it also appears in Mughal India at the end of the sixteenth-century. The paintings in other *Kalila and Dimna* manuscripts, both Arabic and Persian, as is the case with this Jalayirid version, revert to the earlier stage when the hare shows the lion his pretended rival. It is by far the more frequently illustrated moment in later copies of this popular text.

208. A PRINCELY FIGURE ON AN ELEPHANT

> *Minaʾi* fritware bowl
> Iran, late twelfth–early thirteenth century
> D: 8.9 cm (image)
> Washington, DC, Freer Gallery of Art,
> 27.3

The princely figure in the howdah on the back of a tusked elephant painted on the interior of this lobed and footed *minaʾi* bowl has long been identified as Sapinud, a character in Firdausi's *Shahnama*: she was an Indian princess whom Bahram Gur married at the behest of her father Shangul. Yet the figure's hair is fairly short, and the cap and clothing indeterminate; the eight seated attendants in the cavetto holding cups in their hands are similarly dressed; and the inscription on the interior of the bowl is a standard protocol calling down power and prosperity, good fortune and victory upon an anonymous owner.

The inscription names a certain Abu Nasr Kirmanshah, but whether he was the owner for whom it was made is uncertainly expressed. The figure on the elephant might well be a prince, instead of a princess, and an alternative interpretation might be proposed. It may instead be an image relating to a story from the last chapter of the *Kalila and Dimna* stories: that of the king's son in exile who, upon the unexpected death of the king of a different land, acceded to its empty throne and was immediately paraded around the town on an elephant. The earliest (presently) surviving written version of this episode is found in an Arabic manuscript dated 1354 and made in Syria, while the bowl is a product of Seljuq Iran and certainly made in the prior century, if not even earlier. But the image on the bowl should perhaps not be taken as a literal illustration of Nasr Allah's text, although knowledge of the story could certainly have informed the perception of any educated person into whose hands the bowl might have fallen. It is also true that the *Kalila and Dimna* tales, both in Arabic and in Persian, are usually much older than their written versions [206–7].

In any case, the form of this bowl is one of several classical types of Seljuq fritware vessels. Its size and shape were well adapted to the repetition so typical of decorative patterns. The

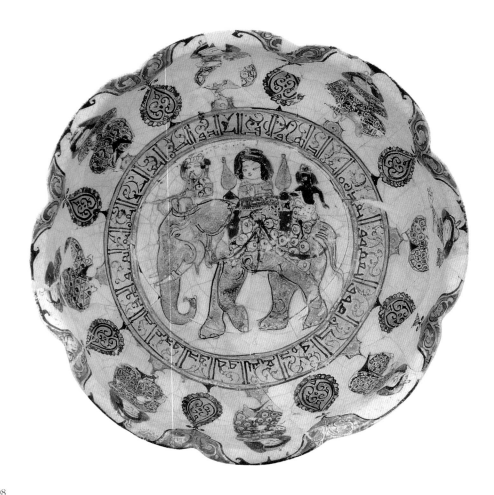

208

painted figure on the elephant, his mahout riding in front and a black-skinned attendant behind him, falls midway between two modes: that of text-illustration, and that of the abstracted decoration suited to the shape of a three-dimensional vessel with a complex rounded surface. Thus, whether the princely personage painted on the inside of this charming fritware bowl might be specifically identified or is only a "type" of princely figure, remains an open question.

209. THE NEW KING PARADED AROUND THE TOWN ON A WHITE ELEPHANT

> Painting illustrating Abu'l-Maʿali Nasr Allah's *Kalila u Dimna*
> Tabriz, between ca. 1410 and 1425; paintings later pasted into a manuscript made for Baysunghur in Herat in 1431
> H: 6.5 (14.9) cm; W: 11.7 cm
> Istanbul, Topkapı Saray Museum, H. 362, fol. 169r

An image in which both humans and animals, rather than animals alone, are the focus of the story well demonstrates the difference in the aesthetic of these small pictures from that practiced in Bayshunghur's workshop in the late 1420s and early 1430s [24].

The story – at greater length – is that of a

prince who, being deposed by his brother, left his own country for another and fell into the company of three destitute young men. When they reached the capital of the new country the king's son encouraged them to practice some useful trade and earn their livings. Within three days the three turned their first wages of 10 dirhams into a profit of 1000 dirhams. It was then the prince's turn to provide, but he merely sat at the city gates, watching as the funeral procession of the king of the city passed by. Apprehended for loitering, he was recognized as a king's son and, as the deceased king had died childless, he was proclaimed king and paraded around the town on a white elephant.

The story appears in both Arabic and Persian texts of the *Kalila and Dimna*, and the image can be well summarized by a white elephant in a certain amount of finery with a princely figure on its back. Here the elephant wears a golden collar with a large tassel and four golden anklets, and a wide golden girth holds its saddle-cloths, richly decorated in gold; the howdah appears to be gilded woodwork. The new king is crowned; he is attended by mahouts, seated before and behind him, and a groom on foot, a *payk*, with a round-headed axe on his shoulder who turns back toward the king, as if to confirm something with him: by this date, the groom is a stock figure already seen in Sultan Ahmad's copy of Khwaju Kirmani's *mathnavi*s [73]. Two

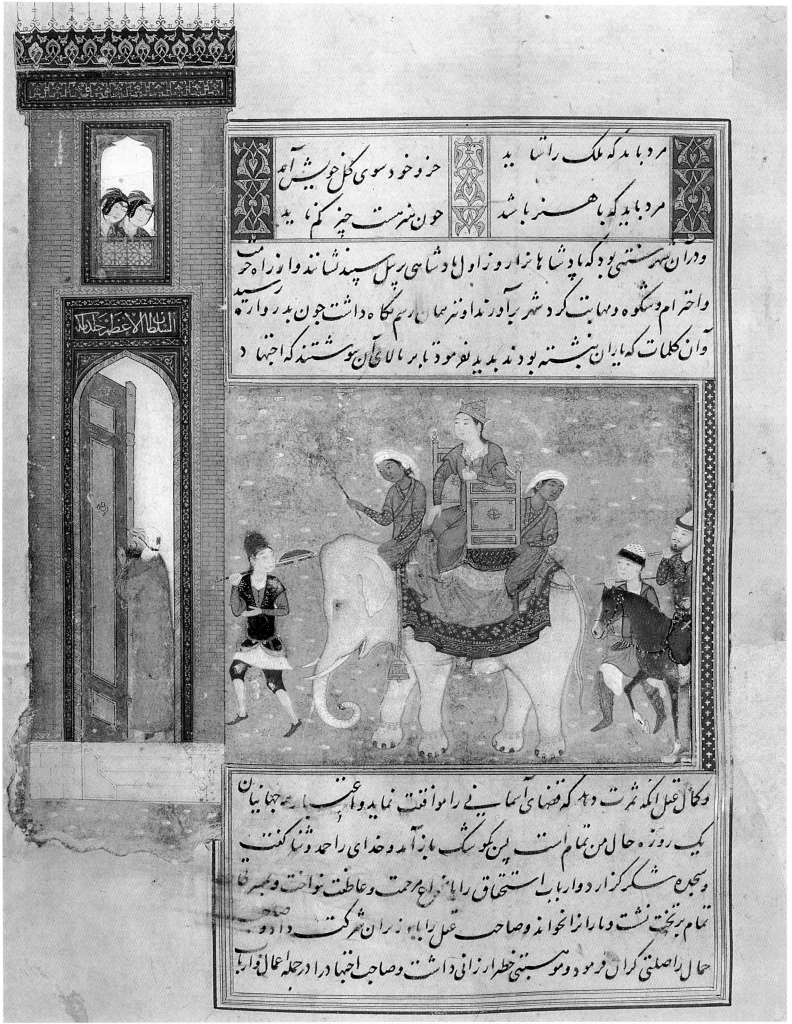

other attendants follow, one wearing a leopard-skin cap. The town is wonderfully summarized by a wall and a window: a flat brick portal-wall on a plinth of green stone, with a partially open door surrounded by a tiled blue frame; above it a window with a decorated frame of tiles and perhaps stucco, with a low wooden balcony, and above that another frieze of blue tiles and a cresting of illuminated ornament. The townspeople are equally well summarized in three figures: a single man in a long robe and a white turban standing in the doorway, and two women with Jalayirid blue eybrows and "cockscomb" headdresses who look down from the window.

In the *Kalila u Dimna* text, the new king raises his motto on the city gates: "Nothing can be accomplished without the grace of God;" here instead the white inscription written over the doorway reads: "the most mighty sultan, may his kingdom prosper."

210. THE NEW KING PARADED AROUND THE TOWN ON A WHITE ELEPHANT

Painting in a manuscript of Husayn ibn 'Ali al-Va'iz al-Kashifi's *Anwar-i Suhayli* (*The Lights of Canopus*)
Qazvin or Isfahan, 1593
H: 30 cm; W: 21 cm (folio)
Geneva, Collection of Prince Sadruddin Aga Khan, fol. 359v

An episode pictured in the delicate little Jalayirid *Kalila u Dimna* pictures mounted into a fifteenth-century manuscript was also illustrated in a later sixteenth-century volume. The two pictures are similar in many ways – hardly unusual in a volume whose Timurid models are frequently to be remarked within its large ensemble of 107 pictures [79, 97, 112].

Essentially the Timurid composition was retained, but flipped and simplified. The new king on his white elephant moves towards the right instead of the left, and his attendants have disappeared. The town is essentially represented by two architectural blocks, one in the main section of the picture behind the new king, and the other as an extension in the margin. The composition also has the irregular outline typical of many others in this manuscript, and it is, of course, much larger than the tiny Jalayirid picture of the same subject.

Fashions and accoutrements have been brought up to date. The new king's crown is now Safavid in form, with a black heron-feather plume; the elephant's saddle-cloth is patterned in the manner of a Safavid rug; the headgear of the three men in the balcony is also Safavid. The four ladies behind them are enveloped in white veils covering their hair and their mouths (and no doubt falling to

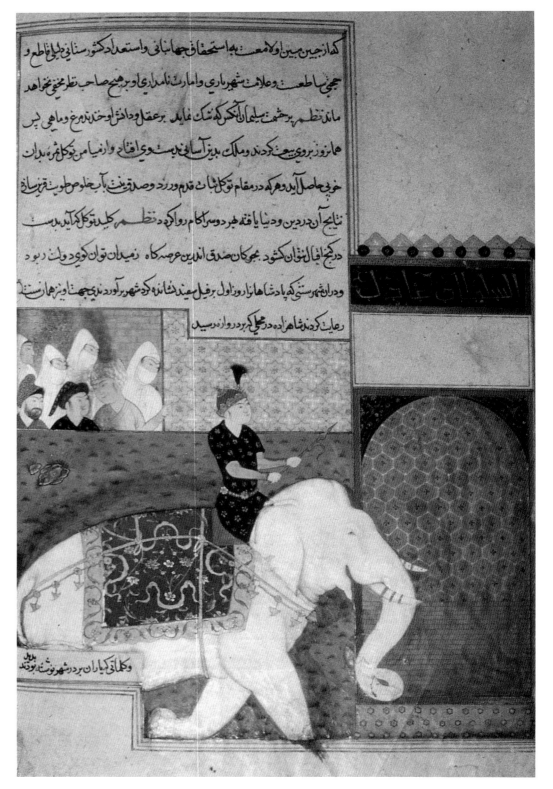

210

their feet). The Kufic inscription over the portal, in the extension to the right, now reads "the just sultan," *al-sultan al-'adil*. Composition and size clearly indicate that this late sixteenth-century manuscript is by no means a copy of the Jalayirid-style picture.

It is therefore surprising to realize that no other recorded version of the scene is known from any time between the early fifteenth-century picture and this picture of 1593. The Jalayirid image and its later reworking remain, for the moment, unique.

211. THE SIEGE OF JERICHO

Silver plate, cast, engraved, and punched, with gilded details
Semirech'e, eighth–tenth centuries
D: 23.7 cm
St. Petersburg, State Hermitage Museum, S-46

Among the many Oriental silver vessels made between the third and the thirteenth centuries, only four cast examples are recorded. Three of them exhibit similar rather primitive engraving with punched details, and all were probably made in one center at the same period. Two show the siege of a fortress – this plate, and another in Novisibirsk, bear almost identical reliefs executed in a masterly fashion; while on the third, decorated with Christian scenes and inscribed in Syriac, the reliefs are as primitive as the engraving. On the contrary, the fourth exhibits engraving as good as reliefs. Its subject matter is King David playing the psalterion. This early ninth-century plate is the oldest in the group.

The artisans responsible for the two fortress-plates must have worked from older models that were aesthetically finer, using a clay or gypsum cast as a mold and achieving fine results. When the mold was modeled by hand, as was probably the case with the third plate, the relief was poor in quality. After the dishes were cast they were polished and the original details almost completely eroded; they were then re-engraved, introducing still further alterations.

The buildings, and the armor and weaponry, on both siege plates date from the eighth century, which must therefore be the date of the common original. The

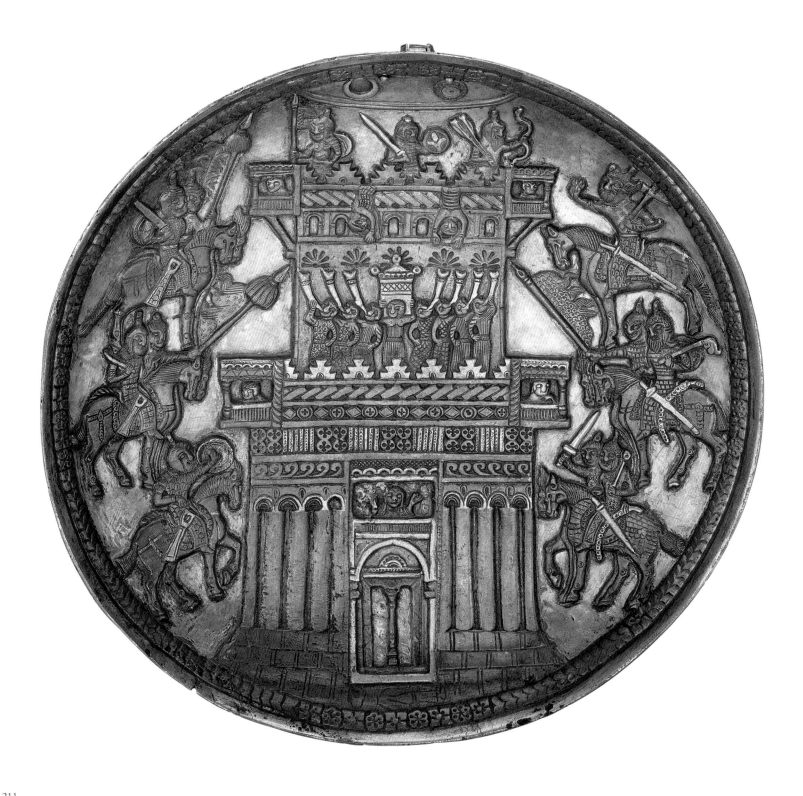

anachronistic details of the engraving on the Hermitage dish, such as the straight, heavy pendants of the horse-harnesses, are at least ninth–tenth century in date if not later. The decoration of the plate with Syriac inscriptions consists of scenes from the Gospels, and also from the Book of Daniel: Syriac was the principal language of the Nestorian Church, whose missionaries had converted the ruler of the Qarluq Turks and his subjects in the last quarter of the eighth century. Until the tenth century, Christian Qarluqs lived in the Tien-Shan Mountains and on the plain along their northern rim, the Semirech'e; among their subjects were the citizens of a number of Sogdian colonies. The technical similarity of the plates, taken together with the historical sketch just recounted, suggests that all four cast silver plates are the work of some Sogdian colonial workshops in the Semirech'e.

The primary event of the Book of Joshua is the subject of the silver plate illustrated here, the siege of Jericho. The figure who raises his hand to a sky where both sun and moon are visible can be none other than Joshua, who made the sun stand still and stayed the moon. Several episodes are shown in the upper parts of the round field, and the besieged town is seen twice, in the upper and in the lower part of the composition. The whore, Rahab, is seen in her window at the city wall, and seven priests with horns, and the bearer of the Ark of the Covenant, are also represented. The priests belong in the upper scene but are placed at the foot of the city wall.

The plate which must have served as the model for this version was almost certainly the work of a Sogdian craftsman who lived in the Qarluq dominions, and its quality was the equal of silver vessels made in metropolitan Sogdiana. But after the Arab occupation of Sogdia, in 722, the quality of the figural arts made in its colonies declined, and later silver wares (surviving only from the ninth or

tenth century) decorated with figural images demonstrate this decline in the ability to render the human figure, even if the artisans who made them were technically good founders and silversmiths.

Here, both style and iconography display a mix of Syriac and other early Christian elements, together with Sogdian, Buddhist, and Chinese details. It is not coincidental that the scenes, in Panjikent mural paintings, of battles near fortresses are similar to Xinjiang representations of the distribution of Buddha's ashes in Kushinagara [88]. Nor is it a coincidence that both are reflected in the basic composition of this silver plate, on which Sogdian architectural details meet with large T'ang Chinese banners adorned with pendant horse-tails, a feature never depicted in Sogdia proper. The late seventh and the first half of the eighth century was the great period of T'ang Chinese influence in the Semirech'e, and both a Chinese fortress and several Chinese Buddhist structures were built there. Thus, craftsmen in the Qarluq state inherited a mixed iconography of Sogdian and Chinese origins which found expression in just such colonial Sogdian objects as this cast silver plate. B.I.M.

212. MOSES DISCOVERED BY PHARAOH'S HOUSEHOLD WOMEN

Painting from the Arabic manuscript of Rashid al-Din's *Jami' al-Tavarikh* (*Compendium of Chronicles*)
Tabriz, 1314
H: 32.5 cm; W: 44.5 cm
Edinburgh, University Library, MS Arab 20, fol. 9v

On a silvery-blue stream, running from the upper left to the lower right margin of the picture, floats what appears to be a coffin; it is in fact the basket that carries the infant Moses

to his rescue. The pair of Egyptian women who will find him are bareheaded and have long dark tresses; they have been bathing in the stream and their clothing hangs from the branches of a bent tree. Their bodies were once painted with silver that has now darkened with oxidation, so that they present an even greater contrast to the third woman who stands behind them; she is lighter of skin and dressed in white with a red headcloth.

No obvious models exist in Islamic painting for this Old Testament subject, and it has long been assumed that the *Jami' al-Tavarikh* painters would have had some recourse to illustrated Christian codices. The presence of such books would hardly have been unusual in cosmopolitan Tabriz in the early fourteenth century, and Byzantine, Armenian, and Latin religious manuscripts have all been suggested as potential models for the Biblical subjects illustrated in Rashid al-Din's universal history.

This picture, however, makes use of so many Chinese elements for its most important feature – the landscape – as to suggest it was conceived quite independently of any models. The stream is a series of swells and foaming waves, in a loosely imbricate pattern (usually considered Chinese in origin but also seen on Sasanian silver objects); the bending, gnarled tree and the inky, uneven slanting ground line, with spiky grasses and angled boulders, are equally features of the Chinese ink-drawn landscape. The water-borne conveyance of the infant heightens the suggestion that the subject of this picture developed directly from the context in which it was illustrated: it is not a basket of bulrushes that holds the child, but instead has the shape of the classical Muslim coffin with a gabled lid and gable-shaped ends.

213

The subject here is Jonah being disgorged
by the whale onto dry land, and the image is
both related to, but different from, the two
paintings of "Jonah and the Whale" in the
illustrated Arabic *Jamiʿ al-Tavarikh* of 1314.[1] One
illustrates a section on the ancient prophets
and shows the whale in the ocean, the naked
Jonah resting on the shore under the gourd
that God caused to grow up and shelter him.
The more impressive version occurs later in
the manuscript, in a section on the history of
the Jewish people; it shows Jonah, dressed in a
shirt, at the very moment the whale disgorges
him. Byzantine pictorial models lie behind it,
whereas the image of Jonah being offered
clothing by an angel as he emerges from the
whale onto the shore is found in neither the
Old Testament nor the Qurʾan, but derives
instead from later Islamic sources.

For Muslims, Jonah was one of the five
Biblical prophets who offered praise to God
in the midst of an ordeal. In Jonah's case the
ordeal lasted forty days, a number with both
hagiographical and mystical overtones, and he
emerged from the fish's mouth pale, weak,
and naked, in need of rest and succor, as well
as clothing. The tenth-century historian al-
Tabari and the eleventh-century compiler of
the *Qisas al-anbiya* (*Stories of the Prophets*), the
thirteenth-century sufi poet Rumi and, in the
later fifteenth century, the historian
Mirkhwand and the poet Jami: all write of
Jonah and of the gift of clothing made to him
or left for him on the shore of the sea. In the
Qisas al-anbiya, the angel is said to be Gabriel
but here the angel is unidentified. In fact, the
only text anywhere on the picture is the
poem, from Saʿdi's *Gulistan*, that is written on
Jonah's bare arms, and it seems to refer to the
beginning rather than to the end of the
ordeal:

213. THE ANNUNCIATION

Painting in the Arabic manuscript
of Rashid al-Din's *Jamiʿ al-Tavarikh*
(*Compendium of Chronicles*)
Tabriz, 1314
H: 33 cm; W: 43.5 cm
Edinburgh, University Library, MS Arab
20, fol. 24r

For this momentous Christian event, the
Annunciation of the Angel Gabriel to the
Virgin Mary, the artists of Rashid al-Din's
scriptorium constructed a picture from a
number of sources. The text which the picture
rests has been identified as the apocryphal
gospel called the Protevangelium of St. James,
in which Mary was filling a pitcher with
water from a well when the Angel Gabriel
appeared to her. Moreover, Muslim tradition
locates the Annunciation in the cave of the
well of Silwan, and there is indeed a pool of
water in the background mountains, whose
shapes are Chinese in derivation and whose
washy execution is also Chinese in manner.

For the figures, the painters appear to have
turned to the Qurʾan: "Our angel . . . appeared
/ Before her as a man / In all respects."[1]
The bareheaded figure brings his message and
gestures eloquently at the Virgin who holds
an equally expressive hand to her face, as if to
shield herself from the gaze of an unfamiliar
male. The painting is a rectangle set in the
middle of the folio, with a height of ten lines
of text; some of the other Biblical images in
the Arabic *Jamiʿ al-Tavarikh* are similarly shaped
and set.

214. JONAH AND THE WHALE

Painting, perhaps from a large manuscript
otherwise unknown
Western Iran, ca. 1400
H: 31.9 cm; W: 48.1 cm
New York, Metropolitan Museum of Art,
33.113

"Jonah and the Whale" is another large
painting on paper that, in style and subject,
seems somehow to belong to the corpus of
Iranian painting made around the year 1400
[156]. Yet precisely where and when the two
were painted, and how they fit into the
broader picture of the illustration of Persian
texts still remains to be explained.

214

The disk of the sun went into blackness
And Jonah was in the mouth of the fish

Like the two Tabriz images in the *Jami' al-Tavarikh*, this fish has scales and fins, and like other fourteenth-century pictures of water, an imbricate pattern denotes the waves of the ocean. Like other Jalayirid angels, this angel is a winged human dressed in a short-sleeved, sashed garment [196]; here the sash flutters languidly and its headgear appears to be a leaf. Both faces are similarly drawn, the large eyes given both an upper and a lower defining line. On the shore grow two flowering plants, one with six-petalled blossoms; a simply drawn tree with large composite five-lobed leaves is meant to be the gourd – several hang from its branches. The painting has a simple and muted palette with an unpolished surface, the finish is matte, and the shore itself appears to be unfinished. Yet the composition is well placed upon the page, and the swinging form of the fish as it disgorges Jonah is a dramatic foil for the swooping angel, its widespread feathers of red and yellow balancing the massive curve of the silver fish. If the execution is broad and relatively crude, the design has strength and the picture is dynamic.

It has been called an illustration from yet another, and now-lost, manuscript of Rashid al-Din's Arabic *Jami' al-Tavarikh*, but size alone counters this argument: this picture is almost twice as wide as the ruled area of a page of the largest of the surviving Rashid al-Din volumes – 48.1, as opposed to 25.5, centimeters. It may instead have served a storyteller somewhere in Western Iran as a hand-held "prop," perhaps one of a now-lost series, intended to accompany a recitation from Rumi, or the *Qisas al-anbiya*, or some other quasi-religious text whose ultimate purpose was to demonstrate the rewards that came to those with faith in God.

215

215. ADAM AND EVE EXPELLED FROM PARADISE

Painting from a dispersed manuscript of the *Falnama* (*Book of Divination*)
Tabriz or Qazvin, ca. 1550
H: 59.7 cm; W: 44.9 cm (entire folio)
Washington, DC, Sackler Gallery, S86.0251

This painting comes from a dispersed mid-sixteenth-century manuscript of the *Falnama*, or *Book of Divination*: *fal*, in Arabic and also Persian and Turkish, means fortune, fate, omen, augury. The text is ascribed to the sixth Shi'a imam Ja'far al-Sadiq (between ca. 700–65). It combines orthodox Muslim hagiography with Qur'anic stories, folk tales, and popular Shi'a literature. *Falnama* volumes are organized as a series of illustrated episodes in the lives of Muslim saints, prophets, and other religious and popular figures. To predict the future using such a text, the volume is allowed to fall open at random and an interpretation of the text pronounced

after reading the text facing the picture.

Having been expelled from Paradise, Adam and Eve are shown riding on extraordinary mounts: Eve on a peacock, and Adam a dragon. Other versions of the subject usually show Adam and Eve walking out of Paradise, often hand in hand and sometimes accompanied by a peacock and a snake. It is unusual that the snake here has the form of a monumental dragon, a transformation occurring in at least one other painting in this manuscript [216]. The snake needs no explanation in this context and the peacock, often a symbol of vanity, is frequently associated with Eve. Both animals appear in popular Muslim texts describing the downfall of Adam and Eve: Ejected from the presence of God, Iblis – Satan – enlisted the help of both serpent and peacock to regain entry into Paradise. Once

there, he wrought vengeance on the first parents of mankind by tempting them to eat of the forbidden fruit from the tree of knowledge. An extraordinary passage in the prologue to 'Attar's *Language of the Birds*, the twelfth-century sufi allegorical poem, illuminates the peacock's role in this unhappy event:

Next came the peacock, splendidly arrayed
In many-coloured pomp; this he displayed
as if he were some proud, self-conscious bride
Turning with haughty looks from side to side.
'The Painter of the world created me,'
He shrieked, 'but this celestial wealth you see
Should not excite your hearts to jealousy;
I was a dweller once in paradise;
There the insinuating snake's advice
Deceived me – I became his friend, disgrace
Was swift and I was banished from that place.[1]

216

216. THE STAFF OF MOSES DEVOURS THE SORCERERS OF PHARAOH

> Painting from a dispersed manuscript of
> the *Falnama* (*Book of Divination*)
> Tabriz or Qazvin, ca. 1550–60
> H: 59 cm; W: 44 cm (folio)
> Genoa, Bruschettini Collection

This dramatic painting from the same large book of fortune-telling or divination illustrates an episode found in both the Bible (Exodus, VII, 8–12) and the Qur'an (VII, 103–22): Pharaoh commands Moses to display a miracle, as a sign of God's favor, and God turns the staves of Aaron and Moses into serpents. In the Qur'anic version of the story, Moses performs a second miracle: his hand turns white, understood to be shining with divine light. The white color distinguishes the goodness of his miracle from black, or evil, magic; indeed, "the white hand of Moses" has become a proverbial Muslim saying.

As always in this manuscript, the episode is rendered with exceptional pictorial verve and coloristic boldness. Moses' head is shown encircled by a flaming golden nimbus, his hand is shown as a radiating star or sun, and his staff has become, not a snake, but a spotted, scaly, writhing, flame-colored dragon with one of Pharaoh's wizards half-consumed in its maw.

Several pictures in this manuscript show dragons when the text calls for a snake or a serpent. Here the four dragons are especially vivid creatures, with variegated hides and flaming golden wings, while the additional snakes brandished by half-garbed figures suggest that the painter included them as additionally expressive details, even though he had already replaced the snakes called for in the text with especially colorful dragons.

In the background of the picture, Pharaoh bites his finger in the conventional Iranian gesture of astonishment [139, 169, 175], and he is accompanied by a phalanx of soldiers seen at the edge of the highest hill. Neither they nor the half-garbed figures would seem to be Pharaoh's sorcerers who, in any case, are said to have prostrated themselves in adoration of the "Lord of the Worlds – The Lord of Moses and Aaron" and are sometimes so shown. They seem instead to be another instance of the originality of conception that consistently distinguishes the images in this most remarkable of all *Falnama* manuscripts.

The text that originally accompanied this painting (on a folio in a different private collection), as always, first summarizes the action on the page it faces:

> When the Prophet Moses threw his stick,
> it became a serpent and devoured the
> magicians.
> [Moses] became glorious and great; the
> Creator was pleased with him, and he made
> the people happy.[1]

Adam and Eve's path from the garden of Paradise is flanked by two rows of angels, both the guardians of Paradise and perhaps a reminder of the fact that God had ordered them to pay homage to Adam after his creation, which Iblis had refused to do [180]. The dark-faced turbaned figure in the lower left foreground is surely the fallen angel, watching the extraordinary procession in a poignant – if not ironic – comment on the success of his plot. To the right is a contemporary Safavid courtier, armed with a sword hanging from his belt but using what looks like a polo stick to drive the dragon and his unfortunate rider from the verdant green meadows of Paradise.

Illustrated works of *fal* are not known before the middle of the sixteenth century, and the magnificent volume to which this painting originally belonged may be the earliest recorded example. It is distinguished by its size, by the pictorial and coloristic energy and audacity of its pictures, and by its fine calligraphy and illumination: it may even have been made for Shah Tahmasp. E.J.G.

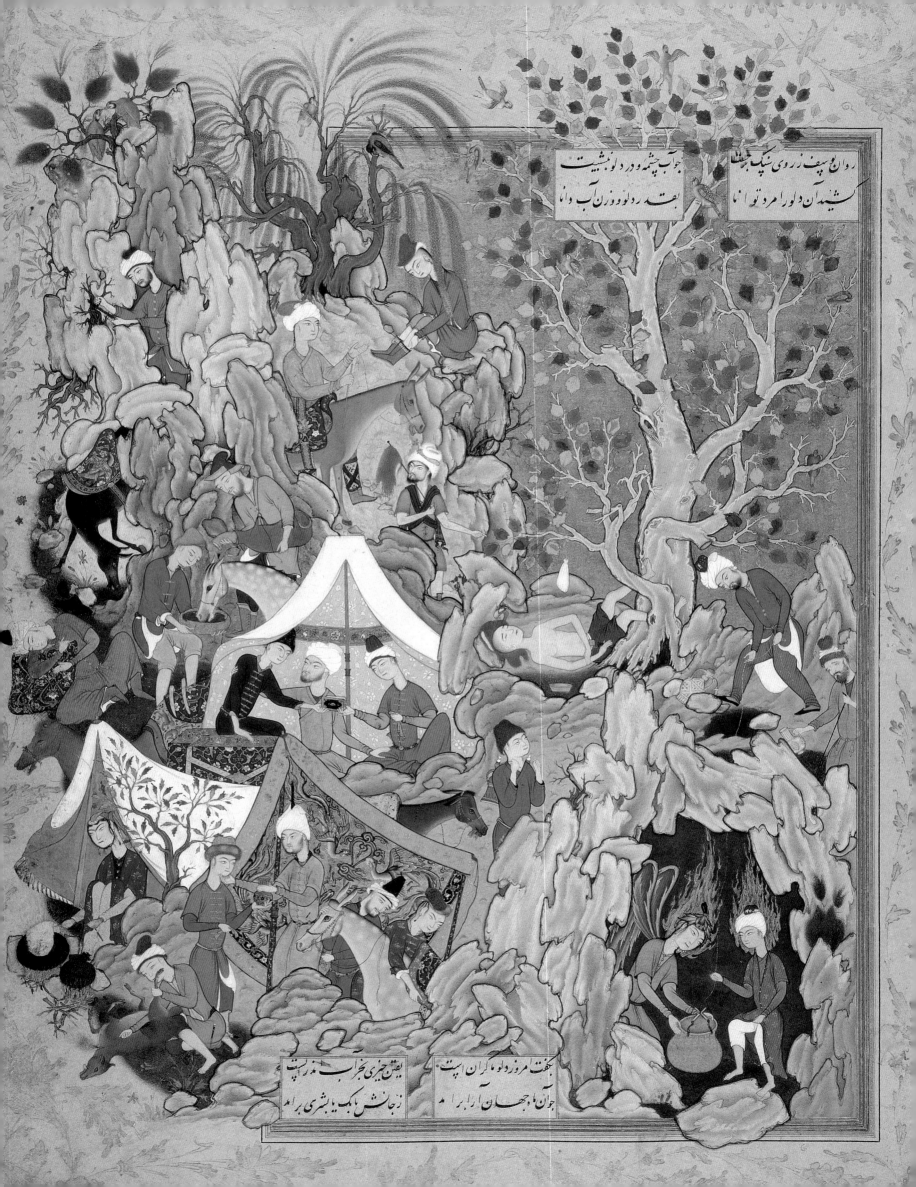

217. YUSUF RESCUED FROM THE WELL

Painting from Ibrahim Mirza's manuscript
of Jami's *Haft Aurang* (*Seven Thrones*)
Mashhad (?), between 1556 and 1567
H: 24 cm; W: 20.8 cm
Washington, DC, Freer Gallery of Art,
46.12, fol. 105r

Again, it would be difficult to discover the
subject of this picture without knowing the
story, which is supplied by the two verses
from the *Haft Aurang* placed at the top right
and bottom left. The painting shows an
elaborate landscape inhabited by a large
number of people. Some read, rest, or indulge
in intellectual pursuits; servants are engaged in
tending animals and the other tasks required
when a caravan halts in a mountainous retreat
– gathering wood, fetching water, slaughtering
an animal, preparing the evening meal.

Above the text-panels at the lower left a
prince under an elaborate canopy is offered
a golden jug, probably of wine, by a youth
and acknowledges the gesture with a caress.
Above this vignette is a simpler tent in which
two youths appear to discuss poetry: a small
manuscript is passed from one to the other,
the latter embraced at the shoulder by a
slightly older, bearded man in the center. An
enigmatic figure, a youth nude to the waist,
sleeps under the branches of a plane tree at
the center of the painting, a small white
pouch hanging from one of the branches
above him.

At the lower right is the key to the picture,
however out of keeping it may seem in so
refined but realistic a camp scene. Against the
darkness of the cave are seen a youth,
beardless but barefoot and wearing a turban,
and an angel, both heads set off with a
flaming halo. The angel offers a large kettle to
the youth. The text discloses that these figures
are Yusuf – the Biblical Joseph, abandoned
down a well by his jealous brothers – and the
angel who miraculously brings Yusuf the
instrument of his deliverance. Malik, a
member of the passing caravan, stands above
the well, holding the rope tied to the kettle in
readiness to pull Yusuf back to the surface.

It is curious that the painter chose to
illustrate the moment just before Yusuf's
rescue. He also omits the brothers, who are
present in the text, to claim Yusuf as their
servant and then to sell him to Malik for a
paltry sum. Thus, although the painting does
depict an episode in the story of Yusuf's
abandonment and his sale into slavery, the
sixteenth-century Qazvin painter is much less
interested in illustrating the text than in
displaying his pictorial virtuosity. As is so often
the case in Safavid painting of this time, the
essence of the story is swamped by an almost
narcissistic display of the artist's abilities: these
may be deliciously accomplished but they do
not actually serve either the story, or the spirit
of Jami's poetry. E.J.G.

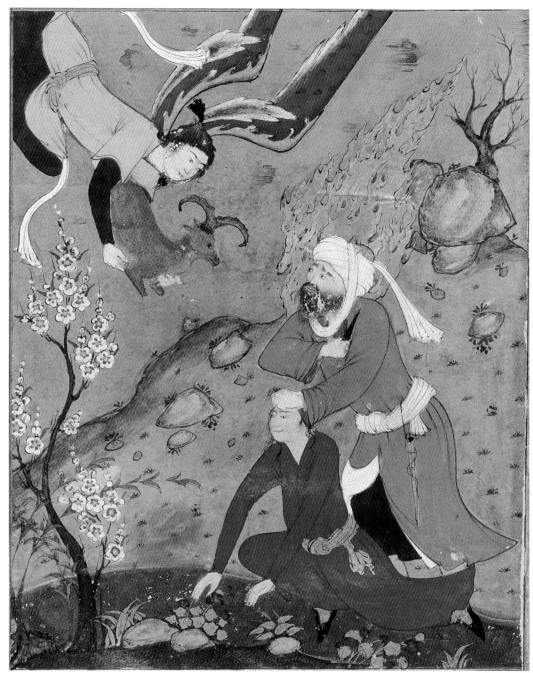

218

218. ABRAHAM'S SACRIFICE OF ISMA'IL

Painting from a manuscript of
al-Nishapuri's *Qisas al-anbiya* (*Stories of the Prophets*)
Isfahan, early seventeenth century
H: 12.2 cm; W: 16.1 cm
Paris, Bibliothèque nationale de France,
Suppl. persan 1313, fol. 40r

The extraordinary act of submission, that of
a father willing to sacrifice a beloved son
because God commanded him to do so, is also
recounted in both the Bible (Genesis, XXII, 13)
and the Qur'an (XXXVII, 102–7). The episode
became one of the most popular subjects of
Muslim literature and was sometimes
illustrated in both poetical and historical texts.
For Muslims, Abraham – Ibrahim – is one of
the most important pre-Islamic prophets, being
both the builder of the Ka'ba and an ancestor
of Muhammad. His life and deeds, especially

his ordeals – thrown into fire by Nimrud, in
addition to the command to sacrifice his son
– are represented in Iranian painting from the
fifteenth century onward.

Abraham's sacrifice is of particular
interest to Muslims: while the Qur'anic
verse describing the event does not specify
which of his two sons he sacrificed (a later
verse does name Isaac), Muslim literary
tradition holds that it was Isma'il whom
Abraham offered up to God, for Isma'il is
considered the ancestor of the Arabs. Muslim
tradition also adds another feature which is
absent from the Qur'anic description of the
sacrifice: at the crucial moment, an angel
appears with the sacrificial ram. This is
clearly an act of divine intervention, just as an
angel rescues Abraham from the flames into
which Nimrud had cast him. In both cases,
the angel is likely to be Gabriel, just as it was
Gabriel who brought the black stone to

Abraham, and the Qur'an to the Prophet Muhammad.

The scene is set in a hilly landscape, the son to be sacrificed kneeling on the ground. Abraham, in a turban, has taken hold of his son's hair with his left hand, and in his right hand he brandishes the dagger with which he is about to cut the youth's throat. Gabriel swoops down from the left just in time, a ram with large bent horns in his outstretched arms, and Abraham looks upward, acknowledging the gift of the sacrificial animal. The sudden appearance of the angel lends a dramatic effect to this and other Islamic paintings of the subject, unlike pictures in the European tradition, in which the angel merely stands beside the bush where the ram appears; the effect of divine intervention is much reduced.

As always in this manuscript [209], the heads of saints and prophets are set off by large flaming haloes. The ram seems more like a mountain goat, if not actually a moufflon, its horns growing from a single stem. The pronounced curve recalls the horns of ibexes and other mountain caprids [120, 196] in Iranian pictorial art, images that are centuries, if not millennia, older than this early seventeenth-century picture. E.J.G.

219. THE VIRGIN MARY AND THE INFANT JESUS

Painting from a manuscript of al-Nishapuri's *Qisas al-anbiya* (*Stories of the Prophets*)
Isfahan, early seventeenth century
H: 11.9 cm; W: 16.5 cm
Paris, Bibliothèque nationale de France, Suppl. persan 1313, fol. 174r

Jesus – or 'Isa – is recognized by Islam as one of the significant pre-Muslim prophets [54, 213]. Stories and anecdotes of his life are recorded in the Qur'an, while various aspects of his life are dealt with in historical works on the lives
of the prophets. The story of his birth was singled out for illustration in several kinds of texts, some of them apocryphal; consequently, the event is depicted in different ways, perhaps the most unusual being one in which the Virgin is shown leaning against a palm tree as she gives birth.

By contrast, this painting is very traditional: the Virgin sits under a palm tree with her son on her lap. She is not actually nursing him, but it is not unreasonable to assume that the inspiration for this picture was just such a European image, very likely one of the many prints, or illustrated books, imported into Iran from the later sixteenth century. Noteworthy is the figure of Joseph – Yusuf – his head uncovered, looking on from afar: he is almost entirely hidden behind the hillside, in accordance with the timid, often marginal representations of Joseph in Western European art.

Apart from this probable iconographic

source [cf. 220], nothing European can be discerned in the execution of this painting; instead it is entirely in the traditional manner of the early seventeenth-century Isfahan ateliers. Moreover, the Virgin and Child have flaming golden haloes, as do most personages of sanctity in Iranian painting [66, 67], and the flaming forms are echoed by the streaming tails of white clouds in the sky above Joseph's head. E.J.G.

220. THE RETURN FROM THE FLIGHT INTO EGYPT

Painting once mounted in an album
Isfahan, 1689
H: 19.5 cm; W: 14.1 cm
Cambridge (Mass.), Harvard University Art Museums, 1966.6

Signed by "the least of the slaves, the son of Haji Yusuf, Muhammad Zaman, in Isfahan," and dated in the late summer of 1689, this

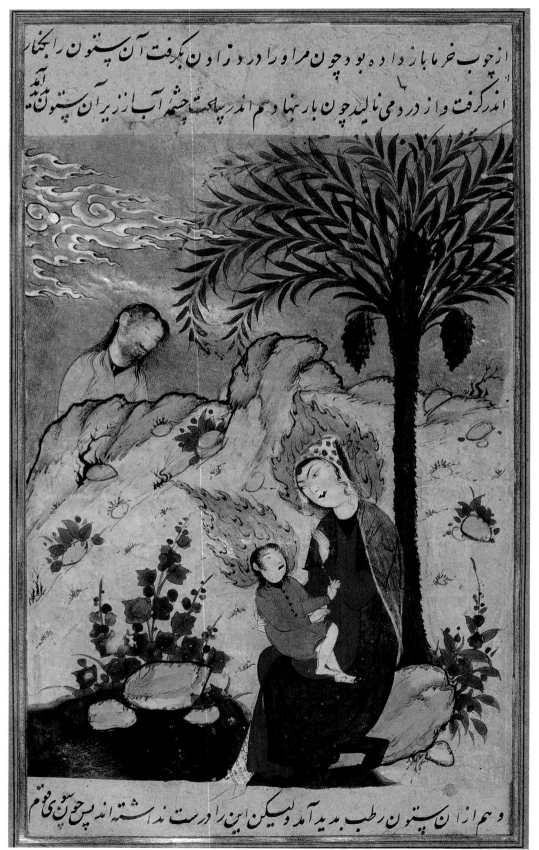

219

side of a center parting; Jesus is now dark haired, and the radiance around his head in the print has become a solid glowing halo in the painting. The Virgin's brimmed hat and tucked-up hair, and the satiny luster of her gown and wrap, have been replaced by an olive-green headcloth and a solid golden halo, long dark curling locks, and large jeweled pearl earrings; the cloth of her gown is both unpatterned and texturally undistinguished. It is impossible to know whether Vorsterman's printed copy was also colored, but we may wonder how it came about that, in Muhammad Zaman's painting, the Virgin's garments retain the colors in which Rubens had painted them: the robe a coral pink with white veiling at the neckline and her enveloping wrap the canonical blue. By contrast, only the olive green of Joseph's garment recalls the darker green of the original, while Jesus' tomato-red robe here is quite unlike the blue-grey color in Rubens' picture.

This is the latest recorded picture in a series of dated figural compositions by Muhammad Zaman that go back more than thirty years to 1649, while his earliest known painting is also a copy of a European image. It is clear that such exotic imports were a constant feature in his work.

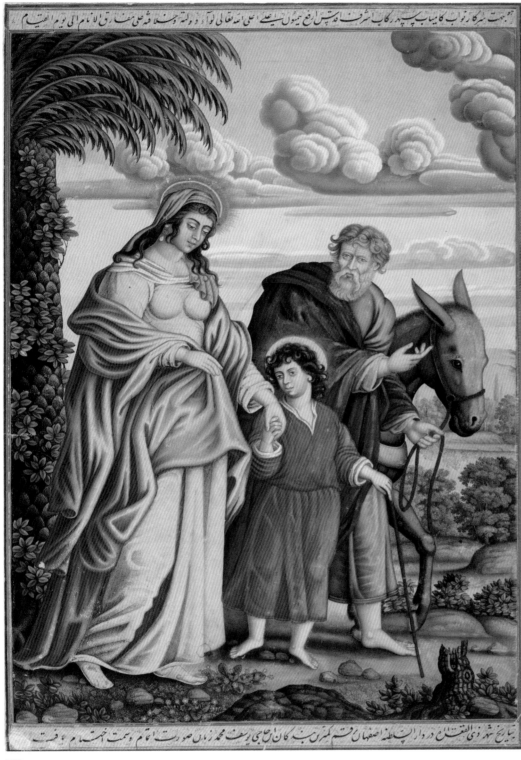

220

small painting on paper is based on a print which in turn reproduces a large oil painting, of an episode from the New Testament, by Peter Paul Rubens.

The print was made by Lucas Vorsterman between 1615 and 1620 under Rubens' supervision; he worked directly from a smaller drawing of the painting which was the work of Rubens' then-principal assistant, Anthony Van Dyck. How large an edition the print was made in, and how and when a copy arrived in Isfahan, are unanswerable questions; but Flemish, Dutch, French, and Italian reproductive prints traveled literally all around the world in the seventeenth century, and

another version of this particular figural group is to be found in the center of a larger painting done in 1681 in Peru by a talented artist of Inca blood.

As is sometimes the case with prints made after paintings, Vorsterman reversed the original direction of the image. Muhammad Zaman retained the reversal but made other alterations: he moved the dominating palm tree to the left of the composition [232] and altered the shape of the puffy white clouds, so that they appear to rise above a streak of grey cirrus cloud. He also made changes to the figures: Joseph is older and has a narrower face, with nearly white hair falling to either

221. THE COURT OF GAYUMARTH, THE
FIRST KING

> Folio from a now-lost (or never
> executed?) manuscript of Firdausi's
> *Shahnama*
> Tabriz or Baghdad (?), ca. 1325–50
> H: 20 cm; W: 20 cm
> Istanbul, Topkapı Saray Museum, H. 2153,
> fol. 55v

An image of the primordial first shah of Iran,
surrounded by his courtiers and all the animals
of the earth, is often the first illustration
in manuscripts of Firdausi's *Shahnama*. This
painting, mounted into the same album as
"Kay Khusrau Victorious Over the Divs"
[102], shares many of the same technical
characteristics, and the figures also display a
similar sense of personage, build, and drawing.
Perhaps both pictures originally came from –
or were intended for – the same large volume
of Firdausi's text.

The poet's description is brief but the
salient details must have struck at the visual
imagination and were almost always
incorporated into pictures of the scene:

> He who compiled the ancient . . .
> tales . . . saith Gaiumart
> Invented crown and throne, and was a Shah. . .
> who dwelt at first
> Upon a mountain; thence his throne and fortune
> Rose. He and all his troop wore leopard-skins . . .

Fur clothing, of ermine, tiger, and leopard
skin, as well as leopards and cheetahs, are
much in evidence here, in a visual echo of
Firdausi's words.

That this painting is among the earliest
recorded images of the subject lends it special
interest. Presently square in shape, it was
almost surely cut down before it reached
the haven of an album and was no doubt
originally higher than it was wide. In this
feature, then, it would present a major
conceptual advance on other recorded early
images from the *Shahnama*, most of which
are narrow, horizontal rectangles in shape. The
landscape is Far Eastern in both inspiration
and detail, and the foreground is impression-
istically colored over a neutral hue, as if on
bare paper in the Chinese manner, while the
medium-blue sky with streaks at the edges
suggests a naturalistic element in the mixture
of sources. On the other hand, the
composition also has Middle Eastern
antecedents that are centuries old and were
continuously reused by Muslim painters [49,
128]. The palette anticipates an unmistakable
feature of later classical Iranian manuscript
painting – the distribution of color
throughout a picture. Here, recurring areas of
red – in the fur-brimmed hats and boots, a
spray of red petals in the foreground, and the
vivid red camellia-like flowers at the left – are
an early example of the subtle color harmony
that would come to characterize some of the
best Timurid and Safavid paintings.

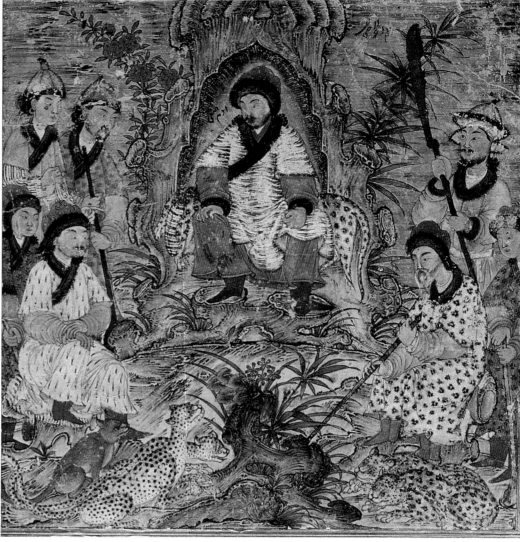

221

The knobs on both sides of Gayumarth's
throne suggest cut-off boughs and, therefore,
that the first king of the world sits upon a
huge, hollow tree stump, with more branches
cut off for footrests. The frothing blue-tinged
shapes at the top are strangely rock-like; they
clearly stand behind one of the most
peculiar and specific features of Shiraz
landscapes from the second quarter of the
fifteenth century – a piled up organic mass
of fantastically colored rock which
"overflows" at the top [222]. But the shape
of the niche cut into the tree stump in
which Gayumarth sits also reminds us that
this painting dates from an earlier moment,
when East Asian Buddhist forms still lay
within the pictorial memories of Iranian
painters. Descending in wide, even lobes
from a pointed apex, it recalls the flaming
halo surrounding some figures of the
Buddha, as if to set the first shah of the land
of Iran into the Buddha's position.

Developed from so many older and
contemporary Asian sources, this is a
remarkable painting: masterful in compositional
asymmetry and coloristic harmony, and
texturally rich. Indeed, the exceptional
handling of animal fur, skin, and hide in the
dispersed Jalayirid *Kalila u Dimna* of about

1360 [203] may well derive from the same
tradition, if it is not actually the work of the
same painters.

222. THE COURT OF GAYUMARTH, THE
FIRST KING

> Painting from Ibrahim-Sultan's manuscript
> of Firdausi's *Shahnama*
> Shiraz, ca. 1431–35
> H: 14 cm; W: 15 cm
> Oxford, Bodleian Library, Ouseley Add.
> 176, fol. 20r

Ibrahim-Sultan's illustrated *Shahnama*, in
contrast to the severely restrained and carefully
chosen program of Baysunghur's, has an
expansive and almost leisurely pace. If the
aesthetic of his painters was that "less is
more," one of the ideas governing the
distribution of pictures in his *Shahnama*
appears to be that "more is better." Thus, to
the opening pictures of Baysunghur's
Shahnama – "Firdausi and the Poets of
Ghazna," and "Jamshid Teaching the Crafts" –
Ibrahim-Sultan added an image of Gayumarth
on a mountain surrounded by his troop of
followers clad in leopard skins.

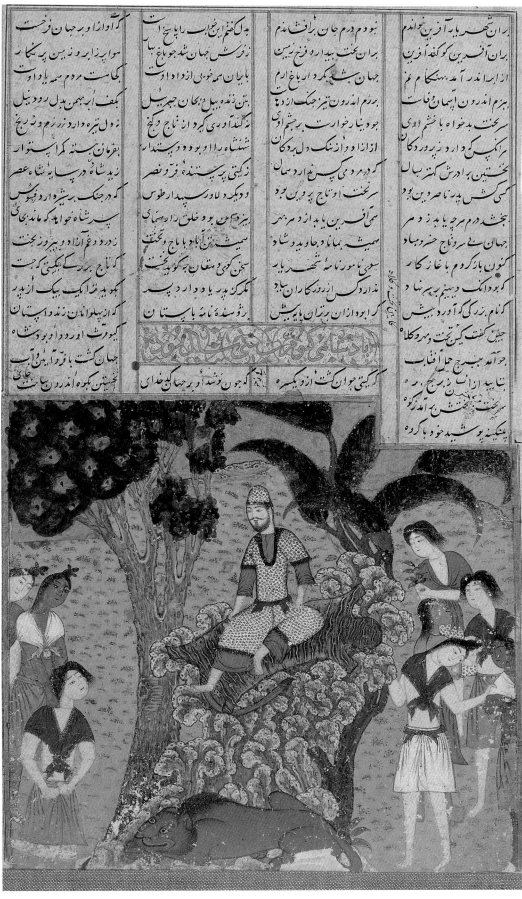

222

one of those Shiraz creations that suggest whipped cream or froth, or a huge exploding fungus; here it is fairly restrained and shares the "piecrust" articulation of the farther horizon.

How much the picture owes to earlier versions of the same scene, such as the "square-format" [221] picture mounted in one of the Istanbul albums, is a matter for speculation, but the essential details of both come directly from Firdausi's text. On the other hand, Baysunghur's majestic *Shahnama* [72, 75] includes pictures copied almost exactly from a celebrated later fourteenth-century *Shahnama*; even the layout of the text of his illustrated Firdausi repeats the somewhat archaizing layout in six columns. Given the long history of bookmaking in Shiraz, we might wonder what visual repertoire remained in the minds and habits of Shiraz painters – if not actually on paper in their workshops – by the time Ibrahim-Sultan came to commission his own illustrated manuscripts.

223. THE COURT OF GAYUMARTH, THE FIRST KING

> Painting from the dispersed manuscript of Shah Tahmasp's *Shahnama* of Firdausi, folio 20v
> Tabriz, between 1525–35
> H: 34.2 cm; W: 24.1 mm
> Geneva, Collection of Prince Sadruddin Aga Khan

Among the

> . . . creations depicted in His Majesty's *Shahnama* is a scene of people wearing leopard skins; it is such that the lion-hearted of the jungle of depiction and the leopards and crocodiles of the workshop of ornamentation quail at the fangs of his pen and bend their necks before the awesomeness of his pictures.[1]

In such words did Dust Muhammad, librarian to Bahram Mirza, the brother of Shah Tahmasp, describe this first of the illustrations to Firdausi's great poem in the manuscript that must now be the most celebrated of all illustrated copies of classical Persian poetry, Shah Tahmasp's *Shahnama* [139, 233]. The painting is unsigned, but Dust Muhammad tells us who painted it, "the rarity of the age, Master Nizam al-Din Sultan-Muhammad," first on his list of seven painters who worked at the court of Shah Tahmasp during the 1540s.

Gayumarth's troop of followers in leopard skins is now a huge circle of courtiers and attendants, drawn from all the races of the world that might have been seen in Tabriz at this time. Men, women, and children gather in the presence of the first king, his son Siyamak, and his principal advisors kneeling in an angled row at the left. The gathering takes place in a verdant glade in the midst of the most flame-like and incandescently colored

Again his painters took their cues directly from Firdausi. As the art of dress is in its infancy, the followers' clothing is as simple as the artist(s) could imagine: the brief skirts worn by *div*s and something indeterminate knotted over the shoulders, in the manner of the animal skins worn by sufis [174] and darvishes. This notion does not extend to Gayumarth, who is instead clad in a leopard-skin *jama* that matches a simple hat, since the kingly head must be ennobled by headgear. The mountain on which he is enthroned is

چو آمد بر جمل آفتاب
جهان گشت با فروبن و آب
بتاپ درآن سان سبنج
کیست جهان شد از و یک

کیومرت چون شد جهان کدخدا
نخستین بکوه اندرون شت جای

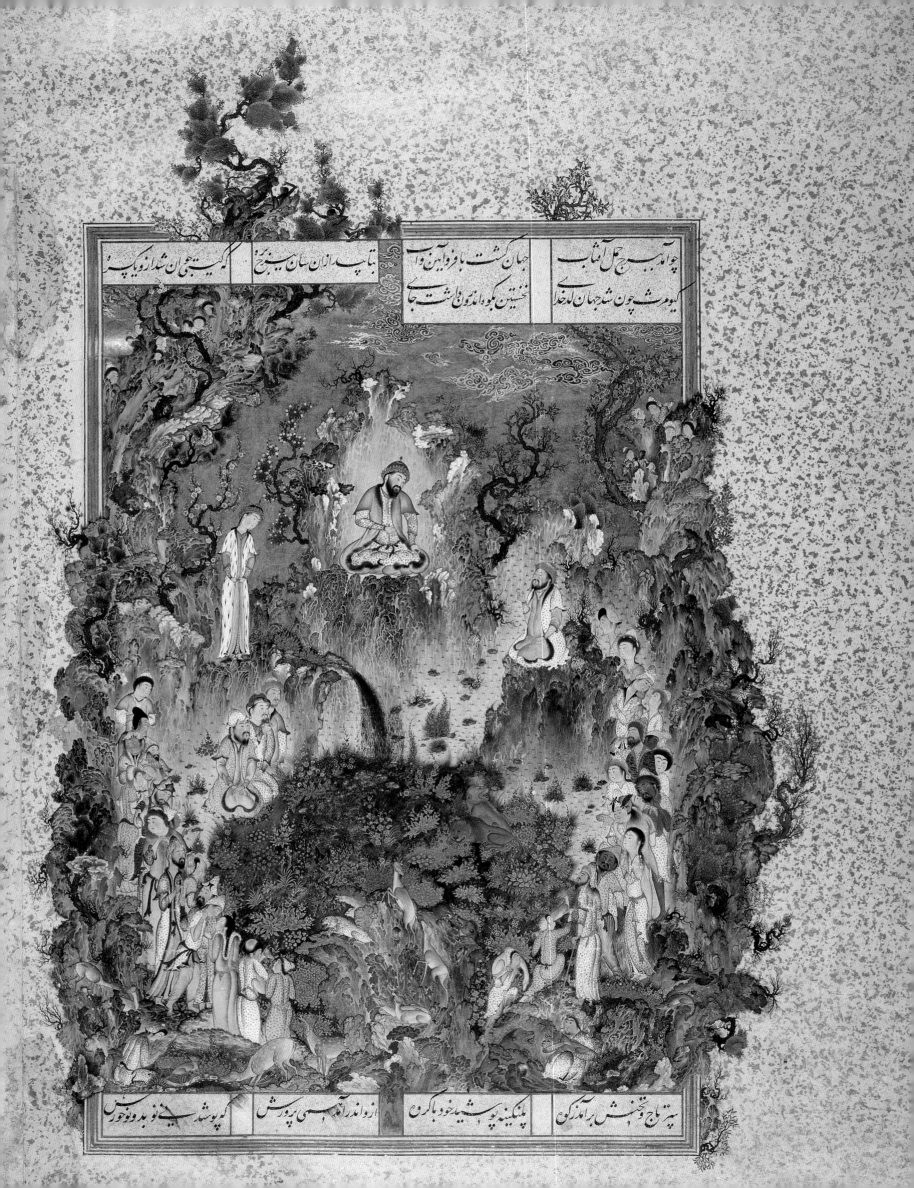

rocky mountains ever painted; lions and leopards, deer and ibex, jackals and monkeys join the throng assembled under the golden sun of a flowering spring day.

"Visionary" is the word usually applied to Sultan-Muhammad's paintings, conveying the exalted atmosphere of the Safavid court often sensed at the period of Shah Isma'il, and in the tone of his own poetry. If the word now seems overused, it is surely apposite for the landscape of this painting. Not so frantic as Sultan-Muhammad's landscapes sometimes are, the rocks are nonetheless painted as if they were burningly alive with internal fires breaking forth in mineral flames of unreal colors and striking juxtapositions: sulphur yellow and lapis blue, intense reddish lavender and a malachite green, deep blue-purple and a turquoise green, flaring orange and tawny brown, judiciously touched with red and white, dun and rusty orange. The rocky ground frames the circle of Gayumarth's followers and breaks out of the margins on both sides of the painting. Spurs project above the circle on both sides, and the more precarious of the two, at the left, also breaks through the top margin, its silhouette extended by a tamarisk tree in which monkeys cavort. In the foreground rises another spur, where a lone leopard ignores the deer climbing behind it; Gayumarth's throne is yet another rocky spur that appears to rise sheer from the desert floor behind the silvery waterfall flooding the central verdant glade of the picture. It is, in Dust Muhammad's words, a vision of a "paradise without shortcomings."

It is also a vision firmly based on Dust Muhammad's "style of depiction now current," a tradition of painting that by this date had been in practice since the mid-fourteenth century. Sultan-Muhammad's breathtaking vision of Gayumarth and his court is, in fact, a sixteenth-century version of the composition of a Jalayirid painting of the same subject [221], however much the personages in it have been multiplied and presented according to early Safavid norms of figural and facial beauty, however much the landscape has been broadened and infused with enchanted forms and colors. In both pictures Gayumarth sits on the same towering rock-throne at the apex of the picture, and the same rocky excrescence marks the foreground space. The broad circle of followers, elegantly long in figure but all deliciously corporeal, has compositional forerunners in two later fifteenth-century double-page paintings, one "The Great Hunting Party of Uzun Hasan" [26], the other the frontispiece of a manuscript made for Badi' al-Zaman ibn Sultan-Husayn Bayqara in 1496.[2] Both pictures could have been known to Sultan-Muhammad in Tabriz in the early years of the sixteenth century – if he was not himself the very young painter of "The Great Hunting Party." The compositional similarities, the dispositions of the animals climbing among the rocks, and the blue-and-white coiling clouds in the golden skies of

both paintings, are striking; they also occur in "The Sleeping Rustam" [78], probably also to be assigned to his hand.

Other echoes of Jalayirid painting can be seen in the faces of followers ranged in the circle before Gayumarth, especially that of a man in a close-fitting fur-edged cap at the right; his closely-set eyes, downturned mouth, and mustache, recall "old Gudarz" at the right of Kay Khusrau's throne in another early Jalayirid painting [102]. These works of the mid-fourteenth-century had almost surely been carried from Tabriz to Herat in the baggage of Baysunghur, when his father Shahrukh appointed him governor in the Timurid capital of Herat in about 1425; they must have returned to Tabriz at the end of the century in the wake of the Safavid conquest of Khurasan, almost surely in the baggage of Badi' al-Zaman. The wonder, then, is not that Sultan-Muhammad, the "wonder of the age," should have based this vision upon a painting earlier by two centuries; but rather that he transformed its large and rather forthright forms into such an extraordinary painting that his companions should have been deeply moved upon seeing it, and that a sensitive contemporary observer should have commented upon it in terms of such awe – but also precision – that we are able to link painting and painter with the comment. It is virtually unique in the history of Iranian manuscript illustration.

224. BAHRAM GUR HUNTS WITH AZADA

> Silver plate
> Iran, seventh–eighth century
> Diameter: 28 cm
> St. Petersburg, State Hermitage Museum,
> S-252

This plate was found in 1927 in the same hoard in northern Russia as the plate with the image of Shapur II [20]. Its shape and technique of manufacture are typically late Sasanian, the background around the figures being carved away. On the outside is a Middle Persian inscription of the owner's name and the weight of the vessel.

Bahram "that great hunter" rides a camel, with Azada, his concubine, seated behind him; they are hunting gazelle, and Bahram has wounded three of the four with his arrows. The scene illustrates a key episode in the legend of Bahram Gur, the Sasanian king Varahran (or Bahram) V, who was something of an epic hero for the later Sasanian period. The image became enormously popular in medieval Iranian art, and versions of it can be read in both Firdausi's *Shahnama* [227–8] and Nizami's *Khamsa*.

According to Firdausi, Bahram as a young prince lived among the Arabs and often hunted with companions. One day, his slave-musician Azada, mounted behind him, challenged him to display his prowess as an archer: with successive shots from his bow, he should turn the male gazelle into a female and the female into a male, and then "sew"

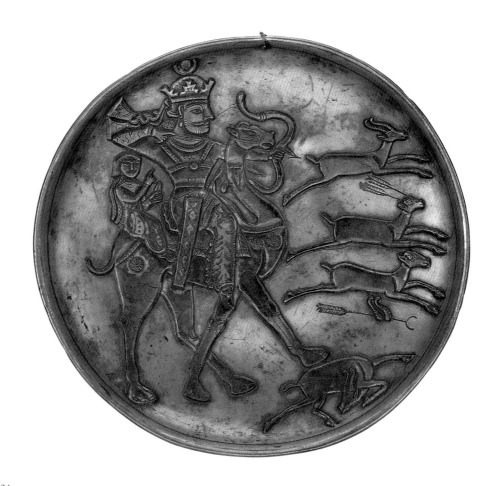

together the ear and shoulder of a third. The prince took up her challenge. With a pair of arrows he made artificial horns on the head of the female, and with a single one, shown here as having a crescent-shaped head, he removed the horns from the head of the male. With his fourth arrow, he grazed the shoulder of the third animal which, in flight, touched its shoulder with its ear – so that the last arrow pinned together the ear and the shoulder of the beast. Instead of rejoicing, Azada accused Bahram of having *div*-like powers, at which Bahram threw her off his camel and trampled her into the earth.

So apparently impetuous and vengeful a reaction seems extreme, but it had a profoundly important meaning for the Sasanians. An unsuccessful hunt, or one conducted with the assistance of *divs*, would have indicated the prince's lack of *farr*, royal charisma, and thus his unsuitability for kingship; and the artisan has faithfully followed the legend. The owner of such a vessel would have hoped to obtain a small part of the enormous skill, and the princely *farr*, of Bahram Gur.

Some details of the prince's attire are mistakenly drawn, such as the absence of the sword, the tiger-stripes on the fluttering ribbons, and even the crown, which is not actually that of Varahran V. This plate (and another showing the same episode)[1] was probably made in the second half of the seventh century, after the Arab invasions of Iran. Interestingly, the story of Bahram Gur and Azada is the only epic motif ever to figure in Sasanian visual art. B.I.M.

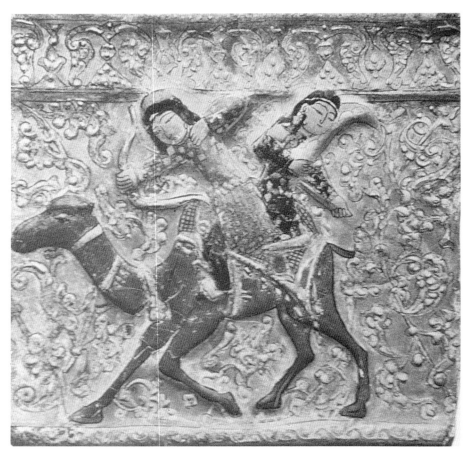

225

225. BAHRAM GUR HUNTS WITH AZADA

> *Mina'i* and relief-molded tile
> Iran, twelfth or early thirteenth century
> H: 20 cm; W: 20 cm
> Present whereabouts unknown

On a square, molded tile from an architectural ensemble which is otherwise completely lost, a nimbed man in a patterned garment, mounted on a camel and accompanied by a female harpist wearing a robe with a different pattern, pulls a bow and arrow. They are Bahram Gur and his slave-musician Azada.

The pair is painted in gold and colors against a turquoise background with molded and gilded scrolls; the groundline is also molded, as is the decorative frieze above their heads. The gazelles which Bahram was hunting that day are not represented; they would have been on the next tile to the left in this ensemble.

Identifiable images from the *Shahnama* are uncommon on ceramic tiles of the Seljuq period; they rarely preserve even the barest of descriptive inscriptions [3] let alone a poetic text they could be said to illustrate. This is also the case with the far more numerous

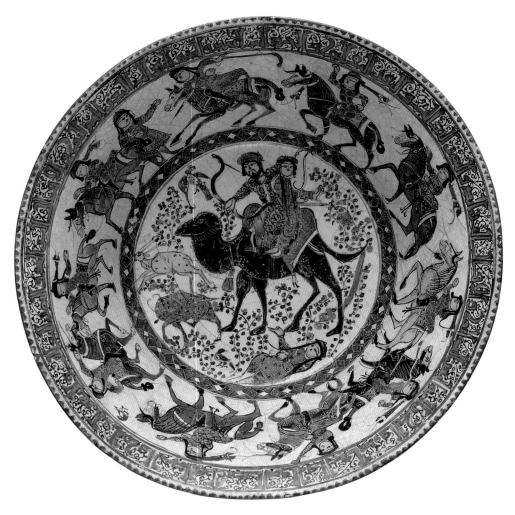

226

Ilkhanid luster-painted tiles which, either in text or word, invoke themes from the *Shahnama*. Indeed, it is hard to escape the conclusion that image and text were not necessarily intended to function together.

226. BAHRAM GUR HUNTS WITH AZADA

Mina'i ceramic bowl
Iran, twelfth or early thirteenth century
D: 21.6 cm
New York, Metropolitan Museum of Art,
57.36.13

Bahram Gur on camelback, his harp-playing slave Azada mounted behind him, hunts in a landscape painted on the interior of a *mina'i* bowl. As on the late Sasanian silver plate decorated with the same subject [224], the episode is epitomized, albeit differently. A female gazelle at the left is crowned with Bahram's arrows, while another, below her, scratches its shoulder and thus permits its ear and shoulder to be pinned together; at the very bottom of the scene lies the outspoken slave, trampled under the feet of the camel.

The silver plate and the ceramic bowl represent two different ways in which a narrative scene with highly specific components – any one of which would identify the subject – might be adapted for decorative use on a three-dimensional object. The silver plate is both smaller and flatter than the bowl and the figures, together with the four gazelles of the story, nearly fill its shallow interior space. The *mina'i* bowl has straight, high-rising sides and thus more registers of vertically circular surface to cover, and its decorative scheme is more elaborate than other *mina'i* bowls with the same subject.

Here the central image of the hunter and his hapless slave is set in a leafy landscape enclosed within a circle surrounded by a diamond-patterned border; in the cavetto ten riders, scarves flying out behind them in the wind, race past a single standing man. They do not carry weapons, nor do birds or hunting dogs appear, but one man brandishes a polo stick: perhaps they are engaged in some feat of horsemanship. The border is of painted kufic letters set against scrolling ornament, a detail often displayed on even the simplest of Iranian fritware vessels. And of course the object is painted in many colors. If the silver plate better conveys a sense of narrative, it does so in a "palette" of monochrome silver, whereas the polychrome effect of the *mina'i* bowl is one of dense, joyous decoration despite the serious import of the subject.

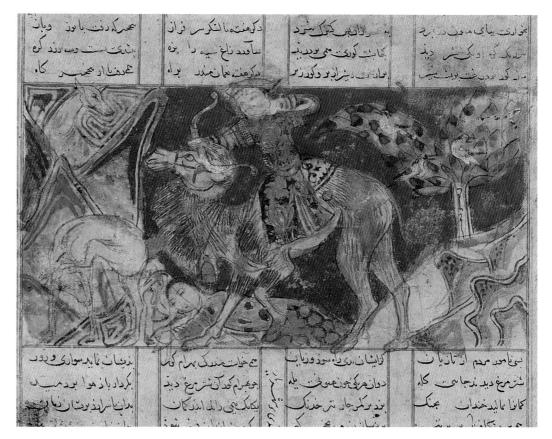

227

227. BAHRAM GUR HUNTS WITH AZADA

Painting from a manuscript of Firdausi's
Shahnama
Shiraz, 1352
H: 8.6 cm; W: 15.3 cm
New York, Metropolitan Museum of Art,
57.51.32

By the middle of the fourteenth century, the episode of Bahram Gur hunting on camelback with his slave-musician Azada was securely placed within at least one version of the illustrative program of the *Shahnama*. The "Great Mongol *Shahnama*" and all four of the manuscripts made in Inju Shiraz between 1330 and 1352 include it; all five depict the crucial moment of the story, the trampling of the lady beneath the feet of Bahram's camel. It does not seem to appear in any of the so-called "Small *Shahnama*" manuscripts, another confirmation of the great difference in the illustrative programs of the same text in this formative period of Iranian manuscript illustration.

This picture is on a folio removed from the last of the four Inju copies, of 1352. Comparison with versions in two of the earlier manuscripts – in Istanbul, of 1331,[1] and in St. Petersburg, of 1333[2] – as well as with a *mina'i* bowl of perhaps a century or more earlier, is revealing. In all three pictures the lady has uttered the fatal words and is shown under the camel's feet; in all three she lies face down; in all three she wears the same dress, of a dark color patterned with large white dots, and her headdress has disappeared, lost in the

fall. Curiously, she faces to the left in all three pictures but in this painting, the figure of the king on his camel above her faces left whereas, in the other two, his image has been flipped and he faces right. Yet in all three Inju illustrations, as well as on the Seljuq *mina'i* bowl, the camel seems to be the same beast, with a large golden bell hung around a shaggy-haired neck; unlike the camel on the *mina'i* and relief-molded tile, which is smaller and more equine in silhouette.

228. BAHRAM GUR HUNTS WITH AZADA

Painting from Muhammad Juki's
manuscript of Firdausi's *Shahnama*
Herat, ca. 1440
H: 17 cm; W: 12.5 cm
London, Royal Asiatic Society, MS 239,
fol. 362v

Representations of one of the oldest legends in all Iranian art, the canonical image of Bahram Gur hunting gazelle on camel-back with his slave-musician Azada, underwent an interesting shift in the Timurid period.

By about the middle of this century, manuscripts made outside of courtly centers, as well as those painted in the Turkman style, still illustrate the episode by showing Azada being trampled by Bahram's camel. But pictures in manuscripts copied and illustrated in court ateliers of greater sophistication – such as Herat, Tabriz, Qazvin, and Isfahan – are more likely to choose the moments prior

to the lady's literal fall from grace: they depict an anodyne, if slightly exotic, scene in which princes and their companions hunt gazelle on camelback. This illustration shows just that – a richly dressed couple mounted (on the same camel) and hunting gazelle, in the classical Timurid version of a desert in which flowering plants bloom at scattered intervals.

The requisite four gazelles are shown, blood spurting from the shoulder of the one being disabled by Bahram's arrow. For good measure, the artist has also included a pair of the wild asses, *gur*, the passionate hunting of which gave Bahram his epithet, Bahram Gur. That a pair of them is shown appears to be a subconscious recollection of the Sasanian convention [20, 224], that the hunted prey on princely silver plates with hunting scenes is almost invariably shown as pairs of animals, whether ferocious or peaceful.

229. BAHRAM GUR SLAYS THE DRAGON

Painting from a dispersed manuscript known as the "Great Mongol *Shahnama*"
Tabriz, ca. 1325–35
H: 19.4 cm; W: 29.4 cm
Cleveland, Cleveland Museum of Art, 43.658

Bahram Gur "that great hunter" – Varahran (Bahram) V – slew not only real animals but also fantastic and composite creatures. Some are called, and represented as, "dragons" but may be described in different terms: this one is ". . . like a lion. From its head / Hair hung down to the ground, and it had breasts / Like those of women." Bahram encounters it almost casually, in the midst of a month of hunting in Turan, and Firdausi has him dispose of the beast in a mere seven lines, devoting only four more lines to freeing the youth

caught in its maw. The relevant text is unprepossessing but the image depicting the episode in the "Great Mongol *Shahnama*" is the opposite: indeed, it is one of the truly unforgettable images of Iranian manuscript illustration.

The unequal size of the protagonists evokes an initial visual, and emotional, impact and will bring to mind David battling Goliath. Bahram is shown from the rear, a figure jauntily striding forward to carve the dragon's breast with his sword, just as Firdausi writes. The dragon is a purely Chinese image: a spotted scaly fin-spined body writhing in loops, with clutching claws and snapping jaws, popping eyes and flaming crest. Far too large for the picture space, it is dreadfully cramped in its death throes and adds to the profound discomfort already induced by the picture. The vertiginous mountain landscape in the background bristles with pine foliage and increases the sense of looming, frowning nature.

The drawing of the dragon is especially fine and beautifully modulated, the palette dramatically dark but enlivened with lighter passages and touched with gold and (now-oxidized) silver. Bahram's head is nimbed, as it is in the painting that immediately follows this episode [167]; it is an unusual feature in this ensemble of paintings and occurs in only ten of them, of which five depict Bahram Gur. Both pictures also display a similar treatment of landscape: they each have a ground-line rising shallowly to the right, with Chinese foliage and spotted fungus-like rocks, although the sugar-loaf shape of the mountains here do not figure in the next picture. Lastly, each picture seems to push against its rulings, as if what each contains were too large for its respective frame. It is hard to escape the conviction that the same hand was responsible for these consecutive illustrations in so splendid a fragment of a particularly fine manuscript.

230. BAHRAM GUR SLAYS THE DRAGON

Painting in a manuscript of Firdausi's *Shahnama*
Shiraz, 1333
H: 10.4 cm; W: 22 cm
St. Petersburg, Russian National Library, Dorn 329, fol. 267v

More than occasionally, a painting in one of the four Inju *Shahnama* manuscripts made in Shiraz shows itself to be extraordinarily close in content and composition to a picture from the "Great Mongol *Shahnama*" probably made in Tabriz. "Bahram Gur Slays the Dragon," from the 1333 Inju copy, is a very good example: it makes us pause to consider just how, and when, the transmission could have occurred.

Against the classical red Inju background, a mounted Bahram Gur looses an arrow

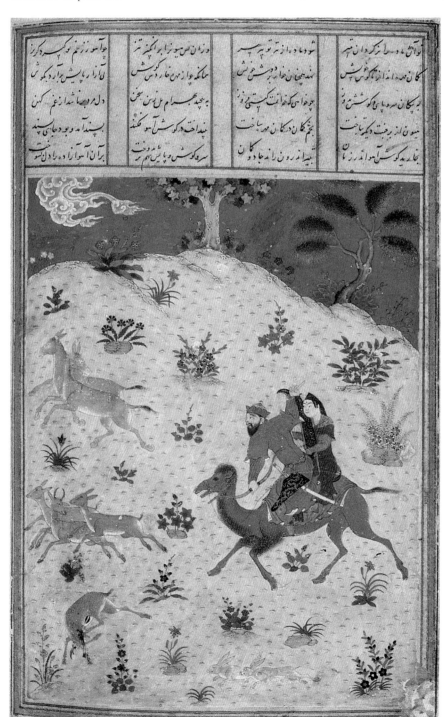

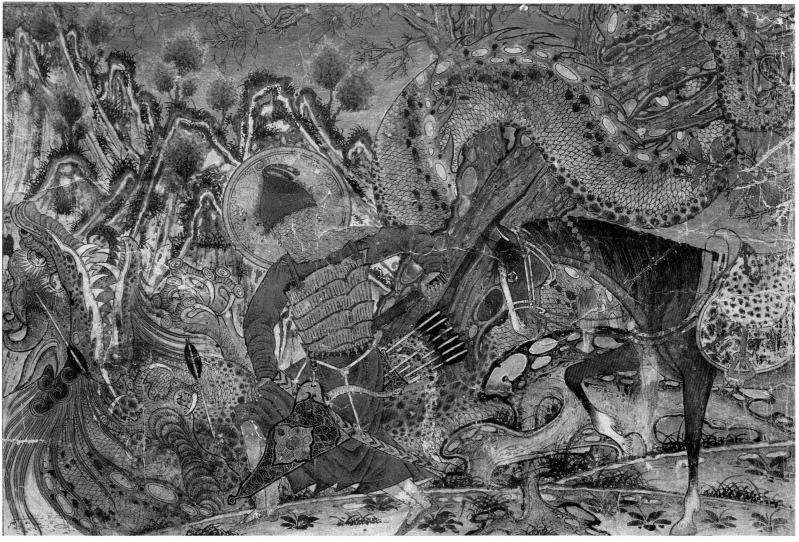

229

230

toward the beast. Bear-like in its head and forequarters, this creature has a thick, corrugated tail that rises and writhes toward the top of the picture (and neatly turns left at the corner). Fins on the spine and spots on the body recall the larger Tabriz image of the impressive Chinese-like dragon [229]; so do the mountains in the lower left, although they seem more like a recollected motif of little visual conviction and have no bristling pine foliage. In compensation, however, the thinness of the color on the dragon's body reveals a literal detail absent from the previous picture: the youth gulped down by the beast.

231. BAHRAM GUR SLAYS THE DRAGON

Painting in a manuscript of Nizami's
Khamsa dated 1442
Herat, ca. 1490–95
H: 12.5 cm; W: 9.4 cm
London, The British Library, Add. 25900,
fol. 161r

In Nizami's story of Bahram Gur and the dragon, the great hunter follows a particularly alluring wild ass to the cave of a dragon. Once Bahram has slain the dragon, he beheaded it and "cleft its form from stern to stem, / and found the ass's foal therein."[1] In gratitude, the ass led Bahram deeper into the dragon's cave where

> he found a treasure; smiled with joy.
> Many great jars were placed therein,
> veiled like the peri-faced from men.
> Bringing the Ass-King to that cave,
> the wild ass left without a trace.[2]

Firdausi's Bahram Gur, like so many of his heroes, is no stranger to the confronting of supernatural beings. But Nizami's Bahram Gur is not so accustomed to such encounters and must gird himself for the ordeal, knowing full well that the alluring ass has brought him to the dragon's cave for a reason:

> . . . I must requite
> the ass, without fear for my life.
> Let be what will be.[3]

Both Firdausi and Nizami develop the *topos* of the heroic encounter of a human being with an unreal and horrendous creature; both compound the heroism of the deed by the retrieval of an innocent young being from within the dragon's body.

The encounter as it is painted in this tiny, exquisitely illuminated manuscript takes place in a landscape of desert and rocks under a shining golden sky. At the right, the dragon emerges from the small opening of its cave; it is fanged and clawed, scaly of skin but anodyne in its pale-blue and whitish coloring. At the left Bahram's horse rears as the prince looses the double-barbed arrow; the ass watches, alone at the horizon. When Bahram returned to Khwarnaq with the immense treasure, he generously dispensed it, sending

231

ten camel-loads to his father in Iran, and giving ten more to Munzir, the new king of the Yemen. Munzir then celebrated the event, as he had Bahram's previous feat of slaying a lion and an onager with a single arrow:

> then called a painter; him
> he bade a painting new to limn;
> The painter took his brush in hand,
> painted the dragon and the king.
> With all such feats Bahram performed,
> the painter Khavarnaq adorned.[4]

232. BAHRAM GUR SLAYS THE DRAGON

Painting added to Shah Tahmasp's
manuscript of Nizami's *Khamsa*
Ashraf, 1675
H: 21.8 cm; W: 18.3 cm
London, The British Library, Or. 2265,
fol. 203v

The third painting Muhammad Zaman added to Shah Tahmasp's great but unfinished *Khamsa* manuscript is the tale of the alluring ass who enlists Bahram's assistance in retrieving her foal, which had been swallowed alive by a dragon. In gratitude, the ass shows Bahram the treasure hidden by the dragon deep inside its rocky lair.

Here the entire story has been telescoped into a single image: in the background, the ass flees towards the cleft in a mass of rock, but Bahram has just begun his assault on the beast. The dragon slinks in the foreground, like a scaly snake with short stubby legs and padded feet, turning its head backward to snarl at Bahram just as his arrow draws blood. Bahram is shown as the very model of a fairytale prince: young, beautiful in face and figure, ideally calm and unperturbed as he releases his arrow at the beast. He is mounted on a narrow-headed thoroughbred horse with a powerfully swelling body on slender legs and delicate hooves. His dress is that of the seventeenth-century Safavid dandy: he wears a padded candy-pink *jama* tightly cinched at the waist and an enormous striped turban with a crisp golden frill surmounted by large plumes of white and black.

The setting is perhaps the *locus classicus* of Muhammad Zaman's landscapes, in which can be found all the details characteristic of any of his pictures, on any scale: the deciduous tree with oak-like foliage "glued" to the left margin; in the foreground, the stump of a tree snapped off close to the ground – here shown falling away to the left; the massing of rock in squarish units of grayish brown, here a high curving mound in the background with several clefts in its surface; another deciduous tree, tall and slender with foliage broader at the top than it is further down, and always seen in the distance. This painting also displays the characteristic application of paint in his landscapes, stippling, the dotting of pigments, which yields an illusionistic effect, rarely seen in Iranian painting before about the middle of the century [cf. 181]. Such landscape features, and the velvety appearance that results from stippling the paint surface, were both adopted by Iranian painters and widely used from that time until virtually the end of the Qajar period [163; Fig. 84].

233. BARBAD THE CONCEALED
MUSICIAN

Painting from the dispersed manuscript of Shah Tahmasp's *Shahnama* of Firdausi, folio 731r
Tabriz, between 1525–35
H: 47 cm; W: 31.8 cm
London, The Nasser. D. Khalili Collection of Islamic Art,
MSS 1030.9

234. BARBAD PLAYS FOR KHUSRAU

Painting in Shah Tahmasp's *Khamsa* of Nizami
Tabriz, 1539–43
H: 30.6 cm; W: 18.2 mm
London, British Library, Or. 2265, fol. 77v

Music must have been highly valued at the Safavid court of Shah Tahmasp. Both his *Shahnama* and his magisterial *Khamsa* include pictures in which the celebrated harpist Barbad enchants the Sasanian monarch

Khusrau Parviz with his singing and playing. Firdausi's story had been illustrated in manuscripts as early as the fourteenth century, whereas the picture in Tahmasp's *Khamsa* appears to be unique.

Firdausi's account seems – but is not – a mere digression, at the time of the New Year Festival in the twenty-ninth year of Khusrau's reign, for it was the shah's custom to celebrate the arrival of the new year, and the spring, within a verdant garden. Khusrau's chief musician was aging, at the same time as a brilliant, younger musician called Barbad began to make a name for himself. The older musician had tried to block his access to the shah but Barbad resorted to a ruse and, dressing himself all in green, hid in the branches of a tall cypress tree near the pavilion where Khusrau was to celebrate the New Year. As night came on, Barbad started to sing; his songs enthralled the shah and his company, save the aging musician, and the shah ordered the musician to be found. First

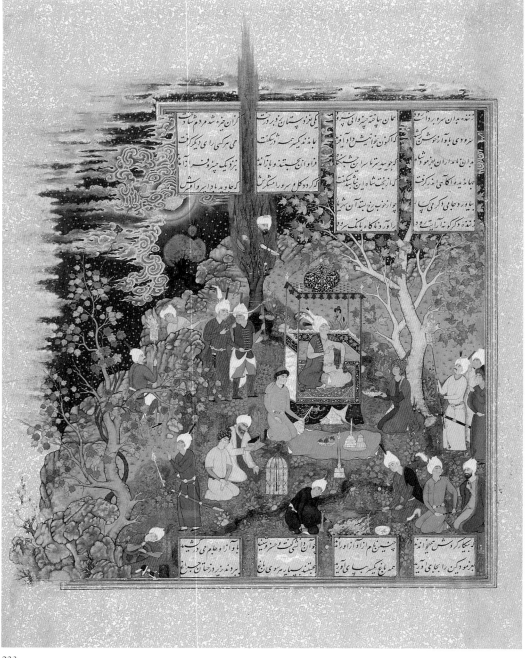

233

the pavilion, and then the garden, was searched, but to no avail. The king was overheard to say in frustration that he would fill the mouth and lap of the unseen musician with gems and make him chief minstrel, at which Barbad descended from his hiding place: thus "Barbad became / Chief minstrel and renowned among the great."

The *Shahnama* picture is one of the larger and more glorious paintings in the entire manuscript. The garden and the night sky spread out over the page beyond the written surface, and the tip of Barbad's cypress tree breaks through the upper margin. Under a sky spangled with stars and a refulgent full moon partly veiled with mist and floating clouds, the royal party has gathered in a glade watered by a stream. The music has been playing for some

time. The shah listens attentively, his head cocked, looking upward toward the sounds drifting from the cypress tree behind him, where Barbad – not dressed in green, for then he would be pictorially invisible – plays upon a huge lute of the type called a *shahrud*.

The search is afoot: two servants hold cresset lamps to light the ground under a tree or behind a rocky outcrop, and another holds a long, lit taper to search under a tree at the outer margin. And Barbad sings his magic music, which eventually brings Khusrau to exclaim:

> An angel this, . . .
> For if he were a div he would not sing,
> Or know to play the harp!

So Barbad entered the service of Khusrau

Parviz. In Iranian legend he was an important figure at Khusrau's court: Nizami, several centuries later, depends much upon his talents in retelling the story of the romance between Khusrau and the Armenian princess Shirin. At one crucial stage not long before the pair are actually wed, a last obstacle is resolved by a musical dialogue, Barbad's songs speaking for Khusrau, as Shirin's replies are made in the songs of another musician, Nikisa.

In Tahmasp's *Khamsa*, however, the courtly image itself is more likely the "story" of the picture. The text does not mention Barbad's playing for Khusrau at this stage, although when Khusrau was still crown-prince his dead grandfather, Khusrau Anushirwan, had appeared to him in a dream naming Barbad. Khusrau sits within an *iwan* with extremely rich tiled surfaces. One of those Iranian "interiors in the out-of-doors," it opens onto an enclosed raised terrace, possibly of octagonal shape, set in the middle of a garden; this is seen on either side of the walkway leading to a two-story building with a projecting balcony. The terrace is paved and cooled by a large round pool and a fountain, emptying out over the edge of the terrace into a stream in the foreground garden, and conveying a sense of cool in the heat of the daytime. Barbad sits just outside the shah's *iwan*, playing a large lute ornamented with what appears to be intricate marquetry; he is accompanied by a youth who plays a tambourine. The audience is almost exclusively male: two pairs of courtiers, and a third seated on a carpet, listen as they drink from golden wine cups. Male attendants carry clothing and accoutrements toward the shah, as if in preparation for an event of some importance. The only woman is a maidservant with a small child, in the balcony at the left: the child may be Shiruya, Khusrau's son by Maryam.

Perhaps this painting was intended to represent Khusrau preparing at last for his wedding to Shirin, for the verses inscribed around his mat include these words:

> With the furnishing of your two eyes you
> make a bridal chamber of that dwelling . . .[1]

And perhaps its inclusion in Tahmasp's *Khamsa* – indeed, its very invention *for* Tahmasp's *Khamsa* – alludes to such an event in Tahmasp's life; just as his nephew, Ibrahim-Mirza, may later have been alluding to his own marriage in several paintings in his own manuscript of Jami's *Haft Aurang* [41]. Over the pavilion can be read verses in praise of the shah, together with a wish: "May this festive assembly be as rain to the garden . . ."[2]

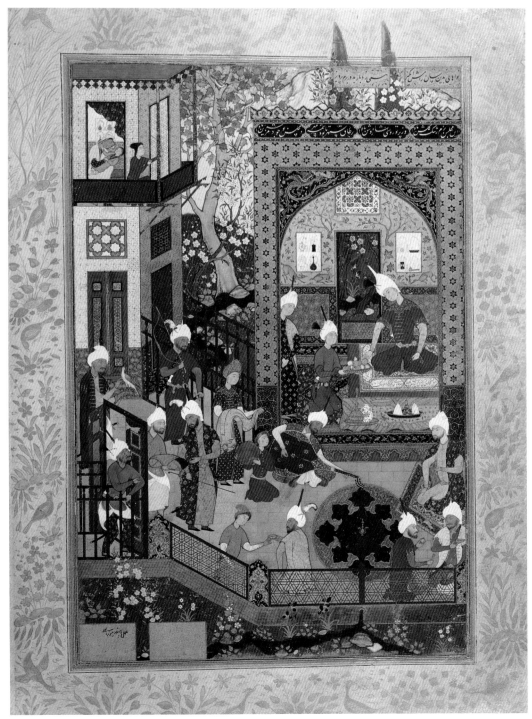

234

235. FARHAD CARRIES SHIRIN AND
HER HORSE

> Molded ceramic jug
> Iran, late twelfth–early thirteenth century
> H: ca. 15 cm
> Present location unknown

The molded images on the side of this lapis-
blue jug are those of Farhad, the sculptor, and
the Armenian princess Shirin, whom he
carried on his shoulders – still mounted on
her fatigued horse – down from Mount
Bisutun, to spare them the long descent.

Farhad and Shirin are two of the three
principal figures in Nizami's romantic poem
Khusrau u Shirin. The exact date of its
completion is uncertain: 1180–81 is a date
found in certain early manuscripts but some
specialists prefer the slightly later date of 1184,
and the difference is small. More to the point
is that this jug, and others made from the
same mold, are virtually contemporary with
Nizami's great poem.

This fact gives rise to reflection. Nizami
lived and worked in Ganja, in Azarbayjan
(west of the Caspian Sea), but the jug, and
most other similar molded monochrome-
glazed Seljuq vessels, was more likely to have
been made in Iran, or possibly even further
east. The discovery, in a hamlet between Marv
and Nishapur,[1] of an unglazed fritware jug
identical in shape, construction, and design to
this lapis-glazed piece reinforces the idea of its
eastern provenance, especially since a related
piece (an unglazed fragment of a mold for
such ware, with a different episode from the
story and a band of inscription above it) was
excavated at Nishapur itself.[2]

Whether Nizami's written text preceded, or
followed, the appearance of the same episode
on this small group of monochrome-glazed
ceramic jugs is impossible to say. More likely
is that Nizami, in Azarbayjan, and the ceramic
makers in Khurasan were all drawing upon

235

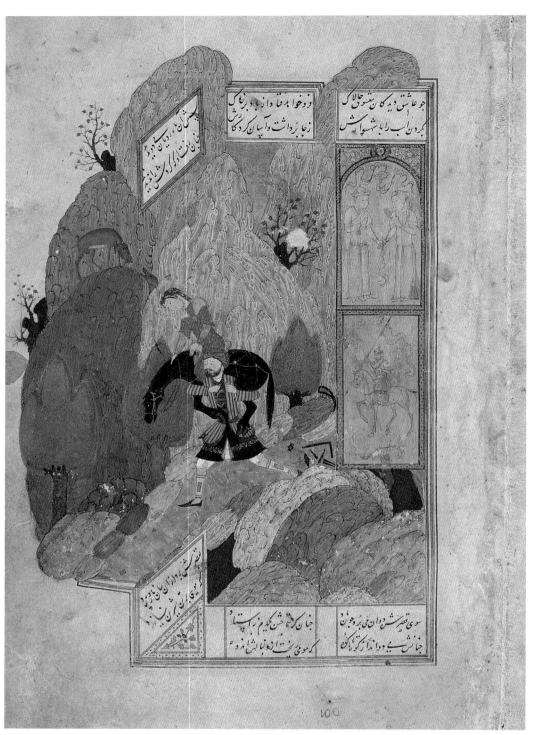

236

the same source for the story, which had been
a popular Iranian subject from as early as the
seventh century. The beautiful Shirin, as one
of Khusrau's wives, is mentioned in early
Arabic texts that echo late Sasanian writings;
the sculptor Farhad, creator of both the
conduit for milk and the carved grotto at Taq-
i Bustan [Fig. 13], appears in tenth-century
sources written in Arabic and Persian alike.[3]

A standard feature of Farhad's appearance in
most later Persian paintings is already seen in
the Seljuq ceramic image: his leg-wrappings.
In later painted versions they appear to be
striped knee-length stockings [40] but they are
more likely to have been simple strips of
bright colored cloth wrapped around the legs.

236. FARHAD CARRIES SHIRIN AND
HER HORSE

> Painting from Shahrukh's manuscript of
> Nizami's *Khamsa*
> Herat, 1431
> H: 15 cm; W: 11.5 (maximum) cm
> St. Petersburg, State Hermitage Museum,
> VR-1000, fol. 100r

This is a particularly beautiful rendering of
an episode in the story of Khusrau and Shirin
that, by 1431, had acquired its classical form:
the lovelorn sculptor Farhad carrying Shirin
and her exhausted horse Shabdiz down from
Mount Bisutun, to spare them the fatigue of
the return journey.

Several illustrations in Shahrukh's little *Khamsa* are extremely similar to the same scenes in an earlier manuscript that is a virtual pictorial pattern book, Iskandar-Sultan's anthology of 1410–11; this is one of them. Shahrukh's artist has taken maximum advantage of the third column of text as well as the spaces on the paper beyond the rulings: he has sensitively used the angled, downward slant of two couplets of text in the third column, to suggest the downward movement of the sculptor and his burden. The result is a painting with an irregular outline that corresponds beautifully to the wild and irregular landscape of the scene itself.

He has also made subtle changes in Farhad's clothing. The outer garment is still striped in blue and white, as it was in the earlier picture (as Shirin's red robe is also repeated); but Farhad's leg-wrappings have here been replaced by a tight-fitting white "stocking" with no foot, and underneath the blue-striped coat he wears a dark-green *jama* with a considerable amount of golden decoration at the chest and in a band near its hem. This reminds us that in pre-Islamic Iranian

tradition, Farhad was not a laborer but noble in status and held the rank of general, a worthy rival to Khusrau for the love of the Armenian princess Shirin.

237. FARHAD CARRIES SHIRIN AND HER HORSE

> Carved and painted decoration on the ceiling and the upper zone of a large *iwan*
> Nayin, ca. 1580
> H: 155 cm; W: 80 cm

In Iranian painting of the classical period, a man carrying on his shoulders a well-dressed woman mounted on a horse can only be the sculptor Farhad carrying the Armenian princess Shirin down Mount Bisutun. The panel at the right on the back wall of the *iwan* in the little Safavid palace in Nayin shows just this image, even though it is part of a larger composition showing mounted men in a verdant, flowering forest.

Unlike the classical image of Farhad

carrying the exhausted Shirin and her horse down the rocky side of Mount Bisutun – three beings alone in the mountain wilderness [236] – here the figures are placed in the company of princely riders accompanied by elegant hunting hounds and attendants on foot carrying small containers. A groom even accompanies Farhad and Shirin; he is dressed in the curious garb of the *payk* [73, 127], his coat shortened in the front and carrying some implement (undoubtedly meant as a mace) over his shoulders. As is the case with Yusuf and Zulaykha in the same ensemble [86], the unmistakable figures of Farhad and Shirin do not so much tell this part of the ancient tale as they evoke the entire episode.

237

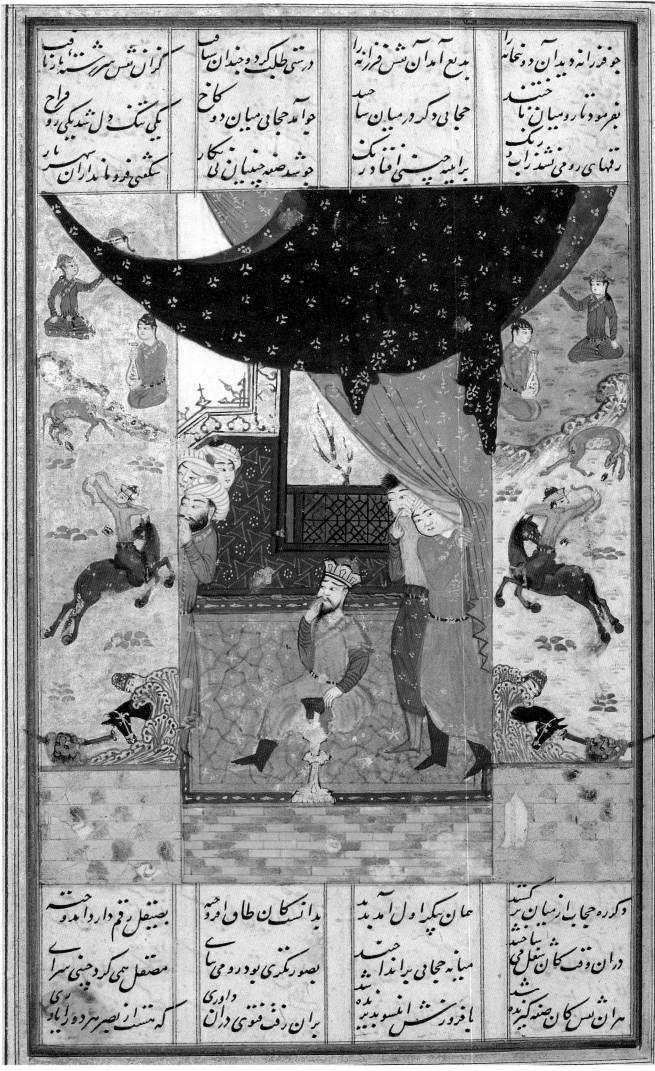

چو فرزانه دید آن دو نخچیر را بدیع آمدآن شش فرزانه را
بفرمود تا روی میان ساخت جمالی دگر در میان ساخت
رقهای رومی نشد زاد و برآید حسنی نشد زاده نیک

درستی طلبکرد و چندان ساخت کزآن نقش سرشته یاقت
چوآمد حجابی میان دو کاخ یکی تنگ دل شد یکی رو
چوشد صفه چینیان نگار سکشی فرو ماندز آن سهیار

دکرره حجاب ازمیان کشید چنان سپکراول آمد بدانسکان طاق فرو حه بصیقل رقم داردآمد و
درآن وقت کشان شعل می میانه حجابی برانداخت بصورتکری بود رومیای مصقل همی کردحبنی سرای
هرآن نس کان صنه کنیزه شد یا فزونش نانسودیده داوری که منتارنصیر هرده زیاد

238. THE COMPETITION BETWEEN ARTISTS FROM CHIN AND FROM GREECE

Painting from a manuscript of Nizami's *Khamsa*
Shiraz, 1449–50
H: 11.8 cm; W: 9.8 cm
New York, Metropolitan Museum of Art, 13.228.3, fol. 332r

Key figures in Nizami's *Khusrau u Shirin* are artists and sculptors [40, 236], and the lives of some of Nizami's principal characters are dramatically altered by seeing a painting [77, 239–42]. So it is that painting is the subject of a fascinating incident in Nizami's *Sharafnama* (one part of Nizami's *Book of Iskandar* – Alexander the Great, who figures prominently in both Nizami and Firdausi): Iskandar is called upon to judge a contest between two painters.

During a visit made by Iskandar to the Khaqan of Chin – by which is meant Chinese Turkestan – an argument had arisen over the merits of various races. To decide which was superior in the arts of painting, a competition was decreed. A Greek artist and a Chinese artist were asked to execute paintings in a room especially constructed for the contest, and the Greek visitor was asked – perhaps with predictable results – to adjudicate. While the artists were at work, the room had been divided down the center by a curtain; once it was lifted, Iskandar and the other spectators were puzzled, for the paintings appeared to be the same painting, but reversed. Unable to tell them apart, Iskandar asked that the curtain be lowered, and the Chinese "painting" then disappeared, only to reappear when the curtain was again raised: the Chinese painter had not painted his side of the room but polished its walls. Iskandar's judgement was inevitable: the Greek was superior in painting while the Chinese was a superior polisher – but both arts enhance human vision.

Nizami's enigmatic story is to be understood in the context of contemporary sufi influences, and perhaps scientific interests are to be detected as well, for Shapur and Farhad are said to be as well trained in the sciences as in the arts. The episode was not often illustrated save in fifteenth-century Shiraz; all four versions presently known are in Shiraz manuscripts, in either the post-Ibrahim style or the Shiraz-Turkman style of the second half of the century, and each is an original composition.

In this painting the contest takes place in a room occupying the central section of the picture; the two wall surfaces of the contest are "flapped" back at each side, so that the consternation of Iskandar and the court, upon seeing the painted and polished creations of the Greek and the Chinese artists, is clearly visible. The wall paintings are shown at the outer margins, as high vertical panels with mirror-image scenes of the hunt set in a

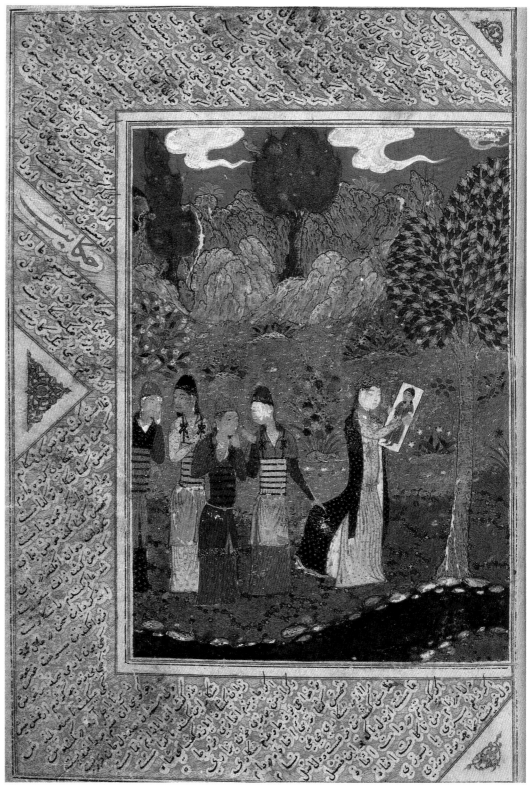

239

landscape [cf. Fig. 83]. The all-important dividing curtain is shown as two in contrasting colors; they sweep across the picture in ballooning folds, one crossing over the other and partially hiding the chamber below, where the other spectators have gathered around Iskandar. Two of them push a curtain aside to peep underneath it, and a group on the other side looks pointedly back and forth at the mystifyingly similar paintings. It is a vivid and original pictorial commentary on a question that was evidently of great interest to Nizami.

239. SHIRIN SEES THE THIRD PORTRAIT OF KHUSRAU ON THE TREE

Painting in a manuscript of Nizami's *Khamsa* in an anthology of various texts
Shiraz, 1410–11
H: 10.7 cm; W: 7.4 cm
London, The British Library, Or. 27261, fol. 38r

In the poetry of both Nizami and Firdausi, seeing a portrait may have a significant, and life-altering, effect on the person who sees it. In the case of Nizami's *Khusrau u Shirin* [77],

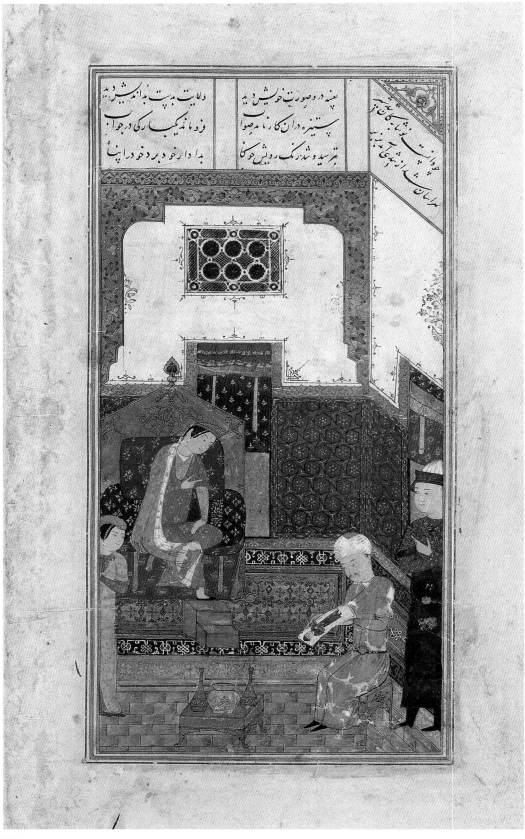

240

occasion does she take possession of it herself before her maids can interfere.

One of the earliest known pictures of this significant episode is an ideal landscape that quickly became its classical setting: a green and flowering meadow watered by a silver stream, with arid land, and then mountains, in the background. Shirin, wearing a golden crown, stands next to a tree and stares intently at the painted picture in her hands; it is neither a miniature nor as large as she is, but perhaps the size of a large piece of paper, and in shape it is higher than it is wide. Her maids stand behind her, their anxiety communicated by the position of heads and the gesturing of hands; one, endearingly, grasps the skirt of her blue, ermine-lined cloak, as if to pull her back from the brink of danger. Scattered clumps of flowers bloom on the golden ground beyond the meadow, at the rocky edges of the mountains the outlines of men and beasts can just be perceived; and the sky is a brilliant blue. Only the painter Shapur is missing from the scene; otherwise the picture conveys Nizami's poetry exactly, just as it is placed in the midst of the text recounting this part of the story.

Copies of the composition occur in several later Timurid princely manuscripts with only the slightest alterations (although the picture is not always set at the correct text-point). In this way were some of the earliest of fully developed Timurid compositions kept within the repertory of later painters.

240. NUSHABA SHOWS ISKANDAR HIS OWN PORTRAIT

Painting from Shahrukh's manuscript of
Nizami's *Khamsa*
Herat, 1431
H: 14.2 cm; W: 8.1 cm
St. Petersburg: Hermitage, VR-1000,
fol. 385v

A more straightforward indication of the significance Nizami accords to the image of a living person occurs in his *Sharafnama*. Iskandar visits the court of Nushaba, Queen of Bardaʿ, in the guise of his own ambassador, but the Queen is not deceived: she already has in her possession a portrait of Iskandar, painted on a piece of silk large enough to be rolled up. When he denies his identity, she hands him the painting and asks of whom it is a likeness, if not he himself? When he unrolls the silk, he is indeed confronted with a painted image of his own features.

The same episode had already been illustrated in Iskandar's anthology of 1410–11 and was repeated, in its fundamentals, in yet another fine Herat manuscript made about fifteen years later for the wife of Muhammad Juki ibn Shahrukh. Both show the Queen facing left, instead of right as in Shahrukh's painting; in neither does the Queen present the portrait to Iskandar but instead inspects it

the Armenian princess Shirin needs but one glimpse of a painting of the Iranian prince Khusrau: she instantly falls in love with the person in the portrait and her life thereafter – in Nizami's version of this beautiful romance – is devoted to finding him and attaining her rightful place at his side.

But the course of true love never did run smooth, and Khusrau and Shirin are no exception. The portrait is the work of

Khusrau's friend and confidant, the artist Shapur. Three times he must draw a new portrait of his prince and hang it on a tree, in the meadow where Shirin and her maids spend the spring days, before Shirin is allowed to keep the portrait. On the first occasion, her maids snatch it from her and burn it, thinking it calls down upon her the charge of worshipping idols; on the second they will not even bring it to her; only on the third

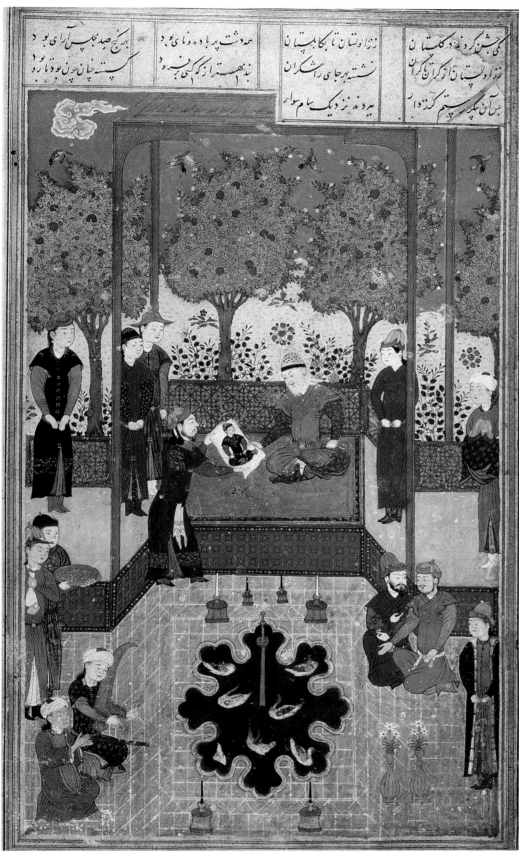

241

241. THE SILKEN IMAGE OF RUSTAM
SHOWN TO HIS GRANDFATHER SAM

Painting from Muhammad Juki's
manuscript of Firdausi's *Shahnama*
Herat, ca. 1440
H: 20 cm; W: 12.5 cm
London, Royal Asiatic Society, MS 239,
fol. 30v

Rudaba's travail at the birth of her son, the
hero Rustam, was great and only alleviated by
the Simurgh's divine assistance. But once
Rustam had made his appearance in the
world, his parents and maternal grandparents
were overwhelmed with joy – and also awe,
for at birth he was the size of a child of
twelve months.

To convey the wonder of this elephantine-
like child to his paternal grandfather Sam,
Rudaba's servants sewed a life-size silken doll
and limned Rustam's features on its face; they
then put a spear, a mace, and a bridle into its
hands and, setting the doll on a chestnut
horse, sent it to his grandfather Sam in
Mazandaran. Sam was so moved that his hair
stood on end; he showered the messenger
with gold and wrote to his son Zal:

I have prayed by day and night
In secret to Almighty God to show me
A son born of thy seed and of my type.

The scene is rarely illustrated. This is the
earliest of only two recorded versions,
interesting for what it does not show as well
as for what it does. The messenger offers to
Sam not the stuffed doll-like image as
Firdausi's text describes but a painted picture
of the new-born Rustam, seated cross-legged
and garbed in a miniature version of his
grandfather's clothing, even to the leopard-skin
hat. What it is painted on, whether cloth or
paper, is impossible to say, but it is shown as a
vertical rectangle of about the same size as the
drawing on paper that Shapur makes of
Khusrau for Shirin to discover [239], and the
likeness on silk that identifies Iskandar to
Nushaba [240]. Interestingly, these are both
earlier fifteenth-century paintings from
manuscripts that might have been known to
the painters of this mid-century *Shahnama*
made for Muhammad Juki. Even more
interesting is that the pictorial similarity of all
three images probably attests to the Timurid
currency of finished single-figure images of
substantial size, even if virtually nothing of this
genre has survived from the fifteenth century
and the surviving late Timurid portraits are
actually smaller [186–89].

with an attendant, while Iskandar sits meekly
at the side of the picture. Shahrukh's painting
depicts the next phase of the episode, when
Iskandar sees his own image on silk; the
drama of the moment is merely the Queen's
gesture as she asks her question. As in the
painting in Iskandar's anthology in which
Shirin finds the portrait of Khusrau [239], the
cloth on which the likeness has been painted

here is no miniature portrait but a picture of
good size. Moreover, Shahrukh's artist has
made an attempt to paint a true portrait if not
a mirror-image: the likeness is unbearded, as
Iskandar is here shown, although he wears a
turban and a green *jama* (the prerogative of a
ruler in many Timurid paintings) while the
cap and *jama* in his portrait are both blue.

242. NUSHABA SHOWS ISKANDAR HIS
OWN PORTRAIT

> Painting in Shah Tahmasp's manuscript of
> Nizami's *Khamsa*
> Tabriz, 1539–4
> H: 28.6 cm; W: 18.2 cm
> London, British Library, Or. 2265, fol. 48v

Again, the figural core of this picture is a
Timurid composition developed over a
century earlier, in a manuscript made for
Shahrukh in Herat. The Queen of Barda',
Nushaba, welcomes an ambassador ostensibly
from Iskandar (Alexander the Great), knowing
all the while that it is Iskandar himself. This
fact she makes clear to him when she hands
him his own likeness painted on a piece of
silk.

The here the two principal figures are placed
in the same relationship to each other as in
Shahrukh's picture [240] but the setting is a
garden-reception held on a luxurious terrace.
Nushaba sits on a throne to the left, and
Iskandar is seated to the right and slightly
below her, on the terrace, head bent as he
examines his own image. As in the Timurid
picture he is dressed in green, and the portrait
is not a mirror-image. Perhaps more to the
point – especially given Tahmasp's interests at
this date – is that the portrait, a kneeling
prince painted on a sizeable rectangle against a
neutral background, perfectly represents the
kind of contemporary single-figure painting
documented from just this period in the mid-
sixteenth century [Figs. 71, 72].

The Timurid compositional core of the
picture has been lavishly elaborated for
Tahmasp's magisterial *Khamsa*. It is far larger
and is set in the out-of-doors, and it has been
opened up and aerated, so to speak. Nushaba's
throne has an even more extravagant shape
and profile than did Khusrau and Shirin's [35]:
it has an elaborate high-lobed back, hooked
golden projections at each side, and lobed
cresting surrounding the seat. Even stronger
here is the suggestion that the object is a
fantasy developed from sources such as
illuminated book ornament, or the appliquéd
decoration of courtly garments. The
watercourse cut into the terrace is edged with
porphyry; the circular pool has an equally
extravagant lobed interior profile, while the
channel has a zig-zag edge. This picture is
among the most occupied of the manuscript:
the terrace crowded with courtiers and
attendants, a clutch of servants in the
foreground bringing food and drink,
Nushaba's maidens clustered behind her
golden throne, and a man just outside the
garden gate who gestures persuasively, his
finger to his lips, as if to silence the older
man seated just inside the gate at the edge of
the terrace. Conveying the reality of a paper-
oriented milieu of Tahmasp's court in Tabriz is
the page, who has brought the picture to
Iskandar in a large brown envelope and who
stands to his side, as if awaiting its return.

This gorgeous painting is presently

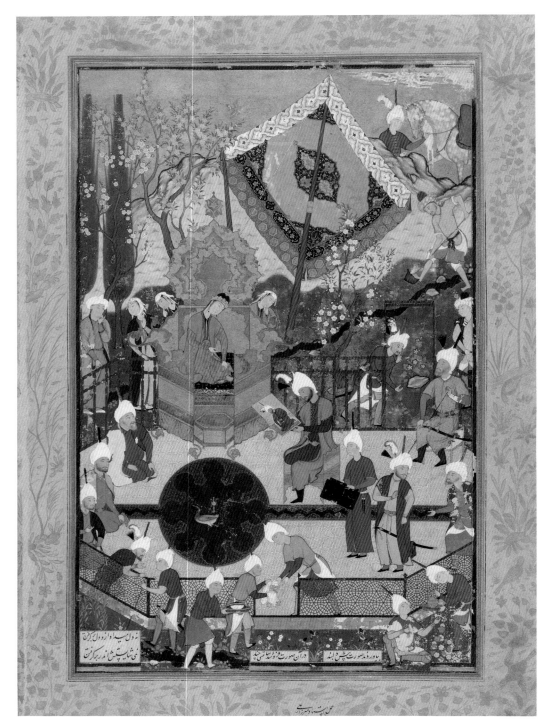

242

misbound within the manuscript, a fact that
does not appear to have been noted until
relatively recently. It is the only surviving
picture for the two books of the *Iskandarnama*,
but it was bound as if it were the first picture
of *Khusrau u Shirin*.

243. THREE BRAHMANS WHO RAISED A TIGER FROM THE DEAD

Painted mural in a private house
Panjikent, Sogdia, ca. 740
H: 50 cm; W: 57 cm
St. Petersburg, State Hermitage Museum,
on long-term loan

This painting is from the same house, and the same room and register, as *The Lion and the Hare* [206]. Three Brahmans found the bones of a tiger; in the vanity of thoughtless and arcane skills, they revived a dead tiger, only to have it attack and kill them.

One Brahman is seated in the upper left corner of the painting; he has already joined the bones together. The second Brahman, working with a knife, has partly managed to cover the skeleton with flesh; the third Brahman is being eaten alive by the tiger he has raised from the dead.

The moral was clearly apposite: do not make use of your expertise without considering the result. The "magical science" of the Brahmans was only a certain kind of scientific knowledge; they are shown as experimenting with the tools of their trade, so to speak. The painting is well-paced, its dynamism increasing from the figure of the first Brahman, sitting quietly; to the second, who is the "operator" and moves, albeit slowly and carefully; to the fierce attack of the tiger on the third. We must also note that the beast's figure is relatively stiff whereas that of his unlucky resuscitator is a truly lively image.

The same story was painted in at least one other house in Panjikent at this period, and it too displays some of the motifs specific to the subject. But Panjikent artists — as did later Arab and Persian painters — virtually never reproduced a model without introducing some subtle variation on their theme. In the second Panjikent painting, the artist created his own

composition from both his own ideas and traditional elements; he probably considered that such variation was his professional obligation. Typical for Sogdian art is that in both paintings, few details — only clothing and hair — are appropriately Brahmanic, while the greater content of the pictures is rendered in the local idiom of Sogdiana with which the painters were familiar.

As to its textual source, the Sogdian painting of this story is similar, but not identical, to an episode of four Brahmans and a dead lion. This does not appear in medieval versions of the *Kalila and Dimna* or in their Middle Iranian and Indian prototypes (the latter being the Kashmiri version of the *Pancatantra*), but it is preserved in other Indian variations, such as the "*Pancatantra* of Purnabhadra," and in later Indian literature. This particular story is not attested in the earlier Arab-Persian literary tradition and might have come to Central Asia directly from India; it reached Iran only much later, by way of Persian writers who were living in India in the fourteenth century. B.I.M.

244. A GAMING SCENE, FROM THE *MAHABHARATA*

Painted mural in a large private house
Panjikent, Sogdia, ca. 740
H: 132 cm; W: 171.5 cm
St. Petersburg, State Hermitage Museum,
SA 14863

This painting is part of a long narrative frieze in the reception hall of the "House of the Gambler," so called because in one room were found a great many sheep knuckle-bones which were used as dice, or gambling pieces. The owner's fondness for dice perhaps prompted his commissioning of illustrations

from the Indian epic, the *Mahabharata*, in which the game is a very important theme.

Represented here are scenes from the "Virataparvan," the fourth book of the epic, but the only Indian elements are the Brahmanic appearance of two characters, and an elephant in one episode on the opposite wall. Everything man-made — architecture, weapons, helmets, and most of the clothes — as well as the style of the painting, is otherwise quite Sogdian.

In the left scene, Prince Uttara and his driver arrive in a chariot at the palace of King Virata, his father; in a lower scene the king meets his son; in the upper right scene the king is shown playing backgammon with a Brahman. The story is that of the five heroic brothers, the Pandavas, who lived in King Virata's palace disguised as his servants — as his gambling companion (Yuddhishthira), his dancing teacher, and also his son's driver (Arjuna), and so forth. When Yuddhishthira had the temerity to say to the king that it was not his son, Prince Uttara, but the prince's driver, Arjuna, who was the genuine victor in a recent battle, the infuriated king struck Yuddhishthira; in a later meeting with his son, Uttara told his father that Yuddhishthira was speaking the truth. Very soon King Virata came to recognize the fame and nobility of his five apparent servants. B.I.M.

245. DETAIL FROM THE "GAMING SCENE," FROM THE *MAHABHARATA*

Painted mural in a large private house
Panjikent, Sogdia, ca. 740
St. Petersburg, State Hermitage Museum,
SA 14863

A Sogdian master-painter has represented the palace of the Indian King Virata as a typically

244

Sogdian fortified building of several stories. The ground floor has an arched portal with a rectangular door and a tiny horizontal window high on the wall; the monster's head placed above the portal is apotropaic and serves to protect the building. Two triangular shapes (one near the ceiling of the ground floor and the other by the flat roof) represent machicolation of some kind, shown in profile. The parapet is shown as a row of stepped merlons with arrow loops; these may – or may not – be purely decorative, as is the case with the sloping row of bricks below the parapet, but at the mezzanine level, the simple vertical arrow loops and the square window with a massive grille are structural elements found in other contemporary Sogdian fortified buildings. The upper floor has a balcony and a large arched double window, with a column in its center; its shutters stand open.

The painter combined a view of the façade with a kind of cross-section of the palace. On the right-hand side of the composition, the two stories of the building correspond to the two registers of the painting. Thus, on its right the characters above are "in" a room on the upper floor, whereas those below are intended to be seen as if in a room on the ground floor, or in the courtyard. This artificial device, together with other details that are selectively enlarged, or reduced, helps to create an impression of a huge building in which a number of large human figures might be disposed. They are, in fact, the *raison d'être* of Sogdian painting and could not be shown on a small scale, for the artist's primary focus was their interaction; only in the later medieval Iranian world did the settings take on greater interest for painters.

It would, therefore, be incorrect to imagine that a Sogdian palatial structure might actually have resembled the outline of the narrow, tower-like structure in this mural, even though its details have been confirmed by the finds made in archaeological excavations in Panjikent itself. Such verism is typical for the images of all man-made objects in the arts of Sogdiana. Moreover, the painter of this mural was a master among masters and apparently delighted in depicting the works of his fellow craftsmen: builder and smith, weaver and jeweler, tailor and shoemaker. B.I.M.

246. ON ILLUSTRATED POETRY AND THE LUNAR ELECTIONS

Folio from the twenty-ninth chapter of
an anthology of poetry entitled *Mu'nis
al-ahrar fi daqa'iq al-ash'ar* (*The Free Men's
Companion to the Subtleties of Poems*)
Isfahan, 1341
H: 8.5 cm; 4: 6.38 cm
Cambridge (Mass.), Harvard University
Art Museums, 1960.186

This folio comes from an anthology of Persian
poetry compiled by Muhammad ibn Badr
al-Din Jajarmi [39]. He may have copied the
manuscript as well, and it was completed in
Isfahan early in the spring of 1341. The
twenty-ninth chapter is a rather personal
creation: in it some poetry by his father, Badr
al-Din, is enhanced by images made especially
to accompany them. There is little reason to
doubt that the compiler also conceived of the
pictures, and painted them, himself.

The first of the three illustrated poems in
the twenty-ninth chapter is a eulogy in praise
of a late twelfth-century Seljuq sultan of
Anatolia, Rukn al-Din Sulaymanshah; this is
attributed to Muhammad Ravandi, a poet
born near Kashan about 1165. The eulogy, and
the two works by Jajarmi's father, an
astrological poem and a *ruba'i* addressed to an
anonymous beloved, were all tied together by
the simple device of illustrating the text with
images lifted directly from it; the picture is
placed below the line of writing.

Perhaps the large number of concrete nouns
in the eulogy suggested the illustrative notion.
The three folios of the eulogy (and the
following three folios on which the
astrological poem is found) are all organised in
the same way: three pairs of alternating lines
of text and pictures. In the eulogy, half a line
of poetry is formally calligraphed in various
colors of ink and gold; the second half of the
verse is completed by two lines of a smaller,
more utilitarian script written in black and
squeezed into a small space, to the left of the
first half-line. Below each line of verse is a
row of figures, or objects, painted in some
detail upon a red ground, much in the
manner of the old *Larousse Illustrée*. The
pictures follow the dictates of the poem:

Before the sultan stand in obedience:
 Human and harpy, demon and fairy.
Before the just monarch Sulaymanshah who
owns:
 Crown and throne, standard and signet.
His minstrel and cook, horseshoe and scribe
are:
 Venus, the Sun, the Moon, and Jupiter.[1]

The pictorial vocabulary is, in large part,
old-fashioned for the time (although the
textiles have an Ilkhanid look), and the
presentation against a solid red ground is
typical of Western Iranian painting of this
period [70, 138, 177, 227]. But the fact that the
notion should have occurred to the poet at all
argues for a deep residue of visual culture

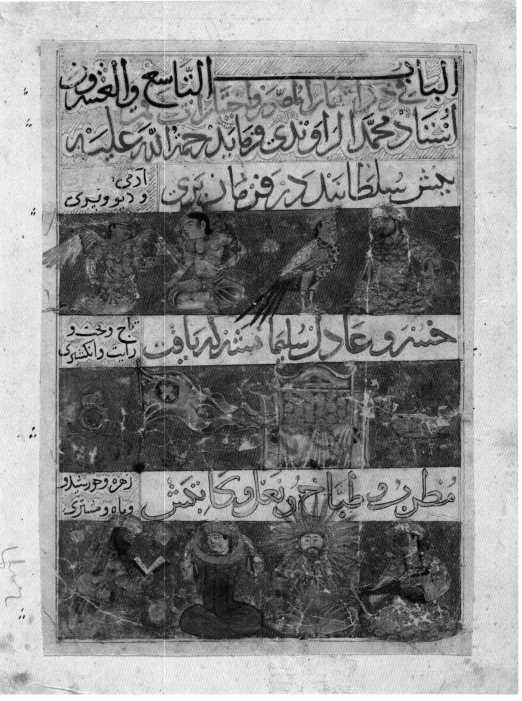

246

among educated and literate Persians. These
images are not created from thin air but
derive from a milieu in which many kinds of
texts, some of them illustrated, would have
been familiar to Muhammad Jajarmi and his
father. Thus, while the illustrative concept
behind these pictures is decidedly child-like,
the drawing is fine, the coloring attractive –
with some gold, it should be noted – and the
entire ensemble is thoroughly charming.

247a. DIVS CARRYING SOLOMON AND THE QUEEN OF SHEBA

247b. DIVS AND AN ANGEL ESCORTING A PAIR OF PRINCELY PALANQUINS

Two paintings on silk mounted in an
album
Western Central Asia or Samarqand, late
fourteenth–early fifteenth century
247a H: 20.5 cm; w: 61.5 cm
247b H: 25 cm; w: 48 cm
Istanbul, Topkapı Saray Museum, H. 2153,
fols. 164v–165r

Two paintings on long, narrow pieces of fine
ecru silk have been mounted on a single
large folio of paper. They display some of the
primary, if apparently disparate, elements from
the entire group of "problem pictures" in

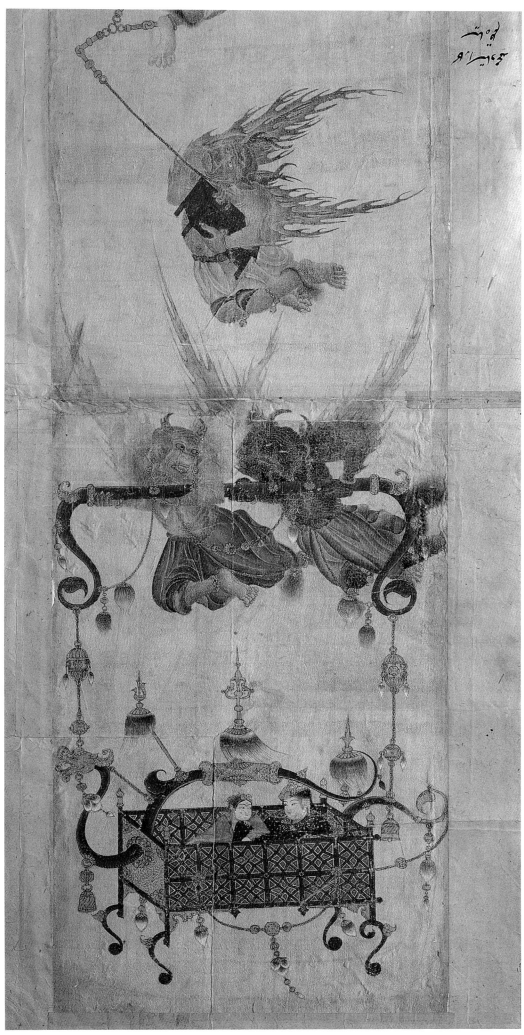

247a

the Istanbul albums. Despite the fact that one pair of figures is oriented counter to the other, the two paintings together breathe a sense of narrative content that, again, hovers just out of conscious reach.

For the past several decades, at least one (if not all) of the three pairs of princely figures in palanquins has been proposed as King Solomon – Sulayman, as the Qu'ran names him – traveling with the Queen of Sheba. This is, in part, because all the figures wear very rich garb and most are crowned: and also because all three palanquins are transported by *div*s and the Qur'an gave Sulayman control over the *jinn* (Arabic for demon), who were compelled to work for him, to do his bidding, and transport him. Another pair of *div*s carries furnishings, a chest and a small table; a crowned and jeweled angel accompanies the flying procession holding the extravagant flutter of a parasol over the first conveyance [247b].

The human figures, the angel, and the marvellous palanquins and other furnishings and accoutrements are fully painted in opaque color onto the bare silk ground. The *div*s are drawn in transparent washes with touches of solid color, as are so many other pictures of *div*s, monsters, and "nomads" in the overall group. The princely figures, smaller than many of the "Chinese-people" types, have the same Chinese appearance and whitened faces. The lady in the right-hand palanquin [247b] wears a golden diadem and a fur-lined blue outer garment, inclining her face behind its collar, as did the lady of "The Lady Travelling;" yet here, the garment is lined with dark fur and the diadem placed over a white fabric, like that of "The Maiden" in another painting on silk [247b]. Both details appear to have been transferred, with slight alterations, from one image to others, although the chronology is far from being established with certainty.

The palanquins are a cabinetmaker's dream. All are essentially boxes, with geometrically patterned sides; but each is finished, and furnished, differently and carried in a different manner. The most elaborate has a gold-embroidered Chinoiserie top of fabric and openwork shutters, and its understructure suggests a carriage to be placed on a rolling cart that could then be yoked to horses or oxen but here is carried, from underneath, by four flying *div*s. The second is a smaller, open version sheltered by the angel's fluttering parasol instead of a canopy; it rests on the shoulders of walking *div*s. The third [247a] is the most fantastic and surely the least stable of the three: a kind of openwork handled "basket" suspended by chains hanging from loops at the ends of brackets curving down from a horizontal wooden yoke carried by flying *div*s.

All three of these extraordinary contraptions are embellished with chains, bells, and tassels, yak-tailed ornaments and finials, and most of the brackets end in dragon heads. The metalwork – braces, brackets and struts, chains

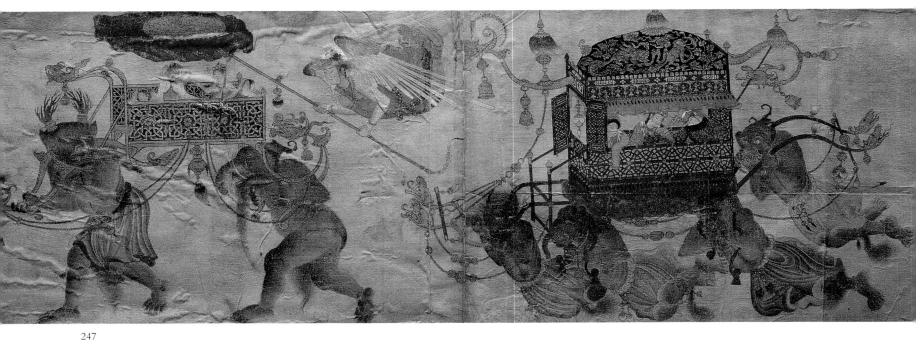

247

and bells, rings and hooks, balls, finials, and tassel-fittings – would bring joy to a metal-craftsman's heart.

The *div*s are as fantastic in variety but as consistently depicted as their fellow *div*s and monsters in the larger group of these Istanbul pictures. They have large feline heads with glaring eyes and faces wrinkled in deep folds, large mouths with prominent teeth, and they are horned and five-toed, with emphatically drawn ribcages and spines. One has an elephant's head, like the Hindu god Ganesh, but it is also horned and is the only such creature not wearing the *div*s' usual garment, the short, wide skirts (here shown fluttering, to reveal their colored lining). Lastly, the canopy of the largest palanquin is not only fringed and shuttered and crowned with a Chinoiserie of *qi'lins*, but also carries two friezes of Arabic pseudoepigraphy. The Arabic letters *lam-alif* – "l" and "a," which are usually thought to be a shortened notation for "Allah" – are written in repeated groups of white letters on a red ground, a variation of the design often found in the borders of rugs. A shorter but larger inscription, typical of the calligraphic friezes of tiles on architecture and also seen in numerous paintings from the fourteenth century onward, is written in white letters on blue on the front of the palanquin.

That this host of features, subjects, and styles exists in several versions, in similarly finely painted compositions – even if the images in them are probably a set of variations on a theme – is one of the most persuasive arguments for a single collecting-spot and a single locale for their creation. For over half a century,[1] one name recurs in the speculative literature engendered by these paintings, somewhere on the eastern fringes of the Iranian world but apart from it, where Islam co-existed with cultures from Inner Asia; a milieu with artists of great skill and sensitivity who were not yet trained in the essentially

narrative and fully painted aesthetic of the Iranian illustrated manuscript, might work in the company of craftsmen with a sophisticated object tradition of their own: Timur's Samarqand, and the Samarqand of his successors, from about 1385 to about 1440.

248. ZULAYKHA ATTEMPTS TO SEDUCE YUSUF

Painting in a manuscript of Sa'di's *Bustan* (*The Orchard*)
Herat, 1488
H: 25.4 cm; W: 15.8 cm
Cairo, National Library (General Egyptian Book Organization), Adab Farsi 908, fol. 52v

Just as the double-page frontispiece [34] of this manuscript takes place in a setting that reflects the architecture, as well as the social practices and the spiritual concerns, of Herat society at the end of the Timurid century, so one of its single-page pictures, of astounding architectural richness and complexity, reflects the literary climate of contemporary Herat. Poet, painter, and patron must all have been in some way involved with the making of this picture: the poet, 'Abd al-Rahman Jami, who was, in the 1480s, writing the gathering of *masnavi*s later to be called the *Haft Aurang* (*The Seven Thrones*) and which included a *Yusuf u Zulaykha* [217]; the painter Kamal al-Din Bihzad, who used Jami's description of the setting of Zulaykha's attempted seduction for a picture in a text by Sa'di; and Sultan-Husayn, who may have suggested the idea in the first place.

Sa'di's text merely refers to the attempted seduction of Yusuf by Zulaykha, wife of an Egyptian functionary, but Jami describes at some length Zulaykha's vain efforts to persuade the beautiful Yusuf to give in to her

wishes. He concludes this part of his story with the description of an architectural construct that is as rich and laden with mystical overtones as is the poetry of Nizami's *Haft Paykar*. Zulaykha, desperate with love for Yusuf, erected a palace with seven chambers, each decorated with erotic paintings of the couple and each more secluded than the last. Accompanying him into the palace, she led him into each chamber in turn and locked each door behind them until they reached the room most beautifully decorated, and the most secluded from view. So well hidden from the sight of man, Yusuf was on the verge of yielding, but he suddenly realized that he could never hide from the sight of God and he fled, the seven locked doors miraculously opening at his touch. That Jami's palace should be a sufi metaphor for the spiritual journey of both Yusuf and Zulaykha is hardly to be wondered at, for a poet who was also the leader of the sufi order of the Naqshbandiya in Herat.

Bihzad's painting is not a literal recreation of Jami's seven chambers with seven doors but a fantasy on the theme that is expressed in the visual language of Timurid architecture and its decoration. Portals and courts, stairs and towers, *iwan*s and projecting balconies and screens; brick and carved stone, woodwork and wooden intarsia, extremely intricate tile mosaic and *haft rangi* (underglaze-painted) ceramic tiles: all play a part in the pictorial translation of Jami's poetry. The architectural forms are exceedingly rich, but also empty. An empty courtyard leads to a luxurious but empty *iwan*, with white walls and a porphyry dado; a small empty balcony with a small square tower projects from the right margin; this is balanced, at the left, by another richly decorated, empty *iwan*; from it a closed doorway leads to an empty staircase of several flights that descends, in zig-zags, to the empty courtyard.

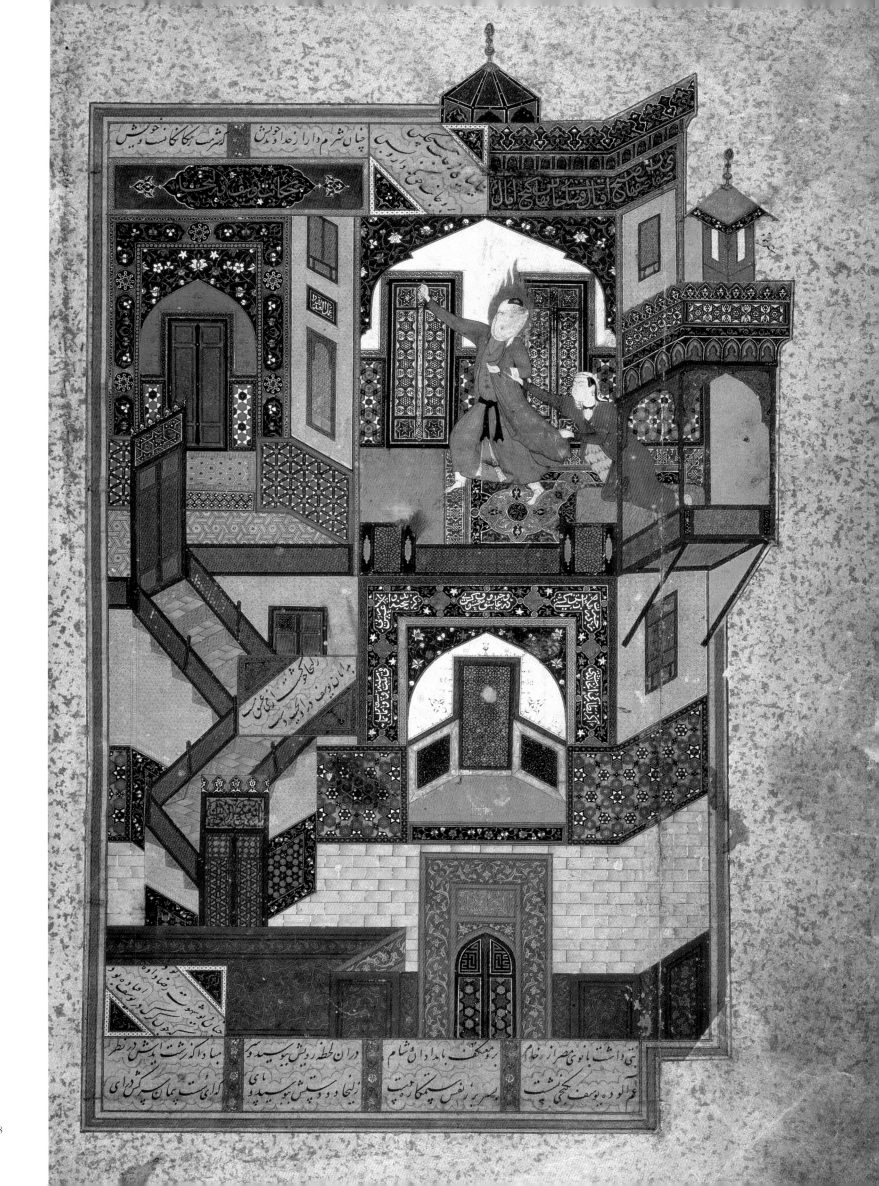

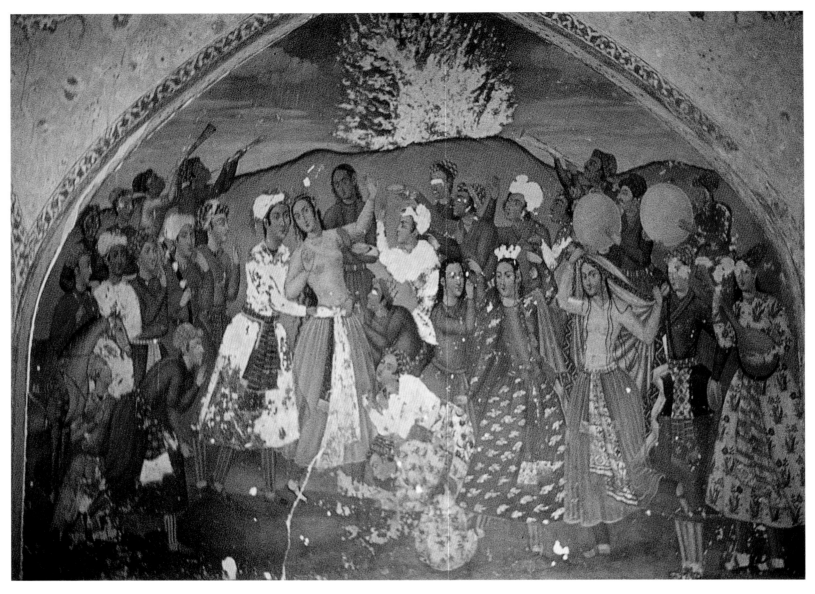

249

In the midst of this patterned elaboration, color and the absence of pattern draw the eye to the two figures and their relationship. Zulaykha's tomato-red robe and golden underdress, and Yusuf's green garments, white turban and boots, carry no decoration, and they stand out against the extremely rich fields of architectural patterns that surround them. The figures are emphasized by the white walls of the chamber in which the frantic Zulaykha grasps at Yusuf's arm and cloak. The white wall, and the bare floor, of the *iwan* directly underneath them, echo this emphasis, and the axis is further emphasized by the small lantern with its pointing finial above Yusuf's nimbed head, and the size and lavender-pink color of the *pishtaq* at the bottom of the picture.

Jami does not specify that Yusuf fled down a flight of stairs, but the staircase provides a wonderful piece of visual drama that brings the eye full circle down to the portal by which it was first enticed to enter Zulaykha's enchanting palace.

249. THE BRIDE PREPARES TO IMMOLATE HERSELF

Painted on the wall of the "Literary Room" in the palace of the Chihil Sutun Isfahan, after 1647

The penultimate scene from a romantic poem composed at the court of a Muslim prince in India is painted in the "Literary Room" in the Chihil Sutun in Isfahan.

Everything about this image epitomizes the intertwining of Iranian and Indian cultural and political life at that time. The Iranian poet Muhammad Riza ibn Mahmud Khabushan, known by the pen-name of Nau'i, wrote a short *masnawi* on a Hindu subject before 1604 for a son of the Mughal emperor Akbar, prince Daniyal. Called *Suz u Gudaz* (*Burning and Melting*), its tragic theme is treated as a sufi metaphor for the soul's burning desire to be united with God. In the middle of the century, a crucial episode from the poem was painted in an Iranian palace in the capital city of the realm, in a monumental but hybrid pictorial style that owes much to the influence of painting from the subcontinent, a style

also found in the same building, in three reception scenes in the audience hall [43, 191, 192] and on the exterior porches. This *Suz u Gudaz* illustration has even been proposed as a pictorial metaphor for a signal event in the political relations between Mughal India and Safavid Iran, the retaking of Qandahar by the Safavids, which occurred early in 1649.

Nau'i's short, tragic poem concerns a Hindu couple betrothed since childhood who grow up knowing, and loving, each other. When finally they are about to be married, the bridegroom is accidentally killed by bricks falling from a building; although she is not yet his wife, the bride sacrifices herself and joins him, as a *sati*, on the funeral pyre, despite the attempts of her family and friends to dissuade her from doing so.

This is precisely the moment shown in the Chihil Sutun. The bride, in the foreground, is entreated and almost physically restrained by Prince Daniyal and his suite of young men in Akbari-style turbans and Indian garments, and young women in clothing of Indian cut but Iranian materials. A distressed crowd has gathered behind them; a woman at the right

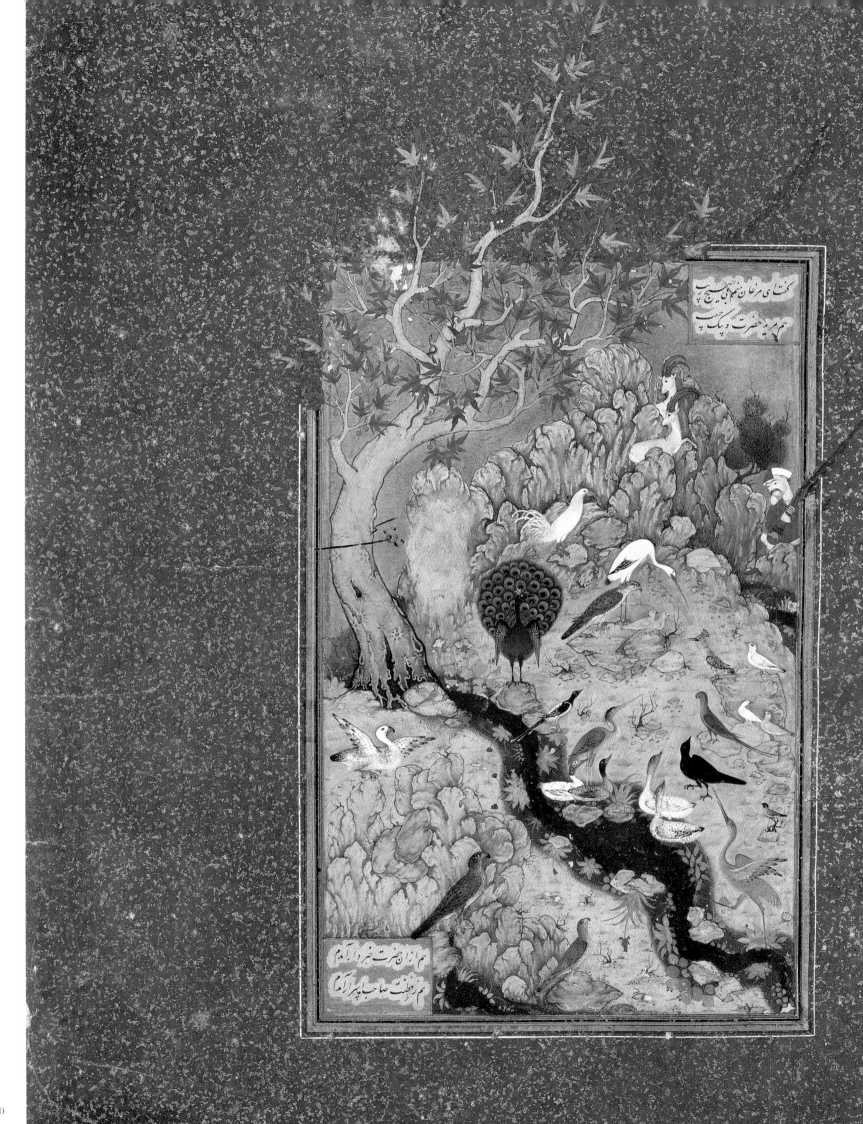

of the picture plays a stringed instrument and, toward the rear of the crowd, other musicians sound trumpets and beat tambourines. In the background behind a hill and at the apex of the composition, a huge fire burns with golden flames.

The painting faces the main entry of the room; it is flanked by pictures illustrating episodes in the stories of other well-known pairs of lovers from Persian literature, including Jami's *Yusuf u Zulaykha*, and Nizami's *Khusrau u Shirin* [85, 158, 231]. The thematic link between all the paintings in this room is clear although the others were painted in the traditional Iranian manner. That the subject is so very Indian makes the appearance of this hybrid and Indian-influenced style seem especially appropriate.

250. THE BIRDS ASSEMBLE BEFORE THE HOOPOE

Painting added to a late fifteenth-century copy of Farid al-Din 'Attar's *Mantiq al-Tayr* (*Language of the Birds*)
Isfahan, before 1609
H: 18.2 (21.3 maximum) cm; W: 11.2 (14.8 maximum) cm
New York, Metropolitan Museum of Art, 63.210.11

Birds of the air and the water have gathered around a stream in the mountains under a blazing golden sky during the season when purple iris and red poppies are in bloom. Ibexes frolic in the highest crags at the upper left of the picture, and at the left margin stands a hunter, with a long-barrelled musket over one shoulder and one hand to his mouth, in wonderment at the avian assembly before him. All appear to listen, with rapt attention, to the hoopoe on a rock, whose outstretched neck suggests that it is he whom the feathered flock has gathered to hear.

This is indeed an assembly of the birds, the opening set-piece of Farid al-Din 'Attar's great mystical poem recounting the search for spiritual annihilation and union with the ineffable One. To illustrate the story of the spirit's momentous journey, 'Attar resorted to the device of speaking beasts so often used in other classical Muslim literature. The notion of using birds as his protagonists may be because of the coincidental Persian pun on the name of the *simurgh* – the wonder-working bird of Firdausi's *Shahnama* that gave such assistance to the family of the great hero Rustam: in Persian, *si murgh* means "thirty birds."[1]

Not that thirty specific birds speak in 'Attar's text: not in the first scene, in which a series of birds are welcomed by name, nor in the next section, when some explain to the hoopoe why it would be unnecessary, or unsuitable, or unadvisable, for them to undertake the voyage to the *Simurgh*, excusing themselves from the rigors of the journey. 'Attar names the finch, the goldfinch, and the

nightingale; the partridge, the pheasant, and a pigeon; a duck and an owl, a hawk, and a falcon, among others. Nor are thirty birds depicted in this illustration of 'Attar's avian assembly, perhaps the most beautiful to be found in any of the illustrated copies of this text known to have survived. Instead, the painter has included in his assembly birds he must himself have known, even if they were not ornithologically correct in their drawing: doves, a warbler and a magpie, geese and a rooster; a crane, a grey heron and a white stork, a crow and an Indian parrakeet; a goshawk and a kestrel, a majestic peacock and of course the crested hoopoe, whom the birds eventually choose as their leader before setting off on their journey.

This marvellous image is the only one of the four seventeenth-century paintings in the manuscript to be signed: on a rock between the geese in the small pond in the middle of the picture is written in small black letters "the work of Habiballah." Known by perhaps six or seven seventeenth-century single-figure paintings in the Riza 'Abbasi style [148], Habiballah of Mashhad appears to have been trained in a pictorial tradition greatly influenced by the classical Timurid style of the fifteenth century, which seems to have enjoyed a certain vogue under the governors of Herat, and Khurasan in general, in the later part of the sixteenth century. This picture may well be his earliest known painting, and certainly the man with the musket at the margin of this image has the appearance of a sixteenth-century, rather than a seventeenth-century, type.

Perhaps it was Habiballah who was, in some way, influential in rekindling an interest in classical Timurid painting at the court of Shah 'Abbas in Isfahan. Were it not for the musket barrel that pokes through the rulings of the painting onto the gold-spattered blue-green seventeenth-century mount, the first impression of this picture would be that it dates from the later fifteenth century, from the time of Sultan-Husayn Bayqara, when this manuscript was copied and four of its eight illustrations executed. The landscape and its treatment, the ibexes on their mountain crag under a flat golden sky, and the otherwise cool palette of this picture, are all derived from classical Timurid painting; the recurring appearance of the silver stream was already seen in "The Man Drowned…," while the nest of eggs high in the branches of the plane tree, at peril from the snake inching its way up the trunk, is a pictorial quotation from "The Youth Who Mourned His Father."

To what extent Habiballah may have appreciated the Timurid plan for the illustrations of this manuscript, in which the parable was both illustrated and pictorially commented upon, is impossible to say. But the snake approaching the bird's nest is an apt image of the precariousness of existence, as is the hunter with his musket. Thus, caught between these illustrated dangers and

persuaded, so very eloquently, by the hoopoe, the birds of 'Attar's great poem decide to submit themselves to the perils of travel, to what they do not know and are afraid to say, and at last, the

Thirty exhausted, wretched, broken things,
With hopeless hearts and tattered, trailing wings,
. . . saw that nameless Glory which the mind
Acknowledges as ever undefined, . . .[1]

There in the Simorgh's . . . radiant face they saw
Themselves, the Simorgh of the world – with awe
They gazed, and dared at last to comprehend
They were the Simorgh and the journey's end. . . .

. . . You came as thirty birds and therefore saw
These selfsame thirty birds, not less nor more; . . .

It is yourselves you see and what you are.[2]

ABBREVIATIONS

Arnold, *PiI*

Sir Thomas Arnold, *Painting in Islam*, London, 1928, and various reprints in paperback

Belenitsky

A. M. Belenitsky (*sic*), "Ancient Pictorial and Plastic Arts and the Shah-Nama," *Trudy Dvadtsat' Pyatogo Mezhdunarodnogo Kongressa Vostokovedov, Moskva, 9–16 avgusta 1960*, III, Moscow, 1963, pp. 96–101

BSOAS

Bulletin of the School of Oriental and African Studies, University of London

CHIr, 4

The Cambridge History of Iran, 4: From the Arab Invasions to the Saljuqs, ed. R. N. Frye, Cambridge, 1975

CHIr, 6

The Cambridge History of Iran, 6: The Timurid and Safavid Periods, ed. Peter Jackson and Laurence Lockhart, Cambridge, 1986

Poetry/Epic

Illustrated Poetry and Epic Images: Persian Painting of the 1330s and 1340s, Marie Lukens Swietochowski and Stefano Carboni, with essays by A. H. Morton, and Tomoko Masuya, New York, 1994

Qadi Ahmad

Calligraphers and Painters: A Treatise by Qadi Ahmad, Son of Mir-Munshi (circa A.H. 1015/A.D. 1606), tr. V[ladimir] Minorsky, with an introduction by B. N. Zakhoder, (Freer Gallery of Art Occasional Papers, vol. 3, no. 2), Washington, DC, 1959

Robinson V&A

B. W. Robinson, *Persian Miniature Painting from collections in the British Isles* (exhibition Victoria and Albert Museum), London, 1967

Roxburgh, *Image*

David J. Roxburgh, *Prefacing the Image: The Writing of Art History in sixteenth-Century Iran* (Studies and Sources in Islamic Art and Architecture/Supplements to *Muqarnas*, vol. IX), Leiden, Boston, Cologne, 2001

RPP

Royal Persian Paintings: The Qajar Epoch, 1785–1925, ed. Layla S. Diba with Maryam Ekhtiar (Catalogue of a loan-exhibition in Brooklyn, Los Angeles, and London, 1998–99), 1998

Silk Routes

Along the Ancient Silk Routes: Central Asian Art from the West Berlin State Museums, (exhibition Catalogue, The Metropolitan Museum of Art), New York, 1982

Stchoukine, *Saf I*

Ivan Stchoukine, *Les peintures des manuscrits Safavis de 1502 à 1587*, Paris, 1959

Stchoukine, *Saf II*

Ivan Stchoukine, *Les Peintures des manuscrits de Shah Abbas Ier à la fin des Safavis*, Paris, 1964

Survey

A Survey of Persian Art From Prehistoric Times to the Present, ed. Arthur Upham Pope and Phyllis Ackerman, London, 1938–39, 6 vols. reprinted in 12 vols. in Teheran in 1977

TPV

Thomas W. Lentz and Glenn D. Lowry, *Timur and the Princely Vision: Persian Art and Culture in the Fifteenth Century*, Los Angeles County Museum of Art, 1989; catalogue of the exhibition organized by the Arthur M. Sackler Gallery, Smithsonian Institution, Washington, DC, and the Los Angeles County Museum of Art in 1989, Los Angeles County Museum of Art, 1989

Thackston, *Century*

A Century of Princes: Sources on Timurid History and Art, selected and translated by W. M. Thackston, Cambridge (Mass.), 1989

NOTES

INTRODUCTION

1. Mirza Muhammad ʿAli Furughi, quoted by A. J. Arberry, *Classical Persian Literature*, New York and London, 1958, p. 47.
2. *Qajar Portraits*: An album of the additional works of art included in the London showing of the exhibition *Royal Persian Paintings, The Qajar Epoch, 1785–1925*, Julian Raby, London, 1999, pp. 11–14.
3. Descriptive categories literally cited, from Ulrich Marzolph's *Narrative Illustration in Persian Lithographed Books*, Leiden, Boston, Cologne, 2001, pp. 24–26.

I. PRE-ISLAMIC PAINTING AND ITS SOURCES IN SCULPTURE AND THE DECORATIVE ARTS

1. D. S. Rice, "The Oldest Illustrated Arabic Manuscript," *BSOAS*, vol. 22, 1959, pp. 208–9.
2. Arnold, *PiI*, pp. 63, 82.

II. THE EARLY ISLAMIC PERIOD

1. Arnold, *PiI*, p. 36.
2. As translated by Thackston, *Century*, pp. 344–5.
3. Geo Widengren, *Mani and Manichaeism* (in an anonymous English translation from the original German edition of 1961), London 1965, pp. 27–8.
4. Jan Rypka, *History of Iranian Literature*, (English translation from the original German edition of 1956), Dordrecht, 1968, p. 63.
5. Arnold, *PiI*, p. 61.
6. *Silk Routes*, 1982, p. 35.
7. Pratapaditya Pal and Lionel Fournier, *A Buddhist paradise: The Murals of Alchi, Western Himalayas*, Hong Kong, 1982, p. 17.
8. R. N. Frye, Preface to *CHIr*, 4, p. xi.
9. Arnold, *PiI*, p. 63.
10. D. S. Rice, "The Oldest Illustrated Arabic Manuscript," *BSOAS*, 1959, p. 208.
11. Arnold, *PiI*, p. 63.
12. Belenitsky, p. 101, quoting Vladimir Minorsky's translation of the *Hudud al-ʿAlam*, p. 10.
13. Arnold, *PiI*, p. 64.
14. Ernst Herzfeld, *Iran in the Ancient East*, Oxford, 1941, p. 291.
15. All quoted Arnold, *PiI*, p. 6.
16. Arnold, *PiI*, p. 9.
17. Ernst Herzfeld, *Die Malereien von Samarra*, Berlin, 1927; Richard Ettinghausen, *Arab Painting*, Geneva, 1962, pp. 42–44, Appendix 5–6, p. 191; Ernst J. Grube, *The World of Islam*, London, 1966, pp. 36–40, color plate 4; Emel Esin, "The Turk al-Agam of Samarra and the Paintings Attributable to Them in the Gawsaq al-Haqani," *Kunst des Orients*, Vol. IX, 1/2, 1975, pp. 47–88; Richard Ettinghausen and Oleg Grabar, *The Art and Architecture of Islam 650-1250* [1] (Pelican History of Art), Harmondsworth, 1987, pp. 124–25; Barbara Brend, *Islamic Art*, London, 1991, pp. 31–32.
18. Charles K. Wilkinson, *Nishapur: Some Early Islamic Buildings and Their Decoration*, New York City, 1986, Figs. 28–33, pp. 282–9.
19. Charles K. Wilkinson, *Nishapur: Pottery of the Early Islamic Period*, New York, [1973], p. xxx.
20. *Op. cit.*, p. xxxiii.
21. Wilkinson, *Nishapur . . . Buildings*, pp. 202–18.
22. Quoted Arnold, *PiI*, pp. 25–26.
23. Quoted by Arthur Upham Pope, *Survey*, p. 979, by way of Mujtaba Minovi.
24. Rice (Note 10 above), pp. 208–9.
25. Belenitsky, p. 101.

III. THE MEDIEVAL PERIOD

1. *Mutaqarib* is usually defined as ". . . a foot of three syllables, one short followed by two long, four times repeated in each half line," . . . the last foot, with the rhyme, having only a short and one long syllable: see Reuben Levy, *An Introduction to Persian Literature*, New York, 1969, p. 65. It is L. P. Elwell-Sutton who proposed that the meter derives from Middle Persian, in *The Persian Metres*, Cambridge, 1976, p. 172.
2. A. J. Arberry, *Classical Persian Literature*, London and New York, 1958, p. 49.
3. Belenitsky, p. 100.
4. A. S. Melikian-Chirvani, "Le Livre des Rois, miroir du destin," *Studia Iranica*, Vol. 17, fasc. 1, 1988, pp. 43–44: the poet is Suzani Samarqandi.
5. Belenitsky, p. 97.
6. Melikian-Chirvani (Note 4), pp. 41–42.
7. Melikian-Chirvani, "Le Shah-Name, la gnose Soufie et le pouvoir Mongol," *Journal Asiatique*, Vol. CCLXXII, 3–4, 1984, p. 296.
8. Melikian-Chirvani (see note 4), p. 45.
9. Gönül Öney, "Kubadabad Ceramics." *The Art of Iran and Anatolia from the 11th to the 13th Century A.D. Colloquies on Art & Archaeology in Asia*, No. 4, Percival David Foundation of Chinese Art, School of Oriental and African Studies, London, 1974, pp. 68–84, not only discusses the Kubadabad excavations but cites most of the relevant studies on other Anatolian Seljuq sites where such ceramics were found.
10. Much discussed and illustrated in the papers to a colloquium on medieval Islamic glass held at the British Museum in 1995: *Gilded and Enamelled Glass from the Middle East*, ed. Rachel Ward, London, 1998; see especially plates D, F, and J, and the articles they illustrate.
11. Morton, in *Poetry/Epic*, p. 55 and notes.
12. Angelo Piemontese, "Nuova luce su Firdawsi: Uno 'Shahnama' datato 614H./1217 a Firenze," *Annali*, Vol. 40, (N.S. xxx), p. 11.
13. Ernst J. Grube, "Prolegomena for a Corpus Publication of Illustrated *Kalilah wa Dimnah* Manuscripts," *Islamic Art* IV, 1990–91: Appendix I, MSS 8–10, pp. 360–61.

IV. THE FOURTEENTH CENTURY

1. Quoted by Edward G. Browne, *A Literary History of Persia*, II, Cambridge, 1906 (reprinted 1964), pp. 427–428.
2. Quoted by Zabihallah Safa, *Taʾrikh-i adabiyyat dar Iran*, (History of Iranian Literature), Vol. III, Tehran, 1341/1959 p. 8.
3. Translated by W. M. Thackston, in Sheila S. Blair, *A Compendium of Chronicles: Rashid al-Din's Illustrated History of the World*, London, 1995: Appendix I, p. 114.
4. Blair (*op. cit.*), pp. 60–6.
5. Thackston, *Century*, p. 345.
6. Morton, *Poetry/Epic*, pp. 50–1.
7. Thackston, *Century*, p. 345.
8. Teresa Fitzherbert, "Khwaju Kirmani (689–753/1290–1352): an Eminence Grise of Fourteenth Century Persian Painting," *Iran*, Vol. XXIX, 1991, pp. 137–51: on p. 147 is a translation of the text relevant to 105, "Nushirwan and Buzurjmihr in Conversation."

V. THE FIFTEENTH CENTURY

1. Reviewed by Ernst J. Grube, "The Problem of the Istanbul Album Paintings," *Islamic Art*, I, 1981, pp. 1–30.
2. First suggested by Richard Ettinghausen, "Some Paintings in Four Istanbul Albums," *Ars Orientalis*, I, 1954, p. 99; the entire argument summarized by Grube, above.
3. H. 2153, fol. 98r. It was first reproduced in facsimile, by M. Kemal Özergin, "Temürlu" Sanatina ait eski Bir Belge: Tebrizli Caʾferʾin Bir Arzi," *Sanat Tarihi Yıllığı*, VI, 1974–75, pp. 471–94; and translated several times, most recently into English, with annotations, by Thackston, *Century*, pp. 323–27.
4. Thackston, *Century*, p. 326, in n. 24, (10).
5. Mostly taken from Mirza Haydar, as translated by Thackston, *Century*, pp. 361–62.
6. Thackston, *Century*, p. 347.
7. *Ibid.*
8. Roxburgh, *Image*, pp. 31, 218.
9. Thackston, *Century*, p. 361.
10. *Babur-nama in English (Memoirs of Babur)*, translated from the original Turki Text of Zahiruʾd-din Muhammad Babur Padshah Ghazi by Annette Susannah Beveridge, London, 1922 (reprinted 1969), p. 291.
11. Thackston, *Century*, p. 226.
12. Qadi Ahmad, pp. 179–80.

VI. THE SIXTEENTH AND SEVENTEENTH CENTURIES

1. Hans Robert Roemer, *CHIr*, 6, pp. 189–90.
2. *Idem.*, *CHIr*, 6, p. 198.
3. *PiI*, App. 150–51, for an English translation; the Persian original and a French translation by M. Qazwini and L. Bouvat, "Deux documents inédits relatifs à Bihzad," *Revue du monde musulman*, XXIV, 1914, pp. 146–61; now further discussed in Roxburgh, *Image*, pp. 24–25.
4. Stuart Cary Welch, *A King's Book of Kings*, New York, 1972, p. 15.
5. Roxburgh, *Image*, pp. 1–5 and *passim*.
6. Qadi Ahmad, p. 135.
7. Quoted by Stuart Cary Welch, *Wonders of the Age: Masterpieces of Early Safavid Painting, 1501-1576*, Cambridge (Mass.), 1979, p. 27.
8. As translated by Arnold, *PiI*, p. 141.
9. Stchoukine, *Saf I*, p. 16.
10. Qadi Ahmad, pp. 142–43.
11. Ehsan Echraghi, "Description contemporaine des peintures murales disparues des palais de Šah Tahmasp à Qazvin," *Art et société dans le monde Iranien*, ed. by C[hahriyar] Adle, Paris, 1982, pp. 117–126; the subject was further discussed by Paul Losensky, at a meeting on Safavid subjects held in Edinburgh in August of 1998, for which the papers remain as yet unpublished.
12. Armenag Sakisian, *La Miniature Persane . . .*, Paris and Brussels, 1929, p. 131; and *Bodl.*, p. 137.
13. Qadi Ahmad, p. 158.
14. Qadi Ahmad, pp. 160, 183.
15. Stchoukine, *Saf I*, p. 193.
16. Grace Dunham Guest, *Shiraz Painting in the Sixteenth Century* (Smithsonian Institution, Freer Gallery of Art, Oriental Studies, No. 4), Washington, D. C., 1949.
17. Qadi Ahmad, p. 192.
18. Stchoukine, *Saf I*, pp. 85–133; Robinson, V&A, p. 64.
19. *PiI*, p. 143.
20. *PiI*, p. 142.

21. B. W. Robinson, "Two Persian manuscripts in the Library of the Marquess of Bute, Part II: *Anwar-i Suhayli*, 1593 (Bute MS 347)," *Oriental Art*, NS, Vol. XVIII, 1972, p. 50; S. Anthony Welch, *Artists for the Shah*, New Haven and London, 1976, p. 176.

22. Massumeh Farhad, *Safavid Single Page Painting 1629–1666*, unpublished doctoral dissertation, Harvard University, 1987, p. 323.

VII. THE EIGHTEENTH AND NINETEENTH CENTURIES

1. Quoted by Edward G. Browne, *A Literary History of Persia*, IV, Cambridge, 1924 (reprinted 1959), p. 282.

2. RPP, Cat. 19–22, pp. 138–45.

3. Sir William Ouseley, *Travel into Various Countries of the East, particularly Persia*, London, 1819–1932, 3, p. 32.

4. *A Persian at the Court of King George, 1809–10: The Journal of Mirza Abul-Hassan Khan*, translated and edited by Margaret Morris Cloake, London, 1988, p. 74.

5. Robinson, V&A, p. 76.

6. B. W. Robinson, "The Court Painters of Fath ʿAli Shah," *Eretz-Israel*, 7, 1964, p. 96.

THE PRIMARY THEMES OF IRANIAN IMAGERY

NUMBER 2

1. A. S. Melikian-Chirvani, "The Iranian Sun-Shield," *Bulletin of the Asia Institute*, 6, 1992, p. 38, n. 6.

NUMBER 11

1. Nasser D. Khalili, B. W. Robinson, and Tim Stanley, *Lacquer of the Islamic Lands, Part Two*, Oxford, 1997, cat. 243, p. 51.

NUMBER 12

1. B. I. Marshak, *Skulptura i Zhivopis' Drevnego Pendzhikenta*, eds. A. M. Belenitski and B. B. Piotrovskii, Moscow, 1959, pls III–IX.

NUMBER 13

1. By Vladimir Livshits, in his appendix to Boris I. Marshak, "Literary Subjects in Sogdian Art," *The Yar-Shater Lectures*, Columbia University, New York, in press.

NUMBER 23

1. Charles K. Wilkinson, *Nishapur Pottery of the Early Islamic Period*, New York, 1973, p. 4.

2. Ernst J. Grube, *Cobalt and Lustre* (The Nasser D. Khalili Collection of Islamic Art, IX), London, 1994, p. 51, summarizing the arguments of Zick-Nissen, Ettinghausen, Shepherd, Marshak, and more recently, Fitzherbert.

3. *Ibid.*

NUMBER 27

1. Boston, Museum of Fine Arts, 28.13; *Survey*, pl. 1023 in color.

NUMBER 29

1. Charles Rieu, *Catalogue of the Persian Manuscripts in the British Museum*, Vol. III, 1883, pp. 1072–73; the manuscript was acquired in 1880.

NUMBER 31

1. Ruy Gonzalez de Clavijo, *Clavijo: Embassy to Tamerlane, 1403–1406*, tr. Guy le Strange, London, 1928, pp. 258–59.

2. M. Ş. Ipşiroğlu, *Saray-Alben: Diez'sche Klebebände aus den Berliner Sammlungen*, Wiesbaden, 1964, pp. 22–3; Filiz Çağman and Zeren Tanındı, *The Topkapı Saray Museum: The Albums and Illustrated Manuscripts*, tr. Michael Rogers, Boston, 1986, pls. 43–4.

NUMBER 32

1. Ruy Gonzalez de Clavijo, *Clavijo: Embassy to Tamerlane*, tr. Guy le Strange, London, 1928, pp. 218–85.

NUMBER 33

1. Thackston, *Century*, p. 104.

NUMBER 44

1. Cornelius le Bruyn, *Travels into Muscovy, Persia, and Part of the East-Indies . . . (Translated from the Original French)*, London, 1738, 2 vols, Vol. I, pl. 85 (facing p. 210).

NUMBER 47

1. *Silk Routes.* pp. 20 and 44, map, p. 16, and sketch plan, Fig. D, p. 76.

2. *Silk Routes*, quoted in translation, p. 41.

3. *Silk Routes*, cat. 107.

NUMBER 49

1. *Survey*, Pl. 722F.

NUMBER 52

1. Although the document has been translated into English several times, the language remains ambiguous; interpretations of phrases concerned with paintings for this manuscript are not always in accord. Compare Thomas Lentz, *Painting at Herat Under Baysunghur ibn Shahrukh*, unpublished doctoral dissertation, Harvard University, 1985, p. 482, with Thackston, *Century*, pp. 323–24.

NUMBER 55

1. Translation by W. M. Thackston, quoted by A. Soudavar, *Art of the Persian Courts*, New York, 1992, p. 159.

NUMBER 57

1. Adapted from the French translation of A. S. Melikian-Chirvani, *Le roman de Varqe et Golshah*, . . . *Arts Asiatiques*, XXII, 1970 (Numéro spécial), p. 206.

NUMBER 60

1. Adapted from the French translation of A. S. Melikian-Chirvani, "Khwaje Mirak Naqqash," *Journal Asiatique*, Vol. CCLXXVI, 1/2, 1988, p. 117.

2. *Op. cit.*, pp. 118–24 *passim*.

3. *Op. cit.*, pp. 98–103; for English versions, See Thackston, *Century*, pp. 225, 347, 362.

NUMBER 68

1. *Silk Routes*, 1982, p. 38.

2. *Silk Routes*, Fig. M, p. 146.

3. *Silk Routes*, see the map on p. 17.

4. Mario Bussagli, *Painting of Central Asia*, Geneva, 1963, p. 111.

NUMBER 70

1. *Survey*, pl. 205, a dish in the State Hermitage Museum in St. Petersburg.

NUMBER 74

1. Mehmet Aga-Oglu, "The Landscape Miniatures of an Anthology Manuscript of the year 1398 A.D.," *Ars Islamica*, III, 1936, pp. 76–98.

NUMBER 85

1. As translated, in Marianna Shreve Simpson [and Massumeh Farhad], *Sultan Ibrahim Mirza's "Haft Aurang,"* New Haven and London, 1997, p. 104; repeated in the same author's *Persian Poetry, Painting & Patronage: Illustrations in a Sixteenth-Century Masterpiece*, New Haven and London, 1998, p. 27.

NUMBER 89

1. *Nizami, Haft Paykar*, p. 36.

2. *Op. cit.*, p. 38.

3. *Op. cit.*, p. 40.

4. *Op. cit.*, p. 102.

NUMBER 90

1. Adapted from Thomas Woodward Lentz Jr., *Painting at Herat under Baysunghur ibn Shahrukh*, unpublished doctoral dissertation, Harvard University, 1985, pp. 410–11.

2. *Ibid.*, p. 410.

NUMBER 94

1. *Nizami, Haft Paykar*, p. 38.

NUMBER 97

1. Marianna Shreve Simpson [and Massumeh Farhad], *Sultan Ibrahim Mirza's "Haft Aurang,"* New Haven and London, 1997, p. 185 repeated in the same author's *Persian Poetry, Painting & Patronage: Illustrations in a Sixteenth-Century Masterpiece*, New Haven and London, 1998, p. 61.

NUMBER 98

1. *Conference of the Birds*, p. 60, ll. 1235–1240.

NUMBER 102

1. A. S. Melikian-Chirvani, "Le Livre des Rois, miroir du destin: II – Takht-e Soleyman et la symbolique du *Shah-Name*," *Studia Iranica*, Vol. 20, fasc. 1, 1991, pp. 94–98, figs 13–15.

NUMBER 105

1. Teresa Fitzherbert, "Khwaju Kirmani (689–753/1290–1352): an Éminence Grise of Fourteenth Century Persian Painting," *Iran*, Vol. XXIX, 1991, p. 147.

2. *Ibid.*

NUMBER 113

1. Ruy Gonzalez de Clavijo, *Clavijo: Embassy to Tamerlane*, tr. Guy le Strange, London, 1928, p. 258.

NUMBER 115

1. *Nizami: Haft Paykar*, p. 290, n. 31:5.

2. *Op. cit.*, p. 104.

3. *Op. cit.*, p. 105.

4. TPV, p. 377, 2a–d.

NUMBER 118

1. Quoted by R. W. Ferrier, from India Office Records G/29/1, in "Charles I and the Antiquities of Persia: The Mission of Nicholas Wilford," *Iran*, VIII, 1970, pp. 51–52.

NUMBER 119

1. A. T. Adamova, *Persian painting and drawing of the 15th–19th centuries from the Hermitage Museum* (in Russian), St. Petersburg, 1996, cat. 49, pp. 266–67, in color.

2. Nasser D. Khalili, B. W. Robinson, and Tim Stanley, *Lacquer of the Islamic Lands, Part One*, Oxford, 1996, cat. 106, pp. 142–43.

NUMBER 122

1. Minhaj ibn Siraj Muhammad Juzjani, *Tabaqat-i Nasiri*, quoted in French translation by Schlumberger, 1952, p. 164.

NUMBER 128

1. Layla S. Diba, "Persian Painting in the Eighteenth Century: Tradition and Transmission," *Muqarnas*, VI, 1989, pp. 155–56 especially, and figs 6–7; and RPP, pp. 148–50, cat. 23.

NUMBER 133

1. Translated by B. I. Marshak, after Bertels' edition of the *Shahnama*, Moscow, 1962, Vol. 2, p. 101, verses 472–73.

NUMBERS 136–38

1. Quoted by A. S. Melikian-Chirvani, "Le Livre des rois, miroir du destin," *Studia Iranica*, Vol. 17, 1988, p. 42.

NUMBER 141

1. Wheeler M. Thackston, "The *Diwan* of Khataʾi: Pictures for the Poetry of Shah Ismaʿil I," *Asian Art*, Fall, 1998, p. 43.

NUMBER 143

1. Glenn D. Lowry et al., *An Annotated and Illustrated Checklist of the Vever Collection*, Washington DC, Seattle, and London, 1988, p. 299; also idem, with Susan Nemazee, *A Jeweler's Eye: Islamic Arts of the Book from the Vever Collection*, Washington DC, Seattle, and London, 1988, pl. 65 and also cover, both in color.

2. Thackston, *Century*, p. 348.

NUMBER 153

1. For example an Iranian-inspired Indian picture from the first decade of the seventeenth century, of the first Mughal emperor Babur, dressed in seventeenth-century Iranian clothing and sitting in a chair reading a book with visible text, one foot free of its slipper and resting on the other knee: *Paintings from the Muslim Courts of India* (Catalogue of a loan-exhibition at the British Museum in the summer of 1976; no author is stated on the title-

page but the pictures were selected and entries written by R. H. Pinder-Wilson, Douglas Barrett, and Ellen Smart), London, 1976, illustrated in color, cat. 102. Or a somewhat earlier painting from Ahmadnagar, in the Deccan, in which an enthroned sultan sits on a throne chair with one bare foot resting on the other knee, his slipper on the ground in front of him: Mark Zebrowski, *Deccani Painting*, London, 1983, color plate II.

NUMBER 156

1. Deborah E. Klimburg-Salter, "A Sufi Theme in Persian Painting: The Diwan of Sultan Ahmad Ġalaʾir in the Free[r] Gallery of Art, Washington D.C.," *Kunst des Orients*, XI, 1976–77, fig. 2, p. 45.

NUMBER 161

1. For example, an early seventeenth-century painting of the Mughal emperor Babur, seated in a chair with one foot crossed at the other knee and reading: *Muslim Courts*, illustrated in color, cat. 102.

NUMBER 164

1. B. W. Robinson, "An Unpublished Manuscript of the Gulistan of Saʿdi," *Beiträge zur Kunstgeschichte Asiens*, Oktay Aslanapa, ed., Istanbul, 1963, p. 226.

NUMBER 173

1. *The Gulistan, or Rose Garden, of Saʾdi*, tr. Edward Rehatsek, London, 1956, chapter I, story 27, pp. 103–4.

NUMBER 177

1. *Survey*, pl. 708.

NUMBER 186

1. *The Babur-nama in English*, tr. A. S. Beveridge, London, 1922, p. 258.

NUMBER 187

1. *TPV*, quoted p. 290.

NUMBER 194

1. RPP, Fig. 10, p. 37.

NUMBER 196

1. C. Hill, "Early Art," *The Arts of Persia*, ed. Ronald Ferrier, London, 1989, pp. 24–25.

NUMBER 197

1. *Survey*, pl. 232A, another dish in the State Hermitage Museum in St. Petersburg.

NUMBER 200

1. Ernst J. Grube, "Prolegomena for a Corpus Publication of Illustrated *Kalilah wa Dimnah* Manuscripts," *Islamic Art*, IV, 1990–91, Appendix III, pp. 411–12 (B.15.22, B.15.25.1).
2. Filiz Çağman and Zeren Tanındı, *The Topkapı Saray Museum: The Albums and Illustrated Manuscripts*, tr. Michael Rogers, Boston, 1986, fig. 27.

NUMBER 201

1. *Gilded and Enamelled Glass from the Middle East*, ed. Rachel Ward, London, 1998: color plates D, F, J, and L illustrate a number of hitherto unpublished pieces with miniature-like figural decoration, as do many of the black-and-white pictures.

NUMBER 202

1. Willy Hartner and Richard Ettinghausen, "The Conquering Lion, The Life-Cycle of a Symbol," *Oriens*, vol. 17, 1964, pp. 161–71.
2. James George, "Achaemenid Orientations," *Akten des VII. Internationalen Kongresses für Iranische Kunst und Archäologie, München, 7–10 September 1976*, Archäologische Mitteilungen aus Iran, Ergänzungsband 6, Berlin, 1979, pp. 196–206.

NUMBER 206

1. Both illustrated in *A Mirror for Princes from India, Illustrated Versions of the* Kalilah wa Dimnah, Anvar-i Suhayli, ʿIyar-i Danish, *and* Humayun Nameh, *Marg*, ed. by Ernst J. Grube, 1991: the Arab picture in fig. 10, p. 21 (Paris, BN, Arabe 3465), and the Mughal picture in fig 142, p. 143 (Bombay, Collection of Sir Cowasji Jehangir).

NUMBER 213

1. Qurʾan, XIX, 17.

NUMBER 214

1. Sheila Blair, *A Compendium of Chronicles*, Oxford, 1995, illustrated on pp. 86–7.

NUMBER 215

1. *The Conference of the Birds*, p. 39.

NUMBER 216

1. Quoted by Anthony Welch and Stuart Cary Welch, *Arts of the Islamic Book: The Collection of Prince Sadruddin Aga Khan*, Ithaca and London, 1982, p. 81.

NUMBER 223

1. Thackston, *Century*, p. 348.
2. *The Arts of the Book in Central Asia*, ed. Basil Gray, Paris/London, 1979 illustrated in color, pp. 192–93, Pls. LXIII–LXIV (but reversed).

NUMBER 224

1. C. V. Trever and V. G. Lukonin, *Sasanidskoe Serevro* (*Sasanian Silver*, in Russian), Moscow, 1987, pl. 28.

NUMBER 227

1. Filiz Çağman and Zeren Tanındı, *The Topkapı Saray Museum: The Albums and Illustrated Manuscripts*, tr. Michael Rogers, Boston, 1986, pl. 41.
2. A. T. Adamova and Leon Giuzalian, *Miniaturi Rukopisi Poemi "Shahname" Goda*, Leningrad, 1985, folio 258v: pp. 34, and 126–27, in color.

NUMBER 231

1. *Nizami: Haft Paykar*, tr. p. 49.
2. *Op. cit.*, p. 50.
3. *Op. cit.*, p. 49.
4. *Op. cit.*, p. 51.

NUMBERS 233–34

1. As translated by Norah Titley, *Miniatures from Persian Manuscripts: Catalogue and Subject Index of Paintings from Persia, India, and Turkey in the British Library and the British Museum*, London, 1977, p. 139, 315, 9.
2. *Ibid*.

NUMBER 235

1. G. I. Balashova, "A Twelfth–Thirteenth Century Pottery Jug Decorated with Epic Subjects" (in Russian with an English summary), *Srednyaya Aziya i Iran, Sbornik Statei*, Leningrad, 1972, pp. 91–106, 181–2, figs. 1–11.
2. Charles K. Wilkinson, *Nishapur Pottery of the Early Islamic Period*, New York, 1973, pp. 272–73, cat. 57a, ill. p. 284.
3. Jan Rypka, *History of Iranian Literature*, (English translation from the original German edition of 1956), Dordrecht, 1968, p. 56; Priscilla Soucek, "Farhad and Taq-i Bustan: The Growth of a Legend," *Studies in Art and Literature of the near East, in honor of Richard Ettinghausen*, ed. Peter Chelkowski, New York, 1974, pp. 39–46 *passim*.

NUMBER 246

1. As translated by A. H. Morton, *Poetry / Epic*, p. 27.

NUMBER 247

1. The notion was first suggested by Richard Ettinghausen, "Some Paintings in Four Istanbul Albums, *Ars Orientalis*, I, 1954, p. 99; the entire argument summarized by Ernst J. Grube, "The Problem of the Istanbul Album Paintings," *Islamic Art*, I, 1981, pp. 1–30.

NUMBER 250

1. *The Conference of the Birds*, pp. 214–15, ll 4152–56.
2. *Op. cit.*, p. 219, ll 4236–40, 4252–533, 4357.

BIBLIOGRAPHY

Compiled by Ernst J. Grube

PART I. PRE-ISLAMIC IRANIAN AND CENTRAL ASIAN PAINTING, AND ITS SOURCES IN THE DECORATIVE ARTS

I. NOMADIC FIGURAL ARTS

A. GENERAL (ARRANGED CHRONOLOGICALLY)

M. I. Rostovtseff, "The Great Hero-Hunter of Middle Asia and his Exploits," *Artibus Asiae*, IV, 2–3, 1930–32, pp. 99–117

Alfred Salmony, *Sino-Siberian Art in the Collection of C. T. Loo*, Paris, 1933

John F. Haskins, "Targhyn – the Hero, Aq-Zhanus – the Beautiful, and Peter's Siberian Gold," *Ars Orientalis*, IV, 1961, pp. 153–69

S. I. Rudenko, *Sibirskaia Kollektsiia Petra I (Svod arkheo-logicheskikh istochnikov, D3–9)* (*The Siberian Collection of Peter the Great*), Moscow, Leningrad, 1962

——, *Kul'tura khunov i noinulinskie kurgany* (*Culture of the Huns and the Noin-Ula Tumuli*), Moscow, Leningrad, 1962

M. P. Gryaznov, "Drevneishie pamiatniki geroicheskogo eposa narodov Iuzhnoi Sibiri (The earliest evidence of the South-Siberian peoples' heroic epics)," *Arkheologicheskii Sbornik*, III (State Hermitage Museum), 1963, pp. 7–31

S. I. Rudenko, *The Frozen Tombs of Siberia: The Pazyryk Burials of Iran Age Horsemen*, tr. by M. W. Thompson, Berkeley and Los Angeles, 1970

The Animal Style: Art From East to West: catalogue of an exhibition at the Asia Society (Catalogue by Emma C. Bunker), New York, 1970

M. I. Artamonov, *Sokrovishcha Sakov* (Saka Art), Moscow, 1973: for the problem of contacts between Achemenid narrative paintings and Saka metalwork

Emma C. Bunker, "The Anecdotal Plaques of the Eastern Steppe Region," *Arts of the Eurasian Steppelands* (*Colloquies on Art & Archaeology in Asia*, no. 7), University of London, Percival David Foundation of Chinese Art, School of Oriental and African Studies, ed. by Philip Denwood, London, 1978, pp. 121–42

M. P. Gryaznov, "Tashtykskaia kul'tura (Tashtyk Culture)," *Kompleks arkheologichesckikh pamiatnikov s gory Tepsei na Enisee* (*Archaeological Sites on the Tepsei Mountain near the Yenisei River*), Novisibirsk, 1979: for the South-Siberian reciters' pictures in the 3rd to the 5th centuries

Emma C. Bunker, "Gold Belt Plaques in the Siberian Treasure of Peter the Great: Dates, Origins, and Iconography," *The Nomad Trilogy 3. Foundations of Empire: Archaeology and Art of the Eurasian Steppes*, ed. by G. Seaman, Los Angeles, 1992, pp. 201–22

Véronique Schiltz, *Les Scythes et les nomades des steppes: VIIIe siècle après J.-C.*, Paris, 1994

B. NOMADIC ARTS: ORLAT

G. A. Pugachenkova, "Novoe o khudozhestvennoi kul'ture antichnogo Sogda (New Data on the Art and Culture of Ancient Sogdia)," *Pamiatniki kul'tury: Novye otkrytiia*, Leningrad, 1983, pp. 521–31 (and as *Cultural Relics: New Discoveries*, Leningrad, 1985)

II. ANCIENT AND PRE-ISLAMIC IRANIAN PAINTING

A. GENERAL, ESPECIALLY FOR PICTURES

Ernst Herzfeld, *Iran in the Ancient East*, London and New York, 1941

Roman Ghirshman, *Iran: Parthes et Sassanides*, Paris, 1962

Georgina Herrmann, *The Iranian Revival*, London, 1977

The Arts of Persia, ed. R. W. Ferrier, London, 1989: Chapters 2–5 have useful illustrations, diagrams, maps and plans

B. SPECIFIC SITES OR MATERIALS

SUSA

Roman Ghirshiman, *Iran: Parthes et Sassanides*, Paris, 1962

CTESIPHON

Die Ausgrabungen der zweiten Ktesiphon-Expedition (Winter 1931/32), Berlin, 1933

KUH-I KHWAJA

Trudy Kawami, "Kuh-e Khwaja, Iran, and Its Wall-Paintings: The Records of Ernst Herzfeld," *Metropolitan Museum Journal*, 22, 1987, pp. 13–52

HAJIABAD

M. Azarnouch, *The Sasanian Manor House in Hajiabad, Iran* (Monografie di Mesopotamia, III), Florence, 1994, Chapter IV, part II, Murals

DAR GAZ

Archaeological Reports of Iran, I, Autumn, 1997: Mehdi Rahbar, "Excavations at Bandiyan, Dar Gaz, Khurasan," pp. 9–32; R. Bashkash-e Kanzag, "Translations of Inscriptions discovered at Bandiyan, Dar Gaz (Dastkard-i Yazd Shapuran)," pp. 33–38

Guitty Azarpay, "The Sasanian Complex at Bandian," *Bulletin of the Asia Institute*, 11, 1997, pp. 193–94

Mehdi Rahbar, "Découverte d'un monument d'époque sassanide à Bandian, Dargaz: Fouilles 1994 et 1995," *Studia Iranica*, 27, 2, 1998, pp. 213–30

Philippe Gignoux, "Les inscriptions en moyen-perse de Bandian," *Studia Iranica*, 27, 2, 1998, pp. 251–58

Mehdi Rahbar, "A Dargaz (Khorassan). Découverte de deux panneaux de stucs sassanides," *Dossiers d'archéologie*, 243, May 1999, pp. 62–65

SASANIAN METALWORK

Prudence Oliver Harper *et al.*, *The Royal Hunter: Art of the Sasanian Empire* (Catalogue of an exhibition at Asia House), New York, 1978

——and Pieter Meyers, *Silver Vessels of the Sasanian Period, Volume One: Royal Imagery*, New York 1981

K. V. Trever and V. G. Lukonin, *Sasanidskie serebro, Sobranie Gosudarstvennogo Ermitzha, Khudozhest-vennaya kul'tura Irana III–VIII vekov (Sasanian Silver . . . in the Hermitage . . .)*, Moscow, 1987

Boris Marschak (sic), *Silberschätze des Orients: Metallkunst des 3.–13. Jahrhunderts und ihre Kontinuität*, Leipzig, 1986

III. CENTRAL ASIA, BOTH PRE-ISLAMIC AND IN THE EARLY MIDDLE AGES

A. GENERAL (ARRANGED CHRONOLOGICALLY)

A. von Le Coq and E. Waldschmidt, *Die Buddhistische Spätantike in Mittelasien*, Berlin, 1922–33, 7 volumes

Mario Bussagli, *Painting of Central Asia*, Geneva, 1963

Along the Ancient Silk Routes, Central Asian Art from the West Berlin State Museums, An exhibition lent by the Museum für Indische Kunst, Staatliche Museen Preussischer Kulturbesitz, Berlin, Federal Republic of Germany, The Metropolitan Museum of Art, New York, 1982

History of civilizations of Central Asia, Volume III: The crossroads of civilizations: A.D. *250 to 750*, ed. by B. A. Litvinsky *et al.*, Paris, 1996

Dictionary of Art, XX, "Central Asia, Western: Painting," pp. 222–34: subsections on prehistoric and the earliest periods, and then geographically subdivided articles, by V. A. Ranov, Yu. A. Rapoport, B. Ya. Stavisky, and B. I. Marshak

B. PANJIKENT

Guitty Azarpay, with contributions by A. M. Belenitskii, B. I. Marshak, and Mark J. Dresden, *Sogdian Painting: The Pictorial Epic in Oriental Art*, Berkeley, Los Angeles, London, 1981

Boris I. Marshak and Valentina I. Rospopova, "A Hunting Scene from Panjikent," *Bulletin of the Asia Institute*, 4, 1990, pp. 77–94

C. JAR-TEPE

Amruddin Berdimuradov and Masud Samibaev, with Frantz Grenet and Boris Marshak, "Une nouvelle peinture murale sogdienne dans le temple de Dzartepa II," *Studia Iranica*, 30, 2001, pp. 45–56

D. SAMARQAND

L. I. Al'baum, *Zhivopis' Afrasiaba*, Tashkent, 1974

Boris I. Marshak, "Le programme iconographique des peintures de la 'Salle des Ambassadeurs' à Afrasiab," *Arts Asiatiques*, XLIX, 1994, pp. 1–20

E. SOGDIAN METALWORK

Boris I. Marshak, *Sogdiiskoe Serebro*, Moscow, 1971

Boris Marschak (sic), *Silberschätze des Orients: Metallkunst des 3.–13. Jahrhunderts und ihre Kontinuität*, Leipzig, 1986

F. OTHER SITES AND CULTURES

GHULBIYAN

Frantz Grenet and Jonathan Lee, "New Light on the Sasanid painting at Ghulbiyan, Faryab Province, Afghanistan," *South Asian Studies*, 14, 1998, pp. 75–85

Frantz Grenet, "Le peinture sassanide de Ghulbiyan," *Dossiers d'archéologie*, no. 243, May 1999, pp. 66–67

THE HEPHTHALITES

Robert Göbl, *Dokumente zur Geschichte der iranischen Hunnen in Baktrien und Indien*, vols. I–IV, Wiesbaden, 1967

DILBERJIN (DALVERZIN)

Tom Fitzsimmons, "Chronological Problems at the Temple of the Dioscuri, Dil'berdzin Tepe (North Afghanistan)," *East and West*, 46, nos. 3–4, 1966, pp. 271–98 (with a list of Kruglikova's publications)

I. T. Kruglikova, "Les fouilles de la mission archéologique soviéto-afghane sur le site greco-kushan en Bactriane," *Comptes-rendues de l'Académie des Inscriptions et Belles-Lettres 1977*, April–June 1977

——, "Nastennye rosposi v pomeschenii 16 severovostochnogo kul'ovogo kompleksa Dil'berdzhina (Murals from Room 16 in the Precincts of the Temple in the North-East Corner of Dilberjin)," *Drevniaia Baktriia* (Ancient Bactria), 2, 1979

Drevniaia Baktriia (Ancient Bactria), 3, 1984

PART II. PAINTING IN THE ISLAMIC PERIOD

I. GENERAL, COLLECTED WRITINGS, AND FESTSCHRIFTS (ARRANGED CHRONOLOGICALLY)

F. R. Martin, *The Miniature Painting and Painters of Persia, India and Turkey from the 8th to the 18th Century*, London, 1912, 2 vols.; reprinted in 1 vol., London, 1971

Ph. Walter Schulz, *Die persisch-islamische Miniaturmalerei, Ein Beitrag zur Kunstgeschichte Irans*, 2 vols., Leipzig, 1914

Edgard Blochet, *Les Enluminures des manuscrits orientaux – turcs, arabes, persans – de la Bibliothèque Nationale*, Paris, 1926

Thomas Arnold, *Painting in Islam*, London, 1928; reprinted New York, 1965, with an introduction by B. W. Robinson (see also X, B, Biographies)

——and Adolf Grohmann, *The Islamic Book, A Contribution to its Art and History from the VII–XVIII Century*, The Pegasus Press, 1929

Arménag Sakisian, *La miniature persane du XIIe au XVIIe siecle*, Paris-Bruxelles, 1929

Laurence Binyon, *The Spirit of Man in Asian Art*, Cambridge (Mass.), 1935: Lecture IV, pp. 105–41 and plates 28–45

Ernst Kühnel, "History of Miniature Painting and Drawing," *A Survey of Persian Art*, London, 1938–39: V, pp. 1829–97, pls. 812–925; later reprints have different volume numbers but both pagination and plate-numbers remain the same

Basil Gray, *Persian Painting*, Geneva, 1960 (and later reprints and French translations)

B. W. Robinson, *Persian Drawings from the 14th through the 19th Century*, New York, 1965 (primarily on manuscript illustration and single-page paintings)

Guitty Azarpay, "Sogdian Stylistic Devices in Islamic Miniature Painting," *Actes du 29ème congrès des orientalistes*, Paris, 1975

Ernst J. Grube, *La pittura dell'Islam*, Bologna, 1980

——and Eleanor Sims, "Painting," *The Arts of Persia*, ed. by R[onald] W. Ferrier, New Haven and London, 1989, pp. 200–23

Yves Porter, *Peinture et arts du livre*, Paris and Teheran, 1992

B. W. Robinson, *Studies in Persian Art*, London, 1993, 2 vols.: reprints of 30 articles written between 1948 and 1993, with some corrections

Ernst J. Grube, *Studies in Islamic Painting*, London, 1995: reprints of 17 previously published articles with extensive corrections and additions

Oleg Grabar, *La peinture persane, une introduction*, Paris, 1999; translated as *Mostly Miniatures: An Introduction to Persian Painting*, Princeton and Oxford, 2000

Robinson Festschrift: Persian Painting from the Mongols to the Qajars, Studies in honour of Basil W. Robinson, ed. by Robert Hillenbrand, London and New York, 2000

II. COMPEHENSIVE CATALOGUES OF COLLECTIONS, AND WORKS BASED ON SINGLE COLLECTIONS

BOSTON

Ananda K. Coomaraswamy, *Les Miniatures Orientales de la Collection Goloubew au Museum of Fine Arts de Boston*, Paris and Brussels, 1929

CAMBRIDGE (MASS.)

Eric Schroeder, *Persian Miniatures in the Fogg Museum of Art*, Cambridge (Mass.) 1942

Marianna Shreve Simpson, *Arab and Persian Painting in the Fogg Art Museum*, Cambridge (Mass.), 1980

DUBLIN

The Chester Beatty Library, A Catalogue of the Persian Manuscripts and Miniatures, vol. I, by A. J. Arberry, M. Minovi, and the late E. Blochet, ed. the late J. V. S. Wilkinson, Dublin, 1959; II, by M. Minovi, B. W. Robinson, the late J. V. S. Wilkinson, and the late E. Blochet, ed. by A. J. Arberry, Dublin, 1960; III, by A. J. Arberry, B. W. Robinson, the late E. Blochet, and the late J. V. S. Wilkinson, ed. by A. J. Arberry, Dublin, 1962

GENEVA

B. W. Robinson, "Catalogue des peintures et des calligraphies islamiques leguées par Jean Pozzi au Musée d'art et d'histoire de Genève," *Genava*, Nouvelle serie, Tome XXI, 1973, pp. 109–279

Anthony Welch, *Collection of Islamic Art, Prince Sadruddin Aga Khan*, Geneva, Vols. III and IV, 1978: the first of several publications of an important private collection; see also III.

ISTANBUL

Topkapı Sarayi Collection: Islamic Painting, Foreword by Kemal Çığ, Texts by Ernst J. Grube, Filiz Çağman, Zeren Akalay, Tokyo, 1978: many large color-plates

Filiz Çağman and Zeren Tanındı, *Topkapı Saray Museum, Islamic Miniature Painting*, Istanbul, 1979

Mazhar Ş. Ipşiroğlu, *Chefs-d'oeuvre du Topkapı, Peintures et miniatures*, Paris, 1980

The Topkapı Saray Museum, The Albums and Illustrated Manuscripts, translated, expanded and edited by J. M. Rogers from the original Turkish by Filiz Çağman and Zeren Tanındı, Boston, 1986

LONDON

Sheila R. Canby, *Persian Painting*, London, 1993

B. W. Robinson, *Persian Paintings in the India Office Library, A Descriptive Catalogue*, London, 1976

——, *Persian Paintings in the Collection of The Royal Asiatic Society, London*, London, 1998

Norah M. Titley, *Miniatures from Persian Manuscripts, A Catalogue and Subject Index of Paintings from Persia, India and Turkey in The British Library and The British Museum*, The British Library, London, 1977: immensely useful for its comprehensive listing of subjects from all the manuscripts and albums then in both the British Library and the British Museum, and for its various indexes

The Keir Collection, Islamic Painting and the Arts of the Book, B. W. Robinson, Ernst J. Grube, G. M. Meredith-Owens, R. W. Skelton, With an Introduction by Ivan Stchoukine, ed. by B. W. Robinson, London, 1976

MANCHESTER

B. W. Robinson, *Persian Paintings in the John Rylands Library*, London, 1980

MINNEAPOLIS

Eleanor G. Sims, "Persian Miniature Painting in the Minneapolis Institute of Arts," *The Minneapolis Institute of Arts Bulletin*, LXXI, 1975, pp. 51–73

NEW YORK CITY

Barbara Schmitz, with contributions by Latif Khayyat, Svat Soucek, and Massoud Pourfarrokh, *Islamic Manuscripts in the New York Public Library*, New York, 1992

——, with contributions by Pratapaditya Pal, Wheeler M. Thackston, and William M. Voelkle, *Islamic and Indian Manuscripts and Paintings in the Pierpont Morgan Library*, New York, 1997

OXFORD

B. W. Robinson, *A Descriptive Catalogue of the Persian Paintings in the Bodleian Library*, Oxford, 1958: the first of his descriptive catalogues, an especially useful "tool" for its lists of "Manuscripts for Comparison"

SAINT PETERSBURG

Persian painting and drawing of the 15th–19th centuries from the Hermitage Museum, A[del] T. Adamova (catalogue, in Russian, of almost the entire Hermitage Iranian painted materials), St. Petersburg, 1996

TEHRAN

Mohammad-Hasan Semsar, *Golestan Palace Library: Portfolio of Miniature Paintings and Calligraphy*, Tehran, 2000

WASHINGTON, DC

Glenn D. Lowry and Milo Cleveland Beach, with Roya Marefat and Wheeler M. Thackston, Contributions by Elisabeth West FitzHugh, Susan Nemazee, and Janet G. Snyder, *An Annotated and Illustrated Check-list of the Vever Collection*, Seattle and London, 1988

Glenn D. Lowry, with Susan Nemazee, *A Jeweler's Eye: Islamic Arts of the Book from the Vever Collection*, Washington DC, Seattle, and London, 1988

VIENNA

Dorothea Duda, *Islamische Handschriften I, Persische Handschriften*, Vienna, 1983, Band 4 (in two parts): Part I: *Textband*, Part II: *Tafelband*

III. EXHIBITION CATALOGUES (ARRANGED CHRONOLOGICALLY)

Miniatures persanes exposées au Musée des Arts Décoratifs, Juin–Octobre 1912, by G. Marteau and H. Vever (catalogue of a remarkable loan exhibition largely drawn from private French collections) 2 vols., Paris, 1913

Persian Miniature Painting, including a critical and descriptive catalogue of the miniatures exhibited at Burlington House, January–March, 1931, by Laurence Binyon, J. V. S. Wilkinson, and Basil Gray, Oxford, 1933, reprinted New York, 1971, with a foreword by B. W. Robinson

Catalogue of a Loan Exhibition of Persian Miniature Paintings from British Collections, B. W. Robinson (catalogue of an exhibition at the Victoria and Albert Museum), London, 1951

Muslim Miniature Paintings from the XIII to XIX Century from Collections in the United States and Canada: Catalogue of the Exhibition, Ernst J. Grube (catalogue of a travelling loan exhibition in Venice and New York City), Venice, 1962

Persian Miniature Painting from collections in the British Isles, B. W. Robinson (catalogue of a loan exhibition at the Victoria & Albert Museum), London, 1967

The Classical Style in Islamic Painting: The early school of Herat and its impact on Islamic Painting in the later 15th, the 16th and 17th centuries: Some Examples in American Collections, Ernst J. Grube (catalogue of a loan exhibition at the Pierpont Morgan Library, New York City), Lugano, 1968

Arts of the Islamic Book: The Collection of Sadruddin Aga Khan, Anthony Welch and Stuart Cary Welch (catalogue of an exhibition drawn from an important private collection held first at Asia House in New York City), Ithaca and London, 1982: a large section is devoted to Iranian manuscripts and single-page paintings

Treasures of Islam, ed. by Toby Falk (catalogue of an loan exhibition in which significant numbers of the most important and beautiful Iranian manuscripts and paintings from private collections were shown together, at the Musée d'art et d'histoire in Geneva), with essays by Anthony Welch, Stuart C. Welch, and Massumeh Farhad, Geneva, 1985

Art of the Persian Courts: Selections from the Art and History Trust, Abolala Soudavar, with a contribution by Milo Cleveland Beach (collection-catalogue also serving as an exhibition-catalogue at the Arthur M. Sackler Gallery Washington, D.C., and at the Los Angeles County Museum of Art), New York, 1992: largely a collection of Iranian manuscripts, detached folios, and single-page paintings belonging to an Iranian private collector

De Bagdad à Ispahan: Manuscrits islamiques de la Filiale de Saint-Petersbourg de l'Institut d'Etudes orientale, Académie des Sciences de Russie, Yuri A. Petrosyan, Oleg F. Akimushkin, Anas B. Khalidov, and Efim A. Rezvan, with the collaboration of Edouard N. Tyomkine et Margarita J. Vorobyova-Desyatovskaya (French version of a catalogue for an exhibition in Paris in 1994)

Pages of Perfection: Islamic Paintings and Calligraphy from the Russian Academy of Sciences, St. Petersburg, written by Yuri A. Petrosyan, Oleg F. Akimushkin, Anas B. Khalidov, and Efim A. Rezvan, with essays by Marie Lukens Swietochowski and Stefano Carboni (the English-language catalogue for the New York exhibition of the same materials), Milan, 1995: Iranian manuscripts and paintings are numerous and important in the collection of the Oriental Institute in St. Petersburg

Splendeurs persanes, Manuscrits du XIIe au XVIIe siecles, Francis Richard (catalogue of an exhibition drawn from the rich holdings of the Bibliothèque Nationale de France), Paris, 1997

Princes, Poets & Paladins: Islamic and Indian paintings from the collection of Prince and Princess Sadruddin Aga Khan, Sheila R. Canby (exhibition catalogue), London, 1998: again, a large section is devoted to Iranian manuscripts and single-page paintings from this important private collection

Royal Persian Paintings, The Qajar Epoch, 1785–1925, Layla S. Diba, with Maryam Ekhtiar, Essays by B. W. Robinson, Abbas Amanat, Layla S. Diba, Maryam Ekhtiar, Adel T. Adamova, Afsaneh Najmabadi, Peter Chelkowski (catalogue of a loan-exhibition at the Brooklyn Museum of Art and the Los Angeles County Museum of Art), London, 1998 (see also IV, 5, VII, and VIII)

IV. STUDIES ON SPECIFIC PERIODS

1. TO THE END OF THE THIRTEENTH CENTURY

Grace Guest and Richard Ettinghausen, "The Iconography of a Kashan Luster Plate," *Ars Orientalis*, IV, 1961, pp. 25–64

Assadullah Souren Melikian-Chirvani, "Materiaux pour servir à l'histoire de le peinture persane – I: Trois manuscrits de l'Iran seldjoukide," *Arts Asiatiques*, XVI, 1967, pp. 3–51

——, *Le Roman de Varque et Golšah, Essai sur les rapports de l'esthétique littéraire et de l'esthétique plastique dans l'Iran pre-mongol, suivi de la traduction du poème*, Arts Asiatiques, Tome XXII, numéro spécial, Paris, 1970 (see also V, 4, Poetic Texts)

D. S. Rice, "The Oldest Illustrated Arabic Manuscript," *BSOAS*, XXII, 1959, pp. 207–20

2. THE FOURTEENTH CENTURY

Sheila S. Blair, "The Development of the Illustrated Book in Iran," *Muqarnas*, X, 1993, pp. 266–74

——, *A Compendium of Chronicles, Rashid al-Din's illustrated history of the world* (The Nasser D. Khalili Collection of Islamic Art, XXVII), London, 1995

Ernst J. Grube, *Persian Painting in the Fourteenth Century. A Research Report* (Supplemento n. 17 agli *Annali*, 38, 1978, fasc. 4): (reprinted, with corrections and additions, in the same author's *Studies in Islamic Painting*, London, 1998, pp. 158–290, and pp. 524–28)

M[azhar] S. Ipşiroğlu, *Painting and Culture of the Mongols*, New York, 1966

Marianna S. Simpson, "The Role of Baghdad in the Formation of Persian Painting," *Art et société dans le monde Iranien*, (Institut Français d'Iranologie de Teheran, Bibliothèque Iranienne No. 26), ed. by C[hahriyar] Adle, Paris, 1982, pp. 91–116

Marie Lukens Swietochowski and Stefano Carboni, with essays by A. H. Morton, and Tomoko Masuya, *Illustrated Poetry and Epic Images: Persian Painting of the 1330s and 1340s*, New York, 1994

Elaine Wright, "The Look of the Book: Manuscript Production in the Southern Iranian City of Shiraz from the early 14th Century to 1452," unpublished doctoral dissertation, Oxford University, 1997

3. THE FIFTEENTH CENTURY

Mulk Raj Anand, Norah Titley, Basil Gray, B. W. Robinson, *Persian Painting, Fifteenth Century*, Bombay and London, 1977

The Arts of the Book in Central Asia, 14th–16th Centuries, ed. by Basil Gray, [with contributions by] Oleg Akimushkin, Mukaddema Ashrafi-Aini, Oktay Aslanapa, Emel Esin, Ernst Grube [and Eleanor Sims], 'Abd al-Hayy Habibi, Anatol Ivanov, Marie Lukens-Swietochowski, Basil Robinson, and Priscilla Soucek, London and Paris, 1979

Between China and Iran, Paintings from Four Istanbul Albums, A Colloquy held 23–16 June 1980, Colloquies on Art and Archaeology in Asia, No. 10, University of London, Percival David Foundation of Chinese Art, School of Oriental and African Studies, ed. by Ernst J. Grube and Eleanor Sims, New York, 1980, also published as *Islamic Art*, I, 1981

Ernst J. Grube and Eleanor Sims, "[History of Miniature Painting:] The School of Herat from 1400–1450," *Arts of the Book in Central Asia*, 1979, pp. 147–78

Thomas W. Lentz, "Painting in Herat under Baysunghur ibn Shahrukh," unpublished doctoral dissertation, Harvard University, 1985

——and Glenn D. Lowry, *Timur and the Princely Vision: Persian Art and Culture in the Fifteenth Century*, Los Angeles County Museum of Art, 1989 (catalogue of the exhibition organized by the Arthur M. Sackler Gallery, Smithsonian Institution, Washington, DC, and the Los Angeles County Museum of Art)

Marie Lukens Swietochowski, "[History of Miniature Painting:] The School of Herat from 1450 to 1506," *The Arts of the Book in Central Asia*, (1979), pp. 179–214

B. W. Robinson, "[History of Miniature Painting:] The Turkman School to 1503," *The Arts of the Book in Central Asia*, (1979), pp. 215–47

——, *Fifteenth-Century Persian Painting, Problems and Issues* (Hagop Kevorkian Series on Near Eastern Art and Civilization), New York and London, 1991

Eleanor Sims, "The Timurid Imperial Style: Its Origin and Diffusion," *aarp (Art and Archaeology Research Papers)*, 6, 1974, pp. 56–67

Ivan Stchoukine, *Les peintures des manuscrits timurides*, Paris, 1954

Timurid Art and Culture: Iran and Central Asia in the Fifteenth Century, ed. by Lisa Golombek and Maria Subtelny, selected papers from a symposium in 1989, including – on painting – A[del] Adamova, Robert Hillenbrand, Güner Inal, Priscilla P. Soucek, and Eleanor Sims (Supplements to *Muqarnas*, VI), Leiden, New York, Cologne, 1992

4. THE SIXTEENTH AND SEVENTEENTH CENTURIES

Adel T. Adamova, "On the Attribution of Persian Paintings and Drawings of the Time of Shah 'Abbas I: Seals and Attributory Inscriptions," *Robinson Festschrift* (2000), pp. 19–38

Massumeh Farhad, "Safavid Single Page Painting 1629–1666," unpublished doctoral dissertation, Harvard University, 1987 (see also VI, Single-sheet images)

Grace Dunham Guest, *Shiraz Painting in the Sixteenth Century*, Washington D.C., 1949

B. W. Robinson, "Painter-Illuminators of Sixteenth-Century Shiraz," *Iran*, XVII, 1979, pp. 105–09 and plates

Ivan Stchoukine, *Les peintures des manuscrits Safavis de 1502 à 1587*, Paris, 1959

——, *Les peintures des manuscrits de Shah Abbas Ier à la fin des Safavis*, Paris, 1964

Anthony Welch, *Artists for the Shah, Late Sixteenth-Century Painting at the Imperial Court of Iran*, New Haven and London, 1976 (see also VII, painters)

Stuart Cary Welch, *Wonders of the Age: Masterpieces of Early Safavid Painting, 1501–1576* (catalogue of a loan-exhibition held at the British Library, the National Gallery of Art in Washington, DC, and the Fogg Art Museum), Cambridge (Massachusetts), 1979

5. THE EIGHTEENTH AND NINETEENTH CENTURIES

S. J. Falk, *Qajar Paintings: Persian Oil Paintings of the 18th and 19th Centuries*, London, 1972

Nasser D. Khalili, B. W. Robinson, and Tim Stanley, *Lacquer of the Islamic Lands*, Oxford. Part One, 1996–7; Part Two, 1997 (see also VIII, Painters)

B. W. Robinson, "The Court Painters of Fath 'Ali Shah," *Eretz-Israel*, 7, 1964, pp. 94–105

——, "Painting in the Post-Safavid Period," *The Arts of Persia*, ed. by R[onald] W. Ferrier, Yale University Press, New Haven and London, 1989, pp. 225–31

Donna Stein, "Three Photographic Traditions in Nineteenth-Century Iran," *Muqarnas*, VI, 1989, pp. 112–30

Ulrich Marzolph, *Narrative Illustration in Persian Lithographed Books*, Leiden, Boston, Cologne, 2001

V. THE ILLUSTRATION OF MANUSCRIPTS

Farhad Mehran, "Frequency Distribution of Illustrated Scenes in Persian Manuscripts," *Student* (Data & Statistics), vol. 2, 4, October 1998, pp. 351-79

—— "Missing Paintings in Dismantled Persian Manuscripts," *Student* (Data & Statistics), vol. 4, 1, June 2001, pp. 61-78

1. HISTORICAL TEXTS

GENERAL

Richard Ettinghausen, "Historical Subjects: Islam," *Encyclopedia of World Art*, VII, 1963, cols. 495–97

G. M. Meredith-Owens, "Islamic illustrated chronicles," *Journal of Asian History*, 5, 1971, pp. 20–34

Eleanor Sims, "The Turks and Illustrated Historical Texts," *Fifth International Congress of Turkish Art*, ed. by Géza Fehér, Budapest, 1978, pp. 747–72

AUTHORS AND TEXTS

Abu-Ja'far Muhammad al-Tabari, *Ta'rikh al rusul wa'l-muluk* (Persian translation by al-Bal'ami)

Eleanor Sims, with a contribution by Tim Stanley, "The Illustrations of Baghdad 282 in the Topkapı Sarayı Library in Istanbul," *Cairo to Kabul: Afghan and Islamic Studies presented to Ralph Pinder-Wilson,*

ed. by Warwick Ball and Leonard Harrow, London, 2001, pp. 222–27

Rashid al-Din, the *Jami' al-tawarikh*

Terry Allen, "Byzantine Sources for the *Jami' al-tawarikh* of Rashid al-Din," *Ars Orientalis*, XV, 1985, pp. 121–36

Sheila S. Blair, *A Compendium of Chronicles, Rashid al-Din's illustrated history of the world* (The Nasser D. Khalili Collection of Islamic Art, XXVII), London, 1995: the two halves of this important manuscript, long divided, are here published together in a reconstruction

Sheila R. Canby, "Depictions of Buddha Sakyamuni in the *Jami' al-Tavarikh* and the *Majma' al-Tavarikh*," *Muqarnas*, X, 1993, pp. 299–310

Burkhardt Brentjes, "The Fall of Baghdad and the Caliph al-Muta'sim in a Tabriz Miniature," *East and West*, 28, 1978, pp. 151–54

Basil Gray, "An Unknown Fragment of the 'Jami' al-Tawarikh' in the Asiatic Society of Bengal," *Ars Orientalis*, I, 1964, pp. 65–75

——, *The "World History" of Rashid al-Din: A study of the Royal Asiatic Society Manuscript*, London, 1978

Güner Inal, "Artistic Relationship Between the Far and the Near East as Reflected in the Miniatures of the Gami' al-Tawarih," *Kunst des Orients*, X, 1975, pp. 108–43

——, "Some Miniatures of the *Jami' al-Tavarikh* in Istanbul, Topkapı Sarayı Palace Museum, Hazine Library No. 1654," *Ars Orientalis*, V, 1963, pp. 163–175

Beyhan Karamağaralı, "Camiu't-Tevarih'in Bilinmeyen bir Nushasına ait dört Minyatür/Zu vier Miniaturen eine unbekannten Camiu't-Tevarih Handschrift," *Sanat Tarihi Yıllığı*, II, 1966–68, pp. 70–80 (Turkish), and pp. 81–86 (German text)

G[lyn] M[unro] Meredith-Owens, "Some remarks on the miniatures in the Society's *Jami' al-tawarikh*," *Journal of the Royal Asiatic Society*, 1970, pp. 195–99

David Talbot Rice, "Who were the painters of the Edinburgh Rashid al-Din," *Central Asiatic Journal*, 14, 1970, pp. 181–85

——, *The Illustrations of the World History of Rashid al-Din*, ed. by Basil Gray, Edinburgh, 1976

B. W. Robinson, "Rashid al-Din's World History: the significance of the miniatures," *Journal of the Royal Asiatic Society*, 1980, pp. 212–22

Abu Rayhan al-Biruni, *Athar al-baqiya 'an al-qurun al-khaliya*

Robert Hillenbrand, "Images of Muhammad in al-Biruni's Chronology of Ancient Nations," *Robinson Festschrift* (2000), pp. 129–49

P[riscilla] Soucek, "An Illustrated Manuscript of al-Biruni's *Chronology of Ancient Nations*," *The Scholar and the Saint, Studies in Commemoration of Abu'l-Rayhan al-Biruni and Jalal al-Din al-Rumi*, ed. by Peter J. Chelkowski, New York, 1975, pp. 103–68

'Ala' al-Din 'Ata Malik Juvayni, *Ta'rikh-i Jahangusha*

Teresa Fitzherbert, "Portrait of a lost leader, Jalal al-Din Khwarazmshah and Juvaini," *Oxford Studies in Islamic Art*, XII, 1995, pp. 63–75

Hafiz-i Abru, *Majmu'a al-tawarikh*

Richard Ettinghausen, "An Illuminated Manuscript of Hafiz-i Abru," *Kunst des Orients*, 2, 1953, pp. 30–44

Güner Inal, "Miniatures in Historical Manuscripts from the Time of Shahrukh in the Topkapı Palace Museum," *Timurid Art and Culture* 1989 (1992), pp. 103–15

Sharaf al-Din 'Ali Yazdi, *Zafarnama*

Thomas W. Arnold, *Bihzad and his paintings in the Zafar-namah MS.*, London, 1930

Eleanor G. Sims, "The Garrett Manuscript of the Zafar-name: A Study in Fifteenth Century Timurid Patronage," unpublished doctoral dissertation, New York University, 1973

——, "Ibrahim-Sultan's illustrated *Zafar-nameh* of 839/1436," *Islamic Art*, IV, 1990–1991, pp. 175–217

——, Ibrahim-Sultan's illustrated *Zafarnama* of 1436 and its impact in the Muslim East," *Timurid Art and Culture* 1989 (1992), pp. 132–43

——, "Sultan Husayn Bayqara's *Zafar-namah* and its Miniatures," *VIIth International Congress of Iranian Art*

& Archaeology, Oxford, September 11–16th 1972, Tehran, 1976, pp. 299–311

Emmy Wellesz and Kurt Blauensteiner, "Illustrationen zu einer Geschichte Timur's," Wiener Beiträge zur Kunst- und Kulturgeschichte Asiens, x, Studien zur islamischen Buchkunst, Vienna, 1936, pp. 20–34

Bijan's *Tarikh-i Jahangusha-yi Khaqan*, composed late in the 17th century, and now dispersed:

Eleanor Sims, "The Dispersed Late-Safavid *Tarikh-i Jahangusha-yi Khaqan*: A manuscript with Mu'in style Illustrations," forthcoming in *Safavid Art and Culture*, London, 2002

Murtaza Quli's *History of the Safavids*, composed in 1667–1668, in the Chester Beatty Library, Dublin (P. 279):

A. J. Arberry, B. W. Robinson, E. Blochet, and J. V. S. Wilkinson, *The Chester Beatty Library, A Catalogue of the Persian Manuscripts and Miniatures*, Vol. III, Dublin, 1962, pp. 51–52

2. RELIGIOUS TEXTS

THE LIFE OF THE PROPHET

Priscilla P. Soucek, "The Life of the Prophet: Illustrated Versions," *Content and Context of Visual Arts in the Islamic World*, ed. by Priscilla Soucek, University Park and London, 1988, pp. 193–217

Zeren Tanındı, *Siyer-i Nabi: An Illustrated Cycle of the Life of Muhammad and its Place in Islamic Art* (in both Turkish and English), Istanbul, 1984: ostensibly on the important late 16th-century Ottoman *Siyar-i Nabi (Life of the Prophet)*, pp. 3–15 are a succinct summary of the development of such texts and images in the Eastern Islamic world

SPECIFIC TEXTS AND SUBJECTS

Ascension Scenes and the *Mi'rajnama*

Richard Ettinghausen, "Persian Ascension Miniatures of the Fourteenth Century," *Accademia Nazionale dei Lincei, 12, Convegno . . . Oriente e Occidente nel Medio Evo*, Rome, 1957, pp. 360–83 (see also IX, B, Religious painting)

Miraj-Nameh ou le voyage du Prophet, ed. du manuscrit supplément turc 190 de la Bibliothèque nationale de Paris, présenté et commenté par Marie-Rose Séguy, Paris 1977

Le Voyage Nocturne de Mahomet, composé, traduit et présenté par Jamel Eddine Bencheikh, suivi de *L'Aventure de la Parole*, Paris, 1988

3. DIDACTIC AND SCIENTIFIC TEXTS

Kalilah u Dimnah/Anwar-i Suhayli

Leila Benouniche, *Le Kalila et Dimna de Genève*, Geneva, 1995

Ernst J. Grube, "Prolegomena for a Corpus Publication of Illustrated *Kalilah wa Dimnah* Manuscripts," *Islamic Art*, IV, 1990–91, pp. 301–481: a catalogue of all then-recorded manuscripts of this text, both Arabic and Persian, with all subjects identified, and a massive bibliography up to the date of publication

A Mirror for Princes from India, Illustrated Versions of the Kalilah wa Dimnah, Anvar-i Suhayli, 'Iyar-i Danish, *and* Humayun Nameh, *Marg*, ed. by Ernst J. Grube, 1991: with contributions by François de Blois, Julian Raby, Ernst J. Grube, Eleanor Sims, Manijeh Bayani, Karl Khandalavala, and Kalpurna Desai

B. W. Robinson, "Two Persian Manuscripts in the Library of the Marquess of Bute, Part II: Anwar-i Suhayli (Bute MS 347)," *Oriental Art*, XVIII, 1972, pp. 50–56

Kitab al-Bulhan

Stefano Carboni, *Il Kitab al-Bulhan di Oxford*, Turin, 1988

Mu'nis al-Ahrar fi daqa'iq al-ash'ar

Marie Lukens Swietochowski and Stefano Carboni, with essays by A. H. Morton, and T. Masuya, *Illustrated Poetry and Epic Images: Persian Painting of the 1330s and 1340s*, New York, 1994

Nizami 'Arudi, *Chahar Maqala*

Eleanor Sims, "Prince Baysunghur's *Chahar Maqaleh*," *Sanat Tarihi Yıllığı*, VI, 1974–75, pp. 375–409

4. POETIC TEXTS

Asafi, *Jamal u Jalal*

K. V. Zetterseen and C[arl] J[ohan] Lamm, *Mohammed Asafi, The Story of Jamal and Jalal, An illuminated manuscript in the library of Uppsala University*, Uppsala, 1948

'Attar, *Mantiq al-tayr*

The Language of the Birds, Special issue of *The Bulletin of The Metropolitan Museum of Art*, New York, May 1976: Marie G. Lukens, "The Fifteenth-Century Miniatures," and Ernst J. Grube, "The Seventeenth-Century Miniatures"

Marie Lukens Swietochowski, "The Historical Background and Illustrative Character of the Metropolitan Museum's Mantiq al-Tayr of 1483," *Islamic Art in the Metropolitan Museum of Art*, 1972, pp. 39–72

Firdausi, *Shahnama*

Edward Davis and Jill Norgren, "A Preliminary Index of Shahnameh Illustrations," (Center for Near and Middle Eastern Studies, University of Michigan), Ann Arbor (typescript), 1969 (still the only available indexed gathering of *Shahnama* illustrations)

Nurhan Atasoy, "Four Istanbul Albums and Some Fragments from Fourteenth-Century Shah-namehs," *Ars Orientalis*, VII, 1970, pp. 19–48

——, "Illustrations prepared for display during Shahname recitations," *Memorial Volume of the Vth International Congress of Iranian Art and Archaeology, 11–18 April 1968*, Tehran, 1972, II, pp. 262–72

A[del] T. Adamova and L[eon] T. Gyuzal'yan, *Miniatyury rukopisi poemy "Shakhname" 1333 goda*, Leningrad, 1985: all 50 folios with paintings illustrated (in black and white, and many in color as well), and a brief English summary on pp. 159–62

A. M. Belenitsky, "Ancient Pictorial and Plastic Arts and the Shah-Nama," *Trudy Dvadtsa' Pyatogo Mezhdunarodnogo Kongressa Vostokovedov, Moskva, 9–'6 avgusta 1960*, III, Moscow, 1963, pp. 96–101 (see also VII, Monumental Painting)

Martin Bernard Dickson and Stuart Cary Welch, *The Houghton Shahnameh*, 2 vols., Cambridge and London, 1981: all 256 illustrations reproduced (the majority in muddy sepia) but all in one place, with copious notes on attributions to Safavid painters of the Tahmasp generation

Oleg Grabar and Sheila Blair, *Epic Images and Contemporary History: The Illustrations of the Great Mongol Shahnama*, Chicago, 1980

Grace Dunham Guest, "Notes on the Miniatures on a Thirteenth-Century Beaker," *Ars Islamica*, X, 1943, pp. 148–52

Robert Hillenbrand, "The Iconography of the *Shah-nama-yi Shahi*," *Safavid Persia*, ed. by Charles Melville (Pembroke Persian Papers, 4), 1996, pp. 53–78

Assadullah Souren Melikian-Chirvani, "Le Shah-Name, la gnose soufie, et le pouvoir mongol," *Journal Asiatique*, CCLXXII, 1984, 3–4, pp. 249–337

——, "Le Livre des Rois, miroir du destin," *Studia Iranica*, 17, 1988, pp. 7–46, especially pp. 40ff.: "La representation figurée du Shah-name"

——, "Le Livre des Rois, miroir du destin: II – Takht-e Soleyman et la symbolique du *Shah-Name*," *Studia Iranica*, 20, fasc. 1, 1991, pp. 33–148

——, "Les frises du *Shah-Name* dans l'architecture iranienne sous les Ilkhan," *Studia Iranica*, cahier 18, Paris, 1996

The Shah-Namah of Firdausi, With 24 Illustrations from a Fifteenth-Century Manuscript Formerly in the Imperial Library, Delhi, and now in the Possession of the Royal Asiatic Society, Described by J. V. S. Wilkinson, With an Introduction on the Paintings by Laurence Binyon, London, 1931

B. W. Robinson, "Unpublished Paintings from a XVth Century "Book of Kings," *Apollo Miscellany*, 1951, pp. 17–23

——, "Isma'il II's Copy of the Shahnama," *Iran*, XIV, 1976, pp. 1–8

——, "The Shahnama of Muhammad Juki, RAS. MS 239," *The Royal Asiatic Society: Its History and Treasures*, ed. by Stuart Simmonds and Simon Digby, Leiden and London, 1979, pp. 83–102

——, *The Persian Book of Kings: An Epitome of the Shahnama of Firdausi*, London and New York, 2002

Sayyid 'Abd al-Majid Sharifzada, *Namvarnama*, Tehran,

1370sh/1991–92

Marianna Shreve Simpson, *The Illustration of an Epic: The Earliest Shahnama Manuscripts*, London and New York, 1979

——, "The Narrative Structure of a Medieval Iranian Beaker," *Ars Orientalis*, XII, 1981, pp. 15–24

——, "A Reconstruction and Preliminary Account of the 1341 *Shahnama*, With Some Further Thoughts on Early *Shahnama* Illustration," *Robinson Festschrift* (2000), pp. 217–47

Eleanor Sims, "The Illustrated manuscripts of Firdausi's *Shahnama* Commissioned by Princes of the House of Timur," *Ars Orientalis*, XXII, 1992, pp. 43–68

——, "Towards a Study of Shirazi Illustrated Manuscripts of the "Interim Period": The Leiden *Shah-namah* of 840/1447," *Oriente Moderno*, ed. by Michele Bernardini, NS, XV (LXXVI), 2, 1996 [1998], pp. 611–25

Priscilla Soucek, "The Ann Arbor *Shahnama* and its Importance," *Robinson Festschrift* (2000), pp. 267–81

Stuart Cary Welch, *A King's Book of Kings: The Shahnama of Shah Tahmasp*, New York, 1972

Hafiz, *Diwan*

Güner Inal, "Onyedinci yüzyıldan bir Hafiz Divan'inin desenlerinde resim ve metin ilişkisi," *Suut Kemal Yetkin'e Armagan*, I, Ankara, 1984, pp. 165–201

Stuart C. Welch, "Miniatures from a Manuscript of Diwan-i-Hafiz," *Marg*, XI, No. 3, 1958, pp. 56–62

Jami, *Haft Aurang*

Marianna Shreve Simpson, "The Production and Patronage of the *Haft Aurang* by Jami in the Freer Gallery of Art." *Ars Orientalis*, XIII, 1982, pp. 93–119

——with contributions by Massumeh Farhad, *Sultan Ibrahim Mirza's Haft Awrang: A Princely Manuscript from Sixteenth-Century Iran*, New Haven and London, 1997

——, *Persian Poetry, Painting & Patronage: Illustrations in a Sixteenth-Century Masterpiece*, New Haven and London, 1998

Khwaju Kirmani, *Mathnawis*

J. C[hristoph] Bürgel, "Humay and Humayun, A Medieval Persian Romance," *Proceedings of the First European Conference of Iranian Studies* (Turin, September 7–11, 1987), *Rome Oriental Series*, LXVII, 2 parts, Rome, 1990, pp. 347–57

Teresa Fitzherbert, "Khwaju Kirmani (689–753/1290–1352): an Éminence Grise of Fourteenth Century Persian Painting," *Iran*, XXIX, 1991, pp. 137–51

Verna Prentice, "A Detached Miniature from the *Masnavis* of Khwaju Kermani," *Oriental Art*, I, N.S., 1981, pp. 60–66

Nizami, *Khamsa*

Larisa Nazarovna Dodkhudoeva, *Poemy Nizami v Srednevekovoi~ Minyatyurnoi~ Zhivopisi* (Poems of Nizami in Medieval Miniature Paintings: Index and Study), Moscow, 1985 (the only indexed gathering of *Khamsa* illustrations)

A[del] Adamova, "Repetition of Compositions in Manuscripts: The *Khamsa* of Nizami in Leningrad," *Timurid Art and Culture 1989* (1992), pp. 67–75

——, "The Hermitage Manuscript of Nizami's *Khamsa* Dated 835/1431," *Islamic Art*, V, 2001, pp. 53–132

Karin Adahl, *A Khamsa of Nizami of 1439. Origin of the miniatures – a presentation and analysis*, Uppsala, 1981

Laurence Binyon, *The Poems of Nizami*, London, 1928

Peter J. Chelkowski, *Mirror of the Invisible World: Tales from the Khamseh of Nizami*, with an essay by Priscilla P. Soucek, New York, 1975

Priscilla C. Soucek, "Illustrations to Nizami's *Khamseh*, 1386–1495," unpublished doctoral dissertation, New York University, 1971

Ivan Stchoukine, *Les peintures des manuscrits de la "Khamseh" de Nizami au Topkapı Sarayi Müzesi d'Istanbul*, Paris, 1977

Norah Titley, "A fourteenth-century Khamseh of Nizami," *The British Museum Quarterly*, 36, 1971, pp. 8–11

Sa'di, *Bustan and Gulistan*

Verna Prentice, "The Illustration of Sa'di's Poetry in Fifteenth-Century Iran," unpublished doctoral dissertation, Harvard University, 1977

B. W. Robinson, "The Durham *Gulistan*, an unpublished Timurid manuscript," *Oriental Art*, N.S. XXII, 1976, pp. 52–59

——, "An unpublished manuscript of the *Gulistan* of Saʿdi," *Beiträge zur Kunstgeschichte Asiens, In Memoriam Ernst Diez*, ed. Oktay Aslanapa, Istanbul 1963, pp. 223–36

Ivan Stchoukine, "Un Gulistan de Saʿdi illustré par des artistes timurides," *Revue des Arts Asiatiques*, X, 1936, pp. 92–96

Others: Amir Khusrau, ʿAyyuqi, Sultan Ahmad, Nauʿi

Amir Khusrau Dihlavi, *Khamsah*

Zeren Akalay, "Emir Husrev Dehlevi ve Topkapı Sarayı Müzesi Kütüphansinde bulunan minyatürlü esersi," *Kultur ve Sanat*, 5, 1977, pp. 8–19, and p. 188, for an English summary

Barbara Brend, *Perspectives on Persian Painting: Illustrations to Amir Khusrau's Khamsah*, London, 2002

G[alina] A[natol'evna] Pugachenkova, "O datirovke i proiskhozhdenii rukopisi ʿKhamse' Emir Khosrova Dekhlevi v sobranii Instituta Vostokovedeniya A[kademii] N[auk] Uz[beckistanskoi] SSR," [The dating and provenance of the MS of the *Khamsa* by Amir Khusraw Dihlawi in the Collection of the Oriental Institute of the Academy of Sciences of the Uzbek SSR], *Trudy A[kademii] N[auk] Tadzh[ikiskoi] SSR*, XVIII, Stalinabad, 1953, pp. 187–96

——, "Minyatyuri mastera musally v Shirazkom spiske ʿKhamse' Emir Khosrova Dekhlevi," *Trudy tashkentskogo Universiteta im V. I. Lenina, Arkheologiya Sdrednei Azii*, V, Tashkent, 1960, pp. 103–17

Norah Titley, "Miniature paintings illustrating the works of Amir Khusrau: 15th, 16th, 17th centuries," *Marg*, 28, iii, 1974–75, pp. 19–21

Sultan Ahmad's *Diwan*

F. R. Martin, *Miniatures from the Period of Timur in a MS. of the Poems of Sultan Ahmad Jalair*, Vienna, 1926

Deborah E. Klimburg-Salter, "A Sufi Theme in Persian Painting: The Diwan of Sultan Ahmad Galaʾir in the Free[r] Gallery of Art, Washington D.C.," *Kunst des Orients*, XI, 1976–77, pp. 43–84

Nauʿi's *Suz u Gudaz*

Massumeh Farhad, "'Searching for the New': Later Safavid Painting and the *Suz u Gawdaz* (Burning and Melting) by Nauʿi Khabushani," *The Journal of the Walters Art Museum*, 59, 2001, pp. 115–30

ANTHOLOGIES AND OTHER VOLUMES OF MIXED CONTENT

The Bihbahan Anthology of 1398:

Mehmet Aga-Oglu, "The Landscape Miniatures of an Anthology Manuscript of the year 1398 A.D.," *Ars Islamica*, III, 1936, pp. 76–98

The Berlin Anthology of 1420:

Volkmar Enderlein, *Die Miniaturen der Berliner Baisonqur-Handschrift*, Berlin, 1991 (*Bilderhefte der Staatlichen Museen zu Berlin, Heft* 1)

Ernst Kühnel, "Die Baysonghur-Handschrift der Islamischen Kunstabteilung," *Jahrbuch der preussischen Kunstsammlungen*, LII, 1931, pp. 133–52

An Anthology asociated with Ibrahim-Sultan in the mid-1430s:

Ernst J. Grube, "Ibrahim-Sultan's Anthology of Prose Texts," and Eleanor Sims, "The Hundred and One Paintings of Ibrahim Sultan," *Robinson Festschrift* (2000), pp. 101–27

VI. SINGLE-SHEET IMAGES

1. PAINTINGS

Massumeh Farhad, "Safavid Single Page Painting 1629–1666," unpublished doctoral dissertation, Harvard University, 1987

2. DRAWINGS

Esin Atıl, *The Brush of the Masters, Drawings from Iran and India*, Washington, D.C., 1978

B. W. Robinson, *Persian Drawings from the 14th through the 19th Century*, New York, 1965: mostly discusses paintings but includes some drawings as well

Marie Lukens Swietochowski and Sussan Babaie,

Persian Drawings in The Metropolitan Museum of Art, New York, 1989

VII. "MONUMENTAL" PAINTING

A. M. Belenitsky, "Ancient Pictorial and Plastic Arts and the Shah-Nama," *Trudy Dvadtsaʾ Pyatogo Mezhdunarodnogo Kongressa Vostokovedov, Moskva, 9–ʾ6 augusta 1960*, III, Moscow, 1963, pp. 96–101 (see also V, 4, Poetic texts)

Layla S. Diba, "Invested with Life: Wall Painting and Imagery before the Qajars," *Iranian Studies*, vol. 34, 2001

Ehsan Echraghi, "Description contemporaine des peintures murales disparues des palais de Sah Tahmasp à Qazvin," *Art et société dans le monde Iranien*, (Institut Français d'Iranologie de Téhéran, Bibliothèque Iranienne No. 26), ed. by C[hahriyar] Adle, Paris, 1982, pp. 117–26

Lis Golombek, "The *Paysage* as Funerary Imagery in the Timurid Period," *Muqarnas*, X, 1993, pp. 241–52

Ernst J. Grube and Eleanor Sims, "Wall Paintings in the Seventeenth Century Monuments of Isfahan," *Iranian Studies, Journal of The Society for Iranian Studies*, VII, (*Studies on Isfahan*, ed. by Renata Holod), 1974, pp. 511–42

Thomas W. Lentz, "Dynastic Imagery in Early Timurid Wall Painting," *Muqarnas*, X, 1993, pp. 253–65

Eleanor Sims, "Five Seventeenth-Century Persian Oil Paintings," *Persian and Mughal Art*, ed. by Michael Goedhuis, London, 1976, pp. 221–48

——, "Late Safavid Painting: The Chehel Sutun, the Armenian Houses, the Oil Paintings," *Akten des VII. Internationalen Kongresses für Iranische Kunst und Archäologie, München, 7.–10. September 1976*, Berlin, 1979 (Deutsches Archäologisches Institut, Abteilung Teheran, *Archaeologische Mitteilungen aus Iran, Ergänzungsband 6*), pp. 408–18

——, "Zand and Qajar 'Descendants' of Full-length Safavid Oil-Paintings," papers delivered at a symposium on Qajar Art and Culture, London, forthcoming

In addition, large-scale painting of the 18th and 19th centuries has recently been discussed in great detail, in *Royal Persian Paintings, The Qajar Epoch, 1785–1925*, (catalogue of a loan-exhibition at the Brooklyn Museum of Art and the Los Angeles County Museum of Art), London, 1998 (see also III, Exhibition catalogues); and throughout the oeuvre of B. W. Robinson, especially in his collected *Studies in Persian Art* (1 above)

VIII. PAINTERS

GENERAL

Persian Masters, five centuries of painting, ed. by Sheila R. Canby, Bombay, 1990

Stuart Cary Welch, *Wonders of the Age: Masterpieces of Early Safavid Painting, 1501–1576*, Cambridge, Mass., 1979: detailed – if attributive – discussions on the Safavid painters of the time of Shah Tahmasp Safavi

"Siyah Qalam"

Between China and Iran, Paintings from Four Istanbul Albums, ed. by Ernst J. Grube and Eleanor Sims, *A Colloquy held 23–16 June 1980, Colloquies on Art & Archaeology in Asia* No. 10, University of London, Percival David Foundation of Chinese Art, School of Oriental and African Studies, New York, 1980, also published as *Islamic Art*, I, 1981: deals with the paintings in H. 2152, H. 2153, and H. 2154, many of which are attributed to "Siyah Qalam"

M. Ş Ipşiroğlu, *Siyah Qalem, Vollständige Faksimile Ausgabe der Blätter des Meisters Siyah Qalem aus den Besitz des Topkapı Saray Müzesi, Istanbul, und Freer Gallery of Art, Washington*, Graz, 1976

J. M[ichael] Rogers, "Siyah Qalam," *Persian Masters* (1990, ed. Canby), pp. 21–38

Pir Muhammad Bagh-Shimali

B. W. Robinson, "'Zenith of his Time': The Painter Pir Ahmad Baghishimali," *Persian Masters* (1990, ed. Canby), pp. 1–20

Mirak

A. S. Melikian-Chirvani, "Khwaje Mirak Naqqash," *Journal Asiatique*, CCLXXVI, 1988, pp. 97–146

Bihzad

R[ichard] Ettinghausen, "Bihzad," *Encyclopedia of Islam*, 2nd ed., I, 1960, pp. 1211–14, Pls. XXXIII–XXXVI

Thomas W. Lentz, "Changing Worlds: Bihzad and the New Painting," *Persian Masters* (1990, ed. Canby), pp. 39–54

Eustache de Lorey, "Behzad. Le Gulestan Rothschild," *Ars Islamica*, IV, 1937, pp. 122–43

——, "Behzad," *Gazette des Beaux-Arts*, 1938, pp. 25–44

Priscilla P. Soucek, "Bihzad," *Encyclopedia Iranica*, IV, 1990, pp. 49–50

Sultan-Muhammad

Priscilla Soucek, "Sultan Muhammad Tabrizi: Painter at the Safavid Court," *Persian Masters* (1990, ed Canby), pp. 55–70

Mir Sayyid ʿAli

Anthony Welch, "The Worldly Vision of Mir Sayyid ʿAli," *Persian Masters* (1990, ed. Canby), pp. 85–98

Shaykh Muhammad

Marianna Shreve Simpson, "Shaykh-Muhammad," *Persian Masters* (1990, ed. Canby), pp. 99–112

Muhammadi

B. W. Robinson, "Muhammadi and the Khurasan Style," *Iran*, XXX, 1992, pp. 17–29, and Pls. IV–XI

Sadiqi

Anthony Welch, *Artists for the Shah, Late Sixteenth-Century Painting at the Imperial Court of Iran*, New Haven and London, 1976

Riza

Sheila R. Canby, *The Rebellious Reformer: The Drawings and Paintings of Riza-yi ʿAbbasi of Isfahan*, London, 1996

Muʿin

Massumeh Farhad, "The Art of Muʿin Musavvir: A Mirror of his Times," *Persian Masters* (1990, ed. Canby), pp. 113–28

Muhammad Zaman

Anatol A. Ivanov, "The Life of Muhammad Zaman: A Reconsideration," *Iran*, XVII, 1979, pp. 65–70

Eleanor Sims, "Towards a Monograph on the 17th-Century Iranian Painter Muhammad Zaman ibn Hajji Yusuf," *Islamic Art*, V, 2001, pp. 183–99

Abu'l-Hasan Ghaffari

Layla S. Diba, "Persian Painting in the Eighteenth Century: Tradition and Transmission," *Muqarnas*, VI, 1989, pp. 147–60, especially 154–57

Other 18th- and 19th-century artists are dealt with in great and useful detail, if not yet monographically, in the following recent works:

Nasser D. Khalili, B. W. Robinson and Tim Stanley, *Lacquer of the Islamic Lands*, Oxford. Part One, 1996–7; Part Two, 1997

Layla S. Diba, with Maryam Ekhtiar, *Royal Persian Paintings, The Qajar Epoch, 1785–1925*, Essays by B. W. Robinson, Abbas Amanat, Layla S. Diba, Maryam Ekhtiar, Adel T. Adamova, Afsaneh Najmabadi, Peter Chelkowski (catalogue of a loan-exhibition at the Brooklyn Museum of Art and the Los Angeles County Museum of Art), London, 1998

Julian Raby, *Qajar Portraits: An album of the additional works of art included in the London showing of the exhibition Royal Persian Paintings, The Qajar Epoch, 1785–1925*, London, 1999

IX. SPECIFIC SUBJECTS AND PROBLEMS

A. ON THE LAWFULNESS OF PAINTING IN ISLAM

K. A. C. Creswell, "The Lawfulness of Painting in Early Islam," *Ars Islamica*, XI–XII, 1946, pp. 159–66; reprinted in *Islamic Culture*, XXIV, 1950, pp. 218–225:

both are revised and extended versions of the relevant section in his *Early Muslim Architecture*, I, 1932, pp. 269–71

Bishr Fares, "Philosophie et jurisprudence illustrée par les Arabes. La Querelle des Images en Islam," *Mélanges Louis Massignon*, Institut Français de Damas, 1957, pp. 77–109

Oleg Grabar, "Islam and iconoclasm," *Papers given at the Ninth Spring Symposium of Byzantine Studies, Birmingham, 1975*, ed. A. Bryner and J. Herrin, Birmingham, 1977, pp. 45–52

M. Ş. Ipşiroğlu, *Das Bild im Islam, Ein Verbot und seine Folgen*, Vienna and Munich, 1971

Henri Lammens, "L'attitude de l'Islam primitif en face des arts figures," *Journal Asiatique*, 11, sér. 6, 1915, pp. 239–79

Zaki Muhammad Hassan, "The attitude of Islam towards figurative painting," *The Islamic Review*, XLIV, No. 7, 1956, pp. 24–9

Daan van Reenen, "Das Bilderverbot, a new survey," *Der Islam*, 67, 1990, pp. 27–77.

B. RELIGIOUS PAINTING IN ISLAM

Thomas W. Arnold, *The Old and the New Testament in Muslim Religious Art*, London, 1932

Richard Ettinghausen, "Persian Ascension Miniatures of the Fourteenth Century," *Accademia Nazionale dei Lincei, 12, Convegno . . . Oriente e Occidente nel Medio Evo*, Rome, 1957, pp. 360–83 (see also V, 2, Religious Texts)

Miraj-Nameh ou le voyage du Prophet, ed. du manuscrit supplément turc 190 de la Bibliothèque nationale de Paris, presenté et commenté par Marie-Rose Séguy, Paris, 1977

Sarwat Okasha, *The Muslim Painter and the Divine, The Persian Impact on Islamic Religious Painting*, London, 1981

Karin Rührdanz, "The Illustrated Manuscripts of Athar al- Muzaffar: A History of the Prophet," *Robinson Festschrift*" (2000), pp. 201–14

Le Voyage Nocturne de Mahomet, compose, traduit et presente par Jamel Eddine Bencheikh, *suivi de L'Aventure de la Parole*, Paris, 1988

Shi'ite Themes

Maria Vittoria Fontana, "Nota sull'interpretazione di una miniatura di soggetto shiita," *Un ricordo che non si spegne, Scritti . . . in memoria di Alessandro Bausani* (Istituto Universitario Orientale, Dipartimento di Studi Asiatici, Series Minor, L), Naples, 1995, pp. 59–75

——, "Una rappresentazione 'shiita' di Medina," *Annali dell'Istituto Orientale di Napoli*, 40 (N.S. XXX), 1980, pp. 619–25

Sufi Themes

Chahriyar Adlé, *Écriture de l'Union: Reflets du temps des troubles, Oeuvre picturale (1083–1124/1673–1712) de Haji Mohammad*, Paris, 1980

Eva Baer, "Aspects of Sufi influence on Iranian art," *Acta Iranica*, 12, *Textes et mémoires*, V, 1976, pp. 1–12

Olympiade Galerkina, "Sufiyskie motivy v iransko miniatyure vtoroy poloviny XVI v." [Sufi motifs in Iranian miniatures of the 16th century], *Iskussvo i arkheologiy Irana*, 1971, pp. 102–10

Peter Greafke, "The Garden of Light and the Forest of Darkness in Dakkini Sufi Literature and Painting," *Artibus Asiae*, XLVIII, 1987, pp. 224–45

C. THE SURVIVAL OF PRE-ISLAMIC THEMES AND MOTIFS

Thomas W. Arnold, "The Survival of Sasanian Motifs in Persian Painting," *Studien zur Kunst des Ostens*, Vienna, 1923, pp. 95–97

——, *Survivals of Sasanian and Manichaean Art in Persian Painting*, Oxford, 1924

1. BAHRAM GUR

Richard Ettinghausen, "Bahram Gur's Hunting Feats or the Problem of Identification," *Iran*, XVII, 1979, pp. 25–31, Pls. I–X

Maria Vittoria Fontana, "Re Bahram e la sua schiava nei manoscritti d'epoca timuride," *Atti del III Convegno Internazionale sull'Arte e sulla Civiltà Islamica: Problemi dell'età timuride, Atti del III Convegno Internazionale sull'Arte e sulla Civiltà Islamica, Venezia 22-25 Ottobre, 1979, Quaderni del Seminario di Iranistica, Uralo-Altaistica e Caucasologia dell'Università degli Studi di Venezia*, 8, 1980, pp. 91–113, Figs. 1–32

——, *La leggenda di Bahram Gur e Azada, Materiale per la storia di una tipologia figurativa dalle origini al XIV secolo*, Naples, 1986. (Istituto Universitario Orientale, Dipartimento di Studi Asiatici, *Series Minor*, XXIV)

Marianna Shreve Simpson, "Narrative Allusion and Metaphor in the Decoration of Medieval Islamic Objects," in *Pictorial Narrative in Antiquity and the Middle Ages*, ed. Herbert L. Kessler and Marianna Shreve Simpson (*CASVA Studies in the History of Art*, 16), Washington, DC, 1985, pp. 131–49

D. LAYOUTS AND MODULES

Chahriyar Adle, "Recherche sur le module et le trace correcteur dans la miniature orientale," *Le Monde Iranien et l'Islam*, III, 1975, pp. 81–105

Grace Dunham Guest, *Shiraz Painting in the Sixteenth Century*, Washington D.C., 1949

Elaine Wright, *The Look of the Book: Manuscript Production in the Southern Iranian City of Shiraz from the early 14th Century to 1452* (Oxford Studies in Islamic Art), Oxford 2003

E. ALBUMS

The Istanbul and The Diez Albums

Chahriyar Adle, "Autopsia, in absentia, Sur la date de l'Introduction et de la constitution de l'Album de Bahram Mirza par Dust Mohammad en 951/1544," *Studia Iranica*, 19, 1990, pp. 219–56

Between China and Iran, Paintings from Four Istanbul Albums, ed. by Ernst J. Grube and Eleanor Sims, *A Colloquy held 23–16 June 1980, Colloquies on Art & Archaeology in Asia No. 10*, University of London, Percival David Foundation of Chinese Art, Schoool of Oriental and African Studies, New York, 1980, also published as *Islamic Art*, I, 1981

M. Ş. Ipşiroğlu and E. Eyuboğlu, *Fatih albumuna bir Bakiş/ Sur l'album du Conquerant*, Istanbul [1955]

M. Ş. Ipşiroğlu, *Saray-Alben, Diez'sche Klebebande aus den Berliner Sammlungen* [*Verzeichnis der orientalischen Handschriften in Deutschland*, VIII], Wiesbaden, 1964

David J. Roxburgh, "Heinrich Diez and his Eponymous Album," *Muqarnas*, XII, 1995, pp. 112–36

——, "'Our Works Point to Us': Album Making, Collecting, and Art (1427–1565) Under the Timurids and Safavids," unpublished doctoral dissertation, University of Pennsylvania, 1996, 2 volumes

——, "Disorderly Conduct?: F. R. Martin and the Bahram Mirza Album," *Muqarnas*, XV, 1998, pp. 32–57. 2.

The Great Petersburg Album

Oleg F. Akimuskin, *Il Murakka di San Pietroburgo, Album di miniature indiane e persiane del XVI–XVIII secolo e di esemplari di calligrafia di Mir Imad al-Hasani*, Lugano and Milan, 1994

A[natol] A. Ivanov, T. B. Grek, & O[leg] F. Akimushkin, *Albom Indiiskikh i Persidskikh Miniatyur XVI–XVIII vv.*, Moscow, 1962

The St. Petersburg Muraqqa': Album of Indian and Persian Miniatures from the 16th through the 18th Century and Specimens of Persian Calligraphy by 'Imad al-Hasani [various authors but no editor listed], Lugano, 1996

X. WORDS ABOUT IMAGES: IRANIAN HISTORICAL WRITERS ON IRANIAN PAINTING

A. GENERAL

'Abd al-Hayy Habibi, "Literary Sources for the History of the Arts of the Book in Central Asia," Appendix I, *The Arts of the Book in Central Asia* (see IV, 3, above), pp. 273–80

A Century of Princes: Sources on Timurid History and Art, selected and translated by W. M. Thackston, Cambridge (Mass.), 1989

B. BIOGRAPHIES

Thomas Arnold, *Painting in Islam*, London, 1928, reprinted New York, 1965, with an introduction by B. W. Robinson, Chapter X: A Chapter of Biography (see also I, General)

C[lément] Huart, *Les Calligraphes et les Miniaturistes de l'Orient Musulman*, Paris, 1908, and photomechanical reprint, Osnabrück, 1978

Tazkira-yi Tuhfa-yi Sami: Persian text, ed. by Rukn al-Din Humayun-Farrukh, Tehran, 1347/1969; comments in English: Mahfuz ul-Haq, "Persian painters, illuminators, and calligraphists, etc., in the 16th century A.D.," *Journal of the Asiatic Society of Bengal*, n.s., XXVIII, 1932, pp. 239–49

Ta'rikh-i 'Alam-ara-yi 'Abbasi, Persian text ed. by Iraj Afshar, Tehran, 1334/1955; trans. R. M. Savory, the *History of Shah 'Abbas the Great*, 2 vols., Boulder, 1978

Mohammad Ali Karimzadeh Tabrizi, *The Lives & Art of Old Painters of Iran, And A Selection of Masters from the Ottoman & Indian Regions*, 3 vols., London, 1985–1991

——, *Qalamdan and Persian Lacquer-Work*, London, 2000

C. PREFACES

Sholeh A. Quinn, "The Historiography of Safavid Prefaces," *Safavid Persia*, ed. by Charles Melville (Pembroke Persian Papers, 4), 1996, pp. 1–25

David J. Roxburgh, *Prefacing the Image, The Writing of Art History in Sixteenth-Century Iran*, Leiden, Boston, Cologne, 2001 (Supplements to *Muqarnas*, IX)

D. TREATISES

Calligraphers and Painters: A Treatise by Qadi Ahmad, Son of Mir-Munshi (circa A.H. 1015/A.D. 1606), tr. V[ladimir] Minorsky, with an introduction by B. N. Zakhoder, (Freer Gallery of Art Occasional Papers, 3, number 2), Washington, DC, 1959

Marianna Shreve Simpson and Massumeh Farhad, "Sources for the Study of Safavid Painting and Patronage, or *Mefiez-vous de Qazi Ahmad*," *Muqarnas*, X, 1993, pp. 286–91

E. DOCUMENTS

On the 'arz-dasht, H. 2153, fol. 98r:

M. Kemal Özergin, "Temürlü Sanatina ait eski Belge: Tebrizli Ca'fer'in Bir Arzı," *Sanat Tarihi Yıllığı*, VI, 1974–75, pp. 471–94: English translations include that by Thackston, *Century*, pp. 323–27

INDEX

ILLUSTRATION CREDITS

The publishers and the author are grateful to the museums, galleries and private
individuals who supplied images for this book, most of whom are credited in the captions;
where there is additional information it is listed below. Illustrations in the historical survey chapters
are given Fig. numbers, all other numbers relate to the primary picture section.

Art and History Trust, Courtesy of the Arthur M. Sackler Gallery,
Smithsonian Institution Fig. 75; 25, 55, 146, 181

Boston, Museum of Fine Arts, Julia Knight Fox Fund, 3

Cleveland Museum of Art, Grace Rainey Rogers Fund, 229

East-West Foundation, Fig. 1, Fig. 3, Fig. 11, Fig. 25, Fig. 27, Fig. 35, Fig. 47,
Fig. 51, Fig. 53, Fig. 54, Fig. 56, Fig. 61, Fig. 62, Fig. 76, Fig. 80, Fig. 81, Fig. 82, Fig. 85, Fig. 89;
8, 16, 28, 36, 43, 75, 86, 90, 23, 101 , 103, 147, 153, 158, 161, 189, 191, 192, 195,
202, 203, 207, 209, 225, 235, 237, 249

The Metropolitan Museum of Art, New York:
Bequest of George D. Pratt, 1935: Fig. 73
Bequest of Monroe C. Gutman, 1974: 125, 136
Cora Timken Burnett Collection, 1957: Fig. 70; 156, 174, 227
Fletcher Fund, 1972: 27, 60, 98, 137, 167, 250
Gift of Alexander Smith Cochran, 1913: 100, 115, 238
Gift of Mr and Mrs Lester Wolfe, 1967: 52
H.O. Havemeyer Collection, Gift of Horace Havemeyer, 1941: 123, 129, 138
Joseph Pulitzer Bequest: 38, 214
Nishapur, Excavations of the Metropolitan Museum of Art, 1937: 30, 38
Rogers Fund, 1912: Fig. 24, Fig. 31, Fig. 32, Fig. 33, Fig. 36, Fig. 37, Fig. 40, Fig. 41;
145, 201 (and gift of the Schiff Foundation): 226
Ufa, Archeological Museum, photograph by Bruce White
© 2000 The Metropolitan Musuem of Art, Fig. 4

The Royal Collection © HM Queen Elizabeth II, Fig. 91; 10, 18, 87, 119, 134

Smithsonian Unrestricted Trust Funds, Smithsonian Collections Acquisition fund
and Dr Arthur M. Sackler: 141, 143, 150, 215

RMN, Fig. 6